YALE UNIVERSITY PRESS
PELICAN HISTORY OF ART
Founding Editor: Nikolaus Pevsner

Robert Treat Paine · Alexander Soper
THE ART AND ARCHITECTURE OF JAPAN
Part One brought up to date by D. B. Waterhouse
Part Two brought up to date by Bunji Kobayashi

After he left Harvard in 1928 Robert Treat Paine lived for over five years in Japan and consequently was familiar with most of its famous temples, private art collections, and museums. In 1932 he entered the Museum of Fine Arts, Boston. He was appointed Assistant Curator in 1945 and Curator in 1963. He died in 1965. His written publications include *Ten Japanese Paintings* (1939) and a number of long articles on Japanese prints.

Alexander Soper took his Ph.D. at Princeton University in 1944 after studying Japanese art and architecture at Kyōto from 1935 to 1938. In 1939 he was appointed Associate Professor in the History of Art at Bryn Mawr College, Pennsylvania, and in 1948 became Professor at the same college. Since 1960 he has been Professor of Fine Arts at the Institute of Fine Arts New York University. He has written numerous articles, and in 1942 published *The Evolution of Buddhist Architecture in Japan*. He is also the author of the section on architecture in *The Art and Architecture of China* which forms part of this series.

Robert Treat Paine and Alexander Soper

THE ART AND ARCHITECTURE OF JAPAN

Yale University Press · New Haven and London

First published 1958 by Penguin Books Ltd
Third edition (with revisions and updated notes and bibliography to Part One by
D.B. Waterhouse) 1981

20 19 18 17 16 15 14 13 12 11 10 9 8 7 6 5

Copyright © The Estate of Robert Paine and © Alexander Soper 1955, 1960, 1975, 1981

Set in Monophoto Ehrhardt, and printed in Hong Kong through World Print Ltd

Designed by Gerald Cinamon and Paul McAlinden

ISBN 0–300–05333–9
Library of Congress catalog card number 75–128606

CONTENTS

PART TWO: ARCHITECTURE
Alexander Soper

ACKNOWLEDGEMENTS TO PART ONE

In a book intended for the general reader, and especially in one which covers many aspects of a very general subject, it would have been confusing continually to name Japanese sources. A few oriental scholars are mentioned in the text and a few more in the selected bibliography, but my debt is much deeper than these scant references suggest.

In particular I would like to acknowledge help from the experts who accompanied the Exhibition of Japanese Painting and Sculpture Sponsored by the Government of Japan which was shown at five museums in the United States during 1953. The members who came with the exhibition to Boston were Mr Masao Ishizawa, Chief Curator, Professor Rikichirō Fukui, Dr Jirō Harada and Messrs Bunsaku Kurota, Sumio Ogushi, and Shigetaka Kaneko. The many recent changes in the ownership of famous Japanese works of art could not have been noted without their assistance.

For permission to reproduce some of the illustrations I wish to express my indebtedness to the following institutions: the Museum of Fine Arts, Boston, Massachusetts; the Freer Gallery of Art, Smithsonian Institute, Washington, D.C.; the Seattle Art Museum, Seattle, Washington; the Art Institute of Chicago, Chicago, Illinois; the Cleveland Museum of Art, Cleveland, Ohio; and the Metropolitan Museum of Art, New York.

Photographs of objects in Japan are difficult to acquire. Particular thanks go to the firm of Asukaen, Nara, which has specialized in sculptures in or near Nara and from which come many of the illustrations, supplemented by photographs provided by the University Prints, Newton, Massachusetts.

The Japanese literature relating to the history of their art is extensive not only in scholarly works but also in reproductive material. Among superbly illustrated books which have supplied illustrations special mention might be made of *Higashiyama Suibokuga Shū* in which many of the finest ink paintings of the Muromachi period have been reproduced.

For secretarial help in preparing the text I wish to thank several secretaries in the Asiatic Department of the Museum of Fine Arts, Boston, and above all to give thanks to my wife for much typing, advice, and encouragement.

ROBERT TREAT PAINE
Cambridge, Mass, 20 June 1954

EDITOR'S FOREWORD TO THE SECOND EDITION

However carefully prepared and written a scholarly book may be, after fifteen years it is bound to be in need of being brought up to date. Robert Paine died in 1965 and so could not do himself what needed doing. I therefore approached David Waterhouse, and I need not add that I did this with the full approval of Mrs Paine. 'Robert Paine', Professor Waterhouse wrote in a letter to me, 'brought to his task a lifetime's experience of Japanese art, and it will at once be discerned that he had a very special and personal approach to it and that his scholarship was always meticulous and detached.' This being so, Professor Waterhouse has principally brought up to date the many references to Japanese collections and has added to the bibliography a selection of works published since 1960.

As regards Alexander Soper, it was lack of time which prevented him from doing his revision. He suggested to me a friend of his who is also a friend of mine: Professor Bunji Kobayashi of Tōkyō. What Professor Kobayashi has done is marked in the text in ⟨angular brackets⟩. He pointed out to me that excavations and the study of documents have crowded the last few years and that he found it inappropriate to interfere more than absolutely necessary with Professor Soper's text. What he did do, however, beyond what I have already mentioned is a supplement to the bibliography.

NIKOLAUS PEVSNER
London, January 1972

PREFACE TO PART ONE (THIRD EDITION)

In preparing a new edition of Robert Paine's contribution to *The Art and Architecture of Japan*, I have had in mind the needs of serious Western students for whom his text is still one of the best available introductions to Japanese painting and sculpture. The main changes are to the Additional Bibliography, which, covering a much larger territory, has been expanded to the same scale as that for Part Two, and should serve above all as a guide to the vast Japanese literature. However, only books are listed, and I have confined myself to those topics actually discussed by Paine. Opportunity has also been taken to make further corrections to the text and to add occasional footnotes, including references to a few recent articles by Western scholars.

DAVID WATERHOUSE
June 1977

No revisions have been made to Part Two, apart from corrections to the elevations and plans of Shitennōji and Yakushiji (illustration 180) and of Hōryūji (illustration 182).

MANCHURIA

INNER MONGOLIA

CHAHAR

• Mukden

JEHOL

Huang-ho

The Great Wall

Ta-tung-fu

Peking

S H A N S I

Pao-ting-fu

HOPEI

Liao-tung Pen.

K O R E A

Cheng-ting

Seoul

Fen R.

Tsi-nan

Tsing-tao

YELLOW

Hsi-an-fu (Ch'ang-an) •

Lo-yang

K'ai-feng

K I A N G S U

SEA

HONAN

Huai R.

Yang-tse-kiang

Nanking

Yang-tse-kiang

Hankow

Hang-chow

EAST

CHEKIANG

CHINA

Ch'ang-sha

Nan-chang

SEA

N

FUKIEN

Ryukyu Islands

Scale of Miles

0 300

Formosa

CHRONOLOGICAL TABLE

552–645 ASUKA
 Suiko's reign: 593–628

645–710 EARLY NARA (LATE ASUKA)
 Hakuhō era: 673–685

710–784 LATE NARA
 Tempyō era: 729–748

784–897 EARLY HEIAN
 Kōnin era: 810–823
 Jōgan era: 859–876

898–1185 MIDDLE AND LATE HEIAN (FUJIWARA)

1185–1333 KAMAKURA

1333–1573 MUROMACHI (ASHIKAGA)
 Nambokuchō (the north-south schism): 1336–1392

1573–1614 MOMOYAMA

1615–1867 EDO (TOKUGAWA)

1868– RESTORATION

GLOSSARY TO PARTS ONE AND TWO

In Romanizing Japanese words it is virtually impossible to achieve an absolute consistency in regard to such editorial niceties as hyphens and capitalization. The list given below has been made as systematic as is usually possible. Names or titles have been distinguished by a capital. Hyphens have been used to show the grouping of ideas in a compound, as in *toko-no-ma*, originally a space-for-a-bed. They have also proved a convenient way of breaking up what would otherwise have looked like a diphthong, as in *fusuma-e*.

Amidadō. A hall consecrated to the Buddha Amida.

be. An hereditary corporation.
beni-e. A print with a dominant tone of rose-red derived from saffron.
benizuri-e. A print generally using two or three colour blocks.
bō. The primary city block, comprising a varying number of *chō.*
Bosatsu. Japanese word for Bodhisattva.
bu. A unit of money equalling 1000 *mon.*
Bugaku. A kind of dance in which masks covering only the face were worn.
buke-zukuri. The residential type of dwelling of the warrior class.
bunjinga. The Literary Men's style of painting.
busshi. Artists attached to Buddhist temples.
Butsuden. A Buddha hall.

Ch'an. The meditative sect of Buddhism in China.
chashitsu. A chamber or small building for the tea ceremony.
chigi. Scissors-shaped finials on a Shintō roof.
chinsō. Portraits of Zen priests in their official robes.
chō. The first subdivision of the city block, *bō.*
chōdai. A bed alcove.
Chōdōin. The Hall of State precinct in the imperial palace.
chūban. A size of paper, used for prints, measuring about eleven by eight inches, sometimes smaller.
chūjin. An area in the Buddha hall, intermediate between the sanctuary, *naijin*, and the outer, public area, *gejin.*

Daibutsuden. A hall enshrining a colossal Buddha image.
Daidairi. The imperial palace.
daidan. A low table-altar used in Tantric Buddhist ceremonies.
Daigokuden. The Hall of State ⟨or the Throne Hall⟩.
daimyo. Feudal lords of provinces.
dhārani. A Buddhist spell or incantation.
dōtaku. A kind of bronze 'bell'.

ebi-kōryō. A curving beam, named because of its fancied resemblance to a shrimp.
Echizen no Kami. A title used in the Tosa family of artists.
Edakumi-ryō. Bureau of Painters.
Edo. Former name of Tōkyō.
Edokko. A native of Edo.
Edokoro. Bureau of Painters.
Edokoro no Azukari. An hereditary title in the Tosa family as painters to the court.
ema. A votive painting.
emakimono. A horizontal scroll painting to be unrolled by hand.
engawa. An outer veranda in a house.
eshi. A painter.

fusuma-e. Paintings on sliding wall panels.

gejin. The outer, public area at the front of a Buddha hall.
gegyō. The pendant at the apex of a gable, named because of its fancied resemblance to a hanging fish.
genkan. An entrance vestibule.

genpitsu. A manner of painting with a reduced number of brush strokes.

Gigaku. A type of comic dance in which masks covering the whole head were worn.

Godaidō. A hall consecrated to the Five Great Wrathful Gods.

goeidō. See *mieidō.*

gongen-zukuri. A tripartite hall type, in which sanctuary, public space, and an intermediate area are all distinguished on the exterior.

gyō. A calligraphic term applied to somewhat abbreviated strokes.

Hachiman-zukuri. A simpler version of *gongen-zukuri*, used to worship the Shintō god Hachiman.

haiden. A free-standing building for public worship, in front of a sanctuary (usually Shintō).

haikai. A poem in seventeen syllables.

hanegi. A long, tree-trunk cantilever, concealed inside the roof to support the eaves overhang.

haniwa. Clay cylinders, sometimes with plastic figures.

hashira-e. A narrow vertical print to be hung.

hatamoto. A direct feudatory of the shōgun.

hattō. The lecture hall of a Zen monastery.

Heian. The ancient name of Kyōto as capital.

Heijō. The ancient name of Nara as capital.

Hieizan. The mountain headquarters of the Tendai sect, north-east of Kyōto.

hisashi. A roofed veranda-like area.

Hōgen. A Buddhist title, literally the Eye of the Law.

Hōin. A Buddhist title, literally the Seal of the Law.

Hōjō. The abbot's quarters in a Zen monastery.

Hokkyō. A Buddhist title, literally the Bridge of the Law.

honden. The main hall or sanctuary (usually Shintō).

honji suijaku. The identification of local deities with Buddhist gods.

hoso-e. A small, narrow print.

hsiang. The ancient Chinese equivalent of *hisashi*; a wing.

hsien. An ancient Chinese roofed porch.

imibe. Abstainers.

Issai-kyō. The whole collection of *sūtras* composing the Buddhist canon.

Jātaka. Stories of the previous lives of the Buddha.

-ji. Often at the end of a word means temple.

Jikidō. The refectory of a Buddhist monastery.

jinja. A Shintō shrine.

Jōdo. The popular Buddhist sect founded by Hōnen (1133–1212), which promises rebirth in Amida's Paradise.

Jōdodō. A hall for rites intended to bring rebirth in Amida's Paradise.

Jōmon. The prehistoric, pre-metal culture characterized by cord-impressed pottery.

Kabuki. The popular theatre.

kaerumata. An inter-beam support, named from its fancied resemblance to frog's legs.

kaidan. A platform of ordination.

Kaisandō. A memorial chapel to a temple's founder.

kakemono. A painting mounted for hanging vertically.

kakemono-e. A print made as a substitute for a *kakemono.*

Kwannondō or *Kannondō.* A hall consecrated to Kwannon or Kannon.

karahafu. A curving, ornamental, 'Chinese' gable form.

Karayō. The 'Chinese style' of Kamakura period architecture (actually the official code of Southern Sung).

katsuogi. Billets set crosswise on the ridge of a Shintō building.

kibana. The moulded or sculptured free end of a beam.

kirikane. Patterning in cut gold leaf.

kō. Conceived.

kōan. A question given Zen monks as a test of their understanding.

koku. A measurement for rice equalling about five bushels.

Kōkyo. The imperial residential precinct.

kondō. The main, 'golden hall' of a Buddhist monastery.

Kongō-kai. The eternal or Diamond World.

Kongō-rikishi. See Niō.

koto. A kind of zither with thirteen strings.

Kōyasan. The mountain headquarters of the Shingon sect, east of Wakayama.

Kudara. The Japanese name for the Korean realm of Pekche.

Kuratsukuribe. The Saddlers' Corporation.

-kyō. Often at the end of a word means sūtra.

Kyōzō. The library of a Buddhist monastery.

magatama. Curved jewels.

magobisashi. A second roofed veranda outside the *hisashi.*

mandala. A schematized grouping of Buddhist deities, in Japanese *mandara.*

Mappō. The End of the Law, when the power of Buddha would cease to be manifested.

meisho. A view of a famous place.

mieidō. A hall commemorating the founder of the Shin sect.

misasagi. An imperial mausoleum.
misogi. A Shintō purification ceremony.
mitsuda-e. Painting in oil and oxide of lead.
miya. A Shintō shrine or a palace.
mizu-e. A type of print with faintly printed outlines.
mokoshi. An outer aisle under a penthouse roof.
mon. A unit of money.
mondō. A method of dialogue in the Zen sect.
moriage. Building of patterns in raised gesso.
moya. The central space under the main roof of a house.
muro. An underground chamber.

nagare-zukuri. A shrine type having the gable broadside to, with the front roof prolonged to shelter the staircase.
naijin. The sanctuary of a Buddhist hall.
namban. A picture of foreigners.
Nandaimon. The 'great south gate' of a temple or shrine.
Nehan. Japanese word for Nirvāṇa.
nembutsu. Repetition of the name of a Buddha.
Nenjū-gyōji. Annual rites and ceremonies.
Niō. Protectors of the Buddhist faith.
nise-e. A portrait in sketchy outline.
nishiki-e. A polychrome print.
Nō. The classic drama of Japan.

ōban. A size of paper, used for prints, measuring about fifteen by ten inches.
pradakṣiṇa. The ritual circumambulation of a Buddhist *stūpa*, hall, image, or altar.

raidō. An area for public Buddhist worship, either a free-standing building like the *haiden* or a *gejin*.
Raigō. The descent of a Buddha to this world.
ramma. A wooden transom frieze, usually carved in openwork.
renjū. A group or association.
rōnin. A warrior without a lord.
Ryōbu. Two parts, referring to the material and the eternal worlds as taught in the Shingon sect.
Ryōbu Shintō. Shintōism viewed from the standpoint of the teachings of the Shingon sect. See *Ryōbu*.

sakaki. An Eurya ochnacea tree, a sacred tree.
samisen. A three-stringed musical instrument.
Sammon. The main gateway of a Zen monastery.
samurai. A feudal warrior.
satori. The moment of insight in Zen Buddhism.
Seiryōden. The imperial bedchamber hall.
settchūyō. The 'mixed' style of late Kamakura architecture.

shibi. An acroterion at the end of a Chinese-style ridge, named from its fancied resemblance to an owl's tail.
Shin. A popular Buddhist sect founded by Shinran (1174–1268).
shin. A calligraphic term applied to formal or static brush strokes.
shinden. The main, central building in a formally laid out upper-class residence of Heian and Kamakura.
shinden-zukuri. The residential type centring on a Shinden ⟨in the Heian period⟩.
Shingon. The Buddhist sect introduced from China by Kōbō Daishi (774–835), specializing in 'white magic'.
Shishinden. The informal audience hall in the imperial palace.
shōgun. The military dictator of Japan.
shoin. A library or reading alcove.
shoin-zukuri. A type of residential architecture that exploited the *shoin*.
shōrō ⟨or *shuro*⟩ The bell-tower in a Buddhist monastery.
shuji. A form of sacred, phonetic writing.
Shumidan. A platform altar whose moulded sides were thought to recall the hour-glass silhouette of the legendary Indian mountain Sumeru.
sō. A calligraphic term applied to a free or running brush stroke, the so-called 'grass' stroke.
stūpa. The domed architectural form developed in India to enshrine a cache of Buddhist relics.
sugoroku. A game played with counters.
suki. An aesthetic quality; artlessness.
sumi-e. Painting in ink monochrome.
surimono. A presentation print on special paper and elaborately printed.
sūtra. A book of the Buddhist canon.
suyari. A convention for representing clouds in band-like form.

tahōtō. The single-storeyed, Tantric type of pagoda.
tai-no-ya. A residential building next to the Shinden.
Taizō-kai. The material or Womb world.
tan-e. A print with a dominant tone of orange-red.
tarashikomi. A method of using wet pigments.
tatami. A floor mat.
Tendai. The Buddhist sect, half Tantric and half exoteric, introduced from China by Dengyō Daishi (767–822).
Tenjikuyō. The 'Indian style' of Kamakura architecture (actually a local style of the south Chinese coast), recently called Daibutsuyō.
tennin. A flying angel.
toko-no-ma. An alcove used to display a painting.
torii. The two-pillar gateway to a Shintō shrine.

tsukuri-e. A technique of painting in which a first outline is hidden under layers of colour and the visible outline is added last.

tsuridono. The waterside kiosk in a Heian mansion.

uki-e. A perspective picture.

ukiyo-e. Genre pictures and prints, especially those of the Edo period.

urabe. Diviners.

urushi-e. A print with colouring thickened and made glossy with glue.

Wayō. The 'native style' in Japanese Kamakura architecture.

Yamato. The name given to themselves and their home by the protohistoric Japanese.

Yayoi. The first metal-using culture in Japan.

Zen. The meditative sect of Buddhism, introduced from China in the thirteenth century.

THE ART AND ARCHITECTURE
OF JAPAN

PAINTING AND SCULPTURE

ROBERT TREAT PAINE

CHAPTER I

INTRODUCTION

The greatness of the early scholars of oriental art lay in their ability to see the art of Asia as constituting a body of traditions which had many points in common and many correlating influences; but that same breadth of view tended to emphasize points of similarity and dependence and to minimize national differences. The debt of Japan to the culture of China has often been stated in such a manner that the indigenous character of the art of the Island Empire has been depreciated or underestimated.

Like so many ancient arts, Japanese painting has remained essentially linear with colour applied in flat masses. In the wide potentialities of hair brush and Chinese ink it indubitably derived from the art of China. And, as in China, art avoided the rendering of forms in shadow or sculpturesque depth. Even sculpture was conceived primarily in terms of line.

The art of Japan is ordinarily one of concrete presentation dealing with visual facts rather than with abstractions, idealizations, or fanciful renderings, except under strong foreign influence. In the native Shintō religion the deities are regarded as spirits and so they remain, too mysterious to portray. The Shintō point of view is clearly to be recognized in the three imperial regalia – mirror, sword, and jewel – which are strictly symbols and not representations of divine power. A cultural antipathy to plastic or graphic expression has prevented the Shintō shrines from becoming great patrons of the arts. The absence of pictorial elements deriving from native mythology has closed one avenue of research which might have revealed ideas and forms original to Japan. The native religion has been almost completely obscured by the vast iconography of Buddhism which has supplied nearly all the religious art of Japan. The gods of Buddhism were represented anthropomorphically. This method of depiction arose from Buddhism in India or at least beyond the limits of western-most China. Unlike western art, that of the Far East rarely depicts abstract ideas such as Virtue or Dawn in glorified human form.

What is remarkable is the divergence between Japanese and Chinese standards in art. For any proper understanding of Japanese art it is essential to try to grasp the difference between the two cultures. Museum men in particular are plagued by the recurring question of how to distinguish Japanese art from

Chinese; yet the same inquirers would expect the arts of France, Spain, or Italy each to require an independent treatment.

Emotional values, those of an impressionable and appreciative spirit, were esteemed in Japan more than the fruits of reason and philosophy. In spite of the proximity of China and of successive waves of cultural influences coming in from the continent there is in Japan a freedom of feeling which stands in strong contrast to the ethical high-mindedness expressed in the arts of China and reflecting the social philosophy of Confucius. There is revealed a faith in accepted ideas rather than an intellectual curiosity about them. The amount, quality, and popularity of Buddhist art is one aspect of the greater emotional longing of the Japanese. For centuries the culture of Japan centred around the Buddhist church and so is opposed to the pattern of university culture in China. The ardent ritualism of the Shingon sect, the devotional faith of the Jōdo and Shin, and the unlearned intuitionalism of the Zen well expressed the artistic imagination of the people. It may be objected that the restraint, the controlled emotion, of the Zen should not be included in such a category, but the concentration of faculties needed to express the proper canons of serious Zen art could only be the result of a strong will and certainly not the product of a rationalizing mind.

The concrete and the particular were favoured in Japan as opposed to the universal in China. The scroll paintings of the medieval period portray an active interest in persons represented with much human sympathy. The subject was man, his loves, his battles, his enjoyment of nature, his social and his religious life. In each instance there was an emotional activity which distinguished this art from the more intellectual traditions of China. Chinese figure painting tends to illustrate the model conduct of sages of the past in dignified poses

befitting their virtuous natures. The Japanese genius is constantly asserting itself as a narrative one, whether in medieval scrolls, in genre paintings of Tosa or Kanō artists, or in the Ukiyo-e field of prints, made for and sold to the masses.

In China landscape art expresses the ideal relation of man to nature. In Japan nature, as the creation of the gods, was too divine to be viewed idealistically. In the field of bird and flower paintings, too, where the Chinese mind sought frequently for a symbolic or intellectual representation, the Japanese was satisfied with a simple statement close to life itself.

To the Japanese the world was an object of beauty and of pleasure. The satisfaction and the gaiety, which were basic, were sometimes tinged with Buddhist ideas of transitoriness or sometimes they reflected the ethical valuations of the Chinese, yet the pride of living in a country created physically by the gods, myths which in their day arose to explain the wonder the early inhabitants felt towards their bountiful land, derived from Shintō thought and gave to many forms of art an expression peculiarly Japanese.

There can be no doubt that the climate of Japan imposed on her artists a different attitude towards art problems. The city of Kyōto, the imperial capital, lies surrounded by hills and is frequently bathed in mists. The visibility, lower than that of the drier climate of many parts of China, has caused the artist in Japan to be more concerned with the strength of outline than with the subtleties of depth sought for by his Chinese neighbour. The decorative flatness and the higher colour of Japanese art also follow as products of the same climatic necessity.

The Japanese have at times been a feudal people and at all times were aristocratic. The ideas which came from China were constantly interpreted to meet the needs of the aristocracy. When the educational system of China was

adopted, it produced far different results. Japan's artists were seldom scholar-gentlemen in the Chinese sense. They arose from court and temple and craft and professional schools. In medieval times when Japanese art was most purely national their art developed along narrative and decorative rather than philosophical lines. Romance and legend, rather than ethics and history, appealed to the taste of the noble and warrior patrons.

The training and the technique of artists still further divide the two Far Eastern cultures. In Japan the school, lineage, and master are important relationships. In Chinese art most frequently a new style is born from the veneration of an artist for a particular ancient masterpiece. Japan's position is again a feudal one. The laborious method of painting in thick colours, whether in Buddhist icons, in scrolls, or in screen paintings, would not have occurred with such consistency had there not existed a long tradition of professional painting. This was not a technique which could be indulged in by the scholar-gentleman exhibiting his powers of brush and ink. The idea so frequently expressed in China that poetry and painting are almost identical arts, that painting is but poetry expressed in visible form, finds little sympathy among the Japanese except as a method of approach used occasionally, and then admittedly in the Chinese manner. In China the esteem for academic virtues, such as moral value, scholarly attitude, and calligraphic touch, has exercised a profound influence. The late, official, Chinese school of the

Kanō family in Japan accepted these ideas, but if it had not been for government patronage the style would not have held a dominant position so long. In fact, there have been few types of Chinese art which were not tried at one time or another in Japan, but there was also a succession of native developments the study of which alone can give a proper perspective in a history of art.

The Japanese feeling for art is summed up in the problem of decorative designing. Here the genius of the Japanese is admittedly unique in the Far East. Pattern is essentially something formal and non-intellectual. It derives from a luxury of feeling which can only satisfy itself by direct vision and lavish ornamentation. If one thinks of European parallels, of illuminated manuscripts or of Sienese painting, the analogy is again between arts dependent on faith and feeling rather than on reason and science. When the desire to be lavish and ornamental goes too far, art forms tend to become an end instead of a means of expression. But, when used with restraint, formal beauty, which starts and ends with enjoyment in the concrete aspect of things, becomes one of the great methods of aesthetic manifestation. The artists of the decorative school show such direct vision, such charm of statement, and such simplification of form that each detail of nature seems to be an object possessed of more than natural beauty. Japanese traditions exhibit both an ease of comprehension and a sensitivity to form which have made them the common property of a nation of art lovers.

THE EARLY JAPANESE

ARCHAIC PERIOD

Where the Japanese came from is one of those questions which, whatever the final solution may be, suggests clues of value to the student of art. The diverse beginnings of the Japanese race lead in many directions but not to ancient China, an area primarily centred on the Yellow River in north China. The origins of the Japanese can be most easily realized by consulting a map. The nearest body of land is the great peninsula of Korea. Next in importance geographically is the Black Current which comes from south China and which reaches the southern island of Japan, Kyūshū. Over the long land route came Tungusic people of Mongolian stock who were the Stone Age settlers of Korea. Over the sea route came other elements from Indonesia or from among Indo-Chinese tribes in what is now southern China. Long before the beginning of Japanese history these groups had coalesced sufficiently to be regarded as a single people, a people very distinct from those of China.

In the Neolithic Age there were both Ainu and Japanese inhabitants. The former need not concern us as they made no contribution to the final culture of Japan. The remains of the Japanese are so closely related to finds of the Stone Age in Korea that both peoples must be thought of as deriving from the same Tungusic stock. The Japanese of the Stone Age can be considered as racially akin to those whose stories form the central theme of the ancient histories. Even at this early period there seem to have been numberless waves of immigration. The mythology of the Japanese contains legends belonging both to mountain peoples and to seafaring peoples. All agree that the present race whose culture is so homogeneous descends from a heterogeneous ancestry. The early eighth-century histories, the *Kojiki* and the *Nihongi*, have preserved the legends of the Yamato people, or rather tribe, who were the real conquerors and unifiers of the nation. And as the Japanese of the myth cycles recorded in these histories were familiar with metals, their culture must be much later in date. The date of the first emperor of Japan, Jimmu, is now generally placed at about the beginning of the Christian era, but a period of more than a millennium must have preceded the first legendary comers. Chinese records depict Japan in the early centuries of the Christian era as a land of many kingdoms and of great female rulers.

Between the Stone and Iron Ages there is evidence of a short-lived bronze culture. The earliest pictures made in Japan occur on certain bronze 'bells' called *dōtaku*, objects of indeterminate origin, date, and use. The simple line drawings executed in low relief on panels which decorate the earlier of these bells are of great interest to the anthropologist. To the art historian, who would understand the development of a national Japanese art, these first pictures are important in subject-matter if not in execution. The panels show men hunting animals, scenes of birds, and occasionally a house or boat. Here is the primitive view of a hunting people.

Little is known of the bronze bell culture in Japan. It was localized near the centre of old Japan in the provinces lying near the present

city of Kyōto, and seems unrelated to other cultural elements which can be distinguished. In date the bells are assigned to a late period of the Stone Age. The closest analogy appears to be the bronze drums of the Miao tribes of southern China. There is little evidence of a true Bronze Age in Japan, and so separate has this culture seemed that little effort has been made to relate the finds to the total picture of Japanese art. The people who made the bells certainly could not have formed one of the dominant tribes of early Japan, but the point of view expressed in their art has a direct naturalness, a persistent characteristic to which close attention must be paid if the fundamental traits of the arts of Japan are to be followed and appreciated. The bell-makers were but one of many peoples who have provided contributory elements in the history of Japanese art.

The proto-historic period, the Iron Age, which began about the first or second century A.D., left monuments of great interest such as tombs and clay figures. The social organization of the time was based on the clan. Exceptional for such an organization was the existence of hereditary corporations or *be* of various professions and trades. The religion is sometimes characterized as a form of Shamanism, the religion of the Ural-Altaic peoples, in which gods, demons, or ancestral spirits were thought of as responsive to the special powers of mediums. Sometimes the religion is classified as ancestor worship, but, in any strict sense, this would denote an influence coming in later from China. The view of the religion as handed down in the rites of the imperial enthronement ceremonies preserves even more closely than do the myths the agricultural and naturalistic basis of early Shintō. Sir George Sansom sums up the religion as 'a nature worship of which the mainspring is appreciation rather than fear', an attitude which has a most profound bearing on the later history of art. The very name for Japan in the old texts as 'the land of fresh rice

ears of a thousand autumns' has significant connotations. Shintō has always been essentially polytheistic. The central deity was the Sun Goddess, Amaterasu, worshipped in particular by the imperial family. But the struggle between the position of this deity and the gods localized around the province of Izumo, where Korean influence was strong, is barely concealed in the ancient histories. Religion still remained in a pre-moral stage. Taboo and divination were more important than morals and devotion. One rite in particular, lustration or ceremonial ablution, seems to have remained to give a special flavour to Japanese custom and art.

The monuments of the time are the tumuli of the emperors or of great chieftains. Of these Robert K. Reischauer wrote, 'The mausolea of Ōjin-Tennō (*c.* 380–94) and Nintoku-Tennō (*c.* 395–427) are the greatest in area in the world and bear silent witness to the power and wealth of the Imperial Family during this, the golden age of old Japan.'[1] That of the emperor Nintoku took forty years to build. Around such tombs were rows of *haniwa* or clay cylinders, some of which were decorated with human figures or rarely with houses, horses, or birds. The traditional originator of the clay figures was Nomi no Sukune who in the reign of Suinin, probably late in the third century, recommended that the custom of burying alive the important retainers of a chief be discontinued and that clay figures be substituted in their place. To carry out his plan Nomi no Sukune had charge of a hundred men of the clay workers' *be* who came from the province of Izumo. Some scholars see in the idea of these figures the importation of a Chinese custom. However, in China such figures were generally placed inside the tomb, though there are examples which exist outside. In Japan both in execution and in use the haniwa seem to have been a native tradition. Unfigured clay tubes far outnumber the figure representations. Most

1. Figure of a man,
Archaic period, fourth-sixth century. Clay.
Boston, Museum of Fine Arts

show a circular base with holes on the sides which would permit of their being arranged in a fence-like manner. A reconstruction of their positions would clearly suggest the palisades decorated with carved wooden figures such as are to be found now in tombs of primitive groups in the former French Indo-China.[2]

These clay figures form the largest body of art works for the early period. Primitive they may be, certainly they are the work of craftsmen rather than of artists. They are native products, in character unlike any objects coming from the continent of Asia. Japanese critics see in them a directness or candour which they admire more than their simplicity. A general softness of modelling is sometimes mentioned as a trait which at a later time helps to distinguish works of art made by Japanese from those imported from the continent or made by immigrant craftsmen.

From a study of the costumes depicted, especially from gilt bronze and silver crowns which have also been discovered, it may be judged that the clothing was very similar to the costumes shown on wall paintings in tombs of the Koguryŏ period (37 B.C.–A.D. 663) in Korea.

The haniwa of a figure of a man [1] in the Museum of Fine Arts, Boston, shows a clay image wearing a sword and decorated with a necklace. The lower half is a simple tube with wide perforations at the sides. The hair of the men is often thus parted in the middle, but sometimes it may be tied behind the ears, a style also found in central Asia. Again, some of the figures show the short upper garment with tubular sleeves which was a costume spoken of by the Chinese as that of the barbarians of the north. The female figures and some of the male ones wore necklaces of curved jewels (*magatama*). These objects, akin to those which form one of the three imperial regalia, are known in various substances. Some are of jade, which it is supposed must have come from the

region of Lake Baikal in Siberia just to the north of Mongolia. The form itself is that of animal teeth, often of magical significance, such as are known in south Pacific cultures.

Some of the haniwa were in the form of arrow quivers. Taken in conjunction with the number of armoured men represented, one gets a picture of the military life of the time. The few line drawings preserved on the walls of some of the cave tombs show very similar military figures, but the drawing seems even less proficient than that of the dōtaku bells.

Japan in this early period had already achieved a considerable unity as a nation. In fact, shortly after the middle of the fourth century she held a dominant position in southern Korea. As a consequence there was a steady influx of culture coming to Japan from the continent. About A.D. 405 we hear of the Korean scholar Wani and the introduction of writing into Japan. The presence of scribes or record keepers must have opened the eyes of the Japanese to the possibilities of the written culture of China. About this time, too, we hear of many immigrants who were placed in charge of different corporations. Although most of the newcomers were probably Koreans of Chinese ancestry, some infiltration of direct Chinese culture may probably be dated as far back as the first century A.D.

The establishment of the various corporations of guilds added to the prestige of the imperial family, introduced new crafts which modified the ancient manner of life, and prepared the way for the great wave of continental culture which followed the conversion of the emperor Yōmei to Buddhism in 587. These corporations provide one of the distinctive features of early Japanese life. In religious life there were the *Imibe*, abstainers, and *Urabe*, diviners, whose hereditary functions are familiar now as family names.

The first mention of an hereditary corporation or *be* of painters occurred in the time of the emperor Yūryaku (457–79), who was eager to get skilled men from Korea. When the artisans arrived in Japan, they were settled in the province of Yamato. Among craftsmen such as brocade-weavers and saddlers we hear of Inshiraga, a Korean of Chinese descent, of the painters' guild. From this it may be imagined that some knowledge of the art of painting existed long before the time when extant objects can prove its existence. But more important still is the fact that art in Japan begins as a craft. Again and again in the course of her art history famous names arise from among the craftsmen of the minor arts. A comparison with the scholar-painters of China provides a contrast which goes far to explain some of the basic differences between the arts of the two peoples.

As one looks back at this early period there is ever present a marked contrast. On the one hand, the greatest body of the population and its contacts point towards Korea and culture coming from there. On the other hand, many of the dominant features such as rice planting, architecture, and sun-worship indicate a southern culture, that of the imperial clan, which was superimposed from above. Though the archaic period may be regarded as deficient in products of artistic significance, yet the pattern of culture as a whole had sufficient vitality to survive and to endow Japanese history with special national characteristics.

THE INTRODUCTION OF BUDDHISM

ASUKA PERIOD: 552–645
AND EARLY NARA PERIOD: 645–710

'This doctrine is amongst all doctrines the most excellent. But it is hard to explain, hard to comprehend. . . . This doctrine can create religious merit and retribution without measure and without bounds, and so lead on to a full appreciation of the highest wisdom.' These words accompanied the gift of a gilt bronze image of the Buddha presented in A.D. 552[1] by the king of Paekche (Kudara) in Korea to the emperor Kimmei of Japan.

The emperor replied that 'never from former days until now have we had the opportunity of listening to so wonderful a doctrine'. But after consultation with his ministers, it was feared that the wrath of the national gods might be incurred, so the worship of the foreign religion was left as an experiment to be tried by the head of the Soga clan. The first Buddhist temple[2] was built to house the image. A general pestilence followed, whereupon protests were made by the chief of the Mononobe clan, who headed the military party, and by the head of the Nakatomi, who had charge of the Shintō ritualists. The statuette was thrown into the Naniha canal and the temple burned. Thus the first official notice of Buddhism arose with a gift which had political implications in the relationship between Japan and the kingdom in Korea. Soon it became involved too with the rivalry between the liberal Soga party and the more conservative Mononobe.

The ultimate victory of Buddhism in Japan was to be so important culturally and the church was to be the patron of the arts for so long a period that its doctrinal aspects must be examined in order to present the religious ideas which all but buried the earlier Shintō beliefs.

Shintoism at the time of its initial encounter with Buddhist thought had evolved neither a cosmic nor a moral order to explain or to harmonize the mysteries of the universe. Reasoning had not yet been applied to relate the myriad gods into a consistent pantheon, nor were the native deities, who had power to bring good or evil fortune to man, graced with moral attributes. Ceremonial purification, agricultural and fertility rites, and divination combine to describe a society in a pre-moral stage. Ideas about a life after death seem to have been but a shadowy reflection of the life in this world.

Strange and revolutionary must have seemed the teachings of the Buddha and the doctrines which had evolved since his death. The Aryan Eightfold Path of right beliefs, right aspiration, right speech, right conduct, right mode of livelihood, right effort, right mindedness, and right meditation in its analytical, psychological, and individual emphasis must have been hard to understand. So, too, the Six Perfections of charity, fortitude, morality, patience, meditation, and intuitive wisdom must have been at first incomprehensible. The ideas of Buddhism, a philosophy in which the individual is awed by an endless cycle of births and deaths implied in the doctrine of karma or moral retribution, cannot at first have been as in-

fluential as the more immediate benefits of charitable institutions, broader education, and the hope of rebirth in Paradise.

The teachings of the historical figure of Gautama Buddha (567–488 B.C.) centred on the problem of the denial of the reality of the ego, of any ultimate or real self, and on the acquisition of enlightenment. The Buddha, the Awakened One, taught the Four Noble Truths of suffering, its cause, suppression, and the way to bring about the final extinction of suffering. Impermanence, the passing away of those things which we would most cling to, and desire, which is the cause of both suffering and spiritual ignorance, were the major themes. The Twelvefold Chain of Causation, which also traces a line of development from ignorance through desire to becoming and so on to old age and death, and the Eightfold Path were doctrines which developed to explain the misery of the actual world and the means of release. Buddhism is a strongly ethical teaching about a practical way of life. Metaphysically, existence is shown to be a continuing series of transformations. Buddhist doctrine is that of a 'middle way' avoiding the extremes both of self-indulgence and of self-mortification or asceticism. The ideal man is the arhat, the individual seeker after truth whose character is refined by self-development and spiritual insight. No doctrine of grace lightened the burden of struggling towards salvation through one's own powers. Nirvāṇa was a beatific state realized by the Buddha at the beginning of his ministry, not total annihilation nor the dream of some future life in Paradise. Buddhism incorporated in its belief the Indian doctrine of karma, the impartial justice in which man was made to inherit the consequences of his own acts. It implied both the freedom of the will to do good or evil and the continuity of life in the future. The doctrine of transmigration of souls could better be called the doctrine of metempsychosis, as it implied

not so much the carrying on of a soul as of characteristics which would direct karmic actions. The teachings of early Buddhism are known as the Hīnayāna, the Buddhism of the Lesser Vehicle.

In distinction to these theories the changes which developed with the scholars and patriarchs of the Buddhist church came to be spoken of as the Mahāyāna, the Greater Vehicle. The general evolution in many ways parallels that of early Christian doctrine where the accent changed from the figure of the human Christ to that of his spiritual and primordial existence. The historic Buddha became an immortal god. Ethical considerations yielded place to metaphysical philosophy. The reality of the Five Aggregates or elements of a being – form, feeling, perception, mental disposition, and consciousness – was denied, and in their place was substituted one Absolute whose nature can never be fully expressed. The Mahāyāna point of view is expressed by D. T. Suzuki in the preface to *The Laṅkāvatāra Sūtra* in these words: 'It is the Tathāgata's [Buddha's] great love (mahakarunā) of all beings, which never ceases until one of them is happily led to the final asylum of Nirvāṇa. . . . The essential nature of love is to devise, to create, to accommodate itself to varying changing circumstances, and to this the Buddha's love is no exception. He is ever devising for the enlightenment and emancipation of all sentient beings.'

Reality or the Absolute was regarded as all-pervading and Buddhahood became a quality inherent in every human being. The Buddha was but one incarnation out of many of this one reality, one aspect of a new trinity which approached at times to a great impersonal consciousness. The trinity consisted of three bodies – the Body of Incarnation, where deity was manifested in the world, the Body of Bliss, the ideal nature of all Buddhas, and the Body of the Law, the essential principle of existence.

The arhat ideal was replaced by that of the Bodhisattvas, beings whose merit acquired through countless lives was so vast that they became deities of bounteous compassion and whose wisdom was so great that they were the essence of perfect knowledge. The accent in the Mahāyāna was on super-individual powers. Under the force of such ideas Buddhism became polytheistic with a huge pantheon of gods. A slight extension of the doctrine of incarnation made it possible for local divinities to be absorbed and identified as avatars or manifestations of Buddhist gods. The mercy of the Bodhisattvas laid the foundation for the doctrine of vicarious atonement. The abundance of their infinite merit could be turned over to balance the deficiency of good karma in human beings. Nirvāna was popularly reinterpreted as a heavenly existence of such duration as to appear as an eternal after-life. The ground of personal identity which the Buddha had tried to destroy was reaffirmed in the very existence of the great Bodhisattvas and in their Paradises. The emphasis was on the enlightenment to be realized in the manifestation of the powers of the Eternal Buddha.

Mahāyāna Buddhism, sometimes called Northern Buddhism, had travelled far by way of northern India and Gandhāra to pass first into central Asia and then across the interior of the Asiatic continent to enter China. From there it reached Korea in the fourth and fifth centuries, and finally was disseminated to Japan.

Undoubtedly among the large number of foreign immigrants in Japan some knew and practised Buddhism before it was officially mentioned in the *Nihongi* for the year 552 during the reign of the emperor Kimmei. According to some accounts, Shiba Tachito, a Chinese from the state of southern Liang, brought Buddhist images with him as early as 522. In 577, monks, a nun, a Buddhist image-maker, and an architect were presented by the king of Paekche (Kudara) to the Japanese emperor. In 584 mention is made of a stone image of Miroku, the Bodhisattva destined to be the next Buddha, as having been brought from Paekche. At the time of the death of the emperor Yōmei in 587, Tasuna, the son of Tachito, made Buddhist images as an offering to cure the emperor's illness. In the following year more monks and a painter arrived from Paekche. Prince Asa of Paekche came to Japan in 597 and he, too, was later credited with being a painter. Enough references have been given to prove that the first elements of the continental style in art came largely through Korea. It is interesting to find mention of a stone image, as the style which sprang up in Japan, though executed in other media, was modelled on a technique appropriate to stone-cutting. The art of painting, too, undoubtedly was indebted to styles current in Korea.

During its early years Buddhism had literally to fight for its life in Japan. Fortunately, it had for its champion a very remarkable prince, Shōtoku Taishi, to give him the Buddhist title by which he is best known. A short civil war followed the death of the emperor Yōmei. During one of the battles Shōtoku vowed, if successful, to build a temple to the Heavenly Kings of the Four Quarters. This was the origin of the Shitennōji temple at Ōsaka. After the succession of the empress Suiko in 593 Shōtoku was made regent. The position of Buddhism became secure, and the number of temples and monks increased enormously. Shōtoku in his enthusiasm for the new religion gave lectures in the palace and wrote commentaries on three sūtras or classic books of Buddhism – the *Yuima-kyō*, the *Shōman-gyō*, and the *Hokke-kyō* or *Lotus Sūtra*[3] which is one of the chief sources for the worship of Kwannon.[4] But Shōtoku's learning was not restricted to Buddhism. A scholar was sent to China in 607 to make a study of Chinese culture. The first history of Japan, the *Kujiki*, was compiled during his lifetime, but was unfortunately later

destroyed. Shōtoku's aims appear in a group of Seventeen Articles which he promulgated in 604. The first emphasized the need for harmony among the different social classes, an idea in accord with Chinese political theory. Among the seventeen, only the second admonished reverence for the Three Treasures of Buddhism, that is, for the Buddha, the Law, and the Priesthood as 'the final refuge of the four generated beings', categories which included all forms of life from the lowest to man. Buddhism appeared here as part of the social problem of good government and high morality.

In this early period Buddhism was probably a very simple religion. Shaka the historic Buddha, Yakushi the healing Buddha, Miroku the future Buddha, and Kwannon the most compassionate of the Bodhisattvas were the most popular deities. To these may be added the Guardian Kings of the Four Quarters. It was a simple pantheon. The temple compounds contained both a pagoda for the veneration of relics, and a Golden Hall where the Buddha could be worshipped.

The revolution in government which Shōtoku was fostering was aided by new ideals of human relationship. The great monasteries like Hōryūji, near Nara, were centres of learning, of community life, and of charity. If the compassionate and healing power of the great Bodhisattvas (*Bosatsu* in Japanese) was the side of Buddhist teaching which had the most appeal, the protective aspect of Buddhism for the state was taught in the *Shōman-gyō*. In this period, even the ancient native religion was forced to compromise with the Indian religion, and the Shintō oracle of Miwa declared that Buddhist priests were the proper persons to perform rites.

The temple of Hōryūji is of unique importance because it remains as a veritable museum of early Buddhist art. In 625 it belonged to the Sanron sect,[5] a type of Mahāyāna Buddhism based on three commentaries written by Nāgārjuna, one of the early exponents of this form of Buddhism. Its highly metaphysical approach in denying the reality of the ego and of all phenomenal existence seems far in advance of the representations of the art of the period. Monumental bronzes still exist at Hōryūji, whereas in China proper most of the pieces on the same large scale have been melted down. Shrines painted in lacquer find no parallel among extant works of art in China and Korea. The sculptures and paintings, though primitive-looking, express mature developments of older continental traditions. The Buddhist art of China was the main source in both style and iconography, but the transmitters of this tradition reached Japan solely through Korea. The prototypes which seem closest today appear in the rock caves of Yün-kang and Lung-mên in China in sculptures cut out of the solid rock during the late Northern Wei period of the early sixth century. More than half a century elapsed before the style got to Japan. Its immediate source must therefore be sought for in Korea, where archaic styles lingered, rather than in China, where new types were constantly being created.

The first great sculptor of Japan, Tori Busshi, the Buddhist master, was the son of the sculptor Tasuna and the grandson of Tachito who had emigrated to Japan in 522. He belonged by inheritance to the saddlers' corporation, *Kuratsukuribe*. As metal ornaments in gilt bronze formed part of the trappings of a horse, the connexion between saddles and sculpture is not as illogical as it seems at first. How far the art of the third generation of an immigrant family differed from continental styles, it is not possible to say. In any case, as religious art it had to be based on a correct tradition. In 606 a great Buddha was set up in the temple of Gangōji. This bronze and an embroidery known only in literary records were both made under the direction of Tori Busshi. The empress Suiko was so pleased that she bestowed

2. Tori: Shaka Triad, Asuka period, 623. Bronze. *Hōryūji*

on the sculptor both lands and a rank corresponding to the later fifth grade, a position of considerable social prestige. That the designing of an embroidery hanging was also done by Tori indicates the common craft basis of the arts.

In the following year, 607, a bronze statue of Yakushi,[6] the healing Buddha, was set up in the Golden Hall of the temple of Hōryūji. It had been vowed many years earlier. Its inscription states quite clearly that it was made in order that the emperor Yōmei's 'illness might be cured'. Though not recorded as being made by Tori, its similarity to the Shaka Triad [2], also in Hōryūji, of 623, undoubtedly made by him, is so close that both must have come from the same atelier. The latter group was set up in memory of Prince Shōtoku by his relatives and courtiers that he might reach 'the Land of Bliss'.

The Tori style as seen in the Shaka Triad, though so excellent as an example of the technique of bronze casting that it argues knowledge and long experience in this art, can best be understood as a transcription in bronze of the art of stone-cutting. Japan possesses little stone suitable for the kind of cave sculpture which was popular in China and which had its origin in India. Yet the model followed by Tori and his school maintains the types which had been evolved during the Northern Wei dynasty for cave sculptures.

A general frontal approach and flatness of planes dominate the whole. Such a method may readily be accounted for in a technique which sought to carve sculptures into solid rock, but bronze sculpture necessitates working from independent models in clay. An accepted traditionalism, not questions of material, directed these early sculptures in Japan. The heads show long faces, almond-shaped eyes, and a gracious archaic smile. The pose is nearly symmetrical, and draperies exhibit a luxurious rhythm of full curves. There exists an emphasis on outline which has no significance for

sculpture in bronze. The linear quality belongs to all the arts of the Far East. In Japanese art, as in that of China or of Greece, there is evident an evolution from an early abstract form of representation towards more human proportions, an anthropomorphic interpretation of deity which culminates in an anthropopathic stage where even the emotions of the gods are stated in quite human terms. The Asuka period was the age of primitive belief, when worshippers were not yet so familiar with their gods as to portray them as glorified human beings. A sense of mystery differentiates the spiritual and material worlds.

The statue of the Bodhisattva Kwannon [3] which is kept in the Yumedono Hall of the Hōryūji monastery is the masterpiece of the early Asuka type of sculpture. The smile on its face reveals a detached kindness, happy but aloof from the troubles of mankind. The tall, slender proportions are unearthly. Long drapery scarves cross before the knees and fall in serrated curves from the elbow to end in widely flung curves at the base. The same rhythm occurs with locks of hair which ornament the shoulders with frond-like curls. An outer band of arching flames on the pointed oval halo carries out the upward movement of the lines. Seen in profile, the statue is poised in a delicate S-curve. The head wears a high crown of perforated copper with long metal streamers hanging down to the level of the waist. The statue is made of wood covered with gold leaf, and though this was to be the natural medium for Japanese sculpture, here it shows no more feeling for its material than do the bronze sculptures of Tori. The serrated outline of the Yumedono Kwannon is paralleled in smaller bronzes in Korea. The style can be distinguished from that of the Tori workshop, and is thought to be closer to that fashionable in Korea. Originally set up on a site which formed part of the palace of Prince Shōtoku, the statue has been so intimately connected with

3. Yumedono Kwannon, Asuka period. Wood.
Hōryūji

him that in later times it was spoken of as of the
exact stature of the prince or even as being his
portrait, evidence of the veneration for this
great patron of Buddhism in Japan.

The earliest painting to be preserved and the
sole record of the pictorial style of the very
early seventh century is the Tamamushi
Zushi, the Beetle-wing shrine, of Hōryūji.
The open-work metal edging was once inset
with the iridescent wings of beetles, a decora-
tive technique known also in Korea. The small
shrine stands on a high base. On the upper part
appear Protectors on the front door-panels,
Bodhisattvas on the side panels, and Pagodas
on the back. The base shows in front the
worship of the Sacred Relics of the Buddha,
on the proper right the Sacrifice for a Stanza,
and on the left the Sacrifice to a Hungry
Tigress. On the back is a scene of Mount
Sumeru, the sacred mountain which supports
the universe. The narrative scenes come from
the *Jātaka* stories which 'minutely described
what self-sacrificing deeds were done by
them [the Bodhisattvas] and how by the karma
of these merits they finally attained Buddha-
hood.' The more immediate source has been
traced to the *Konkōmyō-kyō* and the *Nehan-
gyō Sūtras*.

4. Sacrifice for a Stanza, Asuka period. Lacquer painting. *Hōryūji, Tamamushi shrine*

The panel, Sacrifice for a Stanza [4], tells the story of how once, when the Buddha was born as a Brāhmin, his virtue was tested by Taishakuten (Indra) who recited half a set of verses and then appeared in demon form. Buddha heard his voice exclaiming the verse: 'All component things are transitory. The law is to be born and die.' The demon claimed he was too weak to repeat the second part and that his diet consisted of human flesh. The Buddha hereupon promised to sacrifice his life if he could but hear the next verse. The demon then recited: 'Transcending birth and death, how blissful is the absolute.' When the Buddha heard this, he carved the words on a rock, climbed into a tree and threw himself down. The style of the drawing is freer than that of the sculpture of the period, but it might be

5. Bodhisattvas, Asuka period. Lacquer painting. *Hōryūji, Tamamushi shrine*

questioned whether this is an indication of a later date. Triads are apt to preserve a rigid tradition far more exactingly than less central themes. The Bodhisattvas [5] possess much of the sinuous and austere grace of the contemporary sculpture. The Protectors on the front panels, however, bear little resemblance to other Buddhist guardian gods. So, too, the handling of the rocks in impossible Rococo curves in the scene of the sacrifice finds no parallel elsewhere.

The technique of the painting has been described as a form of *mitsuda-e*, painting in oxide of lead and oil. The method is said to have come from Persia but as it is thought that it did not reach China until the T'ang dynasty (618–906), it could not have been known in Japan so soon. The painting on the Tamamushi shrine is coloured lacquer, a technique which had been used in Korea. The cypress wood of which the shrine is made, however, is said to be of a type found in Japan but not in Korea.

Little other pictorial design has come down to us from the Asuka period. The embroidery known as the Tenjukoku Mandara exists in so fragmentary a state that apart from the fact that it represents a paradise scene, possibly that of Miroku, little can be said about it as a work of art. The names of the designers suggest Koreans who had been naturalized in Japan. The weaving was done by the ladies of Shōtoku's household as an act of religious merit.

In 604 men referred to as the Kibumi painters and the Yamashiro painters were established; that is, they were put under some kind of official protection and settled in fixed localities. In 610 Donchō, a Korean from the state of Koguryŏ, arrived. He was skilled in the preparation of colours and in the making of paper and ink. Already in existence was a system of organized craftsmen, a heritage which was to continue to have a profound influence on the evolution of all the arts.

Among sculptures roughly datable to the middle of the century are the figures of the Guardian Kings of the Four Quarters which stand on the central altar of Hōryūji. The Guardian of the South, Kōmokuten, is inscribed with the name of the sculptor Yamaguchi no Ōkuchi who in 650 was employed to carve a 'Thousand Buddha' image. The set is so distinctive in style as to offer little comparison with other existing sculptures of the same subjects. In the softening of the Suiko angularity some scholars see evidence of an attitude towards sculptural form which has already been noted in the treatment of the haniwa figures. The extraordinary schematic arrangement of the edges of the garments suggests the intrusion of the decorative technique of a craftsman more than it does an accepted iconographical rendering. The wood figures also show a tendency towards more natural proportions. An accent on parallel vertical lines and the flare of free hanging draperies curving from back to front, instead of from the sides outwards, mark steps of advance from the earlier Suiko style. The statue of Bishamonten (or Tamonten), Guardian of the North [6], like the others of the set, stands on a strange demon who crouches down on a purely geometrical type of rock ground. The feeling for patterned symmetry is never again so conspicuous.

Very similar in artistic conventions are the canopies which hang over the Triads on the altar of Hōryūji and which are decorated with heavenly musicians and phoenixes. The angels who sweep down joyously to earth [7] have a long tradition behind them in the cave temples of China, but are the first of many notable examples in Japan. The simple folds arranged in vertical lines seem to suggest a period later than Tori Busshi, yet the pointed halo and the floriate ribbons in pierced work which repeat

6. Bishamonten, Asuka period, *c.* 650. Wood. *Hōryūji*

7. Angel on canopy, Asuka period. Wood. *Hōryūji*

8 (*right*). Kudara Kwannon, Asuka period. Wood. *Hōryūji*

the aspiring outline recall the more active line of earlier tradition.

Perhaps contemporary but indicative of a different style is the Kudara Kwannon [8], also from Hōryūji. It is a wooden statue and may even have been imported from Korea as its name would suggest. On the breast of the figure there still remain traces of a coating of

lacquer and on the clothing fragments of colour. A new sense of verticality is everywhere apparent. The draperies move or curl in depth from back to front, a direction further emphasized by the forward thrust of the right arm. The rounded, columnar quality of torso and limb is a feature more frequent in works of Korean than of Chinese derivation. Opposing and more conservative tendencies are found in a small bronze figure of Kwannon now in the Tōkyō National Museum which has a date in cyclical signs corresponding in the sixty-year Chinese calendar to either 651 or 591. If we accept the 651 date, evidence accumulates that the tradition of the Yumedono Kwannon with its widely flaring scarves had not yet died out.

That the Tori tradition lived on with modifications may also be seen in a beautiful wood figure of Kwannon, sometimes identified as Kokūzō, at the temple of Hōrinji, which it is usual to date about 660. The sense of modelling is still further developed, and the previous stiff X-crossed scarves hang now in a manner more resembling a Y. Again, the many, simple, vertically parallel lines make this figure belong to the same tradition as the Guardian Kings of

9. Miroku, Asuka period, 606(?). Bronze.
Tōkyō National Museum

10. Miroku, Asuka period. Bronze.
Cleveland Museum of Art

Hōryūji. To Hōryūji also belong six wooden figures of Bodhisattvas which cannot be far removed in date from the figure at Hōrinji.

Another group may be made of the statues of Miroku who sits in a dreamy pose, the fingers of his right hand supporting his head and his right leg bending across his left knee. Two of the sculptures have cyclical dates. The date of the one [9] in the Tōkyō National Museum may correspond to the year 606. The other, from the temple of Yachūji in Ōsaka, carries the date of 666. Both represent the deity Miroku in the same pose with triple-pointed crown. The former exaggerates the slenderness of the body and parallel folds of the drapery emphasize the sense of verticality. In the latter the points of the crown thrust out more laterally, the slender body is more squatly seated, the lower folds of the drapery are more softly flaring, and incised designs enrich the surface of the bronze. If the interpretation of the dates can be trusted, these are a few guide-posts to the changes of style.

The bronze Miroku [10], undated, in the Cleveland Museum of Art shows similar characteristics. In relation to the figure dated 606 there is less primitive exaggeration and at the same time greater softness of feeling. In the dated figure the smaller drapery folds are still somewhat angular; in the statue at Cleveland they are more sinuously curved. It seems reasonable to suppose that with the increasing spread of Buddhism many sculptors were needed to supply images and that there must have been many contemporary styles, all expressing an incipient national flavour. However, a wood Miroku at the temple of Kōryūji, near Kyōto, in pose and style follows so closely a two-foot bronze statue in the Seoul National Museum that there can be no doubt as to the Korean derivation of the group considered as a whole.

The most beautiful of these meditating Bodhisattvas is the famous Chūgūji Kwannon or Miroku [11], a large figure made of camphor

wood so carefully tended through the ages at the nunnery where it stands that its dark surface appears to have the lustre of bronze. Like many early statues even the name of the deity is not clearly known. The scholars who recognize in the figure the young prince Siddhārtha, the early name of the Buddha, seem justified both by analogies in Chinese sculpture and by the double top knot of hair which would indicate a young man rather than a Bodhisattva. Much of the richness of drapery curves descends from the Tori tradition, but the softness of rounded modelling which so

11. Siddhārtha in Meditation, Asuka period. Wood. *Chūgūji*

suits the youthful figure is not to be discovered in any other example. The quality of dream-like reverie is aided by the blend of gentle

curves and pseudo-naturalism. The gracious smile has neither the archaic spirit of the Shaka Triad nor the aloofness of the Yumedono Kwannon. Here are warm, human, and emotional qualities which will be met with frequently in the course of Japanese art.

Hard to place in chronological order is the charming little bronze in almost dancer-like pose which represents Queen Māyā and the Birth of the Buddha [12], in the Tōkyō National Museum. A quotation from H. Kern's *Manual of Indian Buddhism* will make the subject clear: 'Arriving at the Lumbini Grove, she felt a desire to enter the wood. Seeing a holy sāl tree, she stretched out her hand to take

12. Queen Māyā and the Birth of the Buddha, Asuka period. Bronze. *Tōkyō National Museum*

hold of a branch, which bent down of its own accord, and whilst she held it, she was delivered, in standing position and holding the branch.' The infant Buddha was born from her side, and is seen with hands clasped in prayer diving out of her long sleeve.

The Taika Reform of 645 when important political innovations modelled on the Chinese administrative system were introduced divides the Asuka and early Nara periods. The first half of the century is often called the Suiko period after the name of that famous empress. The latter half is known as the Hakuhō period after the name of the year period, 673–85, and is also referred to as the early Nara or early Tempyō period because it seems to be related more intimately to what was to come than to the past. But this is partly due to the fact that the more important monuments are placed late in the period. Direct contacts with China increased while Korean influence weakened as a result of the loss of Japan's foothold on the tip of the Korean peninsula, a loss which occurred in the reign of the emperor Tenchi (662–71).

The art of the Hakuhō period shows the trends of Chinese art of the T'ang period. The year 645, which saw tremendous political changes in Japan, was also the year in which the priest Hsüan-tsang returned from his travels in India to Ch'ang-an, the Chinese capital. The Chinese empire had just reached the height of its power. The trade routes through central Asia and beyond to Persia and India were under Chinese control, and new influences were pouring in to make Chinese art more richly diversified than at any other period. In Japan it was an age of great bronzes. The Suiko approach based on stone carving gradually disappeared. A new naturalism and the complete mastery of the technique of bronze casting made this period notable.

Sculpture of the later seventh century has few dated guide-posts. A bronze Kwannon at Gakuenji, dated 692, though not important artistically, proves that even at this time the influence of the Sui dynasty (581–617) in China rather than of T'ang was still prevalent, though traces of the Suiko style were plentiful.

Figures began to possess the slim vitality of adolescence. The heads have a generally human

13. Shaka and Tahō, Asuka period, 686. Bronze. *Hasedera*

proportion, the bodies a naturalistic modelling, and the draperies and jewel strands are both simplified in their lines and carefully elaborated as ornament. But in almost all the sculpture a new tendency towards greater depth is evident. The Hakuhō period is a half-way point be-tween the mysticism of the Suiko and the realism of the succeeding Nara period.

The changes which followed the introduc-tion of the early T'ang style are displayed in the bronze plaque datable to 686 of the Buddhas Shaka and Tahō [13] which belongs to the

temple of Hasedera. The conception derives from the *Lotus Sūtra*, which contains a marvellous exposition of the timelessness of the teachings there propounded and of the infiniteness of the Buddha. The historical Buddha and the eternal Buddhahood are made to appear as one. The plaque pictures the Apparition of a Stūpa, which is one of the chapter headings of this famous book. The upper background is formed of the Thousand Buddhas done in repoussé. Within the stūpa appear the two Buddhas seated, identical in pose. To the right and left are groups of divinities. Below appear the first Japanese sculptural representations of the Niō or Kongōrikishi, protectors of the Buddhist faith. The relatively high relief with emphasis on depth of modelling is a characteristic of the art of early T'ang sculpture. Even more significant is the symmetrical arrangement of many figures in one composition. The Tachibana shrine, the large frescoes of Hōryūji, and several small repoussé images all exhibit the same tendency towards the close grouping of many gods. T'ang art, as it became known in Japan, seems to be essentially compositional. In the rendering of the central three-storeyed pagoda may be clearly noted the use of parallel perspective which was to remain normal for architectural drawing at all times.

The development of the bronze caster's art is reflected in other ways at this time. The clay tile of a single Tennin or angel at Okadera must have been made by a mould. The bronze group, now in the Tōkyō National Museum, composed of Amida, two Bodhisattvas, and two monks, is done in the repoussé technique which is but another extension of the practice of using moulds. Many such reliefs attest to the popularity of the use of clay. The kind of small-figure composition which was usual in these types was also made in stone. A Triad at Ishiidera is the oldest stone sculpture in Japan; it seems a transcription into stone of the type of sculpture in bronze which was then prevalent.

The bronze Yakushi [14] from the temple of Shin Yakushiji embodies the new attitude towards sculptural representations. The proportions of the standing figure are humanly normal. The extra-long ears, the slightly webbed fingers, and the jewel in the middle of the forehead are doctrinally essential as being among the thirty-two sacred marks of the body of the Buddha. Hands and feet are executed with the accent on graceful line rather than on

strict realism, though the body as a whole is well indicated beneath the closely fitting robe. Sculpture at this moment saw the human figure in terms of simple, soft-edged masses, plastically imagined in an ideal form. The folds of the drapery compose a series of measured curves. The sharpness of the lines and the soft modulations of surfaces between carry out the best traits of modelling in wax. It is just in these qualities that the stone Triad

mentioned above is lacking, for the same proportions and the same rhythmic line fail to achieve the same results.

The culmination of the bronze technique was achieved in the Amida Triad of the small shrine of the Lady Tachibana which now stands on the altar of Hōryūji. The date of this masterpiece is generally given as about 710, but all agree that it shows a conservative spirit. As one studies the half-smiling features of its

14 (*opposite*). Yakushi, late Asuka period. Bronze. *Shin Yakushiji*

15 (*above*). Amida Triad, late Asuka period. Bronze. *Hōryūji, Tachibana shrine*

Buddha and the two Bodhisattvas [15], it is impossible not to recall heads in the Suiko style. The paintings which decorate the sides of the Tachibana shrine are startling by contrast, for they seem more Indian than either Japanese or Chinese. The shrine reveals the many influences which were then current in Buddhism, as it reached Japan at the turn of the seventh century.

The conservative spirit seen in the central Buddha and his attendants suggests that the sculptor of these statues belonged to the group of *émigré* artists who had been settled in Japan for a century or more rather than a recently arrived foreigner who favoured an archaic style. The superb delicacy of the open-work halo [16] has the flat beauty of outline of the earlier tradition. Only the fulness of body in the Bodhisattvas indicates that these small statues were up-to-date in the early eighth century, but the long sweep of the ends of the scarves trailing over the sides of the round lotus buds

poised so lightly on lotus thrones anticipate the scenes of later pictures which show the rebirth of souls in Paradise. The curves of thin tendrils topped with lotus buds, the Buddhist flower of purity, harmonize with swirls of ribbon-like scarves which appear to have lightly deposited the souls of those reborn in heaven. The later paradise scenes may be more sublime, but none possesses the joyous spirituality of the figures of this screen.

The more mature T'ang style, which because of the strong indications of Indian influences can be ascribed to the second half of the

16. Halo and screen, late Asuka period. Bronze. *Hōryūji, Tachibana shrine*

on which the figures stand hints at a fondness for older rather than contemporary prototypes.

For delicate low relief in bronze the screen [16] behind the Triad has no rival in Japan or anywhere in the Orient. The heavenly figures

seventh century, is represented in Japan by a notable group of over life-size bronzes from the temple of Yakushiji. Although a Yakushi Buddha in bronze existed at the temple in 686, the figure now there is often attributed to 717,

when the temple was moved to the recently founded capital of Nara. The same problem occurs with the closely related statue of Shō Kwannon [17] in the Tōindō Hall of Yakushiji. Temple records speak of a statue of this deity as having been made in the time of the emperor Kōtoku (645–54), but practically all scholars favour dating the statue much later, the dates varying from the last decade of the seventh century to the second decade of the eighth. In the same group should be placed a seated bronze figure of Shaka at the temple of Kanimanji.

The Shō Kwannon, the lotus-bearing divinity of compassion, is a magnificent sculpture, human in proportions and composed of feature. The very similar Bodhisattvas Nikkō and Gakkō which stand on either side of the central Yakushi show a new thrust of the hips so that the weight of the figures is no longer evenly disposed in perfect frontal symmetry. But the Shō Kwannon, more static, possesses a greater majesty of poise. The complicated folds of the draperies, the suggestion of the full wrinkles of a material, and the transparency of the garments which reveal the conformations of the body all add up to a degree of realism not attempted before. Divinity is thought out in human form, full in face and stout in limb.

In this group should be included another series of remarkable statues: the Miroku in clay and the attendant Four Gods in dry lacquer from the temple of Taimadera. That clay figures should appear just when the art of bronze casting was at its height is natural, since bronze statues had first to be made from models either in clay or in wax. The dry lacquer process, which will be described in the next chapter, also derives from work in clay. The figures from Taimadera prepare the way for the style which was to flourish in the next period. Unfortunately, their many repairs make them difficult to appraise historically. In general, their appearance is more Chinese and less

17. Shō Kwannon, late Asuka period. Bronze. *Yakushiji*

Indian than that of the related group of bronzes.
The Four Gods in particular have complicated
garments, but they do not yet reveal that
tendency for physical movement which became
standard after the Nara period. Their faces, on
the other hand, because they are lesser gods,
have a realism far in advance of that of the more
important gods.

The paintings of the Hakuhō period can be
judged from three sources – those on the
Tachibana shrine, the frescoes on the walls of
the kondō of Hōryūji, and the embroidered
Preaching Shaka of the temple of Kanshūji.
The figures which decorate the Tachibana
shrine are now almost invisible. Those about
the base of the shrine, paintings of those
reborn in Paradise, are the most Indian of any
in the Far East. Nearly nude figures with
languid eyes present a seductive charm which
seldom appears in Chinese or Japanese art.
Evidence of shading further increases the un-
Chinese appearance. H. Minamoto[7] writes:
'Comparing these figures with those of the
Tamamushi Shrine, we see a marked develop-
ment of graphic skill. They are more realistic,
the postures are freer, and the faces more
expressive.' Each quality hints at some of the
characteristics of the Nara style.

The Bodhisattvas on the door-panels, best
seen in outline drawings [18], on the other hand,
have a much stronger Chinese quality in the thin
calligraphic line. They should be compared
both with the Bodhisattva to the right of the
Amida Paradise fresco [19] at Hōryūji, and with
the Shō Kwannon [17] of the Tōindō Hall of
Yakushiji. The drawing on the panel links
together the sculpture and painting, and helps
to explain the spirit of the age. The Shō
Kwannon looks like a rendering in bronze of the
characteristics of this outline drawing. In fact,
the drawing suggests how the new type of
art in all probability reached Japan, that is, in
the form of drawings. In later ages model
books of iconographically proper renderings

18. Bodhisattva (copy), late Asuka period.
Hōryūji, Tachibana shrine

19. Amida Paradise, late Asuka period. Fresco.
Hōryūji

are known in large quantity. As one looks at
the various groups of Hakuhō bronzes, there is
no need to suppose either that bronze or wood
models were needed or that such statues must
have been made by newly imported foreign
sculptors. The Buddhism of the late Hakuhō
period had advanced a long way from the
simple teachings of the Suiko period. At this
time we hear of the *Issai-kyō*, a collection of
several thousands of volumes which composed

the Buddhist canonical books, as being in
Japan. It is natural to think that those who
sought to have the complete canons available
also sought for the latest type of pictures which
would illustrate the holy doctrines.

In this period the Kibumi painter Motozane
went to China and made a copy of the Buddha's
Footprints, a design which had been brought
back to China from India by Wang Hsüan-ts'ê.
It is not without significance that a stone

showing the symbolic icon exists at Yakushiji. The art of the Hakuhō period preserves in particular the Indian style which had been interpreted by Chinese artists. Some at least of this influence was probably a direct reflection of tendencies which existed in India. Doubtless, as in later periods, the Japanese sought for whatever had then the most acclaim.

Both as the most impressive paintings of their time and as representing one phase of T'ang painting at the beginning of its maturity the frescoes on the walls of Hōryūji are supremely important. They have been compared with monuments as widely separated as the frescoes in the caves of Ajaṇṭā in India, especially those which date from the middle of the sixth century, with relics from Bāmiyān near Afghanistan, and with the cave paintings at Kyzil and at Tun-huang in central Asia. Benjamin Rowland[8] says of the frescoes: 'The closest relationship exists with Central Asian and Chinese prototypes. Obviously, although there is a superficial resemblance between certain types at Hōryūji and the Bodhisattvas at Ajaṇṭā, we are dealing with two fundamentally different styles. In the first place, the faces and bodies at Nara are drawn in mathematically more ideal shapes that lack the heavy, breathing sensuality of the Indian models. . . . The Bodhisattvas at Hōryūji belong very obviously to a very spiritualized tradition.' Later he adds that 'they are phases of the same international style of religious art that united India and the Far East in these centuries, and . . . much of the so-called Indian style in China was really Central Asian.'

This non-Indian derivation of the Hōryūji frescoes is supported psychologically by the emphasis on symmetry which is a direct contribution of Iranian art to Buddhism. Attempts to associate the Hōryūji frescoes with the style of any particular artist all depend too much on literary evidence to justify the repetition of the various theories here, but

The Wall-Paintings of Hōryūji gives an excellent account of the problems which confront the student.

The iconography of the paintings cannot be explained satisfactorily from the point of view of the later sects of Buddhism which developed in Japan. The selection seems to have been dictated by independent choice rather than by any strict canonical arrangement. Four sūtras, the *Hokke-kyō*, *Muryōju-kyō*, *Konkōmyō-kyō*, and *Yakushi-kyō*, which were then popular, account for the representations respectively of the Paradises of the Buddhas Shaka, Amida, Miroku, and Yakushi and for subsidiary paintings of the greater Bodhisattvas.

However Indian the form, transparent clothes, or heavy jewels may be, the 'wire line' used in the drawings is essentially a Chinese mode of drawing. The arbitrary shading which follows no law of light and shade has become far more an emphasis for the sake of pattern than a method to indicate relief. The architectural details of the throne of Amida, like the grape-vine pattern on the throne of the bronze Yakushi at Yakushiji, also derive from the far west regions of Asia.

These rare treasures of fresco painting which had preserved a phase of the T'ang style down to modern times were terribly damaged by fire and water in the early part of 1949. Always difficult to see because of the congestion of great relics inside the Golden Hall of Hōryūji, they now seem in the photographs taken after the fire like battered wraiths of a past glory. It is at least fortunate that the damage occurred after actual-size photographs had been made, and when copies in colour were nearing completion.

Another great pictorial representation of the period is the embroidery of Kanshūji which shows a picture of Shaka preaching at the Vulture Peak [20] and which has little 'of the Indian feeling, though its throne with open-work panels of turned wood and geometrical

20. Shaka preaching, late Asuka period. Embroidery. *Kanshuji*

roundels immediately suggests prototypes in the Near East. The great throne is supported by lions symbolizing the Buddha as the lion among men. Here at the Vulture Peak Buddha preaches eternally. Around him are gathered Bodhisattvas, angels above him honour him with music, and monks and laymen below listen to the Buddhist law.

The art of the Asuka period when regarded as a whole does not, like that of the succeeding Nara period, lay a foundation which was to prove a source of inspiration to later generations. The major monuments stand in a kind of splendid isolation, distinguished in themselves, and generally so rare that comparative material is difficult to find elsewhere. It was a Buddhist art tradition, and doubtless because the thought of the period had not reached full maturity, the religious images possess greater diversity than at any later period.

BUDDHISM AS A STATE RELIGION

The history of Buddhism started in Japan with strong political connexions and soon became deeply involved with affairs of state. During the later seventh century Buddhist books such as the *Ninnō-kyō*, the sūtra of the Benevolent Kings, which emphasized the protection of the nation were held in especial esteem. Just as the major political events were concerned with centralization of power, so the idea of a unified religion under national control became more prominent as a means of further expressing the new bureaucratic administration which was being modelled on that of China.

The selection of a permanent capital, situated at Nara, marked a complete break with the past. The ancient Shintō custom of moving the capital with the death of each emperor, which was based on the primitive fear of pollution, could no longer be maintained in the face of the necessity of a more solid foundation for the seat of government. In 710 the city of Nara was laid out with broad streets, great palaces, and temples in imitation of Ch'ang-an, the capital city of China. Here the capital remained until 784 when it was again moved, temporarily to Nagaoka. This period was called either Nara after the new city or Tempyō after the famous period (729-48) in which the Great Buddha of Nara was made. It remains as the classic epoch for the introduction of a foreign culture, to be paralleled in the fifteenth century and again in modern times. Amid all the influences – political, religious, and social – which were being welcomed from the continent so that Japan could not be omitted from among the great nations of Asia, it is sometimes difficult to discover the remains of the national spirit. But it should always be remembered that the Japanese imitations or importations were selected and adapted in such a way that they were made to harmonize with already existing customs and institutions.

Attention was focused on Buddhism by the abdication of the emperor Shōmu in order to devote himself to the Buddhist church. In art the dominating theme was the creation of the Great Buddha of the Tōdaiji temple in Nara, a bronze statue fifty-three feet high. The motive for its erection was an outbreak of smallpox in 735. Two years later each province was ordered to make a Buddhist triad. Other orders followed for setting up statues and for the distribution and copying of sūtras. In 741 the national control of religion was extended by the creation of provincial temples and nunneries: the monasteries were to be administered by Tōdaiji and the nunneries by Hokkeji, the chief temples at the capital. There were prohibitions, too, against the killing of animals on special fasting days.

History has left the statue of the Great Buddha in sad condition today. The great bronze head fell in 855, and twice the image was ruined by fire. The original statue is best preserved in a few engraved petals which form the lotus throne. The idea of such a Buddhist image undoubtedly was based upon colossal images made in China, which are best known today at the cave temples of Lung-mên. But to erect a bronze statue so vast in size was a truly

national undertaking. Before it was finished, gold was discovered in Japan on a sufficient scale to aid in gilding the image. This was interpreted as a gift 'bestowed upon us by the love and blessing of Roshana Buddha.' Lest such a great undertaking should be deemed unlucky, it was considered prudent to consult the oracles of the native gods. The Sun Goddess Amaterasu worshipped at Ise gave a favourable reply, and the emperor had a dream in which the goddess declared the identity of the sun and of the Buddha. In the ceremony of 749, held when the sculpture was ready to be gilded, it was stated that of 'all the various Laws the Great Word of Buddha is the most excellent for protecting the State.' At no other period in Japanese history was the making of a Buddhist image an event of such national importance. The Great Buddha of Nara was the symbol of a new national policy.

Sir Charles Eliot[1] has written: 'Just as the Japanese Court paid special attention to the portions of the Ninnō-kyō which deal with good administration, so they saw an edifying political analogy in this vision' of Roshana Buddha as the centre of the universe. Sir George Sansom[2] emphasizes the same opinion when he says: 'The object of worship of adherents of the Kegon sect is therefore the Roshana Buddha, who in their scriptures is portrayed as dwelling upon a lotus flower of a thousand petals. Each petal represents a universe, and in each universe there are myriad worlds. On each petal is a Shaka, who is a manifestation of Roshana, and in each of the myriad worlds is a small Buddha, who is, in turn, a manifestation of Shaka.' Serge Elisseeff[3] has studied the relation of this image and the *Bommō-kyō*, which is a sort of development of the *Kegon-kyō* sūtra. He expresses the thought of the period in these words: 'In this same way the Emperor occupies in Japan the supreme rank, corresponding to Locana Buddha: the imperial will is transmitted to the thousand officials, who in the

government organization can be considered representatives of the Emperor, as the thousand great Sākya are of Locana. The subjects are compared to the millions of Small Sākya.'

In the Kegon sect, the doctrines of which were then dominant, the Buddhist law[4] is conceived in cosmic terms. As the sūtra says: 'In every particle of dust there are present Buddhas without number.' The pictures incised on the original lotus petals [21] illustrate further

21. Incised lotus petal (detail), Nara period. Bronze. *Tōdaiji*

doctrines of existence in another series of Realms: the Realms of Formlessness which are free from sensuous desires, a life of mystical experience; the Realms of Form, also free from sensuous desires but attained only by the practice of special meditation; and the Realms of Desire, where earthly passions still exist though much diminished in force. Sometimes these Realms are presented as existence above the human world, sometimes as including it. Special to Buddhist thought is the classification

of the Six States of Transmigration – that is, of the worlds of gods, men, demons, ghosts, animals, and purgatory – within the Realms of Desire. Even the gods must pass away before there is final deliverance from the rounds of birth and death. These Realms represent scales of perfection on the way to spiritual unity.

The actual eye-opening ceremony which marked the completion of the statue of the Great Buddha in 752 was attended by the full court including the abdicated emperor Shōmu, his wife Kōmyō, and the reigning empress Kōken. The magnificence of the occasion remains visible today, because many of the personal belongings of the emperor Shōmu which were given by his widow to Tōdaiji in 756 have been preserved in the storehouse called the Shōsōin. The contents of this building, including many importations from China, exhibit in detail the splendour of life in the eighth century.

If religion profited by the backing of the government, it was not long before the dangers of power in the hands of clerics became apparent. The empress Kōken, who ruled a second time under the name of Empress Shōtoku, was enamoured of the monk Dōkyō. He was appointed Minister of State, and it seems clear that he had hopes of becoming emperor. Fortunately, when the empress first sought the advice of the Shintō god Hachiman, the answer which was returned was deemed unfavourable and she died in 770 before Dōkyō could achieve his aim. The power of the church had risen to such heights that when the capital was set up in Kyōto in 794 one of the decisive arguments for the removal was to escape from the power of the priesthood.

It was an act of this empress Shōtoku which has preserved to the world the oldest extant wood-block prints. In 770 she had made one million miniature pagodas each of which contained a Buddhist charm or *dhāraṇī*, as a

means of ensuring greater length of life. The charms were printed on paper, and as technically there is no essential difference between wood-block script and wood-block pictures, they antedate the world-famous polychrome prints of Japan by almost an exact millennium. The practical knowledge must have come from China, and in both countries the method was already approximately known in the carved seals which were impressed on documents. Pictured stamps were used in India in the seventh century – at least they were mentioned as having been brought back from India by Wang Hsüan-ts'ê in 660.

Among the many Chinese institutions which were being introduced into Japan at this time was an educational system which had proved its worth in supplying China with distinguished officials. Education in China was open to all, provided that they could pass provincial and government examinations and so enter final contests at the capital which, if successful, ensured the student an official position in the service of the state. It was a system at once broad in foundation and based on merit. The Japanese established a university at Nara in 735. Outwardly it could be considered a copy of institutions existing in China, but it developed in a manner strictly Japanese. Robert K. Reischauer[5] wrote of it: 'In practice only sons of Fifth Rank or higher officials and exceptionally brilliant sons of the Eighth Rank officials and above were permitted even to enter the Court University where they received training for higher office.' In China the base was democratically wide; in Japan it was aristocratic and limited. In fact, if one had to select one characteristic which fundamentally distinguished the arts of China and Japan, it should be the contrast between the literary, academic, or university training of the great majority of the artists of China with the emphasis on philosophy, poetry, and ethics, and the more professional training of the artists of

Japan who arose from temple or craft. In the traditions of China the artists who were most praised were scholars who modelled their own styles on the examples of their predecessors, while an inherited corporation or school training seems at most times to have dominated the Japanese approach.

In 728 the *Edakumi-ryō* or Painters' Bureau was established in Nara. So enormous was the art production of the Nara period that this bureau, which preceded the later and better-known office of *Edokoro*, must have enlisted the help of all the painters and craftsmen who were locally settled at various places in Japan. At this time, too, the work of making and painting images must have called for a large number of specialists. Art seems to have been a corporate effort with work divided among outliners, colourists, ink painters, and so forth. The art was Buddhist rather than secular. There was no individual as famous as Wang Wei, Yen Li-pên, or Chang Hsüan in China. On the other hand, the period has left a series of great religious sculptures, the most important of which was the Great Buddha of Tōdaiji. The statue, however, has been so badly repaired that other objects must be studied to obtain a knowledge of the Nara style.

It was not until late in the Tempyō year period that sectarian differences of Buddhism began to make a real impression. The major sect was that called Kegon or Avataṁsaka after the sūtra of the same name. The head temple was Tōdaiji, and its doctrine expounded the interpenetration of the Buddha nature and the universe. 'The Tathāgata, the Supreme Perfect Enlightenment, is always staying in calm and immovable condition, yet he reveals himself everywhere in the world of ten directions.'[6] It was an extension of the teaching of the *Lotus Sūtra*. The historic Shaka had become the universal Roshana. Next in importance was the Hossō or Yuishiki sect which had its headquarters at Kōfukuji and which

taught that 'consciousness only' constituted reality. Its teachings, which had been expounded by Hsüan-tsang in China, were introduced to Japan soon after in 650, and taught that not all people had the Buddha nature nor could they become Buddhas, a view which was directly opposed by priests at a later time.

Earlier in point of time, but less important, was the Ritsu sect in which practical discipline was regarded as of more moral benefit than metaphysical reasoning. It was the sect which now insisted on proper methods of spiritual succession, and instituted the *Kaidan* or platform of ordination. At the end of the Nara period there were only three places in Japan where this ceremony could be held. The issue of ordination came to the forefront when new sects with more marked differences were again introduced from China in the ensuing period.

The art of the Nara period may be divided roughly into three parts: early, up to the accession of Shōmu in 724; middle, from 724 to 756, which covers the reign of Shōmu and the dedication of his effects to the Shōsōin; and late, from 756 to 784. In the early period there is much confusion as to the proper dating of objects many of which have been ascribed rather to the end of the Hakuhō period. It is also difficult to make a distinction between late Nara and the early part of the succeeding Jōgan era.

Nara art is most characteristically represented by sculpture. Seventh-century monuments included many wonderful triads. In the eighth century sculpture was used for far more complicated arrangements of Buddhist themes. Later still, in the Heian period, the emphasis turned from sculpture to painting to incorporate new and more involved Buddhist concepts. Techniques developed in the Nara period added clay and lacquer to the older media of wood and bronze, but no adequate explanation has yet been offered to account fully for their new popularity. Fundamentally the

idea of an altar was that of a place for displaying plastic images. The Chinese tradition of cave sculptures was based upon this primary scheme. In China, too, the use of clay supplemented the use of stone, especially in central Asia. There was a new realism, often apparent in freer movements of the limbs of a figure which clay and lacquer were capable of expressing. The wood sculptures of the late Nara period seem almost stiff and reactionary. They belonged to a 'single trunk' style, for complicated joinery in sculpture was not developed in Japan until the twelfth century.

Often included among works of the early Nara period are the Yakushi of Shin Yakushiji, the Shō Kwannon of Yakushiji, and the Shaka of Kanimanji. These bronzes have already been discussed. The earliest clay images of the Nara period are the groups of figures dating from 711 in the pagoda of Hōryūji. The four groups illustrate scenes of the Death of the Buddha on the north, the Sacred Relics on the west, the Paradise of Miroku on the south, and the Discourse of Yuima and Monju on the east. The figure of Monju, or Mañjuśrī [22], is typical of the statuettes used to form composite groups. Illustration 23 shows a statue of Yuima from Hokkeji.[7] The story of these two Buddhist saints is told in the *Yuima Sūtra*, a work of high philosophical content which at the same time is the story of a 'skilful device' to save 'sentient beings'. 'To Mañjuśrī's question concerning

22 (*left*). Monju, Nara period. Clay.
Horyūji, pagoda

23 (*above*). Yuima, Nara period. Dry lacquer.
Hokkeji

the cause of his disease, Vimalakīrti (Yuima) answered that he was ill because all living beings are ill; if their diseases, caused by foolishness and love, were extinguished, he too would be cured.' The difficulty of illustrating the moral qualities necessary to salvation posed a problem to the Buddhist artist. The style of the Monju is vigorous in the early T'ang manner – a slim youthful figure conceived fully in the round. The robes reveal the modelling of the body but not in the diaphanous, so-called Indian tradition. One of the special characteristics of these groups of figures at the Hōryūji pagoda is the narrow pose of the knees, which adds to the feeling of slenderness. The sad mourners assembled around the dead, reclining Shaka show the ability of the artists to undertake the rendering of emotion in the faces. Subjects are realized in purely human terms; Buddhist imagery has descended from the abstract to the real.

The style evolved by the middle Nara period carried out the tendencies already noted with greater sensitivity. A group of the Ten Disciples, of which only six are extant, and a set of the Eight Classes, who form part of the retinue of Shaka Buddha, both made in dry lacquer, once stood about an image of the Buddha in the Western Golden Hall of the temple of Kōfukuji. The Eight Classes include heavenly beings or Deva, water gods or Nāga, demons or Yaksha, heavenly minstrels or Gandharva, fighting demons or Asura, birdlike beings or Garuda, spirits of song or Kinnara, and earth serpents or Mahoraga. These beings weave into the pattern of salvation all the demi-gods and supernatural creatures which Buddhist fantasy has imagined. They are mentioned individually in many sūtras but occur as a group of eight in the *Ninnō-kyō*. M. W. de Visser[8] translates a part of the sūtras as follows: 'If kings, great ministers, monks and nuns, male and female lay-members of the community, listen to it, receive and read

24 (*above*). Kubanda, Nara period. Dry lacquer. *Kōfukuji*

25 (*opposite*). Rāhula (Ragora), Nara period. Dry lacquer. *Kōfukuji*

it, and act according to the Law, the calamities shall be extinguished. Great kings, in the countries there are innumerable demons and spirits, each of whom has innumerable relatives (followers); if they hear this *sūtra*, they shall protect your countries.' Divine protection for the state is again emphasized.

The image of Asura[9] marks a new kind of iconography. Following the custom established in India the figure has three faces and six arms. Such anatomical absurdities were made as acceptable as possible by the Japanese through poses of rigid symmetry. One of the figures has the head of a bird. That of Kubanda [24] has in its forehead the third eye of spiritual insight. Whether one looks at the Kubanda or at the figure of Rāhula (Ragora) [25], the son of the Buddha and one of the Ten Disciples, a new sense of form is apparent. Dependence on either stone or bronze prototypes has disappeared. Details such as the hands and faces show beautiful modelling, but above all there is a simplicity of surface which both reveals the dry-lacquer technique and allows for wide areas to be decorated with patterns in colour. In many statues executed in dry lacquer the softness of drapery folds is eloquent testimony of the particular effect natural to the technique.

Why the technique of making statues in the dry-lacquer process became so popular in the Nara period is a question which has not yet been adequately answered. The specialized knowledge required must have come from China, though few of the Chinese examples existing today exhibit the skill shown in the monuments of the temples at Nara. Clay as a medium was certainly superior to wood in ease of execution, but had the defect of being easily damaged. Lacquer, on the other hand, was light in weight and nearly indestructible, and the involved process though costly in both time and material has preserved many statues from the eighth century in better condition than others from much later centuries.

Technically lacquer statues fall into two major categories, those built up over a solid core of wood and those which were hollow inside. A Miroku at Kōryūji, also of the Asuka period like the one previously mentioned but topped by a raised chignon of hair instead of a crown, is the oldest example of the lacquer-over-wood type. There were several varieties of the hollow-lacquer technique. Sometimes hemp cloths impregnated with the juice of the lacquer tree were built up over a wood armature till a light casing was made and then finished with applications of finer lacquer. Sometimes the cloth casing was built up over a clay core which was later dug out or removed, or the delicate parts were constructed around a wire framework. The Roshana Buddha of Tōshōdaiji is said to be formed on a basketry framework. From a clay core piece-moulds could also be made. Lacquer coatings, conversely ranging from fine to coarse, were then applied. When removed from the moulds, the pieces were sewn together, placed on an armature, and the joints concealed under other coats of lacquer.

Of the influence of the medium on the craftsman Langdon Warner[10] writes: 'Hollow lacquer, supported internally by a wooden armature, imposed on sculpture a vertical balance and a certain rigidity of posture. The artist was driven by these limitations to concentrate his emphasis on facial expression.' It also left ample opportunity for the colourist. Broad areas of simply curved surfaces, often literally calling to mind stretched cloth with a few woolly folds, always had brightly coloured patterns, usually geometrically composed. Simplicity of form and elaborate painted designs endow this sculpture with directness and gaiety. Sculpture, especially when one reviews the vast amount produced, seems certainly to have been a complicated corporate undertaking.

Another aspect of the new realism was the development of portrait sculpture. Gien, who died in 728, was one of the brilliant propagators of the tenets of the Hossō sect; the wood portrait of him kept at Okadera shows the well-wrinkled features of a rather weary old man. The finest of the portrait sculptures is that of Ganjin or Chien-chên [26], a Chinese priest who occupied a position of great importance in Japan. It was he who reorganized the Ritsu sect and who insisted on the necessity of proper ordination platforms. By the time he reached Japan in 753 he had become blind; the sculptor expresses both his blindness and his profound serenity. It is interesting to compare his portrait with those of Gien and Yuima [23] as each figure is that of an aged man. The two historical priests are well individualized in general terms, but no more so than the mythical Yuima. The three statues possess virility, strength of character, and a subtle feeling of repose which permeates the art products of the period. The world as it is looks right to the sculptor, but he is also aware of an ennobling spirit within. This Buddhist sculpture reflects the attitude of the interpretation of the sūtras then popular.

In connexion with portraiture, mention should be made of the Gigaku masks of the period, many of which are still preserved at Tōdaiji. It is known that some were made by foreigners. The masks were worn in comic dances which had been imported from China and which represented the customs of countries foreign to China. Unlike the later Japanese masks they covered not only the face but the whole of the head. Though doubtless used in religious ceremonies, their expression was rather secular. In the Gigaku Mask of an Old

26. Portrait of Ganjin, Nara period.
Dry lacquer. *Tōshōdaiji*

Man [27] the jolliness of the face shows a treatment which was to have many successors in later periods. The exaggeration, fantasy, and emotion revealed in Gigaku masks represent the lighter side of art, one that gradually became essentially Japanese.

27. Gigaku Mask of an Old Man. Nara period. Wood. *Tōdaiji*

A great group of mid-Tempyō sculptures exists today in the Hokkedō or Sangatsudō of the temple of Tōdaiji. The impressive central image is a figure of Fukūkenjaku Kwannon in the dry-lacquer technique. The eight arms, the perforated sun-ray aureole, the elaborate crown with its solid silver image of Amida, once stolen but fortunately again in place, and the canopy inset with bronze mirrors betray the complex taste of the Nara period. Minor accessories preserved in the Shōsōin reflect the same liking for elaborate, almost fussy detail. This is the oldest statue of Fukūkenjaku Kwannon, a deity popular in Tempyō times who helped believers to keep

away from evil karma and aided those who were sick or suffering. The involved iconography prepared the way for the 'secret teaching' doctrines which became so popular in the ninth century. Other statues pointing ahead to the same development are the Thousand-armed Kwannon [30] of Tōshōdaiji, and in the Hokkedō the Shūkongōjin, the vajra or Thunderbolt Holder whose angry features are used to symbolize an inner benevolence.

The Hokkedō was built in 733 for the celebrated priest Rōben. It housed besides the dry-lacquer figure of Fukūkenjaku Kwannon dry-lacquer images of Bonten and Taishakuten, the Four Guardians, and the two Kongōrikishi, fierce-looking protectors of Buddhism better known as Niō. In 743 a great vegetarian entertainment was held at the temple to show reverence to the *Konkōmyō Saishōō-kyō*. The sūtra, which mentions the gods Bonten (Brahmā), Taishakuten (Indra), Benzaiten, and Kichijōten, supplies the basis for the iconographical grouping.

But today the two figures of Bonten [28] and Taishakuten standing immediately on either side of the central Fukūkenjaku are clay images. The two Hindu gods, Brahmā lord of the world and Indra chief of the gods, were introduced into Buddhism at an early period, for the Buddha was teacher of both gods and men. The sculptures have also often been identified mistakenly as Nikkō and Gakkō, the gods of the sun and moon. Bonten stands in an attitude of intent prayer and of religious calm. The highest quality of Nara sculpture, a sense of harmony between spiritual peace and physical form, is perfectly realized in these figures. Five centuries later the Kamakura period, which tried to follow Tempyō prototypes, never attained the union because its more studied realism destroyed the objective idealism of the eighth century. A comparison of the clay Bonten with the dry-lacquer Rāhula among the Disciples of the Buddha shows little

contrast in conception; for both media reveal a softness of edge in the folds of the drapery which indicate a common development.

The clay of Jikokuten [29], Guardian of the East, from the Kaidanin next to the Hokkedō, is almost identical in pose with the same figure in the dry-lacquer set in the Hokkedō, but the general attitude is more dramatic. A greater degree of plastic modelling is evident, especially in the armour, and this together with the somewhat more violent expression of the features discloses less inner restraint than the

28 (*left*). Bonten, Nara period. Clay. *Hokkedō*

29 (*above*). Jikokuten, Nara period. Clay. *Kaidanin*

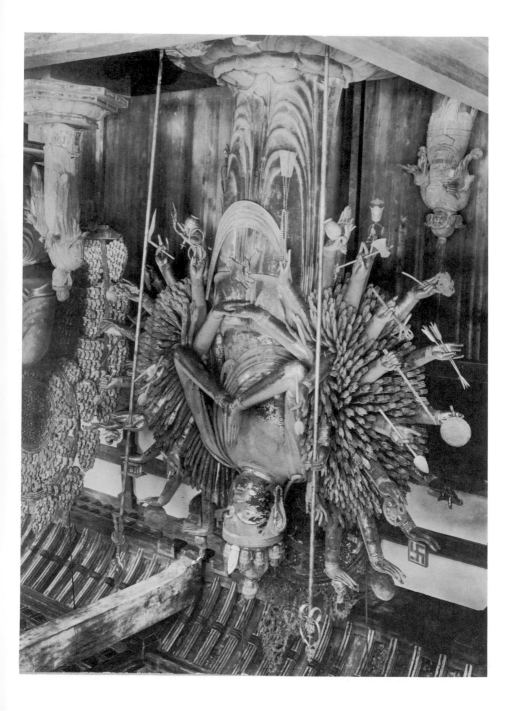

30. Thousand-armed Kwannon, Nara period.
Dry lacquer. *Tōshōdaiji*

corresponding lacquer set. The fullest representation of spiritual vehemence is to be seen in another clay figure, the Shūkongōjin, which is one of the secret or rarely shown images kept in the Hokkedō.

Extreme emotionalizing, the culmination of the realistic tendencies of the age, is expressed in the Twelve Yaksha Generals, clay figures which now stand about the wooden Yakushi Buddha in Shin Yakushiji. They were anciently moved here from Ganenji but are clearly works of the Nara period. Though still remarkable as life-size sculpture, the poses impress one as affected and there is little of that inward power which endows the other clay figures with heroic life.

The largest of the dry-lacquer statues is that of the Thousand-armed Kwannon [30] of Tōshōdaiji. Some eighteen feet tall, it is another example of the scale of the art of the Nara period. The temple was founded in 759, and here Ganjin dwelt until his death in 763. Although various craftsmen had come with him from China, the figure of Kwannon seems rather to belong to the past, to the solemnly religious figures of the Hokkedō. It is the oldest statue of this deity, who was often portrayed in the later esoteric art. The figure is conceived in majestic proportions. The thousand arms – nine hundred and fifty-three by actual count – create an aureole in themselves. Yet in spite of the literalness of the iconography there is no loss of power.

The sculptures of Tōshōdaiji also include figures carved in wood. Although the technique was sufficiently distinctive to be named after the Tōshōdaiji temple, it represented a return to the medium which was thereafter to be the natural material of the Japanese sculptor. The style introduced at this time by Ssu-t'o (Shitaku) and the other craftsmen who came from China with Ganjin, became customary at the end of the Nara period, and prepared the way for the Jōgan or early Heian style to follow.

The sculptures were fashioned out of a single trunk of wood. The sense of activity previously noted yielded to a new feeling for solidity and even heaviness. Some of the joyousness had gone. The new style was weighty and dignified. Another temple, Daianji, also preserves sculptures which should be classified in this general group. In several the prototype appears to have been small sandalwood carvings brought from China, and with some it is difficult to know with any degree of certainty whether they were made in China or Japan. However, it is to be observed that among the many types of sculpture in the Far East, the small pieces carved in precious wood are almost the only ones which were not otherwise adorned with gold or decorated with colour.

The heavy wood style of the late Nara is represented outside Japan by the Shō Kwannon [31] in the Boston Museum of Fine Arts. When compared with the Eleven-headed Kwannon [32] of Shōrinji which was made in the dry-lacquer technique the change of style is readily visible. Gone are the free falling scarves. In comparison, the Shō Kwannon, in spite of the slight rise of one hip and the suggestion of a bent knee on the opposite side, seems stiff and wooden. Though the sculptor even follows the softly rounded edges of the drapery folds appropriate to the lacquer technique, new elements have crept in. The over-simplified expanse of the thighs and the curls of the drapery edges between the leg are details which will be met again in the next epoch. The sculpture should perhaps be more properly dated in the early Heian period as the style continued locally for some time without much change. Certainly the sculptor is not as free in the use of his medium as the artist who made the beautiful Kwannon of Shōrinji.

Sculpture in bronze, which had had such a remarkable development during the seventh century and the early years of the eighth, seems

in the Nara period to have been concentrated in a single effort, in the creation of the Great Buddha of Tōdaiji. This undertaking must have both consumed a very abnormal

31 (*opposite*). Shō Kwannon, eighth-ninth century. Wood. *Boston, Museum of Fine Arts*

32 (*below*). Eleven-headed Kwannon, Nara period. Dry lacquer. *Shōrinji*

supply of bronze metal and required the efforts of all the available bronze casters. Apart from the gigantic image of Roshana, moulded from more than a million pounds of

metal, there is very little bronze sculpture, and what remains is also connected with Tōdaiji. The lantern [33] which stands in the temple courtyard is the oldest of its kind. The idea of lighting numbers of lanterns found sanction in the sūtras: thereby 'repentance is made for many sins'. The lantern of Tōdaiji is one of the finest examples of low relief casting. The standing figures of Bodhisattvas which decorate the door panels have full cheeks and fleshy bodies, the contemporary Chinese ideal of physical beauty. In spite of the volume of the figures they float lightly in a manner befitting heavenly beings. The amazing swirls of the flying draperies turn and twist to give the sculptor the opportunity of exhibiting his skill in relief drawing. This form of art is thoroughly pictorial in the manner of the mature T'ang tradition. Seldom in oriental art have the linear and the relief approaches been so successfully combined. A Bodhisattva banner [36] of the Shōsōin gives in ink line a representation of a related seated figure – yet how one misses the feeling of depth. The art of the Nara period reached its height in plastic imagery.

Paintings preserved from this time are few. However, the records of the Shōsōin present an account which tells of quite a high degree of sophistication in regard to screen paintings. There are mentioned some done in the old Chinese style as well as some in the Kudara style. Their subject-matter included: landscapes, also pictures of palaces; trees and grasses, as well as birds and flowers; and figure compositions. Together they form a classification which takes in most of the divisions into which oriental paintings were grouped in later times. The fundamental approach seems to have been already established. Probably many of the traditions of Japanese art could be traced to the influx of T'ang ideals if more originals or good copies had been preserved from this time.

Among paintings which have come down to us in a style already antiquated in the eighth century are scrolls called Sūtras of Past and Present Karma (*Kako Genzai Inga-kyō*), which illustrate the past and present world lives of the historic Buddha. These are the oldest scroll paintings preserved in Japan. The narrative picture placed directly over the text forms a very harmonious method of literary illustration, but was to be replaced later by alternate sections for picture and text. The scrolls show in horizontal form a special kind of rendering. The primary figure is repeated again and again in episodic treatment. The simplicity of the line drawing, the fan-like foliage, and the naive construction of the rocks all argue that the method of painting was handed on from the Six Dynasties in China. Even the drawing of the Tamamushi shrine seems less primitive than this. The detail [34] from the collection of Jōbon Rendaiji, Kyōto, illustrates the story of the meeting between the Buddha-to-be and the sick man, an encounter which turned the thoughts of the young Indian prince towards the

33 (*opposite*). Bodhisattva on lantern, Nara period. Bronze. *Tōdaiji*

34 (*below*). Sūtra of Past and Present Karma. Nara period. *Kyōto, Jōbon Rendaiji Collection*

sufferings of the world and so to the need of spiritual awakening. The painting preserves most freshly the combination of red, orange, and yellow pigments contrasted with blues and greens. Several versions exist. Copying a Buddhist painting was an act holy in itself, and copying at this time was a task encouraged by the government.

Another picture which probably was done in the Nara period is the portrait of Shōtoku

35. Portrait of Prince Shōtoku, Nara period. *Imperial Household Agency*

Taishi with his son and younger brother [35] owned by the Imperial Household Agency. Because of very strict regulations about costumes the painting could not originally have been made before the second half of the seventh century, for Shōtoku's pink robe follows rules established in 685. The painting

is often regarded as a copy of an earlier version and is the only large secular painting now known. Its convention is not so much Buddhist as it is Chinese in the manner of imperial portraits, such as those done by Yen Li-pên. The curious and to western eyes rather unpleasant shading follows no rule of general lighting or of depth of tone to suggest relief. It indicates a transitional stage where darker areas have the function of producing a ribbed effect rather than a decorative patterning. But it is solemn and respectful. The great prince-patron of Buddhism appears earnest, keen-eyed, and vigorous.

Almost every relic of this time is a first example. The Bodhisattva banner [36] from the Shōsōin, was done in ink on hemp. Though it was an object made for temporary use, it is the only painting in ink which has been preserved. The line work is not so wiry as in the other pictures. Obviously, the image was rendered by a craftsman, but one who was accomplished both in rapid, simple drawing and in careful attention to the symbolic poses of the hands.

Other paintings which preserve an ink outline exist in screen panels, also from the Shōsōin. They show very full-cheeked Chinese ladies standing under trees. The technique of the screens has no extant parallel, for they were coloured in mass, not with pigments but with feathers applied to the surface. They are part of the series of one hundred screens originally offered to this repository.

Closely related to this group are the drawings, now known only in copies, of designs for the doors of the Kaidanin. They were originally painted in 755 by Ōmi no Mibune or Genkai, a high court official. Though very Indian in sensuous charm, they have much in common with the ladies standing under trees in the relation of tall figure to towering tree and in the absence of background. The Two Heavenly

36. Bodhisattva banner, Nara period. *Shōsōin*

Musicians [37] are well combined together. Especially notable is the back view of the lower figure. Figure composition, it can be argued, had reached great maturity when it shows so much skill and ease. The nude little infants in the tree above increase the happy feeling of the whole. It is difficult to imagine that any Chinese artist painted in this particular style as late as the middle of the eighth century.[11] Such art seems rather the continuation of tendencies which had already existed in Japan for more than half a century and certainly was within the ability of Japanese artists.

The most finished painting, one which dates from late in the period, is the tiny figure of Kichijōten [38] painted in full colours on hemp. It is another treasure from Yakushiji temple. Originally a Hindu deity, Kichijōten was regarded in Japan as the goddess of felicity and the incarnation of beauty. In 767 her worship was ordered by Empress Shōtoku (Kōken) in all the Kokubunji, the provincial temples, to 'bring peace, timely rains, good crops, and happiness to the people.' The first special service connected with Kichijō at Yakushiji occurred in 770, so this painting might date from about that period. The use of varied colours, complicated line, and the rendering of transparent gauze garments mark a great advance over the portrait of Prince Shōtoku or the Shōsōin screens. The painting, twenty-one inches high, sums up the feeling of the Nara period for material loveliness. A picture of feminine beauty, it emphasizes the mundane attitude of Kichijō's worshippers who sought for the solid, good things of life. It reminds one that in China too there were artists who specialized in depicting beautiful women. The most famous before Chou Fang was Chang Hsüan, whose types are probably reflected in

37. Two Heavenly Musicians (copy), Nara period. *Kaidanin*

the copy known as Ladies preparing Newly Woven Silk[12] made by the emperor Hui-tsung early in the twelfth century, in the Museum of Fine Arts in Boston. In the Shōsōin a musical instrument decorated with seated beauties has also been spoken of as showing the types fashionable in the days of Chang Hsüan in the first half of the eighth century. There is, however, no evidence that paintings by China's leading artists were being imported to Japan at this early period. Rather, it seems that the influences reaching Japan came as decorative paintings and designs among the minor arts.

To illustrate the classic nature of late Nara painting mention must be made of new kinds of mandara painting, visions of the Paradise of Amida. In one type by the priest Chikō, which dates from the middle of the eighth century, the Buddha Amida and his two great Bodhisatt-vas sit enthroned before a lake. Behind them rise heavenly pavilions. It is a vastly more complicated composition than the simple inter-pretation of the Tachibana shrine of the Hōryūji wall paintings. Better known is the still more elaborate type called the Taima mandara. The original of 763 (an embroidery), whose miraculous origin became the subject of one of the medieval scroll paintings, is so damaged as to be hardly recognizable as a work of art. But later versions like that owned by the Kōmyōji temple of Kamakura are faithful copies. Around the right and left sides of the large central painting are small scenes of the persecution of Queen Vaidehī by Prince Ajātaśatru which follow the text of the Kwan-muryōju-kyō, the sūtra on the meditation on Buddha Amitāyus. Below are nine small panels, descriptive of the nine grades of Paradise where a being may be reborn. It is from one of these minor sections that the later great paintings of the Descent of Amida derive. In Japan the princess Chūjō-hime (753–81) is credited with

the vision which gave rise to the painting, though in actuality it seems to have originated in the teaching of the great Chinese Amidist priest Shan-tao (Zendō) who lived from 613 to 681. Once more one finds the basis of later Japanese art to be ultimately dependent on that of the T'ang period.

The paintings of the Nara period disclose a civilization which was made to please the eye. The rich palette stands far in advance of the restricted colours of the Suiko period. Nor has there yet developed the frivolous spirit and over-elaborateness of the mature Heian times. Worldly this art may appear, yet it was saved from excess. Objective splendour, corporate effort, and national significance were to be replaced later by private luxury, the individual artist, and intensity of religious emotion.

In spite of all the monuments which have survived, few problems are as hard to solve as the degree of nationality of this Nara art. Admittedly it was the age when Chinese art was most in vogue and when imitation was most closely pressed. The names of sculptors like Shōgun Mampuku who made the Asura figure in the Eight Classes of Kōfukuji can per-haps be best interpreted as those of naturalized Koreans. In fact, most of the names which have survived present this difficulty, and even when they sound Japanese to the ear, it can be argued that Japanese names were given to foreign immigrants. That a few Chinese crafts-men came to Japan with Ganjin has already been mentioned. What is necessary to re-member is that the iconography must always have been more important than the artist. Individuality was not desirable, and there were already in Japan hundreds of craftsmen who could be assembled for the great undertaking of embellishing the temples of the capital city of Nara. Art had been organized as an instrument of bureaucracy in the service of the state.

THE SHINGON AND TENDAI SECTS

EARLY HEIAN PERIOD: 784–897

The period called early Heian, which lasted from 784 to 897, goes by many names. Sometimes it is termed Jōgan, the name of the year period from 859 to 876. Sometimes another year period, the Kōnin, which lasted from 810 to 823, is selected to designate this era. Or again the ninth century is classified as the early part of the Fujiwara period. The last name derives from the predominant influence of the great Fujiwara family which controlled most of the administrative positions in the government. The word Heian recalls the centuries when real power was centred in Heian, the city of Kyōto, before the rise of feudalism and the assumption of the reins of government by the military lords of Kamakura.

The important art of the ninth century continued to be Buddhist. Whether the style now seems to us as vigorous, pleasing, and understandable as that of the preceding century is a point of little importance aesthetically. The new manner developed in relation to recently imported and ardently venerated sects of Buddhism. Sculptures and paintings possess a new volume and unreality. They do not aim to be impressive by size or life-likeness. Theirs is rather a forbidding grandeur, frequently expressed by deities ferocious in aspect. To understand the underlying benevolence and significance of such gods requires attention to Buddhist doctrine and to the problems confronting the makers of images.

Whatever may have been the political reasons for the change of capital in 794 to the city of Kyōto, then called Heian, one of the most pressing was the need to escape from the dominance of the Nara clergy. If in spite of the straitened financial circumstances which resulted from the building of so many Buddhist monuments at Nara it was still regarded as necessary to move the capital, the need must have been urgent. Buddhist worship changed too. It became aristocratic, a religion of the court and the nobility rather than for the nation. The greater temples of the new sects were situated not so much in the metropolitan area as in lonely mountain retreats. Religion expressed both the general decentralization of power and the increasing love of ritual and etiquette which characterized the age. It was a period of assimilation. The latest doctrines were adapted to suit their Japanese environment and became dominant teachings for the next four or five centuries.

The Tendai sect was introduced in Japan in 805 by the priest Saichō (767–822), later known as Dengyō Daishi. He had gone to China and studied the sect which Chih-i had established on Mount T'ien-t'ai in 575. It derived its principles from the *Lotus Sūtra*, which emphasized the identity of the historic Buddha and the eternal Buddha-nature asserted to exist in all persons and everything, although knowledge of it was not possible without instruction and morality. Hence it was not unnatural for the priests of the sect to be influenced by those of the Shingon sect and to recognize the position of its central deity Dainichi (Vairocana) as representative of the Absolute. In Dengyō's teachings, too, can be traced the early stages of the later doctrine of the identification of native and Buddhist deities. He

worshipped the old mountain god of Hiei, where the great temple of Enryakuji grew up, under a new name as the local protector of his temples, as guardian against the evil influences coming from the north-east. The doctrines of Dengyō were opposed primarily by the priests of the Hossō sect. They objected to his rite of initiation, in which vows were made not to the priests but to the Buddha himself, and also to his claims for an independent ordination ceremony, by which the sect became free from the control of those at Nara. In many ways the Tendai was an eclectic school. It emphasized the unreality of the phenomenal world. Enlightenment was to be sought for neither in realism nor in transcendental idealism, not in learning nor in meditation, but in a balanced Middle Way. It was just this breadth of view which later made it possible for meditative sects like the Zen, for salvation sects like the Jōdo and Shin, and for the prophetic Nichiren to evolve from the great Tendai monastery situated on Mount Hiei outside Kyōto.

But the sect which dominated the thought of the Jōgan period, including under its influence even the Tendai school, was that known as Shingon, the True Word sect. Its great founder and exponent was Kūkai (774–835), better known under his posthumous canonical name of the Great Teacher Kōbō. This sect, which was the last to develop in China, was introduced in Japan by Kōbō when he returned from China in 807. Both new forms of Buddhism, Tendai and Shingon, aroused great interest. The Shingon teachings especially appealed to the court, and early acquired a dominant position. With the exception of Tōji, correctly called Kyōōgokokuji, which was situated in the capital city of Kyōto, most of the famous temples like those of Kōyasan or that of Jingoji at Takao were built deep in the mountains. Shingon was the most occult of Buddhist sects. As its name, True

Word, implies, it taught magic formulas. Both in its nearly pantheistic view of the world and in its elaborate rites it expressed tendencies closely related to the native character of the Japanese. Like Dengyō, Kōbō aided in the assimilation of native gods by teaching the idea of emanation.

In Shingon Buddhism the revealed doctrines as taught by the historic Shaka were distinguished from the secret doctrines of Dainichi, or the Buddha in his form of ultimate reality. The name Dainichi, the Great Illuminator, was originally but a solar adjective describing the Buddha. The Mahāyāna theory of the three bodies of a Buddha was accepted and expanded. The Body of the Law, the shining light of abstract truth, the Body of Bliss, the glorified deities whose merits continued their existence and made them accessible to mankind, and the Body of Incarnation were accepted, basic ideas. The person of the Buddha had already been transformed into that of a supernatural being who appeared to teach at divers times and places an ever identical law. In the Shingon there are a group of five primary Buddhas – four emanations from the central figure of Dainichi.

The idea of this cosmic soul was paralleled by the idea of the universe as the body of Dainichi. The system is often called a cosmotheism. When Okakura wrote in *The Ideals of the East* 'that the whole universe is manifest in every atom; that each variety, therefore, is of equal authenticity; that there is no truth unrelated to the unity of things; that is the faith that liberates the Indian mind,' he summed up both the virtue and the danger of this kind of thought. If Buddhahood were to be a realization possible for everyone, there was the hazard of so closely identifying the actual and ideal worlds that morality and salvation would lose their meaning. The symbolic and formalistic aspects gradually became sterile, and though the Shingon sect may be regarded as

the most important for the Heian period, by the late twelfth century it was apparant that newer sects had much more vitality.

The differences between Buddhist sects are so metaphysical that they constitute aspects of higher thought rather than true sectarian divergencies. The Shingon inherited the point of view of subjective idealism from the Indian Yogācāra school. It maintained that consciousness made up the universe against the Mādhyamika school, which held that reality was not to be found in consciousness and which had more influence on the Tendai sect. To the Shingon believer the body of Dainichi constituted the world, formed of the six elements – earth, water, fire, air, ether, and consciousness. The body, speech, and thought of Dainichi are the three mysteries which make up the life of the universe. Thus, the outer world is filled with spiritual forces, and these could be and were expressed as different divinities. Man's life when brought into proper communion shared that of the whole cosmos. The sect introduced new concepts of art which through ritual aided in the communion.

One of the incidents in the life of Kōbō which became in Kamakura times the subject of a painting was his Debate with the Eight Sects which occurred in 813. For a moment the priest appeared transfigured in the form of the Buddha Dainichi. It was just this point of the attainment of Buddhahood in the present body in which his sect differed from all others. To his followers he is still regarded as asleep in his tomb on Kōyasan where he awaits the coming of the next Buddha, Miroku. From this it can be observed that the Shingon doctrine was a quick method of salvation. In a practical religion such a teaching must have had great appeal to those who wished to escape from the normal belief in an interminable round of birth and death and inexorable karma.

Under the influence of the Shingon the arts flourished. Worship became so complicated that sculpture alone could not cope successfully with the need for proper ritual adornment. New kinds of paintings were created, because with the many specialized rites it was easier to represent the required gods graphically than plastically. Some of the traits of the sculpture seem to suggest the derivation from drawn models. Iconography, it is certain, assumed a new importance.

The sculpture of the ninth century reveals a new attitude towards deity in human form. The gods of the Nara period were frankly idealized models. Especially the lesser gods seemed fraught with human emotions. Now the solemnity of the gods shows itself in a new massiveness of structure and a disproportion of parts which adds up to the creation of far less approachable forms. But if the figures seem austerely spiritual, they are made alluring with a kind of heavy Indian sensuousness, appealing but still foreign. A sense of gloom distinguishes the Jōgan gods from the more vigorous Nara ones and from the gay and more enjoyable ones of the later Heian period.

Indicating the beginning of a Japanese taste, sculpture which hitherto had been fashioned in so many media was now made as a rule of wood. The usual technique was to employ a single section of tree trunk, so that the whole piece could be carved out of a solid block. It might be guessed that some of the characteristics of early Heian sculpture were the result of the choice of a medium which perhaps tempted sculptors to exaggerate the size of the heads or the length of the arms. Yet this conjecture must be wrong, for the same general traits can be found in the paintings, and religious art must always have depended on the particular model books which were in fashion. Priests at this time were trained in sculpture and painting as an important aspect of their religious education.

The tradition of the Nara period did not die out suddenly. The single-trunk style, now

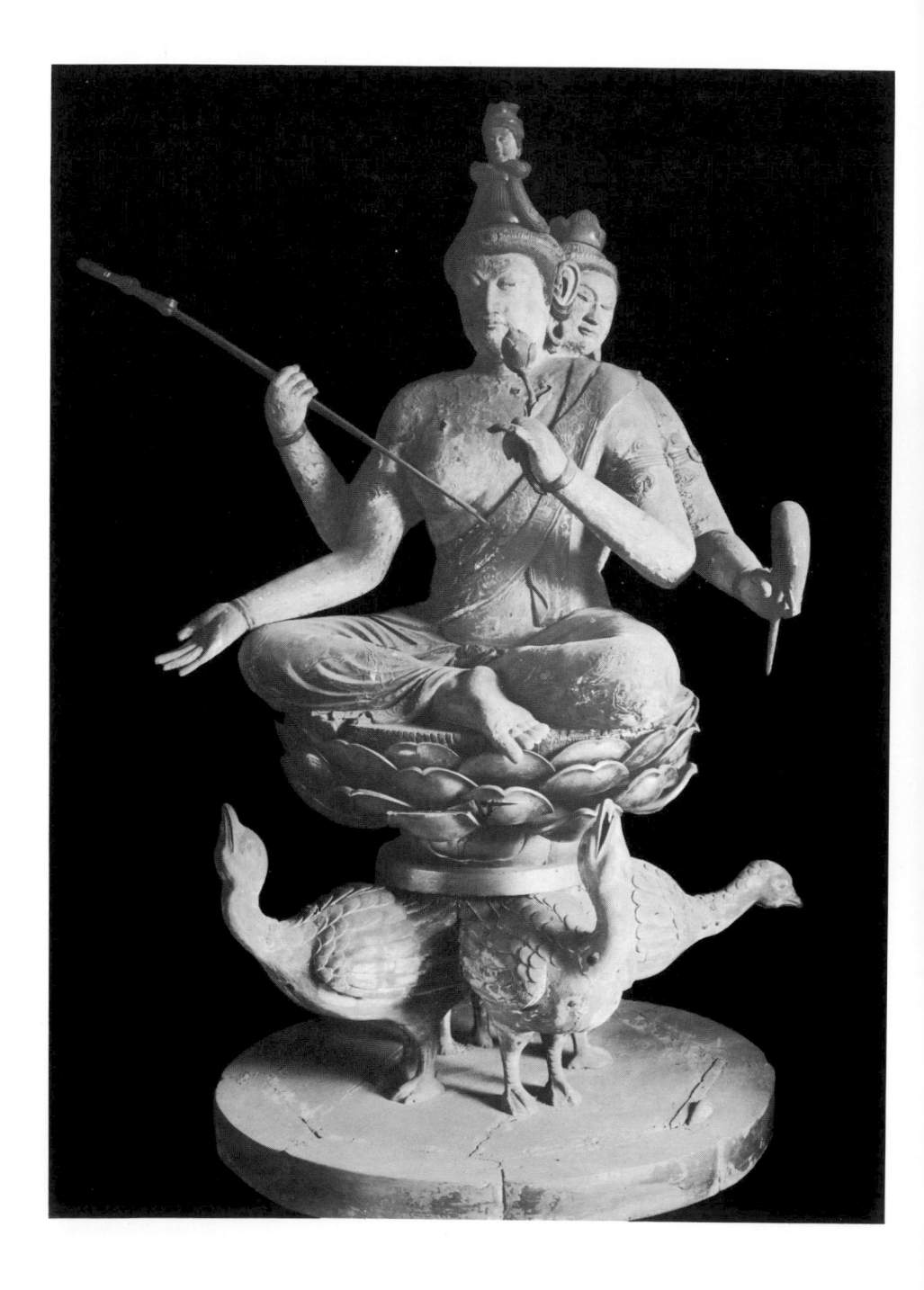

the rule, was but a development of a tradition already apparent in the Tōshōdaiji and Daianji sculptures. Some of the earliest examples of the Heian style, the Four Guardians of the Hokuendō of Kōfukuji which date from about 791, even carry on the dry-lacquer technique. In these a short-necked sturdiness of figure is activated by theatrical gesturing, as though their religious requirements had been interpreted by a stolid mind rather than visualized by someone appreciative of their tutelary function.

One of the sculptures in which the transition is best seen is the Bodhisattva Gakkō[1] at Hōbodaiin in Kyōto in which solemnity, massiveness of figure, and picturesque swirls of draperies reflect the importations of stylistic changes from the later T'ang dynasty in China. This statue according to temple traditions was made by Jikaku Daishi (794–864), a priest of the Tendai sect. Yet it shows many of the traits which are most often associated with the Shingon sect and its art. The early Heian style belongs to a period, not a sect.

The new kind of image which reflects the Shingon doctrines propagated by Kōbō Daishi is clearly felt in the Bonten [39], still at the Tōji temple in Kyōto. The figure is seated on a lotus throne supported by geese (the birds being a restoration of the Edo period). What a totally different conception from the calm, worshipful, clay figure in the Hokkedō! Here the several heads, many arms, and bird mount are products of the Indian rather than of the Chinese mind. The value of human likeness has been supplanted by the value of symbolic meaning. And here Bonten, or Brahmā, follows the iconographical aspects of the mandara paintings of the Shingon sect. The figure formed part of an immense gathering of altar sculptures dedicated to the ideas of the sūtra of

the *Benevolent Kings*. To establish integrated concepts in one vast scheme, Dainichi and the four Buddhas were placed in the centre, to the right was a group of five Bodhisattvas and to the left a group of the five Myōō; in front stood Brahmā and Indra, and in the corners the Four Guardians. The same type of a many-armed, angry-faced conqueror of evil appears in painting in illustration 48. As altar furniture such cumbersome deities become oppressive; as paintings they better fulfil their idealistic intention.

Little sculpture of the Bonten type has survived. In another building at Tōji, the Kanchiin, is a set of Five Kokūzō, the Sky-Womb Bodhisattvas which appear in five different manifestations. They are known to have been brought back from China by the priest Eun in 847. They, too, sit on animal or bird mounts. Though similar in conception to the Bonten, the execution differs. They are more primitive than Japanese sculptures of similar date. At this time Buddhism was persecuted in China, and in 894, half a century later, official Japanese missions to China ceased. It seems probable that the end of the early Heian period marks the inception of styles which, though sharing a common Buddhist ancestry with examples from China, became ever more expressive of Japanese temperament.

The temple of Jingoji, outside Kyōto, contains many examples of the Jōgan style. Founded in about 800, its first main image was a standing figure of the Buddha Yakushi, of heavy proportions, which developed from the Tōshōdaiji school of carving. More graceful and adumbrative of the future rather than reminiscent of the past is a set of five Bodhisattvas, the five great Kokūzō. The Kongō Kokūzō [40] wears a pointed crown, symbolic of wisdom. The arm is sharply bent, and in the hand rests a vajra (Kongō), the attribute of this particular form of manifestation. The Kongō Kokūzō is regarded as an emanation of the

39. Bonten, early Heian period. Wood.
Tōji

40. Kongō Kokūzō, early Heian period. Wood. *Jingoji*

Buddha Ashuku of the eastern quarter. Four other nearly identical statues represent the central figure of Dainichi and three other Buddhas. The set, which dates from late in the second quarter of the ninth century, has a facial type which, though fleshy and short-necked in the early Heian manner, is nearly round in proportion – a characteristic of the mature Heian period, when sculpture was becoming national in form.

The figure of a Standing Shaka [41] from the Murōji temple, near Nara, dates from about the middle of the century and shows most of the special traits of the ninth century. There is the solemnity of expression, the fat cheeks, the large separate curls of hair, contours indicative of the muscular division of chest and abdomen, many parallel lines of carefully patterned drapery, and deeper and sharper cutting of the folds than was usual earlier. This particular statue is notable for the preservation of the painted aureole which stands behind it and which is decorated with images of the seven Buddhas of the past and present world cycles. Their presence suggests the uniformity of the Buddha's preaching. The stance and proportion of this Buddha follow closely those of a Yakushi statue at Jingoji once attributed to the hand of Kōbō Daishi himself, and of another at the temple of Gangōji. Although the Murōji Buddha excels in crispness of cutting, all three show the same arrangement of pleat-like folds and the same disproportionate smooth areas for the thighs.

Another figure from Murōji, a Seated Shaka [42], shows even more clearly the characteristic 'rolling wave' style of carving. The more prominent rounded folds are frequently separated from each other by a less high but sharply chiselled ridge. What relation the technique had to painting is a problem for study. Visually this kind of cutting presents to the eye much the same effect as the ribbon-like darker tones of the draperies which appear in the painted

41. Standing Shaka and painted aureole, early Heian period. Wood. *Murōji*

42. Seated Shaka, early Heian period. Wood. *Murōji*

haloes of the statues at Murōji. In both painting and sculpture there is a deliberate surface patterning through light and dark tones. In the Seated Shaka may also be observed curious swirling curves of drapery at the bottom which have no significance in wood sculpture but which are easily comprehended as calligraphic brush strokes. When these points are considered in relation to the model books and paintings which were brought back by the priestly travellers to China, it seems reasonable to suppose that the style is a special reflection of drawn models. Such an explanation would account, too, for the dissimilarity between the known imported Chinese sculptures like the five Kokūzō mentioned above and Japanese sculptures which are separated by only a few years in date. In the early Heian period and in the Shingon sect orthodox conventions were of paramount importance, superior to the question of media.

One of the most beautiful statues of the age is the Eleven-headed Kwannon[2] [43] of the temple of Hokkeji which probably dates from the second half of the ninth century. It possesses both the faults and virtues of the style. The heavy type of Indian beauty still lingers. Yet the precision of the deep cutting, the gentle curves of free draperies, and even the peculiar twist-back of the drapery ends combine to create a moving rhythm of pleasing lines. Being made of precious wood, the small statue was left almost entirely unpainted, but originally the hair was tinted blue and the lips red. Stone was inserted for the pupils of the eyes. The strands of hair between head and shoulders are of metal, and have a crisp slenderness which would be difficult to achieve in wood. Other statues which are stylistically related are an Eleven-headed Kwannon in the Kwannondō in Ōmi and a Miroku at Murōji.[3]

Quite a different phase of sculpture is to be discovered in a group of Shintō gods made in the last decade of the century. The empress

43. Eleven-headed Kwannon,
early Heian period. Wood. *Hokkeji*

Jingō [44] is an imaginary portrait of the famous empress of the third or fourth century A.D. who led an expedition of conquest to Korea. After her death she was deified. This and other

44. Empress Jingō, early Heian period. Wood. *Yakushiji*

sculptures have been kept in the shrine of the native god of war, Hachiman, attached to the Yakushiji temple in Nara. We have here to note the early association of Buddhist and Shintō shrines in the same compound and the creation of anthropomorphic images of Shintō gods under the influence of the paramount Buddhist thought. These were steps on the way to the doctrine called *ryōbu Shintō*, in which native gods were worshipped as avatars of Buddhist ones. The word *ryōbu* signifies two parts, and refers to the double aspect of the material and eternal worlds as taught by the Shingon sect. The Hachiman of the Hachiman shrine has the appearance of a Buddhist priest. The empress Jingō, on the other hand, is dressed in Japanese costume and preserves

some of the colour which decorated it originally. One is reminded that neither native religion nor custom was entirely repressed by the influences of China or of Buddhism.

The group of sculptures at Tōji suggested some of the difficulties which confronted the Shingon sculptor. The double mandara paintings of the forces of the eternal or Diamond World (Kongōkai) and of the material or Womb World (Taizōkai) sum up the perplexities which faced the painter. The mandara, or diagrammatic representation of Buddhist theology, is characteristic of the Shingon attitude. In the proper Kongōkai painting alone there are four hundred and fourteen figures, each to be drawn according to rules for colour, pose, and attitude. The mind recoils before such complexity. Religious art had become too intricate for sculptural illustration. Such meticulous renderings partook rather of the nature of magical formulas in the belief that the portrayal of correct ideas by itself possessed an inherent power. The ultimate expression was a painting in which 'seed characters' or unintelligible letters derived from Sanskrit were substituted for the figures in these ryōbu mandara.

The elaborateness of conception is illustrated by the inclusion in the Diamond World of figures of Play, Garland, Song, and Dance. As M. Anesaki points out in *Buddhist Art in its Relation to Buddhist Ideals*: 'They are intended to signify the acts of worship and adoration paid to the great Illuminator Dainichi, of whom, however, they are manifestations. . . . Thus the palpable representation of the facts of worship symbolizes the truth that worship or adoration is based on the spiritual ties which unite the worshippers with the worshipped.' Such allegorical figures are exceptional in the course of Japanese art.

There are several extant, early mandaras of the Two Worlds, those kept at Takao and at Kojimadera being the most famous. The five-

45. Dainichi (detail of Mandara), early Heian period. *Kojimadera*

storeyed pagoda at Daigoji which was built in 951 has probably the oldest done in colour.

The Kojima Mandara, said to have been brought back from China by Kōbō Daishi, more probably is a later copy. It was painted in gold and silver outline, a technique which is found decorating boxes in the Shōsōin repository. The contrast of gold on a dark blue ground was a traditional method used in Buddhist manuscripts, and continued in favour for the introductory pictures which decorated many later Buddhist sūtras. The Dainichi [45], which sits in the top row of the nine squares which compose the Diamond World, shows great delicacy of line. The new subtlety and elaborate patterning undoubtedly represent developments in Chinese painting of the T'ang period, and, like the Shingon religion itself, seem to have been more influential in Japan than in China.

Here Dainichi sits in a circle of light. The hands are arranged so that the five fingers of one hand representing the five usual elements clasp the forefinger of the other hand representing the sixth element, mind. In the Womb World, however, Dainichi sits in the centre of an eight-petalled lotus, the Buddhist flower of purity. Its hands rest one upon the other in the position of meditation, and above is placed the eight-spoked wheel, symbol of the Buddha's teaching or turning of the wheel of truth.

Further evidence of Shingon thought is provided in another set of paintings, the Twelve Gods from the Saidaiji temple in Nara, which appear both as independent paintings and in the Womb World mandara. The gods are all Hindu deities who found their way into the Buddhist pantheon and hence appear in Japanese art. They govern the ten regions, the eight points of the compass together with zenith and nadir, and the two luminaries, the sun and moon. Included are such well-known Hindu deities as Kwaten (Agni), god of fire; Bonten (Brahmā), lord of heaven; and Nitten

(Sūrya), the sun god. The iconography differs from that of later sets in that the figures are, like some of the ninth-century sculptures, placed on animal or bird mounts.

Often associated with the mandara paintings are those of the Seven Patriarchs of the Shingon sect. On his return from China Kōbō Daishi brought back five portraits which were painted by a little-known Chinese artist, Li Chên. Two more Kōbō is reputed to have painted himself. In the set are: Hui-k'o (Keiko), Kōbō's own Buddhist master in China; Keiko's teacher Amoghavajra (Fukukongō); three famous eighth-century translators of Shingon sūtras – Śubhākarasiṁha (Zenmui), Vajrabodhi (Kongōchi), and the Chinese I-hsing (Ichigyō); and two earlier propagators of the Mahāyāna, Nāgārjuna (Ryūju) and Nāgabodhi (Ryūchi). Much in the same style of painting is another portrait, that of the priest Gonzō [46], who had been an early teacher of Kōbō Daishi. Its ecstatic intensity expressed in the keen eyes and open mouth and in the mystic gestures of the fingers is in marked contrast to the meditative calm of the Patriarchs of the Tendai sect which will be discussed in the next chapter. The portrait illustrates the positivistic training of the Shingon ritual, and as a portrait carries on with new psychological acumen the realistic tendencies of the Nara tradition. The greatest painter of the first half of the ninth century, Kudara Kawanari, whose work is known only from literary records, was famous for his portraits. The painting of Gonzō which was done during the artist's lifetime is sufficient proof of the contemporary excellence of and taste for exacting portraiture.

Another type of Shingon art is found in the representation of ferocious deities whose benign intent seems totally concealed behind terrifying features. Such are the Myōō whose anger is turned against evil-doers. Most popular of all is Fudō, who in Japan is believed to be a form of Dainichi. He had vowed that those who

46. Portrait of Gonzō, early Heian period. *Fumonin*

47. Red Fudō, early Heian style.
Myōōin

saw his body would give forth the Bodhisattva heart, that those who heard his name would cut off evil and do good, that those who heard his teaching would acquire great wisdom, and that those who knew his heart would reach Buddhahood even while in the body. In the Red Fudō [47] of Myōōin on Mount Kōya there is apparent all the doctrinal seriousness of the Shingon sect. Fudō, the Immoveable, sits on a foundation of rock before a background of flames. Indignation glares from his eyes to terrify away every evil thought. His attributes, sword and rope, suggest his power to menace and to restrain. Two boy attendants stand below, the elder Seitaka symbolizing his 'subjugating power' and the younger Konkara his 'sustaining virtue'. The Kurikara sword and encircling dragon further carry out the idea of evil combated by Fudō in dragon form.

Artistically the picture introduces several new features.[4] Here is a major Buddhist deity without either the usual frontality of pose or symmetry of composition. What has been called the 'expansive style' of the early Heian period is visible in every detail. Each main element crowds the painting to its border and each by itself is large in scale. Equally characteristic is the 'reversed' shading, a convention to produce depth, but one in which what would be high-lighted areas in western art are darkest in tone. The simplicity of the suggested modelling forms an essential part of the monumental style achieved. The sequence from naturalism to religiosity becomes evident, if this painting is contrasted with the Kichijōten of Yakushiji.

The same tremendous religious sincerity which dominates the conception of the Red Fudō is to be found in paintings of the Five Myōō. The Bodhisattva Muryōrikiku [48], which belongs to the Junji Hachiman Association of Mount Kōya, is one of these five Great Power Howl Lords of Enlightenment. The five powers are those of faith, energy, memory, meditation, and wisdom. As howlers

they embody the idea of magical utterances. Their iconography derives from the sūtra of the *Benevolent Kings* through whose power kings could protect their countries, but this version shows considerable variation from other sets and is based on the older translation of the sūtra made by Kumārajiva. In later examples, such as the version to be seen in a detail from the copy of Mitsunaga's Annual Rites and Ceremonies [230], the place of Muryōrikiku is taken by Fudō; in either case they are manifestations of the power of Dainichi. The Muryōrikiku in illustration 48 springs sideways, arched in one continuous sweep. Bulging eyes, canine teeth, huge hands, and curled-up toes illustrate what M. W. de Visser calls in a happy phrase about these gods 'the stern fierceness of their great compassion.' Behind the figure a seething mass of flame fills the picture to its margins. The line work is nearly even, but here and there are hook-headed strokes which denote a new approach to the drawn line. The shading is reduced to an interesting dark and light ribbed pattern. There is little feeling for depth as in the Red Fudō, and in its place is an overwhelming activity of line to which both colour and shading are subordinate. Painting has evolved a long way towards the calligraphic quality of the later Heian style, but the patterns which are used decoratively, though still geometric in the Nara tradition, seem light and trivial. In just this point later Heian art was to develop and to create a new sense of splendour.

As to secular art, none remains to tell us of the style which made the name of Kose no Kanaoka illustrious in literary records. The Sages on the sliding screens of the Seiryōden Palace which he painted in 892 in the Chinese manner probably were related to others which had been done for the palace in the days of Emperor Saga early in the ninth century. Stories about his horses, which were so lifelike that they were said to have strayed away until

48. Muryōrikiku, early Heian period. *Junji Hachimankō*

he painted in halters to restrain them, give an impression of realism and of active line. But with Kanaoka began one of those extraordinary family lines which are so peculiar to Japanese art history. His sons were Kimmochi and Kintada. From Kimmochi descended Fukae, and from him Hirotaka. All were painters distinguished in their day. Such family lines reflect the value placed on heredity even in the arts by the aristocratic society of Japan.

In an article on 'The Rise of the Yamato-e'[5] Alexander C. Soper remarks that 'important evidence of the secular painting of the ninth

century is provided by contemporary poetry.' In fact, the paintings on palace screens frequently became the subject-matter for the courtier poets. 'The earliest recorded instance of the artistic use of a purely Japanese scene' was a screen of ' "red leaves drifting down the river Tatsuta".' Professor Soper adds that 'it is obvious that these screen pictures must have had a primarily sensuous appeal . . . and that their subjects were either designedly Japanese or at least without specific connexion to China.'

The accident that none of the paintings survives makes it impossible to define the origins of a national style already existing before the middle Heian period; yet it can hardly be doubted that Japanese art must have been notably indifferent to and independent of any close imitations of Chinese standards in art even in the ninth century. The period was one of assimilation; there is clear evidence that the Japanese were then adjusting foreign standards to meet their own tastes and needs.

THE TASTE OF THE IMPERIAL COURT

MIDDLE AND LATE HEIAN PERIOD: 898–1185

The long period from the tenth through the twelfth centuries, now referred to as middle and late Heian after the name of the imperial capital, is also known as the Fujiwara period. The dominant power was that of the nobility, and the cream of the nobility was the Fujiwara family. Nakatomi Kamatari, who had planned the Taika reform of 645, had been granted the name of Fujiwara and claimed for his first ancestor one of the heavenly deities who accompanied the descent of Ninigi no Mikoto from heaven to earth. The art of the period reflects the tastes of an ancient aristocracy at the height of its power – a power which it obtained by a policy of supplying consorts to the emperors and by gaining for itself the position of regent. It was a time, too, of retired emperors ruling from cloisters and of child emperors occupying the throne. The life of an emperor had become so onerous with ceremony that a ruler who wished to reign found it expedient to abdicate. The great families which rose to prominence in the twelfth century, the Taira and the Minamoto, were likewise of noble birth, being in fact descendants of the sons of emperors.

The concentration of wealth in the hands of a few, the rigidity of life about the court, and the general acceptance of traditional ideas produced an art which was at once lavish, formal, and homogeneous. Little has survived in comparison with the number of relics from the shorter Asuka and Nara periods. After the removal of the capital in 794 Nara suffered few destructive battles except late in the twelfth century. Kyōto, on the other hand, remained the imperial capital until 1868, and was repeatedly the centre of devastating conflicts. Yet so much still exists from the long Heian period that only the more important phases of its art can be dealt with.

It was a great age for literature. The social life of the late tenth century is described in the romance of The Tale of Genji, which can be read in the well-known translation of Arthur Waley. Written between 1008 and 1020 by Lady Murasaki, it indicates both the influential position of women and the popularity of literature in the native tongue as distinct from a more learned and affected Chinese style of writing. Even at this early time the life of the upper class seems to have been artificial, sophisticated, and over-sensitive. The composing of poems was already an important cultural activity. The Kokinshū, a collection of poems ancient and modern compiled under a decree of 905, was to become the most celebrated of the many anthologies of Japanese verse.

As an age of luxury and splendour, largely centred around the capital of Kyōto, it was a time of sentiment rather than of profound thought. In religion special services were performed for material benefits: for the coming of rain, for ease of childbirth, or to avoid calamities. Ritual, costly and colourful, was ready for each occasion; it suited the times. Visions and superstitious fears dominated thought. The catastrophes which happened to follow after the death of Sugawara no Michizane in 903 were interpreted as the evil portents of his angry ghost. In life he had been one of the

successful non-Fujiwara statesmen; in death new honours were conferred upon him, and a shrine was consecrated to appease his spirit.

Gradually, too, an 'easy path' was sought in Buddhism. There arose special doctrines about the saving grace of Amida Buddha. Men's thoughts were also disturbed by the belief in the End of the Law (Mappō). It was feared that in 1052 the 'Buddha's power should cease to be manifested', and would be followed by a period of degeneration. In a worldly age the dazzling descriptions of the Jōdo or Pure Lands of Bliss of the various Buddhas, especially that of Amida, must have seemed deeply attractive and accessible. Salvation by faith became an attitude of mind which found exponents in many sects. Faith and the repetition of the name (nembutsu) of Amida became the key to his Paradise. Special halls for his worship existed both at Tōdaiji and on Mount Hiei.

The idea of repetitive images, the virtue of which lay in their mere multiplicity, was one of the formal religious practices of the time. To make them wood blocks were cut and printed. Though the process of block printing can be traced back to the Nara period, it was now used for the making of holy images. Among the oldest extant are sheets of paper with ink images of Amida which were found inside sculptures at the temple of Jōruriji and which probably date from 1047.

The worship of Amida became increasingly popular. The age which faced a decline in the Buddha's power required an easier path for salvation than the arduous metaphysics of the Shingon or the strict meditative practices of the Tendai. Famous priests like Kūya (903–72), who with evangelic zeal wandered and preached all over Japan, or Eshin (also called Genshin, 942–1017), who had beatific visions, prepared the way for the rise of the Pure Land (Jōdo) sects in the following period. In 984 Eshin wrote a book called *Birth in the Land of Purity* (*Ojō Yōshū*). In his *History of Japanese Religion*

M. Anesaki translates a part as follows: 'When a pious person dies, the Buddha appears before him. The Lord of Compassion (Kwannon), one of his great Bodhisattvas, brings a lotus flower to carry the pious soul, and the Lord of Might (Seishi) reaches him welcoming hands, while other saints and angels innumerable sing hymns in praise and welcome of the pious. Born in the Land of Purity, the pious man is like a blind man who suddenly recovers his sight and finds himself surrounded by radiant beams and brilliant jewels of untold price. . . . Amida Buddha sits on a lotus seat like a golden mountain in the midst of all glories, surrounded by his saints.'

The sculptures of the Heian period were deeply affected by these teachings. The stern-

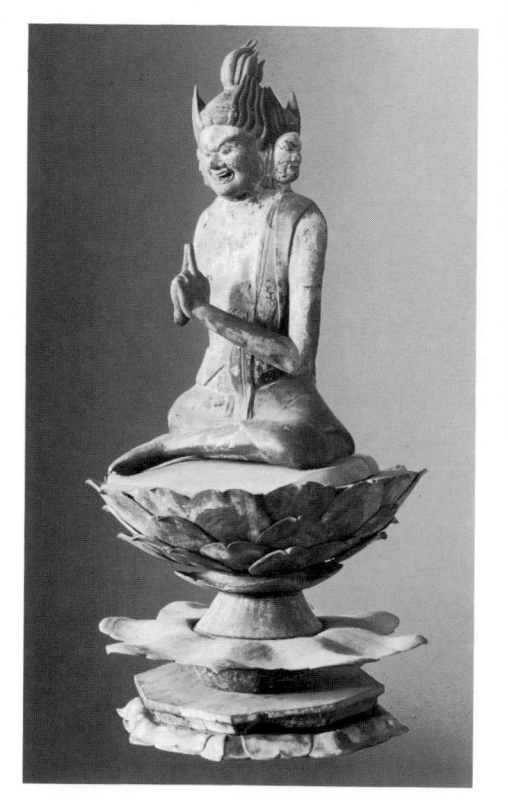

ness of the Jōgan style soon disappeared before the stress of new ideas of gentleness and mercy as well as of charm and splendour. A transitional phase from the early to the later Heian style can be observed in tenth-century sculpture such as the seated, wood Amida[1] of the Iwafunedera temple near Kyōto. The still massive figure is more flatly presented, and there is less depth in the carving. Though the curls of the hair remain large, the face itself is circular in proportion. Especially does the treatment of the eyes – the highly arching eyebrow, the nearly straight upper lid, and the slightly curving lower lid – give a dreamy, meditative, and kindly expression. Such deities seem sympathetic to mankind, the type the Heian age enjoyed.

49 (*opposite*). Daiitoku, Heian period. Wood.
Boston, Museum of Fine Arts

50 (*above*). Enkai: Prince Shōtoku,
Heian period, 1069. Wood. *Hōryūji*

Even ferocious gods such as the Daiitoku [49] of the Boston museum are less terrifying than their predecessors. The iconography demands in the usual figure six heads, arms, and legs to symbolize his activity in the Six States of Transmigration. Daiitoku, the lord of majesty and power, before whom all evil stands in awe and whom none surpass in power, corresponds to the Hindu Yamāntaka, the God of Death. In Japan he is regarded as an emanation from Monju, and is associated with the western quarter. He is counted as one of the Five Great Myōō. Others of the Myōō have already been illustrated. In contrast to the painting of Muryōrikiku [48] this sculptural form of a similar god dating from the tenth or eleventh century is quite restrained. Its intimidating power has been glossed over. Its ugliness is made almost attractive through the use of colour. The flesh is a pale dull green over a gesso foundation, against which the pattern on the shoulder garment in warm colours stands out in contrast. If more statues had preserved their original colouring, it would undoubtedly be observed that most of the Heian examples were brilliantly attractive.

The Daiitoku also shows the beginning of the joined-wood manner of carving which gradually replaced the earlier style of carving from a single trunk or block of wood. On the back and sides are squarely cut-out sections where more arms and legs could be attached. This technique increased the degree of delicacy which could be expressed, and reflects a change in taste, a growing love of refinement.

Still more colourful is the red-robed, seated statue of Prince Shōtoku [50] at Hōryūji which was made by the sculptor Enkai in 1069. The artist who added colour to the carving was Hata Munezane, whose name may also be read as Chitei. The boyish figure looks so proper and gentle that one misses the manliness of the earlier painting [35]. This is a statue to be reverenced, and as such it has much of the

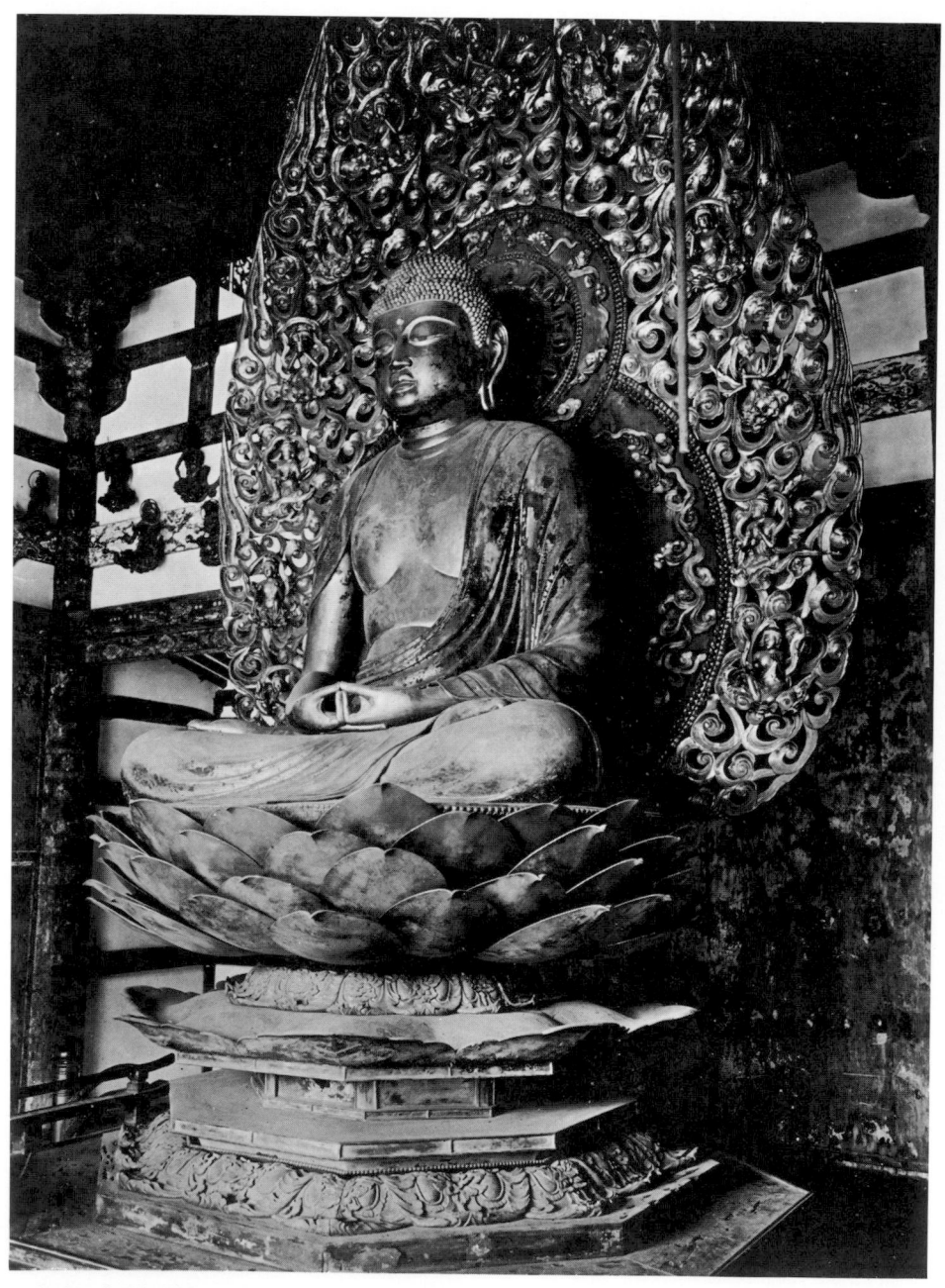

51. Jōchō: Amida, Heian period, 1053. Wood. *Hōōdō*

repose of a seated Buddha figure. Yet the modelling shown both in the face and hands possesses a realism not generally expressed in Buddhist sculpture.

The sculptor who set the fashion for the later Heian period was Jōchō. His name is famous today, especially because the Hōōdō or Phoenix Hall of the Byōdōin temple at Uji, near Kyōto, survives as a Fujiwara building in remarkably good condition, preserving much of its original sculpture, painting, and decoration.

Jōchō's name is associated with that of Fujiwara no Michinaga (966–1027), the greatest member of the clan, who had built a lavish temple called Hōjōji. Jōchō's work here was so distinguished and appreciated that he was honoured with the Buddhist title of *Hokkyō* in 1022. Later he was rewarded by the still higher title of *Hōgen* for sculptures made for the Kōfukuji temple in Nara. His style expressed the taste of his time. He developed the use of the joined-wood technique, and thereby gave to wood sculpture the possibility of greater freedom and delicacy of expression. The Amida [51] of the Hōōdō, which was built by Michinaga's son Yorimichi in 1052, sits before a halo alive with angels, clouds, and flames. In contrast the Buddha seems the embodiment of eternal calm, the very likeness of the negation of desire. It was the genius of Jōchō to find a new proportion to emphasize this quality of stability, in part accomplished by the wide thrust of the knees providing a strong base line for the triangular composition. The tranquillity of the Absolute is made to harmonize with the Buddha's sympathy for the finite.

Closely allied to the Amida of the Hōōdō is a set of nine Amidas in wood of slightly earlier date made for the temple of Jōruriji at Tominoo. They are often attributed to Jōchō or his school. The ninefold set derives from the nine scenes at the bottom of the Taima mandara where Amida is envisioned as saving the nine classes of mankind.

Schools of art in Japan have often been remarkable because gifted families in which artistic talent was inherited for generations dominated a system of professional guild training. Among sculptors, Jōchō and his school are the first authenticated examples. Jōchō's son, Kakujo, established the Shichijō Street school in Kyōto, as opposed to the Sanjō Street school of Chōsei, a pupil of Jōchō. Of Kakujo's sons, Injo remained in Kyōto while Raijo went to Nara. The son of this last sculptor, Kōjo, was the father of Kōkei from whom arose the geniuses who created the Kamakura style of sculpture.

Among many statues of the late Heian period is a group of Amida and the Twenty-five Bodhisattvas [52] at the Sokujōin of Senyūji temple in Kyōto. They form in sculpture as joyous a

52. Bodhisattva playing a musical instrument, Heian period. Wood. *Senyūji*

series as does the group in painting of the Descent of Amida [56] of Mount Kōya. They play on musical instruments, drums, gongs, flutes, and so on. Many have mouths somewhat open as though in song. With lighthearted merriment they descend with Amida to welcome the souls of the dying to his Paradise. The group includes such familiar deities as Daiitoku looking as benign as an angel, great Bodhisattvas such as Fugen and Jizō (here called Muhenshin), and many who symbolize the blessings of heaven. Their humanity recalls the fact that Jōchō was accustomed to use human models for his figures. There is a suggestion of worldliness in their full cheeks and fleshy bodies. Unlike the sculptures of the earlier periods they are nearly hollow, and are made of several pieces skilfully joined.

But generally the conception of the Descent of Amida (Raigō) is reduced to a triad of the central figure of Amida and of two Bodhisattvas, Kwannon bearing a lotus throne and Seishi with hands clasped in prayer. Without colour or gilding, the original appeal to the senses is lost frequently in existing sculptures. But one of the most notable exceptions is the group[2] at the Sanzenin temple, Kyōto, from the late Heian period, which by the brilliance of its gilding gives today an impression of the splendour then in favour. It suggests the intention of representing deities of illuminating wisdom through the light-reflecting surface of gold leaf. Not only are the bodies of the gods done in gold, but even their robes shine brightly. In the quiet light of a temple such statues must have seemed aglow with the world-penetrating light of religious truth.

The end of the Heian period develops the pictorial effect of sculpture to a remarkable degree. The statue of Bishamonten formerly in the collection of the artist Hashimoto Kansetsu (1883–1945) is very restrained for a guardian deity, but it still retains much of its ornate pictorial decoration. It can be reliably dated 1162, and within it have been found wood-block prints of the same deity.

One of the images which best reveals the realism of the late Heian as well as its feminine quality is a white-coloured Ichiji Kinrin [53] at the temple of Chūsonji, far to the north, at Hiraizumi in the prefecture of Iwate. The subject corresponds to the Dainichi of the Diamond World which was shown in painting in illustration 45, but here Dainichi is manifested as 'the revealer of truth'. Comparison shows the rigidity of the iconography and at the same time the Japanization of a particular theme through lifelikeness and charm of feature. The back of the figure is entirely cut away. The eyes are inlaid pieces of crystal, a degree of realism which is said to have started in 1151 with an Amida at Chōgakuji in the prefecture of Nara and which was to become the custom among the sculptors of the Kamakura period.

The temple of Chūsonji was built by a branch of the Fujiwara family which ruled in northern Japan. Here they sought to rival the glories of the far-away capital at Kyōto. The temple remains to testify to the independent greatness of an art centre which was neither an imperial nor a shogunal capital. The Ichiji Kinrin probably reflected the taste of the capital, and was locally preserved because the temple received special protection from the Minamoto family in the Kamakura period.

The prefecture of Iwate had, in fact, earlier in the period produced a style of its own. Several sculptures such as a Shō Kwannon at the temple of Tendaiji possess the curious characteristic of being chiselled horizontally in a manner which seems never to have been painted or gilded over. But these unpainted wood sculptures are exceptional.

Another variety of sculpture of late Heian date is to be found in carvings in stone at Usuki on the island of Kyūshū, where there existed natural stone suitable for carving. Some

53. Ichiji Kinrin, late Heian period. Wood. *Chūsonji*

54 (*above*). Kichijōten,
late Heian period. Wood. *Jōruriji*

55 (*opposite*). Tamenari: Paradise Scene (detail),
Heian period, 1053. *Hōōdō*

of the images in this area go back to the ninth
or tenth century, and they continued to be
made for several hundred years. The sculptures
are interesting for their material rather than
for any special artistic quality of the stone
carving. Like the Ichiji Kinrin, their icono-
graphy also proves the extent of the spread of
the Shingon doctrines.

The goddess Kichijōten has been mentioned
in a painting of the Nara period. Now at the
very end of the Heian her image at the Jōruriji
temple [54] remains as the most important
example of coloured sculpture. The shrine in
which the wood statue was enclosed is kept in
the Tōkyō Geijutsu Daigaku. Were the image
and the painted shrine together, the perfect
correlation between the two could easily be
observed. The standing figure of Benzaiten
painted on the back of the shrine could almost
have served as a line model for the sculptured
Kichijōten. The sculpture is as brilliantly
colourful as the painted shrine. The carving of
the necklace of the Kichijōten avoids the
supplementary use of metal which was the
generally accepted method; and it is by the
application of contrasting colour that the carved
lines are made to appear distinct. The door
panels on the sides of the shrine with figures
of Bonten and Taishakuten recall the drawings
of the Kaidanin. The sculptor and painter of
the Kichijō image and shrine show every
evidence of being familiar with the art of the
Nara period. This ancient tradition was later
one of the influences upon the Kamakura style,
but the statue itself is the climax of Fujiwara
taste in which painting standards tended to
dominate sculptural ones.

Reverence for Amida was most happily
expressed in a number of great compositions.
The Paradise paintings [55] on the walls of the
Phoenix Hall behind the central figure of
Jōchō's Amida mark a new step in the creation
of a national style. Though only preserved in
part, the details such as the treatment of facial

type, tree rendering, and architecture all reveal elements peculiar to Japan. The ascription of these paintings to Tamenari is based on a story in the *Kokon Chomon-jū* of 1254. At a very much later period it became usual to add the family name of Takuma. Not only is this a pure invention, but it is also entirely unjustified. The style of the Takumas was associated with the reintroduction of influences coming from China, while the wall paintings of the Hōōdō, which date from 1053, prove the existence in the middle of the eleventh century of traditions of art which may be called Yamato-e, after the name of the central area of ancient Japan. The detail [55] shows some of the heavenly troop of Amida. The rounded heads and the gay colouring are essentially Japanese.

The greatest of the Heian interpretations of the Raigō conception is the Descent of Amida and the Twenty-five Bodhisattvas [56] in the Reihōkan Museum on Mount Kōya. This painting has long been attributed to the hand of Eshin, but more probably is a work of the late eleventh century. It illustrates the text quoted above from the writings of Eshin. The Amida no longer sits aloof on cloud forms of some sūtra-inspired and grandiose vision of heaven. Rather, the celestial throng descends to earth for the work of the salvation of souls.

Its cheerfulness distinguishes it from the more solemn renderings which had preceded. The general gaiety is developed further in the vividness of bands of contrasting tones of red, oranges, blues, and greens. Although there is not yet anything of the effeminacy of the late Heian, it should be noted that the outline of the figures is drawn in red, which greatly increases the sense of mortal likeness. The gods are rendered in very approachable form. In one corner occurs a bit of true landscape painting. The soft rolling outline of the hills is the result of Chinese T'ang traditions which had been

56 (*above*). Descent of Amida, Heian period.
Reihōkan Museum, Mount Kōya

57 (*opposite*). Munezane: Pictorial Biography of Prince Shōtoku (detail), Heian period, 1069.
Tōkyō National Museum

modified and transformed till what remained was certainly the expression of a Japanese more than of a Chinese hillside.

The paintings of Amida's Descent describe gentle and happy conceptions which go back to the thought of Eshin. From him there also derived a new kind of 'terrible' painting portraying the Ten Worlds – the Six States of Transmigration, Listeners to the Law, the Enlightened, Bodhisattvas, and Buddhas. Kose Hirotaka of the eleventh century is said to have been instructed by Eshin to paint the subject. A set of paintings at the Raigōji temple in the province of Ōmi attributed to him, even though it cannot be earlier than the Kamakura period, probably bears witness to another side of Heian thought. The human world is represented by a picture of corpses in various stages of decomposition, the prey of bird and beast. Mankind, the impermanent, is depicted in contrast to the eternal Buddha Paradise. It is a type of thought which seems to have flourished in various parts of the world when heaven is imagined in too immediate and material terms.

That the life history of Prince Shōtoku should receive special attention in the Heian period is not surprising. Though he was not a Patriarch in the strict sense of the word, the esteem in which he was held as a national hero was a natural product of an age of nationalism. His Pictorial Biography [detail, 57], which was painted on silk pasted on the walls of the Edono Hall of Hōryūji, is an early instance of a type of subject treatment common in Kamakura times. The original paintings, now preserved on screens, were made in 1069 by Hata Munezane or Chitei. The family name of Hata suggests that the artist belonged to one of the early *émigré* Korean groups brought to Japan along with the introduction of sericulture.

The paintings, now in the Tōkyō National Museum, are so damaged as to be but barely

visible. Yet as works of art the Pictorial Biography proves that several elements of technique such as roofless houses, eyes drawn in a single stroke, and hook-stroke noses, which appear in scroll paintings of the twelfth century, were developments at least of the mid eleventh. The pictorial method is like that of the later scroll paintings, but here it is as though the scenes were rearranged in tiers to make a vertical composition. The reverence for

58 (*above*). Portrait of Dengyō, Heian period. *Ichijōji*

59 (*opposite*). Death of the Buddha, Heian period, 1086. *Kongōbuji*

Shōtoku, like the Amida worship, was not limited to any one sect. In the Shingon sect he was regarded as an incarnation of Kwannon, and was held to have reappeared yet again as Kōbō Daishi. In the Tendai sect he was looked upon as the reincarnation of a famous Chinese priest, and his portrait appears with a group of Tendai Patriarchs.

The Tendai Patriarchs of the temple of Ichijōji, usually kept in the Nara museum, might well be contrasted with the Shingon set of Patriarchs referred to in the last chapter, for both include the figure of Nāgārjuna. But they have little in common. They must derive from widely divergent traditions of painting in China. The Ichijōji set possesses the colourfulness and the patterned richness which seem typical of the late Heian period.

The portrait of Dengyō [58] well illustrates the different attitude of the Tendai believer. The portrait of the Shingon priest Gonzō (46) showed him intense in ritualistic prayer. The founder of the Tendai sect in Japan is represented in meditative reverie as though embodying the tenets of his sect. Here are explicitly rendered in portraiture the doctrinal approaches of the two sects. In the later example strong colours are applied in large flat areas, and the surface interest derives from the beauty of small-scale patterning of such motifs as floral medallions, interlocking circles, and interlocking swastika. The large scale of the figure drawing helps to emphasize the meditative calm which exists in all the paintings of the set.

Also belonging to the Tendai tradition of 'revealed' religion as against the 'esoteric' teaching of the Shingon sect are paintings of the Death and Resurrection of the Buddha. The Death of the Buddha, called Nirvāna or Nehan [59], bears a date corresponding to 1086, and is a treasure of the Kongōbuji temple on Mount Kōya.[3] Minamoto writes that 'as the famous painter Fujiwara no Motomitsu was working at Kōyasan during the summer of 1086, it is

quite possible that he painted this picture.' This artist is often claimed, though without any real foundation, as the first ancestor of the Kasuga or Tosa school of painting. One could hardly expect to find a better illustration of the dignity and sentiment of the native style. Here is a great range of sorrowful, weeping figures. Even the animal world is included by the presence of the lion at the lower right. As in the Ichijōji portraits, the colours are bright and widely spaced, the patterns small-scale and plentiful, and yet there is no loss of unity in the whole. Attention is quietly focused upon the recumbent figure whose body is here painted not with yellow but with gold pigment. The Buddha remains serene in death. Above, his mother Māyā worships him from heaven. About him stand the gods who paid him homage at his birth and at his death. His disciples are overcome with grief. The theme

60. Resurrection of the Buddha (detail), Heian period. *Chōhōji*

is one of human emotions. The doctrine of Nirvāṇa, of the great passing away of the Buddha, is difficult to understand, for how can worship be paid to one whose ego has left no trace? *The Lankāvatāra Sūtra* says, 'Thou (the Blessed One) dost not vanish in Nirvāṇa, nor is Nirvāṇa abiding in Thee; for it transcends the duality of knowing and known and of being and non-being.' Another sūtra reminds us that to think of it as a state of annihilation is 'a wicked heresy'. To the Tendai believer, the historic Buddha remained a figure of central importance.

Of about the same period is the Resurrection of the Buddha [detail, 60] from the temple of Chōhōji but usually kept in the Kyōto National Museum. It is based on the mythical story of how the Buddha's mother wept in heaven at his death and how the Buddha came to life again to preach to her. In the painting the upper half of the body of the Buddha appears above his coffin, and looks compassionately downward at his mother. Behind him shines an enormous halo marked with rays of light and filled with Buddha images in gold leaf. Though not as brilliant in colour as the Death of the Buddha, yet it is stronger in line. Like the Descent of Amida of Mount Kōya, the picture is primarily an expression of sympathetic feeling between God and man. The Resurrection is rich in emotion, for the artist unites his composition by a large group of deities and men who show their reverence, wonder, and surprise. It is a unique subject, which never had the vogue of the series of paintings of the Death of the Buddha which occur in all later periods.

Paintings of the Shingon sect continued to be made after the strict formulas of their teaching. To this tradition belongs the painting of the Horse-headed Kwannon [61] of the eleventh century in the Museum of Fine Arts in Boston. Many types of this popular deity have already been mentioned, but here Kwannon appears in a new guise in a painting of the

61. Horse-headed Kwannon, Heian period.
Boston, Museum of Fine Arts

Shingon sect – hideous and yet merciful. It is one of a set of Six Kwannon, manifestations pictured as saviours of each of the Six States of Transmigration. Above the crown designating the Bodhisattva rank rises the small figure of a horse's head to draw attention to the deity's activity as saviour of the animal world. The fierce-faced, triple-headed, and eight-armed

figure is coloured deep red. The brush work has a simplicity and clarity which are qualities of drawing especially appreciated in Japan. Here, too, can be noted the continuation of the technique of reversed shading. The fineness of the pattern elaborates on the tendency already apparent in the Kojima Mandara.

The painting also shows in an elementary form the use of cut gold leaf or *kirikane*. Careful examination of the illustration will show small squares of cut gold leaf forming pendant jewels strung to the canopy over the head of the figure. Smaller in scale but still done in kirikane are the complicated floral shapes on the middle tier of the bottom of the dais or lotus throne. Like many of the technical details to be found in Japan, the cut gold leaf process undoubtedly originated in China, but again, as so often happened, a method which was known in China was used with remarkably different effect in Japan. Early occurrences of the technique in Japan are said to be on the clay image of Bonten at the Hokkedō in Nara, a work of the first half of the eighth century, and on the ridges of the draperies of the Bishamonten, in the kondō, Hōryūji, of about 650. By the end of the Heian period it had developed to express the Japanese desire for clarity of patterning. Small patterns in cut leaf possess a sharpness not possible to a line drawn in gold pigment.[4]

In the Heian period, too, one finds an early example of a further elaboration of the technique, the use of gold kirikane over gold paint. This was a refinement of decoration typical of Japanese art and of the craftsman's technical competence on which it was based. A Kwannon painting kept at the Ryūkōin at Mount Kōya depicts a vision of Kwannon which appeared to Kōbō Daishi when his ship was nearly wrecked on the return trip from China, and also illustrates Kwannon as the saviour from shipwreck. Its style depends on the use of cut gold on gold paint. Kirikane had already been used sparingly in the Descent of Amida, and the Resurrection, but in this Kwannon the subtle splendour of the gold on gold technique anticipates by several centuries a method which was often used to enhance the decorative beauty of later screen paintings.

To complicate the problem of Heian art there are archaistic sets of Shingon paintings done to replace earlier originals which were lost in a fire at the temple of Tōji in 1127. One of the sets painted again was a series of the Five Great Myōō; another was a series of the Twelve Gods. The artist of both was the priest Kakunin who is said to have used models going back to Kōbō Daishi. The Taishakuten [62] shows the general pose of the central figure and attendants common throughout the set of the Twelve Gods. An earlier series exists at Saidaiji in Nara. In it the figures are mounted on animals, and the design more nearly fills the whole of the picture in the Jōgan manner. Here a certain stiffness, the ribbon-like shading in the treatment of drapery which may be seen in the right attendant, and the flare of the ruffle at the elbow betray the traces of an older style. On the other hand, the contrast of colours, the elaborate small patterns, and the use of kirikane would in any case suggest a late Heian dating for these paintings.

Several times mention has been made of model books. The Kongōyasha [63] from a scroll of Twenty-five Bodhisattvas datable to 1184, in the Boston museum, will suffice to show the simple type of outline ink drawings which were handed down especially in Shingon temples in order that iconographical traditions might be correctly perpetuated. Comparison with a companion deity, Muryōrikiku [48], of some three centuries earlier shows both the close kinship in form and the difference in execution. There is a diminution in scale, which is counterbalanced in any painting made after such a model by the superimposing of meticu-

62. Kakunin: Taishakuten, Heian period, 1127. *Tōji*

萩土　金剛夜叉

63. Kongōyasha, Heian period, 1184. *Boston, Museum of Fine Arts*

lously worked-out detail. The worship of these gods was especially popular at the time of the wars between the Minamoto and the Taira in the second half of the twelfth century.

Several other famous paintings should at least be named. The Bodhisattva Fugen of the Tōkyō museum, mounted on his special attribute, an elephant, is one of the most brightly coloured paintings of the twelfth century. He is associated with the *Lotus Sūtra* and with the Tendai sect. Also brilliant in colour is a set of the Sixteen Rakan, the disciples of the historic Buddha, at Raigōji. The set is of considerable importance as it derives not, as do most of the later Rakan paintings, from prototypes of Southern Sung origin but from an older style

64. Landscape screen (three panels), Heian period. *Tōji*

perhaps of Northern Sung date. The accent is more on colour than on line. In contrast to these paintings, those connected with the Shingon sect seem quieter in tone, perhaps because their colour scheme was more strictly prescribed. The Eleven-headed Kwannon, formerly in the Baron Masuda collection, or the Bodhisattva Kokūzō of the Mitsui Gōmei Company are marvels of ingenious pattern. The technical skill required, whether for harmonies of rich colour or for complicated patterning, argues for a long line of professional artists.

Among the Shingon ceremonies the initiation service was one of special sanctity, requiring the adornment of the temple with screens to divide two altars. The landscape screen called the Senzui Byōbu [64] at Tōji in Kyōto has long been known as such a religious screen. However, the subject of a hermit visited by a noble does not correspond in any way to the cult requirements of the Shingon sect, and its secular figure-in-landscape composition has been identified by T. Kobayashi[5] as appropriate for screens used to decorate the seating arrangement of the empress at special ceremonies. Here is preserved one of the few examples of secular painting on a large scale. In style prototypes from the T'ang period in China can easily be recalled, and yet the more closely one examines the smoothness of the hills in the background, or the concentration

of interest in the figures in the foreground, or even the decorative drawing of the foliage, the more convinced does one become that this is a slightly old-fashioned painting done in the late Heian period.

Later examples of the same tradition made in the Kamakura period exist at Jingoji[6] and at Kongōbuji. Like the screen paintings of the Shōsōin, they are indications of a vast tradition of secular, large-scale painting which has otherwise almost completely disappeared. Because they carry on a Chinese type of landscape design in strong colour, it is interesting to note that Japanese literary records commenting on the treatment of great artists like Kanaoka and Hirotaka say that the former piled up his mountain ranges in fifteen layers, the latter in five. In this process it may be correctly surmised that the precipitous mountain ranges of China were gradually being transformed into the more rounded hills of Japan.

Most of the secular art of the late Heian has survived only in the form of horizontal scrolls. Because of the continuity of the tradition throughout the Kamakura period and later, it has been thought wise to sacrifice historical sequence and to group such secular art in a later chapter under the title of the Yamato-e tradition. Such a method at least allows the last great period of Buddhist art to be studied as a continuing development.

THE POPULARIZATION OF BUDDHISM

KAMAKURA PERIOD: 1185–1333

The rise of a military government based on feudal power and the co-existence of two capitals, one the courtly and classical city of Kyōto and the other the growing administrative centre at Kamakura, mark a special feature of Japanese civilization which was to be repeated under the Tokugawa regime. The new system was preceded in the last years of the Heian period by the rise of the Taira family in 1159 and by its downfall at the hands of the Minamoto family in 1185. The values established by the Fujiwara nobility then rapidly declined. The Minamoto and their relatives, the Hōjō who succeeded them, controlled the government for the next century and a half.

Minamoto no Yoritomo, the first of the military dictators of Japan, chose Kamakura, near the present Tōkyō, for his capital because of its advantageous position in relation to his feudal domains. Further, the site possessed the virtue of distance from the enervating attractions of the effete imperial capital. The new age was marked by directness, simplicity, and indigenous sentiment. The stalwart soldiers of Kamakura had little of the book learning and refinement of the Fujiwara courtiers. If culturally there was no escape from the prestige attained by the city of Kyōto, learning at least could be simplified. Religion, literature, and art each exhibited in different ways the popularization of the ancient cultural standards.

The end of the thirteenth century witnessed the attempts of the Mongols to invade Japan – in 1274 and in 1281. The terrible danger of the great force of Kublai Khan was averted by fortunate storms which broke up the Mongol fleet as well as by the superlative quality of the swords of the defenders. The war and the long period of anxiety were politically disruptive and artistically deadening, which may account in part for the curious phenomenon in the fourteenth century of strong Chinese influence immediately succeeding the nationalist tendency of the Kamakura period.

Two distinct traditions, religious and secular, dominated the art of this age. The latter will be discussed in the next chapter. In religious matters there were far-reaching changes. Buddhism was no longer under state patronage, as it had been in the Nara period, nor was it dominated by the interests of the nobility, as in the Heian age. The extension of Buddhism to the masses has left its permanent impression on the national character of the people. This religious and emotional belief, in fact, expresses one of the major differences between the temperaments of the peoples of China and Japan.

The national spirit showed itself not only in doctrinal changes. Early Kamakura sculpture is best understood as a renaissance of the ideals of the Nara period. The new attitude also reflected a growing feudal spirit by its emphasis on loyalty to the teachings of Japan's religious leaders. Whatever undercurrents of thought reached Japan from China in the twelfth and thirteenth centuries can only be understood against a background of traditions which had long since become national.

The temples of Kōfukuji and Tōdaiji, and hence the great Buddha of Nara, were destroyed in 1180 by the troops of Taira no Shigehira. Temple troops were common in Japan, and the priests of Nara had given their aid to the cause of the Minamoto against the tyranny and intrigues of Taira no Kiyomori. One of the acts of the finally triumphant Minamoto was the rebuilding of the Nara temples by Yoritomo in 1195, an event which produced some of the greatest sculpture made in Japan.

Because the rebuilding of Nara was so vast an undertaking, sculptors were called for from the schools of sculpture which had remained in Kyōto. To recast the damaged head of the Great Buddha even a Chinese, Ch'ên Ho-ch'ing, was brought to Japan in 1183. A pair of stone lions at Tōdaiji made of imported stone by a Chinese artist suggests how distinct the Chinese and Japanese styles were at this time. So, too, the standing Shaka of Hōjōji in Kyōto shows by the wavy outline to all the edges of the draperies that Sung influence existed in Japan.

Fortunately, the Japanese Buddhist temples could provide the necessary number of sculptors, and among them one family is outstanding. The genealogy of those sculptors descending from Jōchō, the artist of the Amida in the Phoenix Hall, has already been listed down to Kōkei. In its second great development the family originated a new school of sculpture. Kōkei's son and his best pupil were respectively Unkei and Kaikei. Unkei's sons, Tankei, Jōkei, Kōben, and Kōshō, were all famous, and carried on the style which Unkei originated down to the middle of the Kamakura period. Later still was Kōen, the son of Tankei.

The originality of the new school of sculpture, which advocated strength rather than prettiness, and realism rather than formality, is usually ascribed to Unkei. But many of the sculptures of the period were co-operative efforts, and it is difficult to trace distinctions between one hand and another. In the Fukū-kenjaku Kwannon[1] of the Nanendō Hall of Kōfukuji made in 1188 by Kōkei, the father of Unkei, the dependence on models of the eighth century is already apparent. The figure is more real in a physical sense than the dreamy creations of Fujiwara sculptors. The treatment of the drapery folds especially seems archaic, while the fine divisions to mark the strands of hair have the realistic touch which was a general trait of Kamakura times.

A Dainichi, dated 1176, at the temple of Enjōji is the best authenticated sculpture by Unkei. Because it is so early a work and because it represents a Buddha image, it does little to reveal the active quality he sought in sculpture. It belongs rather to the 'gentle' style which is usually associated with the name of Kaikei.

Unkei may be better judged by the gigantic statues of the Niō [65] which stand guard in the entrance to the south gate (Nandaimon) of Tōdaiji. These two spiritual protectors are about twenty-six feet tall. Made in 1203, they were the joint undertaking of Unkei, Kaikei, and some twenty other craftsmen. The work required only two months' time, which itself is proof of co-operation. The Niō exhibit the special characteristics associated with the name Unkei. Their features recall the terrifying countenance of the Shūkongōjin, the protector with the vajra or thunderbolt, of the Hokkedō Hall in Nara. In each statue face and hands are dramatic – the vajra has almost become a club. The body is furrowed with strong musculature which if not scientifically correct is none the less impressive. The figure tells its own story so vividly that doctrinal explanation is unnecessary.

Another side of Unkei's power is shown in the standing figure of Mujaku, the Indian

65. Unkei: Niō, Kamakura period, 1203. Wood. *Tōdaiji, Nandaimon*

Asanga [66], made in 1208 for the Hokuendō Hall of the Kōfukuji temple. The ancient Indian teacher of Mahāyāna Buddhism is imagined as an individual rather than as a type. He stands life-size, impressive both in scale and in simplicity of handling. The new realism portrays the outward man even to the natural

66. Unkei: Mujaku, Kamakura period, 1208. Wood. *Kōfukuji, Hokuendō*

hang of the garments. To promote this effect, the joined-wood technique which permitted great freedom of detail was made use of. To give to the eyes a realistic sparkle, crystal was inserted into the eye-sockets. In statues such as this, Unkei proclaimed not only his own manner and achievement, but also that of the age in which he lived.

Portrait sculpture illustrates the revival of Nara art forms. Direct comparison can be made by contrasting a Yuima at Kōfukuji sculptured by Jōkei in 1196, or, less directly, the Mujaku of Unkei, with the eighth-century Yuima [23] of the temple of Hokkeji. The earlier style was more grand and restrained, the later more life-like and energetic. The carving of Jōkei's figure took fifty-three days. More surprising still, the colouring applied by another hand required the nearly equal time of fifty days. Portrait types were numerous and elaborate. But the realism of Unkei and Jōkei was more successful than that to be seen in the Six Patriarchs of the Hossō sect which Kōkei made for the Nanendō Hall of Kōfukuji, in which formal beauty was sacrificed in the attempt to be true to life.

The emphasis placed on portraiture in the Kamakura age is not easy to explain in terms of western thought. Portraits expressed not so much a feeling for the individual and his characteristics as veneration for his accomplishments. The Chinese custom of ancestor worship was known and influential, but the Japanese expression of personal loyalty must also be recognized. At this time portraits of Buddhist priests, especially those of the Pure Land sects, were reverenced almost more than the Buddhist gods. A new feature in architecture was the Mieidō or portrait chapel. In court circles sketchy portraits called *nise-e* were fashionable, especially as a record of illustrious poets, past and contemporary.

The 'quiet' style of Kaikei is seen in his Miroku [67] in the Boston museum, which is

documented by writings found inside bearing the date 1189. It is a wooden statue completely covered with gold. The charm of the figure depends upon the intricacy and cleverness of the modulations in the draperies. Comparison should be made with the Shō Kwannon [68] from Kuramadera, the work of Jōkei in 1226.

Both statues break away from the Heian style of standing Bodhisattva figures. The Shō Kwannon especially possesses a tense expression, a slenderness, and an arrangement of more real garments which blend together to illustrate the Kamakura ideal. If one misses the ennobling quality of the Nara and the sensuous beauty of

67. Kaikei: Miroku, Kamakura period, 1189. Wood. *Boston, Museum of Fine Arts*

68. Jōkei: Shō Kwannon, Kamakura period, 1226. Wood. *Kuramadera*

69. Kōshō: Kūya, Kamakura period. *Rokuharamitsuji*

the Heian, one must still admire the mundane directness which the Kamakura artist bestowed upon his gods. The work of Kaikei appears in more realistic vein in two painted sculptures at Tōdaiji – one of Hachiman, the Japanese god of war, dressed as a priest, which is dated 1201, and the other of a standing Jizō.[2] In both, the colouring creates a feeling of directness even more than of beauty, and the artist's personality adds a gentleness which makes these sculptures typical of one phase of the early Kamakura style.

The climax of Kamakura realism was attained in the wood statue of the priest Kūya [69] from the Rokuharamitsuji temple in Kyōto. Kūya, one of the early expounders of the virtue of the nembutsu, or the recitation of the name of Amida, has already been mentioned as an important figure in the history of the rise of the Jōdo sects. Kōshō, a son of Unkei, portrays him in travelling costume, with gong and striker. His staff is tipped with real deer horn. From his mouth issue miniature Buddhas. The sculptor is not satisfied with representing physical action but must also try to express the very words which Kūya taught.

The same taste for wilful and graphic art is humorously shown in such a figure as that of a lantern-supporting demon called Tentōki,[3] the work of Kōben, another of the sons of Unkei. It was carved in 1215 for Kōfukuji. The mischievous spirit which pervades the demon makes it a creature more exciting to our curiosity than to our sense of terror. In many Buddhist sculptures a lack of respect towards deities makes one wonder whether the artists were really moved by devotion.

Not all the sculptors were able to maintain the union of spiritual vigour and physical gusto achieved by Unkei. A certain lack of harmony or exaggeration of facial expression unconvincingly related to the active poses of the figures occurs in many carvings by anonymous followers of the Unkei style. These weaknesses

70. Santeira, Kamakura period, 1207. Wood. *Kōfukuji, Tōkondō*

are apparent in the statue of Santeira [70], dated 1207, at Kōfukuji in Nara. He is one of the Twelve Generals attendant on the Buddha Yakushi, and any series of these gods suggests comparison with the late Nara set at Shin Yakushiji. The Kamakura concept fails to come up to the ancient models because of melodramatic postures and features. Hips are thrust out too far. Arms swing about too freely. Faces glower and threaten. There is skill, but theatrical realism robs the representations of the dignity which belongs to gods or their

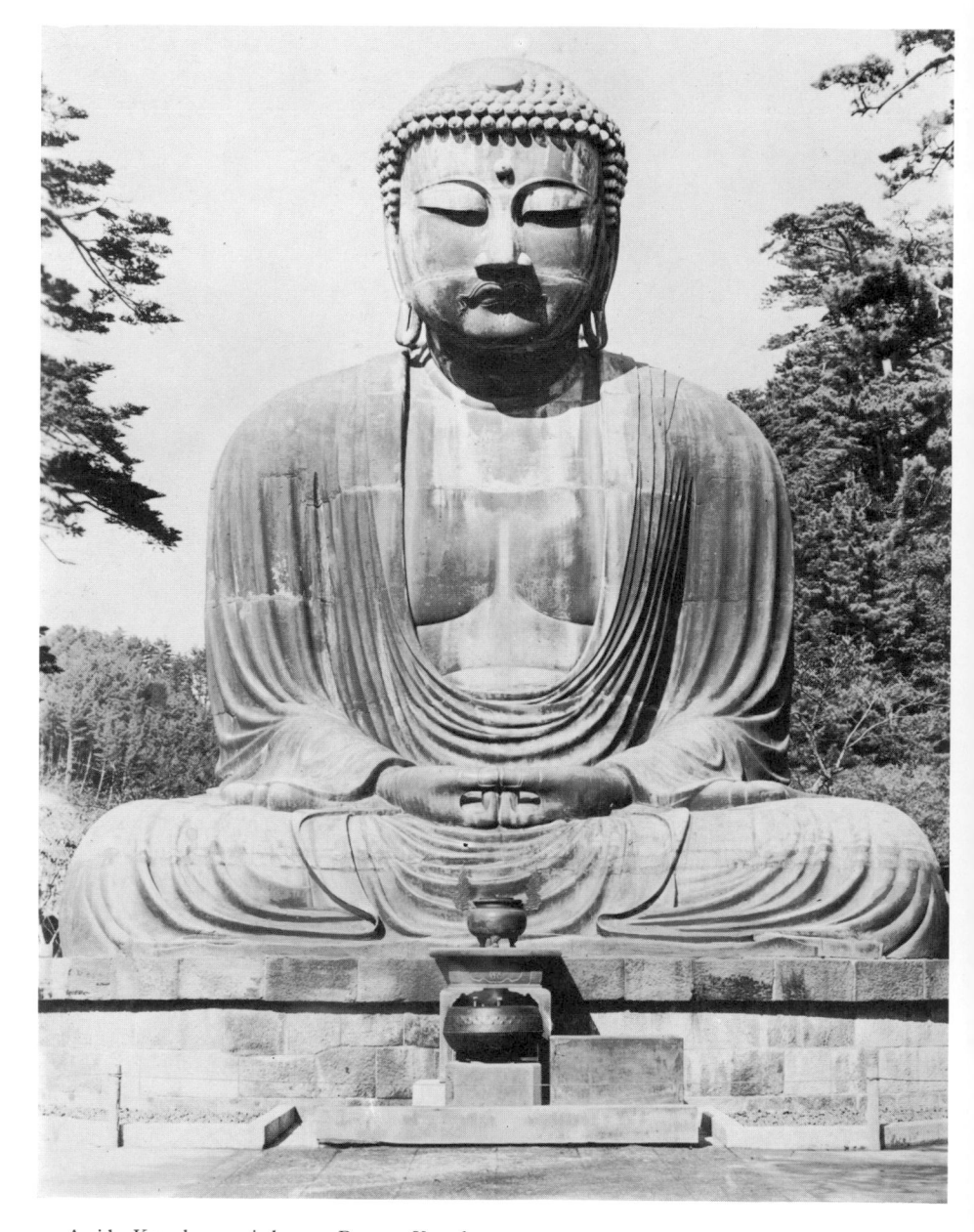

71. Amida, Kamakura period, 1252. Bronze. *Kamakura*

attendants. The Kamakura age was too vigorous to pay attention to psychological finesse: this latter field remained to be experimented with by sculptors of later generations.

A great centre of mid-Kamakura sculpture was the Sanjūsangendō Hall of Myōhōin in Kyōto. The central image of Kwannon is accompanied not only by twenty-eight attendants but also by a retinue of one thousand statues of the thousand-armed Kwannon which stand in serried ranks on either side. The literalness of the interpretation of the Buddhist idea is self-evident. The group probably dates from about the middle of the thirteenth century, and the names of Tankei, the eldest son of Unkei, and of Kōen, the son of Jōkei, are usually assigned to the central Kwannon and to some of the attendant figures.

From 1252 dates another vast sculptural undertaking, the bronze Amida of Kamakura [71], forty-nine feet high including the dais. Again, one senses a rivalry with the great Buddha of Nara. Today the Kamakura Buddha stands open to the sky – testimony to the many tidal waves which destroyed a still earlier colossus in wood as well as the temple which once enclosed the bronze statue. Behind its creation were no national resources such as had been used to defray the cost of the eighth-century image. Instead, money was raised by popular subscription, and the statue remains as an expression of the appeal of Buddhism to the common people. Vast and imperturbable, yet downward-looking and compassionate, the Buddha sums up the qualities which the age expected to find in its most popular deity. The conventionality of the pose and the regularity of the handling of the robes may reflect a formalizing tendency which was beginning to affect the arts. But on this heroic scale such a scheme directs the attention of the worshipper to the all-merciful features of the Buddha whose paradise was open to all who called but once

72. Benzaiten, Kamakura period, 1266. Wood. *Tsurugaoka Hachiman shrine*

with believing heart on the name of Amida Buddha.

Also from the mid-Kamakura period comes a nearly nude figure of Benzaiten [72], the deity who 'manifests herself in musical song'. The statue in the Tsurugaoka Hachiman shrine in Kamakura was made by an unknown artist in 1266. Although physically attractive in a manner which, normal in the classical tradition of Europe, is unusual in Japan, it actually is only a new rendering of the musical angels who accompanied the Descent of Buddha in earlier paintings and sculptures. The factual taste of the Kamakura period has bestowed earthly charms on heavenly beings with an obvious relish which would have shocked the over-refined sensitivities of Fujiwara patrons.

A certain amount of true secular sculpture has been preserved from late in the period and should perhaps be correlated with the ancestor worship then current in Japan. The portrait of

73. Shigefusa, Kamakura period. Wood.
Meigetsuin

Uesugi Shigefusa [73] seems to be a translation into wood of a type of portraiture in court costume which was far more common in painting. The Meigetsuin in Kamakura in which it is housed was built by the Uesugi family in the fourteenth century, and the statue was made to honour Shigefusa who lived a century earlier.

Late Kamakura sculpture of perhaps the early fourteenth century is well exemplified by a figure of the esoteric deity Aizen [74] from the Boston museum. Aizen is painted deep red, the colour of passion or more accurately of ardent love kept under control. The attributes in his hands show him equipped to fortify the good-hearted who would conquer their desires and be awakened to the presence of the imma-nent Buddha-nature. The sculpture, though the reproving expression is powerful, shows the hardness and obviousness which had crept into Buddhist art and thought. The period of vitality had already approached its end, and though Buddhist art was to continue down to the present time, its later styles lack diversity and creativeness.[4]

A minor aspect of Kamakura sculpture consists of the carving of masks for Bugaku or posturing dances. The mask had already had a long past, and was to have an even greater future. Masks were introduced into Japan early in the seventh century, and many from that time are preserved in Hōryūji. The Gigaku mask then popular was derived from Turkestan.

74. Aizen, Kamakura period. Wood.
Boston, Museum of Fine Arts

It covered the whole head, and was made for a pantomime. One hundred and forty-seven which were used in the ceremonies connected with the Great Buddha of Nara in 752 remain in the Shōsōin. Later in the eighth century the Bugaku mask, deriving from India or Indo-China, was brought to Japan. Like the Nō drama masks of the Muromachi and Edo periods, the Bugaku mask covered only the face. As sculpture the surviving examples are distinguished for their breadth of treatment and intensity of expression. From the Heian period the temple of Tōji has preserved a fine set of masks of the Twelve Gods with the date 1086.

Since sculpture reached its final development in the Kamakura period, rather than interrupt the later course of the history of painting it may be as well to digress further and include here not only a few examples of Nō masks, but also a few later pieces of sculpture which are too distinctive to be entirely omitted. The Nō mask marks a more popular extension of Buddhist influence, especially of the Zen sect, than had yet occurred. Ethics had come to be taught in the kind of morality play known as Nō drama, and sculptors found in the making of masks for these plays a new field for the portrayal of moods and emotions. The dramas were both religious and aristocratic. They became popular after 1374 when the shogun Ashikaga Yoshimitsu attended a performance. Women's parts and supernatural

roles required the use of masks. They are remarkable as sculpture, as plastic forms of such stereotyped emotions as sadness, jealousy, and ferocity. So subtle was the carving that even in one mask worn throughout a performance a shift in the tilt of the head produced a change of expression. Two of the greatest early craftsmen were Shakuzuru, who in the second half of the thirteenth century developed a mask expressing 'superhuman fury', and Tatsuemon who about the end of the fourteenth century went to the opposite extreme and created a type suggesting 'perfect calm'.

The mask of Masukami [75] in the Kongō family collection shows the features of a sad woman. Dated about 1370, it is the work of Zōami Hisatsugu who is said to have been the personal friend of Yoshimitsu. The Gyōja [76], owned by the Teirakusha in Nara, presents

the wrinkled face of a venerable old man. The sculptor Deme Mitsuteru belonged to a family of artists which continued for centuries to exercise its professional and hereditary craft. Mask types, once started, persisted without much variation. Between masks of the early and late periods the differences in technique and type are so minor that their history belongs to specialized studies. The Nō dramas became the classic theatrical amusement for the educated upper classes; the masks and costumes associated with the roles provided a field wherein the peculiarly national qualities of Japanese taste continued to be expressed.

To return briefly to sculpture in the round, by the fourteenth century Chinese influence was on the increase, and styles developed in China in the late Sung period were reaching Japan. Such a statue as the Suigetsu Kwannon

75. Zōami: Masukami, Nō mask, *c.* 1370.
Kongō Family Collection

76. Mitsuteru: Gyōja, Nō mask, *c.* 1500.
Teirakusha

77 (*left*). Suigetsu Kwannon, fourteenth century. Wood. *Tōkeiji*

78 (*below*). Confucius, Muromachi period, 1534. Wood. *Ashikaga, Seidō*

[77] of Tōkeiji in Kamakura is both novel and strong. The heavy sensuous folds of the drapery possess a realism which is reminiscent of some sculpture of the late Gothic period when a similar evolution towards realism was running its course.

The type of portraiture developed especially in the Zen sect and called *chinsō* also was reflected in wood statuary. A portrait of the priest Butsugai[5] carved in 1370, quite apart from the characteristic posing of the figure in a chair and in official robes, has a gauntness of feature which makes such sculpture a far more personal record of a man than any which had preceded. The faces of the figures rendered according to the canons of the Zen tradition are not mere expressions of noble types, nor simply of the outward man. They seek to reveal individual character.

By the fifteenth century, when Chinese ideas were still more dominant, it was natural that even the figures of the great men of China should be carved in Japan. The most famous statue of Confucius [78] is a wood image at the Seidō in Ashikaga which dates from 1534. The philosophy of the great sage of practical social organization was soon to hold a more important position in the life of the Japanese than the tenets of Buddhism. With this change, too, sculpture ceased to be important.

The great shrines of Nikkō, the immense mausolea of the Tokugawa shoguns of the seventeenth century, are covered, even crowded, with carved and painted ornament. But sculpture had become the handmaiden of architecture more than of religion. It never again recovered the independent position among the major arts it had occupied in the past.

After this cursory treatment of the later sculpture it is necessary to turn back again to the Kamakura period and to follow the history of painting. In the discussion of Buddhist

sculpture we have seen that the rebuilding of the Nara temples supplied the motive for the return to ancient models which at times obscured the novelty of the style of Unkei and his school. In the field of painting the variety and strength of the Kamakura style is clearly indicated in the paintings produced for the new Buddhist sects.

The most important, novel, and far-reaching changes in Buddhism have already been suggested in the statues of Kūya and in the great Amida of Kamakura. The Pure Land teaching had two famous exponents early in the Kamakura period, and hence arose two new sects of Buddhism. Hōnen (1133–1212), founder of the Jōdo sect, was a priest who had studied at the Tendai monastery on Mount Hiei. Here he read the works of the Chinese priest Shan-tao (Zendō, 613–81) who had written: 'Only repeat the name of Amida with all your heart. . . . This is the practice which brings salvation without fail, for it is in accordance with the original vow of the Buddha.' Simple faith – not one's own merit and the destruction of evil karma but dependence on the stored-up stock of merit by which a Bodhisattva became a Buddha – sufficed for salvation.

Shinran (1173–1262), founder of the Shin sect, who also was taught first at Hiei and then became a follower of Hōnen, carried the popularizing tendencies still further by encouraging the marriage of the clergy. Something of the new spirit of the times is suggested by his saying that 'I should never regret, even if I were to go to hell by being deceived by Hōnen.' In a military age emphasis on loyalty is understandable, but seldom has it been expressed so frankly among religious leaders. Shinran's was a religion for the householder – simple, easy, and in opposition to the earlier arduous ritualistic practices. The appeal was intentionally popular. The metaphysical argument was that the Body of Law of the Buddha could be perceived only through faith, and that

in this act one's own will was destroyed, but popularly salvation was regarded as depending simply on the mercy of the Buddha. Such basic ideas of the Pure Land sects were bitterly opposed. Myōe of Kōzanji protested that 'every man should form for himself the aspiration to become a Buddha'. A little later in this battle of the doctrine of faith versus the doctrine of works the great priest Daitō Kokushi of the character-building Zen sect commented, 'When there is no evil thought or selfish desire, there is the Land of Bliss, and nowhere else!'

Serious sectarian disputes now appeared in Japanese Buddhism. Nichiren (1222–82), who founded a sect named after himself, hated both the Jōdo and Zen sects. Like so many other religious leaders, he, too, was trained at the monastery on Mount Hiei, but for the 'later degenerate age' in which he lived he found truth in a new veneration for the *Lotus Sūtra*. Prophetic sayings about the Mongol invasion won him great fame, and directness of character gained him the respect of many of the military men at Kamakura, but his sect made little impression on the art of his country.

The Raigō conception attained immense popularity. In the Descent of Amida across the Mountains [79] from the Konkaikōmyōji a new sentiment towards the presence of deity is conveyed. Huge standing figures of Amida and his two great Bodhisattvas descend over a panoramic landscape. The images are utterly flat, resplendent in gold, and decorated with cut gold leaf. The picture scale is greater than that of the Amida Buddha of Kamakura. Earth seems but a little thing in the presence of the Buddha Triad in its glory. In the *Heiji Monogatari* is a description of such a triad: 'Sounds of celestial melody are heard far off, and from the regions of the setting sun Amida comes to save the world.' The *Tannishō*, a book of the Shin sect of thirteenth-century date, contains a passage even more expressive of the attitude of Jōdo believers: once they have embarked on

79. Descent of Amida across the Mountains,
Kamakura period. *Konkaikōmyōji*

the boat of Amida's vow, they should feel 'able
to cross over the turbulent sea of birth and
death, and arrive at the shore of the Pure Land;
the dark clouds of worldly passions will then
hasten to clear away, for the enlightening moon
of truth begins to shine; and this is the time we
have the supreme enlightenment in which we
are identified with the infinite light shining
throughout the ten quarters and bestowing
benefits on all sentient beings.'

There are many versions of the new type of Raigō painting. The one at Zenrinji has much the same composition as the preceding Descent, but Kwannon and Seishi appear in lesser scale and in the foreground stand King Bimbisāra and his Queen Vaidehī who first had the vision of Amida's Paradise. In the version formerly in the S. Ueno collection several Bodhisattvas appear. In the painting at the temple of Chionin in Kyōto the older tradition of Amida and the Twenty-five Bodhisattvas is preserved, but the whole group rushes diagonally down to the dwelling of a dying man. An unusual painting in the Murayama family collection shows the scene portrayed in reverse: the lotus-born soul of the dead man is being hurried back to Paradise. The sense of speed in some of these paintings is characteristic of the middle and late Kamakura period.

The gold on gold technique of flat splendour precedes by three centuries the period of screen paintings on gold grounds. The earlier art is religious, the later secular. Yet both express the same quality of pure Japanese taste. Both are lavish, sensuous, ornamental, and at the same time restrained, harmonious with a flat colour scheme, and light-giving literally and spiritually.

Another type of Amidist painting is exemplified in the White Way between Two Rivers which originated in a commentary of the priest Shan-tao on the *Kwan-gyō Sūtra*. One of the best-known versions[6] is that in the Murayama family collection. The rivers are the waters of passion and the flames of greed between which the way of faith is a literally very straight and narrow path. Among surviving portraits of Shan-tao himself, that at the temple of Chionin has an inscription with a Chinese date corresponding to 1161. However, the painting, which represents the saint half in gold and half in colour, must have been executed later and is typical of that decorative use of gold which is so characteristic of Kamakura painting and sculpture.

80. Shōga: Gatten, Kamakura period, 1191. *Tōji*

Among paintings of the Shingon sect one of the most instructive is a set of the Twelve Gods at Tōji which was painted by Takuma Shōga in 1191. With the Gatten or Moon Deity [80] began a new type of iconography with these gods as standing figures. This particular deity is further unusual in being depicted in profile. In contrast to earlier types of the Twelve Gods which must have descended from models created by the Buddhism of the T'ang period, Shōga's are drawn with a fluency of line which suggests an origin in the art of the southern Sung period in China. The colour is simple, the patterning limited, and the emphasis mainly on brush work. The lines, which often start thick-headed and vary from broad to thin, buckle and fluctuate to provide an attractive display. Priests travelling between China and Japan must have introduced the new influences, but Shōga, who worked at the very beginning of the Kamakura period, was one of the first artists to reflect them. And the Takuma family continued to be associated with the stylistic changes reflecting currents of the southern Sung tradition.

A painted Bishamonten [81] in the Boston museum shows clearly the usual mode of delineation: the thin, wire-like line and the bright colours such as orange-red, deep blue, green, and white had been favoured since Heian times. The flat patterning in kirikane bespeaks the native feeling for decoration. Artistically, there is almost a conflict between line used to convey a sense of formal depth and gold ornamentation used to embellish flat surfaces. Though the painting is probably of mid thirteenth-century date, the style maintains the standards that could perhaps be called Kasuga or Tosa.

So little is known of the various schools of Buddhist painters that it is not yet clear how precisely the artists of the Kasuga school who worked for the Kasuga shrine at Nara differed from those attached to the other great temples and shrines. The Takuma family stands as the

81. Bishamonten, Kamakura period. *Boston, Museum of Fine Arts*

representative of Chinese ideals, the Kasuga as representative of Japanese. But what the relations were between these schools or *edokoro*

82. Monju crossing the Sea, Kamakura period. *Daigoji, Kodaiin*

attached to temples, and artists referred to as *busshi* or Buddhist masters, and those artists who had court titles such as Tosa no Kami remain as problems to which future studies will provide solutions.

Another painting in which to observe the new Sung line is the Monju crossing the Sea [82] from the Shingon temple of Daigoji. The subject illustrates the story of Monju's coming from India to China. Monju, enthroned on a lion, carries a sword in one hand and in the other the stem of a lotus on which rests a copy of the *Hannya* (*Prajñā-pāramitā*) *Sūtra*. His hair is divided into five knots, each decorated with a Buddha image and collectively symbolizing the teachings of the five Buddhas. Monju is here fully represented as the god of wisdom, yet the iconography fails to be as impressive as the picture itself. The holy group is led by King Udayana, famous in Buddhist legend as the first person to have had a statue of the Buddha made. But though the concept derives from model books after a Chinese prototype, and though details in the drawing of the costumes and in the clouds also indicate influences from abroad, the execution remains demonstrably Japanese in the softness of the touch. In fact, only somewhat later, in the fourteenth century, did Japanese art ever approximate Chinese models closely enough to cause confusion in attributing a particular object.

Very similar to the Monju crossing the Sea in general composition but completely Japanese in iconography and type are pictures of Fugen and the Ten Rākshasī, deities who have sworn to protect the followers of the *Lotus Sūtra* from which the concept derives. In several paintings of mid-Kamakura date these deities are dressed like real Japanese ladies in stiff costumes, and show a degree of modernity and charm thoroughly in line with the character of the time.

The same influences which produced the new Amidist sects also account for the rise to special prominence of the worship in other sects of

83. Jizō, Kamakura period.
Boston, Museum of Fine Arts

Jizō, the saviour of the dead in Purgatory or
Hell. His staff 'opens the doors of Hell', and his
pearl 'illuminates the Region of Darkness'. At
this time doctrinal essentials are less important
than a deity's reputation based on the visions
in which he has appeared and the miracles
credited to his power. Jizō worship appealed
both to Taira and Minamoto warriors and to
women who worshipped him for ease of child-
birth and for his saving the souls of children in
Purgatory. He is the most human-looking of all
Buddhist divinities. The Jizō painting [83] in
the Museum of Fine Arts in Boston, of mid-
Kamakura date, shows the thick outline asso-
ciated with artists of the Takuma tradition.
Other elements too may derive from prototypes
of Sung art in China, but the delicate tracery of
cut gold leaf shows a perfect fusion of Japanese
aims and Chinese influences. The small scale of
the patterns – the tendency toward minute,
angular forms together with others of more
naturalistic foliage – is a tradition stemming
from Sung painting, and it replaces the earlier
style of bolder floral elements geometrically
arranged.

In an age when Buddhism was being made
popular it is hardly surprising to find that local
pride was recognized by the closer incorpor-
ation of native Shintō gods into the Buddhist
pantheon. The system known as Ryōbu Shintō
made it possible to recognize local gods as
incarnations of Buddhist deities. The idea of
amalgamation was now called *honji suijaku* or
'traces of descent from the true source'. Such
identification was aided by the tenets of both
the Shingon and the Tendai sects. Had not the
Lotus Sūtra said, as Sir Charles Eliot points out,
'In all the Universe there is not a spot as small
as a mustard seed in which Shaka has not
sacrificed his body for the sake of living
creatures'? By the end of the Kamakura period

84. Nachi Waterfall, Kamakura period.
Nezu Art Museum

this trend of thought had produced many new types of painting.

Although a growing love of nature is shown in the foregrounds of paintings of the Descent of Amida across the Mountains, yet they hardly prepare one for the picture of the Nachi Waterfall [84] in the Nezu Art Museum. At first sight it looks like an example of pure landscape painting. The great fall and the towering trees present a particular view beautifully conceived, as any photograph of the actual scene can prove. This is not in the tradition of idealized landscape which was to come in shortly from China. Instead, it expresses the deep appreciation of the Japanese for their own land, and owes its creation to the belief that the waterfall was the residing place of the local Shintō god. No attempt was made to represent the unseen god, since to depict the wonders of nature was felt a sufficient way to illustrate the presence of a deity. Barely visible at the bottom are the architectural lines of pagodas and a shrine which were erected in 1281. This is a religious painting which would hardly have been produced without the stimulus of Buddhist icon-making and which would never have had its landscape form without the nature veneration of Shintoism.

Along with native landscape, paintings of native gods became more common in the Kamakura period. One of the earliest is the figure datable to 1204, in the Mrs Sue Hara collection, of the divinity Seiryū Gongen, the Shintō goddess of Mount Daigo. The deity is painted as she appeared in a dream to a believer, and looks no more nor less than a very beautiful lady clad in court costume. In much the same vein is a later painting of the Shintō goddess Nibu [85] at Kongōbuji on Mount Kōya. She was a local deity associated with that mountain where Kōbō Daishi established his most famous monastery. In the text of scrolls on the *Life of Kōbō* she is made to say, 'For a long time I have desired glory and good fortune for the Shintō faith. Now you [Kōbō] have come here. This

85. Nibu, Kamakura period.
Kongōbuji

brings me happiness.' Later she adds, 'For all time I want to make manifest my devotion to the [Buddhist] faith,' and thereupon she offers him her lands.

In the painting a landscape is seen behind the deity. The pattern of shore line, projecting like a rounded cloud formation, is typical of such scrolls of thirteenth-century date as the Tales of Sumiyoshi. Neither decoratively conceived nor descriptive of any natural philo-

sophy, still it possesses the artificial attractiveness of landscape gardening. One of the *shuji* characters, a form of sacred writing phonetic and hardly intelligible, is placed in a medallion above the landscape.

Under the inspiration of national and local thought animal paintings began to appear. The close association of the Deer Mandara with the Kasuga shrine at Nara, the clan shrine of the

86. Deer Mandara, Kamakura period.
Murayama Family Collection

Fujiwara family, produced a number of very similar deer paintings, of which that in the Murayama family collection [86] is an especially fine example. The deer represents the deity of Mount Mikasa in Nara. From its saddled back arises the sacred *sakaki* tree which supports a mirror, the most reverenced of Shintō symbols. Yet on this mirror appear the images of five Buddhas; thus, the holy manifestations of two religions are immediately conjoined.

The expression of native feeling can be related not only to local deities, as has been suggested above, but also to national heroes. At the Ninnaji temple in Kyōto is a painting of Prince Shōtoku holding a long-handled incense burner. In the painting can be seen designs raised in low relief, a decorative treatment which was known in both the sculpture and painting of the late Kamakura period and which reappeared in later times. Shōtoku, venerated as a great Buddhist, was a favourite subject. Here he is represented as praying for the recovery of his father, the emperor Yōmei, from illness. The picture is to be interpreted as portraying an act of filial piety, a Confucian idea and the basic ethical way of the Chinese. It combines in one painting Japanese execution, Buddhist religion, and Chinese sentiment in a new arrangement expressive of the age in which it was made.

A picture of Shōtoku and Two Attendants in the Y. Hashimoto collection, though assigned to the first half of the fourteenth century, also belongs to the so-called filial piety type of portrait of the prince. The treatment repeats that of a painting in the T. Nakabashi collection which is attributed to Kanaoka of the ninth century and which in turn recalls the type of imperial portraiture of the Thirteen Emperors attributed to the Chinese artist Yen Li-pên of the T'ang dynasty. The scarcity of early paintings from both China and Japan makes it all but impossible to judge the relative antiquity of traditions which appear in extant Japanese

works of art. In so far as the Japanese favoured a tradition of figure painting, the origin of many of the influences which reached them from China should be sought for late in the T'ang period when figure composition was predominant there.

Kamakura taste which found visions, portraits, and national legends so congenial is also revealed in child portraiture. In the Murayama family collection a painting shows Kōbō[7] as a child of five or six when he dreamed that he knelt upon an eight-petalled lotus and desired to converse with all the Buddhas. The charm of realistically presented childhood is united to the easily understood symbols of the halo and the lotus throne to make a very moving and sincere Buddhist picture. As with a well-known type of sculptural image of Shōtoku as a child of two, the appeal is a twofold one of everyday human emotions joined with the sentiments of hero worship.

Kamakura art possessed a virility which is shared with the Nara period, but whereas Nara art was made to harmonize with a dominating idealism, now art was motivated by a more practical frame of mind. The realism which ensued turned towards man for themes of action and emotion and towards nature for scenes of simple-hearted enjoyment. Art forms tended to be either quick-moving or decorative. In all these respects the development of traditions consonant with the Japanese temperament should be noted. But they were expressed most freely in the secular scroll paintings which had arisen in the Heian period and which are so distinctive a feature of Japanese native art as to be called Yamato-e or painting in the national tradition.

THE YAMATO-E TRADITION OF NARRATIVE SCROLLS

For mature developments in a truly national style no section of Japanese art history possesses so much interest and importance as the scroll paintings, *emakimono*, of the twelfth and thirteenth centuries. It is unfortunate that few originals have survived, that those in western museums are naturally very limited in number, and that illustrations are inadequate to suggest either the richness of the colour or the unity of the composition.

Long horizontal paintings, only some ten to fifteen inches high and anywhere up to thirty or more feet in length, were a specialized form, derived from China and already applied to painting in Japan in the eighth-century scrolls of the Sūtras of Past and Present Karma. But the method developed particularly to illustrate the romances, stories, and biographical accounts popular in the middle ages. In the scroll paintings of the Heian and especially of the Kamakura periods, even when the subject was Buddhist, secular elements predominated. The narration of a story with fictional, sensational, popularizing tendencies gave to these scrolls a distinctive character.

Some indication of the close relation between painting and prose may be obtained from literary sources. The Picture Competition chapter of the *Tale of Genji* tells of the pictorial appreciation of the nobility in the early eleventh century. About the middle of the thirteenth century the author of the *Kokon Chomon-jū* (Remarkable Stories of Ancient and Modern Times) wrote that he was so fond of pictures that he collected stories principally 'for the sake of preserving them and doing them into paintings.' The book followed the type of the *Uji Selected Tales* which included texts very similar to those on which the scrolls of the Legends of Mount Shigi and the Story of Ban Dainagon were based.

Illustration is a branch of art which, when the power of the imagination is strong, can be as telling in effect as the story itself. The text may set the theme, but even in cases where the text has been lost, the medieval scrolls are frequently so fast in action and so rich in descriptive detail that knowledge of the story is not necessary. What has caught the eye of the artist is treated with such sympathy and insight and the composition flows with such ease that we hurry to reach the next *dénouement*, curious to note the details of lively figure composition.

The Chinese developed the scroll form mostly as a panoramic view of landscape which could include a whole succession of mountain ranges, near and far, possessed of a geological sense of space and time. In the same form the Japanese described the nature of man. Perspective was of less interest than the line of action, and the atmosphere was that of the hidden recesses of the heart. To the tradition has been given the name Yamato-e, Japanese paintings, in contrast to styles more after the Chinese manner.

The oldest surviving examples from the Heian period are the scrolls of the *Tale of Genji* [87], the classic romance of Japan. Three of the four surviving scrolls are kept in the Reimeikai Foundation. Pictures, here of narrow width, alternate with text. The artist to whom they are attributed, Fujiwara no Takayoshi, lived in

87 (*below*). Takayoshi: Tale of Genji, Eastern House chapter, Heian period. *Reimeikai Foundation*

88 (*opposite*). Sūtras offered by the Taira Family, Praying Ladies, Heian period, *c.* 1164. *Itsukushima shrine*

the first half of the twelfth century. Several remarkable characteristics are to be noted. The architecture frequently is roofless in order to paint indoor scenes with intimacy. Tilted backgrounds offer a perspective which gives scope for telling a story, and depth as such is a subsidiary factor. To produce effects of dreamy unreality the faces are simplified so that dashes suffice for the eyes and a hooked line for the nose. The colour is built up thickly: a first outline is hidden under later layers of pigment, and the final definition of line is added last. The technique, called *tsukuri-e* or 'make up', gives great depth of colour. Essentially Heian in its sensitivity to the variety, harmony, and richness of colour schemes, the tsukuri-e represents the taste of the end of that long period. Whatever paintings had preceded are lost, but the static and colourful style should doubtless be regarded as the culmination of a method which had taken long in maturing.[1]

That the art of China had at some time provided the prototypes can hardly be doubted. The 'dash eye' can be observed in the painted bricks of late Han or early Sixth Dynasty date (second to fourth century A.D.) which depict an Animal Fight in the Shang-lin Park. They are preserved in the Boston museum. Although it is not easy to cite a Chinese figure painting extant today in which both wide variety of colours and richness of tones predominate, these qualities are to be found in the Hui-tsung copy of Chang Hsüan's Ladies preparing Newly Woven Silk, also in the Boston museum. The figure style of the T'ang dynasty must have supplied many elements of composition and technique which were assimilated by the Japanese. But it is obvious too that by the twelfth century Japanese artists had made the tradition distinctly their own.

The illustration[2] is that of the Eastern House chapter (Azumaya) from the *Tale of Genji* scroll,

and shows the splendid elegance of a lady's apartment, the world of fashion in a haughty age. The colours, as vivid as a group of spring flowers, present a startling contrast of yellow, orange-red, lake, and touches of deep blue against the green used for the fresh straw mats of the floor and the partially rolled-up bamboo blind. The mask-like faces and the staid postures of the ladies with their widespread robes and long, flowing black hair conform to artistic conventions too subtle to be readily understood. As figure paintings no appeal is made to physical charms – there is only a setting chosen to emphasize the moods of the subjects. The gravity, refinement, and splendour are characteristic of a society which took itself seriously, and still retained the political power to maintain its respected position. The landscape paintings which decorate the sliding screens at the back of the room have a richness of colouring perhaps reminiscent of T'ang designs but still more

suggestive of free adaptations based upon them and transformed by the nature-loving spirit of generations of Japanese artists.

To the same static and colourful tradition belongs a set of illuminated manuscripts called the Sūtras offered by the Taira Family [88], still kept at the Itsukushima shrine. Done between 1164 and 1167 by members of Taira no Kiyomori's family, they illustrate the last part of the Heian era, the ultimate in extravagance and the taste of Kiyomori himself, the dictator of Japan. They have little in common with the normal Buddhist fashion for copying sūtras; theirs is the decorative style of the court, and courtiers painted them according to the sumptuous mode of the day. Everywhere is the sparkle of colour, the paper is decorated with gold and silver dust, and the top and bottom margins have painted designs over scattered squares of gold. The prefatory pictures mostly illustrate the Lotus Sūtra. The Praying Ladies

on whom descend a shower of lotus petals are arrayed in the elaborate dresses of the court set against a silver ground. On their own small scale the paintings give a foretaste of the decorative use of gold and silver which was to be a characteristic of the Momoyama age, when the great screen painting style originated for the decoration of castle walls and state apartments.

As a picture of the times, with subjects sometimes drawn from the lower classes yet executed in a similar style and contemporary in date, there remain the Sūtras written on Painted Fans. In these sacred texts the paper surface is embellished with mica. The scene By a Well [89] shows both the decorative flatness in the drawing of the trees which seems part of the ornamental visualization of the Japanese and the elaborate use of gold squares and spicules which is commonly associated with more courtly figures. But the most remarkable fact about the fan paintings is that the under-drawing, which only shows where the surface pigments have been worn off, was printed by wood blocks. Here, late in the twelfth century, are hand-coloured printed designs of the common people, an anticipation of the Ukiyo-e print by some five centuries. In medieval Japan the reduplicative print process was found expedient in producing pictures on a quantity basis, but the ritualistic taste of the age and the assurance of reward for acts of virtue gave rise to a fashion never carried out again with such lavishness.

Still in the romantic pictorial tradition of the *Tale of Genji*, still static and with richly decorative elements are several other scrolls illustrating classic literature. The scroll of the Nezame Tales possesses the same aristocratic quality, but uses a more restricted palette. The scrolls of the Diary of Murasaki Shikibu, often attributed to Nobuzane, prove that the tradition survived into the early Kamakura period.

89 (*above*). Sūtras written on Painted Fans, By a Well, late Heian period. *Shitennōji*

90 (*opposite*). Legends of Mount Shigi, The Flying Storehouse (detail), late Heian period. *Chōgosonshiji*

Even as late as the early fourteenth century the *Kasuga-gongen-reikenki* scrolls continued to express the same attitude though with more realism and motion in their pictures. By then, however, the sense of living in an unmoving dream world of charmed magnificence had vanished. The matter-of-fact pragmatism of people of Kamakura times sharply contrasted with the air of sophisticated illusion in the Genji scrolls.

A second great tradition of scroll painting also dates from the late Heian period. It was based on popular, not classical, literature. It began, as far as surviving scrolls are concerned, with the Legends of Mount Shigi [90] which had an important though diffuse influence on the art of scroll painting. While the Genji illustrations are short, those of the Legends of Mount Shigi are long, continuous pictures measuring some thirty feet. Where the colour of the Genji is brilliant and heavily applied, in these it is a wash of colour used to accent the speed of the line drawing. The well-known method of continuous representation was used and the same figures appear again and again in lively episodes.

Since the hand-scroll was to be viewed in variable and convenient lengths measured by the hold of outstretched arms, it could only be convincing as art and suggestive of coming incident when the composition matched the fluidity of the narrative. In such a long form the absence of bounding lines on the sides made it possible for the artists to arouse interest, to shift the setting, and to unite the whole in a continuous design. The scroll has no rival as a medium to harmonize narration and artistry.

As one tries to analyse the particular genius of the scrolls of the Legends of Mount Shigi and later of others in the Kamakura period, one is reminded of the words of Leonardo da Vinci: 'What should first be judged in seeing if a picture be good is whether the movements are

appropriate to the mind of the figure that moves.' In Japan, where no humanist tradition existed to stir the imagination of men in the the study of man, the introspective attitude of Buddhism took its place; subjective philosophy and meditative practices help to explain Fujiwara sensitivity as well as Kamakura emotionalism. Buddhist insistence on life as an aspect of mind produced the keen psychological insight which in scroll paintings supplied a background of penetrating observation. The men and women in these scrolls are no symbols of profound ideas. They have real individuality of act and emotion, which is different, too, from saying that they are developed as so many personalities.

The Legends of Mount Shigi ought to describe miracles wrought with the help of the god Bishamonten, but his name does not appear in the text, and only a racy story is left. Of the three scrolls belonging to the temple of Chōgosonshiji, the scroll of the Nun is noteworthy because it contains a picture of the Great Buddha of Nara as seen by a Heian artist before the statue was destroyed in 1180. But by far the best known is the scroll of the Flying Storehouse, a detail of which is illustrated [90]. A hermit has been customarily fed by a magic bowl which flew his food from the storehouse of a rich man to his mountain retreat. One day the bowl is forgotten, and the whole storehouse is transported through the air amidst a scene of wild confusion. Here can be seen the beginning of the Japanese ability to depict groups of figures in action. Earlier examples of scenes of grouped figures united in action or experiencing

91. Abbot Toba (attr.): Animal caricatures, a monkey worshipping a frog (detail), late Heian period. *Kōzanji*

a common emotion are hard to find. A possible exception might be made in the case of the Death of the Buddha of 1086, where the scene is described by the violence of the emotions evoked and by crowded figure composition. If in the history of world art the Chinese have used the horizontal scroll form to achieve the highest expression of landscape art, similarly the medieval scrolls of Japan are a major contribution to the art of painting active figure groups. In the scene from the Flying Storehouse a frenzy of emotion is clearly indicated in the open mouths and excited gestures of the rich man on horseback and his servants on foot. Equally amazing is the way the action is related to the unrolling of the landscape background. Compositionally, the figures and the landscape unite into one fast-moving rhythm.

A third tradition of scroll painting which originated in the late Heian derived from the simple ink draughtsmanship of the Buddhist copy books. The scrolls of Animal Caricatures [91, 92] of the temple of Kōzanji began a style of ink outline drawing at once wonderfully pleasing in itself and remarkably different from the far more polished and varied use of the brush by the great masters of ink painting in the fifteenth century. The new freedom of linear rendering combined with skilful, humorous caricature has traditionally been associated with the name of the nobleman-priest, the abbot Toba Sōjō (1053–1140). However, all four scrolls are obviously not the work of one hand. Professor R. Fukui suggests the priest Jōchi of the temple of Miidera as the probable creator of some of the pictures. Other scholars

92. Abbot Toba (attr.): Animal caricatures, a frog throwing a hare, late Heian period. *Kōzanji*

would date some of the scrolls to the early Kamakura period. But the problems of authorship and age are not as significant as those of the art of the pictures themselves.

The sophisticated artist, whoever he may have been, parodied the actions of men through the antics of animals. Though there is no specific identification, the animals caricature monks who lived at Mount Hiei, Hiyoshi, or Kasuga. Illustrations 91 and 92 come from the best-known of the scrolls, which deals with contests between monkeys, hares, and frogs. The artist laughs at his fellow-clerics, and in the mock worship of the Buddha-like frog the burlesque on the dignity of the church is blasphemous. The emperor Shirakawa, a contemporary of the artist, once remarked that there were three things he could not control: the Kamo river, the fall of the dice, and the monks of Mount Hiei. The religion of the twelfth century must often have been more turbulent than reverent, more outwardly spectacular than inwardly satisfying, and the monks were warlike, venal, and undisciplined. The spirit of the

93. Hungry Demons, Water Offering, Kamakura period. *The Commission for the Protection of Cultural Properties*

scroll harmonizes more with the robust worldliness of the late Heian period than with the feeling of disenchantment which followed at the end of the twelfth century.

Many scrolls dating from the beginning of the Kamakura period already express the disillusionment which in part explains the popularity of the idea of the Six States of Existence, Kumārajīva, one of the early Mahā-yānist writers, said: 'All living beings pass through the six paths of existence like unto a wheel revolving without beginning and without end. And they become by turns fathers and mothers, males and females, and 'through generations and generations one is in debt to others.' Professor Fukui would group together as reflecting this peculiarly Buddhist point of view, the various scrolls of the Hells, Hungry Demons, Animal Life, and Diseases. Illustrations showing the Six States also occur in the eighth scroll of the Legends of the Kitano Shrine.

The state of the Hungry Demons [93], ghosts with never-satiated appetites, is represented in a scroll formerly kept at the temple of Sōgenji. Like the Sūtras written on Painted Fans, here is a picture of the lower classes making a water offering in the Bon festival of

94. Wasp Hell, Kamakura period.
*The Commission for the
Protection of Cultural Properties*

the dead. The crouching, large-bellied, thin-necked demons gloat over drops of water splashed about for their salvation at a wayside Buddhist pillar. The style is vernacular and without affectation. Buddhist morality is presented as it acts on the hearts of men without ritualistic trappings or argumentative iconography. The everyday scene with its simple moral satisfied people who merely wanted to see their accepted beliefs in picture form.

In a picture of the Wasp Hell [94], a scroll owned by the Commission for Protection of Cultural Properties, ugly emotions are beautifully expressed. Hideous women swim around in the waters of Hell. Over their heads fly enormous wasps, and the artist with merciless skill makes one woman point a finger of scorn at another whose head has just been stung, while over her own a great wasp hovers. Such satire, used here to expose the human follies of the inhabitants of Hell, is much more profound than the didactic pictures of the Kings of Hell popular at the end of the Kamakura period.

The human world is partly represented by the scroll of Diseases formerly in the A. Sekido collection.[3] The Man with Loose Teeth [95] is a pitiable fellow. Yet by a line drawing of agony of mind as well as of body the artist arouses our sympathy and, lest the scene be too painful, our sense of humour as well.

Also from very early in the Kamakura period and illustrating its tendency towards secular realism are a number of portraits at the temple of Jingoji. All but one were painted in the usual Buddhist manner. The exception was a portrait of Yoritomo [96], a hanging picture which is included here because the conception

95 (*opposite*). Scroll of Diseases, the Man with Loose Teeth, Kamakura period. *Sekido Collection* (*formerly*)

96 (*above*). Takanobu (1142–1205): Portrait of Yoritomo, Kamakura period. *Jingoji*

is that of the Yamato-e. Yoritomo, the founder of the Kamakura government, had been influential in re-establishing the temple. His portrait made as a patron of the temple was an innovation; equally new was the style of painting. The line is thin, the outline angular, and the colouring simple. Its artist, Fujiwara no Takanobu (1142–1205), was a courtier and a poet, half-brother to Sadaie, one of the leading poets of his time. Like Unkei in sculpture, Takanobu not only exemplified the new realism but founded a lineage of artists who continued to be great portraitists. Throughout the Kamakura age the family demonstrated the close interest of the nobility in the arts of poetry and painting. Little is known of Takanobu's life as an artist, the most interesting fact being his special employment to paint the faces in certain processional pictures made for the imperial palace in 1173 by another famous artist, Mitsunaga. From Takanobu descended in successive generations Nobuzane, Tametsugu, Korenobu, Tamenobu, and, perhaps grandson to the last, Gōshin, who early in the fourteenth century painted a portrait of the emperor Hanazono in the Takanobu tradition.

The most famous artist contemporary with Takanobu was Tokiwa Mitsunaga, a man of endless energy and of wide sympathy for his fellow-men. His name survives as the great recorder of the ceremonies of the court. In 1171 he painted for the palace Five Court Festivals, and in 1173 he made the paintings of imperial processions in which Takanobu co-operated with him. Of about the same date was a series of sixty scrolls of Annual Rites and Ceremonies (Nenjū-gyōji) [213, 222, 224, 230, 252], which were the largest undertaking in scroll form but which are now known only in copies. Among original paintings those most closely associated with the name of Mitsunaga are the scrolls of the Story of Ban Dainagon. Granting the attribution, to him must be credited the extraordinary development of the

painting of large groups in action. Dozens of figures swarm out to see a fire, a milling crowd tense with physical excitement. In liveliness of figure drawing, whether of individuals or groups, Mitsunaga is without rival.

The scroll called the Adventures of Kibi in China [97] which, with a few texts, measures over eighty feet, represents the continuation of the style of Mitsunaga. It is one of the treasures of the Boston museum. In paintings of the Mitsunaga tradition the rich colour of the Genji is united to the moving outline of the Legends of Mount Shigi, thus achieving an exceptional balance between the colourful and the lively. Kibi was a great historic figure of the eighth century who twice went to China and who is credited with important developments in the Japanese syllabic alphabet. But to the late-twelfth-century artist, whose version is closely related to that of a text in the Kōdanshō by Ōe no Masafusa (1041–1111), Kibi in China is more a magician who, with the help of the ghost of another Japanese, Abe no Nakamaro, overcomes groups of Chinese scholars in sheer academic learning, much to the confusion of the latter. The story as told is humiliating to the Chinese, and conversely shows the Japanese attitude of the time. Everywhere there is incidental humour, rapid story-telling, and keen psychological observation of human nature.

The detail [97] lacks any depth of thought, but, as in good fiction, the action is clearly indicated and comprehension is easy. The artist has aroused a feeling of sympathy between his figures and his audience. The prolonged composition is the perfect form for such narrative subject-matter. In this scene of grooms waiting outside a gate to the palace the artist skilfully handles the drowsiness of man and beast. People of all classes are treated as interesting material, for the aristocratic patrons did not find only themselves entertaining.

The Genji was a fictional classic, the Legends of Mount Shigi a miraculous fable, the Animal

97. The Adventures of Kibi in China (detail), Kamakura period. *Boston, Museum of Fine Arts*

Caricatures a satire on institutional Buddhism, and the Kibi a sensational novelette. The light narrative tendency was carried still further with stories of shrines and temples, records of warfare, and biographies of famous priests and poets. The new kind of hero worship often occurred combined with a new type of landscape setting.

98. Life of Michizane (detail), Kamakura period, 1219(?). *Kitano shrine*

The story of the Life of Sugawara no Michizane [98] offered just the right kind of theme for the early Kamakura age as that of a great noble, poet, and angry ghost. Commonly known as Tenjin, the divinity of literary men, his spirit was especially worshipped at the shrine of Kitano where the paintings are still kept. The Kitano Tenjin scrolls[4] of 1219 are the oldest of many versions devoted to his biography, the story of a deified Japanese. The detail chosen for illustration, from the sixth scroll, shows a scene at the Seiryōden palace where the emperor Daigo is having his head shaven preparatory to entering the Buddhist church just before his death. It is a scene of great solemnity. The highest nobility wait inside and on the porch, while imperial guards attend below. Diagonal lines of architecture were one of the accepted tricks of the trade for a scroll artist; skilfully used in a horizontal picture, they help to tell the story by separating one incident from another.

A detail from a later version called the *Matsuzaki-tenjin-engi* painted in 1311 is shown in illustrations 255 and 285. Artistically the century which had elapsed since 1219 was marked by more factual presentation and charm of selected detail, but with a loss of artistic simplicity.

Parallel to the illustrated shrine literature represented by the Kitano Tenjin scrolls are temple chronicles like the Legends of the Kegon Sect [99], at Kōzanji, which depict the lives of Gishō and Gangyō, two Korean priests who set out for China in the T'ang dynasty and whose work laid the foundation of the Kegon sect of Buddhism. Both the Kitano and the Kegon sets of scrolls have at times been attrib-

99. Legends of the Kegon Sect, Gangyō preaching (detail), Kamakura period. *Kōzanji*

uted to Nobuzane, the leading artist of the early thirteenth century. But the first does not possess that correctness of drawing of palace architecture which should be expected from a court artist, and the latter is so much closer to types of drawing to be found in Buddhist copy books that neither attribution can be sustained. Both sets seem rather to belong to the freer style which flourished at the temple of Kōzanji. In the scene of Gangyō preaching the broad use of the brush and the absence of detail create a simple rendering which has been compared to the Buddhist style in the Animal Caricatures and to a portrait of Myōe by Jōnin, a Buddhist painter of the temple. Myōe revived the Kegon sect at Kōzanji and his portrait, a picture of the early thirteenth century, is still kept there. It is, however, more a landscape than a portrait, for the priest is seated in meditation high in the

branch of a tree in the thick woods of Mount Toganoo. Mists float about the tree tops, and with literal exactness there is a profusion, if not an outright confusion, of near-by trees and branches. Even the drawing marks a transitional stage. The artist Jōnin has applied to landscape the free ink drawing which had developed among the makers of religious copy books.

Just as the return to Nara traditions was a major factor in the sculpture of the Kamakura period, so the tendency to look backwards and to regard the past as part of the national consciousness found expression in several other ways. The old subject-matter of the Sūtras of Past and Present Karma was used again by the artist Keinin in 1254 in a series of scrolls which show much of the stiff composition of the ancient ones but which at the same time have the free racy line of Kamakura times. The

100. Nobuzane: Thirty-six Poets, Kintada, Kamakura period.
Washington, Smithsonian Institution, Freer Gallery of Art

Taima Mandara, a famous embroidery composition of the Nara period, was now interpreted not as a single great vision of Amida's paradise, but as a legend of the making of the holy image in Japan. Elements of Buddhist doctrine, historic personality, and literary story-telling often combined to give a special flavour to the treatment of Kamakura scrolls.

In portraits the painting of Yoritomo marked a new development. Fujiwara no Nobuzane (1176–1265?), the son of Takanobu, carried on the family tradition for portraiture and at the same time gave expression to the taste of the court. Many paintings have been attributed to him. The most credible is a set of Thirty-six Poets now divided up, but originally in scroll form. They were formerly in the collection of Marquis Satake. A second set of Thirty-six Poets also generally attributed to Nobuzane shows the poets seated on mats. It is known that Nobuzane did a set of thirty-six poets in 1233, yet this fact does not prove that he painted either series, for the date might just as well refer to the painting of a set of contemporary poets, a fashion of the time. Though these scrolls of poets are some of the oldest surviving, prototypes probably existed from the eleventh century. Like the much larger portrait of Yoritomo, that of the poet Minamoto no Kintada [100], one of three in the Freer Gallery of Art, Washington, shows the stiff, angular robes of the courtier's starched costume, and concentrates the attention on the face. Since Kintada lived in the tenth century, the portraiture is imaginary. Yet it is individualistic in intent, an example of the *nise-e* or 'likeness pictures', where the skill consisted in catching a man's character in a few simple lines.

A scroll which continued the Nobuzane tradition for line drawing and portrait interest is the Imperial Bodyguards [101], in the Ōkura Shūkokan collection. There are a few touches of colour and broad masses of ink. The guards, who are individually named, could not all have been contemporary with the artist, but since one figure is dated 1247 it may be supposed that some of the guards were known to him and that the likenesses of others were obtained from older scrolls of a similar kind. This scroll is doubly remarkable. It is portraiture of animals as well as of men, and thereby argues for the great contemporary interest in sportsmanship. To represent the inward energy and nobility of the horses the artist has used an excited, unrealistic line which in some ways anticipates the 'expressionism' of modern schools of art.

Another type of ink painting – one which combined the delicate line work of the Nobuzane tradition with the massing of thick ink areas – is represented by a remarkable scroll called Makura no Sōshi in the collection of N. Asano. It provides illustrations to a classic piece of literature, the *Pillow Book* of Sei Shōnagon, a court lady and writer of the tenth century. The pictures are attributed to the imperial princess Shinko, and the scroll dates from the fourteenth century. The type is not as rare as was once thought. A fifteenth-century copy of a scroll in this style was formerly in the collection of M. Kujō. Known as the Imperial Party at the Chūden Palace, it is the painting of an actual party held in 1218. Such works anticipate one of the styles followed by the traditional painters to the court, the Tosa family. The illustration of the Genji [140] by Tosa Mitsunori is a seventeenth-century revival of this manner which was current in the Kamakura period.

101. Imperial Bodyguards (detail),
Kamakura period, 1247.
Ōkura Shūkokan Collection

102. A Fast Bullock, Kamakura period. *Seattle Art Museum*

Interest in animal portrayal can be further studied in a cut-up scroll of Fast Bullocks [102], of which the Seattle Art Museum has one section. Dating from the early fourteenth century, the scroll shows the sturdy animals which had to draw the heavy ox-carts of the day. Although it belongs to the ink tradition, here a thick ink is massively used as though it were a colour pigment, bounded by broad and paler strokes. The technique calls to mind details of the animal drawing in the Kibi and was later revived by Sōtatsu in the seventeenth century.

These two ink styles, the one massive and flat and the other so delicate that the outline is barely visible, ran counter to the general development of the Yamato-e tradition of strong colour. Yet both styles prepared the way for schools of art distinctly national in character.

Further, the Yamato-e style was not limited to scrolls. The portrait of Yoritomo has already been mentioned as a hanging painting. Other rare hanging paintings of interest especially in the history of landscape art are a Mount Kagami[5] attributed to Nagataka, in the Nezu Art Museum, and an Imperial Palace in Snow attributed to Tsunetaka, formerly in the Z. Yasuda collection. How they were used in contemporary architectural settings is not fully understood, but they indicate special court traditions of landscape paintings as distinct from those of Buddhist or Shintoist derivation. The theme of the former connects it with a well-known class of *meisho* paintings, or views of famous scenes. Such paintings were fashionable in the Heian period, and screens of this type are known in literature to have been painted from the time of the emperor Murakami (947–67). Some of the paintings referred to in the Picture Competition chapter of the *Tale of Genji* must have belonged to the tradition of local views and have been painted by courtly rather than professional artists. In size

the painting of Mount Kagami looks like a section of a horizontal scroll, but the treatment differs somewhat from any appearing in scroll paintings. It seems rather like a simplified excerpt from a screen. The rock forms might derive distantly from the T'ang style, but the lighter handling suggests some court painter, the brush of a noble exercising his talent rather than that of a professional master. Even the screens and the wall paintings which occur in scrolls as details of interior scenes are more solidly handled than is the picture of Mount Kagami.

In the Imperial Palace in Snow[6] the decorative rather than the literary side of the court taste is emphasized. Like the sixfold landscape screen [64] of the late twelfth century at the temple of Tōji, all the more or less 'pure' landscapes have a special importance because they reveal a truly Japanese taste and one completely at variance with the ink standards of Chinese landscape painting which were to monopolize taste in the fifteenth century. Slight though the evidence is, it suffices to prove both that court artists indulged in painting landscapes and, if we may include the landscapes on sliding screens which decorate the background of so many scrolls, that the court taste was especially pleased by landscape art.

The set of scrolls which best represents the militaristic spirit, the veneration for heroes, and the excited narrative of the mid-Kamakura period is the Tales of the Heiji Insurrection. Three scrolls have survived. The one in the Boston museum, the Burning of the Sanjō Palace [103], is perhaps the greatest of battle pictures, of fire and confusion. It comprises in one long, continuous treatment a series of incidents of the Heiji war of 1159 which began the struggle between the Taira and Minamoto families. The revolt started with the firing of the Sanjō palace and the capture of the ex-emperor Shirakawa.

The scroll shows a new appreciation of the problem of figure composition. Even in the short section illustrated, showing courtiers rushing to the aid of the palace, the strong accent on direct motion is obvious. Below stands a small group arranged in a semicircular form, a device repeated with variation in the next group, and both but introductory to a larger semicircle which contains the two. They are like themes in some grandly growing orchestral composition. Then, too, the dark, massive, whirling wheels and the long, fragile, curving bows are like the heavy and light motifs in a complicated symphony. In scrolls such as this the repetition and diversity of forms and the growth and decline of rhythms seem to transcend the limits of visual imagery and to find their closest parallel in the more measurable unfoldings of music.

Beyond the scene of bullock carriages, armed men, and confusion comes the terror of billowing flames and of the disorder of escape. The words[7] of the text describing the moment when many have thrown themselves into a well read: 'Alas, the lowermost are drowned in the water, those in between are crushed to death, while those on top are engulfed in flames.' Written in an age of warriors and exalting the glory of warfare, the sentiments expressed in the text have the semi-heroic emotions of a melodrama, but the imagination of the artist goes far beyond the narrative powers of the prose writer.

In general, the later part of the century was one of confusion because of the threatened invasion of Japan by the Mongols, a period of terror that lasted from about 1268 to 1281. Following the defeat of the Mongols, there seems to have been a marked revival of scroll

103. Tales of the Heiji Insurrection,
Burning of the Sanjō Palace (detail),
Kamakura period.
Boston, Museum of Fine Arts

painting. A set of scrolls called the Pictorial Record of the Mongol Invasion illustrates the war with the accent on individual prowess. It dates from late in the thirteenth century. Also appealing to the military taste are the *Tengu-zōshi* scrolls, one of which has the date 1296. They treat satirically of the warrior priests of the seven great temples, soldier-monks whose armour was hidden beneath their long robes and who must always have looked incongruous among the followers of Buddhism. The figure drawing has become thin and sensitive, the tree drawing broad and simplified. Like so many other artists at the end of the thirteenth century, the painter may lack some of the simplicity of conception of the earlier masters, but he has compensated by breadth of interest and greater adaptation of draughtsmanship to subject-matter.

The period also gave expression to a renewed interest in the subject of priestly biography and temple history. The scrolls of the Life of Ippen of 1299 and of Hōnen of the first decade of the fourteenth century were propaganda about great Buddhist divines, while the *Kasuga-gongen-reikenki* painted in twenty scrolls on silk by Takashina Takakane in 1309 illustrated the miracles which occurred at the famous Kasuga shrine. The latter immense painting, like so many great works of art which come late in a period or tradition, suffers from its own combination of virtues. The classic or courtly figures are finely drawn, brilliant colour glows everywhere, and the whole composition is varied with scenes of indoors and out. Illustrations 228 (*left*), 229, 250, 284, 286 (*middle*), 291, 292 offer good sources for knowledge of carpentry, domestic buildings,

temple and shrine architecture. But somehow the many merits of these scenes are more intellectually entertaining and charming than impressive. Kamakura taste preferred beautified realism to the refined detachment enjoyed in Heian times. To Takakane are also attributed the first three scrolls of the Legends of the Temple of Ishiyama [283, 287 (left)]. The artist, however, seems earlier, less restrained, and less finished.

Of the two propagandist sets of scrolls mentioned above, the version of the Life of Ippen [104] at the Kangikōji temple in Kyōto was painted by an otherwise unknown priest, Eni.

Ippen (1239–89), whose Buddhist name means 'for one and all', was an itinerant preacher who like Kūya travelled about Japan. He founded a branch sect of the Jōdo known as the Ji or the 'sect of his own age'. At the Kumano shrine, a stronghold of Shintoism, he had a revelation that words of praise to Amida Buddha's name alone sufficed for salvation. So his position became one of extreme faith in the saving power of Amida's virtue. The scrolls possess an unusual charm in the smaller scale of the figures. In relation to the architecture of temple and shrine [232, 253, 254, 281,

290] and to the setting of tree and landscape the people move quietly with an increased degree of realism produced by the more just scale between landscape and figures. The change illustrates the kind of influence which Chinese art was having on the artists of Japan late in the Kamakura period. The subject of Ippen's travels gave Eni a wonderful opportunity to show his skill as a landscape artist. His rich, natural colouring, which can best be felt in the russet tones of autumn forests, must have come from direct observation. In the sixth of the twelve scrolls occurs one of the early representations of Mount Fuji. Although it is even more steeply sloped than in Hokusai's prints, it already reflects the feeling of the Japanese for their beautiful mountain.

Hōnen, the founder of the Jōdo school of thought, became the subject of a biographical painting in forty-eight scrolls kept at the temple of Chionin. The section illustrated [105] shows him as a child playing horse with a bamboo stick in a group of children. The scrolls, which must have been done by many artists, are not free from the hardening of line which marks the final stage of the Kamakura emakimono. The conventionalized white lines at the top,

104 (*opposite*). Eni: Life of Ippen (detail), Kamakura period, 1299. *Kangikōji*

105 (*below*). Life of Hōnen (detail), Kamakura period. *Chionin*

indicating clouds by a method called *suyari*, also occur in the Life of Ippen and show the growing rigidity of this tradition. Yet the regard for children differs but little from the attitude of Hanabusa Itchō some three centuries later.

Still another aspect of scroll painting, fondness for nature and hence the depiction of poets who wrote of natural beauty, found expression in the scrolls devoted to the life of the priest-poet Saigyō (1118–90). The detail [106] from

106. Tales of Saigyō (detail), Kamakura period. *Reimeikai Foundation*

the scroll in the Reimeikai Foundation shows a thatched cottage which Saigyō passed on his way to get permission to renounce the world. Saigyō ranks among the greatest of Japan's poets. He embodied the escapist ideas of his age, and his poetry expressed the evanescence of worldly things. He possessed a Wordsworthian sense of the beauty of mountain hamlet and sequestered vale, remote from the turmoils of a troubled world. He was as much a travelling poet as Ippen was a travelling priest. The scrolls, probably of late thirteenth-century date, prove the popularity of his thoughts and feelings long after his death. Much later the scrolls were one source of the revival of the national style in art, for early in the seventeenth century Sōtatsu made free copies of a version of the Tales of Saigyō by the artist Kaita Uneme Sukeyasu of the late fifteenth century.

By the end of the Kamakura period influences from the art of China were beginning to be more and more apparent. Scrolls called Tōsei Eden of 1298 which tell the story of the coming of Ganjin to Japan and of the introduction of the Ritsu sect in the Nara period possess mannerisms of line reflecting a renewed interest in calligraphic draughtsmanship in the Chinese style. Stylization of line, attractive though it

107. Boki Eshi (detail), Kamakura period.
Nishi Honganji

may be in itself, fundamentally was at variance with the freedom of expression which gave life to the Yamato-e tradition.

From about the middle of the fourteenth century came a set of scrolls known as the Boki Eshi illustrating the life of the priest Kakunyo (1270–1351), the great-grandson of Shinran. The scrolls [107] were done probably a year after his death, and several artists attached to the Gion shrine co-operated to paint them. Of these Fujiwara no Takamasa seems to have been the most active, and did some remarkable landscape views. The pictorial setting is highly romantic with decorative pines placed on hills jutting out of the ocean. Though not a great painting in the manner of some of its fore-runners, it illustrates both the end of the tradition and the general mode of expression which were closest in time to artists who later wanted to return to the tradition of the past.

The art of horizontal scroll painting, the beginning of which is as difficult to trace as that of landscape art in China, sprang into promin-ence with the development of Japanese litera-ture. Of the two arts, painting seems the greater. The human interest involved all classes of society from nobleman and warrior to pil-grim and peasant. Especially in the Kamakura period the native character disclosed itself as lively, adventurous, and masculine, and social life as it was lived at this particular moment was fundamentally more free than at any other time.

Contemporary with the end of the Yamato-e style were innovations in architectural fashion imported from China. With the introduction of the *toko-no-ma*, the picture alcove, the shape of paintings was transformed from the horizon-tal to the vertical in order to fit the alcove. The habit of handling scrolls which had to be un-rolled sideways to follow the story gave way to hanging paintings, *kakemono*, which were more static in theme and reflected more reposeful ideas.

THE RENAISSANCE OF CHINESE TRADITIONS

That artists who inherited the colourful and lively Yamato-e tradition should disavow their heritage and revisualize the world in an ink monochrome technique deriving from China requires explanation. The short and disrupted period known as the Nambokuchō (1336–92), when two emperors claimed legitimacy of succession and demanded fidelity, provides little elucidation. The underlying reasons must be sought for early in the Kamakura period with the introduction of the Zen sect of Buddhism and the conversion of many military leaders. This branch of religion, though known centuries earlier, now emerged as the method of attaining the ultimate truth of Buddhism in a manner singularly well adapted to attract military minds. The radical transformation which occurred in art at the beginning of the fifteenth century could not have been so sudden, complete, and lasting, if Zen had not appealed directly to some deep aspect of the Japanese character. Perhaps it is not an overstatement to find in both Zen religion and in the native Shintoism a common acceptance of the world as it is, an introspective attitude about man, and a silently intuitive understanding of nature.

Zen was a 'self-salvation' sect. There was no appeal to the saving power of Buddhas and Bodhisattvas; instead, its followers sought to relive the mystical experiences by which the Buddha became the Awakened One. Its teachings descended from the Yoga and intellectual practices of India, and according to tradition were introduced to China by the Indian Bodhidharma in 520. On Chinese soil they were re-interpreted to suit the pragmatic nature of the new environment. The great master Pai-chang (Hyakujō, 724–814) graphically phrased the new anti-quiescent teaching with the words, 'No work, no eating.' Book learning, argument, and philosophy were discarded as of no value. Seeing into one's own nature, character-building and concentration of the will became the prime factors of religious life. It was a practical discipline for fortifying the will in its fight against every trace of self-ness. It was not a slow, intellectual process but a straight-armed blow which would knock the individual out of logical ruts of mind and the tight cage of personality. It especially appealed to the mind of the warrior, for indifference to learning suited his temperament and frugality of living agreed with the standards emphasized by the Hōjō war lords of Kamakura. This, the religion of influential people, has been a formative element in the national character.

In the training of the Zen monk there evolved strange questions called *mondō* and *kōan*, dialogues by question and answer and tests of understanding. Logically incomprehensible, their purpose was to break through the accepted way of looking at the world and to foster a positive mystical attainment.

Zen is the world's most irreligious religion. 'There is nothing holy' in good works, according to Bodhidharma. 'If you encounter the Buddha, slay him,' said Lin-chi (Rinzai). To him, too, sūtras were 'no more than waste paper'. To a monk who asked, 'What is enlightenment?' Tê-shan (Tokuzan) stormed, 'You get out of here and don't scatter dirt

around.' Neither the Buddhas nor the sūtras, not even the essential doctrine of enlightenment received conventional respect.

The men who brought this religion to Japan were the priests Eisai (1141–1215) and Dōgen (1200–53), both of whom were educated at the Tendai monastery on Mount Hiei and both of whom travelled to China. Great Zen monasteries soon were established: Kenninji in 1202, Tōfukuji in 1243, both in Kyōto; Kenchōji built by the shogun Tokiyori in 1253, Engakuji built by Tokimune in 1282, both in Kamakura. Myōshinji, the palace of the emperor Hanazono in Kyōto, was made into a temple in 1337. In 1344 Ashikaga Takauji founded the Tenryūji for the Zen priest Musō who showed a keen business sense by advocating overseas trade with China, an undertaking profitable both economically and culturally.

One of the first Japanese artists to paint in the Zen ink style was Mokuan who went to China about 1333 and who unfortunately died there some ten years later. In China he is known to have been praised as the re-incarnation of the great Zen painter Mu-ch'i who had established a school of painting at the Liu-t'ung temple in Hangchow early in the thirteenth century. Most of Mu-ch'i's paintings are today preserved in Japan. The Ashikaga shoguns Yoshimitsu and Yoshimasa both collected his works, and his style was eagerly perpetuated by such artists as Nōami in the fifteenth century and Sesson in the sixteenth. A follower of the Mu-ch'i school, Liang K'ai, was also popular in Japan and especially influenced the figure drawings of the sixteenth century artist Yūshō.

Yin-t'o-lo (Indara), another artist of the Zen school at Hangchow, may well have been known to Mokuan. These Chinese artists receive little or no recognition in the standard old writings of Chinese scholars. Their style was neither academic nor of 'literary' flavour. Most of them, as Zen monks, used ink sparingly and boldly.

With the change in technique came a new departure in subject-matter. Eccentric figures drawn from Zen or Taoist legend, animals depicted for their natural symbolism and panoramas of idealized landscapes became the repertoire of the new school of artists in Japan. With the Zen style also came asymmetric composition, a visual evaluation of unfilled space, an emphasis on line not so much for directing the continuity of a theme as for a suggested sense of formal or artistic bálance. The poise of an object in space gives to each particular representation a special inner vitality. The ink artists of the fourteenth century were religious and serene. At this time they seem to have been neither mere professional makers of icons nor aesthetes painting for their own pleasure.

The Hotei [108] in the Sumitomo collection is one of the best-authenticated paintings by Mokuan and one of the first great *sumi-e* or ink paintings to be made by a Japanese. Hotei, the Chinese Pu-tai, is one of the new subjects. Fat and jolly, he sums up symbolically the type of man who through intuitive understanding has passed beyond the doubts and troubles of practical life and returns home happy in mind and rich in spirit. Paintings of another of the popular Zen figures, Jittoku, have the same

三會龍華未厭當
長街逞券恩猶在
而衰衰許乾坤大
挂丈頭邊日月長
覺束陀天乾尿板
尼盧梅閑水雲鄉
石言我是真彌勒
哀眠無端向外揚

quality of inner laughter. On the other hand, a second great design attributed to Mokuan, a Kingfisher[1] in the S. Ōhara collection, draws upon nature directly. In the pure ink monochrome picture one is reminded of the Zen saying that 'many colours blind your vision'. The painting also possesses a famous inscription, four terse characters reading: water clear, fish visible. In the painting there is neither water nor fish. Here both picture and text emphasize the instant of activity when the bird is about to dart for its natural prey. Perception of natural relationships has become part of religious consciousness.

Gradually evidence is accumulating that the fashion for painting in ink preceded by nearly a century the formerly accepted date of its rise in the early fifteenth century. Perhaps even a little earlier than Mokuan was the shadowy figure of Takuma Eiga. As his family name implies, he belonged to a school which since very early in Kamakura times had been importing ideas from Sung China into the art traditions of Japan. How he may have descended from Takuma Shōga is by no means clear, nor are his dates at all certain. Eiga made many paintings in colour of Rakan,[2] or arhats, the ascetic holy men of Buddhism. In these pictures the influence seems to be rather of professional Buddhist artists like Yen Hui, of the contemporary Yüan dynasty, than of earlier prototypes. However, it is evident from a painting of Hotei formerly in the collection of Baron Masuda that Eiga also worked in ink.

Another artist who proves the early existence of a school of ink painting is Ryōzen. His White

108. Mokuan: Hotei, fourteenth century.
Sumitomo Collection

Heron [109], in the collection of N. Asano, is thoroughly Zen in spirit; direct statement of fact vies with economy of execution. Whether this artist is identical with the ink-painter Kaō[3] or with the Buddhist painter Ryōsen is by no means clear. All three names have been attributed to one personality, but it is probably safer to keep them separate pending further study. Associated with this group of names are also paintings in colour of Rakan. A set at Kenninji bears the Ryōsen signature, and another set at Honkokuji, more dubiously attributed, supplies the date 1352. At least it is certain that this type of painting flourished in the middle of the fourteenth century, and that the work of Chinese professional artists of the Buddhist school was greatly appreciated in Japan.

Still more characteristic of Zen painting in this early period are portraits in the chinsō style, official pictures of high ecclesiastics. An early Japanese example is that of Daitō, the National Master, at Daitokuji, which bears a date corresponding to 1334. If the Rakan type portrays the concentration of mental faculties required to become an arhat, the portraits of Zen priests in full colour and true to life reveal the strong character of the Zen masters to whom was entrusted the succession of the Zen monasteries.

From the second half of the fourteenth century come strange paintings of Fudō in ink outline by a Zen priest Myōtaku (1307–88). He was reputed to have done a drawing of Fudō every day for twenty years and may be regarded as a specialist, but this narrow concentration, too, marks a change in the fashions of art.

Most famous as a specialist was Bompō (1348–c. 1420) who followed the ink monochrome style for painting orchids of the late fourteenth-century Chinese artist Hsüeh-ch'uang. The personal element, common to artists of the Yüan period in China, had entered into art. Bompō's paintings are sometimes regarded as early evidence of the influence of the Nanga or so-called 'southern' school of Chinese art, in which the association between the sentiments of poetry and the aims of painting was especially close. Bompō was one of the great priests of the temple of Nanzenji. His paintings tell of the growing sophistication of the period and of the interest in Chinese learning in the Zen monasteries of Japan.

For chronological reasons it now becomes necessary to refer again to the subject of Japanese wood-block prints. Some of the largest figure prints known, nearly as large as the screen panels which they follow in design and use, are a series of the Twelve Gods of the Shingon sect, one set of which can be dated Ōei 14 or 1407. Though the colour was applied by hand, the outline blocks show such vigour and beauty as to make these prints remarkable in any civilization. Again, scrolls called the *Yūzū Nembutsu Engi*, or the Legend of the Resounding Nembutsu, were an immense undertaking in woodblock printing. A painted version was made in 1314, printed versions in 1390 and 1414. The version of 1390 was carved on wood blocks and printed in about 1391. The printed texts and pictures measure nearly a hundred feet in length. A copy exists in the Dainembutsuji in Ōsaka. The 1414 version, in two scrolls kept at Seiryōji, was also carved on wood. Unfortunately, the only known surviving printed copy was lost in the earthquake of 1923. Printing was a happy expedient for sectarian propaganda. The older prints of the Heian period had been made for the virtue contained in the very act of creating a holy image; here, as in the case of the Twelve Gods, printing was chosen because it was a convenient method of reproduction. It proves the familiarity and the excellence of the technique centuries before the days of the popular broadsheet.

To return to painting, Chō Densu (1352–1431) was the traditionalist who summed up the professional Buddhist painting and gave to

109. Ryōzen: White Heron, fourteenth century. *Nagatake Asano Collection*

it a new life. In fact, he may even be considered the last great Buddhist painter. For the Tōfukuji temple in Kyōto he painted a set of Five Hundred Rakan, done in fifty kakemono. His set carried on the style of the paintings of the same subject originally in a hundred paintings, now largely kept at Daitokuji, which were done in 1178 by Chou Chi-ch'ang and Lin T'ing-kuei. These artists were men of Ningpo in southern China – a further proof of the close connexion between Zen priests and this area in China. An anecdote tells how for his only recompense for the great set of paintings in

110. Chō Densu: Shōichi, the National Master, Muromachi period. *Tōfukuji*

colour Chō Densu requested that the cherry trees of Tōfukuji be cut down as their beauty was too pleasurable. In 1408 he painted for the same temple a Death of the Buddha measuring thirty-nine by twenty-six feet.

His portrait of the National Master Shōichi [110], also kept at Tōfukuji, shows the official type of Zen portraiture with the emphasis on feature and correct robe. Shōichi, who lived from 1202 to 1280, had founded Tōfukuji. He is known to have been painted many times during his life; so the artist doubtless had models to rely on. Chō Densu was much concerned with realism. In a small sketch[4] he made of Shōichi the features are the most detailed part, and in both the sketch and the portrait Shōichi is shown as blind in one eye. The painting illustrates in addition the power of the curving outlines of the brush work for which Chō Densu's style was especially famous. Portraiture in the western sense of the word is relatively rare in oriental art, but many noteworthy exceptions are to be found among chinsō portraits of which this is one of the great examples.

To Chō Densu is ascribed an ink landscape dated 1413 at Konchiin. This Hut in the Valley is the oldest pure ink landscape now known. Above the painting are many inscriptions by admiring priest friends. As this feature occurs again in the works of Josetsu and other artists, it may be judged how keen the interest in art and literature was in Zen circles in the early days of the fifteenth century. Zen influence had entered the secular field and was no longer exclusively religious.

However, the artist who from the days of Sesshū was believed to hold the place of ancestor of ink paintings in Japan was Josetsu, a priest of Shōkokuji in the Ōei period (1394–1427). Only one painting, Catching a Catfish with a Gourd, of the Taizōin sub-temple in Myōshinji, can be certainly attributed to him. It illustrates a Zen subject painted for the shogun

111. Josetsu: The Three Teachers, Muromachi period. *Ryōsokuin*

Yoshimitsu (1358–1408). Tōhaku, a later artist, claimed that it was not inferior to works by Mu-ch'i, though this seems excessive praise today. Very generally accepted as by Josetsu is another painting called the Three Teachers – Buddha, Lao-tzu, and Confucius – [111] of Ryōsokuin in Kenninji. The idea of the painting is that though there may be several great doctrines there is only one truth. It is highly probable that some Chinese painting provided the model on which the treatment is based. Such unflattering facial characterization, such elimination of non-essentials, and such powerful brush strokes enable us to see why Josetsu was regarded so highly.

It is interesting to contrast this ink treatment of Chinese figures with that of a painting of the Four Greybeards at Hōryūji also done early in the Muromachi period. In this the hard line and the full colour indicate an older Chinese technique, perhaps that of a professional Chinese artist rather than a painter of the scholar class whose works are recorded with such respect in Chinese art histories. Both the Four Greybeards and the Three Teachers are newly-introduced Zen subjects. But the Hōryūji treatment is incidental and narrative in the manner of the late emakimono tradition, while Josetsu's bold ink washes proclaim him to be one of the great masters of the Chinese style of ink painting.

The central figure of what was surely a conscious renaissance in the idealistic school of the fifteenth century was another priest, Shū-bun. Judging by the works attributed to him it is possible to see why he was the great teacher of the period, but unfortunately not a single painting is documented with any certainty. His life is moderately well known. About 1414 he was a pupil of Josetsu. In 1418 he painted the Studio of the Three Worthies (Sanekisai) – pine, bamboo, and plum – [112] in the Seikadō Foundation. He took a trip to Korea in 1423 to get a set of the Buddhist sūtras. In

112. Shūbun: Studio of the Three Worthies, Muromachi period, 1418. *Tōkyō, Seikadō Foundation*

1430 he painted a sculpture at Darumaji, near Nara, and has indeed occasionally been mentioned as a sculptor. From then on there are many landscape paintings which are associated with his name, the two most famous being one of 1445 now in the Y. Fujiwara collection and one of 1448 in the Tōkyō National Museum. It is possible that about 1458 Sesshū became his pupil. After 1465 he is no longer recorded.

Josetsu and Shūbun were both priests at the temple of Shōkokuji which was built by Yoshimitsu as the Ashikaga mortuary temple. However the relationship between the Ashikaga lords and Shūbun came about, it would seem certain that the closeness of the style of Shūbun to the 'northern' manner of Hsia Kuei and Ma Yüan, both artists of the late twelfth and early thirteenth centuries, could have been achieved only through familiarity with the collection of Chinese paintings formed by the Ashikaga shoguns.

The 'northern' style reflects not so much direct Zen influence in China as the amalgamation of Buddhism and Confucian philosophy and is most apparent in landscape paintings. Art embodying this philosophy of nature gave to every selected detail a pre-established value. Indestructible mountain ranges weather out the ever-changing seasons. Man is depicted as one who searches for, finds, and fills himself with natural purity. Mountain, tree, and man bear a definite proportion. Atmosphere is used to suggest by shifting areas of mist a sense of distance so extensive in height and width that what first seems a naturalistic panorama becomes a cosmic view, pulsating with the energy of life itself. The beauty of nature thus intellectually conceived reflects the profundity of Chinese thought about nature by the measure of ideal forms. The tradition is as distinctive a contribution to art history as the ideal proportions with which the Greeks represented the physique of man. A more Zen way to phrase the same ideal would be to state that the artist seeks to catch 'the principle of things as they move on'.

The tradition attained so dominant a position in Japanese life that for hundreds of years Japanese artists, especially the official ones, painted mountain views of China which they had never seen. But against this tendency to be as Chinese as possible there was a natural reaction too. The solution which finally emerged was that Japanese artists painted in two styles of quite different ancestry. The same division is true of the Japanese language. While words of purely national origin may be used, official Japanese is patterned on literary Chinese and normally a combination of the two is used. Hence, it is not peculiar that the art traditions of the official or educated classes had a twofold background, and it was only the art of the commoners in later times which combined both manners in a more popular way.

With the name of Shūbun are connected several confusing problems. From the Shūbun of Shōkokuji descend most of the famous names of the fifteenth century – Sesshū, Jasoku, and Sōtan, as well as lesser men like Bunsei and Gakuō. An artist sometimes called Soga Shūbun, in which case the 'Shū' is written with a different character, came into prominence in the seventeenth-century art histories, and was dwelt upon by E. F. Fenollosa in his *Epochs of Chinese and Japanese Art*. But in all likelihood this artistic personality was invented very much later when the Soga family of artists was contriving for itself a noble-sounding ancestry. There is, however, evidence that still another Shūbun, who may have been a Chinese but was more probably a Korean, was active about the first half of the sixteenth century. A painting of Doves in the collection of H. Iwasaki attests his existence.

The question of a second or third Shūbun is not nearly as important as the identification of Bunsei as one of the remarkable artists of the mid fifteenth century. In the past Bunsei has

113. Jasoku (d. 1483):
Portrait of Lin–chi,
Muromachi period. *Yōtokuin*

been confused with Josetsu, but today he is well known for Zen portraits in half-length style at Daitokuji.

The tradition of Zen portraiture is found also in the works of Jasoku, whose known paintings begin with a portrait of the Zen priest Ikkyū in 1452 and end in 1483, the year of his death. The Lin-chi [113] at Yōtokuin shows the ninth-century Chinese Zen priest with massive fist. He was famous for his 'rough treatment' and for his ability to create the psychological crises which helped Zen students in the psychic understanding of truth. Jasoku was a layman who studied Zen. As a member of the samurai class, like his contemporaries Kagenobu and Sōtan, he exemplifies the shift away from the priest-painter towards the military circles of the day. The change to more sophisticated standards in art is visible in the sliding landscape panels[5] (*fusuma-e*) which presumably Jasoku painted at Shinjuan in Daitokuji for his Zen master Ikkyū who lived there. He is also claimed as the ancestor of the Soga family who a century after his time rose to fame with the first and second Chokuan.

Oguri Sōtan (d. 1481) remains a far more vague figure than Jasoku. No certain works

exist, but since he succeeded to the official position occupied by Shūbun he must have been well regarded in his own day. At Shōkokuji he had special opportunities for the study of Shūbun's works. Sōtan first comes to notice with sliding panel paintings made for the Takakura palace in 1462. Among his friends was Kikei, one of the authors of the *Onryōken Nichiroku Diary*, which gives a few glimpses of the artists of the day. As a man with the proper kind of *entrée* to the cultural circles of Kyōto, Sōtan's works must have been deeply imbued with the spirit of the Chinese renaissance. That he drew direct from nature (at Arima Springs) is also a fact of special interest.

The Eight Views at the Confluence of the Hsiao and Hsiang Rivers [114] in the Boston museum shows the style traditionally associated with his name but is stamped with a seal reading Zōsan. The idea of depicting eight sights in one or two continuous compositions and at the same time including the four great seasonal changes as a background setting can hardly be regarded as a realistic approach. Not only must famous sites at the confluence of the rivers be imaginatively joined together, not only must the seasons be represented in visible sequence,

114. Zōsan: Eight Views at the Confluence of the Hsiao and Hsiang Rivers, Muromachi period. *Boston, Museum of Fine Arts*

but the artist must also pay attention to specific atmospheric effects such as night rain, autumn moon, a clearing breeze, and a snowy evening. The solution to such problems could only be achieved intellectually, and forms one aspect of the idealistic approach. Here the 'northern' style of Chinese artists with its stiff strokes and angular shadings has been the ideal of the artist.

The greatest of the fifteenth-century artists was the priest-painter, Sesshū. He crowned the tradition starting from Josetsu and continuing with Shūbun. With him the ink style which was so intentionally Chinese in spirit achieved a handling that must be called definitely Japanese. He became the ideal for many later artists who, after the Kanō family had nearly monopolized the official presentation of the Chinese manner, required an old master as standard-bearer to show the way to other but equally great traditions.

Sesshū (1420–1506) came to Kyōto as a youth. About 1457 he may have studied under Shūbun. In about 1467 he took a famous trip to China and visited the well-known Zen monasteries in the south as well as Peking in the north. For the Chinese he painted views of Japan such as Mount Fuji and the pines at Miho. After his return to Japan he lived mostly in the southern provinces, for Kyōto, owing to the Ōnin civil wars (1467–77), had been reduced to ashes.

What Sesshū learned in China may be fairly clearly summarized. Living Ming artists like Li Tsai, whom he mentions in one inscription, were certainly not his equals in perpetuating the traditions of Hsia Kuei or Ma Yüan. If one also considers the numerous small copies Sesshū made of works by ancient Chinese artists such as Hsia Kuei, Li T'ang, and Yen Tz'u-p'ing, it is evident that in Sesshū's day art appreciation in Japan venerated the Sung traditions and undervalued the new styles of the Ming.

Sesshū's normal ink style belongs to the 'northern' tradition, but such was the breadth of the artist that there also exists a scroll dated 1474 in the soft 'southern' manner of Kao K'o-kung (collection of N. Asano). Sesshū painted it for his pupil Tōetsu and tried the 'southern' style because, as he said in the inscription, he had found it to be popular in China. It has the soft and rounded 'mountain wrinkles' which are a trait of the school.

The Winter Landscape [115] owned by the Tōkyō National Museum illustrates the mature Sesshū manner. In the view of a temple almost submerged beneath a jutting cliff it nearly repeats a design in a painting by Hsia Kuei which Seesshū had copied. While less atmospheric depth is perceptible than in a Chinese work of the same tradition, the line is so concentrated upon as to be the dominant artistic interest. This tendency was to develop more and more on Japanese soil.

The most famous of all Sesshū's paintings[6] is the 'long scroll' of 1486 in the collection of the Hōfu Mōri Hōkōkai Foundation. Some fifty-five feet in length, it unfolds that panoramic view of mountain ranges, of water, and of half-hidden temples so loved by Chinese artists. Yet it has something of the view of the ardent traveller and the lover of near-by hills. It is painted neither strictly in the Zen nor in the idealistic spirit.

The artist who could paint Mount Fuji for the Chinese and make topographically interesting landscapes of Chinese temples such as that of Ching-shan in the collection of C. Kuroda was obviously too deeply concerned with factual representation to be a perfect exponent of Chinese idealism. The very intensity of Sesshū's brush line also violates the harmonious relationship to be expected in a Chinese painting. The inscription which he wrote on the 'long scroll' forms part of the documentary history of the period. It ends with the words: 'After a few years I returned to my own land. I was well acquainted with the works of Josetsu and Shūbun. Their aim was to follow the works of their predecessors. There is nothing to be added

115. Sesshū (1420–1506): Winter Landscape, Muromachi period. *Tōkyō National Museum*

nor to be taken away. While searching in both China and Japan, I grew ever more respectful of the attainment of these two old men.' From this statement the ancestry of the ink style may be traced back to Chinese artists through Sesshū's own teachers, Josetsu and Shūbun. The spirit is that of a renaissance, but like all historic revivals it is also a new interpretation.

Few artists have shown as much desire to experiment with diverse styles. The Ink-Splash Landscape [116], in the Tōkyō National Museum, painted for Sōen in 1495 in a manner which might be called idealistic impressionism, again proves the range of Sesshū's ink technique. Dark and light ink tones applied while the paper was still wet in varying degrees assured blurry edges which greatly increased the imaginative effect.

In subject, too, Sesshū showed an enormous range. Particularly remarkable is a portrait of Masuda Kanetaka of 1479 in which Sesshū demonstrated his ability to work in a more Tosa or national style of line work. Bird and flower screens[7] of 1483 help to date the fashion for a new kind of treatment which was common from about that time. But surely one of the greatest Sesshū paintings is the Daruma and Hui-k'o of 1496 at Sainenji. Here at the end of the century Sesshū used again the heavy, bounding line which had been part of the great achievement of Chō Densu, and endowed the older tradition with a new excellence. In this painting of the wall-gazing Bodhidharma, the

116 (left). Sesshū (1420–1506): Ink-Splash Landscape, Muromachi period, 1495. *Tōkyō National Museum*

117 (right). Shūkō: Monkeys, Muromachi period, late fifteenth century. *Boston, Museum of Fine Arts*

118 (far right). Shūgetsu: Wild Goose and Reeds, Muromachi period, late fifteenth century. *Zenjurō Watanabe Collection*

founder of Zen Buddhism in China, and of his pupil Eka (Hui-k'o), who offers his cut-off arm as a pledge of spiritual earnestness, may be studied the Zen quality of Sesshū. The presentation is more convincing as art than as religion.

Two of the pictures mentioned above were to play important roles a century or more later. The Mōri scroll of 1486 was loved and copied by Unkoku Tōgan; the Asano scroll of 1474 was owned and treasured by Hasegawa Tōhaku.

Both scrolls served as models on which these artists founded their styles and based their rights to claim artistic descent from Sesshū.

What might be called graduation pictures seem to have been a particular fashion of this time. Great paintings given to Tōetsu and to Sōen have been mentioned already. To whom the 'long scroll' of 1486 was given is not known, but it probably served the same purpose. In the same way the Waterfall Landscape of

another great artist, Geiami, was a parting gift to his pupil Kei Shoki in 1480.

The Sesshū school spread far over Japan. Shūkō was active in the province of Yamato. His Monkeys [117], in the Boston museum, owes its soft technique to the tradition of Mu-ch'i. Sōen, the pupil to whom Sesshū gave the Ink-Splash Landscape of 1495, came from the province of Sagami. The firm, linear style of the Sesshū tradition is to be recognized in his work, especially in such a painting as that of the Rakan Badara in Engakuji, Kamakura. Shūgetsu came from the province of Satsuma far to the south. He was the pupil closest to Sesshū and probably accompanied him on the trip to China. To him Sesshū gave in 1490 a self-portrait which is known through a copy. Shūgetsu's Wild Goose and Reeds [118] in the Z. Watanabe collection shows his indebtedness to the Sesshū style. Since he did not return to his native province until 1492, his art was not as much original as it was loyal to that of his famous master. The brush work in the drawing of the reeds is a less powerful version of the blunt-headed and firm line of Sesshū.

In the sixteenth century the Sesshū style was carried on independently by a very individualistic artist, Sesson (c. 1504–89). He is associated with places in the provinces of Hitachi and Iwashiro in the northern part of Japan. His manner, sometimes eccentric, is probably in part the result of his having been a self-taught artist. In the Hawk on Pine Tree [119], now in the Tōkyō National Museum, a blunt brush is used in large bold splashes to give a sparkling contrast of values. His figure drawing especially seems weird at times, but such a picture as Li Po gazing at the Waterfall, formerly in the collection of Viscount Fukuoka, reveals a very powerful imagination. One of Sesson's favourite subjects was the Eight Views; he rendered a version after Mu-ch'i in 1563, another set after Yü-chien in 1564, and still a third in screen form in 1589.

The Sesshū style has been traced into the sixteenth century. Now it becomes necessary to return to the fifteenth and to study another important tradition. This started with Nōami (1397–1494). He was neither monk nor soldier. As attendant to the shogun, painter in his leisure time, and poet, he may be classified as a

of which was edited by Nōami's grandson Sōami in 1511, lists Chinese artists in three classifications or grades of esteem. Most of those mentioned as copied in Japan are included in the first group, among them being Mu-ch'i, Yü-chien, Liang K'ai, Yen Hui, Hsia Kuei, Ma Yüan, Li T'ang, and Yen Tz'u-p'ing. It is a record not of paintings but of painters, and it is in the field of the history of taste that its value lies.

Nōami personally belonged among the ardent followers of Mu-ch'i, but he also made copies of works by Ma Lin and Mokuan. The screen of The Pines of Miho [120], formerly in the collection of S. Kuki, claims special interest as a scene of Japanese landscape painted in the soft technique associated with the style of Mu-ch'i or Yü-chien. In figure painting, a Kwannon[8] in the collection of N. Asano is distinguished both for the sinuous and graceful line of the figure drawing and the soft dark-to-

119 (*opposite*). Sesson (*c.* 1504–89): Hawk on Pine Tree, Muromachi period. *Tōkyō National Museum*

120 (*below*). Nōami (1397–1494): The Pines of Miho, Muromachi period. *Formerly Shūzō Kuki Collection*

kind of country aesthete. He was the great critic and cataloguer of the shogunal collection, and could perhaps even be called the first art expert in Japan. Under the title of *Kundaikan Sa-u Chōki* he compiled a list of the artists represented in his lord's collection. The first text was finished in 1476. The catalogue, a later version light modelling of the landscape setting. Another subject known to have been done by Nōami was a set of the Twenty-four Paragons of Filial Piety. Such a Confucian theme is proof that the Zen learning imported into Japan brought also in its train knowledge and appreciation of Chinese moral teachings.

121. Kei Shoki (d. 1523):
Daruma, Muromachi period.
Nanzenji

The second generation of the 'ami' line, Geiami (1431–85), the son of Nōami, might well be included rather among the Shūbun school. Mention has already been made of his Waterfall of 1480. The style, thoroughly in the manner of Shūbun, is more crowded in detail. The Shūbun-Geiami style of painting was continued by Geiami's pupil, Kei Shoki, who came to Kyōto from Kamakura in 1478. He returned in 1480 to Kamakura, a city whose Zen temples were rivalled in number and wealth only by those of the capital, and died there in 1523. He is best known for his portrait of Daruma [121] at Nanzenji. The subject was a difficult one, for however uncouth the features or commanding the expression of will power, the flash of Zen spiritual realization, the moment of *satori*, had to be suggested as well. Kei Shoki also worked in light colour in paintings of episodes chosen from Zen stories. An album-size set of the Eight Views now in the Hakutsuru Museum, Hyōgo, shows him to have been one of the masters of ink painting, though his actual brush strokes were 'wetter' and less diversified than those of Shūbun or Sesshū.

Sōami (d. 1525), the son of Geiami and representative of the third generation of this extraordinary family, was attendant to several shoguns but especially to Yoshimasa (1435–90). He is a prototype of many later artists of the multiple-talented type. As a painter he has left a great set of landscape fusuma-e in Daisenin, Daitokuji. As a critic he continued the *Kundaikan*. He was famous, too, for his work connected with the tea and incense ceremonies, flower arrangement, and landscape gardening – all arts which reflect the pervading influence of Zen restraint. He stood out against the tendency of his time which favoured the stiff style of Hsia Kuei, Ma Yüan, and other Chinese artists of the 'northern' school by continuing the preference which his grandfather had shown for the traditions of Mu-ch'i. Each one of this Chinese artist's paintings in Japan,

whether of dragon, tiger, monkey, crane, or set of the Eight Views supplied a model of design to be followed, a painting technique to be emulated, and a standard of taste to be perpetuated.

Of the developments so far discussed none was as lasting and profound as the rise of the Kanō family of artists and the style it initiated. To Fenollosa in the late nineteenth century the work of the Kanō artists supplied the backbone for the history of Japanese art and showed them to be the closest heirs of the Sung period in China, which again had carried on traditions of still earlier times. These artists formed in Japan both the Chinese school and the official school. From beginning to end the family served military masters, the men who ruled Japan nationally and locally. What might be called the lofty and moral symbolism of the Kanō tradition was at the same time the political ideal. But between the training of the Chinese school of artists in Japan and that of the best-known artists in China there was one important difference. The Kanō school lasting from the time of Masanobu in the fifteenth century down to Hōgai and Gahō in the nineteenth represented the standards of professional training as opposed to the scholar-artist attitude of China.

The school arose at a time when, however predominant culturally Chinese ideals may have been, there had already existed quite a long development of ink painting in Japan. The Kanō style, Chinese-looking though it appears to the eye, was actually a very Japanese form of expression. Just as in the late Kamakura period Chinese styles were gradually incorporated into the scroll tradition, so now a national spirit or handling became increasingly visible despite the Chinese subject-matter and the Chinese ink medium.

If one were to look through the history of the world's art for another family which in direct blood line produced so many men of genius, a rival to the Kanō would be hard to find. The

first Kanō was an amateur artist and samurai named Kagenobu. It was his son, Masanobu, who became the accepted first generation. The following table presents the chief members of the Kanō family in genealogical form. The Roman numerals record the generations counted in the main branch by Japanese tradition.

young man when Shūbun was the major influence. Like Shūbun and Jasoku, he frequently did Buddhist figure subjects. Literary sources mention a Miroku and a portrait of Nichiren. Another reference speaks of a copy made by Masanobu in 1485 of a Yuima by the Chinese artist Li Lung-mien of the late Nor-

Of these, Motonobu summed up the idealism of the Muromachi period. Eitoku created the style of the Momoyama period. And Tanyū established the academic art standards of the Tokugawa government. For seven generations, for over two hundred years, the leading artists were supplied by one family, and the official style was to remain in their hands for still another century or more.

Kanō Masanobu (*c.* 1434–*c.* 1530), like most of the great men of the mid fifteenth century, seems to have begun painting in the style of Shūbun. The first record is for 1463, when he painted a Kwannon and a Rakan on the walls of Unchōin at Shōkokuji. He was still active in 1493. Since he lived to the great age of ninety-six, the tradition that he died in 1530 would then make it possible for him to have been a

thern Sung period. From these remarks his figure style can be vaguely imagined. Later, he seems even to have occasionally painted portraits in the old Tosa manner. Though no such Buddhist and Tosa figures are known today, their past existence suggests that landscapes in the renaissance tradition were by no means the only subjects by which to judge the art of the period.

Next to landscapes and figures the third great division of art in China was formed by paintings of birds and flowers. This type of subject naturally made a strong appeal to the Japanese. The crane was treated so frequently by Kanō artists that one has been selected for illustration. Masanobu's Crane [122] of Shinjuan appears before a backdrop of Sung philosophy. The atmosphere retains great

122. Masanobu (*c.* 1434–*c.* 1530): Crane,
Muromachi period. *Shinjuan*

depth, and rock, tree, and mountain are related in a tight proportion. Among the great paintings by Mu-ch'i which are kept at Daitokuji, one is a crane. Its companion piece is a monkey, and together they make a triptych with a central painting of Kwannon. To elevate animal life to such a position was possible only because such animals were regarded as without guile or purpose, symbols of purity of spirit. Kindred subjects like the tiger and dragon were as generally favoured in Japan as the Venuses and Apollos of the Italian Renaissance.

A crane[9] was also painted by Motonobu, the son of Masanobu. Here it is perched on a pine branch above a cascade of water. Near by a waterfall crashes. The airy, vaporous depths of Masanobu have been replaced by the mists of pounding waters and a nearly empty background. Gradually the depth of the picture has been worked into two simple planes. Kanō Eitoku, half a century later, did the subject again. By this time the treatment had resolved itself almost into a single plane of pictorial interest, and a Chinese tradition had been naturalized.

Motonobu (1476–1559) is the artist to whom this particular contribution is usually ascribed.

The greatest body of his work survives today at Reiunin, built in 1543, in Myōshinji, where his friend and instructor, the Zen priest Daikyū (d. 1549), lived. Here on sliding panels Motonobu consciously chose to follow the modes of expression of Mu-ch'i, Hsia Kuei, and Yü-chien in separate rooms. Ability to re-express the tradition of some venerated master of the past, a sophisticated knowledge of styles, and an imitation of a manner without loss of one's own personality were characteristic of many of the artists of China. With Sesshū and even more with Motonobu it became a Japanese habit, too, and one aspect of the oriental homage to antiquity. Motonobu's brush strokes could be stiff after Hsia Kuei, soft after Mu-ch'i, or vague after Yü-chien, yet the rooms which seek to be so Chinese in spirit are rather the expression of a thoroughly Japanese artist's sympathy for the ancient styles of China.

The manner of using the brush was Motonobu's own. He concentrated on the value of the ink outline: on its strength as brush work, on its consistency as a type of stroke, and on its quality of direction. Consequently an obviousness of outline was achieved, quite different from that aimed at in Chinese art. In many ways

the hard outline of the Kanō style was the answer to the dull visibility of the Japanese climate. Just as a photographer in Japan today must increase the time of exposure, so the artists of Japan have had to strengthen outlines to give clarity to their paintings. For the same reason subtlety of atmospheric depth was not esteemed as much in Japan as in China. Surface values came to be more and more appreciated, and made possible special flat and decorative treatments.

It is also possible to view the rise of the screens or sliding panels with a gold ground as a Japanese answer to the problem of architectural lighting. In large rooms such paintings face the light and reflect it. The gold ground, flat design, and obvious outlines can be regarded as in part a climatic necessity imposed on artists and helping to create the splendour of the Momoyama age, the flat patterning of the Kōetsu school, and the strength of the Kanō technique.

In the Kanō brush line the Japanese discovered a moral quality which is difficult to explain but which at the same time goes a long way towards accounting for both the regard in which the style was held and the long success of the Kanō heritage. The brush was held perpendicular to the paper, and the ink settled evenly on either side of the line described by the course of the tip of the brush. It was a masterly technique for solidity of line impression and one that quickly revealed the strength of the artist's handling. In the days of Ōkyo's naturalism in the eighteenth century the brush was inclined to one side with a consequent deepening of ink tone on one side more than the other. For realistic representation the change of technique produced the intended result. For the idealistic paintings of the Kanō their arduous skill was admirably matched to their lofty ideals.

In the Story of the Zen Monk Hsiang-yen [123] by Motonobu, in the Tōkyō National Museum, many of the traits of the Kanō style are visible. The figure drawn from Buddhist lore is too active for the picture to be entirely true to Chinese landscape standards. The mountains, the swirling white mist, and the foreground rocks are nearly in one vertical plane, and so again violate Chinese principles. However Chinese the underlying philosophy may be, the type of brush stroke and the composition both express a Japanese temperament and would have been treated very differently by any Chinese hand.

Like Masanobu before him and like most of the Kanō artists after him, Motonobu occasionally worked in the Tosa style. He had special reasons in that he had not only married the daughter of Tosa Mitsunobu but had also been given the title of *Echizen no kami*, usual in the Tosa line. Of greatest importance for the future are some of Motonobu's paintings of birds and flowers at Daisenin, Daitokuji. Here the strong colour, boldness of composition, and increasing naturalism prepare the way for the art of the Momoyama period.

Yukinobu, also known as Utanosuke, was the younger brother of Motonobu and painted in much the same manner. His Harvest Scenes, also at Daisenin, show figures hard at work in a landscape setting. Though the choice of subject may perhaps reflect the political desire to inculcate the virtues of a practical morality according to Chinese ideas, the execution is true to the Kanō method. A sense of realism, as if the artist had actually watched such a scene, makes these paintings remarkable among the products of the idealistic school.

Lastly, it is necessary to inquire briefly into the history of the native school, the Yamato-e tradition, in this Chinese renaissance period. The great name in the older histories is that of Tosa Mitsunobu (1434–1525) whose daughter married Kanō Motonobu. He is classed by later chroniclers of art with Mitsunaga of the early Kamakura period and with Mitsuoki of the

123. Motonobu (1476–1559): The Story of Hsiang-yen, Muromachi period. *Tōkyō National Museum*

early Edo period as one of the 'three brushes' of the Tosa family. As an official painter he had a great reputation, but the paintings now surviving fail to suggest a corresponding degree of greatness.

Historically, the use of the family name of Tosa requires explanation. Tsunetaka of the twelfth century had the title *Tosa Gon no kami* (vice-lord of Tosa), and from this arose the later claim of Tosa artists. But there is no proof of any lineal descent. The use of the Tosa name properly began with either Yukimitsu of the late fourteenth century or with his son Yukihiro of the early fifteenth. Yukihiro was one of the group of six artists who did the original painting for the Yūzū Nembutsu Engi, the scroll which was reproduced in wood-block form. His son Yukihide, who was active about 1430, is credited with a painting of Fishing with Cormorants, in the Murayama family collection. In this the Tosa style appears in a large-scale painting. The patterns made by the waves, the decorative scheme of red maple leaves, and the native court costumes make it a forerunner of styles which were to be reborn as soon as Japanese artists looked backwards to their own traditions rather than abroad to those of China. To Tosa Hirochika, painter to the court from 1439 and father of Mitsunobu, is attributed the design for the screen of the Willow Trees at Uji Bridge, a later example of which is shown in illustration 133.

Perhaps the reputation of Mitsunobu suffers today because in his scrolls of the Tales of Ishiyamadera and of the Kitano Legends his work seems inferior to other greater and earlier examples. Yet even if one compares Mitsunobu's portrait of the emperor Goenyū (1358–93) at Unryūin in Kyōto, done in 1492 for the ceremony of the hundredth anniversary, with other imperial portraits such as those of the emperor Daigo, it is difficult to place Mitsunobo on the highest level. The refined classical line of the Tosa seldom looks sufficiently strong in

large paintings, especially if comparison is made with the firm, bounding lines of the contemporary Kanō artists.

From the end of the Muromachi period come several anonymous paintings which must be considered. A pair of screens of Landscapes with Sun and Moon[10] owned by Kongōji temple in Ōsaka is a painting which revives much of the Yamato-e tradition. The decorative beauty of nature, the repeat pattern of pine or wave, the strength of colour, the adornment of gold foil for the clouds and of silver for the waves, are elements which show how easily both the grand naturalism of the Momoyama period and the decorative splendour of the Kōetsu style will develop. *Moriage*, the building up of lines in raised gesso, is a curious technique which appears here and was often used later as the decorative spirit asserted itself. The Moon Landscape [124], in the Tōkyō National Museum, is sometimes identified as one of the Sun and Moon screens of the imperial palace which were attributed to Tosa Mitsuyoshi (1539–1613). However, they seem older, though it is not possible to make attributions among the little-known Tosa painters of the first half of the sixteenth century. If comparison is made with the Boki Eshi [107], many features will be found to be similar, especially perhaps the tree drawing. Both paintings express the common background of ideas natural to a Japanese who was neither individually original in his own school nor an exponent of the fashionable foreign styles.

Parallel to the Kanō and Tosa anticipation of the Momoyama spirit in nature paintings, there seems to have been within the Kanō school itself a foretaste of the later Ukiyo-e spirit. One of the sons of Motonobu, Kanō Hideyori, who will be discussed in the chapter on the Early Paintings of the Ukiyo-e School, painted a screen of Maple Viewing at Takao [125] which reveals not only how closely Kanō and Tosa traditions were related at this time

124. Anon.: Moon Landscape, late Muromachi period. *Tōkyō National Museum*

125. Hideyori: Maple Viewing at Takao, late Muromachi period. *Tōkyō National Museum*

but also how much interest was shown in contemporary life, a characteristic of the Yamato-e style. While Hideyori is variously stated to have died in 1558 or 1562, at least it is certain that his accomplishment should be credited to the late Muromachi period. Since the marriage of Motonobu to the daughter of the head of the Tosa line, the two styles seem to have been equally at the disposal of the Kanō artists, both in favourite subject-matter and in method of execution.

The renaissance period was notable for recapturing the spirit of Sung China. To this ideal Japanese art has been more faithful than the later styles of painting in China itself. It was a true rebirth of a manner which had all but died out in the land of its origin. To many westerners the Kanō or Chinese school of painting has been the only kind of Japanese art generally recognized. In consequence, the very limited opinion that all Japanese painting is imitative and without original features of its

own has arisen. However, no Chinese, looking on the products of this school, is deceived by the similarity of approach to Chinese ideals into confusing the products of Japan with those of China. With Westerners it becomes a necessity, too, to view the idealistic paintings of Japan so as to recognize the distinctively Japanese values of the use of line and ink.

Throughout the history of Japanese art it is frequently found that the contemporary crafts preserve better than the graphic arts the native, conservative spirit. Lacquer and metal sword-guards, for instance, even though they, too, came under the influence of the Chinese renaissance in Japan, appear by their use and technique stamped with Japanese characteristics. It is also noteworthy that the fifteenth century, which marked the apogee of Chinese influence in painting, was also the period when the Nō mask developed so phenomenally. In the crafts the Japanese feeling, because of the close association of design and utility, remains as a guide to the degree of the penetration of foreign ideas.

THE DECORATION OF CASTLES

The decline of the power of the Ashikaga shoguns, which involved the fortunes of the imperial court and the influence of the capital, led to a long period of civil war, of nearly autonomous local feudatories, and of decentralization. The major political problem became the re-unification of the country, and this took place under the three great soldiers and strategists, Oda Nobunaga, Toyotomi Hideyoshi, and Tokugawa Ieyasu. It was in 1603 that Ieyasu was made shogun and so re-established officially a united government. Yet so great had been the turnover in the personnel of the most important families before the Momoyama period that hardly any of the major feudatories of the fifteenth century were still leaders in the late sixteenth century. The revolution in society was bound to be, and was indeed, reflected in the art of the period.

In the Momoyama period, which was named after a palace built by Hideyoshi but which included also the rise to power of Nobunaga and artistically the first few years of the Tokugawa regime, the new powers were all warriors. Many, like Hideyoshi, were men who rose from nothing, by the sheer drive of their own ambition. They had little learning. The tranquil and transcendental standards in art which were monastic in origin could not be expected to appeal to such men, fresh from the battlefield or contemplating new campaigns. They wanted and got an art which was grand in scale, manly in design, and ostentatious in technique to give substance to their own desires.

During this short period of re-unification, too, there arose a new type of castle architecture,

determined in part by the introduction and manufacture of guns and cannon following the arrival of the Portuguese in 1542. The first of the new castles – and few survived into the Edo period – was the fortress of Azuchi, built for Nobunaga between 1576 and 1579. It was pillaged in 1582 after Nobunaga's death by treachery. In 1583 Hideyoshi built the huge castle of Ōsaka which was largely destroyed in 1615. Other great mansions or palaces built for Hideyoshi, were the Jurakudai in Kyōto in 1586 and one at Momoyama near Fushimi, in 1594. Before the end of the century both of these were destroyed or dismantled and only a few parts, moved elsewhere, remain to show the glory of the man who has been called the Napoleon of Japan.

The necessity of decorating the walls of many and vast new buildings gave rise to a rapid and vigorous style of painting. To understand the new development it is necessary to recapitulate. The last two chapters presented the flowering of the national tradition of scroll painting and the near obliteration of that style by the influx of Chinese Sung styles, largely in ink monochrome. In the Momoyama period many artists continued to paint in ink monochrome and to express Chinese attitudes and techniques. However, the use of colour in thick pigments now developed more and more. It differed from the light washes of warm and cool tones which had frequently been employed in some of the ink paintings. Perhaps in part the desire for a more colourful art was stimulated by Chinese paintings of birds and animals in colour by such artists as Chao Ch'ang and Mao I, respectively

of the eleventh and twelfth centuries. Both names appear in the first grade in the *Kundaikan*, and their works as represented in the shogunal collection may well have been influences on Motonobu's paintings in colour. Evidence of knowledge in Japan of contemporary Ming dynasty academic and colourful styles of painting is very slight, though it cannot be altogether excluded, particularly for designs of flower and bird pictures.

Motonobu, except for a few works in the Tosa style, continued to apply his colour in the conservative tones acceptable to Chinese tradition. His son Shōei (1519–92) had the originality neither of his father nor of his son Eitoku, the leading spirit of the Momoyama period. Some of the panel paintings of Tigers and Bamboo at Jukōin, which was built about 1573 in Daitoku-ji, seem to be by the hand of Shōei, but his style is hardly distinguishable from what might be termed the Motonobu influence. At this temple some of the rooms were decorated by Eitoku. His painting of Cranes and Trees has already been mentioned. Another room with figure paintings of the Four Accomplishments (music, the game of war, calligraphy, and painting) is sometimes attributed to Eitoku, sometimes mentioned only as in the style of Motonobu. The new manner does not seem to have materialized until the building of the castle of Azuchi.

In the short Momoyama age the screen painted in strong, thick colours against a ground of gold leaf came into fashion. It is a technique uniquely Japanese, and can best be explained as having developed in relation to the problem of lighting the interior of large rooms. The strong colours, richer than those which descend from the Chinese tradition, were in no sense new. The ancient screens depicted in the Genji scrolls by Takayoshi in the twelfth century show even stronger colour contrast. Wall panels, too, which require a greater lateral composition than the independent folding screen, were well illustrated in the early fourteenth century in details of Takakane's *Kasuga-gongen-reikenki*, which show beautifully the native feeling towards nature – a feeling also distinctive of the Momoyama period. In these scrolls, interior scenes look out on garden views while the many sliding panels to be seen on the walls repeat indoors still other views of nature.

Nor was the use of gold entirely new. Mention has been made of kirikane to heighten the effect of Buddhist art. The Imperial Palace in Snow attributed to Tsunetaka of the late twelfth century made use of flecks of gold leaf to enliven areas of cloud with formalized pattern. If it is hard to point to any paintings of the early Muromachi period with gold clouds, the treatment was not uncommon for objects made of lacquer, so that the technique was ready to be taken over into painting whenever it might seem desirable. The Landscapes with Sun and Moon of Kongōji referred to in the last chapter make a more than ample use of large flecks of silver and gold leaf. Now, in the Momoyama age, nearly the total background often became an area of gold leaf. To harmonize with its lively reflecting surface the colour needed to be strengthened. Japanese art returned for inspiration to its own medieval sources, discovered there indigenous and appropriate methods for its new needs, and developed a type of brilliant painting that has made the Momoyama style one of dazzling splendour.

The creative genius of this great age was Kanō Eitoku (1543–90), the son of Shōei and the grandson and probable pupil of Motonobu. The largest body of his surviving works consists of the sliding panels of Landscapes and of Cranes and Trees at Jukōin, and though these are early works, they show the nervous vigour of his brush style. To the eye of a Chinese artist they would seem to be lacking in depth and stiff to the point of brittleness. Yet it was just this foreground interest and sweep of line which

later enabled him to simplify his design, to become more expansive and decorative, and thereby to originate a new style. In 1574 he painted for Nobunaga a Life in the Capital and Suburbs, a pair of screens to be sent as a present that Nobunaga might court favour with the great warrior Uesugi Kenshin. The figures are small; and the subject is of Tosa origin. Two years later he painted walls in the keep of Nobunaga's Azuchi castle, some of which are known to have been done on a gold ground. One was a Famous Views of Three Provinces. Although nearly all the early paintings of the native landscape have been lost, such local subject-matter was one of great antiquity. Literary sources provide records of screens of famous places in Japan from the tenth century. In the *Tale of Genji* Prince Genji won a picture competition with scenes of Suma and Akashi. Now the old type of subject began to reappear, and Eitoku must have painted the Views also in a modified Tosa manner. Strong national influences occurring just at the time when the gold ground was developing reinforce the theory that the origin of the new style must be sought for among native traditions.

After the death of Nobunaga in 1582 Eitoku was patronized by Hideyoshi, and painted at Ōsaka castle and Jurakudai palace. He died

before he could have worked in the palace of Momoyama.

In the Daihōjō apartments at Nanzenji wall panels of the Twenty-four Paragons of Filial Piety and of Hermits are certainly by Eitoku. Originally they formed part of the dowager empress's apartments in the imperial palace, and were moved to Nanzenji when the temple was rebuilt. The dignity of pose, so dissimilar from the medieval, active figure treatment, derives like the subject-matter itself from Chinese art, but here the episode is almost lost in the breadth of naturalistic interest. Still more typical for hurried sweep of composition, for pure nature design, and for strength of individual brush stroke is the screen of Cypress Trees [126], attributed to Eitoku, in the Tōkyō National Museum. Golden, cloud-like areas representing mist are placed arbitrarily in the background, and emphasize the decorative magnitude of what is otherwise the powerful drawing of giant tree forms. Equally enormous in scale is a screen of Chinese Lions owned by the Imperial Family of Japan and another pair of screens of Eagles and Pines in the Tōkyō Geijutsu Daigaku. The latter is said to have been one of the 'hundred pairs' of screens assembled to line the approach to a flower party given by Hideyoshi in 1588.

126. Eitoku (1543–90) (attr.): Cypress Trees, Momoyama period. *Tōkyō National Museum*

The standard kakemono in ink by Eitoku is the painting of Chao Fu (Sōfu) and his Ox [127], now in the Tōkyō National Museum, which has a companion piece in a picture of Hsü Yu (Kyoyū) standing beside a Waterfall.

127. Eitoku (1543–90): Chao Fu and his Ox, Momoyama period. *Tōkyō National Museum*

Chao Fu and Hsü Yu were hermits in the reign of the legendary Chinese emperor Yao in the third millennium B.C. Hsü Yu was requested by the emperor to take over the government, but in fear of being contaminated by political temptations and corruption he would not listen to the proposition and literally washed his ears out under a waterfall. The illustration shows his friend Chao Fu leading his ox away from such tainted water. The men are symbols of purity of conduct, and the Confucian moral points to the dangers inherent in political position. Since the wars of the Momoyama period were occasioned by just such thirsting for power, the painting depicts precepts popular at the time. Such moralizing pictures were to be much more in demand in the succeeding period, when authority had been settled and when loyalty was to be specifically recommended.

Eitoku stands out as one of the great figures in the history of Japanese art. Though most of his paintings have been destroyed and though those which remain can hardly be ascribed with certainty, enough is known about his works to pass the judgement that he created the main features of the stirring Momoyama style and that most of his contemporaries either were his pupils or were influenced by him.

An artist whose active period almost exactly spanned the Momoyama age was Kaihō Yūshō (1533–1615). His surviving works include examples both in the rich colours developed by Eitoku and suited to castle apartments and in the quieter ink tones which were more generally favoured for the decoration of temple rooms. More is known about him than about most of the artists, perhaps because he was tutor to an imperial prince. He came of a military family, but, being a younger son, entered Tōfukuji as a monk. The tradition which says that as a youth he studied under Kanō Motonobu is probably more correct than that of the *Honchō Gashi*, an early art history, which speaks of him as a pupil

of Eitoku. It is also said that Motonobu praised him with the words: 'This youth has the skill of Liang K'ai.' In figure painting the broad strokes and loose shapes of Yūshō may well have derived from the ancient Chinese master. Yūshō liked the military life, and, in keeping with the fashions of the day, he would sometimes sport a Portuguese cloak. The Momoyama period for a short time enjoyed foreign novelties and Japan was not exclusively under influences from continental China. Among Yūshō's friends was one Saitō Toshimitsu, a retainer of Akechi Mitsuhide, who had turned on Nobunaga and destroyed him. When Toshimitsu was taken prisoner in a campaign in 1582 and crucified, Yūshō together with some friends dug up the body and re-buried it. He was patronized by Hideyoshi and later by the emperor Goyōzei (r. 1586–1611) who as a prince had been his pupil in art. He was greatly

admired in Japan during his lifetime, and his reputation spread even to Korea through a painting of Dragons which was presented to the Korean king.

Yūshō probably painted at Hideyoshi's Jurakudai palace in 1587, where· with Sanraku he assisted Eitoku in decorating the walls. In 1598 he took a trip to the shrine of Itsukushima which possessed the Sūtras offered by the Taira Family. The sight of these most colourful paintings of the twelfth century may well have influenced his style. About 1598 he returned to Kenninji in Kyōto, and here is preserved the largest body of his work. In the Tōkyō National Museum is a landscape screen which was originally painted for the Katsura palace in Kyōto in 1602. Records state that the work required five days' time.

The Plum Tree [128] in ink, which together with rooms painted with landscapes and others

128. Yūshō (1533–1615): Plum Tree, Momoyama period. *Kenninji*

with dragons make up some of his work at Kenninji, possesses the directness of the Zen manner of simplification and the vitality of straight long line typical of one who yearned for the military life. His brush line was long without being monotonous and simple without being weak. Only a master hand can control the flow of ink in such a manner that it represents so abstractly and yet so completely the vitality of a living thing. Another aspect of Yūshō's skill in brush work appears in the Dragons. Their depths of ink tone and surface disposition of light and dark masses are the oriental counterpart of western chiaroscuro. Here, too, is a grace of line seldom sought after by the masters of the Kanō school who esteemed greater variety and angularity of stroke. In this Yūshō was followed by Kōetsu and Sōtatsu, the founders of the decorative school. Yūshō's vivid colours also influenced Sōtatsu, and it is significant that both men were familiar with the ancient Japanese manner of painting.

In the Imperial Household collection is a pair of screens of Fishing Nets [129] by Yūshō. The gold ground, the deep dark blue of the water, the light green of the foreground reeds, and a dull pinkish tone for the nets make up a brilliant colour scheme. Other pairs of screens with the same subject and treatment existed before the war in the T. Ōhara and A. Fuse[1] collections. Grouped together they suggest the grandeur which the Momoyama artist achieved for the decoration of enormous rooms. If the screens of Fishing Nets by Yūshō and also those of Pine Trees [130] by his contemporary Tōhaku are compared with the large ink painting of a Fisherman's Abode[2] attributed to Hsia Kuei, in the Boston museum, the contrast between the Chinese and Japanese points of view becomes self-evident. Following the philosophical ideas of the Sung period, in the Chinese painting so much attention is paid to trees, mountain, and background that the fishing nets

and the fisherman can hardly be made out. Yūshō has centred his interest on a detail, which in the Chinese scheme of things was an indication of the activity of man living close to nature, and made it the foreground theme in screens of decorative splendour. Tōhaku has isolated trees half buried in mist and made of them his entire subject. These trees do not help to measure the scale for man and mountain. They exist as objects of beauty for their own sake.

In many of Yūshō's works there seems to have been a conscious attempt to solve the problem of handling areas of rock, normally done in ink, in a more colourful manner so as to harmonize with other brightly coloured parts of a picture. This is particularly evident in screens of Peonies and Plums at Myōshinji. In screens such as the Four Accomplishments in the same temple the use of a brush style called *genpitsu* (reduced number of strokes), the tradition descending from Liang K'ai, marks a personality quite independent from the Kanō line. Yūshō looked backwards for his manner of ink painting; his method of brilliant colouring prepared the way for the future.

Miyamoto Musashi, better known in art as Niten (1584–1645), was probably a pupil of Yūshō, but developed independently of any school. He was not only a soldier but the inventor of a method of fencing with two swords. His contemporary Kōetsu was professionally a connoisseur or judge of swords. Both were men of a transitional period and both exemplified the close connexion between art and the military way of life; the one was filled with the spirit of Zen, the other was a great tea-man and decorative designer.

Niten fought at the battles of Sekigahara and at Ōsaka. Later he served the Hosokawa family in Kyūshū, and it is the present house of Hosokawa that possesses the largest collection of his works.

129 (*top*). Yūshō (1533–1615): Fishing Nets, Momoyama period. *Imperial Household Collection*

130. Tōhaku (1539–1610): Pine Trees, Momoyama period. *Tōkyō National Museum*

Niten's Crow on a Pine Branch [131], formerly in the collection of Viscount Matsudaira, is a thoroughly Japanese painting in the Chinese ink manner. The simplicity, directness, and vitality of the drawing of the bird in ink monochrome make it a true successor to the spirit of Zen art. The principles which Niten advocated in fencing are explicit in his art. He once said: 'When I stand with sword in hand against a foe, I become utterly unconscious of the enemy before me or even of my own self, in truth thrilled with the spirit of subjugating even earth and heaven.' This statement, so reminiscent of Zen training, lies behind his art. Zen directness saved flower and bird paintings from sensuous prettiness on the one hand and from sentimentalism on the other. Because of this quality Niten's paintings were much appreciated in the nineteenth century by Watanabe Kazan, another great samurai artist. Other bird paintings by Niten, such as that of a Shrike, in the Nagao Museum, Kanagawa, where the bird rests atop a tall branch drawn with only two strokes, offer the best proof that Niten was the pupil in art of Yūshō, whose Plum Tree has the same virtue of Spartan directness and military feeling.

A pair of screens of Wild Geese in the Eisei Bunko, Tōkyō, like a pair of screens of Herons and Crows by Tōhaku, in the former I. Dan collection, shows in one screen a composition of white against darker values and in the other a reverse scheme of tones. The bird life so commonly depicted at this time vividly tells the story of contemporary taste.

The style of Eitoku had been so successful, so suitable to the needs of the times, and so dominant in the old capital city of Kyōto that to create a separate school required the appearance of artists of marked individuality and courage. One of the artists to challenge the

131. Niten (1584–1645): Crow on a Pine Branch, Momoyama period.
Formerly Viscount Matsudaira Collection

supremacy of Eitoku was Hasegawa Tōhaku (1539–1610). Though contemporary with and equal in magnitude to Yūshō and Eitoku, Tōhaku remains a shadowy figure and his life has to be reconstructed largely from his works in spite of notes on artists which he compiled under the heading of *Tōhaku Gasetsu* or Talks on Art.[3] He was the son of a dyer, and came from the province of Noto to study painting at the capital. The name of his master is not known, though the Kanō artists Munenobu, Shōei, and even Eitoku have all been suggested as well as a little-known painter Soga Shōshō. What Tōhaku succeeded in doing was to break away from the dominating influence of the Kanō school, and to accomplish this he returned to the standards of ink painting in the manner of Sesshū. Nor was he alone in claiming an art lineage from the fifteenth-century master. Tōgan, another great name of the Momoyama period, made exactly the same assertion and called himself the third generation from Sesshū, while Tōhaku signed himself as the fifth generation. Each had Sesshū scrolls on which to base his style: Tōgan had the Mōri scroll of 1486 and Tōhaku the Asano scroll of 1474. It is

recorded that the matter had to be settled in court and that Tōgan won the right to the Sesshū name. However that may be, Tōhaku proved to be the more original artist.

Among his works those now at Ontokuin, a sub-temple of Kōdaiji, which itself had been moved from a sub-temple at Daitokuji, have been identified by T. Doi. They probably date from some time about 1586. Sen no Rikyū, the great tea-master of the age, had connexions with Daitokuji, and both he and Tōhaku agreed in their dislike of the Kanō family. As the quarrel with Tōgan occurred early in the nineties, Tōhaku must by then have been using the signature in which he claimed descent from Sesshū. It is interesting to speculate whether the claim may not have arisen as part of the protest against the Kanō at this time.

In the paintings from his middle life at Kōdaiji Tōhaku shows himself the heir to Jasoku and Sōami, whose paintings also remain at Daitokuji. His great veneration for Mu-ch'i is proven by many ink paintings of monkeys at Ryūsenan, at Myōshinji, in the Boston museum, and elsewhere, and by the Dragon and Tiger screens in Boston. The Tiger [132], painted by

132. Tōhaku (1539–1610): Tiger, Momoyama period. *Boston, Museum of Fine Arts*

Tōhaku when he was sixty-eight, possesses a vehemence and openness of composition which characterize the developed Momoyama style. The versatility of brush line in one artist's work never ceases to be a surprise to the western student of oriental art. Tōhaku's screens of Rakan at Chishakuin, painted in colour and with suavely curving line, hardly suggest the hand which drew the screens of the Seven Sages of the Bamboo Grove of Ryōsokuin at Kenninji done stiffly and even coarsely in ink.

The pair of screens by Tōhaku of Herons and Crows, in the former Dan collection, where white birds in one screen contrast with black in the other, is a clever example of pictorial rather than of conceptual variation. How the Japanese delighted in contrasting values, how even in poetry the same visually interesting quality occurs is sharply apparent in the well-known poem by Bashō (1644–94) written some three-quarters of a century later.

> The usually hateful crow –
> How lovely on the morn of snow.[4]

Such antithetical playing with ink values can be related to the decorative feeling of the Japanese.

The non-intellectual approach has already been referred to in connexion with the screens of Pine Trees [130], where one detail of a Chinese type of ink painting has been abstracted from an intellectual complex and made the all-sufficient excuse for its own being.

To Tōhaku the great series of sliding panels of Maples and Trees[5] at Chishakuin are also attributed today. These are perhaps the greatest examples of Momoyama art in strong colour on a gold ground which have survived. The gold ground of the paintings, the vivid colours, the immense scale, and the richness of detail, unfortunately, do not come out satisfactorily in photographs.

Another painting sometimes attributed to Tōhaku is the Uji Bridge [133], in the Kyōto National Museum. It was a traditional subject whose popularity at this time is attested by many examples. Here, grace of silhouette is the dominant factor of the design and the use of gold-on-gold the technical means of execution. On a gold ground the bridge is outlined by raised gesso under the gold. Cloud masses are rendered by different tones of reddish and greenish gold leaf embellished with flecks of

133. Anon.: Uji Bridge, Momoyama period. *Kyōto National Museum*

gold leaf, and washes of gold paint bring out the highlights of the drawing on the dull brown trees. Such treatment would be superfluous in a work of art to be understood intellectually. The lavish use of gold-on-gold in one sense may be interpreted as the luxury of a *parvenu* age, but the harmony of the tones and the feeling of restraint in spite of the richness of the surface materials is the very symbol of the Japanese character where excess and restraint seem to be held in equal balance.

Great geniuses though Eitoku and Tōhaku were, they were also professional artists fitting into the feudal pattern of life in Japan. It is known that in 1577 Eitoku drew the design of a saddle for Hideyoshi. A copy of a map or chart of the Jurakudai palace by Tōhaku also exists.[6]

Unkoku Tōgan (1547–1618), who won the law-suit from Tōhaku over the Sesshū art lineage, started his career as a pupil of the Kanō. Most records state that he was the pupil of Eitoku, but one asserts that he studied under Shōei, a tradition which seems more reliable when the ages of the persons concerned are reckoned up. The greatest single body of his remaining works is preserved at Daitokuji in the sub-temple of Ōbaiin built in 1588. One of the rooms, which is decorated with ink paintings of the Seven Sages of the Bamboo Grove, offers a good chance to compare the manners of Tōgan, Tōhaku, and Yūshō. Tōgan's figures executed with massive breadth have neither the strength of those of Tōhaku nor the grace of those of Yūshō.

Towards the end of the sixteenth century Tōgan was patronized by Mōri Terumoto who had him live at Unkokuken in the province of Suō, a place where Sesshū had stayed. It was here that Tōgan became so familiar with the great Mōri scroll by Sesshū and wrote an inscription to it, dated 1593. In the screens of Chinese Landscapes [134], in the Boston museum, Tōgan closely adhered to the style of that master. Parts of the screen composition seem to be a reflection of parts of the Sesshū scroll. Although Tōgan could not equal the fifteenth-century artist in his power of a dominant, even line, he made up for it by producing one of the most carefully worked-out examples of graded atmospheric depth in the Chinese manner. His tone relations melt one plane of

134. Tōgan (1547–1618): Chinese Landscape, Momoyama period. *Boston, Museum of Fine Arts*

depth into another in a way which recalls the Chinese scroll in the Boston museum called Clear Weather in the Valley, attributed to Tung Yüan.

Another phase of Tōgan's art can be found in the screens depicting Mount Yoshino, in the collection of the Masuda family of Nagato. The approach could hardly be more different. The softly rounded hills of Japan, the blossoms of this famous place for viewing cherry trees, the hazy air all make the screens seem like pictures drawn from memory but still true to the local scene. In the Kikkawa collection at Iwakuni screens of Deer also illustrate the unaffected naturalism so close to the hearts of the Japanese.

More conservative in spirit than any of the preceding masters was Soga Chokuan. He was the founder of the Soga family of artists. To strengthen the family prestige his son, Chokuan

cocted ancestry occurred also with the Tosa and Sumiyoshi families of painters.

Chokuan I was a conventional artist and holds a position similar to that of Kanō Shōei at the beginning of the Momoyama period. While the room of Tigers and Bamboo at Jukōin, attributed to Shōei, reveals an artist thoroughly imbued with Chinese ideals, Chokuan took his subjects of animal life directly from nature. His period of activity can be dated from 1596 to 1610. In the latter year he made an *ema*, or votive painting on wood, which was presented to the Kitano shrine. He lived in Sakai, a city which preceded Ōsaka as an important port, and where the Tosa artist Mitsunori and, for a while, Kanō Sanraku also lived.

The Three Laughers [135] of Henjōkōin, on Mount Kōya, by Chokuan tells the story,

135. Chokuan I (active 1596–1610):
The Three Laughers, Momoyama period.
Henjōkōin

II, called himself the sixth generation both from Shūbun and from Jasoku. Such genealogical fantasies seem to have been typical of the mid-seventeenth century, for the same con-

derived from Chinese legend, of a recluse who never descended beyond the little bridge of Hu-hsi (Kokei). One day he and his friends, lost in the ardour of conversation, passed un-

wittingly over the demarking bridge, where-upon all three broke into laughter. Here can be studied the stiff brush work peculiar to Chokuan and the speedy execution typical of the age. The line itself derives from Sesshū. The colouring, in a low key, recalls the fifteenth-century manner of Sōtan, and the scale of the figures, treated largely on the large surface of the screen, is paralleled in the figure paintings of Tōhaku, Tōgan, and Yūshō.

But Chokuan is especially famous in art as a painter of fowl, as his son Chokuan II is as a painter of falcons. Ever since the Muromachi period some artists, not generally those of major importance, had specialized in portraying birds. Among them members of the Doki family were outstanding, and the style of Tō-bun, of the first generation, was followed closely for a long time. Both the Doki and the Soga families supplied an enormous output of hawks and eagles – a branch of art obviously representing a special demand of the military caste.

In this age of warrior patronage the subject of horses also continued to be popular. An anonymous pair of screens of Stabled Horses owned by the Imperial Family of Japan has been dated variously as late Muromachi and as Momoyama. Each fold of the screens contains one horse tethered in its stall. The subject-matter recalls the story of Kanaoka's tethered horses. Close in treatment are the horses in a late Kamakura scroll, the Bai Sōshi or Scroll of Horse Doctors of 1267. The subject of stabled horses had become a classic one and was fre-quently done with little variation. One of the extraordinary features of these horse paintings of Japanese origin is that the changes of land-scape during the four seasons are sometimes incorporated in the background, a scheme deriving from Chinese thought and long con-tinued as though it were especially favoured by the Japanese.

The artist who stands midway between the Momoyama and Edo periods was Kanō San-raku (1561–1635). Hideyoshi so favoured him that he had Sanraku adopted into the Kanō family by Eitoku whose pupil he was and whose son-in-law he became. Actually, Sanraku was the son of Kimura Nagamitsu, a painter and military retainer of the Asai family.

In general, the dearth of signed works – for it was customary never to sign sliding wall panels and screens only rarely – has left more problems than solutions concerning many of the extant groups of paintings. Particularly unfortunate in this respect was Sanraku. His panel paintings in ink of Falcons in the Shō-shinden at Daitokuji according to temple tradition were ascribed to Eitoku. So, too, in Myōshinji his two pairs of screens in colour of the Four Greybeards and King Wên and Lu-shang and of the Three Laughers and Yen Tzu-ling have for long been attributed to Yūshō.

To complicate the problem still more, at Tenkyūin, a sub-temple built at Myōshinji between 1631 and 1636, the many decorated rooms which have long been regarded as typical works by Sanraku are now thought by Japanese scholars to be by his adopted son Sansetsu. Especially famous have been the Morning-glory panels done on a gold ground. The composition seems to possess too static a decorative quality, too concentrated a study of nature, and too calm an expression of feeling to be the work of one of the leading artists of the Momoyama period. The room of Red Plums at Daikakuji which is accepted as by the hand of Sanraku retains much of the crowded rich-ness of design of the rooms of Maples and Trees at Chishakuin now thought to be by Tōhaku. Such a reshuffling of attributions has in no way detracted from the fame of the master; rather, it has helped in the creation of a consistent personality.

The screen of Birds of Prey [136], in the J. Nishimura collection, is now taken as a standard for the study of Sanraku's paintings. Both rocks and trees have a structure specially formulated by him to create depth of tone by a volume of many similar lines. The restless energy characteristic of his work is visible too.

As a pupil of the Kanō, Sanraku must also have been familiar with the subjects and methods of the Tosa family. A painting almost certainly by him but totally different from the Birds of Prey in concept is the Fight of the Carriage Attendants now in the Tōkyō National Museum. In the frenzy of small figures of this subject drawn from the *Tale of Genji* the attendants in ancient costumes are crowded together, and shown bustling with activity in a manner which was then occasionally being applied to the contemporary scene. In the collection of the Kujō family, the former owners, have also been discovered Landscapes of the Four Seasons, used as wall paintings. Copies of records of the family dated 1655 prove that Sanraku and his son Sansetsu made paintings for the family's Kyōto residence, and also mention the painter Kanō Einō, the son of Sansetsu. Clearly, the Kujō family patronized one of the Kyōto branches of the Kanō family for three successive generations

A pair of screens by Sanraku, now in the Nishida collection, introduced a new category of figure painting. The artist drew on a Chinese book of 1573 called *Ti Chien T'u Shuo* (*Teikan Zusetsu*) which had illustrations portraying the conduct of good and evil emperors. The book became popular in Japan, and was published there in 1606, which seems to date the beginning of the fashion for a wider range of ethical figure subjects derived from Chinese history, especially for the type rendered in fairly large scale on a gold ground. Following Sanraku, many later artists of the Kanō school relied on the book for ideas for decorating great apartments like those in Nishi Honganji and in

136. Sanraku (1561–1635):
Birds of Prey, Momoyama period.
J. Nishimura Collection

Nagoya castle. The emphasis on moral precepts with political implications began late in the Momoyama age. With the increase of learning intellectual symbolism received a new lease of life. Bamboos were held up as examples of moral straightness and tigers of extreme physical endurance. Such sentiments, which were suited to the regulative needs of a dictatorial government, became typical under the Tokugawa regime.

The works of the sons of Eitoku are even more confused than those of Sanraku. According to the *Honchō Gashi*, Mitsunobu (*c*.1565–*c*. 1608), the elder son, did not follow the style of Eitoku and on the death of the latter had to learn the family tradition from relatives and pupils. It also added that he liked the Yamato style and he was, in fact, married to a daughter of the Tosa house. In 1592 he painted for

Hideyoshi at the camp of Nagoya in the province of Hizen. Later he served Ieyasu and was given a house in Kyōto, and about 1606 he was summoned to paint in Edo, the new capital now called Tōkyō.

The major works associated with his name are the rooms of Cryptomeria Trees and of Pines and Birds at Kangakuin in Ōtsu. In contrast to the vastness of Eitoku's design and to the breadth and complexity of the anonymous compositions of the early Momoyama period at Nanzenji, the elements of Mitsunobu's designs have a thinness and openness which is less grand. His style also lacks the dramatic posing of natural forms of the Morning-glory or Clematis rooms at Tenkyūin and the more exacting sense of realism which characterized the early Edo art. The wall panels at Hōnenji, which are very similar to those at

Kangakuin, make it likely that they may be ascribed to Mitsunobu too.

His younger brother, Takanobu (1572–1618), remains a very uncertain artistic personality. He is chiefly distinguished through the fame of his sons, especially Tanyū. He held the title of *Edokoro no Azukari*, normally an hereditary title in the Tosa family as painters to the imperial court. It is not therefore extraordinary that, according to the *Honchō Gashi*, he is recorded as having painted in the Sentō imperial palace. Very few paintings by him are known, although wall paintings now at Sosenji but originally at Myōshinji are associated with his name. The style is close to that of Eitoku and yet differs from those of other identifiable artists.

In this chapter many temples have been named in an attempt to give some idea of the wealth of material which survives in or near Kyōto. No great series of wall paintings exists outside Japan. Nor is it possible to see an important work of Eitoku or Yūshō except in Japan.

Screens and wall paintings in strong colour on a gold ground were the special achievement of Momoyama times. Subject, composition, and technique were derived from the background of Chinese culture. But the subjects, so frequently of tree or flowering shrub, presented the world not idealistically conceived but as a world of natural beauty ready to be appreciated by anyone who would use his eyes. The compositions, flat, sensuous with colour, and boldly selective of design, bespoke the quality of vision natural to a Japanese. The technique of painting on a gold ground was that of the craftsman-painter, not of the scholar-gentleman. In screen and panel paintings, traditional characteristics of Japanese and Chinese art were united in a happy balance, indebted intellectually to the ancient arts of China and dependent emotionally on the past history of Japan.

The Kanō family in the Momoyama age set the stage for official art in both the imperial and shogunal capitals of Kyōto and Edo. Under the Tokugawa regime the Kanō school became more responsive to the Chinese intellectual approach. Those artists who valued nature for its own sake had to create a new school for themselves, and those who venerated the native traditions established the decorative school, the true successor to the ancient Yamato-e.

THE LATER KANŌ AND TOSA SCHOOLS

In contrast to the expansiveness and breadth of the Momoyama period the Edo age, which lasted for two and a half centuries, was one of increasing narrowness and introspection. After the battle of Sekigahara in 1600 the position of Tokugawa Ieyasu was pre-eminent. In 1603 he set up a new capital at Edo (the present Tōkyō). The fall of Ōsaka castle in 1615 saw the final ruin of the house of Hideyoshi.

To Ieyasu and his heirs fell the delicate problem of maintaining the feudal spirit, which was the basis of power, while discouraging its excess, which might tend to the overthrowing of the government. One of the policies used to achieve this balance was the spread of education especially in the military class. Confucianism was adopted as an official philosophy, but the final result was quite different from the original intent. In China the foundation of political philosophy was one of loyalty to the emperor. In Japan the scholars of Chinese social ethics, to be consistent, eventually had to raise the issue of loyalty to the emperor as against that of loyalty to the shogun or military dictator. In doing so they prepared the way for the restoration of the imperial family in the nineteenth century. The new learning soon branched out to include the study of ancient Japanese history which still further increased the sense of nationalism.

Differences of opinion among the Christian missionaries who had been in Japan for nearly a century helped to bring about the exclusionist policy which about 1637 closed Japan to all foreign intercourse except for a minimum permitted at the harbour of Nagasaki. The country became more self-contained than it had ever been. By the eighteenth century even new Chinese ideas had a difficult time in penetrating the blockade.

The period also saw a remarkable development in the rise of an economy based on money rather than on a standard of wealth measured in rice. The change brought great hardship to the military clans and made possible fortunes among the new bourgeoisie. The luxuries of life became the property not of those whose power rested on the sword but of those who had the money to pay for them.

In its attempt to stabilize its position the Tokugawa government chose the little village of Edo as its capital, safely distant from the enervating effects of the old capital of Kyōto. Edo slowly grew to be one of the largest cities of the world, and its art in many ways reflected the spirit of the new and boisterous metropolis. The tightened economy of the shogunate gave rise to rigid class distinctions and to petty laws in a vain attempt to perpetuate the system just as it had been at the beginning of the Tokugawa rise to power. Fortunately the activities of each class, as long as they did not seem to conflict with the prestige of the military clans, were allowed a free development. Hence there arose new types of art appropriate to the interests of merchant, intelligentsia, and commoner.

Feudal society was organized into four classes descending from nobility and soldiers on the top of the scale through farmers and artisans to merchants at the bottom. The Kanō and Tosa schools which were patronized by the first class retained some vitality, so that for the

first century of the period one can still point to distinguished developments. The peasants who formed the second social division are barely represented artistically, though the paintings with religious or moralistic flavour made at Ōtsu, just outside Kyōto, reveal a certain peasant spirit by their acceptance of traditional subject-matter and by the quality of sound craftsmanship.

By the end of the seventeenth century the merchant class was strong enough to create the lavish fashions which made the Genroku period (1688–1703) synonymous with extravagance. The artisan class joined with the merchants to form the urban taste which expressed itself in varying types of art appreciation. As members of the new intelligentsia they found enjoyment in new modes, some arising from the Japanese love of nature and some stemming from old or new Chinese models. As patrons of the theatre and the gay quarters there developed for them the famous colour prints of Japan. The art of each class was vital though restricted in its appeal to one group. Hence, in feudal Japan during the Edo period there was far more diversity than in the corresponding Ch'ing period in China, when the canons of an academic school held too dominant a position under the imperial regime.

The Kanō school, which had already produced a succession of leading artists and which had been patronized by both Nobunaga and Hideyoshi, found its position now guaranteed by the Tokugawa dictators. With them the school moved to Edo, though the pupils of Sanraku and some others did remain in Kyōto. After 1621, when Kanō Tanyū was given a residence in Edo, the Kanō became the official school of art. Because it was patronized by the shoguns, the school also came to be spread all over Japan by the daimyos at whose lesser courts the tastes of the shogunate were copied.

Mitsunobu and Takanobu, the sons of Kanō Eitoku, have already been discussed. The former had a son, Sadanobu (1597–1623), who by command of the shogun was ordered to move to Edo. Takanobu's sons were Tanyū (1602–74), Naonobu (1607–50), and Yasunobu (1613–85). With this distinguished trio the Kanō line broke into three sub-branches which were designated by their places of residence in Edo – respectively the Kajibashi, Kobikichō, and Nakabashi lines. Yasunobu, however, was adopted as heir by Sadanobu, and thus is counted as the eighth generation in the main Kanō line. The son of Naonobu was Tsunenobu (1636–1713). Many more names, ramifications, and later generations of this extraordinary family might be mentioned. A study of their inter-relationship by marriage would interest a genealogist. At any rate whether because of inheritance or training the family continued to be the official school down through the nineteenth century, and as such was directly supported by the shogunate. The artists did not form an academy in quite the usual sense of the word; yet with their official position, copy books, and pupils their art constitutes a vast reservoir of tradition in painting.

The deaths of Mitsunobu in 1608 and Takanobu in 1618 followed by that of Sadanobu in 1623 left the leadership of the family an open problem. The gap was filled by the best of the pupils of Mitsunobu, Kōi (c. 1569–1636), who became the teacher of Takanobu's sons and on this account was allowed the Kanō family name. In about 1619 he served the Kii branch of the Tokugawa family at Wakayama, and was paid the handsome salary of three hundred *koku* of rice or some fifteen hundred bushels. Here he is said to have trained Naonobu and Yasunobu for a time. As Tanyū had already been given a residence in Edo, it is likely that he was too accomplished to have been greatly affected by Kōi.

Kōi represented the teaching of the main branch of the Kanō house, but in his painting such as the landscape screen in the Tōkyō

National Museum, influences deriving both from Sesshū and from the new spirit of the Tokugawa government are apparent. About 1625 Nijō castle was being prepared for the shogun Iemitsu who was to receive a visit from the emperor there. Its vast apartments were decorated by Kōi, Tanyū, Naonobu, and other Kanō artists. None of the paintings is signed, but those of the Shiroshoin rooms are often assigned to Kōi, those of the Ōhiroma to Tanyū, and those of the Kuroshoin to the young Naonobu. Confusing the problem still further, many of the castle's buildings were later moved elsewhere and only those set up in the temple of Chionin now remain with their paintings. The problem of attributions is acutely difficult, although the amount of Kanō material surviving from the third decade of the seventeenth century is tremendous. The paintings in the Shiroshoin apartments offer a fine example of landscape in the new manner and, however they may be attributed, reflect the teaching of Kōi. The sweeping power of the Momoyama screens has been replaced by clever compositions. The parts forming the design, whether tree, rock, or architecture, stand with isolated dignity. The scale has diminished, and the Japanese fondness for misty clouds worked out in powdered gold has increased. Decorative tendencies are on the rise, and the emphasis on brilliant outlining brush work has become so strong that it makes many of the works of this time seem cold and formal.

Kanō Tanyū, first named Morinobu, was precocious and recognized as a genius early in his career. He soon became the most influential artist of his day. In 1612 at the age of ten he went to Edo with his father, and on his way had an audience with the shogun. In 1617 he renounced succession to the main Kanō line, and was made painter to the shogun and given an estate at Kajibashi. In 1621 he was given further houses in Edo and another in Kyōto for his mother and brothers. He was employed in decorating various castles, and several times in Kyōto he painted in the imperial palace. In 1636 he was ordered by the shogun to shave his head like a monk, indicating a kind of retirement for practical and not monastic reasons. He then changed his name from Morinobu to Tanyū. Two years later he was honoured with the empty Buddhist title of Hōgen, and in 1665 he was made Hōin, a still higher title which gave him a position at court corresponding to the lower grade of the fourth rank. The appreciation lavished on him shows how thoroughly he expressed the feelings of the age in which he lived.

About 1625 he not only painted in Nijō castle but, while he was on his way to Kyōto, he also worked in the Shōrakuden part of Nagoya castle where the shoguns stayed on their trips to and from Kyōto. Some of the subjects were taken from the *Teikan Zusetsu*, the book which Sanraku before him had used to illustrate the deeds of Chinese emperors. Scrolls of the Legends of the Tōshōgū shrine at Nikkō painted by Tanyū in 1636 illustrate the life of Ieyasu, and show his style when he chose to work in the Tosa manner. In 1642 he painted wall panels of Sages for the imperial palace, and his designs undoubtedly preserved much of the conventional treatment of this ancient subject. Extraordinary brush facility, diversity of technique, and nobility of concept explain why Tanyū became the outstanding leader of the Kanō house in his day. So great was his fame that he was called the reviver of the school and one of its 'three famous brushes' along with Motonobu and Eitoku.

Tanyū set the type which all later generations of the Kanō family followed as if the rules of painting could be rigidly prescribed. One of his best works is a pair of screens of the Four Classes – soldiers, farmers, craftsmen, and merchants – in the collection of N. Asano. It reflects the official and now rigid division of the people. The artistic freedom of the Momoyama

age is a thing of the past, and elegance and dignity have succeeded gorgeousness and boldness. In the picture of Confucius and Two Disciples [137] in the Boston museum, reverence is being paid to the greatest of Chinese philosophers at the Apricot Terrace where Confucius met with his pupils. The disciples are Yen Hui, the favourite of Confucius, and Tsêng Tzu who is said to have composed the *Classic of Filial Piety*. Sincere feeling for the subject, dignity in portrayal, and seriousness of approach unite to make this a great picture. The draughtsmanship is of the stiffest kind, and the outlining strokes have almost the quality of those of Sesshū. The absence of background – for the inclusion of the apricot branches overhead is in a single picture plane – emphasizes the brush work so that it can be judged brilliant or obtrusive according to the taste of the viewer. The technique stresses surface line, not pictorial depth, and in the hands of lesser artists of the school such

virtuosity of brush stroke gave rise to a cold and academic kind of painting.

The second genius of the Kanō family in this period was Naonobu, the younger brother of Tanyū. Before going to Edo he painted in Nijō castle in the Honmaru Shoin apartments panels which, like those of the Shiroshoin, were moved to the Chionin temple. In 1630 when he moved to Edo he established there the Kobikichō line of Kanō artists. He was married to the granddaughter of Kanō Sōshū, a brother of Eitoku.

As early as the fifteenth century it had become customary for artists to work in styles of ink monochrome which were classified after terms used for styles of calligraphy as: *shin*, standing or stiff; *gyō*, slow moving; and *sō*, running or grass. In the seventeenth century, a time of introspection culturally and artistically, this artificial, idealistic approach to art turned in upon itself to find a new stimulus in varied modes of expression. Naonobu was noted

especially for the 'grass' style in which he surpassed even his brother Tanyū. The free, highly imaginative style suited his personality. A pair of landscape screens in the Tōkyō museum and the figure screens of Po I and Shu Ch'i [138] in the Boston museum, though quite different in subject, both show the broad free brush strokes used in the 'grass' style. There are several versions of the story of the two brothers Po I and Shu Ch'i, but they all illustrate the virtue of loyal allegiance, a theme thoroughly suited to the moral code of the shogunate. In one account the father wanted the younger brother Shu Ch'i to succeed him. This he refused to do and affirmed the right of the elder brother. Po I, however, could not respectfully disobey his father's wishes, so both brothers retired to the mountains while a third son was made heir. The simplicity of Naonobu's ink wash, limited to barely two tones, attracts our attention to a developed manner which in many ways can be paralleled

by the drawings of Tiepolo in relation to the art of the Renaissance.

The third brother, Yasunobu, became the head of the main branch of the Kanō family, but he was not so famous a painter as either Tanyū or Naonobu. The connoisseurship of paintings was a kind of special activity in his house, and on many old Kanō paintings are certificates of authenticity signed by him. Yasunobu was married to the daughter of Kanō Kyūhaku I, one of the brothers of Eitoku. In the Boston museum is a pair of screens of the Four Lovers of Flowers in which four philosophers and poets are grouped together because of their love of plum, lotus, chrysanthemum, and narcissus. One of them, Chou Mao-shu, the admirer of the lotus, had been painted by Masanobu, the first ancestor of the Kanō family. The theme of the painting combines love of nature and respect for virtue, but the style has neither the quiet elegance of Tanyū nor the brilliant vigour of Naonobu.

137. Tanyū (1602–74):
Confucius and Two Disciples, Edo period.
Boston, Museum of Fine Arts

138. Naonobu (1607–50): Po I and Shu Ch'i (four panels), Edo period. *Boston, Museum of Fine Arts*

Among Tanyū's pupils one of the most distinguished was Tsunenobu (1636–1713) whose father, Naonobu, had died too early to teach him. Continuing the Kanō custom of marrying relatives, Tsunenobu married a daughter of his uncle Yasunobu. In the Tōkyō Geijutsu Daigaku the pair of screens of Phoenixes by him is a magnificent example in colour and line movement of the late Kanō school. But somehow these Chinese mythological and symbolic birds lack the vitality which is felt in so many of the earlier paintings of dragons and tigers, beasts representing the forces of nature. The screens of Landscapes of the Four Seasons [139] in the Boston museum may be taken as an example of the solid training of the Kanō school. By this time it was the technique rather than the individual that was beginning to count. The school was already two hundred years old, and it was difficult for an artist to paint freshly.

The themes of the Kanō artists of the seventeenth and eighteenth centuries included most of those which had occurred in the Muromachi period, but there was also a wider range of subject. While ancient Chinese masters were still copied, the models were more varied than in the days of Yoshimasa. Bird and flower paintings by the Chinese emperor Hui Tsung of the Northern Sung dynasty or horses by Chao Mêng-fu of the Yüan dynasty furnished new prototypes to follow and admire. Paintings by Ming dynasty artists also became known and appreciated.

It was an eclectic age. Not only were the Kanō and Tosa styles so thoroughly mixed that it is sometimes difficult to distinguish to which school a work belongs, but frequently the traits of still other schools were adopted by the Kanō masters. And certainly the Kanō so strongly influenced the descendants of the Hasegawa school of Tōhaku, the Unkoku school of Tōgan, and the Kaihō school of Yūshō that the later artists of these schools barely show their independent characteristics. More important than style was a common taste.

The official school was now standardized and strict. Taste had become moral not in the former Zen manner of concentration of will but in the Confucian tradition of pragmatism. Art was to ennoble man, to illustrate models of conduct, to serve in the purpose of good government, and to suggest virtues symbolically. This was a crushing programme, and art

139. Tsunenobu (1636–1713): Landscapes of the Four Seasons, Edo period. *Boston, Museum of Fine Arts*

in the service of good government soon ceased to be great art.

The best work – that is, the most original – was often done by pupils who rebelled from the strict tenets of the Kanō training and were forced to found independent schools of their own. Such a painter was Kusumi Morikage, who was another pupil of Tanyū and married to the daughter of Tanyū's sister. Little is known of the details of Morikage's life except that he was patronized by the daimyo of the province of Kaga. In such ways as this the Kanō teaching was spread through the nation. Morikage was a man of stiff and haughty character, and it is sometimes said that he was expelled from Tanyū's studio. His style shows enough individuality to account for the legend about him. Simplicity, breadth, and a taste for quiet genre subjects give his work a new kind of sincerity. The tradition of the Kanō school in general belonged to the 'northern' classification; Morikage possessed more the 'southern' personal point of view. Although at times he seemed to reflect the broad 'dot' technique associated with the Chinese artist Mi Fei, he primarily painted what his eyes saw rather than what his mind had been taught was correct.

A real rebel from the Kanō was Hanabusa Itchō (1652–1724), a pupil of Yasunobu. Except for the Kanō brush style which is everywhere apparent in his work, he would be more appropriately classified with the Ukiyo-e masters. His subjects, however, were not confined like those of the Ukiyo-e artists to the theatre and the gay quarters. At a time when Chinese thought was in fashion, Itchō impresses one as intensely Japanese. His fondness for genre and the humour of the moment recall the keen psychological perception and the emotional freedom which can be found in so many of the medieval scroll paintings, and his charm is that of a person who enjoys and sympathizes with his fellow-beings.

As a physician Itchō's father belonged to a class which at this time occupied much the same social position as the artists. In 1666 the family moved to Edo. Itchō typified the gay life of the Genroku period, especially that of the Yoshiwara where before the days of public restaurants men of wealth and culture met and entertained. He was the friend of the poets Bashō and Kikaku, of the calligrapher Genryū, and of the metal worker Sōmin. In 1698 he was exiled to Miyakejima for satirizing the shogun.

He seems to have been far too lively to maintain the seriousness of the Kanō point of view.

Before leaving the Kanō school it is necessary to revert to the city of Kyōto and to comment on the school there. Since Kanō Sanraku had no son, Sansetsu (1589–1651) was married to his daughter and given the Kanō name – the usual manner of adoption which perpetuated the family name. Sansetsu became the leader in the old capital, when so many of the Kanō artists moved to Tōkyō. Mention has already been made of paintings at Tenkyūin which are now assigned to Sansetsu rather than Sanraku. Besides the rooms of Morning-glories he decorated others with Tigers and Bamboos and with Plum Trees and Birds. He maintained closely the style of the Momoyama period. The drawing became a little more elaborate, but the tradition of decorative splendour remained. These tendencies are exemplified in a well-known pair of screens of Sea Birds[1] in the I. Hosotsugi collection. The details are worked minutely. The stiff draughtsmanship suggests many works in lacquer. And the subject too would appear to derive from such a lacquered chest for holding sūtras as that of middle Heian date at Kongōbuji on Mount Kōya which has a design of small sea birds flying over rocks and iris at Suhama. Especially in Kyōto artists must have been cognizant of their own ancient traditions.

Sansetsu's son Einō (1631–97) continued the style, but is more famous as the author of the *Honchō Gashi*, a biographical history of the artists of Japan written from the Kanō point of view.

It is difficult to classify so independent an artist as the priest Shōkadō (1584–1639). As one of the three great calligraphers of his time he reverted to the style of writing of Kōbō Daishi. About 1615 he was living at Otokoyama in order to escape the wars connected with the siege of Ōsaka castle, and became the pupil of Kanō Sanraku. The simplicity of his ink tones in paintings of birds or Rakan suggests the spirit of the Muromachi period and recalls the style of the Chinese priest Yin-t'o-lo. In Shōkadō's work the contrast of massive dark tones with fainter ones harmonizes completely with the kind of calligraphy then fashionable, and expresses the native decorative spirit even in ink monochrome. Sometimes Shōkadō made paintings such as the screens of Flowers and Birds[2] in the collection of A. Watanabe which were designed to be inscribed with verses following a custom reintroduced at this time by Kōetsu, another of the three great calligraphers. Here Shōkadō's style has no relationship with the touch of the Kanō school. Yet it would be still less appropriate to group him with the great decorative artists to be treated in the next chapter. In every age non-professional artists like Shōkadō were independent of the traditional trends of the major schools of art.

Contemporary with the Kanō and lasting like it throughout the Edo period was another official school, that of the Tosa family. Both claimed descent from great fifteenth-century masters, but while in general the Kanō carried on the traditions of painting which had come to Japan from China, the Tosa school devoted its talents to subjects and methods descending from the ancient art of Japan. In theory the Tosa family provided the official painters attached to the court. During the sixteenth century, the two families were much intermarried, and when Kanō Takanobu was placed in charge of the Art Bureau of the court, the event marked a low point in the fortunes of the Tosa family.

The line which descended from Tosa Mitsunobu of the fifteenth century died out when his grandson Mitsumoto was killed in battle in 1569. How Tosa Mitsuyoshi (1539–1613), who lived at the port of Sakai, a popular place of refuge from the wars around the capital, got his training is not quite clear. He is generally said to have been a younger brother or pupil of

Mitsumoto, son of Mitsumochi who was the eldest son of Mitsunobu and who died in 1559. He assumed the Tosa name, and with him the school began to revive.

Illustrating Japanese classics had formed a part of the Tosa tradition. No subjects were so frequently done as those taken from the *Tale of Genji*, and both Tosa Mitsunobu and Kanō Eitoku had used its themes in their art. In the sixteenth century small sets of illustrations in album size became popular. Many were painted in scroll or album form by noblemen of the court dependent on the imperial family in order to supplement their livelihood. One of the best paintings in the Tosa style is the album of the *Tale of Genji* [140] in the Freer Gallery,

140. Mitsunori (1563–1638): Tale of Genji, Barrier House chapter, Edo period. *Washington, Smithsonian Institution, Freer Gallery of Art*

Washington. The artist, Tosa Mitsunori (1563–1638), the son of Mitsuyoshi, draws in the most delicate ink line following a style which was used in the fourteenth century in the Makura no Sōshi and which continued in favour with the nobility. If Mitsunori's sinuous, fragile line is compared to the force of the contemporary Kanō line, it seems a gossamer kind of artistry. When colour was added, as was usually the case, the result was often merely precious-looking.

The artist credited with re-establishing the school on a par with the ancients as well as with Kanō Tanyū, his contemporary, was Tosa Mitsuoki (1617–91). With him Tosa art again became important. After he settled in Kyōto in 1634, he was appointed Edokoro no Azukari, the title of the painters attached to the court. His fame rested on his paintings of birds and flowers of fine composition and delicate line. Especially well known were his paintings of quails, in which he followed Chinese prototypes attributed to Li An-chung of the twelfth century. Here was the strange paradox of an artist of Tosa lineage adopting a particular Chinese manner of subject and treatment to revive the school whose major characteristic had been its adherence to Japanese subject and technique. Mitsuoki was also the first of the

Tosa line to sign his works, a custom usually associated with the Chinese school. On the larger scale of screen paintings he often selected a design replete with bending grasses where the minuteness of his handling would show to best effect.

The pair of eightfold screens of Quails and Millet [141] now in the Atami Art Museum is a very ambitious presentation of the Tosa manner. Other screens by Mitsuoki, such as the Suma and Akashi formerly in the T. Kanemitsu collection, take their content from chapter headings of the *Tale of Genji*. As landscape paintings they show the brightness of colouring and the small-scale treatment of the Tosa style. Misty rounded hills familiar in the Japanese landscape bespeak the normal feelings of a Japanese towards his own geographical environment. The Mitsuoki line of the Tosa family maintained its position into the nineteenth century in rather pretty pictures of birds and flowers.

Far truer to the ancient Tosa style and endowed with a more original mind was Jokei (1599–1670), a pupil of Tosa Mitsuyoshi. He was patronized by the shogunate in Edo. At the command of Emperor Gosaiin (reigned 1655–62) he took the family name of Sumiyoshi. As one more example of the fictitious genealogy-

141. Mitsuoki (1617–91): Quails and Millet, Edo period. *Atami Art Museum*

making so characteristic of the Japanese vener-
ation for aristocracy, his art lineage was traced
back to Sumiyoshi Keion of the thirteenth
century, the reputed artist of the scroll illustrat-
ing the Burning of the Sanjō Palace. For the
emperor Gomizunoo, Jokei made in 1626 a copy
in twenty scrolls of Mitsunaga's Annual Rites
and Ceremonies which was then in the palace.
The original was destroyed in the great fire of
1653 which also wiped out much valuable art
of the early Edo period.

Jokei's son Gukei (1631–1705) painted in the
Tosa or Sumiyoshi manner a remarkable scroll
called Life in the Capital and Suburbs. It is in
the collection of the Tōkyō National Museum.
The subject had been used in screen form by
Eitoku, but in the scroll the direct vision of the
old Yamato-e artists reasserts itself and the
details of life along the streets or in the country-
side are treated with realism and humour. This
very point of view was about to be taken up and
exploited with more freedom by the artists of
the rising Ukiyo-e school such as Moronobu
and Chōshun.

Matabei could perhaps be most properly
discussed as an artist of the Tosa school, as he
claimed when he signed one of his works as the
'later stream from Mitsunobu'. But he has so
often been associated with the Ukiyo-e school

that discussion of his art will be deferred to
the chapter on the Ukiyo-e paintings.

The later Tosa style of the eighteenth century
showed little strength or promise. The school
was affected by the growing popularity of the
study of Japanese history and the consequent
rise in prestige of the imperial family. In the
nineteenth century there was a distinct revival
under Tanaka Totsugen (d. 1823) and Reizei
Tamechika (1823–64). Their work is interesting
as a reaffirmation of the Japanese spirit of the
old Yamato-e of which they made many copies.
But the thin Tosa line seldom showed to
advantage in hanging scrolls, the form which
they chose most frequently. Their art reflected
the changes of political philosophy and often
had a special historical appeal, because several
of the artists were also patriots in the imperial
cause. As revivalists they were so fond of
painting historical figures that they overlooked
the special greatness of the medieval artists
which lay in action and robust realism. The
true successors to the colourful tradition of the
Yamato-e scrolls were the artists of the decora-
tive school; they not only venerated their own
artistic past but created an entirely new and
purely Japanese tradition of painting in strong
colour and with an intense feeling for natural
beauty.

THE RETURN TO NATIVE TRADITIONS

EDO PERIOD: 1615–1867

The artists of the Momoyama period expressed the splendour-loving taste of warriors. The later Kanō artists, also in the service of the military, reflected the restraint, elegance, nobility of concept, and moral attitudes which the Tokugawa government expected to be made manifest in art. But peace, prosperity, and the power of money gave rise more and more to an extravagant kind of art which was patronized by the rich and the merchants. The school founded by Kōetsu perhaps in conjunction with Sōtatsu and continued by Kōrin possessed a vivid unrestraint of colour, a decorative patterning particularly in form, and an easy comprehensibility which appealed to the senses rather than to the mind.

The new school was close to the spirit of the Momoyama period both in its love of nature and in its sense of gorgeous display. But whereas artistic conception in the Momoyama period which succeeded to the renaissance of Chinese ideals was still largely Chinese, that of the new decorative school represented a return to native and more ancient traditions. Approach to subject-matter, execution, and a quickened sense of colour had made Momoyama ideals harmonious with the character of the Japanese; now theme and handling proclaimed a taste in which foreign influence was almost forgotten and native sensibility was emphasized.

That the new style was classically Japanese cannot be doubted. It followed the naturalistic and colourful elements of Momoyama art back to their native origin. Exaggeration of scale for natural detail, which can be noted in such late Kamakura scrolls as the Nayotake Monogatari

or in the version of the Life of Michizane at the Matsuzaki shrine, began to reappear. The very forms of pines and waves now employed more decoratively recall conventions used anciently as in the Boki Eshi scroll. Since the days of Motonobu screen designs had been becoming flatter. The depth customary to Chinese painting lingered only in the outlines of mountains which no longer really indicated atmospheric depth. In the decorative school the shapes of things were especially important, and were filled in with nearly flat colours. The subtlety of gradation in Chinese art was replaced by the subtlety of mass outline in the traditions of this school.

It is impossible to point to any one group of paintings or even to any narrow limit of time as giving rise to the new mode. However, it is significant that the school was associated primarily with the city of Kyōto until the time of Kōrin, that is, until the end of the seventeenth century, when it moved to Edo also. In Kyōto the classic Japanese taste survived and the literature of the native poets was very much in fashion. This double link with the past, artistic and literary, ran counter to the insistence on Chinese learning and styles of painting as advocated by the Tokugawa government especially in Edo.

Honnami Kōetsu (1558–1637) who shares with Nonomura Sōtatsu (d. 1643) the honour of founding the school was probably the pupil of Kaihō Yūshō in painting. In this connexion the trip that Yūshō made to the shrine of Itsukushima in 1598 deserves to be mentioned again. The Sūtras offered by the Taira Family

which were kept there were repaired in 1602 by Sōtatsu, proving that the extravagant style of the Taira became familiar again to great artists after some four hundred years had elapsed. These dates also suggest the period when the new style began.

Kōetsu was one of those versatile artists who had so much originality that every art in which he worked was made distinctive by his gift for design. His family had been known for generations as experts in sword connoisseurship. Beyond this Kōetsu was famous for calligraphy, in which he was classed along with Shōkadō as one of the three greatest in his time; for pottery making, in which craft his tea bowls with soft Raku glaze are still among the most prized objects of their kind; for lacquer, to which he introduced new inlays of lead and pewter; and as a painter. He was also a landscape gardener and devotee of the tea ceremony. His love of nature as expressed in his art was not for distant hills but for near-by flowers and animals, and, following the principles advocated by the tea ceremony, his presentation was refined by further selectivity and restraint. In character he was simple and generous.

Land for a house at Takagamine on the outskirts of Kyōto was given to Kōetsu by Tokugawa Ieyasu in 1615. He had been invited by the shogun to go to Edo but this he had refused to do, nor would he accept any allowance from the shogunate. His insistence on staying at the old capital seems entirely natural, if one first considers Kōetsu's fondness for the ancient native style and then relates this tradition to the taste of the imperial court centred in Kyōto. At Takagamine Kōetsu lived in retirement and collected together friends and artisans. There are said to have been fifty-seven buildings housing devotees of the tea ceremony, potters, and lacquerers, a colony of craftsmen in the arts, a group transcending social distinctions. Among his friends were Prince Sonchō, his teacher in calligraphy for a time, and such famous noblemen as Konoe Sammyakuin and Karasumaru Mitsuhiro. If one recalls that the emperor Goyōzei as a prince had been taught painting by Yūshō, it seems as though at this time the court took a real interest in the arts which deeply affected one section of the taste in Kyōto.

Many of the works of Kōetsu are no more than ground designs on which to inscribe verses. He originated new types of 'poem squares' and poem scrolls. His knowledge of the so-called minor arts led him to perceive the appropriateness of harmonizing his powerful script composed of both bold and light touches with designs which did not illustrate the poems but which merely suggested an atmosphere suitable for the appreciation of poetry. Such an insight was that of neither a designer nor an illustrator but a subtle compound of an artist's sensibility to his subject-matter and a craftsman's to the material side of art. Typical of his decorative genius was the calligraphy of the text and the lotuses decorating a scroll of the Hundred Poems formerly in the T. Ōkura collection but unfortunately destroyed in the war.[1] Gold and silver washes, almost flatly applied and with graceful yet truthful outlines, suggest live natural forms.

In many poem scrolls Sōtatsu co-operated with Kōetsu. The Deer scroll formerly in the K. Mutō collection[2] conjoins the bold calligraphy of Kōetsu and the broad painting without outlines of Sōtatsu. A Bamboo poem scroll by Kōetsu, in the Ōkura Shūkokan, has the date 1626 from which the period of this particular fashion may be judged. The style of calligraphy deliberately followed by Kōetsu goes back to Kōbō Daishi, the famous Shingon saint, in the ninth century and to Ono no Tōfū in the tenth. To this period or a little later are attributed manuscript versions of the Poems of the Thirty-six Famous Poets written on decorated paper, formerly in the collection of

K. Ōtani. Moreover, here too gold and silver pigments were used for decorations of birds and flowers and grasses, the subjects chosen by Kōetsu. The courtly literary fashion of the middle ages was reborn early in the seventeenth century.

Kōetsu also sometimes painted screens of flowering plants with verses inscribed above. An example by his friend Shōkadō was mentioned in the last chapter. The union of literature, calligraphy, and art in a single work indicates a change in taste brought about by peace and the cultural prominence of the court.

The biography of Nonomura Sōtatsu is so far from clear that almost any statement is controversial. A lineage which connects him with Kōetsu cannot be completely proven, but as it also shows the relationship of Kōrin to Kōetsu it is given here in a form slightly modified to include several well-known artists of the decorative school.

having lived in Kyōto as a young man. The fact that several of his works exist at Daigoji, while indicating that he may have had some connexion with the temple, would also hint at a residence in or near the capital.

Among the older chronicles of art Sōtatsu was variously described as the pupil of Eitoku, of Yasunobu, and of Jokei. The last two suggestions are chronologically impossible and make it probable that Sōtatsu should be included among 'forgotten' artists. He could have been taught by Eitoku, but his manner is so much closer to that of Kōetsu that even this suggestion seems unwarranted.

The only clear dates referring to his activity are 1602 when he repaired the Sūtras offered by the Taira Family and 1630 when he copied the scrolls of the Tales of Saigyō. The colophon to the latter painting states that it was made from a version treasured by the imperial house. The words of the scroll were transcribed by

HONNAMI FAMILY

According to this lineage, Kōetsu and Sōtatsu married sisters, a clue to Sōtatsu's place in the decorative school and possible proof of his

Karasumaru Mitsuhiro, the friend of Kōetsu. A third possible date is supplied by the screens of Poppies in the Boston museum [143]. On

the back of one is a Meiji period label, nearly obliterated, from which it may be assumed that the screens were presented to a temple on Mount Kōya in 1623 when an older temple was renamed Tentokuin to house the ashes of Tentokuin, the wife of Maeda Toshitsune (1562–1614) and the second daughter of Tokugawa Hidetada. The label substantiates statements of older art histories that late in life Sōtatsu served the lords of the province of Kaga, the Maeda family, which had given a special allowance to Kōetsu. Sōtatsu may have died in 1643 at Kanagawa in Kaga.

Sōtatsu's return to native tradition is confirmed by his choice of themes from Japanese literature, by his copies of ancient pictures, and by his technique. Several times he painted screens illustrating the Barrier House (Sekiya) chapter of the Tale of Genji, and in others drew upon incidents from the Tales of Ise. From this it might be thought that Sōtatsu should be classed as a Tosa artist, but the breadth of design and draughtsmanship which he had absorbed from his study of ancient scrolls was never achieved by the members of the Tosa family.

Apart from the Taira Sūtras which he restored and the Tales of Saigyō which he copied, it is clear that the twelfth-century scrolls of the Genji and the Tales of the Heiji Insurrection must have been seen by him and freely reinterpreted for his treatment of kindred subjects. A pair of eightfold screens, composed of scattered fan shapes depicting incidents from the Hōgen and Heiji wars, is one example.[3] The screens are said to have come from the imperial palace and are still in the Imperial Household collection. If Sōtatsu's active figure composition calls to mind the Tales of the Heiji Insurrection, his drawing of excited open mouths and the barely indicated gestures of the hands can be traced to the Legends of Mount Shigi. Liveliness and strong colour reappear as envisioned by a great decorative composer. On the other hand, for the figures in the screens of the Wind and Thunder Gods[4] at Kenninji he reinterpreted the type of representation in the scrolls of the Life of Michizane of the Kitano shrine. Later in the history of the decorative school both Kōrin and Hōitsu repeated Sōtatsu's designs. The screens of the fancifully clad figures of Bugaku Dancers at Daigoji must also

have been taken from some early source. Even the type of screen covered with scattered painted fans was no more than the new expression of a much older fashion. Sōtatsu continually looked backwards for distinctly Japanese traits.

Many poem scrolls decorated with pictures of flowers or animals in washes of gold and silver very similar to the Hundred Poems by Kōetsu are signed with a seal reading Inen, a fancy name used by Sōtatsu. The Deer scroll [142], now in the Seattle Art Museum, and the Flowers of the Four Seasons, in the former collection of I. Dan, both have the Inen seal and calligraphy by Kōetsu. The evidence that Sōtatsu often made such paintings is incontrovertible. However, many scholars have also attributed to Sōtatsu some scrolls in which his seal is lacking and which hence have only the name of Kōetsu associated with them. But even if Kōetsu never executed paintings in this style, both the idea behind it and the technique seem more nearly related to his personality than to that of his friend Sōtatsu. Here if anywhere in Japanese art is that close association of painting and poetry so often praised in the annals of Chinese art history and so typical of the scholar-gentlemen. Although Kōetsu certainly and Sōtatsu probably were closely associated with crafts rather than with universities, their poem scrolls display jointly poetical sensitivity and decorative simplicity.[5]

Another aspect of Sōtatsu's style is to be found in ink paintings. The Cormorants and Lotus Flowers formerly in the K. Magoshi collection[6] shows in places a nearly solid mass of heavy ink used as if it were a pigment, a type of rendering which had occurred long before in the scroll of Fast Bullocks. In other parts the 'boneless' method of rendering is used to give a contrasting lighter touch. The latter technique, called *tarashikomi*, possibly derives from the paintings of Mu-ch'i, and Sōtatsu also adapted it to paintings in colour. H. Minamoto describes it as a method 'of first putting on colour with a wet brush, and then adding other colours before the first layer has dried, so that the two colours interpenetrate and a very soft effect is obtained.' The screen of Poppies [143] in the Boston museum is an example. The technique possesses the further advantage that when the colour is thinly applied over gold the gold

142 (*opposite*). Sōtatsu (d. 1643): Deer scroll, Edo period. *Seattle Art Museum*

143 (*above*). Sōtatsu (d. 1643): Poppies (three panels), Edo period. *Boston, Museum of Fine Arts*

ground gives a vibration through the thin pigment and establishes an intimate relationship between the colour and the gold ground.

In the works of this decorative school the use of backgrounds nearly disappears in the concentration on the few foreground essentials. Kōetsu excels in skilful patterning, Sōtatsu in lively naturalism. In supple gracefulness Sōtatsu has few rivals except perhaps for an occasional work by Yūshō.

The immediate artistic heirs of the decorative style, Honnami Kōho and Kitagawa Sōsetsu, grandson of Kōetsu and son of Sōtatsu respectively, lacked the breadth of the earlier artists. Sōtatsu, a much more prolific painter than Kōetsu, had handled figures as well as flowers and birds. Their successors worked in the style which they had inherited but limited themselves almost exclusively to floral subjects.

The artist who made this school most famous internationally was Ogata Kōrin (1658–1716). His paintings and designs, lacquers and pottery possessed a decorative power in colour and in spacing which did more than the works of any other artist to arouse the western world to an interest in Japanese art. In Japan too his fame was rated so highly that art histories favouring the Kanō school claimed him as a pupil of Yasunobu or Tsunenobu, while those favouring the Tosa school set up a similar claim for Gukei. Certainly the Kanō influence is strong in some of his works, and Kanō Yasunobu seems the most likely teacher.

Kōrin's ancestry provides a rare illustration of the family of a knight becoming merchants. His great-great-grandfather was a samurai in the service of the Ashikaga family and was eventually forced to become a *rōnin* or soldier without a lord. His great-grandfather was Dōhaku, a Shintō priest at the Ogata shrine, near Kitano. Dōhaku married a sister of Kōetsu, and their son Sōhaku, Kōrin's grandfather, was a member of Kōetsu's group at Taka-gamine. The close connexion between the two

houses accounts for the possession by Kōrin of some of Kōetsu's model books. While Sōhaku was a man of great wealth, a dry-goods merchant who was patronized by the ex-empress Tōfukumon-in, a daughter of the shogun Hidetada, his son and Kōrin's father, Sōken, was an artist. As a calligrapher Sōken studied under a pupil of Kōetsu, and was so fond of Nō drama that he had his children practise it. An educative interest such as the Nō would have turned Kōrin's mind back to the classic past, and the richly coloured costumes of the Nō may well have caused him to feel unsatisfied with anything but tones of equal strength and magnificence.

Kōrin's life reflects the prosperous extravagance of the merchant class during the luxury-loving Genroku age. Kōrin stands out as its greatest exponent in the courtly city of Kyōto in contrast to Itchō, the gayer and more popular representative of the taste in the shogunal city of Edo. In 1701, at a picnic party at Arashiyama, Kōrin and his friends held a lavish entertainment in which each friend showed off his splendid dishes. As a climax Kōrin produced his food wrapped in bamboo leaves specially decorated by himself with gold. When the meal was over, Kōrin tossed the leaves into the river. For this wasteful action which infringed the laws of 1698 forbidding the use of gold and silver among the common people he was banished from Kyōto and went to live in Edo. There he was befriended by the Fuyuki family, timber merchants of tremendous wealth. One of the customs of the great merchants was a kind of fashion show where a group of friends gathered to exhibit the fine costumes of the female members of their families. For a daughter of the Fuyuki family Kōrin painted a gown with a broadly placed decoration of autumn flowers.

The wealth of the merchant class could be spent freely along restricted lines, but only as long as it did not conflict with the theories of

the government. The taste for lavish decoration endowed their art with material splendour, while the inherited culture of the old capital gave it a quality which one would otherwise not expect to find in an art patronized by merchants who were officially looked down upon.

Another aspect of the merchant taste was the great number of paintings then produced of the seven gods of good fortune, a popular complex of Chinese, Buddhist, and Japanese origin. Among the subjects which Kōrin often painted were Ebisu, Daikoku, and Fukurokuju, the first two being the special favourites of the merchant class. These are generally handled in the Kanō manner, the tradition of Kōrin's early training. Reminiscent of the same style are dragons and figures like Kanzan, Jittoku, and Lin Ho-ching (Rin Nasei), one of the four lovers of flowers who is associated both with plums and cranes.

Typical of the age also was the revival of interest in Shintoism to be found in subjects such as the *misogi*, or Purification Ceremony, or a scene of Nonomiya where the vestal virgins lived who were attached to the shrines of Ise and Kamo. The former exists as a screen formerly in the K. Magoshi collection, the latter as a lacquer ink-box formerly in the M. Katō collection. Sōtatsu earlier had painted the misogi and Hōitsu later was to paint it again. These themes for decorative treatment were new and stood apart from the usual selection from the general classic literary tradition.

As heir to the style of Kōetsu and Sōtatsu it was natural that Kōrin should frequently choose to paint or to make designs of the Thirty-six Poets, or to single out one of the more famous, Narihira, or even to depict the angular bridge by an iris pond, the Yatsubashi bridge, which was connected with the name of Narihira. At this time, too, the authoress of the *Tale of Genji*, Murasaki Shikibu, was so popular that she was painted composing her great work at the Ishiyama temple. Such paintings were made by Kōrin as well as by Kanō, Tosa, and later Ukiyo-e painters.

But like all the followers of the decorative school Kōrin was greatest as a painter of nature, sometimes of landscape but generally of flowers and animals. A pair of screens in the Nezu Art Museum depicts a border of Iris Flowers [144] on a gold ground. Only two colours are used, a green and a violet blue, yet with so restricted a palette complete naturalism is achieved. The

144. Kōrin (1658–1716): Iris Flowers, Edo period. *Nezu Art Museum*

quality of the pigments, the harmony of the colours, the truthfulness of the drawing, and the disposition of the clumps of flowers – in spite of the lack of any attempt to suggest depth – unite to create a picture so simple that it almost defies analysis. Kōrin filled many sketch-books with careful studies from nature, and indeed such a course of training alone could account for the literalness of his presentation. Here is none of the exaggeration of the elements of design which make some of his works seem abstract and 'modern'. If simplicity is the crown of artistic achievement, here is art stripped of all verbosity. The process is neither the intuitive abstracting which the Zen masters sought nor the rational, clearly outlined style of the Kanō, but the essence of a visual sensuousness. What the eye saw and the heart delighted in, Kōrin has made into a colourful pattern convincingly true both to aesthetic principles and to nature.

The pair of screens of Red and White Plum Trees [145], now in the Atami Museum, combines naturalism with the pure patterning which is often characteristic of Kōrin's style. In the right-hand screen a large S-curve

145. Kōrin (1658–1716): Red Plum Tree, Edo period. *Atami Art Museum*

indicating the water's edge separates the realistically drawn red plum from the central area of water, where swirling patterns in gold decorate a silver ground. Direct naturalism and pattern for its own sake are strangely associated. The band-like clouds, *suyari*, pictured in the ancient Yamato-e and the flat, bulging forms used by the Kanō for ambient clouds and mists, especially those done in *moriage* or low relief, are also pure conventions. From the scientific point of view of the west the conjunction is highly inconsistent. To the Japanese both methods were equally easy to comprehend and equally successful as a means of decorating the plane surface of a screen or piece of lacquer. Indeed, the more intently one looks at the details of the naturalistic forms, the more readily the abstract presentation of their shapes will be perceived. Branches are arbitrarily left out, while roots, forming a pictorially stabilizing pattern, are visible. But the total mass of the outlining shape is so vigorous that the eye is deceived into thinking it natural.

This attitude when applied to pure landscape can be found in the Matsushima or Wave screen in the Boston museum. The romantic-looking, pine-topped islets of Matsushima, one of the three famous sights of Japan, presented just the right motif for the artist to remake the scene as a unified pattern after nature. The shapes of clustering pine boughs, of bare, blank walls of rock are hardly less formalized than the rhythmic lines of cloud sprays and wave. This screen is another example of Kōrin's indebtedness to Sōtatsu, whose earlier painting of Matsushima is in the Freer Gallery of Art. In their choice of native landscape both artists anticipated the taste of the nineteenth-century print-makers who were also commoners and who also chose to make pictures of the scenery of Japan.

Kōrin's younger brother, Ogata Kenzan (1663–1743), followed his style, but he possessed a retiring nature and was interested in

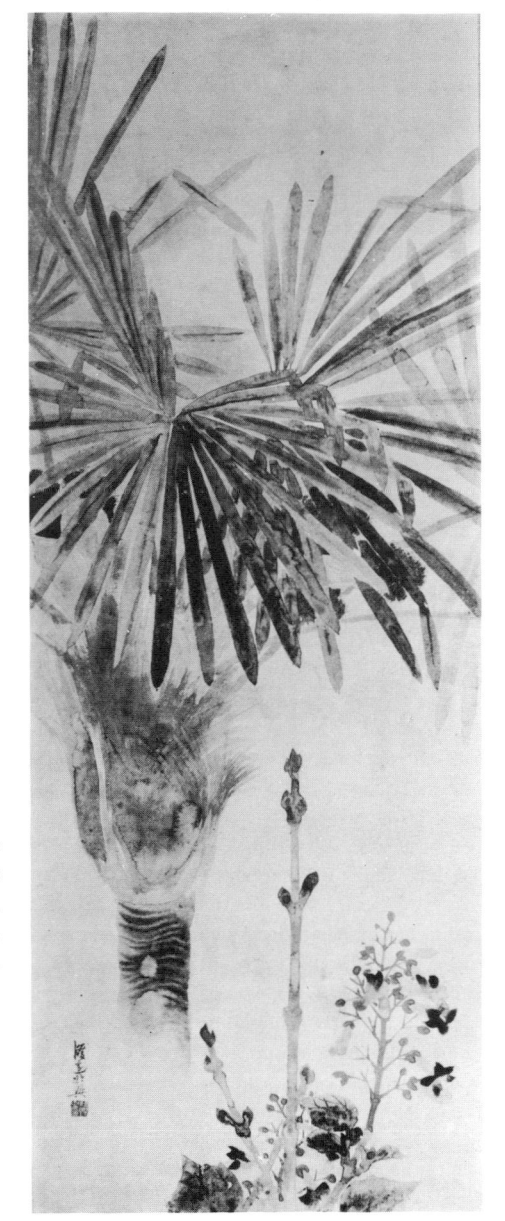

146. Shikō (1684–1755): Palm Tree, Edo period. *Formerly Fumimaro Konoe Collection*

the intellectual life of the times. More famous
as a potter than as a painter, he carried over into
the field of ceramics the new type of design.
Occasionally Kōrin himself made the designs
which Kenzan fired in pottery. Although the
Ogata family traditionally belonged to the
Nichiren sect, Kenzan favoured the Zen, and
his taste was that of the tea master influenced
by the restraint of the Zen philosophy. The
decorative placing of his floral designs in his
small paintings often has an unfinished quality,
as though he sought to avoid the technical
brilliance and finish of his brother's style.

Watanabe Shikō (1684–1755), like so many
artists of the time, was first the pupil of a Kanō
painter. Later he followed the Kōrin style so
ably that he may be called the greatest artist to
continue the decorative tradition into the
middle of the eighteenth century. Palm Tree
[146], one of a set of twelve pictures formerly
in the collection of F. Konoe, is the best known
of his works. The wet brush of the Sōtatsu-
Kōrin style is clearly visible, but there is less
decorative flatness and more filling in of the
composition. The sense of naturalism stands
half-way between the Kōrin school and the
later Maruyama school whose leader, Ōkyo,
greatly admired Shikō.

In the second half of the eighteenth century
Jakuchū had the same ability to paint nature
in the bold, decorative patterns of Kōrin, but
his style emphasized strong colour and over-
literal naturalism. Early in the nineteenth
century the school was revived by Sakai Hōitsu
(1761–1828), the younger brother of the lord
of Himeji. Though born in a daimyo family he
wanted to be a painter, and studied under many
artists of different schools both in Tōkyō and
in Kyōto. The realism of the Maruyama school
especially appealed to him, and he studied for a
time with Watanabe Nangaku (1767–1813), an
artist of the Ōsaka branch of the naturalist
school who had moved to Edo. Finally, he
followed the style of Kōrin. He published a

147. Hōitsu (1761–1828): Iris and Mudhen,
Edo period. *Formerly Takeshi Mizuno Collection*

book of the *Hundred Designs of Kōrin*, and in 1815 he held a ceremony in honour of the hundredth anniversary of Kōrin's death.

As a revivalist Hōitsu was extraordinarily successful, for though he favoured the simplicity of Kōrin he also was mindful of the changes which had been introduced by Ōkyo. The four sets of twofold screens with pictures of the Four Seasons formerly in the Beppu collection leave no doubt that Hōitsu venerated Kōrin and that he was indebted as well to the Shijō school of naturalism. His Iris and Mudhen [147], formerly in the collection of T. Mizuno, is an example of the strong colours and the realism which were popular early in the nineteenth century, and were carried on by his pupil and close follower Suzuki Kiitsu (1796–1858). Except that the painting shows more of the brush strokes of the Shijō school,

the general presentation is closely paralleled in the bird and flower prints of Hiroshige. The Kōrin tradition was ended, but Hōitsu's books gave Kōrin's designs a wider influence than they could ever have hoped to have had in his own lifetime.

In its insistence on formal design, general adoption of themes drawn from Japanese sources, and direct expression of natural beauty the decorative school acquired a position which entitles it to be considered as the true bearer of the ancient native traditions during the Edo period. The exclusion of foreign influences and the consequent introspectiveness of the age had prepared the way for the re-emergence of a truly Japanese manner, and under the leadership of Kōetsu, Sōtatsu, and Kōrin one of the great original schools of art in the Orient had been created.

THE RETURN TO NATURE

EDO PERIOD: 1615–1867

After a century of regimentation under the Tokugawa government the official schools of painting, the Kanō and Tosa, had become stultified both by repetition of subject-matter and by repression of original conception. However, the Kanō, like many academic schools, could still supply good teachers of art, although it is often difficult to perceive in the newer masters the characteristics of their early training. Early in the eighteenth century the Ukiyo-e or popular school, which had arisen in the seventeenth century, was associated especially with Edo and with the production of prints. The course of its history will be treated in later chapters. In Kyōto the Kōrin school which had been a great creative force during the seventeenth century soon declined. The taste of the city, however, was so strongly classical that it provided poor ground for the expansion of the rising Ukiyo-e school. And it is to Kyōto that one must turn to study the developments in painting which had the greatest influence on the history of painting in the future. These later schools were not officially connected with either the court or the military government, and are remarkable in that they rose in a feudal society through the genius of an individual and that once started they continued for long periods through their appeal to the merchant class. The restraints placed upon military society were more than balanced culturally by the rise of an urban intelligentsia.

Because of the exclusion policy of the government, which limited the amount of foreign trade to an economic minimum and nearly prohibited the importation of contemporary foreign ideas as well, the art of the period remained distinctly national. Whereas Kōrin and Kōetsu had gone back to the medieval traditions on which to build solid foundations for a new style, the great artists of the naturalist school which dominated the second half of the eighteenth century looked not backward but outward at the world of living beauty about them.

The leader of the new school was Maruyama Ōkyo (1733–95). It is not without significance that he was the son of a farmer, and thus came from the only one of the four classes into which society was divided which had not hitherto produced any outstanding artist. Ōkyo's first teacher, Ishida Yūtei (d. 1785), belonged to the Kyōto branch of the Kanō school and had been a pupil of Tsuruzawa Tanzan, who in turn had been one of the distinguished pupils of Kanō Tanyū. But Ōkyo's paintings seldom suggest any influence stemming from the Kanō. Like Kōrin, he often used a broad, flat brush, a treatment which lent itself both to decorative and to realistic representation. By loading the brush more on one side than the other with ink or colour it was possible to paint broad, clear, and graded strokes. The method, though not unknown before, now gave a new character to art.

The naturalistic artists who just preceded Ōkyo in date were Watanabe Shikō and Shên Nan-p'in (Chin Nampin). The latter was a Chinese of no great ability who visited Japan in 1731. He belonged to the 'southern' or Literary Men's school, and his method of painting gave rise to a new school especially in Nagasaki. His

paintings of birds and flowers were pretty in colour and truthful in intent. To Ōkyo, however, they were lacking in proportion. The scale of attractive objects was exaggerated in a way which seems false in a realistic setting. Ōkyo preferred the Japanese style of Shikō. But it was nature itself which was his master.

As a young man he admired the styles of the Chinese masters Ch'ien Hsüan (1235–c. 1290), who was famous in part for his precise drawing of flowers, and Ch'iu Ying (c. 1522–c. 1560), one of the great figure painters of the Ming dynasty. Yet his liking for these Chinese masters is more an indication of his objective attitude than a record of any paramount influence from abroad. Out of respect for the former he took for his name the 'kyo' character which formed part of one of the fancy names of Ch'ien Hsüan. In Chinese fashion, too, Ōkyo for a time signed his family name in one character, in which case he called himself En rather than Maruyama. His use of a Chinese style in names may mark the occurrence of a Chinese fashion in Japan, but it would be incorrect to assume that the realism of Ōkyo typified any art save that of Japan. Exact similitude to his subjects was his aim, and several anecdotes remain to prove his success in truthful rendering.

The eighteenth century frequently presents anomalous experiments which are surprising in themselves. Evidently, in the non-canonical schools the search was on for novelty. In 1767 Ōkyo painted a Harbour View, a perspective picture, small in scale and used as part of a set for peep-show pictures. A generation before there had been a craze for Dutch perspective prints in the foreign manner, and early in his career Ōkyo made a set of small prints of architectural views which emphasize a single vanishing point. But this interest soon passed. Ōkyo also experimented briefly with nudes which, as usually happened in the Orient, were associated with pornographic pictures.

Ōkyo's realism departed both from the Kanō technique based on stylized drawing and from the Literary Men's school based on sentiment. He coldly analysed his own observations and through accuracy of brush drawing achieved the most convincing truthfulness to nature. His approach parallels in part the point of view of the majority of Dutch painters whose burgher patrons valued material likeness. As an oriental artist, however, Ōkyo could never lose his fondness for living nature, and the flow of brush line inevitably depicts the animate better than the inanimate.

When in 1769 Ōkyo painted a Kingfisher and Trout[1] (S. Hayakawa collection) the new style was quite apparent. Centuries before Mokuan had painted a similar subject. While the older master working in ink left as much as possible to the imagination, Ōkyo's depiction with touches of colour is explicit. Above, the bird is eagerly poised. In the middle ground a huge rock juts forth, and below this swim fish beneath transparent water. Fish, rock, and bird are painted with enormous care for truthful detail and for actuality of composition. Ōkyo's style, which expresses the level of popular taste, appears as serious, realistically convincing, and easy to understand. His Geese alighting on Water at Emmanin, Ōtsu, though done as early as 1767 is just the kind of presentation which westerners would expect from such a title. It does not even suggest that the subject once formed one of the themes of the philosophical and academic renderings of the Eight Views of the Hsiao and Hsiang Rivers.

In 1772, Ōkyo painted a Waterfall for his patron at Emmanin, the Prince Abbot Yūjō. His famous scroll of Fortunes and Misfortunes, kept at the same temple, proves the breadth of his abilities. By returning to the ancient scroll manner of active figures excited by emotions he has well represented the terror of fire and earthquake. Also from 1772 is a scroll of nature studies once in the S. Nishimura collection.[2]

Sketch scrolls of a similar nature by Kōrin and by Tanyū are known, but neither observed with such accuracy. Ōkyo and his school developed an art of likeness rather than of idealism or emotion, and their straightforward vision influenced the imaginations of so many later artists that their approach seems modern.

The next year Ōkyo painted Pine Trees in Snow for the Mitsui family which controlled a great commercial house that developed into one of the giant industrial firms of modern times. An early snow painting, it is not intellectually conceived as one season in a philosophic scheme, and in spite of being in ink monochrome on a gold ground it is realistically treated. The wet brightness of snow piled on huge limbs and weighing them down furnishes a theme attractive in and for itself. The strokes are broad and choppy for the bark, thin and bristly for the pine needles. No attempt is made to create the continuous line treatment of the Kanō or the decorative simplification of the Kōrin traditions.

Direct comparison with the Kanō can be made by looking at the Crane by Kanō Masanobu [122] and the Crane and Waves [148] which Ōkyo painted for the Kongōji temple at Anafuto where he was born. The solidity of formal handling and depth of idealistic conception may, according to the standard of critic or observer, cause the fifteenth-century picture to be rated as the finer of the two. Ōkyo's simple statement in his later manner, however, may well have the readier appeal. Both artists started traditions which had predominant influence. But whereas the school of the Kanō received governmental and official support which fitted it into the hieratic pattern of feudal times, that of Ōkyo was popular and soon split up into various branches so that one does not find the same lineal continuity even though the direct influence of his ideas has continued.

Just before his death in 1795 Ōkyo painted a huge view of the Hozu Rapids, a pair of eight-fold screens once in the S. Nishimura collection.[3] It shows both his greatness and his weakness. The local scene, the near or foreground presentation, especially the scale of tree and rocky mass, the tight descriptive handling, are all modernly realistic. When the same brush method is applied to Dragons, the conflict between factual approach and idealistic subject

148. Ōkyo (1733–95): Cranes and Waves, Edo period. *Kongōji*

becomes too obvious, and the beasts seem to struggle among clouds rather than soar freely. Ōkyo's style is not so much that of an original genius imposing a new attitude of his own creation as a reflection of the ideas of the practical people of his own class and time. Even without his leadership it is probable that other artists would have traversed much the same course. He came from the soil of Japan and remained true to the natural feeling of the Japanese.

His fame spread so that he was commissioned to paint for both emperor and shogunate. He had his own school, the Maruyama, and was one of the best art teachers of the day. He experimented with every branch – figures, landscapes, birds, fish, even puppies. His followers more often specialized. In composition also he possessed a breadth and simplicity seldom rivalled by other members of his school.

Of Ōkyo's direct pupils the most independent and distinguished was Nagasawa Rosetsu (1755–99). The brush style of this artist was personal and unrestrained, wet and hurried, qualities which seem only to add liveliness to the accuracy of his drawings. Another pupil, Komai Genki (1747–97), specialized in the drawing of female beauties, but his models were Chinese artists of Ming date such as Ch'iu Ying and T'ang Yin (1466–1524) who had also appealed to his master, Ōkyo.

Another exponent of the principles of naturalism was Matsumura Goshun (1752–1811) who in 1788 came to live with Ōkyo. Hitherto he had been taught by Buson of the Literary Men's school, but his change of heart was so complete that he is now best known as the founder of the Shijō school, a branch of the Maruyama school established by Ōkyo. Some of Goshun's best work exists at the temple of Myōhōin where he was patronized by Prince Shinnin. His brush work was more soft and pliable than that of Ōkyo and his pictures are less exactingly detailed. Technically he was greatest when he could use his brush broadly and slanted, a style which in his hands had much clarity, fluency, and charm. The gentleness of spirit often apparent in his works seems characteristic of the artists of Kyōto, when their paintings are contrasted with those of artists who lived in Edo. Goshun's brother Keibun (1779–1843) and his pupil Okamoto Toyohiko (1778–1845) carried on the precepts of the Shijō school well into the nineteenth century.

The relationship of pupil and artist at this time was similar to that in modern art schools, not to that in the academies of the Kanō and Tosa where family inheritance was rated so highly. A new development was the co-operative production of a single work by a group of artists. In the Boston museum is a pair of twofold screens where on one side Plum Blossoms, Crane, and Deer were painted by Goshun, Ganku, and Tōyō while on the other Keibun, Tōyō, and Toyohiko painted Pine, Bat, and Deer.[4] Tōyō, an independent like Ganku, was influenced by both the Maruyama and Shijō schools and yet was not attached to either. These men held similar views executed in slightly differing techniques, and as friends could meet and paint together. The big cities developed art circles independent of the feudal society of which they formed so minor a part.

Specialists in painting who were deeply indebted to the new realism were Kishi Ganku (1749–1835), mentioned above, and Mori Sosen (1747–1821). The former was famous for his tigers, the latter for monkeys. Ganku flourished in Tōkyō and was influenced by the style of Shên Nan-p'in perhaps as much as by the realism of Ōkyo. Ganku's picture of Deer [149] at Boston has much more solidity than many of his paintings. His care in the handling of depth, unusual in the naturalist schools, is due to the influence of Chinese traditions.

Sosen, on the other hand, went directly to nature as Ōkyo had. If the Peafowl [150] in the same collection shows the broad, wet ink tones

149. Ganku (1749–1835):
Deer, Edo period.
Boston, Museum of Fine Arts

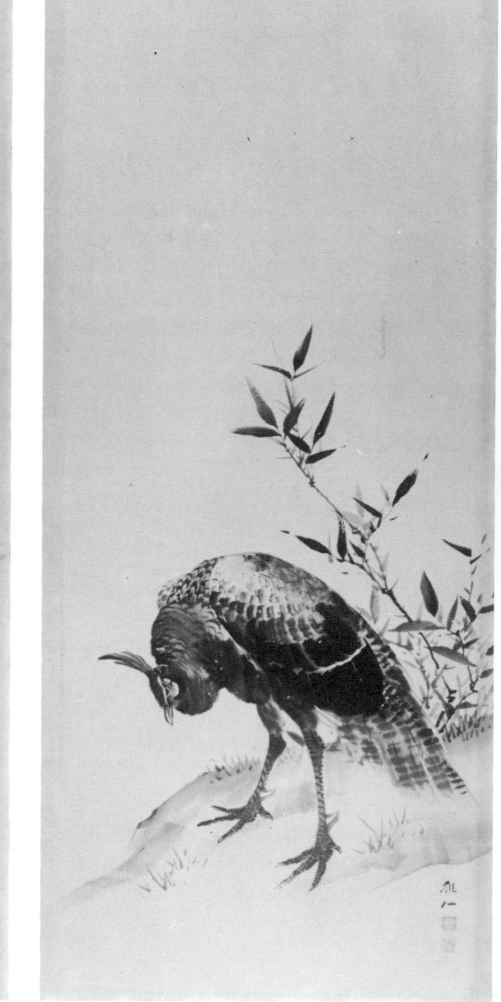

150. Sosen (1747–1821): Peafowl, Edo period.
Boston, Museum of Fine Arts

associated with the Shijō school, his more common pictures of monkeys are worked out with greater variety and detail of brush work. Paintings of this period often possess the charm peculiar to zoological gardens, of wild life trapped for the benefit of careful observation,

of natural life appraised for its own sake. No artist has studied simian characteristics as closely or with so much curiosity as Sosen.

Another aspect of eighteenth-century naturalism can be found in the work of Itō Jakuchū (1713–1800). He belonged to a gener-

ation older than Ōkyo but exercised little influence on subsequent history. Jakuchū was the son of a greengrocer, a man of humble origin. Like many artists, he first studied under a Kanō teacher. His taste demanded precision of line drawing and strength of colour. At times his composition reminds one of the work of Tatebayashi Kagei who was a pupil of Ogata Kenzan and flourished in the first half of the eighteenth century. By natural disposition Jakuchū was a decorative painter. By generation he belonged to the eighteenth century with its love of naturalism and foreign novelties, but his work holds a solitary position between the styles of Kōrin and Hōitsu.

Little is known of Jakuchū's life. Stories tell that he kept fowls in order to study the living animals. Like Sosen in the painting of monkeys and Ōkyo in the painting of wild boars, he was intensely realistic. But while the fowls which Ōkyo painted were those native to Japan, Jakuchū loved best the fancy birds which had then been recently introduced.

He was the friend of a priest of the temple of Shōkokuji, and for this temple he painted his greatest set of pictures, now owned by the Imperial Family of Japan. Here he also made copies of old masters preserved in the temple collection such as the works of Wang Yüan (active, middle of the fourteenth century) and Lin Liang (active, second half of the fifteenth century), both of whom were Chinese artists of birds and flowers. Another type of Jakuchū's art shows that he painted the disciples of Buddha in the ink manner after prototypes attributed to the tenth-century Chinese master Kuan-hsiu. A set of Rakan paintings in this style exists in the Boston museum. For Shōkokuji he did a Shaka Triad in colour after the Chinese Buddhist artist Chang Ssu-kung of uncertain medieval date. But these facts indicate merely that he was primarily self-taught and that because of his social position he was dependent for models on treasures housed in

Kyōto temples and open to the public. It is interesting to note that as a religious man he followed in the steps of the ink masters of the fifteenth century while as a naturalist he expressed the contemporary taste.

The Fowl and Hydrangea [151] from the set of thirty paintings of plant and animal life,

151. Jakuchū (1713–1800): Fowl and Hydrangea, Edo period. *Imperial Household Collection*

originally made for the monastery of Shōkokuji but now in the Imperial Household Collection, was begun in 1758. Twenty-four were finished by 1765, and in 1770 six more were added. Shells, fishes, flowers and birds and other living things are depicted, many species to a single

picture as though an amateur zoologist had collected all his favourite specimens into one grouping. In some the all-over display of flowering branches makes a pattern so finely dispersed that the effect is like that of a textile. In the first type Jakuchū represents the spirit of scientific curiosity which was developing in the eighteenth century. In the second he exhibits with marked individuality the Japanese sense of decorative beauty. Showing the same characteristics is a set of bird and flower prints of his design which are dated 1771.

Jakuchū's rise to fame illustrates again the ever-weakening hold exercised by the government and its official schools of art. The great men of this period were of lowly birth, and their eminence is at once the index of new artistic currents and a re-expression of the national consciousness.

Soga Shōhaku (1730–83) is included in this chapter for chronological reasons, but he himself would have been the first to realize that he did not belong to the eighteenth century or to any of its artistic phases. Looking backward,

he founded his art on the traditional principles of the fifteenth century. He first studied under a teacher of the Kanō school in Kyōto, Takeda Keiho, but his brush work was so unrestrained that he cannot be said to have followed the Kanō method. On some of his paintings he called himself the tenth generation from Soga Jasoku, an artist whose work would have been accessible to him at the temple of Daitokuji. While this kind of self-created genealogy normally implies little more than devotion to the style of a particular master, in Shōhaku's case it drew attention to his disgust with contemporary art.

As a young man who came to Kyōto from Ise he must have been aware of the dearth of great masters in the capital. The Tosa, Kanō, and Kōrin traditions were dying out, a new and pretty kind of painting was being imported from China, and realistic delineation was being made fashionable by Ōkyo. Where were the heirs to the great manner of the Muromachi age? Shōhaku set himself out to re-create the brush style of the days of its glory. In the eyes

152 and 153. Shōhaku (1730–83):
The Four Sages of Mount Shang, Edo period.
Boston, Museum of Fine Arts

of most of his contemporaries he succeeded in making himself ridiculous, and was said to be mad. Haughty by nature, proud of his style, bitter from lack of appreciation, he once remarked, 'If you want a picture come to me, if you want a drawing go to Ōkyo.'

But he had the ability to achieve the strength of brush work of the old masters. The power of the Sesshū or of the Soga line was his ambition, and he wanted no easy line work which might have been pleasant to look at. That he succeeded is evidenced by such a painting as the Four Sages of Mount Shang [152, 153] in the Boston museum. Shōhaku was old-fashioned in theme as well as technique, and these sages, who lived in the time of the emperor Kao-tsung (reigned 206–195 B.C.), were pictorial types of moral rectitude. They had retired early in the reign of the emperor, but were summoned back to court to prevent the displacing of an imperial prince through the intrigues of a favourite concubine. The Four Sages stands apart from the work of any of Shōhaku's contemporaries. Power of line, breadth of stroke, and traditional subject-matter make him seem like a lonely ghost from the past.

His position clarifies the changes which were current. The merchants, who should have been his patrons, cared not at all for his moral principles and his high-mindedness, nor could they have understood the quality of his brush work, sometimes extreme but often revealing the formal strength of line which had hitherto been the basis of all sound craftsmanship in ink monochrome. But this was an urban age. The more simple subjects chosen by the naturalist painters and the more detailed draughtsmanship were easy favourites. The common man wanted and got an art tradition which he could both understand and enjoy.

Even today the innovations of Ōkyo and Goshun retain their popularity in a way that is hard to define but which is also typically Japanese. Lucidity of expression, clarity of brush work, and cleanness of treatment are qualities both physically and spiritually attractive to the Japanese.

THE LITERARY MEN'S STYLE

EDO PERIOD: 1615–1867

The eighteenth century saw a revival of interest in Chinese art traditions as well as of naturalism. The study of Chinese moral philosophy had been encouraged by the government in the seventeenth century and had become popular by the eighteenth. The increase in learning was further accompanied by a new esteem for the later phases of Chinese painting. However, intercourse between the two countries ran counter to the isolationist policies of the shogunate, and as a consequence knowledge of the Literary Men's style in China as practised by artists of the Ming and early Ch'ing dynasties could only be very limited. Certainly the first generation in Japan to attempt the later Chinese style had difficulty in finding proper prototypes. Even the great masters of the eighteenth century, though they intended to be as Chinese and correct as they were able to, remained distinctly Japanese at heart. The influence from abroad depended largely on an imported philosophy, on book illustrations, and on paintings by minor Chinese artists.

'Spirit-harmony', a moral quality fundamental to the Chinese conception of the universe, was the essential aim to be realized. The contrast with the more materialistic attitude of Ōkyo and the naturalist schools lies particularly in whether the artist should copy nature directly or whether he should illustrate the universal scheme of life, an idealistic attitude often tending to the idyllic.

Ancient Chinese art had already been roughly divided by Chinese scholars into a 'northern' school and a 'southern' school. The first was more objective and detailed, the second more subjective and free. The artists of the 'southern' school considered that they were painting the underlying spirit rather than the world of outward appearances. Often their approach was intensely personal. This art was looked upon as the special province of Chinese intellectuals. It represented the style of gentlemen, highly trained in literary studies, who wanted to express the nobility of their concepts or the keenness of their poetical insight. Artists following the 'southern' style may sometimes have been professionals but they seldom formed schools. More often they were scholars and poets who painted, hence their art came to be called in Japanese *bunjinga*, the art of literary men.

The style can be recognized by special methods of using the brush for representing different elements in nature. The drawing of rocks and 'mountain wrinkles' became stylized. Ancient masters were each appraised for the effects they had achieved and were imitated for peculiarities of style. An eclecticism of technique was apparent which, while it simplified some of the artist's problems, opened the way to much amateurish expression in art.

The 'southern' style of painting was both collected and practised in Japan during the Muromachi period. Sesshū himself occasionally painted in the style of Kao K'o-kung, one of the exponents of the style during the Yüan dynasty. The Kanō with their emphasis on strong and detailed line work naturally expressed the style of the 'northern' school, but some Kanō artists like Morikage did work in the manner associated with Mi Fei (1051–1107)

and others who belonged to the 'southern' school.

The fall of the Chinese Ming dynasty in 1644 was the occasion for the coming of some Chinese artists to Japan. The best known was I-jan (Itsunen), a priest whose influence did not extend beyond Nagasaki. At this early date the style failed to arouse much interest. But during the first quarter of the eighteenth century several Chinese artists did arrive in Japan who created by their example a new fashion.

Shên Nan-p'in has already been mentioned. He first came to Japan in 1731 and returned again in 1733. His paintings made in China were also sent by way of merchant ships to his Japanese admirers. His work was devoted especially to bird and flower paintings, and their delicacy, harmony of colour, and realism were new at the time. Another Chinese, I Fu-chiu (I Fukyū), who worked in Japan in the second quarter of the eighteenth century, made his first trip in 1720 to deliver horses contracted for by his brother, a merchant, who had died. His paintings, however feeble, were landscapes painted in the 'southern' manner. Other Chinese artists visiting at about the same period were specialists in ink bamboos and ink orchids. From the examples of such minor artists the Japanese had largely to re-create the style for themselves.

The first Japanese accomplished in the Literary Men's style were Yū Hsi (1713–72) and Sō Shiseki (1716–80). The former carried on the style of Shên Nan-p'in and that of Watanabe Shūseki, a pupil of I-jan, in Naga-saki. Yū Hsi's devotion to Chinese principles was natural for him, as his family held the position of official interpreters of the Chinese language. Sō Shiseki also came to the seaport, and was influenced both by Yū Hsi and by Sung Tzu-yen (Sō Shigan), a Chinese pupil of Nan-p'in in Nagasaki. Shiseki was the first to introduce the style to Edo.

The first artist to practise the new style in Kyōto was Gion Nankai (1687–1761). He was a samurai and a Confucianist scholar who served the Tokugawa family in the province of Kii, and had studied under the great teacher of Chinese political philosophy Kinoshita Junan (1621–98). To such a man Chinese art alone could appear to be correct. He represented the scholar-gentleman class from whose circles many of the artists of this group came. His approach was through his Chinese learning and Chinese books. Such a Chinese illustrated book on painting as the *Pa Chung Hua P'u* of about 1620 opened his eyes to the styles of the Literary Men's school. He was also familiar with another Chinese treatise on painting of the same tradition, the *Mustard Seed Garden* (*Chieh-tzu-yüan Hua Ch'üan*) which had begun appearing in 1679. This book, with illustrations printed in colour, became a favourite with all the painters of the school. Although Nankai's own paintings were never free from amateurish qualities, his influence on other artists is the justification for calling him the ancestor of the Literary Men's school in Japan.

Among the artists taught or influenced by Nankai was Yanagisawa Kien (1706–58). In Chinese fashion he often abbreviated his family name to Ryū, and he is perhaps best known under the name of Ryū Rikyō. He was a well-to-do member of the military class. Interested in painting, poetry, and calligraphy, a generation later he might have shown a more exact knowledge of the principles of the Literary Men's school. In actuality, however, much of his work was influenced by Chinese paintings owned in Japan and can be traced back to the older styles of the Yüan and Ming dynasties. The new type of Chinese art was essentially a wash technique, but, while Rikyō was especially fond of painting baskets of flowers, his style combined firm line and careful colour. It was as though a Japanese with tendencies towards the Tosa type of line had become fascinated by

the composition of the Chinese prints of birds and flowers which were gradually becoming known in Japan. The result was novel, vivid, and Chinese in composition. But whether his art was, properly speaking, inspired by the 'southern' school can be doubted. Often he crowded his compositions decoratively so that some of his work recalls that of Jakuchū. Both men must have seen decorative bird and flower paintings of Ming date and adapted ideas differently to serve their varied aims.

Ernest F. Fenollosa in his *Epochs of Chinese and Japanese Art* hardly touches upon the men of the Literary school. To him the style was nearly below the level of mention. He says, 'From any universal point of view their art is hardly more than an awkward joke. A Kano painting was anathema to such men.' Fenollosa's historical approach, which saw in the Kanō tradition the main link binding the art of Japan to that of ancient China, blinded him to any even moderate appreciation of the school.

From his point of view its chief fault lay in the mincing brush strokes which defied the canons of the Kanō teaching. Yet quite naturally artists who wanted to be impressionistic, gay, and individual avoided the increasingly stiff, formal, and academic Kanō style. It is unfortunate that none of the best work of this school is represented outside Japan.[1]

The two artists who gave the style an impetus which has continued to modern times were Taiga and Buson. Ikeno Taiga (1723–76) was influenced both by Ryū Rikyō and by Nankai as well as by paintings by I Fu-chiu and Chinese books on art. More important than his training in art is the fact that he was startlingly good at calligraphy at the age of seven or eight, for in this school of art the relation between writing and painting was especially close. Taiga at first made his living by selling fans which he painted. But he was too carefree and eccentric to be a good business man, and his book-keeping in learned, beautiful

154. Taiga (1723–76): Sages in a Mountain Retreat, Edo period. *Henjōkōin*

writing which no ordinary person could read did not help matters financially. His friends included other artists like Shōhaku, Buson, and Fuyō – eccentrics, poets, wanderers. His wife Gyokuran also became a well-known painter of the school.

Taiga met Ryū Rikyō in 1736. In 1748 he went to Tōkyō and for several years travelled and climbed the famous mountains of Japan. Probably about 1752 he met Nankai. Apart from these facts little is known about the influences on his early life. His style as it appears in his mature works shows a nervous, heavyish outline and masses of feathery, light brush strokes often suggestive of an effect of stippling. Because he was a bunjinga artist at the time when Chinese prototypes were scarce, his work was far more original than that of many of the later artists of the school. In his hands the 'mountain wrinkles' which formed so important an element in the Literary Men's drawing were not stiff conventionalizations, and unlike many later artists he did not paint in the style of a dozen previous masters at will.

The sliding screens of Sages in a Mountain Retreat [154] at the temple of Henjōkōin on Kōyasan, probably painted about 1761 or 1762, form one of his major works. The sages look like fellow-Bohemians more than learned officials who have retired from the world. Other temple paintings by Taiga such as the Five Hundred Rakan at Mampukuji, near Kyōto, seem even less respectable as exponents of Buddhist teaching. His insistence on painting ugly types was perhaps a reaction to the number of Chinese and Japanese beauties then being painted by some of the Maruyama school artists and perhaps also to the craze for beauties in the tradition of the Ukiyo-e school. Kindliness of feature and bag-like draperies are interpreted in disconnected calligraphic strokes of great vitality.

In 1771 Taiga and Buson co-operated in making albums, now in the Kawabata Yasunari Kinenkan collection, called the Ten Advantages and the Ten Pleasures, which illustrated poems by Li Li-wêng, a Chinese of the early Ch'ing dynasty. Taiga emphasized the human joys of country life, Buson the scenic beauties of the seasons. Among Taiga's 'advantages' of country life were included such subjects as watering the garden, fishing, fine views, and the pleasure of having mountain water to drink – the selection of a townsman and not of a peasant. Sentiment about nature rather than objective truth was the quality he valued, and the fact that such sentiments were subjective widely separates this school from the philosophic approach of the fifteenth century.

Yosa no Buson (1716–83) is the second great figure of the school in its early maturity. While Nankai and Gion were gentlemen-scholars and Taiga a fine calligrapher, Buson exemplifies the third aspect of the school, its close connexion with poetry.

He was born in a village near Ōsaka, spent his early life in Edo, where he studied poetry under the haikai master Hayano Hajin, and settled in Kyōto some time after the middle of the century. He became the greatest poet of the later eighteenth century, and it was with poets that he mixed and made friends. But his double talent kept urging him to paint. Not until he was about forty did he do much painting, and he was apparently self-taught. The works of I Fu-chiu and Hō Hyakusen, a Japanese contemporary of Nankai, had supplied earlier examples of the bunjinga landscape methods. By Buson's time knowledge of their techniques was supplemented by the paintings in Japan of such Ming dynasty artists as Shên Chou, Chang Lu, and Wên Chêng-ming. Yet Buson's style remains a personal one. One of his spring poems helps to explain his art:

How luxuriant the young foliage,
Leaving only Mount Fuji unburied![2]

Masses of foliage composed of a multitude of tiny strokes half hidden in tones of soft

155. Buson (1716–83): Wild Horses, Edo period.
Kyōto National Museum

colour suggest in many of his paintings the luxuriant growth of early spring. Other subjects like a cuckoo and the fresh green of early summer or deer in a lonely autumn forest indicate the special flavour of his naturalism. His paintings illustrate the depth of his poetic feeling, and are often made realistic by the presence of farmers, village dwellings, and animals. His power to depict hamlet and human activity as well as his skill in impressionistic landscape reveal the peculiarly Japanese feeling of Buson. It would be difficult to find a Chinese bunjinga artist with the same degree of human sympathy. The kindly psychological acumen which was so characteristic of the medieval scrolls of Japan reappears in the otherwise sinified pictures of Buson.

Occasionally he experimented with incidental lighting effects. His Fishing Boats on a Dark Night, in the I. Kobayashi collection, shows trees illuminated from two sources of light, from a charcoal fire in the boat and from lanterns hidden inside a cottage. A single source of light would be scientifically preferable in the art of the western world, but the realistic touch of the double lighting appealed to Buson's poetic nature.

A subject very close to his heart was horses, a field in which he may almost be regarded as a specialist. The pair of screens of Wild Horses [155] of 1763, which is kept in the Kyōto National Museum, shows how much careful study from nature these artists made in order to be convincingly true. Yet the pinkish tone of some of the animals makes them seem unreal, and the featheriness of the foliage gives an idyllic atmosphere.

The artists of the first half of the century were imitative and only partly successful as interpreters of the Chinese Literary Men's school. In comparison with their predecessors Taiga and Buson exhibited the new principles and yet remained basically Japanese. To them the near-by woods more than mountain ranges, the common man more than the legendary sage, and the intimate enjoyment of nature more than its idealistic presentation were the important aspects. Especially because of this attitude they seem typical exponents of the naturalism with which the upper middle classes were so charmed in the eighteenth century.

Among the pupils of Buson was Matsumura Goshun. For the decade from 1777 to 1787 he worked in the Literary Men's style, and was

first known as Gekkei. His training under Buson gave to his art a poetical content, wanting in the Maruyama school, which he passed on to the Shijō school. He has already been mentioned as a friend of Ōkyo and as the founder of

appraised; his fault – and that of his period – was over-sophistication. There was too much knowledge about art, too much experimentation at combining too many styles. Some of his works remind one of his early training under a

the Shijō branch of the naturalist school. Because of the prolific and brilliant work of his pupils Toyohiko and Keibun who received their training in the period of his later naturalist style, this phase of his art had the more permanent influence. But such a painting as the Willows and Heron [156], formerly in the S. Ueno collection, has more emotional appeal than anything which he did after he yielded to the influence of Ōkyo. However Chinese the treatment is, the simplicity of the subject and the large scale of the bird arising in flight from a willow-bordered bank attest the Japanese nationality of the artist.

The man who united the tendencies of both the 'northern' and the 'southern' schools was the eclectic Tani Bunchō (1765–1842), the author of several books on art and art history. He was broad-minded, knowledgeable, and fluent in many manners. His vigorous style matched his personality. He enjoyed painting with a large brush in a room filled with people. By his time Chinese styles had been re-

Kanō master. In spite of the fact that his normal style stemmed from China, he painted in the Tosa manner two scrolls of the Legends of Ishiyama Temple which had lacked illustration. The painting of Mount Hiko [157], in the Tōkyō National Museum, was done in 1815 when Bunchō was at the height of his powers. In this the lateral-dot method associated with the name of Mi Fei creates none of the soft, dreamy feeling which it was originally intended to produce. Rather, it expresses the threatening violence of mountain heights.

Bunchō wielded his brush with great strength. Yet conscious imitativeness often mars his style, and a monotony of brush stroke which is characteristic of most of the artists of the bunjinga school is also visible. Their reverence for particular masters often outweighed truth to their own personalities. Some of Bunchō's best work consists of portraits of startling individual likeness in which there is little emphasis on style and much on objective realism, but as he grew older he leaned more

156 (*opposite*). Goshun (1752–1811):
Willows and Heron,
Edo period. *Formerly Seiichi Ueno Collection*

157 (*above*). Bunchō (1765–1842):
Mount Hiko,
Edo period. *Tōkyō National Museum*

and more to the approach of the 'northern' school. The brush work of his paintings in this style has a dominant and obtrusive quality.

His most famous pupil was Watanabe Kazan (1792–1841), a man of much greater originality. Like Bunchō, Kazan too had his models among earlier Chinese artists. In his paintings of birds and flowers in a technique of free washes he followed the style of artists like Yün Nan-t'ien (1633–90). In landscapes he had models in the works of Wang Hui (1632–1720) and Chu Tuan (active in the early sixteenth century). He got ideas for some of his paintings also from foreign books which were coming in from the west and being secretly treasured, and even made a sketch, which still exists, of Hippocrates frankly done after a European book illustration.

A Chinese illustrated book on *Agriculture and Weaving* (*Kêng Chih T'u*) of the K'ang-hsi (1662–1722) period was the probable source for much of the rather western perspective that occurs in some of Kazan's larger paintings. But his style was always corrected by observation,

六旬誕日寫傳神鷲
見着顏一老人烏帽
戴來雖似貴綿裘着
得竟應真繁名文苑
瘤相顴游手墨池龜
有因無事散閒能到
七重逢垂白盡中身

戊戌九月六日
末筆自題

158. Kazan (1792–1841): Beian,
Edo period, 1837.
Gorō Katakura Collection

and great numbers of sketch books prove his constant aim at accurate drawing. A painting such as his Working a Loom by Moonlight, in the collection of H. Iwasaki, represents the culmination of his style. The diminishing perspective in no way interferes with a thoroughly oriental composition, and the observation of a craft is as exact as any in the craft pictures of the Tosa or early Ukiyo-e school. In short, sound human interest and portrayal of the activities of men and their surroundings endow such a picture with a realism generally at variance with Chinese prototypes.

Another type of Kazan's work has been chosen for illustration because it represents an achievement of oriental art little known in the west. The portrait of Ichikawa Beian[3] [158], painted in 1837 and now in the collection of G. Katakura, is almost Teutonic in the frank realism of its presentation. It also shows that a suggestion of modelling was not beyond the capacity of oriental technique. If Kazan's life had been longer, the transition to modern western styles would have been easier.

This extraordinary man, the retainer of a lesser daimyo, was a scholar of both Confucian and Dutch learning. As an administrator he treated the peasant farmers on his lord's estate with wisdom and kindness. As a politician he foresaw the future dangers of the exclusion policy of the Tokugawa shoguns and advocated the opening of the country and the strengthening of the nation's defences. For such sentiments he was confined by the government, and as a consequence committed suicide. To this day Kazan is still revered as one of the patriots of Japan.

Many and brilliant were the pupils of the masters already mentioned. Noro Kaiseki (1747–1828) was deeply influenced by Taiga; Tanomura Chikuden (1777–1835) was a pupil of Bunchō; Tsubaki Chinzan carried on the style of Kazan. Other artists like Okada Hankō (1794–1845) arose in Ōsaka, while Yamamoto Baiitsu (1783–1856) and Nakabayashi Chikutō (1776–1853), both of Nagoya, went to Kyōto and established independent schools there. Throughout the nineteenth century the two great schools were those of the naturalists and of the Literary Men, but by the latter part of the century the bunjinga had become the more influential.

It is easy to criticize the works of the Literary Men's school for their limited point of view and mannered brush strokes. Yet the leaders of the school were great artists. They created a distinctive type of art, refined in sentiment which derived from Chinese learning, impressionistic in technique, and characterized by an indigenous love of nature and of man.

EARLY PAINTINGS OF THE UKIYO-E SCHOOL

SIXTEENTH AND SEVENTEENTH CENTURIES

In many ways the most remarkable by-product of the Tokugawa governmental system was the emergence of a kind of art made for and by the common people, especially the city dwellers, the artisans and traders. As Ukiyo-e traditions developed, two phases have to be noted. The first was represented by paintings of a true genre character, indicative of an important change in taste. Man and his activities, especially his pleasures, produced a great variety of new pictorial themes. The second and later phase, to be treated in the next chapter, was that of the print-makers when the genre art came to express the taste of the lowest groups of feudal society. The new type of art, because of its reduplicative nature, could be purchased by the poor and, in accord with the restless taste of the masses, changed to please each fashion of the moment. It centred on pictures of great courtesans and of famous actors. Well have such prints been called pictures of the floating world, the most popular translation of the words Ukiyo-e.

To understand the origin of the Ukiyo-e school it is necessary to look far back into the past. The disruption of the period of the northern and southern courts in the fourteenth century followed by the Chinese renaissance in the fifteenth had meant a real break with ancient traditions. A reaction to the intervening Chinese school could not begin to set in until late in the Muromachi period. In addition, the unsettling wars of the period created a mood in which new ideas could arise, and in which the populace seems to have been less restrained socially than during the rigid Tokugawa regime.

Art reflected its environment in the gradual emergence of genre paintings. While the new style did not strictly follow the narrative attitude of the Yamato-e scroll tradition, it was also far removed from the ethical approach of the Kanō masters towards figure subjects.

The style originated in the old capital of Kyōto, and among the works of the Kanō artists who lived there are to be found some which depict and emphasize the contemporary scene in preference to an ennobling idealism. The new spirit was stimulated by Hideyoshi's talent for spectacular display. This lowly but heroic figure liked to impress people. The great fête or tea-party at the shrine of Kitano in 1587 introduced a novel kind of popular entertainment. For the occasion Hideyoshi had placards set up in Kyōto, Nara, Ōsaka, and Sakai inviting all to come irrespective of class or wealth. At the tea-party Hideyoshi's treasures were ostentatiously exhibited. The next year he gave a great flower-viewing party at the temple of Daigoji. The popular art of the period deals with masses of people, as though these joyful occasions had also impressed the artists.

The earliest large-scale genre painting – that is, one which cannot properly be classified within the range of the courtly scenes or classical illustrations of the Tosa school – is a single screen in the Tōkyō National Museum called Maple Viewing at Takao [125]. It was painted by Kanō Hideyori, the second son of Motonobu, and probably antedates the Momoyama period. In 1574 Kanō Eitoku himself painted screens of the Capital and its Suburbs, Tosa in subject and Kanō in handling. Like

the later prints of similar landscape settings, it contains scenes with innumerable small figures showing the life of the town and its activities. The interest was more geographical than social, but in either case it was the actual world which appealed to the artist.

Tosa artists, too, were not slow to handle subjects expressive of the change of attitude. The album of the Festivities of the Year now in the S. Yamaguchi collection has the charm and delicacy of the best Tosa line. In these Momoyama paintings of children represented in brilliant costumes the unknown artist undoubtedly was carrying on the spirit of the ancient Tosa *Nenjū Gyōji*, or Ceremonies of the Year, which since the time of Mitsunaga had been part of the repertoire of the Tosa school, but here a new attitude is shown in the gaiety of the contemporary costumes and in the factual representation of the scenes.

Hence, there is evidence that both the traditional schools handled genre subjects. In fact, since the marriage of Motonobu to the daughter of Tosa Mitsunobu it may be assumed that the Tosa technique and point of view were familiar to the Kanō artists and that at the same time the predominant influence of the Kanō masters reacted on artists of every school. As will be seen, such paintings often were not signed, as though the artists of the proud Chinese school hesitated to add their names to subjects of popular interest. Frequently when signed the names are those of lesser men. It seems that the latter were in closer touch with the popular taste, whereas giants like Eitoku, Tōhaku, and Yūshō responded more to the fashion set by the great lords.

Among the earliest Ukiyo-e paintings are Landscapes with People and Shrines on the walls of the Emmanin temple, Ōtsu. The anonymous Kanō artist of the end of the sixteenth century shows in part a crowd of people outside a shrine set in the woods. Details drawn

from life which formerly occurred in the narrative scrolls have developed to the full size of sliding panels and illustrate the love of the time for outdoor parties. So too does a pair of screens called Dancing under the Cherry Trees now owned by the National Commission for Protection of Cultural Properties. Painted by Kanō Naganobu Kyūhaku (1577–1654), the fourth son of Shōei, it may be dated early in the seventeenth century. The figures are still larger in scale, and the strong rhythm of the dance starts a motive which will continue throughout the works of the school. But so much of the art of the Momoyama period has disappeared that it is difficult to trace the origin of the Ukiyo-e school with any consistency.

Another type of subject occurs in a set of Pictures of Crafts kept at Kitain, Kawagoe, which bear the seal of Yoshinobu (1552–1640). This Kanō artist, the grandson of Yukinobu, depicts armourers, weavers, and so on, as they looked in the early years of the century. The subject, however, was a traditional one in the old Tosa school, going back to such an ancient scroll as that called Tōhokuin Shokunin-zukushi Utaawase of 1214.

The names of Naganobu and Yoshinobu have both been suggested as the painters of the genre scenes which decorate the walls of Nagoya castle, completed in 1614. Because of the custom of not signing paintings used to decorate walls, there are no external helps to differentiate one Kanō artist from another. Naganobu and his friend Yoshinobu are those who seem most likely, but Kanō Sadanobu, the son of Mitsunobu, is also supposed to have worked here. Perhaps because the latter was so prominent a member of the Kanō family he may have been titularly in charge. Scenes such as boat-launchings, house-building, and an archery contest show the interest of the artists in realism.

Kanō Naizen Shigesato (1565–1608) has left a painting probably done in 1604 of the

Hideyoshi Festival which was celebrated at the Hōkoku in Kyōto. In this painting swirling masses of tiny figures appear before the shrine of the great Hideyoshi. Shigesato is known also as the artist of a pair of *namban* or foreigner screens now in the Kōbe Municipal Art Museum. The subject of the foreigner, especially the great galleons of Portugal and Spain, fascinated the artists of the period and was repeated many times. Since the galleons which brought merchants and missionaries to the Far East landed at the ports of the southern island of Kyūshū, the artists of Kyōto could only obtain their knowledge second hand from sketches and pictures which have not survived. Like the other genre paintings, the namban were mostly unsigned. The group, however, was a large one and continued to be fashionable until the time of the expulsion of foreigners in 1638.

At times pictures of foreign subject-matter showed a direct copying of the method of oil painting. Perhaps the best known is that now in the Hakone Art Museum of Men and Women playing Musical Instruments.[1] The scene has a landscape background reminiscent of Patinir. Pictures of European knights and heroic figures are known, but the Christian pictures which must also have been painted have nearly all disappeared because of the severe persecution of foreign religions in 1637.

Sporting interest continued to provide a special branch of painting, directly appealing to the military powers. Their taste is reflected in several anonymous Kanō paintings such as the screen Shooting from Horseback owned by the Imperial Family of Japan or the pair of screens called Training Horses, kept at the temple of Daigoji, which shows the young bloods of the time enjoying their mounts. The latter picture has been attributed to Sanraku though without any proof, and probably dates from the Momoyama rather than the early Edo period. Such genre subjects prove the increasing

revival of native traditions and provide the background from which the Ukiyo-e style soon developed. Properly speaking, they reflect the varied interests of the official classes.

A screen of the Fight of the Carriage Attendants by Sanraku has already been mentioned. It is always difficult to know whether to classify such a work as an example of a Kanō artist painting a Tosa subject or whether to assert boldly that such a treatment of human figures, so strongly recalling the ancient Yamato-e, illustrates the budding Ukiyo-e style. As in the preceding paintings, the execution reveals the Japanese spirit as it affected even the official Chinese school of artists.

Perhaps the most famous of all the early Ukiyo-e works is that called the Hikone screen, owned by N. Ii. Attempts made to ascribe it to artists like Sanraku or Matabei have never been generally accepted. Great attention is paid to the costumes in bright colours and bold designs and to the poses of the figures. Actually, however, it illustrates the traditional subject of the Four Accomplishments. Men and women are placed before a gold ground; some are writing, some play the game of sugoroku with black and white counters, others perform on the samisen. In the background is shown a fine screen painting in ink. Extravagant costumes and sensuous lines here fully describe the Ukiyo-e manner. Such leisurely sumptuousness developed only after the military spirit had yielded to one of peacefulness, and such worldly seductiveness was tolerated only when a more vigorous moral code was not so essential to the state. From screens such as these a feeling of calm, gaiety, and charm emanates, replacing the power and virility of the Momoyama age.

Still more intimately related to the spirit of Ukiyo-e are the pictures of the theatre which began to appear early in the seventeenth century and which run parallel with the development of the *Kabuki* or popular stage. A fragmentary scroll formerly in the N. Tsuchiya

collection shows O-Kuni, the female dancer from the province of Izumo, to whom the origin of popular performances is generally traced. In date it is ascribed to somewhere between 1605 and 1615. A little later and far more gorgeous is a Kabuki Theatre scroll now belonging to the Reimeikai Foundation. Associated with the popular stage too are single panels of dancing figures such as the Woman Dancer [159], in the Boston Museum of Fine

159. Anon.: Woman Dancer, early Edo period.
Boston, Museum of Fine Arts

Arts, which must originally have formed one panel of a pair of screens. Parts of at least four sets exist today. In each the outlines of the figures are similar, and yet each set differs in pattern and colour. The best known is the single screen owned by Kyōto Municipality. Here is evidence of a workshop production which in its turn implies that these dancing figures represented the popular demand of the time and provided for a new kind of patronage. The output suggests a parallel with the later work of the Kaigetsudō artists, when there was a sudden production in quantity from a group of artists working under the guidance of one master-hand.

The interest in the early theatre is shown still more directly in pictures of the River Bank at Shijō, also known in several collections. In these are assembled several theatres in which can be distinguished Nō-like plays, puppet shows, rope-climbing acts, juggling scenes, and cages of rare animals. The circus element hardly exists later in art, but in the second quarter of the seventeenth century it was part of the common life which was obviously being painted to please the new patrons.

Another phase of taste is to be seen in definitely sensuous figure paintings with outlines of such writhing contours that the line itself rather than the form is seductive. A painting in the Atami Museum illustrates the customs of prostitutes or bath-house girls known as Yuna. These last two classes of paintings – that is, of the theatre and of low-class women – form the main divisions of the later Ukiyo-e print art when the genre tradition was more strictly the expression in art of the Tōkyō masses.

The artist who has received the most credit for the founding of the Ukiyo-e school was Iwasa Matabei (1578–1650), also known as Shōi or Katsumochi. At one time it was supposed that he had painted the Hikone screen. He was the son of a soldier, Araki

160. Matabei (1578–1650):
Daruma,
Edo period. *Atami Art Museum*

Murashige, who had once served Nobunaga and who had finally to commit suicide. For this reason Matabei was brought up under his mother's family name of Iwasa. Matabei was trained under Kanō Shigesato but was still more influenced by the Tosa style.

Some of his most distinguished paintings like those of the poets Hitomaro and Tsurayuki now in the Atami Art Museum are executed in the broad, free brush of the Kanō or Unkoku traditions. The Daruma [160] also in the Atami Art Museum brilliantly exhibits the power of ink painting in a narrow range of tones. The brush work is neither entirely Kanō nor Tosa in handling but an adaptation of both, individual to Matabei. However, the greatest body of his work is in a manner clearly of Tosa origin, yet very personal and delicate, and, as might be expected, the subjects repeat old themes from the *Genji* and *Ise* tales. Because Matabei lived in the Edo period, mixed with these subjects are others drawn from Chinese legendary sources.

Late in life he lived at Fukui in the province of Echizen where he painted for the daimyo. Through this connexion his fame spread to the shogun, Tokugawa Iemitsu, who in 1640 employed him to make paintings of the Thirty-six Poets for the Tōshōgū temple at Kawagoe. Preceding the signature of the artist are the words 'Eshi Tosa Mitsunobu matsuryū', or 'the artist Matabei of the later current from Tosa Mitsunobu.' No particular Tosa master is named as his teacher, but his indebtedness to the school is clearly affirmed. A self-portrait of Matabei, also in the Atami Art Museum, is said to have been painted in Edo when he was ill and dying. It is his only accepted work in the genre manner.

It is hard to explain why Matabei has come to be regarded as the creator of the Ukiyo-e school. The name of an artist called Ōtsu no Matabei occurs in one of the plays of the great dramatist Chikamatsu, loved by the theatre-goers of Edo. The true style of Iwasa Matabei seems to have been forgotten, while around the name of the other Matabei, a supposed painter of the popular school, legends arose to confuse the two names and to cause the ascription of Ukiyo-e types of paintings to a great independent artist of the Tosa tradition. The patrons of Iwasa Matabei were so high in the social hierarchy that it is hard to believe that Matabei could have created the Ukiyo-e tradition.

Iwasa Matabei's son, Katsushige (d. 1673), is known, however, for paintings of dancing figures. The style is later than that of the group of paintings already mentioned.

The Ukiyo-e school did not stem from any one hand. It arose naturally as the Japanese spirit reasserted itself in very worldly pictures which were made to be frankly enjoyed as part of the pleasure of living. Between the time of Kanō Hideyori's Maple Viewing at Takao and the creation of the Japanese print by Moronobu in Edo there lie nearly a hundred years. During this century, Ukiyo-e painting was quietly practised, especially in Kyōto, while the later developments of the school are almost exclusively associated with Edo and print-making.

PRINT DESIGNERS OF THE UKIYO-E SCHOOL

The stratification of society enforced by the Tokugawa government made possible the emergence of art traditions associated with only one class, even the lowest. The Ukiyo-e style became a popular mode of expression, but it cannot be considered a democratic one. It was not enjoyed by the whole people. The scorn with which the popular prints were regarded by the upper classes explains the extent of the vast collections of prints assembled in Europe and America. To the plebeian class in Japan which enjoyed them the prints were an ever-shifting reflection of contemporary fashions, each decade or so distinguished by a characteristic approach.

That there should have been a print tradition at all, that this tradition should be far grander, more varied, and more sophisticated than any folk art, and that these prints should be acclaimed as one of the most remarkable of art achievements poses a difficult problem. It argues for the homogeneity of Japanese culture, one of the positive and permanent blessings of the shogunate, and it proves the penetration of the civilization through all the classes. That the sons of firemen, superintendents of tenement houses, and embroiderers should be counted among the great artists of the world is not surprising today, but that these men of little education should have arisen in the late feudal age in Japan is only explicable if one admits that artistic sensibility can be quite independent of other aspects of education.

The artist who started the Ukiyo-e tradition of print-making was Hishikawa Moronobu (c. 1625–c. 1695). He was the son of an em-broiderer, a craft in which the drawing of designs was an essential. So the school of popular prints begins with a craftsman who turned from one art to another. It seems unlikely that he had training under any particular painter. His style shows that he studied both the Tosa and Kanō styles as well as paintings in the genre manner. About the middle of the century he moved from the province of Awa to Edo. During his lifetime, the Yoshiwara or gay quarter of Edo reached its height in refined entertainment. The plays of Chikamatsu, the greatest dramatist of Japan, then enjoyed an immense popularity, and Edo actors such as the first Danjūrō gave the roles of his plays a special masculine or even ferocious interpretation. Moronobu, too, was an *Edokko*, or son of Edo, who caught the spirit of his time and portrayed it with a heartiness which won him an enthusiastic public. And it is the spirit of Edo, the newly risen military capital, that separates the popular art of this city from that of all other artistic centres.

Although texts in block print form had existed since 770 and noteworthy Buddhist prints from Heian times on, secular books now required illustration owing to the expansion of education which resulted from the Tokugawa policy of peace. The *Ise Monogatari* of 1608 has sometimes been selected as the first book worthy of notice for its technical excellence. To this the name of Kōetsu is attached as the reputed writer of the calligraphy. Part of its charm was the result of the designs having been printed on pages of differently coloured paper, but except for such technical innova-

tions its illustrations point backward to the Tosa tradition.

In 1658 *Kamo no Chōmei Hōjōki-shō* (An Epitome of a Record of a Ten Foot Square Hut), illustrated by Moronobu, was published, and with this book Laurence Binyon and J. J. O'Brien Sexton begin their history of *Japanese Colour Prints*. The pictures of Moronobu catered for a new public, one which was just ready for a more popular form of literature. His historical position can best be understood in his work as a book illustrator, for he had no rival as an exponent and prolific manufacturer of picture books. It is here that his remarkable sense of spacing in broad patterns of black and white, the creation of a visually exciting page, can be most readily appreciated. The wood cutters who translated his designs faithfully copied the vigour and flexibility of his drawn line, and a new style was brought into being which was aesthetically and technically a marked advance on anything which had preceded.

Some time about 1673 Moronobu is supposed to have produced his first single-sheet prints – what we think of as the ordinary print. His work in this form is exceedingly scarce. Single sheets were not his particular invention, for even as early as 1615 the fall of Ōsaka castle was broadcast by a 'tile print' announcing the event.

Moronobu's art as a print designer is also known in album-sized sheets which could be mounted as scrolls. The most famous set of these is the Representations of the Yoshiwara of 1678. However, the scroll print had a long ancestry. In the Museum of Fine Arts, Boston, is a scroll dated 1626 illustrating the Visit of the Emperor Gomizunoo to Nijō Castle. Still further back it can be traced to scrolls such as the Yūzū Nembutsu Engi dated 1391 in the Muromachi period. In relation to such earlier

161. Moronobu (*c.* 1625–*c.* 1695): Scene at the Nakamura Theatre, Edo period. *Boston, Museum of Fine Arts*

printed Yamato-e pictures it seems quite natural that Moronobu should have prefixed to his name the words *Nippon eshi* or *Yamato eshi* (Japanese painter).

The subject-matter of prints from this time on can be grouped into a few simple divisions reflecting the pleasures and amusements of the common people. Most numerous are the prints of celebrated women of the gay quarters. Next come the favourite actors of the various theatres. For Moronobu's time, perhaps because he was closest to the older traditions, one would have to mention warrior pictures too, drawn from legend and history. These were to have little independent sale in the eighteenth century, but attained enormous proportions in the nineteenth century in the work of Kuniyoshi and others. Subjects drawn from classic literature maintained a more even interest at all times. A special branch of work indulged in by most of the print artists pictured pornographic

scenes in album or book form. As long as the artists kept clear of subjects which might reflect on the reigning power and its policies, they were allowed considerable licence.

Prints made before the invention of colour printing, about 1741, are spoken of as belonging to the primitive period. They were made from black outline blocks. When coloured, the colour was added by hand. Most common was an orange-red which has given the name *tan-e* to prints with this dominant tone. The fashion seems to have lasted through the first quarter of the eighteenth century. Another type of hand-coloured print was called *beni-e*; there the main colour was a rose-red derived from saffron. This colour is said to have been first applied about 1710. But the terms descriptive of hand colouring were very loosely used. Even in the early years of print-making there is apparent a quadruple relationship in the creation of wood-block pictures between designer, publisher, colourist, and engraver. The artists have become internationally famous. But it was the publishers who financed and directed the new medium to suit the new taste. Evidence about the colourists is meagre, although old women are mentioned as being the best. The men who cut the blocks form a fourth group to be remembered in appraising the technical merits of the medium.

Moronobu's vitality and special style are clearly illustrated in his paintings, which are naturally more monumental than his prints. A pair of sixfold screens in the Boston museum shows a Scene at the Nakamura Theatre [161] and a House in the Yoshiwara. Bustling activity and a healthy vigour not only reveal the personality of the artist but go further to show how the people of the time looked on life and found its pleasures enjoyable. The same attitude can be found in a painted scroll in the Tōkyō National Museum. Here, various short horizontal pictures have been mounted together, and as they are dated from 1672 to 1689, they

form a series in which to follow the development of Moronobu's style.

It is in the field of painting, not prints, that Moronobu's school can best be studied. His eldest son, Morofusa, eventually gave up art to return to the dyeing business which was closely related to the former business of the family. Moroshige, his best direct pupil, is especially known for his book illustrations. After the time of the latter's son, Moromasa, the school degenerated. But perhaps before this account is concluded mention should be made of a precocious woman painter, Yamazaki Joryū, who was strongly under the influence of Moronobu and who worked in the first quarter of the eighteenth century.

The main line of the Ukiyo-e tradition of actor portrayal started with the Torii family. Kiyomoto, the father of the first print-maker, was an actor of female roles and also a painter of theatre posters. It is definitely known that he designed the sign-board of the Ichimura theatre in Edo in 1690. His son Kiyonobu I (1664–1729) came with his father to Tōkyō in 1687, and in the same year began illustrating books which show the influence of Moronobu. The close connexion between the family and the stage gave rise to a very special style of rendering. Bold line, which was a necessity in the painting of sign-boards and which appears also in the theatre playbills, was taken over into the field of prints, especially for the large size, single sheets of actors, the first appearance of which can be dated to about 1695. The following quarter-century which includes most of the large primitives from the hands of Kiyonobu I, Kiyomasu I, the Kaigetsudō artists, and Masanobu is one of tremendous force. The marshalled rhythms of fluent lines aided by simply spaced and massive flat patterns with or without hand colouring cannot fail to arrest the eye. Such prints were made to advertise.

162. Kiyomasu I (1694–1716?):
A Famous Beauty,
Edo period. *Art Institute of Chicago*

In the second generation of the Torii family Kiyomasu worked in a style so close to that of his father Kiyonobu I as to be almost indistinguishable from him. At times his line appears to be more subtle, elastic, and attractive. In Kiyomasu's black and white print of A Famous Beauty [162], in the Art Institute of Chicago, is combined a twisted pose, strong, tapering, outlining brush strokes, and a rich patterning in blacks, which make the prints of this period notable. Primitive they may be in relation to more realistic effects achieved later, but in the elimination of non-essential detail they are masterpieces of sophistication.

Some of Kiyomasu's best work is to be seen in horizontal compositions of theatrical scenes with two or three figures, which can be dated to the years 1715 and 1717. Their designs have an interrelationship between the figures which if not dramatic is certainly narrative. In contrast with later actor prints, where several figures are more often united by a purely pictorial background and where individual pose and expression are more emphasized, the earlier prints are closer to the spirit of the lateral composition of the older Yamato-e masters.

Many prints by Kiyonobu I and Kiyomasu I have a kind of hand colouring called *urushi-e* or 'lacquer picture' technique, in which the black tone has been thickened with glue to give a lustre stronger than that normal to ink. The surface may be further enriched by particles of brass filings for a sparkling effect which the Japanese were accustomed to see in the coloured patterns in gold dust or flecks on so many of their screen paintings, albums, and works in lacquer. It is a peculiarly national taste in decoration.

The lineage of the Torii family only mentions one·Kiyonobu and one Kiyomasu. Dates on the Torii tombstones, where Buddhist death names appear and not the artists' names, have been worked out to give the following genealogy:

Kiyonobu I (1664–1729), the father
Kiyomasu I (1694–1716), son
Kiyonobu II (*c.* 1702–52), son
Kiyomasu II (1706–63), son-in-law

And there is the possibility of another son who has been called 'the elder brother of Kiyonobu II' and who could have been active *c.* 1717–24. The problem of the usage of the Kiyonobu and Kiyomasu names is too complicated and too far yet from a solution to go into further. One of the difficulties is illustrated by the fact that some of the signed works of Kiyomasu I can be dated to the year after his reputed death. The works generally assigned to Kiyonobu II and Kiyomasu II carry on the tradition but with less vitality. Other artists who followed the Torii style during the primitive period were pupils of Kiyonobu I such as Kiyotada, Kiyoshige, and Hanegawa Chinchō. Chinchō is interesting as the first case of an artist originally of samurai rank who turned to the popular standards of the Ukiyo-e school.

Another puzzling group of artists are the Kaigetsudō. The five or six artists of this group have a style so absolutely identical that their work has occasionally been referred to as that of a single hand. Kaigetsudō Ando was undoubtedly their leader, though he remained always a painter and never made prints. Their work ceased soon after Ando was banished to Ōshima in 1714. The Kaigetsudō applied the heavy, sign-board line of the Torii style to paintings and prints of courtesans whose dress patterns command attention with obtrusive charm. To us they appear like fashion plates, but in the context of their time they advertised the seductive poise and unparalleled magnificence of the popular entertainers and carried their fame and beauty to a wider public than could afford the pleasures of the Yoshiwara. Large upright prints are excessively rare among the works of the Kaigetsudō artists. Fortunately, the vivid costume paintings of the school, such

163. Kaigetsudō Ando: A Beauty,
Edo period, c. 1710. *Boston, Museum of Fine Arts*

The life of Okumura Masanobu (1686–1764), the most important rival of the Torii family, ended just before the invention of the full colour or polychrome print in 1765 and covered a wide range of experiments in the history of the development of the wood-block process. His early work showed strongly the influence of the first Kiyonobu. Dating from the first decade of the eighteenth century is a series of horizontal album-sheets in ink. The theatre, the Yoshiwara, historic legends, and parodies of classic themes all offered subjects for his precocious genius. His line, though lacking some of the force of that used by the Torii, showed more restraint and dignity.

Some authorities ascribe to Masanobu the invention of the urushi-e. After he set himself up as a book publisher, he himself claimed to have originated one style of Ukiyo-e print, but it is doubtful if this event took place as early as 1710 when the first urushi-e seem to have been published. To Masanobu, too, is attributed the invention of the narrow *hashira-e* form, the so-called pillar print. This took place about 1740. From about the same time the *uki-e* or pictures with perspective backgrounds appeared for a few years, and those of Masanobu are the best in the early period. In the Ukiyo-e world, where one craze followed another rapidly, the search for novelty brought about many short-lived specialities and curiosities inspired by technical research. Sometimes designs with lines picked out in white against black were experimented with. Nishimura Shigenaga (1697–1756) made direct use of this Chinese technique of 'stone prints', the design showing entirely in white against black.

Many of the fashions of the period suggest influences coming from Chinese prints. The perspective picture must be thought of as deriving from this source, as there is no evidence of direct foreign or European influence at this time. The stone print certainly is an oddity in the field of Japanese print history, but

as the Beauty [163] by Kaigetsudō Ando in the Boston museum, surpass the prints in quality as well as quantity. The style had many imitators, among whom may be mentioned Baiyūken Katsunobu and Matsuno Chikanobu.

164. Masanobu (1686–1764): Lovers, Edo period. *Boston, Museum of Fine Arts*

was natural in China where prints were mainly used to reproduce famous paintings. The book *Minchō Shiken* published by Shunboku of Ōsaka in 1746 marks the popularity of Chinese bird and flower paintings at the time, but the purchasers of such a book doubtless were not the same as those who patronized the Ukiyo-e print.

But the most important development was the invention of the two-colour print which seems to have occurred in 1741 or 1742. A publisher, Kamimura Kichiemon, is given credit for the solution of the problem of registering the colour blocks. An abortive start in the art of colour printing had been made in 1730 with a book called *Chichi no On* to commemorate the actor Danjūrō I. The illustrations were made from designs by Itchō and Haritsu, the latter a lacquerer and painter who here showed that he was interested in the art of printing as practised in China. The two-colour technique when it really appeared brought an immediate modification in style. The earlier boldness of patterning was replaced by one of tiny areas of contrasting colours in a taste essentially Japanese. Delicacy and soft colouring characterized the new prints, and Masanobu quickly followed the mode. The Lovers, O-Shichi and Kichisaburō [164], in the Museum of Fine Arts, Boston, wonderfully preserves the freshness of the dominant pink tone, which contrasts with patches of pale green and still lesser areas of solid black. When such prints are in good condition, there is so strong a colour vibration that one is entirely unconscious of the very limited palette. In both the urushi-e and the *benizuri-e*, as the new colour prints were called, Masanobu continued to produce vertical prints surpassing in quality most of the Kakemono figure paintings of the period.

The closest rival of Masanobu was Ishikawa Toyonobu (1711–85). Early in life he called himself Nishimura Shigenobu, but about 1747 he changed his name to Toyonobu, and is famous under both names. From his pillar prints it is certain that the two-colour print did not suddenly and entirely replace the older urushi-e hand-coloured print.

Soon the two-colour print also underwent changes. The delicate grass green of the first prints gradually changed to a thicker green. Then in about 1755 a third colour block was added, and a little later a colour scheme dominated by brick red came into fashion.

The leading artists of this transitional period were Toyonobu and the two Torii artists, Kiyohiro (active *c*. 1751–*c*. 1760) and Kiyomitsu (1735–85). The nudes done by the first two artists are exceptional in the whole field of Japanese art. The best works by Kiyomitsu, the man who was called the third generation of the Torii family, were his actor prints of *ōban* size (about fifteen by ten inches).

It is now necessary to go backwards, to two artists who are hardly represented in prints, and to the achievements of Ukiyo-e artists who specialized in painting. The first, Miyagawa Chōshun (1682–1752), made no prints, yet he was pictorially the ancestor of Shunshō, the most prolific designer of actor prints in the second half of the eighteenth century. Chōshun came as a child to Edo and fell under the influence of Moronobu's works. Although many of his paintings are of beautiful women, the type for which the Kaigetsudō artists were so acclaimed, his style had more breadth and more subtle colouring. His fame as a colourist drew the attention of the Kanō artists, and Chōshun was employed by them to repair the tombs of the Tokugawa family at Nikkō. At some time there was a fight between Kanō Shunga, who was in charge, and members of Chōshun's family, for which Chōshun was for a short while exiled.

His scroll of Theatre Scenes, in the Tōkyō National Museum, has a brilliance and strength of colour which make it one of the masterpieces

165. Chōshun (1682–1752): Lion Dance,
Edo period. *Boston, Museum of Fine Arts*

in painting of the school. The illustration of
the Lion Dance [165] in the Boston museum
shows another scroll by him which at once
challenges comparison with works by such a
Kanō artist as Hanabusa Itchō. Under the
social system of Japan, Ukiyo-e artists acquired
prestige more easily as painters than they could
as print designers. The old scroll form some-
times favoured by artists like Chōshun had
the further advantage of presenting a contin-
uous panorama of contemporary life which,
owing to space limitations, was impossible in
prints. It was a more classical treatment, and
both in line and in content possessed more
refinement than the work of the print artists.

Nishikawa Sukenobu (1671–1751) would
hardly be known as a great Ukiyo-e artist were
it not for his book illustrations and paintings.
Single-sheet prints by him do exist, but they
are extremely rare. He lived in Kyōto, the old
capital, where the classic tradition was ap-
parently too strong to allow the Ukiyo-e print
to flourish. He first studied under Kanō Einō
and Tosa Mitsusuke, and, perhaps just because
he was of Kyōto, which was still regarded as
the centre of fashionable taste, supplied a new
stimulus to the artists of Edo.

The painter of the Literary Men's school,
Ryū Rikyō, once wrote that among Ukiyo-e
artists Hanabusa Itchō was good and though
there were also Okamura Masanobu, Torii
Kiyonobu, Hanegawa Chinchō, and others,
the only one who really excelled as a painter
was Nishikawa Sukenobu. Illustrations from
his books show that he emphasized feminine
grace and domestic types. In Ōsaka the artist
Tsukioka Settei (1711–86) a little later was
likewise turning from a Kanō training to the

exposition of the popular style in paintings. But there was no city which could rival Edo in the production of prints.

The next great development was the beginning of the true polychrome print or *nishiki-e* in 1765. Some further technical improvement, credited to an engraver named Kinroku, perfectly solved the problem of exact registration for many superimposed colours.

The new technique appeared first in a special type of calendar-print in which the cyclical characters used to denote years in the sixty-year cycle of the Chinese and the numerals designating the succession of the long and short months were hidden cleverly in the design. Sporadic examples of these calendar-prints can be traced to the primitive period. Now they became a fad. Perhaps because of the difficulty of registration the size of the new prints was reduced to the *chūban* form measuring approximately eleven by eight inches. At the same time, the care required to print the many colour blocks forced a wild increase in price. It has been estimated[1] that in Harunobu's time the usual *hoso-e* or small, narrow print cost twelve mon, the ōban twice that amount. One of Harunobu's chūban would sell for nearly twelve times as much as a hoso-e, while such a set as his Zashiki Hakkei, Eight Interior Scenes, in a box cost one bu. The actual value of one bu can be estimated as one-quarter of a koku of rice, the contemporary medium of exchange, or as equalling four or five days' wages for carpenters or plasterers.[2] The amount is difficult to equate in pounds and pence, but it suggests a figure far above ordinary middle-class spending power. The full colour prints issued in chūban size were accordingly twelve times as costly as the older two- and three-colour prints, an increase in price which implied a corresponding change in patronage. Such prints were no longer souvenirs or keepsakes, but had now become expensive objects of art to be enjoyed by an intellectual group which possessed the money with which to encourage their production.

Many of the calendar-prints have inscriptions ending with the word *kō* which, it has finally been settled, means conceived. Often the word *renjū* (group or association) precedes, so that we get the sense that some member of an art club contrived the idea executed by Harunobu or other artists. The prints were then distributed among the group. Pride of craftsmanship is apparent in many, for we find several sheets which include the names of the printer and engraver as well.

It must have been a stirring time among the artists of various schools. Soon after the invention of the polychrome print an early artist of the Literary Men's school, Sō Shiseki, made a few prints using the new technique in calendars for the years 1768 and 1770. As an artist with different traditions behind him, it is possible that the very Chinese manner visible in his work correctly suggests one of the ways in which this tradition came to have momentary influence in Ukiyo-e circles. The *Mustard Seed Garden*, originally published between 1679 and 1701, was certainly known to some editors in Japan and aroused interest. This is the time, too, when Jakuchū, the naturalist painter, made a set of bird and flower prints which are best known in popular reproductions of the Meiji period but which were first printed in 1771. Artists from other schools of painting experimented with the new print technique soon after its introduction, but their influence did not make much impression, so firmly were the standards of the Ukiyo-e established in the popular mind.

The artist who first really exploited the polychrome print was Suzuki Harunobu (1725–70), and he in turn developed through its usage, captivated the world of the print artists, and attained a leadership such as was not matched at any other time. The last six years of his life are among the most remarkable in

166. Harunobu (1725–70): Boy, Girl, and Viewing Glass, Edo period. *New York, Metropolitan Museum of Art*

the history of Ukiyo-e. In contrast his work, before he was forty, seems to have had no significance. His earliest known work is an actor print of Danjūrō IV of about 1754 or 1755,[3] and shows little distinction. That he was interested in technical experiments can perhaps be judged from his prints of the kind called *mizu-e* (literally, water prints) in which the outline block is faintly printed in colour, giving an effect of extreme delicacy. These prints are generally dated slightly before or after 1760. The influences apparent in his early work derived not from his reputed master Shigenaga but from Toyonobu or from the Torii artists. In 1765 he blossomed forth with the first of many calendar prints. Between this year and his death he made more than five hundred prints outstanding for beauty of line, subtlety of sentiment, and a most delicate colour harmony.

The ability to portray idyllic love delighted Harunobu's generation. In this line he has remained supreme. The rare print of a Boy, Girl, and Viewing Glass [166] from the collection of the Metropolitan Museum in New York belongs to a set of the Six Tama Rivers. It is easy to imagine that this simple peep-hole and mirror was an imported novelty of the time, about 1766, and the upside-down landscape which is reflected in the mirror is an extremely early example of pure landscape. But to Harunobu the instrument is a mere detail in a picture. The square label which gives the title as the Tama River of Mount Kōya and quotes a poem by Kōbō Daishi is likewise but scantily related to the major theme of the interest of boy and girl.

So tremendous was Harunobu's success that immediately after his death an imitator arose in Shiba Kōkan (also called Harushige).[4] Kōkan's curious mind showed another facet of the lively artistic research of the time; for after a stay at Nagasaki, the only port open to foreign influence, he produced, in 1784, a copper-plate landscape in perspective.

Because Harunobu became so pre-eminent, it is interesting to compare him with Sukenobu. The themes selected by the two artists are almost identical. The books of the older Kyōto artist were popular in Edo and undoubtedly exercised a great influence on Harunobu. The typical Harunobu interior showing a girl doing her hair before a mirror or playing a koto or stretching the cloth of a dress on a frame to dry all appear in the books of Sukenobu. From this point of view it is possible to say that Harunobu lacks originality of thought; but then one sees the force of his rendering and emotion. By the addition of a background, by the interplay of curving figure lines against straight lines – the same juxtaposition that existed in so many medieval scrolls – and by the delicacy of rather neutral colours the effect becomes a sympathetic picture far beyond the powers of Sukenobu's simple book illustrations.

Next to the chūban, Harunobu's best work is to be seen in hashira-e. The slender forms of his youthful, dreamy figures represent some of the triumphs of Ukiyo-e composition. In this field his pupil Isoda Koryūsai (active 1764–88) rivals if he does not surpass his master. Koryūsai belonged to the military class, and though he was a *rōnin*, a soldier without an overlord, it is still remarkable that a man with his background should have sought fame as a print-maker. Especially distinguished are his bird and flower pictures in chūban form. The fragile delicacy of Harunobu's style soon passed out of fashion; in Koryūsai's works the figures became more plump and worldly. His biggest undertaking was a series of ōban called New Patterns for Young Leaves which was begun in about 1776. This series of 'beauties' consists of about one hundred prints, and was so popular as to be continued by Kiyonaga.[5] Koryūsai's activity in the field of prints lasted till about 1780, when he turned more to painting, an evolution repeated later by Eishi, another print-maker of samurai origin.

The year 1765 is still further noteworthy in that it saw the first of the new style of actor prints which began with Shunshō and his contemporary Bunchō. Hitherto, the business of supplying prints of actors had been led by artists of the Torii family, but their style had become stereotyped. The name of the actor and often the role as well were inscribed on the print. In the new realistic spirit the portrayal became so individual that the theatre-loving purchaser required no label to inform him of the name of his hero.

Mamoru Bonchō's career extended from 1766 to 1790, though the first ten years really cover his best known prints. In his early work the influence of Harunobu was predominant, but he was original in his colour scheme and in the poses of his figures. The combination of orange and green tones gave an acid colouring to his prints which harmonized well with the weird and aloof expression of his figures. Like Harunobu, he was fond of representing the celebrated tea-house waitress O-Sen, but he is best known for actor prints. In 1770 he and Shunshō co-operated in a book of actor portraits called *Ehon Butai Ōgi* (Picture Book of Stage Fans), which is one of the finest of colour-printed books. In this work he is often praised more than Shunshō, but the latter will always be more associated with the prints of actors, as he founded the Katsukawa school which included such famous artists as Shunkō, Shunjō, Shunei, and Shunrō, an early name used by Hokusai.

Katsukawa Shunshō (1726–92) was the pupil of Shunsui who had been taught by Chōshun, and this may in part explain Shunshō's twofold greatness. While on the one hand he may be regarded as the creator of the new type of actor prints, his paintings which are so little known to the print world are the best in the second half of the century. In his prints he deals almost entirely with actors. In painting he is famous for his beautiful women.

In theatre prints Shunshō continued the hoso-e form, but with a new emphasis on triptych and even pentaptych sets. He is probably also to be credited with the first large portrait heads, a fashion greatly prized in the last decade of the century. In a series of ten such heads done on fan shapes in about 1776 Shunshō created a type of portraiture which was at once timed to the realism of his period and suggestive of future developments. His interest in the theatre was further expressed in views of actors' dressing-rooms.

Shunshō made almost no prints of beautiful women, but one kakemono-e called the Pink Lady represents with graceful line the quiet charm to be found in his paintings. The book *Seirō Bijin Awase Sugata Kagami* (A Mirror Reflecting the Forms of Fair Women of the Green-Houses) of 1776 in which he co-operated with Kitao Shigemasa contains superb illustrations of the robust type of beauty which was popular from about 1775.

But it is in his paintings that Shunshō shows his ability as colourist and designer. The Seven Women of the Bamboo Grove in the Tōkyō Geijutsu Daigaku, a parody on the old Chinese subject of the Seven Sages of the Bamboo Grove, portrays the costumes of the merchant class of his time. The most famous of his paintings is a set of twelve pictures of women engaged in activities appropriate to each of the Twelve Months, now in the Atami Art Museum.[6] Elaborate architectural and landscape backgrounds mark these paintings off from the rather trivial background treatment apparent in his actor prints. In such works Shunshō reverted to the attitude of earlier Ukiyo-e masters, and escaping from the restricted interest of the theatre or of the beauties of the licensed quarters created true genre paintings of the life of his time.

Not many of the Ukiyo-e artists, however, can be appreciated as much for their paintings as for their prints. Men of military extraction

like Koryūsai and Eishi were prolific painters, a fact which in itself indicates the higher social esteem in which painting was held. Harunobu, on the other hand, made few paintings. In the case of Kiyonaga the strength of brush work apparent in both his prints and his paintings proves him to have been a student of the particular quality of line of the Kanō masters. As a Torii artist he occasionally had to paint theatre advertisements and votive paintings. Later masters like Utamaro and Toyokuni I, Hokusai and Hiroshige all painted. The latter two artists also made notable sketches, but the paintings of Hiroshige hardly suggest the supreme tonal relations which occur in his prints. One is here reminded that however great these men may have been as designers, much of the quality of the prints was due to the abilities of the colour printers and engravers.

The most brilliant of Shunshō's pupils was Isoda Shunei (1768–1819), who was at the height of his powers from about 1791 to 1795 and who influenced both Sharaku and the first Toyokuni. Sometimes the fashion for large portrait heads of actors is traced back to his Yaozō III of 1787. His special contribution lay in his psychological insight and the individual characterization he gave his portraits.

A lesser personality of the period was Kitao Shigemasa (1739–1820), the son of the book publisher Suharaya Saburobei. Shigemasa has already been mentioned as Shunshō's collaborator. He started life with more promise than Shunshō, but he only succeeded in imitating whatever style was most fashionable at the moment. Among his pupils were Kitao Masanobu, Kitao Masayoshi, and Kubo Shunman.

Kitao Masanobu (1761–1816) was even better known in the field of Japanese literature (as Santō Kyōden) than he was as a print designer. The finest of his prints is the Call of the Cuckoo, which shows both the influence of his master Shigemasa and the rivalry which he momentarily offered Kiyonaga. An oversize horizontal print, its composition recalls the figure designing of medieval Yamato-e scrolls. This strange man, whose portrait was done by Eiri, made his living at times by running a tobacco shop, a drug store, and a cake shop. About 1789 he gave up art for the writing of novels and comic poems.

Another member of the Kitao school was Masayoshi (1792–1824), also called Kuwagata Keisai. He illustrated over one hundred and sixty books and did a few nishiki-e. At times a light and racy outline which he adopted from a study of ancient scrolls carried on the old humorous and narrative method of drawing. In his book of 1790, the Kaihakurai Kinzui (A Collection of Foreign Birds), the bird and flower prints show the precise realism of vision currently in favour. Before the end of the century he too, like other members of the school, gave up prints for paintings.

Kubo Shunman (1757–1820) was probably better known in his lifetime as a poet than as an Ukiyo-e artist. Artists whose styles apparently became unpopular and whose works may not have sold to the satisfaction of their publishers often had to give up print-making. Late in his life Shunman devoted himself to poetry and to surimono. The latter were elaborately printed with gauffrage and imitation gold and silver dust on special paper and were inscribed with short poems by the literary men of the day. In his prints he may be reckoned as a follower of Kiyonaga; yet in such triptychs as the Picnic beneath Cherry Blossoms and Street Scene at Night he reveals a love of nature far removed in feeling from anything which Kiyonaga created.

Another school which started in the late eighteenth century was the Utagawa. Toyoharu (1735–1814), its founder, revived an earlier fashion and made a speciality of perspective prints or uki-e. The presentation of a single vanishing point was one aspect of the 'Dutch learning' being studied by the curious, while

specialization of subject or manner occurred in both the Ukiyo-e school and the Maruyama school. Toyoharu also did many paintings of beauties and distinguished himself for the gaiety of his colour and the clarity of his outline. He should be remembered further as the teacher of Toyohiro, from whom Hiroshige descends, and of Toyokuni, whose school continued through the greater part of the nineteenth century.

The culmination of the colour print – a new mastery of the wood engraver's technique, a wide range of colours applied with utmost harmony, and figure drawing which combined naturalism and line composition – was reached in the works of Torii Kiyonaga (1752–1815). Adopted by Kiyomitsu, he became the head of the fourth generation of the Torii family. Though he had on this account to carry out the job of painting signboards and producing playbills, his main achievements ran counter to the tradition of actor prints. The period of the eighties marked the development of his greatest powers, and at this time he dominated the field of prints of famous beauties as Harunobu had before him. For some reason, after about 1792, when he was only forty years of age, he almost ceased to make notable prints.

In *Kiyonaga*, a book of much greater range and depth than the simple title suggests, Miss Chie Hirano wrote: 'The epoch-making years of the Ukiyo-é school were 1783, 1784, and 1785, when Kiyonaga produced his most admirable types of women. It is almost incredible that this son of a superintendent of tenement houses near a large fish market, living among people of the lower class who, even when wealthy, could scarcely boast of any great culture or high ideals towards life but indulged themselves in every kind of worldly luxury available – it is almost incredible that he could have produced such a noble, pure, and healthy type of female figure.' She added: 'His ladies of high birth look nobler and more dignified than those by Hosoda Eishi, who really was a *hatamoto* [a direct retainer of the shogun] and who in his young days served as an attendant to the shogun in the latter's practice of painting.'

The large diptychs and triptychs which Kiyonaga designed and made popular in the early eighties make the hoso-e prints of Shunshō and his followers seem thin by contrast. The engravers of Kiyonaga's prints showed unsurpassed skill in their ability to cut hair lines of excessive fineness, and the printers could now place one colour over another so as to reveal the tone of an under-garment beneath a thin outer robe of differing colouring.[7] The processional composition of Kiyonaga was well adapted to the slow motion and quiet dignity of his figures. But Kiyonaga showed his mastery further in placing around many of his figures a natural setting, frequently architectural. The Party to See the Moon across the Sumida River [167], in the Boston Museum of Fine Arts, made in 1787, achieved a perfect balance between the foreground figures and the airy, realistic, perspective background.

In such series of prints as Tōsei Yūri Bijin Awase (A Contest of Fashionable Beauties of the Gay Quarters), executed between 1781 and 1784, and Fūzoku Azuma no Nishiki (Beauties of the East as Reflected in Fashions) of about 1783 to 1785 – each consisting of some twenty large prints including diptychs – the mature and stately types of Kiyonaga's ideal of feminine beauty mark a notable contrast with the lyrical and delicate types of Harunobu before him and with the more passionate or motherly types of Utamaro after him. The breadth, richness, and power of his style in the Temmei period (1781–8) made it all but impossible for his contemporaries to escape from his influence. As with Takakane in the field of emakimono, the culmination of a tradition had been attained.

Kitagawa Utamaro (1753–1806) developed slowly like Shunshō. One of the peculiarities of

167. Kiyonaga (1752–1815): Party to see the Moon across the Sumida River,
Edo period. *Boston, Museum of Fine Arts*

the Ukiyo-e print-makers was the way that some suddenly emerged comparatively late in life as great artists while others, having achieved fame, just as suddenly disappeared from the field. It was not until the practical retirement of Kiyonaga that Utamaro, then aged thirty-nine, fully developed his powers. Among his earlier works his book of *Insects* of 1788 was an innovation which united keenness of observation and delicacy of colour printing in the field of nature studies. Nothing like it had been seen before. Here was none of the symbolic naturalism which descended from China but rather the point of view of Japan's own naturalistic school of painters, the Maruyama, and a rendering which was indebted to the style of Sō Shiseki. It serves as an introduction to the bird and flower prints which were to follow in the work of Hokusai and Hiroshige.

In technique, the prints of beautiful women by Utamaro showed many new developments. As a *tour de force* of printing there are the pictures of the beauties O-Kita and O-Hisa, each printed on both sides of a piece of paper in such a way that the main outline block was identical for front and back views. In 1793 Utamaro made use of mica grounds in prints of famous beauties which rivalled in extravagance and quality the actor portraits of about the same time. Another contrivance of his was a two-tiered triptych of six prints issued in 1798 of a view of the Ryōgoku Bridge with a promenade of women on the upper half and a group of boating parties below. In other prints such as the triptych of the Shell Divers he used a pink outline to increase the realistic representation of flesh.

Utamaro was the greatest artist of womanhood. Especially distinguished were his half-length portraits of women, effectively beautiful as types rather than as individuals. In the distribution and depth of his black tones he showed himself a master of design. His sets of the Physiognomies of Women of 1794 marked a new step in the observation of women's moods. His diptych of a Kitchen Scene with a yellow background is centred round a steaming kettle, and his interest in women's occupations is again notably successful in an album of twelve sheets of continuous design showing the

168. Utamaro (1753–1806): Catching Fireflies, Edo period.
Boston, Museum of Fine Arts

tasks connected with silk culture. Nor has any other Japanese artist handled the tender relationship of mothers and babies so ably and yet without sentimentality. His triptych of Catching Fireflies [168], in the Boston museum, illustrates his refinement and elegance with figures of exaggerated height whose bodies bend and whose garments sway with the same slender grace as the willow tree above them. A happy moment of summer-time holds attention more than the seductiveness of the women.

At the end of his life in 1806 Utamaro portrayed subjects dealing with the story of Hideyoshi,[8] and infringed upon the law governing the use of names and crests of important people on prints. Ukiyo-e art was expected to be respectful towards the great families of Japanese history, and for his temerity Utamaro was imprisoned for a short time.

The last decade of the century produced extraordinarily fragile types of feminine beauty by Chōki and Eishi and equally great actor prints by Sharaku and Toyokuni. What little is known of Momokawa Chōki's biography is very confused. He probably began life as Shikō,

made his greatest prints as Chōki, and then reverted to the Shikō name, but the contradiction of dates connected with his use of names has given rise to the theory that two artists were involved. The Chōki who was active in the last decade of the century, roughly the Kansei period (1789–1800), was a rare and singularly elegant artist. He has left several triptychs of boating parties, where the women possess a delicate yet noble poise, but he was neither prolific nor always of even achievement.

Hosoda Eishi (1756–1829), another artist eminent in the last decade of the eighteenth century, came from a military family, and gave up his position in order to make prints. His slender and unsubstantial beauties mark the beginning of the decline; yet some of his work, in which the almost complete absence of reds gives a new colour scheme of cool tones, was an original convention. Eishi began to use this scheme at some time just before the last decade of the century.

The career of Saitō Sharaku flashed across the Ukiyo-e world for a brief ten months. Without artistic past or future his prints of

169. Sharaku (active 1794–5): Mitsugorō II, Edo period. *Boston, Museum of Fine Arts*

actors appeared first for a play given in the fifth month of 1794 and ended with another given in the first month of 1795, during which time he made at least one hundred and thirty-six prints. Explanation of such a phenomenon in the face of a dearth of any biographical data can only be based on conjecture. But it does seem reasonable to suppose that Sharaku as a facile draughtsman or caricaturist was discovered by the publisher Tsutaya Jūsaburō who was also the patron and publisher of many of Utamaro's finest prints. Jūsaburō would in any case have seen to the cutting of the blocks, and the extravagance of the colour printing was likewise the publisher's responsibility. About all that is known of Sharaku is that he was a Nō actor in the service of the daimyo of Awa and that his prints were said not to have been popular. As the retainer of a military lord he must have been an incongruous figure among the actors of the kabuki or popular stage.

Certain it is that his portraits of actors are frank to the degree of being cruel. The portrait in the Boston museum of the actor Mitsugorō II [169] as Ishii Genzō, the relative and aide of the Soga brothers in a famous story of revenge, possesses all the intensity and weird draughtsmanship which were so habitual with Sharaku. The peculiar simplification in both faces and figures is easy to imagine as displeasing to at least a portion of the actor-worshipping Edo populace. There is no trace of idealization as Sharaku visualizes the actor in his role, and yet he has created the most penetrating, if slightly perverse, studies of the heads of Japanese actors. His half-length figures against the silvery sheen of a mica ground are the most extravagant undertakings in the field. Late in 1794 a governmental edict prohibited the use of mica, and many of the later prints have a simple yellow ground, a fashion which had gained popularity in 1788 when such grounds were used by Kiyonaga. Sharaku fortunately had few imitators, for his exaggerations, when

attempted by lesser personalities, produced gross and vapid renderings as in some of the work of Toyokuni I and Kunimasa I.

Utagawa Toyokuni I (1769–1825) produced his best work in rivalry with Sharaku. His set of actor prints with the title Yakusha Butai Sugatae (Stage Representations of Actors) appeared between 1794 and 1796, and show him at the height of his powers. In pictures of women, too, he was for a time equally successful. His diptych of Boys gesticulating before a Black-lacquered Wall and the triptych Seven Women of the Bamboo Grove, in which one woman is falling over from the effort of pulling out a bamboo sprout, show an increasing interest in action which in his hands was soon to become melodramatic.

With Toyokuni I the great days of the figure print came to a disappointing end shortly after the turn of the century. The degeneration which affected all the artists of this period is hard to explain. Probably the publishers, who should be credited with many of the advances of the school, must also be held responsible for the sudden lowering of taste.

The artist whose life linked the creative activity of the past with that of the future was Katsushika Hokusai (1760–1849). Like his master Shunshō, he developed slowly. As Katsukawa Shunrō he worked at actor prints till about 1794. Two years later he took the name Sōri, and some time about 1798 added the name Hokusai to his signature. In the same year he also began signing his works Kakō and made several charming prints of beauties and a series of ghosts. In all he used some twenty different names.

In 1798 Hokusai did, in a semi-European style, a tiny set of Eight Views of Edo which foreshadowed his interest in landscape, the type of work for which he is universally famous today. But it was not until some time between 1823 and 1829 that his Thirty-six Views of Fuji (actually forty-six prints) appeared. No

artist before Hokusai had shown such direct observation of the national landscape, and with this set a new phase of Ukiyo-e art was born. Here was true landscape art as seen by a man with a lively human sympathy. His dramatic composition is well shown in the Wave which towers above a small Fuji in the background, or in the Thunderstorm where lightning breaks across the base of the mountain, or in the Fuji seen from Mishima Pass where a group of people stretch their arms around a giant tree in the foreground. Mannered his style may be at times, but Hokusai was an artist who was above all appreciative of form in art and who depicted local scenery with such truth, colour, atmosphere, and startling imagination as to make his prints of landscape a novel artistic creation only rivalled in their own field by his contemporary Hiroshige.

Equally distinguished and dating from the end of the 1820s are sets of Bird and Flower prints which possess the same quality of dramatically poised beauty as the landscapes. In them a branch of art which had so often been favoured in the past by Japanese painters asserted its right to an independent existence in the wood-block medium. The Imagery of the Poets of about the same time, a set of ten, vertical, two-sheet prints, is often selected as his best work. While it is impressive, the drawing of the figures is done with a nervous line which Hokusai had created and which disturbs the quiet of the spacious setting.

For illustration a sketch has been selected called Setting Up a New Year's Tree [170] from a Night and Day series in the Boston museum. Hokusai has caught with his candid-camera eye the restless life of Edo with town

170. Hokusai (1760–1849): Setting Up a New Year's Tree, Edo period. *Boston, Museum of Fine Arts*

criers, night stalls, and pilgrims, and placed them in artistically interesting space relations. The same style appears in his sketchbooks, the *Hokusai Mangwa*, which started to come out in 1814 though the fifteenth volume was not published until 1878. Nothing was too trivial to jot down, and a better record of a man's cleverness with a brush hardly exists. If at worst he possessed the spirit of a charlatan or virtuoso, at his best he must be credited with an amazing variety of output of fine quality from his Shunrō actor prints and his Kakō prints of beauties to his landscapes.

When he was seventy-five Hokusai said of himself: 'Since the age of six I have had the habit of drawing forms of objects. Although from about fifty I have often published my pictorial works, before the seventieth year none is of much value. At the age of seventy-three I was able to fathom slightly the structure of birds, animals, insects, and fish, the growth of grasses and trees. Thus perhaps at eighty my art may improve greatly; at ninety it may reach real depth, and at one hundred it may become divinely inspired. At one hundred and ten every dot and every stroke may be as if living. I hope all good men of great age will feel that what I have said is not absurd.'[9] Such energetic expression and ceaseless ambition well describe his life and art.

Among Hokusai's pupils Hokuju, who was active from about 1802 to 1834, has left many interesting landscape prints. Hokkei (1780–1850) better caught the figure style of his master and did some remarkable surimono, elaborately printed with gauffrage and gold and silver dust on special paper.

Andō Hiroshige (1797–1858), the son of a fireman, had a personality the reverse of Hokusai's. Where the latter was conceited, spectacular, and personal, Hiroshige was modest, poetic, and objective. His landscapes warm the heart of the Japanese, because this is the way they feel about Japan. What an endless series of famous scenes Hiroshige drew! They start with the Famous Views of the Eastern Capital of about 1831, and the best known is a set of the Fifty-three Stages of the Tōkaidō Highway of 1833. The Eight Views of Ōmi which followed and the famous Views of Kyōto of 1834 contain many more scenes of equal excellence. The Miidera Temple [171], an unusual print in grey monochrome, from the Eight Views of Ōmi series in the Boston museum, is a challenge to the older artists of the ink painting tradition, but its sense of actuality is the result of insight rather than education. Hiroshige knew how to create the mood of a scene. Even more remarkable for atmospheric tone is the set of Eight Views of the Edo Suburbs of about 1838. The Sixty-nine Stages of the Kiso Kaidō Highway is his second tremendous series. In this he had the help of Ikeda Eisen (1790–1848) for twenty-four of the actual seventy prints. The Hundred Views of Edo, a vertical set, dates from late in his life, about 1853 to 1856, and cannot compare with his earlier work nor even with the triptych landscapes of 1857 such as the Moonlight on Kanazawa.

Hiroshige, who was probably the most prolific of all Ukiyo-e print designers up to his time, also made so many distinguished bird and flower prints that they can be regarded as another contribution of original importance in the art of Ukiyo-e. Such a print as the Bird and Red Plum Blossoms [172] has little in common with the stiff, conventionalized bird and flower pictures which in the days of the early Torii and Masanobu seemed like crude transcriptions of the Kanō. Nor are they slightly foreign-looking like some flower prints made in the time of Harunobu, when the Chinese colour print had a passing influence, nor yet are they of the correct realism so superbly composed and delicately coloured which is to be found in the nature books of Utamaro. Hiroshige shows the instinctive attitude of the Japanese towards

171 (*below*). Hiroshige (1797–1858): Miidera Temple, Edo period. *Boston, Museum of Fine Arts*

172 (*opposite*). Hiroshige (1797–1858): Bird and Red Plum Blossoms, Edo period. *Boston, Museum of Fine Arts*

nature, a feeling of reverence so profound that it is never tinged with subjective sentiments. Rather, it expresses the fascination which a poetic heart feels for the kindly world about him. Hiroshige's passionate devotion to natural beauty stayed with him throughout the whole of his life, and a poem he composed as he was dying describes in his own words his intent and achievement:

> I leave my brush at Azuma,
> I go to the Land of the West on a journey
> To view the famous sights there.[10]

After Hiroshige the only artist of note before the opening of Japan in 1853 was Utagawa ˙Kuniyoshi (1797–1861), a pupil of Toyokuni I.

Kuniyoshi's most popular prints were the warrior heroes of Japan, but he also made landscapes with a new relation between large foreground figures and the landscape background. In his most famous work, a set of prints on the Life of the Priest Nichiren, he combined both incidents drawn from history and the new kind of landscape treatment.

The field of Japanese prints from start to finish shows barely perceptible influences from China. It was a tradition born in Edo and maintained by popular support. Few developments in art have been so localized. The hero worship of actors and the glamour of beautiful women, paralleled in this century in the fame of Hollywood, found in eighteenth-century Edo

a fortunate conjunction of artists, publishers, craftsmen, and appreciative public which has given permanent fame to the transitory joys of a people.

The art of the Japanese print during the eighteenth century recaptured the interest in human affairs which had characterized the Yamato-e traditions of Japan. In the nineteenth century the prints of landscape and flowers went even deeper into the Japanese consciousness to express love of country and of nature. Since feudal leaders neither expected nor encouraged nobility of sentiment from the common man, the class distinction of the age blinded them to the fact that the fundamentals of taste had become a common possession, that every man could appreciate fine art, and that the national consciousness was refined and enriched because of the ability of Japanese artists to express visually the enjoyments of the people.

As one looks back over the thirteen or fourteen centuries through which the course of art in Japan has been traced, one is continually impressed by its vitality. Japanese art had its roots in the craft or guild system descending from proto-historic times. From the seventh century onwards the art of painting never lagged or was uncreative. If on the one hand traditions were preserved with feudal loyalty, until they finally withered like later Buddhist painting or the last work of the Tosa and Kanō schools, there was always sufficient energy to start fresh movements. Japanese history has been insular and national. Courtiers, monks, soldiers, and commoners all contributed to form national artistic traditions so marked that even when Chinese influences appear to have been in the ascendant a substratum of native expression is still clearly perceptible. Art has penetrated few civilizations as deeply as the Japanese. Among the people of Japan it has existed not as a superfluous luxury but as an essential pleasure in their way of living.

ARCHITECTURE

ALEXANDER SOPER

CHAPTER 17

ARCHITECTURE OF THE PRE-BUDDHIST AGE

HOUSES AND SHINTŌ SHRINES

The earliest culture, or aggregate of cultures, known to us in the Japanese islands was a very primitive one. Its practitioners were hunters or fishermen, who, when we first make their acquaintance, were ignorant even of stone-working. Their tools and weapons were of wood, bone, horn, or shell. Their most highly developed craft was a monochrome pottery, exuberantly decorated by scratching or by impressions of string or matting. It is from this last characteristic that their cultural phase takes its modern name, Jōmon, literally 'cord-pattern'. The Jōmon age seems to have had a very long development in Japan, during which its people advanced to a Neolithic status. That it was originally an offshoot from the culture of the north-eastern Asiatic mainland is argued by the similarities in form and decoration between the earlier Jōmon vessels and the Neolithic incised wares found widely over north China and Manchuria. These last may be placed, by the roughest sort of criteria, in the third and second millennia B.C.

In the last centuries before Christ, Jōmon dominance gave way before a new cultural phase, called Yayoi, from the place where its typical ware was first identified. Finds suggest that the bearers of this new way of life were invaders who crossed into western Kyūshū by the straits from Korea. Their cultural assets at the outset included agriculture and a knowledge of stone-working. The centuries of their early push into central Japan were also those in which the vastly more mature civilization of China was enjoying its first imperial expansion under the Ch'in and Han dynasties. Around the time of Christ, the Chinese pressure carried to Japan the art of bronze-casting, as well as articles of export like mirrors and weapons to imitate. The beneficiaries were the Yayoi people, who, as possessors of these advantages, must have been greatly aided both in their struggle to displace the aborigines and in their slow drive toward cultural betterment. It was to them, again, that a later current from the continent delivered the even more revolutionary asset of iron-working, perhaps in the third century A.D.

With the Iron Age, the inheritors of Yayoi culture emerge into proto-history as the 'men of Yamato', the half-legendary hero ancestors of the historic Japanese. Their inveterate

enemies, pushed ever farther back, become identifiable (by a necessarily rough equation) as the Ainu. Iron Age Japan under the Yamato stock was well enough organized and armed not only to ensure control of home territories, but even to undertake military aggression on the mainland. From the late fourth century on, the Japanese adventured in Korea, through generations of sporadic fighting and intrigue that led to their final expulsion in the mid seventh. The ultimate importance of this period for Japan lay not in a balance-sheet of battles won or lost, but in long contact with a country on a higher level of civilization. Through loot, tribute, and presents the Yamato chiefs secured not only material of greatly superior value, in much greater quantities than ever before; better still, they acquired Korean or even Chinese craftsmen, whose knowledge and skill could be planted in Japanese soil to ensure a permanent gain. With the late sixth century, the export of Buddhism carried the relationship into a new phase of intimacy. At the same time the quality of influence exerted by the Korean kingdoms began to rise steadily, under the pressure of a reviving Chinese cultural imperialism. As a result the Yamato standard of living, which at the end of the Bronze Age had been perhaps 1500 years behind the Chinese, moved forward with a constant acceleration. At their final pace the Japanese achieved a forced growth almost unique in world history before the Industrial Revolution. By the beginning of the eighth century they had equalled or outdistanced their former tutors, the Koreans, and stood within striking distance of the Chinese ideal.

As I have suggested, the equations between the Jōmon-ware people and the known Ainu, and between Yayoi and Yamato, must be loosely stated. The origins of neither strain can be clearly defined. Those on the Japanese side are puzzlingly complex, with elements traceable to both north-east and south-east Asia. The distinction between the two antago-

nists was certainly blurred by interbreeding and cultural exchange. Between them there may well have existed intermediate peoples, who eventually lost their identity to one side or the other, but once were sufficiently individual to increase the confusing variety of archaeological evidence. It is still useful, however, to be able to draw a general contrast between the two major phases: the earlier, which in time lost its dominance, sank to an increasingly subordinate position, and (to some degree) survives today among the Ainu in the far north; and the later, which increased steadily in coherence and amplitude until it could stand for what we recognize as Japanese.

The present stage of our knowledge of architecture in prehistoric and proto-historic Japan leads naturally to the same antithesis. There is on one hand a primitive building type, the pit-dwelling, which is associated with Jōmon finds, loses its predominance, and survives in historic Japan only in the humblest uses. There is on the other a variety of forms, some erected on the ground, others raised on piles, which contain in embryo many of the basic preferences of mature Japanese architecture. The two types have different advantages that tell something about the experiences of their creators. The pit-dwelling, easily made of rough materials, draws from the warmth and shelter of the earth itself a defence against severe winters. The surface building is apt to be more carefully framed; its most ambitious variant, the pile-house with a raised floor, is designed to escape the ground damp of a subtropical climate. The pit-dwelling points north; its use in Japan with a pottery allied to the prehistoric incised wares of the mainland recalls the ancient north Chinese memory of a time when people lived still in 'scraped holes'.[1] The pile-house points south, to the kind of tropical architecture seen today in the Philippines and Indonesia. It would be imprudent to claim that the first belonged solely to the Jōmon people,

or that the raised house was introduced to the islands by the Yayoi invasion. It is certainly not true that the two racial complexes in the first centuries of their struggle maintained sharply distinguished architectural forms. There also interchange must have occurred, the more readily because neither building type was perfectly at home in Japan. The pit-dwelling is appropriate enough in Korea, or in the far north of Honshū and Hokkaidō, as the pile-house suits the humid heat of Kyūshū. In the intermediate climatic zone where Japanese civilization was to develop, along the Inland Sea in central Honshū, neither was more than partly suitable, one being oppressively damp in summer, the other cheerless in winter. Still, granting these exceptions, it seems broadly true that the distinction in building types was an aspect of the general contrast between the Jōmon and Yayoi phases.

The remains of pit-dwellings have been found in a fairly large number of sites, mostly in central and eastern Japan. The typical site is close to fresh water; sometimes the pits number several hundred, and cluster on a diluvial terrace that may well have been chosen as a stronghold. The individual house is traceable as an excavation from four to six metres across, roughly circular or squarish with rounded corners. The depth can only be estimated, since it is hard to be sure of the original ground level; the range seems to have run from a yard to a few inches. The floor is usually of pounded earth, with a hearth hole at or near the centre; occasionally the area round the hearth is crudely paved with stones. The superstructure may be reconstructed from post sockets. These may be found at the centre, or around the circumference, or some distance in from the earth walls, in which case there are usually four. The different combinations perhaps testify to a very slow advance in building skill, starting from a roughly conical or domed-up roof of poles and brush. The most advanced

type may have looked like a small, clumsy forerunner of the traditional Japanese farmhouse. One may imagine a central area like the later moya room, bounded by four main posts; a rectangle of substantial beams above; and a thatched gable roof with open ends to discharge smoke. From the now squared-off circumference would have slanted a secondary lean-to roof, like that over the later hisashi. There would of course have been no walls above ground.

The pit-dwellings can be dated safely only by the objects they contain. In some cases those are potsherds so primitive that they might be called proto-Jōmon; at the other extreme they enter the Yayoi phase. The Japanese histories reveal the persistence of the type at least into the Iron Age. It must have been a habit of living below ground that made the men of Yamato refer to one group of their aboriginal enemies as 'earth spiders', Tsuchigumo. A description of the barbarous habits of another group, the Eastern Emishi, around A.D. 300 says that 'in winter they dwell in holes, in summer in nests'.[2] More unexpected is the evidence that the conquerors themselves made at least occasional use of the form – called *muro* – even at a fairly late stage. The (doubtless half legendary) account of the first conquest of the land of Yamato by Emperor Jimmu speaks of his ordering a great muro to be dug in which his enemies were feasted and then massacred.[3] The word is rendered by a Chinese character with the same original sense, which by the T'ang dynasty was degraded to mean merely an ice-house. It is natural, then, to find an ice muro for summer storage mentioned in the early fifth century.[4] More surprising is the use of the character at the end of the seventh, in connexion with an imperial audience in a much more sophisticated age. The Japanese court can hardly have received T'ang envoys in a pit-hall.[5] But the survival of the word, if only as a chronicler's archaism, at least argues a

familiarity acquired by long use. Whether or not the Yayoi invaders were originally accustomed to the pit-dwelling, it is probable that they perpetuated its use – with more advanced fittings, and perhaps only in winter – until their enthusiasm for Chinese civilization made it seem unbearably primitive.

For the building types to which the Yayoi people gave first preference we must turn to various secondary sources of information; a house of wood and thatch leaves no such easily-

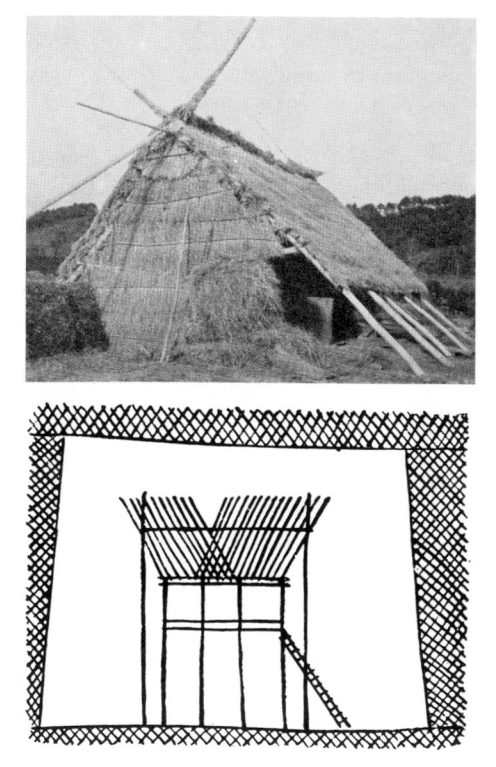

173 (top). Harvesting shelter, traditional modern

174 (above). Dōtaku (detail; redrawn).
Ōhashi Collection

175 (opposite). Mirror back from Nara Prefecture, fifth century. Bronze.
Imperial Household Department

read traces as an excavation. The fact should be remembered in connexion with the Jōmon phase as well. It is not at all unlikely that long before the Eastern Emishi were described, the primitive inhabitants of Japan moved from their cold-weather pits to a summer life in 'nests', roughly framed of bamboo and vines. Even today the back-country peasants make use in warm weather of quickly-assembled shelters near their fields that may well perpetuate a prehistoric form. Essentially a gabled roof of bamboo and thatch rising directly from the ground like a tent, these huts are like a pit-dwelling without the pit [173]. It is a curious fact that in the craft language of carpenters their form has been known at least for centuries as tenchi-gongen-zukuri, the 'building type of the age of myth'.

Yayoi-Yamato preferences are shown by a variety of evidence: small, contemporary representations of buildings; references in early literature; and existing Shintō shrines, which though of recent date may preserve styles of great antiquity. Each of these has its own advantages for study, and the combination provides a picture that in many details is quite clear.

The first source is of the greatest value in dating. Architectural representations are of two kinds, outline drawings on bronzes, and pottery models. Two bronze objects are of first importance. The earlier and simpler is a dōtaku, i.e. one of those usually large, bell-like objects peculiar to Bronze Age Japan. It is said to have been found in Sanuki, the northernmost tip of the island of Shikoku, across the narrow Inland Sea from the centres of Yamato development.[6] Twelve decorative panels show the interests of a people still absorbed in hunting and fishing: drawings of insects, herons, turtles, archers and their game. One panel contains a pile-house, with an exterior ladder leading to a high floor or balcony. The roof is gabled, and seems to splay out widely at either end as it

rises, so as to give the apex a wide overhang [174]. The projection is given extra support by what seems to be an isolated pillar holding the ridge-pole.

The other bronze is a mirror, found in an ancient tomb in Nara Prefecture ascribed to the first half of the fifth century A.D.[7] The mirror design in general is based on a Chinese model of Han; but here the large central field, instead of being filled with monsters or Taoist deities, holds only four buildings rendered in outline, on the cross axes [175]. Each is an individual. One recalls the dōtaku house. Another is more elaborate, with what looks like a balcony at the raised floor level, a hand-rail for the ladder, and a parasol. The roof already has the complex form, hipped below and gabled above, that is a standard variety later. A third stands on some sort of low platform; the last seems to be a pit-house. All

the roofs are shown thatched, and in the pile-houses have extra lines protruding beyond the gable apexes that recall the forked timbers, *chigi*, of Shintō shrines [176]. Parallel lines between the post are horizontal, to indicate boarding, or chevrons that suggest matting. The group presumably records the variety of buildings – from master's dwelling to granary – on an estate; and so may have been intended as a symbolic signature of the individual for whom the mirror's magical protection was sought.

The pottery houses belong to the general class of tomb models known in Japan as *haniwa*.

They were found as a group of eight in a tomb mound attributed to the fifth century in Gumma Prefecture, north-west of Tōkyō.[8] Here there are five different forms with a marked contrast in size [177, 178]. The larger are single-storeyed, and stand on the ground; several storehouses are two-storeyed. All but one hipped storehouse have saddle roofs, flaring widely and rounded at the top, with wide, ornamental bargeboards rising well above the ridge. Low doors and windows are shown. The largest model has a carefully detailed ridge construction, with evenly spaced billets

176. Ise, inner shrine, sanctuary, traditional since the third century

to lend extra weight against the wind: the feature that in shrine architecture is called *katsuogi*.

A problem of origin is raised by the obvious similarities between these Japanese models and existing house or granary types of the East

177 and 178. Pottery house models from Gumma Prefecture, fifth century. *Tōkyō National Museum*

Indies; particularly the more elaborate structures of the Celebes and Sumatra. The likely inference is not that Japanese culture was rooted in the Indies, but that both island groups received a similar stimulus from a common centre, perhaps on the south Chinese coast. It should be noticed that in one respect the latest Japanese forms are markedly less southern than the earliest. If proportions are to be trusted, the dōtaku shows a building that might still have been intended to meet the sudden floods of an equatorial rainy season. The haniwa models are no further above ground than the floors of Japanese houses today. It is interesting, finally, that all the representations emphasize the long side; the drawings by their choice of elevation shown, the models by the placing of doors. In this they agree with immemorial Chinese practice, though whether by derivation or coincidence I cannot say.

It is convenient to bracket the evidence given by the first Japanese histories and by existing Shintō buildings. Neither source can be completely trusted. The two histories were written down only after a long oral transmission, the *Kojiki* being completed only in 712[9] and the *Nihon Shoki* in 720. Much of their matter is frankly mythological, or hovers in the twilit zone between myth and record. Another portion is suspect, as being a patent attempt to give the text a flavour of Chinese sophistication. Of the Shintō buildings, again, none is more than a few centuries old. At the same time it is clear that a number of the most famous shrines have kept architectural features of an extreme archaism through their various rebuildings. In the case of the best known, the imperial precincts at Ise, the traditional practice has been to reconstruct the entire complex in identical form every twenty years.[10] All historical experience makes it unlikely that this very expensive custom could have been carried out with anything like regularity, however, particularly during the long, medieval eclipse of the imperial house. At any rate the practice was instituted only in 685, a century after the introduction of Buddhism had begun to modify Japanese religious practices, and in a generation when Chinese influence was mounting to a new peak. These partial disqualifications demand a careful criticism of the testimony given by books and visible buildings. The latter, however, can contribute a great deal to our knowledge, particularly at the levels of state religion and court life, about which the bronze and pottery representations are silent.

Though the founding of none of the traditional Shintō shrine types can be unimpeachably dated, both legend and modern criticism agree in granting the most primitive place to the sacred precinct on the north-west coast facing toward Korea, the Izumo Taisha. The stories told in the histories about the deity worshipped there, Ōnamochi, take an unusual turn. In myth he is a nephew of the Sun Goddess; being the son or more distant descendant of her tempestuous brother Susano-ō, a god whose story involves relationships with Korea. Ōnamochi was persuaded to relinquish his right to temporal rule in favour of the Sun Goddess's 'august grandchild' by a bargain giving him control over divine affairs.[11] Dimly to be glimpsed behind this fiction may be a territorial agreement between the Yamato invaders and another strong racial group already in possession of western Honshū and the approaches to Korea.

Concerning the first erection of the Izumo sanctuary, the *Nihon Shoki* records a curious promise of the Sun Goddess: it was to be built for her accommodating nephew with a rope of 100 fathoms made from the paper mulberry, tied into 180 knots; the pillars were to be tall and massive, and the planks broad and thick. The visible building of 1744 is a large gabled box of wood, with a high floor and surrounding balcony [179].[12] Like a megaron, it is ap-

179. Izumo shrine, sanctuary,
traditional (last rebuilt in 1744)

proached from the end, up a steep stair. Since its end is only two bays wide, there is an axial pillar, to the right of which are stair and door. There is also a central pillar inside, joined to the right-hand wall by a partition, and behind this stands the Holy of Holies which must therefore be approached around a corner. All of these details are convincingly primitive; the design is like a permanent version, with walls, of the peasant's field shelter. In other respects the Izumo building (whose type is called *ōyashiro-zukuri*) has lost more of its archaic purity than, for example, the shrines at Ise. The bizarre silhouette feature, chigi, which at Ise is still functionally achieved by extending the bargeboards in a high 'V' above the apex, has lost its meaning. The bargeboards here

end against a tile-ridge acroterion, of Chinese stylistic origin like the curves in the roof and the balcony railing. The chigi survive only as isolated, scissors-like pieces of wood; while their traditional associates, the ridge billets, are too few and too widely spaced to serve their original purpose as weights. The remainder of the Izumo compound is laid out with the elaborate symmetry of the Chinese monumental style.

The central pillar of the Izumo sanctuary recalls a passage in the Japanese creation myth. The male and female primal deities, Izanami and Izanagi, after their descent from Heaven, are said to have erected a hall of eight fathoms and a 'pillar of Heaven'. Before their first mating they wooed each other by going round

the pillar until they met.[13] Cosmological symbolism of the sort widespread in early architecture is obvious here; the marriage hut was meant as a constructed universe in microcosm, with the axial shaft that joins earth and sky at its centre. Because the text contributes no further details and it is impossible to date the setting of the myth even by millennia, it is as likely that the 'eight fathoms hall' was a round one (like the pit-dwellings, or, at a higher stage of evolution, the circular hut of Samoa), as that it was a gabled box like the Izumo sanctuary.

A short step beyond the naivety of the ōyashiro-zukuri is typified by the Ōtori Jinsha at Ōsaka. The principal change has been to make the building three bays wide, to permit the greater formality of an open central axis. In details like the straight-line gables and the lack of a balcony, the construction is more properly primitive than its close relative at Izumo. Unfortunately not even a legend remains here; we know only that the precinct was ranked in the ninth century among the Grand National Shrines. Next, in the Sumiyoshi Jinsha outside Ōsaka, the sanctuary has been doubled in depth to four bays, permitting two rooms and thus a progressive increase in holiness within. There also is our first sign of the kind of simple group plan multiplication made natural by Shintō belief. The shrine was laid out to worship three deities, so their three identical sanctuaries are found one behind another. A fourth stands alongside the first; an obvious late-comer, dedicated to the empress Jingō of the later fourth century A.D., whom Shintō tradition makes the founder of the Sumiyoshi precinct.

All the above types, as a hall-mark of their antiquity, retain the strikingly non-Chinese gable façade. The revolutionary change whereby the building is entered on its long side first appears in the typological sequence at Ise. There are two closely similar Ise precincts, each

of which is duplicated every twenty years. The so-called inner shrine, Naigū or Kodai Jingū, is said to have been founded under Suinin, in the late third century A.D. The *Nihon Shoki* explains that in the reign of Sūjun, his predecessor, an unexplained plague brought general panic.[14] Ignorance made the emperor dread all unseen powers, even the formidable two ' who had hitherto been worshipped together in the great hall of his palace, his ancestress the Sun Goddess and the territorial god Yamato-no-ōkunidama-no-kami. He removed their cults to a safer distance, while appointing his own daughter the high priestess of a special shrine to the Sun Goddess. Under Suinin the latter was established permanently at Ise.[15]

The second Ise precinct, known as Gegū, the outer shrine, or as the Toyo-uke Daijingū, was laid out under Yūryaku in the later fifth century for the worship of the Goddess of Cereals, Toyo-uke-bime-no-kami.

In their similar group plans the two precincts have kept an unusual degree of archaic simplicity. Both face south and are arranged with a noticeable respect for symmetry: characteristics that may show a distant awareness of the grand Chinese ideal, acquired by contact with Korea. The traditionally earlier is the less consistently balanced of the two, its approach being well off axis. At both shrines the worshipper reaches the sanctuary within the last of a series of four enclosures. These are unlike Chinese courtyards in differing widely in depth, and in the fact that their enclosing walls are continuous about the whole compound. Thus at the sides and back the innermost area is bounded by four closely set palisades.

The sanctuaries – almost identical in the two precincts – have preserved their ancient designs almost untouched by Chinese influence. Their general type appears in less well-known shrines elsewhere, and there is called *shimmei-zukuri*. The two Ise buildings, being unique, bear their

own style-name recognizing that fact, *yuitsu shimmei-zukuri*. They are constructions of extraordinary beauty and impressiveness, true monuments of architecture where the Izumo sanctuary is an archaeological curiosity [179]. In their visual effect simplicity and forcefulness are complemented by unexpected refinements. The design is dominated by the heavy thatched gable. Elongation (the Naigū hall is three bays by two, nearly 37 feet by 18) produces a dramatic stress on horizontals: at the top the rich cresting of ridge billets, then the deep, slanting reveal of thatch at the eaves, then the balcony rail and floor. The suavity of Chinese curves is completely lacking; instead, to avoid an overbalance, the thatch narrows as it rises. At each end the gable projects well beyond the wall. The overhanging ridge-pole is supported by a free-standing pillar, which also tapers noticeably as it rises from the ground, through the balcony. Pillars, floor- and wall-boards, and billets have a fine solidity. The chigi, formed by the ends of the bargeboards, are curiously cut out, as if to reduce wind resistance. From each bargeboard, on either side of the projecting ridge-pole, there emerges a row of very long, close-set pegs, square with rounded ends. Here the original function has been even more completely forgotten than in the case of the Greek guttae, and today can only be surmised.

Nothing in the Ise design need have been added later than the first of its periodic rebuildings, in 685. The unusually large number of metal fittings – now a very happy colour contrast to the soft graining of the unpainted wood – may date from that period; as may the railing, which has a vaguely continental look. It is interesting, on the other hand, to find that much the same sort of details that characterize the Ise halls (without, of course, their perfection) may still be found in back-country farmhouses along the north-west coat of Honshū, where customs have changed most slowly. A ridge construction still used in Ishikawa Prefecture, northward from Nagoya, may for purely practical reasons duplicate the complex of members – even chigi and billets – seen at Ise.

The Ise precincts use in key positions the kind of ceremonial gateway that has always remained the special property of Shintō: the *torii*. The design there is of the greatest simplicity: two vertical posts, a beam projecting widely across their tops, another beam stopping against them a short distance below. The posts are cylindrical; the top beam is rectangular in section, with its upper surface bevelled to shed water; the under beam is a simple rectangle. The origin of so primitive an entrance-marker can hardly be traced. The Shintō repertory includes an even simpler form, the *kuroki torii*, a combination like that at Ise made up of unplaned and deliberately irregular logs, but that may well be the product of a late nature romanticism. There may be some relevance in the fact that the ancient Chinese included among their gateway types, as the simplest possible, a so-called 'crow's head gate' made in much the same way.

Mention made in the histories of secular architecture fills in a number of valuable details. The emperor Yūryaku, of the late fifth century, is said to have once caught sight of a house belonging to a local chieftain that had billets on its ridge. He was so angered by what he took to be a presumptuous imitation of his own palace that he was with difficulty kept from burning the mansion down.[16] Here it is clear that just as in the case of the Ise sanctuaries, what had originally been an ancient functional member was now jealously guarded as a sign of status. Occasionally one finds illuminating signs of technical progress. In the final episode of the myth of the primal deities, when Izanami seeks for his spouse in the realm of the dead, it is said that 'she raised the door of the palace and came out to meet him.' On the other hand in a later legend a deity

woos a maiden by pushing and pulling at the plank door she has shut.[17] The first story has preserved the memory of a primitive way of life in which the only doors were suspended strips of matting; the second deals with proper wood architecture.

As late as the account of the conquests of the emperor Jimmu, a palace built for him is described as being 'raised on a single foot' or 'on a single pillar', presumably in the fashion of the Izumo sanctuary.[18] Various passages reveal a growing appreciation of size and properly chosen materials. To the myth of Susa-no-ō has been attached an opinion on the desirability of various kinds of woods for special uses.[19] Several descriptions of the dwellings of demigods, down to Jimmu himself, stress the solidity of their rock-embedded posts and their towering height; their chigi 'mount to the plain of High Heaven'.[20] A much later story whose hero is the exiled prince Kenzō (ruled *c.* 495–7) shows incidentally the degree to which the traditional ways of building had come by that age to be valued emotionally. The occasion is a house-warming given by a local chief. The disguised prince sings a song in which he praises the building, signalling out each of its main structural features to stand for some attribute of the master's good heart: pillars, beams and purlins, rafters, laths, cords (to tie the framework together), and thatch.[21] Whether this warmth of feeling was real or a form of politeness, it prepares us for the obstinacy with which the Japanese were later to maintain the traditional way of building against the enormous pressure of the Chinese ideal.

There is a special interest in the occasional mention of unusually sophisticated building types. The earliest detailed Chinese description of Japan, in the *Later Han History*, tells of the emergence from civil wars of the late second century A.D. of a queen called Pimiku. The account given of her closely guarded palace speaks of its 'towers, look-outs, walls, and palisades'. These, of course, may have been no more pretentious than the simple, domestic fortifications shown in picture-scrolls of the Kamakura period. The Japanese of that time are described as tattooing or painting their bodies, and as using weapons of wood, bamboo, or bone.

Again, a well-known story tells that the emperor Nintoku (*c.* 395–427), mounting to a high terrace with his consort, was distressed to see how little of the smoke of prosperity was rising from his land.[22] His tastes had been austere to begin with; in his palace of Takatsu at Naniwa 'the buildings were not plastered; rafters, beams, and pillars were not ornamented; the thatch of the roof was not evenly trimmed. This was so that his personal desires might not interfere with seasonal work in the fields.' Now, to lighten his subjects' burdens, he is said to have abolished all *corvées* for three years. During that time, his dwelling fell into dilapidation, but it was only when their prosperity had been assured that he ordered them to work on the palace. Unfortunately the passage is not above suspicion. Nintoku here seems to be merely an actor performing the role of sage monarch in the Chinese tradition, as assigned him long afterward by the Sinophile compilers of the *Nihon Shoki*. Even the details of his frugality are unconvincing; it was the ancient architecture of China, not of Japan, in which walls were normally plastered. A proper history in the Chinese sense must always contain at least one outstandingly good, and therefore economical, ruler to encourage others. It must also include at least one bad, and therefore extravagant, ruler as a horrible example. In the *Nihon Shoki* that role is taken by Buretsu (*c.* 504–10); the accusation against him, as conventional from the Confucian standpoint as the praise given to Nintoku, is that he 'had a lake dug, and made a park that he filled with birds and beasts.'[23]

In spite of their moralizing flavour, however, neither claim should be incontinently dis-

missed. The opening of the backward Yamato kingdom to contact with Korea, in the later fourth century, unquestionably brought in time a marked change in the architectural setting of upper-class life. Sporadic references suggest what must have occurred. Among the Korean artisans whose periodic immigration is noted, a number of skilled carpenters from Silla arrived in the reign of Ōjin (c. 380–94?). They are said to have been the founders of the later carpenters' guild, Inabe.[24] Vivid anecdotes suggest the impression made by these new-comers or their descendants. The extraordinary manual precision of one master carpenter of the Inabe so astonished the emperor Yūryaku (c. 457–89) that he slyly provoked the man to a careless slip by letting him see the court maidens wrestle half naked. Another carpenter was at work on a 'tower' for the same ruler; a hand-maiden serving Yūryaku was so absorbed in watching his agility that she fell and upset the imperial dish.[25] Both of these stories conclude in a folk-tale pattern: the ruler is infuriated, vows to execute the hapless crafts-man, and is dissuaded only by a happily-improvised poem. If not quite believable as history, they at least illuminate the natural astonishment of a still naive people in the face of superior technical achievements. It is pos-sible, then, that first-generation Korean car-penters might have built palaces with a contin-ental flavour, particularly in decoration, and in the provision of towers and high terraces. Buretsu, in turn, may actually have set a new standard of imperial extravagance, and so have imitated the garden lake and hunting park of mainland rulers.

Little evidence for the general layout of the palace and none for that of the city round about have remained. The fact that both were con-sistently moved to new sites on the accession of a new ruler speaks for relatively modest size and easy dismantling. We know that the palaces were carefully enclosed. Several were given names based on the embankments or palisades running round them; a traditional epithet is 'the eight-fold fence', suggesting the multiple barriers around the Ise shrines. It is probably safe to assume for at least official architecture the awareness of orientation shown in an edict of Seimu (c. 325–55?), by which the boundaries between towns were lined up on the cardinal directions.[26]

THE TOMB

The fragments of evidence that may be com-bined to give a picture of pre-Buddhist build-ings of wood and thatch may be interesting from a specialist's standpoint. To the Western layman, accustomed to measure early cultural achievements against the standards of Egypt and Mesopotamia, they can hardly be impres-sive. It is perhaps only the visitor to Ise who would be ready to recognize any possibility of beauty and dignity in the Yamato style, or see in it evidence of a civilization higher than that of the Batak of Sumatra. The Japanese histories contain little to redeem such an estimate. Their myths might be transferred without incon-gruity to a textbook on the anthropology of Polynesia. The dynastic annals, stripped of their veil of Confucian decency, are as disorderly and disgraceful as those of the Merovingian kings. It is only in the imperial tombs that the greatness of the Yamato age is immediately recognizable. As nowhere else, one finds in them the evidence of a material power of quite unexpected magnitude. At the same time the extraordinary pride they reveal, the overriding devotion to one symbol of racial dominance – the emperor – are a preparation for those later achievements that make Japanese history unique.

Abundant finds in western Kyūshū demon-strate the burial practice of the Yayoi phase. The dead were simply buried in pottery urns, usually a pair set mouth to mouth. The

accessory objects found include a fairly high proportion of bronze artifacts, including mirrors of Western Han design that allow this stage to be dated about 100 B.C. to A.D. 100.

In the most marked contrast stands the mound tomb characteristic of the early Iron Age, most highly evolved in the Yamato region of central Honshū, and so presumably a development by the Yamato conquerors. The idea doubtless was derived from the continent, where a Chinese tradition of royal sepulchral mounds was already very old. The fully evolved Japanese version is unique in the ground plan of its tumulus, a circle at the back and a wedge-shaped projection at the front. Representatives have been found all over the Japanese islands, their distribution pointing to the gradual extension of Yamato rule. The imperial mounds, *misasagi* – shaped like the rest, but much larger – rise around the old cultural centre.

Almost all the misasagi are identifiable by local tradition or records.[27] Japanese respect for the imperial house has made it unthinkable that any should be opened for archaeological research. Their interiors remain *terra incognita*; but a careful study of what is accessible – primarily dimensions and proportioning – makes the group valuable not only as an index of imperial power, but also as a typological guide for the private mounds. The circle-and-wedge plan typifies the misasagi that may be assigned to the imperial line between the tenth ruler, Sūjin (*c.* 230–58?), and the thirtieth, Bidatsu (572–85). Marked differences of proportioning seem to have followed an orderly (though inexplicable) process of change. In the earliest the projection is much narrower and lower than the circular rear; in some private tombs it may look like the long handle to a mirror. The relationship gradually alters, until in the middle of the series the wedge is over twice as wide as the tumulus. Later that disproportion is relaxed, but the front remains wider than the rear.

Three complexes far outdistance the rest in size, those of the fifteenth, sixteenth, and seventeenth rulers. Largest of all is that of the sixteenth, Nintoku (*c.* 395–427?), the frugal emperor of the *Nihon Shoki*. The total length of his complex is about 1600 feet.[28] The diameter of the mound accounts for about half of this; its height is about 130 feet. The precinct is ringed by three moats. In several cases the tumulus is known to have been covered with stone slabs. Both the imperial and private tomb types were originally surrounded by a symbolic rampart of haniwa, pottery figurines planted in the earth as a substitute for human defenders.

It is natural to connect the exceptional size of the imperial mausolea of the late fourth and early fifth centuries with the sudden increase in Japanese power and prestige that followed the early victories in Korea. Perhaps much of the labour required for such immense accumulations of earth was furnished by enslaved prisoners. To the leaders of this same period, intoxicated by success and in actual possession of far greater resources than ever before, should probably be assigned the occasional dolmen tombs of Japan. An impressive example of these, roofed with huge stone slabs, is the so-called 'Stone Stage', at Yamatoshima in Hyōgo Prefecture.

The interiors of the unexplored misasagi might well reveal the same sort of megalithic core around the coffin. In the private circle-and-wedge tomb, the chamber at the centre of the mound seems to have been designed primarily to protect the coffin from being crushed; no access to it was left. The typical coffin has the look of a long canoe, first made of a hollowed-out log and then in stone. Its proportions determine the shape of the roughly corbelled stone enclosure around it.

Throughout this sepulchral art there is a consistent stress on symbolism that might well (if we knew the language) explain the circle-and-

wedge form. The boat coffin, twenty feet or so long, is an impractical frame for a single corpse. In the same way the burial objects of this age are not so much duplicates of the useful paraphernalia of daily life as they are signs of status. It is surely significant that the most frequent items – iron swords, bronze mirrors, and 'jewels' – correspond to the traditional imperial regalia; just as the private tomb follows the extraordinary form of the misasagi.

The appearance of a new tomb type is one of the first signs of the acceleration of cultural change that reached its climax in the later seventh century. A handy date is given by one of the most surely identified of the misasagi, the one constructed in the early seventh century for the mother of Prince Shōtoku, and occupied also by him and his own consort. Here there is nothing above ground but a tumulus; the tomb chamber, on the other hand, is carefully constructed of ashlar, and communicates with the surface. The form is closely similar to a long-established Korean standard; appropriately, the richest concentration of the corridor tomb type is close to the straits, in north-west Kyūshū. There both the constructed tombs and similar rock-cut caves show a number of novel features allied to Korean and more distantly to Chinese practice. There may be several rectangular burial chambers off the corridor, since accessibility made it natural to use the tomb for more than one burial. The chamber may be surmounted by a rough barrel vault or dome, corbelled or imitated in the solid rock. The coffin emplacement may be marked by a stone platform, or a special recess at the rear; the latter may be dignified by an architectural frame, imitating the entrance to a building of continental type with a tiled roof. Kyūshū chambers of such ostentation usually have their walls faced with stone slabs, decorated by incised and painted abstract patterns.

The ancient Japanese insistence on conspicuous burials received its death-blow in the period of surrender to Chinese ideals. With the Taika Reform of the mid seventh century, a new Confucian frugality dictated severe limitations on the size and elaboration of the tomb. At the same time Buddhist theory and the new practice of cremation emphasized an impermanence that robbed the vault and mound of their chief reason for existence. In addition the vastly increased expense of providing for the architectural needs of the living – a huge new capital, permanent city mansions and palaces in the Chinese style, temples of unprecedented splendour and costliness – made it impossible to continue the cult of the dead on anything like its former scale. The 'hill mausolea' still erected, through the inertia of custom, in the Nara and early Heian periods, were of modest dimensions. In the end they were supplanted entirely by the practice of enshrining the imperial ashes in a Buddhist temple.

BUDDHIST ARCHITECTURE OF THE ASUKA AND NARA PERIODS

THE MONASTERY-TEMPLE[1]

The commonly accepted story of the introduction of Buddhism to Japan is told in the *Nihon Shoki*.[2] The first move is said to have been made by a king of Pekche in south-west Korea, anxious to tighten a traditional alliance. His mission to the Japanese court in 552 included among the usual presents a novel gift with his personal recommendation: 'an image of the Buddha Śākyamuni in gilded bronze, with several banners and canopies, and a number of scrolls of canonical books.' For a generation the new faith made little headway. The emperors treated it gingerly; the conservative opposition was strong and determined. At length the whole question of foreign influence became one of the issues in a brief civil war in 588. The anti-foreign party lost, and as a result Japanese policy veered sharply toward enthusiasm for ideas from the continent.

Through the long reign of the empress Suiko (593–628), under the energetic regency of Prince Shōtoku, the imperial authority was used to encourage the closest possible intercourse, first with the Korean states, and then with China. By the help of Korean monks and craftsmen, the Buddhist Church was domiciled in a number of well-organized monasteries. The exchange of embassies with the continental powers became more frequent, and by the inclusion of China acquired a new momentousness; Japanese for the first time began to visit the mainland in search of knowledge rather than loot. A generation after the death of Prince Shōtoku in 622, the emperor Kōtoku showed so marked a partiality that he was remembered as having 'honoured Buddhism and despised Shintō'.[3] In his first years were promulgated the epoch-making Taika edicts, by which the framework of the Japanese state was recast on a Chinese model (645–6). An extraordinary effort to change an entire civilization – its governmental structure, its man-made environment, the living habits and functions and even the modes of thought of its people – went on thereafter with increasing confidence. The climax of the process, reached at Nara in the eighth century, set at least a standard for living in the grand manner that the Japanese have never since equalled.

When the period of wholesale borrowing began under Prince Shōtoku, the practice of Buddhist worship on the continent was linked to a specific architectural standard. It is one of the striking facts of Chinese history that that standard, serving an Indian religion, was almost completely Chinese. Its forms, structural methods, and principles of design were those that had been worked out to suit the general needs of monumental building. The Chinese Buddhist monastery, inheriting those long-established habits, was basically very like the Chinese palace, or any other major secular structure. Like all representatives of the grand tradition, the monastery was made up of solidly framed buildings, standing on masonry terraces and crowned by tiled roofs. Its group design was based on the courtyard, entered through a formal gateway, and dominated by a main hall; the fitting together of these parts was strictly regulated by symmetry and southward orientation. Only one major element, the pagoda, was specifically Buddhist. In con-

sequence it proved the one strongly disturbing factor in the early centuries of Far Eastern temple design. Always an intruder, it was assigned one role after another in the grand plan. No solution proved permanently satisfactory until the last: which was to abandon any attempt at reconciliation, and so either to give up the pagoda entirely, or to relegate it to a site outside the traditional courtyard scheme.

In the early centuries of transplanted Buddhism, the pagoda – or its Indian ancestor the *stūpa* – still enjoyed a high prestige. In the religious communities of Gandhāra and Afghanistan, whose way of life contributed greatly to the Chinese standard, all other architectural forms were subordinated to a main stūpa, rising at the centre of its court with smaller stūpas and enclosing chapels round about. It was natural that at the outset the pagoda should have been given a comparable importance in China. The early references to Buddhist architecture in Chinese texts, beginning in the late second century A.D., speak most often of pagodas. The first regularization of Buddhist planning was probably achieved during the early sixth century, when both the Tartar state of Wei in north China and its Chinese rival, Liang, in the south devoted an unprecedented share of their resources to the building or enlargement of temples and the manufacture of images. No clear evidence for the Liang standard remains; but the Wei type (which may well have stemmed from a Liang original) is attested by a nearly contemporary description of the most magnificent of the capital temples, Yung-ning-ssu, erected in 516. In addition, the still traceable foundations of south Korean establishments in Silla and Pekche, built during the following century, reveal the same scheme (which may have been borrowed from either Liang or Wei). The essential is the primacy given the pagoda in combination with the classic Chinese design. The worshipper entering the main courtyard through the southern

gateway found the pagoda in front of him on the axis. The rival building that was eventually to supplant it, the Buddha hall, at this stage still took second place, some distance behind. Both of these major foci of worship stood isolated in the court, which was closed at the rear by another large building, the lecture hall where the monks met to hear expositions of the sacred writings.

The accounts of the first erections in Japan duly emphasize a pagoda, which is said to have been set up by the first licensed believer, Shiba Tattō, in 585, and was pulled down again by the chief of the anti-foreign clique. The earliest monastery of which visible evidence remains – Shitennōji in Ōsaka, built as a thank-offering to the Shitennō, the Four Celestial Monarchs, after the victory of 588 – was given the standard mainland plan. Its present state, at the end of a long series of fires and restorations, bears forceful testimony to the new permanence added to Japanese architecture by the coming of Buddhism. Irrespective of buildings, Shitennōji has retained, in the platforms on which they must stand, all the essentials of its first foundation. A single axis dominates; inside the court the pagoda rises in front of the Buddha hall [180, A and B]. Japanese historians refer to this simplest of monastery designs as 'the Kudara plan', from its probable immediate source in 'Kudara', i.e. Pekche. To clinch the argument, the *Nihon Shoki* has recorded the arrival of a new Pekche mission in the same year of 588, bringing two temple architects, an expert in casting pagoda spires, skilled tilers, and a painter. A variant account, preserved in the history of another monastery founded in this decade, Gangōji, has even remembered the fact that these craftsmen brought with them the model for a Buddha hall.[4]

⟨This latter temple, first known as Hōkōji, the product of a collaboration between the foremost non-royal family of the time, the Soga, and the Imperial house, was the most

A

C

Refectory

Existing Hall

Exact size and position
of these four are not known

Refectory

Pool Pool

Lecture
Hall

Kondō

Pagoda

Chūmon

Nandai-mon

10 10

9

8 7

6

5

3 3 4

2

1

1. Nandai-mon (South Main Gate) 6. Kōdō (Lecture Hall)
2. Chūmon (Middle Gate) 7. Shurō (Bell Pavilion)
3. Pagoda 8. Kyōzō (Sutra Storage)
4. Kairō (Corridor or Peristyle) 9. Jikidō (Refectory)
5. Kondō 10. Monks' Dormitory

180. Reconstructions of early monasteries: (A) and (B) Shitennōji; (C) Yakushiji

ambitious of all the early Japanese centres of Buddhist worship. The stages of its construction and its completion in 596 are noted in the *Nihon Shoki*. Excavations of its original site in the capital region of the time, Asuka, were carried out in 1956 and 1957. The dig has made it clear that while the general plan centred on a pagoda, seen directly ahead as the worshipper entered the gate on the south, that traditional focus of devotion was supplemented by no less than three image halls or *kondō*, one to its north on the main axis and the other two balanced symmetrically on east and west [181].

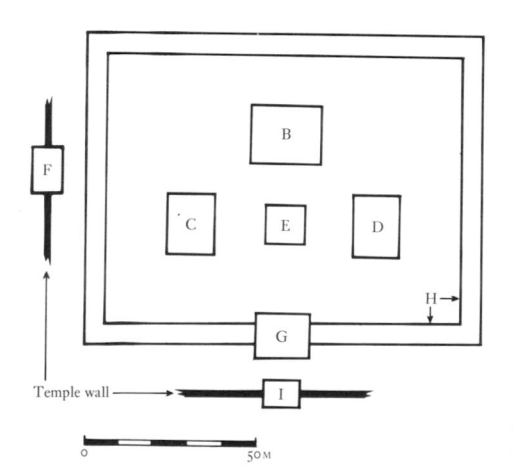

181. Hōkōsi, plan

A Kōdō (Lecture Hall)
B Kondō
C Western Kondō
D Eastern Kondō
E Pagoda
F Western Gate
G Chūmon (Central Gate)
H Kairō (Peristyle)
I Southern Gate or Front Gate

Each side of the cloister-like courtyard had its own gate. The most spacious building of all, an assembly hall for the monks called a *kōdō* or lecture hall, rose at the rear outside the courtyard, though still on the south–north axis. The remains of a generally similar design found at the ruined temple at Chung-am Ri, five miles north-east of Pyongyang in modern North Korea, make the continental origin of the scheme its most likely explanation.

Other suggestions of Korean prototypes were found at Shitennōji, when after one more destruction by fire during the Second World War its site was excavated in 1950–8. The most unexpected among many interesting discoveries was the imprint left in the hard-packed earth of the corner of a roof, close to the position of the *kōdō*. This revealed both that the original rafters were round in section, and that they were laid at the corner on a radiating system: both features familiar on the continent, rather than in later Japanese practice. >

A more modest establishment of Prince Shōtoku's generation, Hōryūji, has had the good fortune to retain its major buildings to the present day.[5] The general plan there reveals a unique variation. Within the courtyard, the two chief elements stand not on axis but alongside each other, the pagoda on the west, the Buddha hall – there called *kondō*, or 'golden hall' – on the east. Custom is reasserted at the rear in the single large lecture hall, *kōdō*, and at the front by a single entrance-way, the 'middle gate'. The latter, however, stands one bay closer to the west end of the enclosure than to the east, to restore the balance upset by the unequal masses inside. Stranger still, instead of a single opening or three, it has two [182].

In the Hōryūji visible today, a consistent early style – that of the seventh century, or roughly speaking the Asuka period – runs through all the buildings in front of the setback at the rear of the court: gatehouse, pagoda, Buddha hall, and three sides of the veranda

182. Hōryūji:
(A) and (C) reconstruction of
original buildings;
(B) and (D) plans of present buildings

1. Courtyard nucleus
2. Kaminodō
3. Direction of the great south gate
4. Shōryōin
5. Refectory complex

6. East gate
7 and 8. Yumedono complex
9. Edono and Shariden
10. Dempōdō

183. Hōryūji, courtyard nucleus from the south-east, seventh century

corridor enclosing the whole [183, 184, 192]. Written evidence for the mid-eighth-century state of the monastery has been preserved in an inventory of its properties submitted to the Throne in 747. Unquestionably the courtyard at that time had a simple rectangular form.

⟨Both textual evidence and recent archaeological finds have made it clear that there was no lecture hall in the compound until the early Heian period. The existing building, linked by jogging corridor arms to the courtyard, dates from after a tenth-century fire. In this respect the reconstruction of the original Hōryūji plan shown in illustration 182 is inaccurate.⟩

The tenth-century change added one other feature to the uniqueness of the Hōryūji layout. In the early Japanese monasteries (and presumably also in the mainland types they imitated) common practice set just north of the courtyard a pair of small, identical, symmetrically balanced pavilions, a library, kyōzō, on the west, and a bell tower, shōrō, on the east. This equipment is still visible at Hōryūji, in the form of two-storeyed buildings of eighth-century style [186].[6] Originally they doubtless were free-standing; in the tenth century they were picked up on the new north-south extension of the veranda corridors.

From the start a proper monastery must have provided quarters for its monks, set out with a decent respect for the general plan. The first obvious place was on the main axis behind the rest; it is known that the Hōryūji lecture hall [185] was rebuilt on the site previously occupied by such a dormitory. Eighth-century practice supplemented this block by a wing

184. Hōryūji, middle gate, seventh century

185. Hōryūji, lecture hall, tenth century

186. Hōryūji, sūtra library, eighth century

on either end at right angles, so that the whole formed a 'U' open to the south. The wings remain at Hōryūji, though in erections of later date.

Another necessary unit was a large refectory, the more essential since Buddhist practice made the maigre feast a grand periodic cere-

present jikidō; with their place on the list, they suggest a lecture hall, and no lecture hall is named. The fact has been variously explained. My own belief is simply that the functions required of kōdō and jikidō were so similar that a single building could answer both uses. Presumably it was not until the final extrava-

187. Hōryūji, refectory complex, eighth century

mony. At Shitennōji the eating-hall or *jikidō* stands some distance to the rear of the lecture hall; the same solution is known for a number of other monasteries around Nara. The existing Hōryūji refectory [187] represents an alternative more popular in the eighth century (from which it dates): a site on the east, outside of the main precinct. The inventory of 747 poses a minor puzzle in that it mentions a refectory immediately after the 'golden hall'. The dimensions given are much larger than those of the

gance of Nara Buddhism that the separation of the two was required; by 747 the relatively small and unfashionable Hōryūji had not yet managed to satisfy the new standard.

The major puzzle posed by the plan of the Hōryūji nucleus draws in another long argued problem: whether or not the original monastery was burned and rebuilt. Two extremes of opinion and several attempts at compromise have in two generations of study amassed a a bewildering total of facts and surmise. For

the irreconcilables in one camp the lack of any material evidence of a general fire in the courtyard soil, and the consistent archaic style of the buildings have been proof that there never was any conflagration. The other extremists have argued around an entry in the *Nihon Shoki* for 670: 'After midnight there was a fire at Hōryūji; not one building was left.' The case seems now settled by the recent discovery and excavation of another monastery courtyard south-east of the present one. The priority of this long-buried complex is attested by several facts. Its group plan is that of Shitennōji, and follows an axis less accurately drawn toward the south than the present one. The tiles found have simpler lotus patterns than those of Asuka style on the existing Hōryūji roofs. There is, finally, no doubt that this monastery was burned.

From the new premise, the architectural history of Hōryūji in the seventh century may be reconstructed as follows.[7] The first foundation occupied the south-east site. It was completed around 607, as is recorded by the inscription on the halo of the first Hōryūji Buddha, the bronze Yakushi vowed by Empress Suiko and Prince Shōtoku. Its layout was the straightforward one that had been used for Shitennōji twenty years earlier. In 670 that original Hōryūji was destroyed. There remained, however, one building saved by its distance from the rest. The second Hōryūji icon in point of time, the Śākyamuni (or Shaka) with two attendant Bodhisattvas who now occupies the middle throne of the 'golden hall' altar, had been cast in 623 as a prayer for the recovery of Prince Shōtoku from his last illness. So important a votive image must have been furnished its own building, to serve as a mortuary chapel for the regent. Having little to do with the primary activities of the monastery, this was set up on an open site to the north-west. When the fire obliterated the rest,

its survival made a focus about which rebuilding could begin. The former chapel became the 'golden hall' of the new design, and so has remained to the present day.

This happy issue from the catastrophe must have met one grave technical difficulty. The mortuary chapel had its proper icon, the Shaka Triad of 623 [2]. The monastery as a whole had as its object of worship the Yakushi of 607, rescued and temporarily homeless. The two were of equal rank in the pantheon, and were peers also through their association with Shōtoku; the earlier had been vowed by him, the second for him. It was unthinkable either that the chapel image should be superseded in its own shrine, or that the Yakushi should be banned from the main hall of the rebuilt monastery, or admitted as a subordinate. From this dilemma grew the unique Hōryūji group plan. The two Buddhas were enshrined side by side in the kondō, with the axis vacant between them. This duality was made the dominant theme of the whole design. If there were no icon on the axis, it should be occupied by none of the other principal elements. So the pagoda and the kondō were set side by side also; and through the gatehouse were opened two passages, about an axis blocked by pillars.

The reconstruction was carried out in a style consistent with that of the 'golden hall', probably in a decade or so after the fire of 670. Hōryūji seems to have recovered its normal functions by 693, in time to participate in a nation-wide celebration in honour of a newly popular scripture, the *Ninnō-kyō*. In that generation artistic fashions were being rapidly modernized. By the beginning of the eighth century a new style was dominant. Had the reconstruction of Hōryūji been postponed until those years, as it was once argued, the buildings could hardly have been cast in so archaic a mould as that furnished by the kondō. The fact that reverence for tradition could still be a

decisive factor a generation earlier, however, is substantiated by the two small dependencies of Hōryūji still extant near by, Hōkiji and Hōrinji. Each of these has retained until modern times a three-storeyed pagoda that closely recalls the five-storeyed prototype at Hōryūji [202]. The two are almost indistinguishable; according to a reliable thirteenth-century history, Hōkiji's was erected in 685.

The early date of Hōryūji's establishment is revealed both by style and by modesty of scale. Measured in the T'ang foot (about 11·6 English inches), the pagoda was about 108 feet high, rising from a block 21 feet square. The plan of the kondō was an oblong about 47 by 36·3 feet.

The standard expected of an imperial monastery at the end of the Asuka period may today be seen or imagined at Yakushiji. The present temple so named stands among rice fields and small villages south of Nara. It was erected there, for the most part in the 720s, on a site that then lay on the outskirts of the capital. Its proper chronological place comes not at the beginning of the classic Tempyō era, however, but a generation earlier. It was moved to Nara in 718, following the transfer of the imperial residence, from an original location at Asuka. There it had been founded in 680 and completed around the turn of the century, as a prayer to the Buddha of Healing to secure the health of the empress Jitō. That the second construction followed the first with the same sort of reverence I have attributed to Hōryūji is argued by two facts. The still decipherable ground plan at Asuka checks closely with that of the present Yakushiji [180c]. Again, the single Yakushiji survivor – the pagoda – shows a style that was probably backward by the standard of the 720s [204]. It has even been argued that the building belonged to the Asuka original, and was dismantled and carried piecemeal to Nara.

Apart from a general increase in size, the Yakushiji formula differs from that of Shōto-ku's time by a new general plan. The Buddha hall at last emerges to supremacy, and so to its closest approximation to the throne hall of the Chinese palace. The change is accomplished at the expense of the pagoda, which leaves the axis for good. In so doing it becomes subject to the law of symmetry, and is doubled. Yakushiji, like a number of contemporary Korean monasteries, typifies a stage of compromise. The twin pagodas are still part of the nucleus; but they are drawn as far as possible away from the Buddha hall, and so rise from the front corners of the enclosure. It is the eastern one that remains at Yakushiji. That the rest of the nucleus retained its original composition until a late date is attested by an Edo period print; today all but the pagoda is lost or nondescript. The still-used pillar bases show that the kondō was erected at a scale befitting its new dignity; its plan covered 80 by 40 T'ang feet.

The monasteries that congregated around Nara were more numerous than ever before. The major new foundations far outstripped even Yakushiji in size, complexity, and expense. In the most ambitious of all, the gigantic Tōdaiji, Buddhist architecture became the instrument of a convulsive national effort to break through the limits of possibility. The motives that prompted this fury of building and adorning must have been as complex as those that created the medieval art of Christendom. Beside the purer religious stimuli they certainly included calculations of profit. One large fraction of Buddhist literature frankly lists the enormous benefits, temporal and spiritual, that await the prudent investor. For generous rulers, in particular, there are scriptures that promise dynastic stability, the prosperity of the state, and confusion to all enemies.

One motive specially important in Japan was national pride. For all Buddhist works the reckless Indian imagination gave a first stimulus toward immensity and enormous numbers. At the level of human accomplishment the standard was set by T'ang China, where the resources of a huge empire made possible a seemingly effortless magnificence. The Nara Japanese strove with fierce single-mindedness to push their poorly endowed realm up to the Chinese level. The pursuit for a generation was astonishingly close.[8] In quality the Japanese versions of T'ang style in architecture and the other arts must have equalled all but the thin top layer reserved for creative genius. In quantity at least the same relative limit was reached. In 740 and 741 the saintly emperor Shōmu decreed that every Japanese province should build a monastery centring on a seven-storeyed pagoda, to be called a 'realm-guarding temple'. This was the same sort of final multiplication that the Chinese had aimed at when the Sui emperor Wên Ti, for example, ordered each of his provinces to erect a temple and relic pagoda. For sheer size, finally, the casting of the colossal bronze Buddha of Tōdaiji, and the erection of the Daibutsuden, or 'great Buddha hall', to house it, brought Japanese achievement at least momentarily abreast of the T'ang maximum. It was a proud Japanese boast, indeed, that there was nothing like Tōdaiji even in China.

The two historically most important foundations of Nara have been preserved well enough (though neither retains a main building earlier than Kamakura) to suggest their original states. Kōfukuji is earlier by a generation, having been begun in 710 as one of the first Buddhist strongholds in the new city, and was substantially complete by the 730s. Its scale is that of the average first-class monastery; a fact that defines the high, but not yet supreme authority wielded by its patrons, the Fujiwara clan. Its effect must have been less monumental than it was rich and varied, like the personalities who determined its growth. Tōdaiji, begun in 745 and dedicated in 752, was first of all a monument, enormous and overpoweringly direct; a unique symbol of the unity of the nation under the imperial will.

Kōfukuji was assigned a four-block square of the Nara gridiron, within which the main buildings stood in a rectangle one block wide by two deep. The main hall rose from the centre of this area, with the impressiveness of great size; it was nine bays across by six deep, 124 by 78 feet. The design gave it an added importance by isolation. The competing mass of the lecture hall was withdrawn, to form with the dormitories a secondary nucleus. In the opposite sense, the pagodas were pulled forward out of the courtyard, to stand more widely separated in front. The primacy of the Buddha hall was asserted also by an extension of its functions outside of the cloister area; there were two lesser kondō (each larger than Yakushiji's) at right angles, balanced on east and west. The refectory occupied a somewhat detached position on the east of the dormitory complex. Roughly matching it on the northwest was a mortuary chapel to the temple's founder, the great minister Fujiwara no Fubito. (The existence and placing of this mortuary precinct of course helps to give credibility to the theory that a similar chapel existed earlier in the original Hōryūji.) At Kōfukuji T'ang sophistication showed in a specialized form; the central hall inside its own small cloister circuit was octagonal. There were two two-storeyed gates 78 feet long, a middle gate and a great south gate, fairly close together.

I have spoken for convenience of a two-pagoda scheme at Kōfukuji, but actually there has never been more than an eastern one. The consensus of eighth-century usage is so clear, however, that it seems reasonable to suppose that the western twin was never erected because its building was too long deferred. In 813 the

188. Hōryūji, Yumedono chapel, eighth century

site was used for another octagonal chapel; either because of straitened finances after the emperors had moved away from Nara, or because the vogue for Chinese symmetry was no longer at its height. The original look of the Kōfukuji chapels and their dependencies may be imagined from that of a similar precinct at Hōryūji, on the east. There the octagonal chapel of 739, the Yumedono, still retains most of its eighth-century character; and Kamakura alterations have left its surroundings not too unlike a colonnaded courtyard [188].

The area allotted to Tōdaiji, eight city blocks on a side, equalled that taken by the imperial palace and was four times as spacious as Kōfukuji's. All the major elements were built and spaced on a corresponding scale [189]. The twin pagodas in front were surrounded by their own sub-precincts. Seven storeys tall

and some 325 feet to the tip of the spire, they were more than three times the height of those at Hōryūji. The Daibutsuden rose on a rectangle 290 by 170 T'ang feet, being eleven bays by seven. (In the present Peking palace, the largest hall, the T'ai-ho-tien, is only about 200 by 100.) To combine monumentality and convenience, it was completely framed by veranda colonnades; but was also linked to its enclosure by spur corridors, so that the courtyard was divided into front and rear halves. To the north the dormitories traced a mammoth double 'U' round the lecture hall. The refectory lay a short distance to the east, and was laid out in a curious dumb-bell shape to which I shall return below.

The architectural history of Tōdaiji, like its scale, suggests China rather than Japan. Apart from the feuds carried on between a few

TO THE SHŌSŌIN
AND TENGAIMON

A

TO THE KAIDANIN

TO THE HOKKEDŌ

0 400FT

TO THE NANDAIMON

B

Kōfukuji

Hōryūji Yakushiji

189 (*opposite*). Tōdaiji, reconstruction of original nucleus:
(A) general plan; (B) block plan for scale comparison with other monasteries

190 (*above*). Tōdaiji, Daibutsuden or 'great Buddha hall', second rebuilding *c.* 1700

monasteries, the destruction of religious buildings in Japan has been normally the result of natural causes or carelessness. The Daibutsuden, protected perhaps by its size, stood unscathed through the typhoons that twice blew down the towering south gate, and the lightning-set fires that destroyed the pagodas. Like a Chinese temple, it was twice deliberately burned by a raiding army. On the first occasion, in the late twelfth century, after the Tōdaiji monks had been fearfully punished for meddling in the civil war between the Taira and the Minamoto clans, the victory of the latter ensured a rapid rebuilding of the whole establishment. The second atrocity took place in the mid sixteenth century, when feudal anarchy had enfeebled every power except that of destruction. Then the ruined hulk of the Buddha sat in the open for over a century. When a restoration was finally carried out in the early eighteenth, as a sign of the recovery of national morale under the Tokugawa, it could cover only a part of the original, the great hall, and the front half of the courtyard; and could build only with nondescript or corrupt details. The now visible Daibutsuden [190] is shorter by four bays than the original, and looks strikingly unlike the Nara period norm.

From its twelfth-century predecessor it has inherited the strange, forceful bracketing of the 'Indian style' (about which I shall speak in a later chapter). The vulgarity of its own time shows in the heavy arched-over window, clumsily inserted on the axis between the two eaves. In spite of all changes, however, enough remains of the grandeur of the T'ang design to make the Tōdaiji nucleus uniquely impressive (like the brutalized but still awe-inspiring bronze Buddha it enshrines). The extant group does include one magnificent building, the great south gate, erected in the 'Indian style' of the twelfth century.

THE BUILDINGS

More than two dozen constructions remain, chiefly around Nara, to show through varying degrees of restoration the characteristics of the seventh- and eighth-century styles. The list gives a fairly good idea of the repertory of the age. There are eight pagodas, two of them accurate miniatures now in the Nara museum. Five buildings, including the famous imperial Shōsōin at Tōdaiji [191], are storehouses, built like log cabins on high piles. There are three gates, representing both the single-storeyed and two-storeyed varieties. Several smallish buildings cover an intermediate level of use, as minor halls of worship or refectories. Two more are octagonal chapels. Hōryūji retains the standard pair of two-storey 'towers', housing the library and the temple bell; and of course has also most of its original cloister colonnade. Five buildings have the size or formality appropriate to the lecture hall or to the Buddha hall.

Chinese architects have experimented with a variety of regular geometric ground plans. In the simplest they have been followed by Japanese imitators. The octagon furnished the Nara age with a standard chapel type. The square set a pattern for pagodas, and, as we shall see later, was popular in another period of Chinese influence, for medium-sized halls. Chinese ingenuity has also exploited the greater convenience or picturesqueness achieved by breaking out of such regular limits. Here too it was only the simpler additions that were taken over in Japan (though their influence proved extraordinarily important in the post-

191. Tōdaiji, Shōsōin storehouse, eighth century

Nara period). The most fundamental Chinese plan of all, and the most consistently imitated, was the rectangle with an entrance on the long side.

Since the classic oblong plan has an axial doorway, its columns must space out an odd number of bays across the façade. The normal minimum is three. There is no necessary maximum, because extension involves only an addition of like units. One exceptional Kamakura hall in Kyōto, designed to contain a thousand life-sized images of Kannon, is thirty-three bays long (and hence is popularly called the Sanjūsangendō).

The dimension of depth, on the other hand, is restricted by the practical difficulties of holding up a heavy roof. Since Far Eastern builders have never systematically exploited the principal of the truss, their large hall designs have been held within the span limits of the wooden beam. There, of course, the range depends on the quality of timber available; it was the magnificent forests of Japan that made possible the Daibutsuden's depth of 170 feet. The theoretical structural basis for all more elaborate designs is a system one bay deep: two pillars, a transverse beam, some sort of king-post to hold the ridge-pole, and rafters. This is the formula used in the veranda corridors of Hōryūji, with slight variations [192]. The design there also shows the longitudinal elements required at the minimal level: the ridge-pole; then on each line of columns a purlin above, and a bracing beam below to join the column tops.

A solution one degree more complex is offered by the small eighth-century *saikondō*, 'western golden hall', of Kairyūōji [193].[9] The beam is longer, so that it has become an advantage to set under it an intermediate pillar. This is done only in the end walls, to avoid crowding inside. The greater beam length makes necessary a more elaborate substitute for the king-post; corbels, accordingly, raise a second beam above the first. The multiplication brings an extra purlin on each slope of the roof; and the supporting complexes are laid out so as to be able to give both transverse and longitudinal bearing at each crucial point.

The next step is normally a cross-section three bays deep. A Chinese version, illustrated here because of its classic clarity, is that of the

192 (*left*). Hōryūji, veranda corridor

193 (*above*). Kairyūōji, west kondō, detail of end wall, eighth century

eleventh-century Hai-hui-tien of Hua-yen-ssu in Ta-t'ung-fu, Shansi [194B].[10] The central space is like the whole interior of the Kairyūōji saikondō. All around it has been added a single-bay aisle, narrower than the central area so as to emphasize the latter's spacious dignity. The columns in the wall plane are shorter than those that stand free inside; the aisle beams must therefore butt into the latter some distance below their tops.

Two other developments merit attention. With a further increase in depth, it is possible to enclose a design like that of the Hai-hui-tien by a second, outer aisle at a still lower level. That was the means chosen for the Daibutsuden, where the depth is seven bays. Again, it is not necessary to run a continuous roof across the whole plan. There may be a break at any line of columns; in the Daibutsuden the outermost aisle was covered by its own penthouse roof, above which the rest rose like a kind of clerestory [189].

In Chinese practice the roof type provides an appropriate index of the building's importance. The simplest constructions are covered by gables. The most monumental have the most symmetrical, and hence the ideal type, the hipped roof. The intermediate class is given a compromise form that I shall call the hip-and-gable. From the structural standpoint, the Chinese roof is a thin shell of sheathing, clayey earth, and tiles, laid directly on the rafters. The exterior silhouette is thus determined by the spacing of the purlins inside. Often these are visible from the floor, though pretentious buildings usually have a ceiling. Being completely frank, the Chinese ideal is also completely simple and consistent. It prefers a left-and-right symmetry for aesthetic and symbolic reasons. Its matching of front and rear, on the other hand, seems primarily the result of structural logic; the roof framing is naturally symmetrical, and should properly be held by symmetrically placed supports.

The simple nobility of the formula outlined above is of course inconsistent with any high degree of convenience. The aisle surrounding a central area does serve well enough for a part of Buddhist worship, the *pradakṣiṇa* or ritual procession round the altar. In other respects front-and-rear symmetry contradicts even the requirements of Chinese ceremony. The emperor, or the Buddha image, sits throned at the centre, facing south. The ministers, or the priests with their paraphernalia, range themselves in front. In a temple the clerical congregation may also extend round the ends of the altar; the area at the rear, equally wide, goes unused. Floor space cannot be enlarged where it is needed without adding to the superfluity elsewhere. Nara period architecture shows a few timid attempts to reconcile these conflicting requirements. As we shall see below, a very important part of the Japanese effort after the Nara age was directed toward the problem. The final solution reached in late Heian, the creation of a Buddha hall type with much of the dignity of the Chinese original and little of its stiff impracticability, was one of the major achievements of the national style.

In freeing the ground plan of the hall from Chinese limitations, the Japanese were inevitably led to attack the Chinese structural system at its crux: the framing of the roof. The Japanese innovations will be traced later. Here it should be noted that since even a tiled roof is subject to relatively rapid deterioration, every building that remains from the early period must have been re-roofed. In almost every case the repairs have been carried out in the mature Japanese technique. This is a double-shell system, in which the rafters that rest on the classic complex of beams and purlins may be far removed from the outer skin of tiles. The space between is filled with an invisible framing. The extent of the change produced by repairs may be realized by a comparison of the cross-sections of the Hai-hui-tien and a Japanese

194. (A) Tōshōdaiji, kondō or 'golden hall', with present roof (*left*), reconstruction of original roof (*right*); (B) Hai-hui-tien of Hua-yen-ssu, China

A

0 20FT

B

0 20FT

hall of the eighth century, the kondō of Tōshō-daiji [194A].[11] For the latter I have suggested an original design, based on Chinese usage, in the right half of the drawing. One visible result of the structural revolution is a rise in the outer slope of the roof. In the kondō the difference is great enough to derange what must once have been a very carefully contrived set of proportions. Other early Japanese buildings have been less drastically improved; but the only constructions free from any such suspicion are the three miniatures whose history has been one of continuous shelter: the two small pagodas in Nara style belonging to Gokurakuin and Kairyūōji, and the Asuka style reliquary called the Tamamushi shrine, kept on the altar of the Hōryūji kondō [195].[12]

195. The Tamamushi shrine, seventh century. *Hōryūji*

The space available permits analysis of only a handful of monuments from the Asuka and Nara periods. The essentials of the earlier style are summed up in the kondō of Hōryūji. The ground plan there is a short oblong, five bays by four [196A]. The interior is laid out with extreme simplicity. A central space, three by two, is filled by a platform altar for the temple's most holy images; round this runs a narrow, single-bay ambulatory [197]. Such, at least, was the original design; its impracticability made it so obsolete within a century that a second, outer aisle was added in the Nara period. In elevation the central area rises through two storeys. The upper, however, is purely monumental, being neither floored for separate use nor utilized to give a true clerestory [196]. The aisle has its own skirting roof, with eaves projecting so far that the outer passage – called a *mokoshi* – is completely sheltered. Unassuming as it is, the latter is aesthetically an encumbrance; how much more effective the clean lines of the kondō would be without it may be realized by a look at the unaltered middle gate [184].

The kondō interior is covered by a reticulated ceiling, the higher space over the altar being emphasized also by a cove. All the interior details are strong and direct; in some the watchful eye will also detect a remarkable refinement. The pillars have an invigorating entasis; the bracket arms swell as subtly as a Greek Doric capital. The whole look is markedly archaic, and for this very reason provides a perfect setting for the images in Asuka style on the altar platform.

All Chinese-style buildings of any architectural quality derive both structural and aesthetic advantages from their use of bracketing. The kind of unit selected has depended on a combination of factors: structural requirements; building type (in China bracketing, like other forms of display, has been subjected to sumptuary regulation); the stylistic preferences

196. (A) Hōryūji, kondō;
(B) Tōdaiji,
Hokkedō (original portion drawn
on right of plan and section,
and on left of general exterior view)

0 20FT

A

0 20FT

B

197. Hōryūji, kondō or 'golden hall', seventh century, interior from the south-west

198. (A to E) schematic development of bracketing;
(F) engraving from a lintel of the Ta-yen pagoda at Hsi-an-fu, China

of the time. In illustration 198A-E I have drawn a theoretical sequence of bracket types in the eighth-century manner, beginning with the simple cushion member that the Japanese call a 'boat bracket', and proceeding through forms that assume more and more responsibility for both longitudinal and transverse bearing. In the last the complex has been extended outward to help support moderately wide eaves. The look of this formula spread across a façade is given in a T'ang engraving in illustration 198F.[13]

For more ambitious overhangs the Chinese system in the centuries of its greatness (i.e. until the Ming) made use of an entirely different member: a long, slanting arm, acting as a kind of lever parallel with the slope of the eaves. In the archaic language of seventh-century Japan, these two devices are merely juxtaposed. The bracketing in the interior of the kondō is a sturdy version of the fourth type drawn in illustration 198: an arm crowned by three bearing-blocks, running on each axis through

the capital at the head of the column. In the wall the eaves bracketing complex necessarily starts from a longitudinal arm of this sort. The lowest transverse member, however, though it projects into the aisle as a conventional arm, is transformed outside into a fantastically cut-out 'cloud corbel'. This holds what is actually the end of a beam; and that in turn braces the slanting lever. The design is, so to speak, two-

199 (*above and below*). Hōryūji, kondō, eaves bracketing

dimensional until its last step upward, when another corbel widens the bearing for the eaves purlin [199]. Its flatness and linear elaboration have a perfect stylistic aptness; the same qualities are those of the archaic sculpture of the Six Dynasties and of Asuka Japan. In point of structural efficiency the complex is less satisfactory. In a building on the modest Asuka scale, the narrowness and the wide spacing of the final supports for the eaves purlin are acceptable for an ordinary wall bay. At the corner, where the only bracketing projection is on the diagonal [200], the unsupported purlin span – and the danger of collapse – become much greater.[14] Since the repairs of around 1700 the corners of the kondō eaves have been prudently propped up by elaborately sculptured pillars.

Until late T'ang all Chinese bracketing was developed only above the heads of columns. Intercolumnar supports remained always distinct; they were simply shaped and kept in the wall plane, to separate tiers of longitudinal

200. Hōryūji, middle gate, seventh century, detail of corner

201. Hōryūji, kondō, seventh century, eaves bracketing and railing

beams. The Asuka remains were all built too small to require any proper intercolumnar members. Both kondō and middle gate, however, possess a secondary frieze of bracketing under their balconies; and here there appears an alternation between a conventional three-headed arm on each column axis, and a smaller inverted 'V' half-way between [201]. This last is the most primitive version of a bifurcated motif that the Japanese have nicknamed *kaerumata*, 'frog's legs', and which we shall find perennially popular in later centuries. Both historical probability and visible evidence agree that the sources of all these Asuka characteristics were continental. Chinese Buddhist reliefs in the caves of Yün-kang and Lung-

mên repeat many times (with necessary simplifications) the bracketing alternation described above, under rock-cut eaves. In Korea, where the early monasteries may be traced only in outline on the ground, the same sort of half-structural and half-ornamental detailing occurs many times, painted or cut in rock, in contemporary tombs of the Kokuli kingdom.

Both the entasis of the Asuka column and the simplicity of its capital look surprisingly familiar to Western eyes. It is not unlikely that the ultimate prototype was what a first glance would suggest, the Greco-Roman Doric order, transmitted by way of Gandhāra. The Yün-kang rock carvings, again, show a clear knowledge of the same form, alongside a voluted

capital type that suggests either the Ionic or a garbled Corinthian.

Chinese taste in architecture prefers a pronounced colour scheme. On the exterior this period held to a forceful simplicity, reproduced in all later Japanese re-painting: dark red wood against white plaster. Interiors were more elaborately decorated, presumably with an emphasis on gilding that justified the nickname 'golden hall'. At Hōryūji, where the figure paintings were of such surpassing beauty, the structural members were left – or have been allowed to return to – a dark monochrome. Doors were flat; those of the kondō are perfectly plain, and made from a single cypress slab apiece. The mokoshi doors alongside show eighth-century preference, being assembled from several vertical and horizontal planks and decorated by gilded bronze bosses. The early window type is well shown in the veranda corridors: a vertical lattice, with close-set bars at 45 degrees to the frame. It should be emphasized that the same sort of directness that characterizes roof framing in the Chinese style governs the whole appearance of the building. There is no separation of interior and exterior architectural effects; the wall is simply a screen. In moderate climates, like that of Japan, it is a thin screen of wood and plaster; so that the system of columns, wall beams, and bracketing in the kondō is equally visible inside and out.

Finally, the roofs of this age were decorated by a large tile acroterion at each end of the main ridge, called from its curious shape *shibi*, 'owl's tail'. Although the Hōryūji examples have been lost, the Asuka type is well known from finds elsewhere; in addition it is perfectly reproduced on the roof of the Tamamushi shrine [195]. Later it was the general practice to give special interest to the gable end, where one existed, by defining the slopes with bargeboards and marking the positions of ridge-pole and purlins with ornamental wooden pendants. If anything of the sort was used at Hōryūji it

was lost when the roofs were rebuilt. The Tamamushi shrine has no pendants; the small triangular field exposed under each gable merely reveals the actual framing at that level, a roof beam, slanting braces, and the king-post.

The middle gate follows the design of the kondō, with no differences beyond those imposed by its plan. The Hōryūji pagoda and its two smaller cousins at Hōrinji and Hōkiji differ only in the peculiarities common to the pagoda *parti*. Each storey there is a square, three bays on a side [202]. Inside, a sturdy core structure – four columns on the axes, running

202. Hōrinji, pagoda,
seventh century

from storey to storey, and a giant central mast – gives special stability. The mast has its own foundation stone, hollowed a step below the socket to receive holy relics. At the top it supports a metal spire, in which the traditional Indian form symbolism survives on a reduced scale. One can trace clearly the cube and hemisphere of the stūpa; above rise nine

203 (*above and below*). Yakushiji, east pagoda,
eighth century, eaves bracketing

The Yakushiji pagoda, whatever its proper date, reveals in its bracketing a radical change [203]. Two-dimensional quaintness and inconsistencies have disappeared; both to the eye and in use the design has a new forcefulness. The tower as a whole is unique [204]. It has only three primary roofs; but these are widely separated, and, in between, each floor has a narrow mokoshi with its own shallower penthouse. Perhaps this solution was an answer to the same problem of crowding, and the architect hoped to tie the extra ambulatory into his design by repeating it on every floor. The result

204. Yakushiji, east pagoda,
eighth century

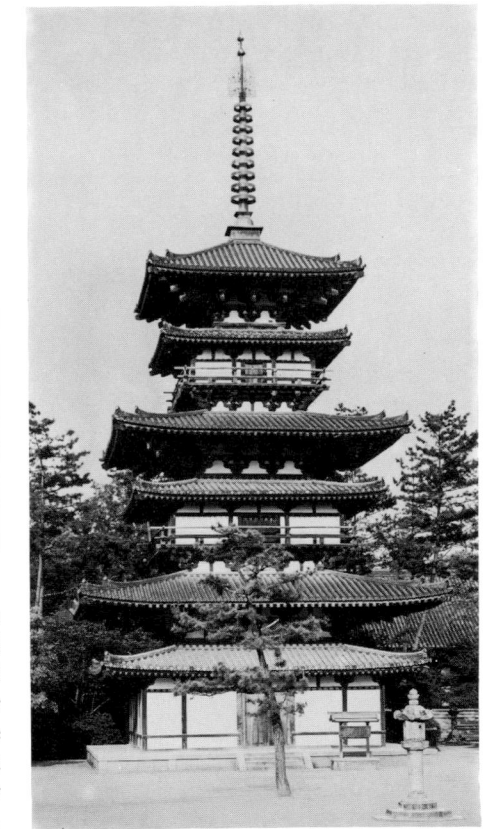

parasol disks, and finally a delicate openwork finial fans out. The ground floor of the Hōryūji pagoda contains four sculptural groups added in 711, in niches between its four interior columns. Access to these around a narrow aisle seems to have raised the same difficulty as in the kondō, and to have been improved later by the addition of the same sort of outer mokoshi.

has an ungainliness that probably explains why it was not imitated. After Yakushiji I know no further attempts to widen the floor area of the pagoda, presumably because all attention was being concentrated on the perfection of the Buddha hall.

The Hōryūji kondō reveals its early date by an exceptional traditionalism in its interior layout. The ambulatory surrounds an altar on which the images face toward all four quarters. There is, then, something like the central focus of divinity, radiating in all directions, that had been so powerfully suggested in the Indian stūpa. By the eighth century this link with the past was cut, in favour of an interior design that must have been based on the Chinese palace. The change is well shown in a chapel of the 730s, now part of Tōdaiji, the so-called Hokkedō or Sangatsudō.[15] On first acquain-

tance this hall is confusing, because a large ante-room was subsequently built across its southern facade. ⟨At first the two blocks had separate roofs; the present single roof covering both rooms dates from the Kamakura period.⟩ Inside, the original chapel survives intact; in the drawing of illustration 196 it occupies the right-hand half of both plan and cross-section. The basic scheme is like that of the Hōryūji ground floor, save for an emphatic shift of orientation. All but one of the images now face south, like an emperor and his attendants [205]. At the back of the altar a partition closes off the rear aisle; beyond it only a single statue stands guard over the back door. By a happy chance the Hokkedō has kept the single-shell technique of its original roof, and so comes exceptionally close to the Chinese standard of illustration 194B. Details are as consistent with

205. Tōdaiji, Hokkedō or Sangatsudō,
eighth century, interior from the south-west

206. Tōshōdaiji, kondō, eighth century, interior from the east

207. Tōshōdaiji, kondō, eighth century, front

the mature T'ang style as those of Hōryūji are archaic. In the same way they state the stylistic preferences that are seen in sculptural form on the altar; now solidity, and discipline tempered by grace. The bracketing under the eaves is simple; inside it combines with subtly arching girders and a rich coved and reticulated ceiling. The intercolumnar unit is a simple strut in the wall plane. Between the two tiers of beams that step up to the king-post, the kaerumata that hold the upper level are solid blocks, cut in a strongly cusped silhouette. The wood-joiner's taste and sureness are seen at a climax in the miniature balconies and mouldings that surround the octagonal dais of the main icon.

The largest surviving Buddha hall of the period is the kondō of Tōshōdaiji, erected in 759 or soon after as the centre of the abbey

established for the great Chinese missionary Chien-chên. The plan is seven bays by four, about 92 by 48 feet; it is about 27 feet to the eaves, and 51 to the (rebuilt) ridge [194A]. These generous dimensions permit a greater latitude in planning than we have so far seen. Of the four bays in depth, the first is an open porch across the front. The last is a rear aisle, screened as in the Hokkedō. The two at the centre are used for what it is convenient to call a chancel. Floor area here is ample enough, so that in spite of the bulkiness of the image platform a free space is left in front [206]. Details recall those of the Hokkedō, with the greater impressiveness given by large size [207, 210]. The exterior bracketing reveals the T'ang standard at the height of its strength and architectonic consistency [208, 209]. A comparison here with

208 (*top*). Tōshōdaiji, kondō,
eighth century, detail of south-west corner

209 (*above left and right*). Tōshōdaiji, kondō,
eighth century, eaves bracketing

210. Tōshōdaiji, kondō, eighth century, ceiling

Yakushiji shows the advances made in a generation or two towards a more highly organized display of power. The extraordinary progress beyond the Asuka style is most evident in a contrast of corner treatments. Hōryūji's solution had been precariously naive; at Tōshōdaiji the corners are locked into a formidable solidity all their own. Across the long kondō facade the whole bracketing frieze serves visually as an exercise in clear demarcation and just proportioning. As the size and dignity of the hall make proper, its roof is hipped. One of the two shibi at the ends of the ridge is original; ⟨the eastern is a replacement of 1323, as an inscription on it testifies⟩.

The monastery of Taimadera, famous for its miraculously woven picture of Amida's Paradise, owns also the only extant pair of east-and-west pagodas.[16] Three storeys high, the two illustrate slightly earlier stages in the formation of the mature bracketing system seen at Tōshōdaiji.

Of prophetic importance, finally, is the evidence that even in eighth-century Buddhist architecture the Japanese could fail to comply, or show an impatience, with the requirements of the Chinese ideal. Temple inventories prove that below a certain level of importance it was still common practice to build in the traditional island way, with shingled or plank or even

thatched roofs. The level might be set fairly high; for example in the very large imperial foundation of Saidaiji[17] the inventory of 780 records that even two secondary halls of worship, devoted respectively to the Eleven-headed Kannon and the Four Monarchs, were roofed with cypress shingles. Modern research has reconstructed the details of a building of this sort, used as a lecture hall at Ishiyamadera on Lake Biwa, which will be discussed later.[18] The same sort of conservatism, as we shall see, was evident to an even more marked degree in domestic architecture.

The inconvenience of the oblong, fully symmetrical Chinese plan gave rise to one fairly widespread means of escape: an extra fore-building, set immediately in front of the hall proper to accommodate its overflow. This scheme is still visible at Hōryūji, where the eighth-century refectory is made up of two parallel, close-set oblong halls [187]. It must have been used more ambitiously at Saidaiji for the shingled halls of worship described above, for the inventory describes each of them as 'paired halls'. The same *parti* was followed in Shintō architecture to create the typical Hachiman shrine [235].[19] At Tōdaiji, again, the refectory was not only enormous, but was laid out (if its remains may be trusted) in an attempt to create a more workable form; the remaining column bases suggest a kind of dumb-bell, a main block and a fore-building with a transverse link between [189]. A later chapter will make clear the importance of these eighth-century exceptions for the future of Japanese building.

SECULAR ARCHITECTURE

OF THE ASUKA, NARA, AND HEIAN PERIODS

THE CAPITAL

The drive to refashion the Japanese way of life on a Chinese model demanded an architectural reform affecting first of all the buildings that stood as chief symbols of the national greatness: the ruler's palace and his capital city. The new fashion required a much greater splendour and monumentality, achieved by larger size, more permanent methods of construction, and a novel insistence on decoration. The composition of the new bureaucratic state, dramatized in audiences before the emperor, necessitated a setting of strict symmetry, oriented to the south. The centralization of authority and the creation of new governmental functions entailed the layout of administrative offices on a new scale of amplitude and complexity around the imperial courts. What was essential within the palace enclosure was only a degree less imperative in the city outside. In Chinese tradition the formal order and dignity of the capital had been a visible sign of the extension of power and goodness outward from the ruler's person. One can imagine something of the look of the early Yamato capitals from that of Edo (Tōkyō) in the seventeenth and eighteenth centuries, built up in an age of reaction against the Chinese ideal; narrow, winding streets, inconspicuous buildings, a general look of impermanence. The attempt to transform such an overgrown village into a proper centre of the realm must have been initiated without any idea of its eventual costliness. That it was made with such obstinacy, and even re-made several times in one century, is the most impressive

testimony possible to the strength and passion of the Japanese urge towards self-improvement.

Scattered historical references point towards experiments preceding the final decision. A note for 645, the year of the Taika Reform, tells that the empress held court in a Daigokuden, or Hall of State. Perhaps the very existence of so specialized a building was an innovation; the name used was that of a Chinese equivalent, the T'ai-chi-tien of Six Dynasties palaces. The same ruler's residence from 643 on had been called Asuka no Itabuki, 'the plank-roofed palace at Asuka'. In contrast a note for 655 records that work had been begun on a palace at Ōharida that was to be roofed with tiles. The annals of Temmu's reign (672–86) refer to palace buildings whose titles, at least, suggest a new formality of placing and function.[1] Under the regency of Jitō (686–97), finally, the revolution entered a new phase with the building of a new capital – the first to follow a continental model throughout – at Fujiwara in the Yamato plain.

Summary data in the *Nihon Shoki* give the building of the new city a chronological framework. Imperial inspections of the site were begun in 690. The land was parcelled out and purified by religious services; the impending move was announced to the four most honoured Shintō dieties. At the end of 694 Jitō formally transferred her residence to the new palace.[2] The traditional pattern of imperial behaviour was still so strong, however, that Fujiwara could be enjoyed only through the reign of her successor, Mommu (697–707). On his death it was decided to make a further move

northward to Nara. The later history, *Shoku Nihongi*, notes for the latter a similar sequence of events, from a formal notification to the realm in 708 to the transfer in 710.

The experiment in city-planning at Fujiwara (now largely lost in rice-fields) was so completely overshadowed by the accomplishments at Nara and Kyōto that only its main characteristics need be discussed here. As reconstructed by architectural historians, the city was an oblong chequerboard, with eight large square blocks running east-west (about $1\frac{1}{3}$ miles) by twelve north-south (about $2\frac{2}{3}$ miles). The palace enceinte occupied an area two blocks wide by four deep, in the centre at the rear, north end. On its axis opened a grand central avenue, Shūjaku-ōji, running southward to divide the metropolis into left and right halves. Each large block, *bō*, was divided by minor streets into four equal *chō*. Correlating this scheme with the allotments of land recorded in 691, we find that the largest announced share, that given the Minister of the Right, was a full bō, one-sixty-fourth of the total acreage apart from the palace. Officials of the second and first court ranks were allotted half of that maximum apiece; those of the third rank and lower, a quarter (i.e. one chō). Those from the eleventh rank down got shares proportionate to their land-holdings elsewhere, from one to one-quarter chō. That this formula turned out to be inconveniently generous is indicated by the much smaller shares later assigned within the more spacious limits of Nara and Kyōto.

The model followed in laying out Fujiwara was certainly a Chinese one. Whether it was any single Chinese city, or rather an ideal from which even the Chinese deviated in practice, is not clear. One cannot be sure even that the standard was not still approached through a Korean intermediary. In the last quarter of the seventh century Sino-Japanese relations lapsed to a much lower level than before or after. The Japanese entered that generation in terror of a Chinese invasion; the Chinese themselves were bedevilled by the usurpation of the empress Wu. T'ang prestige fell; even the glory of the T'ang capital was dimmed temporarily by the empress' sudden move from Ch'ang-an to Lo-yang. Under such circumstances it may have seemed safer to the Japanese to fall back on the earlier Chinese fashion visible in the Silla capital at Kyongju, which had been extensively remodelled from the 670s on. Proof is hampered by the scantiness of the Korean remains. The layout of Ch'ang-an itself can be reconstructed from texts and landmarks on the site. The general scheme was certainly the same as that of Fujiwara. The T'ang original differed primarily in proportioning, being somewhat wider than deep; while its major blocks were of different sizes.[3]

Nara, or (to use its proper title) Heijō, 'the Citadel of Peace', served as the imperial seat from 710 to 784. Its abandonment then, at the midday of its brilliance, must have been urged by the most powerful reasons.[4] One was very likely to have been the oppressive monopoly of wealth and influence held there by the great monasteries (Tōdaiji, as we have seen, occupied a city acreage as large as that of the palace itself).[5] Kammu (781–806), who carried out the transitional removal to a new site at Nagaoka in 784 and then the final choice of Kyōto ten years later, seems to have been a forceful and worldly-wise ruler, better equipped than his predecessors to cope with priestly pressure. Perhaps he was susceptible to a last prick of the old impulse to move because his accession stabilized a real dynastic shift. Nara had been founded and built up to its final splendour to glorify a succession of monarchs who had all been the male or female descendants of Temmu. When that line had finally run out, the throne reverted to the lineage of Temmu's elder brother, Tenchi, by the choice of his grandson, Kōnin (770–81).

Kōnin's economical reign, taken up when he was already old, gave a much-needed breathing spell. Under the bold administration of his son, Kammu, heavy expenses began again, and were doubled when the first new site proved unsatisfactory. The final choice of Kyōto, however, must have been more wisely made than any other, for that capital survived an unprecedented length of time (being set aside only in the twelfth century, when the whole social system that it served was in full collapse). Indeed, the advantages that made Kyōto a successful capital throughout the Heian period continued to aid it thereafter in holding at least the status of a major centre of population. Fujiwara has relapsed into farm land; Nara has shrunk into a small town about the religious establishments that have been its chief reason for survival. Kyōto still retains and uses a very large part of its ancient chequerboard plan; and so today is not only a busy and populous city, but incidentally bears witness to the design and visual effect of its ninth-century original.

The close similarities in plan and scale between Heijō and Kyōto (or Heian, 'Peace and Tranquillity'), and the much more abundant evidence about the latter, justify describing it alone. After the choice was made in 793, work was carried forward at top speed. Kammu made his official transfer in the autumn of 794. In 806, his last year, the special Office of Works that had supervised the building of the palaces and government offices was abolished, and its remaining business was handed over to one of the regular bureaux. The city was of course not completely built up at that time, and the completion of some of its secondary monuments dragged on for generations. There were, naturally, endless minor changes everywhere, even in the relatively static centuries of the Heian period. Fires were succeeded by rebuildings; unexploited land around the outskirts was taken up for villas, or detached palaces, or

new temples; whole districts laid down on paper were never more than sparsely settled, and in time reverted to rice-swamps. We may accept the city plan itself, however, and the general design of the palace enclosure, as dating from the last years of the eighth century; i.e. from a generation still under the spell of Chinese prestige.

The perimeter of Heian enclosed a rectangle which, like that of Fujiwara, was deeper than its width, about 3½ miles north-south to 3 east-west. Size and shape were thus approximately those of the present Inner or Tartar City of Peking (which, however, is wider than deep). Ch'ang-an was approximately 6 miles east-west by 5¼ north-south. Whatever may have dictated the ratio of width to depth in the Chinese original or at Fujiwara, at Kyōto the natural setting, hemmed in by hills on either side, made it possible to expand only to the south.

The grand chequerboard was made up of eight major divisions running east-west and nine and a half north-south, at regular intervals. Each big square, bō (which here might best be rendered 'ward'), was subdivided into 16 chō, about 400 feet square. The entire rectangle, including the palace enceinte, thus comprised a theoretical 76 bō, or 1216 chō. In actuality the palace, at rear centre, took up an area 2 bō wide and 2½ deep that was not included with the rest; so that the chō available for general uses numbered 1136.

The annals for 734 record an allotment of land within the city limits of Nara, in which the maximum received (by those of the third court rank or above) was one chō (there also about 400 feet square). The holdings were rapidly diminished thereafter. For those from the sixth rank down, secretaries, recorders, and the like, the share was a maximum of one-quarter chō. The prudence shown at Nara in this distribution probably owed much to experience at Fujiwara, and was made the more

BURAKUIN CHŌDŌIN KŌKYO

MAIN SOUTH GATEWAY

211 (*above*). Kyōto, imperial palace compound, plan showing the imperial residence
(Kōkyo) and the Chōdōin and Burakuin

212 (*opposite*). Kyōto, imperial palace, plan of the Chōdōin

necessary by a great increase in population. It is clear that the Japanese gentry, whose ancestors had enjoyed the freedom of country life, were now being forced into the pattern of metropolitan congestion.

At Kyōto the mildly anti-clerical policy of Kammu brought about a further degree of economy, in lessening the acreage assigned to major Buddhist temples. A final mark of frugality was placed on the Heian palace enceinte. Its size, about $\frac{4}{5}$ of a mile east-west by $\frac{3}{4}$ of a mile north-south, was fairly spacious (being about half as large again as the present Forbidden City in Peking). In comparison to the gigantic T'ang palace (something like 4 square miles if one includes the area occupied by government offices), it was both modest in dimensions, and a much smaller proportion of the whole city. Incidentally, neither Nara nor Kyōto was walled in the Chinese sense, and neither was completed by the sort of vast imperial park and hunting preserve that sprawled beyond the northern limits of Ch'ang-an.

An illustration will show the directness with which an address could be given in the Chinese-style capital. An eighth-century document concerns the property at Nara of a court official of the lower third rank, Ki no Ason

Katsunaga, located at Nijō, Gobō, Shichichō; i.e. the fifth ward lying just north of Nijō, Second Avenue, within which Katsunaga owned the seventh chō.[6]

THE PALACE

In the layout of the Heian palace enclosure, Daidairi, complex functional requirements seem to have prevented a completely consistent application of the Chinese ideal. There was not even a clear separation, like that at Ch'ang-an between an area for government offices at the front and a Forbidden City at the rear; at Heian the administrative buildings straggled all round the perimeter. At Nara the placing of the imperial residential area, Kōkyo, on the central axis, had conformed to the continental formula. At Kyōto, as if to show that the peak of Chinese cultural dominance had been passed, this was well off centre [211]. Only the courts of audience, Chōdōin or Hasshōin, still followed T'ang precedent strictly in being set on axis at the front. It was there, in fact, that architecture most faithfully mirrored the governmental system also borrowed from T'ang. As that system itself remained at least nominally in force until the twelfth century, so the Chōdōin remained obstinately Chinese in

appearance through numerous fires and re-buildings, deep into the period when a re-surgence of national preferences had abandoned or transformed everything else that was foreign in the secular arts.

The Chōdōin occupied a fairly narrow but deep rectangle, surrounded by veranda corridors like those in the contemporary monasteries, and entered through the same sort of monumental gateway [212]. The precinct comprised first a rather shallow forecourt, in which two isolated halls stood on left and right as shelters for state occasions; then, beyond a middle gate, the main courtyard, in which twelve similar buildings were spaced around an open centre;[7]

and finally a projecting area at a higher level, in which stood the Hall of State, Daigokuden.

The Daigokuden was a monumental building, eleven bays by four, about 176 by 52 feet (i.e. about as deep as the kondō of Tōshōdaiji, but twice as long). It rose from a stone platform reached at the front by three stone staircases. Its woodwork, including a railing, was painted the conventional red. The floor was tiled; the hipped roof had emerald-green tiles and shibi finials. At grand audiences the emperor sat throned in the centre inside, within a kind of baldachino. It was probably the fact that the interior was not used except as a grandiose frame for the imperial person that made the

213. Buddhist Ceremony in front of the Heian Hall of State (Daigokuden), Kyōto, from the picture-scroll *Nenjū-gyōji*, copy of a twelfth-century original

214. Kyōto, the Heian Jingū, reproducing the Heian Hall of State, nineteenth century

Daigokuden so disproportionately shallow in comparison to a temple hall.

A view of the lower part of the Heian Hall of State has been preserved as the setting of a scene in a twelfth-century picture-scroll [213]. Using this and written evidence, a modern copy of the building has been set up in Kyōto (on a new site), under the name Heian Jingū [214].[8]

The details of the Chōdōin included some not found in the repertory of Buddhist architecture. Convenience was doubtless the reason for linking the Daigokuden by an axial corridor with a smaller building behind, the 'small hall of ease'. Where the veranda corridors turned for their final run northward, just in front of the Hall of State, they were crowned by curious 'towers', roughly like those seen in similar positions in the backgrounds of the Tun-huang Paradise pictures, or those still extant on the Hōōdō at Uji, but more complicated.[9] Each was a miniature two-storeyed pavilion, with four smaller replicas at its corners. Again, some distance on either side of the main gateway, spur corridors ran south from the front wall of the precinct, and terminated in the same sort of 'towers'. These were perhaps a piece of learned archaism: imitations of the two lookout towers, ch'üeh, that in the ritual books of the Chou dynasty had been mentioned as standing outside the gateway of the Son of Heaven.

The Chōdōin was used for the highest state occasions: coronations, the reception of envoys, New Year's audiences, and the like. Somewhat less solemn assemblages, such as banquets, the five annual festivals, and archery exhibitions, were taken care of in a closely similar precinct adjacent on the west, the Burakuin.[10]

Anyone who has visited Peking will be struck by the fundamental difference between the layout of the most formal buildings in the Forbidden City and those of the Japanese precincts described above. In the Peking version, first erected by the Ming rulers and restored by their Manchu successors, there are three main halls on axis beyond the formal gateway. The southernmost and largest, the T'ai-ho-tien, stands at the rear of a spacious courtyard, serving as a solemn audience hall like the Daigokuden. Behind it is the square Chung-ho-tien, which, as a waiting-place for the emperor, had a function similar to that of the Heian 'small hall of ease'. The third building was used primarily as a banqueting hall, and for the annual reception of graduates of the doctoral examination; its equivalent at Heian would thus seem to have been the main building in the Burakuin.

The history of the Chinese palace form is still largely unexplored. It seems likely that the single-axis scheme visible at Peking was initiated in the Sui dynasty renaissance, with the intention of recovering a lost classical purity. (The *Chou Ritual* had stated cryptically: 'Under the Chou, the Son of Heaven and the various feudal lords all had three *ch'ao*, courts; one outer and two inner.') During the Six Dynasties, on the other hand, a quite different design is suggested by records of important imperial functions that were carried on in an 'east hall' or a 'west hall'. In the *Sung History*, for example, a revealing sentence runs: 'In the Chin age, the emperors usually remained in their inner apartments. When they showed themselves at court audiences and banquets, it was only in the east or west halls.' The language may be clear enough to show that these buildings (at least sometimes) existed in addition to the Hall of State. Presumably, then, the Japanese were for some reason following a Six Dynasties prototype at Heian, rather than Sui and T'ang usage.[11] In their handling, the design became asymmetrical, but not to any extreme degree. The main precinct on the east side of the Chōdōin was the chief sub-imperial office, the Dajō-kan, presided over by the Prime Minister. It might be visited by the

215. Kyōto, Kōkyo (imperial residence),
block plan

emperor, and its main hall was even used occasionally as a substitute for the Daigokuden in coronation ceremonies. In choosing such a solution the Japanese were perhaps guided by a Chinese usage of the Han dynasty as well; for at that time the pronouncement of the *Chou Ritual* had been interpreted so as to make the Prime Minister's office the 'outer ch'ao'.

The imperial residential quarter, Kōkyo, occupied a quite small area a little to the east of the middle of the whole palace enceinte. Its surrounding palisade was about 720 feet north-south by 570 east-west. The ground plan was crowded and complicated [215, 216]. The largest open space, on the axis just inside the

entrance, was dominated by the largest and most formal building, the Shishinden, a kind of semi-formal audience hall. A characteristic of the Kōkyo layout was a close spacing of similar buildings in file. The Shishinden, then, was backed up by two lesser halls of the same length. Intercommunication across the narrow intervening courts was facilitated by short veranda corridors and open bridges. Behind this trio, at a greater remove, lay the rear complex assigned by immemorial custom to the empress. There were in addition two other important groups just behind the Shishinden, facing east-west on either side. The western of these was the emperor's customary residence, a two-building unit beginning with the Seiryō-den. Of the corresponding halls on the east, the first served as an alternative imperial dwelling-place; the second housed the sacred imperial mirror. Thus the Kōkyo contained another west-centre-east composition to serve the emperor in person, carried out with a greater symmetry than was practical in the plan of the Daidairi as a whole, and so probably closer to Six Dynasties' usage in China.

The most interesting fact about the Kōkyo is that all evidence ascribes to its buildings a character as unmistakably Japanese as that of the Chōdōin was Chinese. The change was announced by the Kōkyo's two gateways. The outermost, sharing the formality of the audience courts near by, was two-storeyed, with red pillars and a tiled roof. The inner gate was single-storeyed, and was covered by cypress shingles. Even the throne-hall beyond, the Shishinden, had a raised, plank floor, carried outside as an open veranda with a railing, and reached by a wooden staircase. Its hip-and-gable roof was shingled. The remaining buildings were even more lightly constructed, in the traditional Japanese materials. Their look has been reproduced with fair accuracy in the mid nineteenth-century rebuilding of the Kyōto palace [217–21].[12]

216 (*top*). Kyōto, Kōkyo (imperial residence), plan of the central buildings

217. Kyōto, imperial palace, Shishinden, nineteenth-century rebuilding

218. Kyōto, imperial palace, Shishinden, nineteenth-century rebuilding, front veranda (hisashi)

219. Kyōto, imperial palace, Shishinden, nineteenth-century rebuilding, throne chamber

220. Kyōto, imperial palace, Seiryōden seen from the rear of the Shishinden, nineteenth-century rebuilding

221. Kyōto, imperial palace, Seiryōden, interior

One cannot be sure to what extent this striking preference for native ways dominated the original Kōkyo of around A.D. 800. The evidence available must be drawn mainly from sources of late Heian or Kamakura: court diaries and romances, incidental references in the annals, partial views in the picture-scrolls [222], and a set of twelfth-century ground plans. It is known that the Kōkyo suffered from a great number of fires, some of them total losses. One can hardly imagine that so many rebuildings could be carried out without marked changes, particularly in an age when taste was swinging so far away from Chinese fashions. On the other hand arguments may be used to demonstrate that essentials of the

222. Ceremony in the courtyard of the Shishinden, Kyōto, seen from the east, from the picture-scroll *Nenjū-gyōji*

mature Kōkyo architectural type were present from the beginning. The basic differences between Chinese and Japanese living habits begin at the floor. Had the principal Kōkyo halls been properly Chinese at the start, they would have had stone platforms and tiled pavements. These would have survived the fires, and would have governed every rebuilding. It is unthinkable that such expensive and ponderous constructions should have been demolished, stone by stone. Had they ever existed, a change in living habits could have

been accommodated by laying a wooden floor on the platform. Presumably, then, the floors, verandas, and stairs were of wood from the outset.

Another argument concerns the historically famous sets of paintings that were the chief decoration of the Shishinden interior. An entry in the court history *Tei-ō Hennenki*

cultural dominance; not merely in country districts, or at a low economic and social level, or in the outbuildings around a monumental nucleus, but also in the very mansions of the gentry, in the capital as well as outside. This was natural enough. The eighth-century Japanese gentleman, no matter how convinced of Chinese greatness, must have half-consciously

records that in 818 the sliding screens, *shōji*, were given paintings of 'Kenjō, Kommyōchi, and Araumi'. The subjects were purely Chinese. For our purposes, however, it is noteworthy that the pictures were not set on walls, like the great compositions of the T'ang masters at Ch'ang-an and Lo-yang, but on light sliding screens, which cannot have differed greatly from those still in use in Japanese houses.

There are abundant indications, again, that the comfortable native ways of building were carried on all through the period of Chinese

resisted any fundamental change in his more intimate ways of life, just as stubbornly as his modern descendant resists complete westernization. That this conservatism hampered the reformers is betrayed by a report of the Council of State, issued at Nara in 724.

'The capital, where ruler and princes make their residences and whither the myriad regions come to pay court, lacks the majesty and splendour that should display its virtue abroad. There are still plank-roofed houses and thatched dwellings, survivals from the forms of antiquity,

which are difficult to build and easily destroyed
and so waste the people's substance. We there-
fore humbly beg that a decree be issued order-
ing that all persons of the fifth rank and above,
and all others able to do so, shall erect tiled
dwellings and paint them red and white.'

It is true that pro-Chinese enthusiasm was
sometimes carried so far that restraint rather
than encouragement was necessary. The degree
of pomp displayed by a private gateway opening
on one of the main avenues had to be limited,
in a decree of 731, to persons of the third rank
and higher. In particular the great minister
Fujiwara no Nakamaro (710–64) exceeded
propriety by building on his property east and
west belvederes of such height that he could
look down on the imperial palace. In contrast,
however, stand a number of contemporary
references to the prevalence of humbler archi-
tectural habits. I have mentioned earlier the
large number of buildings with roofs of
shingles, plank, or thatch listed in the late
eighth-century inventory of Saidaiji in Nara.
It is worth remembering that even two icon
halls of secondary rank there were shingled.
The evidence about domestic architecture
typically runs in the following way, drawn in
this case from an inventory of secular proper-
ties belonging to Tōshōdaiji. The property of
this temple included a mansion in the 'left'
(east) half of Heijō, in the first ward off Seventh
Avenue, the lessee being a gentleman of the
lower fifth rank. The buildings comprised: one
house with cypress shingles and a plank floor;
four out-buildings with plank roofs; three
plank-storehouses; and a thatched kitchen.

The most informative written evidence has
to do with the purchase in 762, by the mona-
stery Ishiyamadera on Lake Biwa, of three
houses. The three had been erected at Shiga-
raki, one of the emperor Shōmu's tentative
sites for a capital during his period of restless-
ness from 742 to 745. It was intended that they
should be dismantled, moved, and set up at

the temple for use by the monks. Two of them
had belonged to the most important Fujiwara
scion of that generation, Toyonari (704–65), a
nobleman so high in Shōmu's confidence that
he was several times left behind at Nara as
imperial representative during the emperor's
travels. The two buildings were probably set
up as part of his projected mansion at Shigaraki
in 743–4. Doubtless they were sold because
the decision to make Shigaraki the capital was
rescinded. The temple records of the purchase
are so complete that they include an inventory
of all materials, with the numbers and dimen-
sions of the most important. From them it has

223. Mansion of Fujiwara no Toyonari,
reconstruction

been possible to reconstruct in detail the appearance of at least one of the houses of Toyonari; the one that was probably re-erected to serve as a temple lecture hall.[13]

This building, the 'northern hall', must have represented a Japanese architectural tradition not fundamentally different from that seen in the Ise shrines [223]. In plan its main portion was an oblong five bays by three, 50 by 26 feet. The floor, laid of wide, heavy planks, 4 to 5 inches thick (and so apparently requiring no joists below), extended beyond the walls to form an open veranda like the modern *engawa*. Across the front and rear there were three-bay porches, each some 17 feet deep. The main posts seem to have lacked bases, being set into the ground (like the gable pillars at Ise) a depth of 3 feet. The roof was simply framed, with a triangle of beams for each bay, and king-posts only at the two ends. The roof surface was a plank sheathing. There was no bracketing. The columns were braced at the floor and eaves levels by running through heavy longitudinal beams, *nageshi*. There were four large hinged doors, each with two leaves; and two latticed windows. The inventory lists only enough members to fill two bays with a plank wall; it is not clear whether the rest were plastered, or whether the building was still incomplete when bought. The two porches had their separate roof timbers, and so probably were roofed at a lower slope than that of the main block.[14]

If the Kōkyo buildings are re-studied in terms of this nearly contemporary vernacular architecture, it will be seen that the Shishinden, for example, was not essentially different from the 'northern hall' of Toyonari [216, 223]. There, too, was a large, central room, the *moya*, free of interior supports and covered by its own gabled roof. Instead of relatively narrow projections on front and rear only, there was one the full dimension of the moya on each of the four sides. These spaces, *hisashi*,

were not open porches but secondary rooms; they formed symmetrical pairs, but the two on front and rear were much deeper than those at the ends. Since the hisashi themselves were not continuous, structural logic should have made their roofs four separate, porch-like projections from the moya block. The earliest extant drawings of the Shishinden, made in the twelfth century, show instead a kind of continuous penthouse. This solution required a rather naive compromise; to overcome the four big re-entrant corners in the plan, each salient corner of the penthouse roof had to be supported by a free-standing post.

About A.D. 800 a design of this sort, supplemented by wood flooring and a shingled roof, must have passed as being traditionally Japanese, by contrast with the monumental style of T'ang. At the same time it is not impossible that it owed something to a much more ancient Chinese type, transmitted earlier through the Korean kingdoms. So far as one can judge from the scraps of literary evidence, the standard plan of the Han dynasty palace hall, mansion, or government office included east and west *hsiang* (plan elements written with a character used later for the Japanese hisashi). The Han dictionary *Shuo Wen* equates *hsiang* and *lang*, the character for veranda corridor; indicating that the former too was a relatively narrow space with its own roof. A description of the Hall of State of the Han dynasty Ch'ang-lo Palace gives it an overall length of 497 Han feet, or 350 feet inside the two *hsü* (equivalent to *hsiang*); while the total depth was 120 feet. Each side chamber would thus have been $73\frac{1}{2}$ Han feet wide, or roughly 60 English feet, about one-fifth the central block. The hsiang seem to have been used for those day-to-day activities for which the awesomeness of the central throne room was unsuited. The texts refer also, by other names, to typical subdivisions elsewhere whose size and position are less clear. I believe that there was frequently a porch-like

hsien across the front. The corresponding projection required by symmetry at the rear may have contained the bed-chambers or retiring rooms mentioned without specific location.

I know no visual evidence for the appearance of a Han building so compartmented. Curiously enough, the one convincing illustration is given by a Japanese architectural model of the haniwa type, dating presumably around the fifth century like the group discussed earlier. The form here is quite unlike those of the other haniwa houses and granaries, whose designs recur without much modification throughout the subsequent history of farmhouse architecture in Japan. Except for its primitive details it suggests rather the elaborate, quasi-baroque palace complexes seen in Sung palaces, or even a type of semi-monumental structure still visible in Peking. I interpret the model, therefore, as a half-barbarized imitation of a continental house form; and see in it a demonstration of the fact that the Yamato people already knew a building type that might have been the ancestor of the Shishinden.

The name 'Shishinden' was probably borrowed from the hall erected at Ch'ang-an in 662 to be the rear element in the trio of state buildings dominating the new Ta-ming Palace. 'Seiryōden', in contrast, the 'clear, cool hall', had been the title of the Han summer apartments. Perhaps that Chinese original also had faced east or west rather than south, to minimize heat. The ground plan and construction of the Heian version were even more consistently Japanese than those of the Shishinden; though again one cannot be sure how much of the final design existed in 800. The Seiryōden of the later descriptions and the picture-scrolls was almost totally non-monumental, being asymmetrical, irregular in relation to surrounding buildings, and conspicuously light in structure [216]. What might be called the imperial drawing-room, the Hiru-goza, was off-centre

and irregularly shaped. A series of small outside rooms, all running the same way, straggled across the rear and down the right end, turned across the front, were interrupted to permit access to the Hiru-goza, and then ended with one more at the left front corner. The naivety of the scheme looks like an outgrowth of simple convenience, untroubled by any preoccupation with clearness or formality; it is known, for instance, that the odd corner room was added in the eleventh century as a kind of chapel. Even so, there are vague reminders of the Han formula. With only a little rearrangement one could arrive at balanced hsiang-hisashi at the two ends. Front-and-rear symmetry is prevented chiefly by the fact that the front projection is a double one; the hisashi proper is taken up by rooms, and still further forward runs an outside porch, magobisashi. Since this device, also, is not unknown in China, it seems at least possible that the first Seiryōden perpetuated in plan as well as in name the memory of an ancient Chinese form.[15]

Though the Kōkyo was in principle the imperial residence, it was far from being the only place where an emperor might dwell. In the Heian age, indeed, the ancestral urge to move and find a home of one's own seems to have regained strength. It was no longer feasible to shift the city or the Daidairi, but the ruler could at least select some alternative residence in Kyōto that suited his personal taste better than the official quarters. The variety of choices made in nearly four centuries is bewilderingly great. It was directly reflected in the emperors' popular names. From the tenth century on, the Chinese custom of identifying a deceased ruler by some sort of descriptive binomial like Buntoku, 'Literary Virtue', was replaced by a system of place names; Ichijō was the ruler whose favourite residence had been in First Avenue, and so on. Some of the 'detached palaces' were used in many reigns, and so took on an institutional

character; thus the Kanin-dairi in time became a smaller replica of the Kōkyo. The process of dispersion was encouraged by the custom of early abdication. The retiring emperot naturally yielded the Daidairi to his infant successor, and signalized his new independence by going where he wished, usually to some existing noble mansion. The new residence must always have been less formal than the palace, and sometimes was more spacious. To its comfort could be added all the charm of a cunningly contrived natural setting; the Kōkyo courts were as bare as a parade-ground, except for a few fenced-in clumps of green. The new home, finally, would have something of the character of a Buddhist monastery, since the emperor relinquished his throne to become a prince-abbot. In such great houses, then, there met and mingled what survived of three once partially independent architectural traditions: the pomp of the Chinese palace, the intimacy of the Japanese home, the other-worldliness of the Buddhist temple. From this association, as we shall see, Heian Buddhist architecture as a whole derived a tendency toward secularization. From it, even more directly, Heian domestic architecture – the way of building favoured by the gentry, that is to say the court nobles, Kuge, and their imitators – derived an ideal type: the kind of mansion described in modern histories by the term *shinden-zukuri*.

The shinden-zukuri, as a group of buildings in a garden environment, must have been one of the happiest products of Heian cultural fusion. The plan in its framework was still Chinese, as was proper in a society still nominally organized in the classic Chinese way, with a clear separation of functions and classes, and a strict balance of right and left. The buildings and their natural setting were set out with at least a general respect for symmetry, and an orthodox southward orientation. What gave the type its special flavour, however, was an equally strong admixture of native informality, in the

Heian sense of the word; the kind of charm and sweetness that pervaded the court literature of the age, and that could colour even the standardized art of Buddhism. One could apply to the shinden-zukuri, as never to architecture in the pure Chinese style, or even to the Kōkyo, the favourite adjectives of well-bred Heian society: *imamekashii*, 'up-to-date'; *natsukashii*, 'moving'; *okashii*, 'gay'.

The look of the vanished shinden-zukuri estates must be reconstructed in the usual way. Contemporary texts are the safest source; pictorial evidence becomes clear only with the twelfth century, in an age when Heian institutions were breaking up, and a new kind of domestic architecture was in the process of formation. The fragments give only a blurred picture; in part, perhaps, because the shinden-zukuri was less a clear-cut formula, like the Chinese, than an ideal approached in various ways and not often fully realized. A standard characteristic was the first division of the lot, buildings going to the north and the garden to the south. The main hall, *shinden*, like its ancestors the Daigokuden and the kondō, was an oblong block at the centre of the building complex, facing south. In front of it lay an extensive garden, with the classic Chinese landscape components, mountains and water, a pond and artificial knolls. The pond would be likely to have a miniature island, reached by a bridge, and would be fed by at least one rivulet that meandered down from the north. The prospect was enriched by carefully set-out trees and bamboo copses; Chinese garden tradition survived in 'standing stones'.

A short distance to either side of the shinden, at right angles to it and linked by veranda corridors, were subsidiary living quarters, *tai-no-ya* (literally 'matching houses'). There must almost always have been at least a pair of these, the eastern and western *tai*. On large estates there might be others, to the north of these three main units, connected in the same way.

This part of the design was clearly not unlike the plan of the Kōkyo, though the shinden-zukuri elements must have been more loosely strung together. From the complex of buildings on left and right, two long corridors ran southward toward the garden. Entrance to the estate was no longer gained on the south, but through one or more informal gateways on east and west. These lateral approaches interrupted the long corridors to create 'middle gates'. Farther to the south at least one of the corridors was likely to terminate in an open kiosk standing over the pond, the so-called 'fishing-hall', *tsuridono*. In the most ambitious designs east-west balance might be extended to these elements also. As one would expect, the buildings were all single-storeyed and unpainted,[16] with plank or shingled roofs usually taking the hip-and-gable form. They were raised a few feet from the ground on posts, and had floors, surrounding verandas, and exterior stairs of wood. A minor compositional charm was gained from the interplay of the rivulet and the buildings it passed. Often the water flowed into the garden side of the compound between the shinden

and one of the flanking tai-no-ya; in that case the spur corridor over it would be arched to simulate a miniature bridge.

Our best visual record of the shinden-zukuri is preserved in copies of a twelfth-century picture-scroll illustrating the traditional observances of the Heian court year, the *Nenjū-gyōji*. Illustration 224, showing a cock-fight in front of a shinden porch, reveals as much of the typical complex as the dimensions of the scroll allow. The picture has the incidental value of reminding us of the Japanese habit of using tents to accommodate crowds on special occasions. The users must have been musicians and other persons of relative unimportance; seating privileges were assigned by social status, with highest honour given to the interior of the shinden. The degree of charm attained by the most successful Heian shinden estates is most easily imagined from passages in *The Tale of Genji*, accessible in the expert translation of Arthur Waley.

The prototype of the Heian building-and-garden complex was certainly Chinese. No great Chinese house was ever quite complete without its garden; no Chinese layout of water, rocks, trees, and artificial hills was complete without its garden architecture. In large designs this must normally have included a main

224. Cock-fight in the courtyard
of a Heian mansion,
from the picture-scroll *Nenjū-gyōji*

building overlooking the garden prospect to the south. The Chinese histories often mention such 'pleasure-domes' (to use Coleridge's word, not theirs) by name. T'ang fashion certainly governed the placing in the eighth-century Silla palace of an 'overlooking-the-sea hall', where the king gave banquets beside his royal lake. The most telling confirmation is provided by the recently discovered remains in Manchuria of a palace of the P'o-hai kingdom, allied to the T'ang from 700 to the early tenth century, and unquestionably subject to the strongest Chinese cultural influence. There the vestiges of a royal garden, equipped with artificial lake and hill, are faced on the north by the column bases of a hall; complete in its turn with a corridor at each end, running out to enclose the north edge of the water, and ending in a small kiosk [240]. It is natural to look for an intermediary between the T'ang standard and the shinden-zukuri in the imperial garden of Kyōto. The latter, the Shinsenen, was laid out as part of the original capital, in an area of about thirty-three acres adjoining the Daidairi on the south. There must have been a lake and an island from the start; and presumably it was from that still Sinophile age that the buildings derived the Chinese style betrayed by their shibi finials and red-lacquered railings. When

fully built up the complex included east and west *tsuridono*, waterside kiosks.

It should be emphasized that the shinden-zukuri seems to have been derived only from the park element in the full Chinese design. The Chinese house or palace proper must always have faced southward across formal courtyards to the entrance gate. Even in Kyōto the Shinsenen was laid out not as an alternative residence for the emperor, but merely as a place of entertainment. Thus in choosing to put all emphasis on a pleasure complex that in China was relegated to the rear, the Heian Japanese revealed the unique hedonism of their ideal of life.

In the next chapter I shall trace the appearance of a similar group design in the formal Buddhist architecture of Heian. There the immediate inspiration was probably a vision of the Paradise of Amitābha, whose unearthly beauties were summed up in palace buildings fronting on a lotus lake. The vision was transmitted to Japan by T'ang paintings; all of the details not specifically Buddhist were probably borrowed from the great Chinese garden tradition. Thus the Kyōto temple and the shinden estate were related first by inheritance. It was all the more natural, then, that the two, being used by the same society and affected

by the same tastes, should approach each other even more closely, to produce shinden-like temples or mansions with an ecclesiastical flavour. We shall see that an establishment of this equivocal sort may be traced in the remains of the twelfth-century Mōtsuji. Something of the fusion may be glimpsed in the still-standing 'phoenix hall', Hōōdō, at Uji [227].[17]

The shinden design was probably carried out with anything like completeness only by the wealthiest courtiers; and even for them can hardly have been practicable except where a general fire had swept the plot clean. Such a combination of circumstances occurred to make possible what may well have been the most ambitious of all such mansions, the Tsuchi-mikado-dono erected by the regent under whom Fujiwara fortunes reached their peak, Michi-naga. The site comprised a full two chō in the north-east corner of the city, about 400 by 800 feet. The first residence, expanded gradually as the owner's fortunes rose, was burned in 1016 (the year in which Michinaga, having married two daughters to two successive emperors, placed his nine-year-old grandson on the throne). Rebuilding was begun at once, and was completed in two years. The estate included ten odd major buildings, of which the eastern tai-no-ya is the best described. Its central area, *moya*, was five by three, was surrounded by a single-bay hisashi, and had an additional hisashi across the south. The plan was thus nearly symmetrical, and could have belonged as well to a Buddhist hall of worship. Presumably the shinden itself was a bay or two larger in both directions. The other buildings included, in unspecified locations, a 'dance platform' and a race-track lodge (doubtless supplemented by a paddock and stables).

Toward the end of Heian the two most characteristic features of shinden-zukuri archi-tecture – its balanced arrangement, and the conception of the buildings as independent units – began to give way before a more infor-mal ideal. A typical great house of this age, the Higashi-sanjō-dono occupied by four gener-ations of Fujiwara ministers from the late eleventh to the mid twelfth century, is well enough described to permit the reconstruction of at least the plan of its nuclear buildings. Immediately noticeable is the breakdown of group symmetry; the western tai-no-ya has disappeared. Each of the surviving main units has been made more irregular by varying the spaces added outside the moya, making the hisashi on one side markedly deeper, and con-sistently using the doubled hisashi. Moreover the connecting corridors have been doubled, or tripled, with the result that continuity has begun to count more than isolation.

In details it is clear that the Heian mansion already reflected a conscious pleasure in sim-plicity. Floors were of polished wood, mats being provided only for individual use. Parti-tions might take the movable form of sliding paper screens, or be plastered for greater seclusion. Along the front façade were grilled wooden shutters, arranged in two halves; when not used, the upper half, being hinged at the top, could be held open by an iron bar hanging from the eaves, while the lower panel was simply removed. The shutters were backed up by sliding wooden doors. Privacy in various degrees was facilitated by the use of split-bamboo shades and several kinds of portable screens. The master's ultimate retreat was the *chōdai*, a raised and curtained bed alcove.[18] The structural system was unobtrusive, lacking all the monumental paraphernalia of brackets and visible girders. The eaves line could be broken, permitting the roof edge in front of an important room to be raised for emphasis.

BUDDHIST ARCHITECTURE OF THE HEIAN PERIOD

THE MONASTERY-TEMPLE[1]

In the Heian period the re-emergence of a national taste, much more sophisticated and self-confident than that of the archaic age, led in secular architecture to the perfection of a residential type almost totally different from the Chinese. In Buddhism, where respect for the authority of the continent remained at a high level, the change was naturally less extreme. It was none the less an irresistible process. None of the surviving Heian temple buildings (except the obstinately conservative pagoda type) could be mistaken for a Chinese construction, and some are almost as radically altered as the houses of their time.

Important changes were already noticeable in the first generations of the new era. The shift of capital has often been explained by the desire of the secular government to free itself from the stranglehold of the great Nara monasteries. It is clear at any rate that the designers of the new city took care to establish the formal subordination of religion to the state. The two large Buddhist establishments for which they provided were tied rigidly to the city plan, in identical lots balanced on east and west of the grand central avenue. Their acreage was generous, but on the scale of a prime minister's compound (while Tōdaiji had vied with the palace itself). The novel prudence of the government was supplemented by a dramatic transformation within Japanese Buddhism. The two Tantric sects transplanted from China at the end of the eighth century, Tendai and Shingon, brought not only new doctrines and a new kind of religious art, but also a zeal for reform within the church. The founders of the esoteric sects adopted the lives of hermits; and the headquarters they established, deep in the mountains – the Shingon on Kōyasan southeast of Ōsaka, the Tendai on Hieizan northeast of Kyōto – were in their lifetimes little more than collections of huts. The testament of the Tendai leader, Dengyō Daishi, read on his death in 822, enjoined on his followers a cheerful poverty, in words that at the same time implied a sharp rebuke for other Buddhists grown soft and luxurious. Whether the motives behind this austerity were devout or whether they were calculating, the result was politically effective against the Nara monopoly, and so a further discouragement to building on the old scale.

The seizure of imperial favour by Tendai and Shingon ensured a long life for the type of mountain monastery they believed in. Primitive simplicity was quickly lost, to be sure. As the orders gained in power and wealth and their establishments spread, the main headquarters at least were dignified by an architecture of imposing size and magnificence. What remained from the first generation was a sensible irregularity of general plan. The mountain sites were of all kinds, but in most a formal Chinese layout was clearly impossible, had it been desired. At the Shingon Kongōbuji on Kōyasan, the central cleared area is a fairly spacious and level one that might have permitted at least a minimal Chinese scheme. Instead, as if by a deliberate rejection, the main elements, though they face south, are on independent axes. Elsewhere the terrain may make even a general orientation to the south, or in any single direction, impracticable; the buildings stand where they can.

The tradition of the city monastery was not gravely endangered by its new competitor. Formal temple building survived in Kyōto throughout the Heian period, matching the T'ang formality of the imperial palace. There seems, indeed, to have been a recovery of enthusiasm for such projects, particularly when the Fujiwara clan took first place as patrons in the tenth century. The two original monasteries provided by the Heian city plan were long in building, and the western twin, Saiji, won so little support that it had only a short life. The other, Tōji, was guaranteed importance through its assignment to Kōbō Daishi in 835 to be the principal metropolitan branch of Shingon. Even so its layout was unimpressive by Nara standards. There was only one pagoda, on the east, and that took most of the century to raise. The other major elements were simply strung along a single axis, as at Shitennōji two centuries earlier. The careless extravagance of the Fujiwara regents, on the other hand, naturally favoured temple building as a means of conspicuous waste. The foundations made periodically by the heads of the clan seem to have grown steadily in magnificence. The climax must have been reached under the Fujiwara full-moon, when Michinaga built his famous Hōjōji at the beginning of the eleventh century. In the succeeding age, when power returned to the emperors, the process continued without any apparent lapse until the early twelfth. Judging from the texts, the emperor Shirakawa's Hosshōji of 1077, and the emperor Horikawa's Sonshōji of 1102, were intended to eclipse even the marvels wrought by Michinaga.

In the written accounts of such middle and late Heian city temples it is hard to detect any evidence of a failing capacity to produce monumental architecture. The vanished great halls were as big as any at Nara (with the exception of Tōdaiji), and must have been more sumptuously ornamented. They still had stone platforms and floors, painted wood, tiled roofs, and great altars with colossal images; they still faced south on a rigidly symmetrical plan. For their proper evaluation, it should be remembered that they were the rare survivors of an organism that elsewhere had long since become extinct; and that where the eighth century had produced such monuments with careless fecundity, the power of the Heian age to continue was limited to not more than one a generation.

Even in the history of Japanese Buddhism such great temples are revealed as no more than a surface phenomenon. None had a better reason for existence than the generosity of some all-powerful individual. As a functioning part of the Buddhist complex such a temple might survive for centuries, housing monks who performed their daily or special offices, receiving costly gifts of icons or manuscripts or articles of furniture, being burnt down and rebuilt again, with the sort of vitality that inheres in a solid, well-managed family trust. It never became a centre of popular devotion, or bred famous doctors, or even matched the political and military power of more solidly established houses. In the interminable ecclesiastical feuds of late Heian it was not Hōjōji, Hosshōji, and Sonshōji that acted as principals, marching and counter-marching with their private armies, burning each others' buildings, threatening the Throne with their curses in some quarrel over patronage. Instead the champions were those whose power had the broadest possible base: primarily the sprawling Tendai headquarters, Enryakuji, on Hieizan, its jealous offshoot Onjōji (or Miidera) on the far side of the same mountain, and – interestingly enough – the two redoubtable survivors at Nara, Tōdaiji and the double foundation of the Fujiwara clan, Kōfukuji and the (Shintō) Kasuga shrine.

Several peculiarities that may be traced in the plans of the metropolitan temples merit attention. All the great establishments later than Tōji have disappeared and must be

reconstructed from texts, primarily from the detailed records of their dedication ceremonies. The best known is Michinaga's Hōjōji, since in addition it is the subject of a long panegyric in one of the court romances of its time, the *Eiga Monogatari*. All the sources agree on its exceptional size. The main Buddha was 32 feet high, twice the usual scale; the largest timbers were too big to be hauled in carts, and so had to be floated down the Kamo River to Kyōto. By comparison with the standard Nara plan, Hōjōji seems to have exhibited three notable innovations. The sūtra and bell towers, instead of rising behind the main hall, now were placed in front of it, probably close to the corners of the courtyard. Again, two secondary halls of worship, of the type that at Kōfukuji had been kept outside the nucleus, were here incorporated in it, presumably as elements interrupting the corridors on east and west. Finally, the centre of the courtyard was taken up by a large pool.

It can hardly be an accident that the second and third of these features also characterize the setting of the standard T'ang devotional picture of the Paradise of Amida (found in quantities at Tun-huang, and known in Japan especially through the miraculous version preserved at Taimadera). In the Heian age the cult of Amida coloured popular Buddhism more deeply than any other; it had, in particular, a fervent devotee in the Regent Michinaga. The descriptions of Hōjōji in the *Eiga Monogatari* are couched in a high-flown style not much different from that used in the sūtras, telling of the beauties of the Pure Land. For the author, its earthly materials sparkle with a supernatural brilliance. The trees have leaves of pearl, gold, amber, or lapis; the pool is of gold and jade; making up the halls are 'columns with bases of ivory, roof ridges of red gold, gilded doors, platforms of crystal.' The temple, to be sure, was dedicated not to Amitābha but to Vairocana. That primal, ineffable, all-embracing Buddha occupied the kondō on axis; the Lord of the Western Paradise had only a secondary position, in the flanking hall on the west side of the courtyard. The distinction, however, must have been purely theological. In the realistic terms of faith, Vairocana might be a symbol of everything – or of nothing – like the child emperor of eleventh-century Japan. It was Amida, like the Regent Michinaga, who ruled; and it was Amida's hall, the Muryōjūin, that was first dedicated in 1020, two years before the rest.

The primary theme of the plan of the Hōjōji group, the happy land of flowering trees and cool waters, is traceable ultimately to the first 'Paradises', the royal pleasure gardens of the ancient Near East. Reaching China through the Buddhist books, Amitābha's Heaven was there visualized naturally in terms of its best-known earthly counterpart, the Chinese imperial park. The classic Pure Land picture was first of all a view of the central garden complex, with lake and bridges and symmetrically laid out buildings, at the rear of the T'ang palace (whose descendants may still be traced in Peking). In the Japanese temple, therefore, the ambition to mirror on earth the beauty surrounding Amida gave a special longevity to the monumental Chinese scheme that elsewhere had fallen into disuse.

The minor change in plan at Hōjōji, by which the twin 'towers' housing bell and library were brought in front of the kondō, very likely reflected a Chinese innovation of late T'ang or early Sung, drawn to Japanese attention by the report of pilgrims such as Chōnen (who returned from the Northern Sung capital and a tour of the mainland monasteries in 987). Thus a description of the Northern Sung palace at K'ai-feng speaks of the presence just inside the main gateway of 'two tower-pavilions, as in a Buddhist temple'.[2]

At Hōjōji, as we have seen, the kondō was dedicated to Vairocana (or in Japanese Dainichi-

nyōrai), the unearthly prototype of the human emperor. The hall on the west, in the person of Amida, epitomized divine mercy and the promise of eternal bliss. The balancing hall on the east was devoted not to the cosmological opposite – the eastern Buddha, Yakushi – but to the terrible power against evil that in the Tantric system must complement love and goodness: a power personified at Hōjōji in the Five Great Wrathful Gods, Godaison. One of the records speaks of a 'courtyard behind the kondō', and thus implies the existence of a lecture hall to close off its rear. There was at the outset a single pagoda, but in a rebuilding that followed a disastrous fire of 1058 a pair was provided, apparently in the traditional balance. Several other buildings of various degrees of importance are named in the texts; the inconspicuousness of one, a Shakadō, illuminates the relative indifference of the Heian age to the historic Buddha. The largest apart from the courtyard group was apparently a hall of Yakushi, set up somewhere on the east side of the temple area facing west.

The main elements of the Fujiwara masterpiece seem to have been repeated half a century later in the emperor Shirakawa's Hosshōji. In addition the latter possessed, from 1083 on, one unique and dominant feature: a giant single pagoda, set on axis on an island in the courtyard lake. We know that this was octagonal, and rose through nine storeys; the account of its burning in 1342 calls it 'without peer in the universe'. If any scriptural justification can explain this choice it is not one of Amida, but the *Lotus Sūtra*, where the most dramatic miracle described is the welling of a gigantic stūpa out of the earth in front of the Buddha and His audience. The octagonal plan, almost unknown in Japanese towers,[3] suggests a Chinese source, however; and so there may be some relevance in the fact that the diary of the pilgrim Jōjin, sent home in 1073, describes with special enthusiasm an octagonal, thirteen-storeyed pagoda he had seen on the Huai River.[4]

⟨ The plan of the temple compound is tentatively restored by Dr Toshio Fukuyama as shown in illustration 225. The major buildings were dedicated by 1077, and the Yakushidō, the nine-storeyed octagonal pagoda, and the octagonal hall were added in 1083. ⟩

Sonshōji, dedicated in 1102, seems to have been laid out in deliberate imitation of the Nara standard. The dedication text mentions no halls on east and west like the Amidadō and Godaidō of Hōjōji. There were two pagodas from the start, and the bell and library were returned to their old positions at the rear. The explanation for this archaism may perhaps be found in the altered political balance of the time. With Shirakawa's reign the Fujiwara monopoly had been broken, and real power restored to the imperial house. Sonshōji was thus perhaps constructed to be a symbol of the imperial renaissance. How short-lived the revival proved to be is shown by what followed it fifty years later; not another proud monument, but the first outbreak of catastrophic civil war.

The last formal Heian temple was Mōtsuji, an early twelfth-century erection of the Fujiwara lords of the north-east, Kiyohira and Motohira, at Hiraizumi. There the remains are identifiable [226]; up a gradual slope to the north may be traced the pillar bases of a gatehouse, a Buddha hall, and a lecture hall. Between the first two are the remains of a small artificial pond, containing an island that once was reached from the south by a bridge on axis. Veranda corridors orginally emerged from either end of the kondō, turned, and ran south to stop at the edge of the water against small pavilions housing the bell and library. On a modest scale and with the informality proper to a country site, Mōtsuji must have come fairly close to the look of a typical shinden-zukuri mansion. Details draw the parallel still

225. Hosshōji, plan

The image is rotated; the visible labels read:

River Shirakawa

South Gate

Hall of Amitābha

Nine-storeyed Pagoda

Sutra Storage Bell Tower

Kondō

Second Avenue

West Gate

Kōdō

Godaidō

Yakushidō

North Gate

100 M 50 0

Present buildings

Stone base of a building

Traces of stone bases of a building

Pond
Benten

Hokkedō

Kondō

Kōdō

Enryūji

Jōgyōdō

Kashōji

Drum
Tower

Bell Tower

Northern Bridge

Pond
Ohizumi

Southern Bridge

South Gate

Entrance Gate

Present Main Hall

0 50 100 M

closer; the sites of the two terminal pavilions are still bordered by garden rocks, as would have been those of the similarly placed kiosks in the mansion. Again, just as in the picture-scrolls that have preserved the look of the noble houses of late Heian and Kamakura, a rivulet ran down from behind the Buddha hall on either side, crossed under the spur corridor, and emptied through rocks into the little lake.[5]

The plan of the celebrated 'phoenix hall', Hōōdō, at Uji provides an apt postscript. The beauty of this riverside location led the regent Michinaga to choose it for a villa about 1000. His son, the hardly less illustrious and extravagant Yorimichi, turned the residence into a temple called Byōdōin in 1052, and set up the Hōōdō to house its Amida icon the following year. The building still stands, mirrored in its

T'ang palace, it is not surprising to find, where each Hōōdō corridor turns, a small kiosk straddling the roof; thus repeating more simply, in miniature, the corner 'turrets' of the Heian Hall of State [213, *right*].

⟨The Hōōdō, originally called an Amidadō, represents one of two quite different building types used in the Heian period to celebrate the cult of Amida. Its elaborate wings and corner pavilions seem to represent in miniature the Palace of the Western Paradise. A much

226 (*opposite*). Mōtsuji, plan

227 (*below*). Byōdōin, Hōōdō ('phoenix hall'), eleventh century

lotus lake, as the chief surviving glory of Heian architecture [227]. Its odd form, with a short corridor at each end turning the corner and then stopping short, suggests an abbreviation proper to the small size of the whole precinct. Contemporary descriptions, like those of Michinaga's Hōjōji, stress the Hōōdō's likeness to the golden glories of the Pure Land. Since behind all these Japanese versions must lie the

simpler building type, on the other hand, the long, shallow, single block of the Kutaidō of Jōruriji, which enshrines a row of nine large Amida figures, seems to sum up the complete world of the Western Buddha. Both of these buildings face east, with a lotus pond in front to stand for the sacred lake of the Paradise.⟩

Wherever located, the large Heian monastery was likely to possess a much greater

variety of buildings than before. To accommodate the enormously expanded pantheon of Tantric Buddhism, it was necessary to house new deities or specialized aspects of old ones. The most popular of Bodhisattvas, Kannon, might be worshipped in his essential form in a Kannondō; he might also be addressed in chapels named Nyōirin, Juichimen, Juntei, or the like, after his separate manifestations. The Five Great Wrathful Gods were sometimes placated in a single Godaidō for the group; elsewhere their leader might be signalled out in his own Fudōdō. The pantheon, summed up in the two great Mandalas, was often housed in a special Mandaradō. Shingon houses frequently honoured their founder, Kōbō Daishi, by a memorial Mieidō. Other buildings were required by new methods of worship. A type found very widely in late Heian was the Hokke-sammaidō in which monks practised a penitential rite based on the *Lotus Sūtra*. Out of the novel techniques for attaining meditative ecstasy that had been transmitted to

228. Ceremony in the lecture hall of Kōfukuji, from the picture-scroll
Kasuga-gongen-reikenki, completed 1309

Tendai by its founder, the headquarters on Hieizan provided early buildings for two: a Hangyō-hanza-sammaidō for the mode of 'half walking, half sitting', and a Jōgyō-sammaidō for that of 'constant walking'. Shingon, in turn, laid emphasis on a kind of baptistery, *kanjōdō*, where a lustration rite was performed as an initiation to higher mysteries. The supplement to this was a *gomadō* for the rite of burnt offerings, *goma*. Most of these buildings were small and simple, so that functional variety could be provided even in a compound of modest size. Finally both new sects adopted a new type of pagoda, the single-storeyed tahōtō, which will be discussed later.

THE HALL

The one impressive achievement of Heian Buddhist architecture lay in the planning of the individual hall of worship. There in the course of four centuries was carried out a transformation more radical than any other traceable in the Far East (except the similar formation of a Japanese domestic style). The end product was a type almost as purely national as the eighth-century formula had been foreign: a

type with its own aesthetic properties, and a vastly increased efficiency.

The change was hastened, certainly, by the inability of the T'ang model to meet the requirements of a new age. The classic chancel-and-ambulatory plan had been inconvenient even at Nara. Its impracticability was now high-lighted by two new problems: first, the desire to accommodate a lay congregation indoors, within easy hearing and seeing distance of the service; second, the opposite need to perform all important Tantric rites in the utmost secrecy.

It is not easy to learn exactly what right of entry into an icon hall the layman had possessed during the Nara period. Presumably he was barred at least from attendance inside during services, as his East Christian contemporary was barred from the chancel of the church; in part to preserve monastic purity, and also because there was no place for him except in the ambulatory, where his presence would have interfered with the ritual procession. Like the vassals at an imperial audience, the lay congregation probably stood or knelt in the courtyard, under some sort of temporary shelter in inclement weather. The most immediately

convincing piece of evidence for this situation is an illustration to an early fourteenth-century picture-scroll, the *Kasuga-gongen-reikenki* [228]. The scene is the annual Yuima-e or celebration of the *Vimalakīrti Sūtra*, held at the lecture hall of Kōfukuji, as one of the invariable traditions of that monastery. The building is shown packed with monks on either side of the image altar; the lay audience, represented by an imperial envoy, attends under the sky.

In the Heian period Buddhist values spread more widely through the aristocratic way of life than ever before. Buddhist provisions against every human need – at the highest level an eloquent promise of Heaven, at the commonest an emotional stimulus through sermons and processions – found among those of gentle birth the widest possible audience. The Heian audience, at the same time, grew with every generation more completely conditioned to its small world of peace, security, luxury, and indolence. To fit within its shrinking circle of experience, much of Buddhist practice was given a new homeliness. The setting of everyday worship might be the palace or mansion itself, or a new hybrid type, half temple and half nobleman's residence (the higher clergy

were of course of noble or imperial birth). In this domestic environment pious observances were no more onerous than any other social activity. It was doubtless inevitable that a strong effort should be made to adapt more formal architecture to the same standard of comfort and familiarity.

Tantric ritual necessitated first a much larger floor area for the performance of the rite; then the possibility of a complete screening; and finally a number of minor altar complexes in addition to the major one. Ritual furniture in the eighth century must have been fairly simple, and modest in its space requirements. The narrow ambulatory of the Hokkedō can have accommodated nothing more elaborate than the sort of complex shown in Tun-huang paintings: a stand with flower vases and incense-burner, and a cushion or dais for the priest. The Tendai and Shingon formula may still be seen in a number of Kamakura halls, and through texts may be carried back at least to mid Heian. The altar platform, *Shumidan*, with its images is much narrower than before, and is pushed against the rear wall of the chancel. Statues are fewer or smaller; the holiest, for full secrecy, may be set inside box shrines. In front, on the floor, stands first a wide table for offerings; and then the low, square ritual altar, *daidan*. This last, rather than the traditional Shumidan, provides the most direct access to divinity within the building, and so is its ritual heart. Its surface is laid out as a kind of Mandala, formed of quasi-utilitarian objects: corner-posts and flower-vases, dishes and vessels in a prescribed pattern. In front of the daidan, again, is the priest's dais, with a gong-stand on his right, and a low table with additional utensils on his left. All of this takes up perhaps twenty feet in front of the Shumidan. The chancel in addition often contains, as more specialized foci of worship, the two Tantric Mandalas in pictorial form, the Taizō-kai and Kongōkai, hung between columns on

the east and west respectively, each with its daidan complex on the lateral axis [229, 274].

Only a radical redesigning of the Nara standard could provide a chancel spacious enough to hold even this assortment of furniture. The additional need for supplementary altars could have been met in the old scheme only by sacrificing portions of the ambulatory. That compromise proved necessary in one of the earliest Shingon centres, the Shingonin, a chapel maintained in the imperial palace from the time of Kōbō Daishi onwards. There, in the periodic ceremonies held on behalf of the ruling house, almost the whole of the building was used for a combination of secret rites, each jealously screened from the rest. The chapel had a traditional plan, a chancel five by three bays with a surrounding aisle. In the grand New Year's ceremony, the central area, scrupulously screened, was equipped with the twin hanging Mandalas and their daidan complexes. Against the rear wall the icons of the Five Great Wrathful Gods were hung as pictures – perhaps to save space. In the northwest corner of the ambulatory was an enclosure holding an altar for burnt offerings made 'to increase blessings'. South of this, along the west wall, was another, of different shape, 'to dispel calamities'. In the rear aisle was still another, dedicated to the elephant-headed twin deities called Shōden, as defenders of the precinct against evil spirits. Along the exterior wall on the east were hung pictures of the Twelve Gods, personifications of fire, water, etc., with an altar below [230]. The only space left free for a congregation of monks was the south aisle. Among other inconveniences this new crowding must have hampered or prevented the old performance of circumambulation. Perhaps it was at least partly for this reason that the most purely esoteric rites began to accept instead a pradaksina around the daidan, or even out-of-doors around the whole building.

229. Prayer in a Shingon sanctuary, from the *Kasuga-gongen-reikenki*

230. The Imperial Chapel (Shingonin) in the Heian palace, from the *Nenjū-gyōji*

None of the extant Heian icon halls shows more than a minor adjustment of proportions to meet the new problems of use. The oldest remaining buildings in which the difficulties have been overcome are of the thirteenth century. A search through Heian texts, however, makes it clear that all the important experiments were carried out at that time, and indeed that a stage just prior to the final solution was reached as early as the latter half of the tenth century. Before analysing the existing Heian buildings, then, I shall indicate the kind of progress that written evidence ascribes to the monuments that have disappeared.

Three improvements in the plan of the hall of worship were tried out during the Heian period, with varying success. The simplest was to add an aisle across the front – a 'grandson aisle', *magobisashi* – covered by a prolongation of the main roof. Next was the provision of a building some distance in front of the hall, either free-standing or joined to it by some sort of gallery. The third, most complicated but in the end most satisfactory, was to erect the same sort of fore-hall – a *raidō*, or 'hall of homage' – across the front of the main building, with only a partition separating the two.

The magobisashi had one obvious disadvantage. The deeper and more generous it was, the more had the front roof to be lengthened, and the lower became the eaves across the façade, precisely where dignity asked for a maximum height. The extra aisle was thus adopted most often in small buildings where no monumentality was necessary; for example the *jōgyō-sammaidō*, the 'hall of Samadhi attained by constant walking', that the Tendai doctor Jikaku Daishi erected on Hieizan after his return from China, about 851. On the other hand its advantages were still granted sufficient weight a century later to permit its use in an enlargement of the most important Tendai building of all, the 'original main hall', Komponchūdō, at Enryakuji [231].[6]

231. Enryakuji, Komponchūdō (main hall), reconstruction

A magobisashi may be traced in the remains of the Tōdaiji lecture hall; whether as part of the original construction, or as a fashionable addition made in a rebuilding of 935, is not clear. The perennial question of an ultimate Chinese source cannot be answered here with much confidence. The scheme was doubtless known on the continent. It may occasionally be seen in fairly formal buildings today, as for example in Peking, in a shrine to the Fire God, the Ch'in-an-tien, on the major axis in the gardens of the Forbidden City. The fact that Jikaku Daishi's 'hall of Samadhi' was designed to house a rite of invoking Amida's name 'as it was practised on Wu-t'ai-shan' suggests that the plan of the building may have been borrowed at the same time.

The device of a fully or partially free-standing fore-hall could be handled with a much greater flexibility, and so varied widely in use. At its simplest the building could be no more than a shed with a single-slope roof:[7] the form illustrated in the Kamakura period picture-scroll *Ippen-shōnin-eden*, in a scene

232. The revivalist Ippen preaching, from the picture-scroll *Ippen-shōnin-eden*, completed 1299

showing the revivalist preacher Ippen with crowds listening to his sermon [232]. A detailed inventory of 890 sets what was apparently this version in front of the kondō of Kōryūji in Kyōto, with a strong likelihood that it had been there since a general rebuilding not long after a fire of 818. The record mentions a plank floor, continued outside as a veranda, and notes the presence of 'suspended, half-length shutters on the four sides'. Though the roof is not mentioned, it was doubtless shingled, like that of the contemporary kondō [233]. Aptly enough, then, this earliest known Heian raidō, intended to shelter a lay audience, was put together out of the elements proper to Japanese domestic architecture. The association became traditional thereafter; a wooden floor and shutters of the sort used also in great mansions are characteristics of the fully developed Kamakura standard. The ninth-century Kōryūji kondō apparently retained a stone paving from its predecessor. That feature, too, may reappear in Kamakura for special reasons; in some of the great halls of that age the domestic character of

the raidō across the front is opposed by a traditional formality in the rear half.

Much more convenient than the isolated shed and so common in more ambitious establishments was the raidō attached to its hall by a

233. Kōryūji kondō, reconstruction

raised passage. That must have been the solution adopted for the Oku-no-in, the tomb precinct of Kōbō Daishi on Kōyasan, in an enlargement undertaken in 1023. The elements linked were a tomb sanctuary (then a square hall with a pyramidal roof) and a fore-hall three bays across. The passage is called a 'bridge building'. At the Shingon Daigoji a late Heian inventory describes a complex devoted to the Juntei Kannon in which the raidō was given a greater emphasis than in any of the preceding examples. It and the hall proper had the same size and plan, a chancel-and-ambulatory type five bays across; there was a five-bay corridor between [234]. The increased size testifies to the pressure of numbers that the fore-hall was designed to meet. At the same time the immaturity of the Daigoji solution is clear; it was illogical to make two buildings identical that differed so completely in use.

In the Kōyasan texts the Oku-no-in fore-hall is referred to both as a raidō and a haiden. The two have approximately the same meaning, the latter being preferred for Shintō use. Their equation helps to illumine the pre-Heian background of the isolated fore-hall. In the Nara period a haiden had been frequently used in Shintō precincts to accommodate lay worshippers in front of the sanctuary, doubtless with very much the look of the shrine complexes illustrated in Kamakura picture-scrolls [235]. The element, indeed, must have been made necessary by exactly the same practical difficulty that I have traced in Heian Buddhism, more quickly realized in Shintō because there the sanctuary was smaller and more rigorously closed. We have seen, again, that a side-current of Nara Buddhist architecture furnished experimental fore-halls analogous to those of Heian. The refectory of Tōdaiji may even have been

234 (*above*). Kami-daigo, Junteidō, reconstruction

235 (*right*). A typical Hachiman shrine sanctuary

built on a dumb-bell plan that was the monumental equivalent of the three-part complex of Daigoji. That a Chinese source lay at the back of these variations is substantiated by evidence from the mainland. Explorations carried out in the north by Chinese architectural historians in the 1930s have revealed the survival there of fore-hall designs closely linked to the Japanese. Some, in front of Taoist sanctuaries, are freestanding. The three-part scheme has been found in two interesting variations. One, a straightforward dumb-bell with the blocks of approximately equal size, appears in the Shêng-ku-miao at An-p'ing-hsien in West Hopei, erected in 1309 [236]. This complex not only suggests a reduced version of the Tōdaiji refectory, but even more closely resembles a design later popular in Japan under the name *gongen-zukuri*. The other, of indeterminate date but oddly reminiscent of certain Shintō designs, is the more complicated Huo-hsing-shêng-mu-miao in the Fen River Valley in Honan [237].

The loose connexion of two blocks by a corridor is visible today in Peking in the Taoist Shrine of the Eastern Peak. This, the most primitive version, was doubtless developed long before the dumb-bell, and probably in the Chinese palace; there such groupings are a traditional commonplace, and so were widely borrowed by the Japanese in the Nara period for secular use. The religious application must represent a fairly late stage, in making the two buildings face each other and represent sharply opposed functions. In the palace tradition they are functionally oriented in the same direction, the rearmost being an annexe.

The third experiment of the Heian period, the construction of the raidō as a fore-hall in contact with the main building, is attested by the history of one of the famous foundations of the Fujiwara clan, Myōrakuji on Mount Tonomine in Yamato. The lecture hall there, first erected in 683, passed through the usual vicissitudes. Its historically critical form was

236. Shêng-ku-miao, 1309, reconstruction

237. Huo-hsing-shêng-mu-miao (Honan), reconstruction

238. Myōrakuji, lecture hall,
rebuilding completed in 972, reconstruction

reached in a rebuilding completed in 972, for which (as an exceptional detail) the name of the architect was recorded. He is called Tsunenori; presumably he was Asukabe no Tsunenori, better known as a painter and decorator at the Heian court. The ground plan of his compound building is reconstructed in illustration 238. It bears a close resemblance to the standard Kamakura icon hall, being almost identical, for example, with that of the present Shakadō of Enryakuji. Its immaturity is revealed only by a passage of the history that speaks of 'two ridge-poles'. Each of the two blocks must have had its own roof, meeting the other in a common valley. Inside, the line of demarcation between the public and clerical halves, the *gaijin* or *raidō* and the *naijin*, was created by 'five bays of grilled partitions, flanked on east and west by one set of swinging doors.' Here at last the basic functional demands of the Heian age were satisfied. The lay congregation was housed in a spacious room immediately adjacent to the sanctuary. The two halves could be completely separated, or when the ceremony permitted could be thrown together by opening the partitions to permit a full view. At the heart of the naijin was a chancel area spacious enough for the main esoteric ritual, with the image altar filling only the back third. It is possible that what corresponded to the old outer aisle was used at the ends and rear to provide chapels for supplementary altars, as is often the case in extant buildings from Kamakura onwards.

The same basic plan is extremely common on the mainland in the official Ming-Ch'ing style of north China, being crowned in the same complex way, since Chinese structural logic has always insisted that two blocks so distinct in function should be identified by individual roofs. In addition the fore-hall is usually shallower and shorter than the main building, so that it looks something like an enclosed porch. Its roof is frequently curved, to make the contrast unmistakable. Behind existing buildings the same usage may be traced in earlier evidence. I believe that it was this form that the Han dynasty called *hsien*, and attached in various ways to the palaces of the time, principally across the front but also on other sides, and sometimes in two storeys.[8] Architectural paintings of the Sung show that in that period the picturesque freedom given by the hsien was exploited to produce buildings of an extraordinary baroque richness. The texts are reinforced by a few visible remains. At Cheng-ting-hsien in Hopei, the Buddhist Lung-hsing-ssu has retained a hall of Northern Sung date, from whose square core a kind of cross-roofed vestibule emerges on each face [239]. Even more apt is the information given by the remains of a garden hall in the recently excavated royal palace of the P'o-hai kingdom in southern Manchuria, a state culturally dominated by the

239. Mo-ni-tien of Lung-hsing-ssu, schematic view and plan

240. P'o-hai palace (southern Manchuria), schematic view and plan

T'ang. The building, with its wing colonnades, must have looked not unlike the Hōōdō from across its lake; in addition it had a small hsien attached in front [240].

It should be noticed that these ways of increasing variety and efficiency were admitted into Chinese practice only at a semi-monumental level. For the same reason they seem to have been banned not only from the monumental side of Nara architecture, but also from the most grandiose Heian continuations of the T'ang tradition. There is no mention of a raidō in the accounts of Kyōto temples like Hōjōji, Hosshōji, and Sonshōji.

Of the sixteen or so remaining Heian buildings, the great majority are small and modest. They are not representative of the once existing whole for the same reason that explains their survival: most stand in out-of-the-way places, and so have escaped the civil wars that devastated the capital. The majority, again, were built only for specialized monastic needs. Their chancel-and-ambulatory plans reflect the relatively simple use to which they were put, as chapels to Amida, where a few monks performed the pradakṣiṇa around an image altar, calling on His name. That, presumably, is why most are square or squarish. The one marked exception in plan, the main hall of Jōruriji, owes its unusual length to the divinity it houses: a ninefold Amida, personified by nine large statues in a row.[9]

The design of the Hōōdō is unusual in two respects. First, its short end corridors that lead nowhere suggest an abbreviation of a larger group design. Then the hall proper, though it follows the ambulatory formula, breaks with front-and-back symmetry in a way foreshadowed in the kondō of Tōshōdaiji. Here only the rear aisle is enclosed, the others serving as an open porch. The intention must have been to preserve ease of circumambulation. Since the throne of the colossal Amida backs

up immediately against the rear wall of the chancel, it would have been impossible to pass behind it without going out-of-doors. The porch in turn adds a sense of lightness and movement to the exterior.

The cross-sections of extant Heian buildings seem at first sight no more advanced than their plans. The chancels and aisles are enclosed above by what look like mere decorative variants of the Nara repertory. Sometimes there are open roofs with exposed beams and rafters, as in the lecture hall of Kōryūji [241, 242].[10] Elsewhere the ceilings may be flat, and coved and coffered with varying degrees of richness; the version of the Hōōdō, crossed by girders and elaborately bracketed around its cornice, is a descendant of the Nara form seen at Tōshō-

daiji. Detailed analysis, however, proves that at least in some buildings this apparent conservatism conceals an all-important change. Their designs, that is, *necessitate* a double-shell roof of Japanese type. All the Heian buildings have been re-roofed, and now show such double shells as a matter of course; in several cases it is clear that the form must have been used at the start.

The fact is most obvious in the case of Jōruriji. There the roof is open throughout; in the middle bay, where the Amida is larger than the others, the ceiling is several feet higher [241]. Chinese logic would have demanded that this bay project on the exterior, as at the Lama Temple in Peking, where a kind of skylight accommodates the extra height of the

241 (*opposite*). (A) Kami-daigo, Yakushidō, and Hōkaiji, Amidadō; (B) Kōryūji, lecture hall, and Jōruriji, main hall

242 (*below*). Kōryūji, lecture hall, interior

main Buddha. It is impossible to imagine such an excrescence in Japan; the change of level must always have been hidden between the two shells. Much the same situation exists in the Yakushidō of the hill-top half of Daigoji, Kami-daigo.[11] There a break occurs inside between the level reached by the aisle rafters and that of the chancel ceiling [241]. Theoretically this might have been admitted outside by a kind of clerestory, but everything argues against the possibility.

These almost certain examples help to carry the case of the Kōryūji lecture hall, where the difficulty is less extreme [241, 242]. There is a sharp change of angle between the chancel and aisle rafters; the latter have the usual very low Heian slope, around 13 degrees. The Chinese average begins around 20 degrees, and the change at each purlin point is always slight. Again it is hard to believe that the lecture hall roof either exposed such a sudden change in direction, or (in a land of heavy rain and some snow) terminated in so low a slope.

In all these buildings the original roof framing may well have been less radically different from the Chinese formula than the present one. Probably the outer shell was less steep and the hidden framing less expert. There was a less complete dependence on invisible girders and cantilevers, and so the visible members – the rafters, the embryonic truss at Jōruriji, the classic two-tier beam system of Kōryūji – were less completely deprived of structural significance. It was the initial break with Chinese principle that was revolutionary, however, in separating exterior and interior design. With that accepted, the Japanese could experiment and gain boldness through the Heian centuries; most important, they could keep their structural method abreast of the changes accomplished in ground plan.

A notable instance of experimentation within fairly traditional limits is given by the Amidadō of Hōkaiji.[12] The core of the building is a five-

243 and 244. Hōkaiji, Amidadō, late eleventh or early twelfth century, front and interior

bay square, surrounded by a single-bay porch under a lower roof [241, 243, 244]. In the main block the Nara formula would have produced a chancel three bays square; instead, there is only a single bay, somewhat wider than those of the wall plane. The space in front of the chancel (which is still filled with an image altar) is thus deepened. Since the interior and wall columns are on different axes, they cannot be tied together by aisle beams. They are joined, in fact, only by the rafters, and by invisible slanting beams above. Here, then, is another design requiring a double-shell from the start, for the framing would have been impossibly flimsy – even under cypress shingles rather than tiles – had the roof been laid directly on the rafters.

245. The tahōtō form in a Mandala

THE SINGLE-STOREYED PAGODA, TAHŌTŌ

Both Tendai and Shingon made widespread use of a novel pagoda form, imported separately by each sect in its first generation. The type is usually called *tahōtō*, 'pagoda of many treasures', presumably with reference to the miraculous stūpa-pagoda of the *Lotus Sūtra*; that gigantic manifestation had revealed itself as a reliquary about the body of the Buddha of Many Treasures, Tahō Butsu.[13] The earliest Tendai versions were given the abbreviated name *hōtō*; while the most ambitious of the Shingon erections, which was undertaken by Kōbō Daishi on Kōyasan, won by its place and unique size the title *Kompondaitō*, 'original great pagoda'.

Although no example remains from Heian, the type then established is clearly enough known so that we may accept as substitutes the numerous tahōtō of Kamakura date. All of these vary in one important particular from what must have been the imported norm. The latter is known from the tahōtō as drawn for inclusion among the Tantric symbols of the Mandala, or as fashioned in bronze for use as a

miniature shrine [245]. The basic elements are: a cylindrical body, rising into a domed top; a zone of bracketing, surmounted by a wide, square roof; and a central mast, with base, disks, and finial. Ultimately this design must go back to the Indian stūpa type, visible for example in its Guptan stage at Ajanṭā.[14] The one striking change effected by its transfer to China was a concession to Chinese building habits. There had to be an overhanging tiled roof, preferably square. The natural place to add it was above the dome, where it could replace an analogous Indian feature, the corbelled *harmika*.

Imitation in Japan brought one more transformation. The Chinese pagoda was probably built of stone or brick; the Japanese, lacking skill in masonry, imitated in plaster over a wood framing. A generation or so must have revealed the vulnerability of such a curved plaster surface to rain. The Japanese answer that created the final tahōtō form was to enclose the cylindrical core in a square penthouse with its own roof; leaving exposed a part of the

246. Ishiyamadera, tahōtō, late twelfth century

dome, since that was already well sheltered by the main eaves [246].

The tahōtō seems never to have been used as an element fitting into the composition of an axial monastery plan; its place was sufficient to itself. Perhaps for that reason it never ousted the conventional multi-storeyed pagoda, even in the service of the esoteric sects. Of the two surviving Heian five-storeyed towers, both rise (in forms close to the Nara standard) in Shingon houses, the earlier and smaller at Murōji, the other at Daigoji.[15]

247. Byōdōin, Hōōdō, eleventh century, detail of canopy over image

GENERAL DETAILS

Being small and simple, the majority of Heian remains require little eaves-bracketing under their shingled roofs. Jōruriji has none; elsewhere the minimal 'boat' bracket is frequent. The exceptional buildings – the Hōōdō, and the two pagodas of Murōji and Daigoji – follow Nara precedents almost without change.

Where some sort of contact with earlier practice remains, Heian taste is revealed by a substitution of obviously decorative effects for the old combination of strength and subtlety. The columns lose their entasis, the transverse girders their just perceptible arching, the bracket curves their refinement. In compensation there may be a more overt variety. The

porches of the Hōōdō and the Hōkaiji Amidadō have square, chamfered posts instead of columns; even more noticeably, the porch roofs break up to a level several feet higher than the rest, in a central section [227, 243].[16] The intercolumnar motif, the *kaerumata*, is given new emphasis. Where necessary it may still be a solid block, capable of real support. The same silhouette is transferred to a purely ornamental cut-out kaerumata in the bracketing frieze: a pair of long, elegant legs with cusped feet. The most pretentious interiors show an extraordinary decorative brilliance. In the Hōōdō all of the chancel woodwork is intricately painted; the altar platform is lacquered, with a

delicate, all-over inlay of mother-of-pearl and panel divisions marked by gold plates. The undersides of the beams are punctuated by gilded rosettes, and pierced gold plates again mark the intersections. The canopy over the icon exceeds everything else in the shimmering delicacy of its colours and openwork carving [247].

At Chūsonji, where the Fujiwara barons of the north tried to outdo their cousins at the capital, the chapel-sized Konjikidō remains to show an even more consistent invasion of architectural design by the taste and methods of cabinet-making. The whole exterior was originally gilded; the interior is still lacquered

248 (*opposite*). Chūsonji, Konjikidō, twelfth century, interior

249 (*below*). Shiramizu, Amidadō, twelfth century, interior

throughout, and further enriched by mother-of-pearl patterns [248].[17]

The infiltration of habits from domestic architecture is noticeable first of all in a general preference for raised wooden floors and shingled roofs. Two new types of door are probably borrowed from contemporary mansions. These are often used together: the reticulated wood shutters, *shitomido*, on the outside, the sliding *mairado* inside. The traditional hinged doors and windows are now framed by *karatomen*, a simple but beautifully detailed combination of plane and curved mouldings. The floor is extended outside to become a veranda under the eaves.

One twelfth-century interior, that of the Amidadō of Shiramizu, marks a new degree of success in fusing the aesthetic properties of the two traditions.[18] To achieve the simplicity and refinement of the best domestic design, every possible detail that might give a now unwanted monumentality is abandoned. There are no visible brackets or girders; the necessary columns are not stressed; the wood surfaces act as a plain foil to the lightly applied decoration. The ceiling derives from the old coved and reticulated form seen at Hōryūji, but has been diminished in scale until two sizes of square are necessary to preserve the clarity of its design [249].

SHINTŌ ARCHITECTURE FROM NARA TO KAMAKURA[1]

For Shintō, the cultural invasion of Japan that reached its height in the eighth century ushered in a long age of accommodation or subservience. The existence of the native religion was never seriously threatened; it was simply surrounded and grown over by the vast Buddhist protoplasm. The local gods whose cults had been built up through centuries of folk worship were accepted now as devoted defenders of the new faith, like the nāgas in India and the Chinese mountain spirits before them. Their presence as guardians of the new monastic system was carefully demonstrated. The local god had his miniature shrine and his modest allowance of offerings inside the Buddhist precincts. The larger shrine, *jinsha*, that was his traditional seat was given a new dignity by imported architectural forms: impressive gateways, stone lanterns, symmetrical outbuildings, perhaps a new sophistication in the sanctuary itself. All these novelties that brought the primeval shrine up to date were paid for by a loss of individuality. A few key features like the torii gates and the basic smallness and simplicity of the sanctuary still remained to identify the Shintō jinsha; but the effect of even these was sometimes counteracted by an intrusion of the most distinct of all Buddhist architectural forms, the pagoda.

Only those holiest recesses of the Shintō system that treasured the prerogatives of the imperial house were kept noticeably free from assimilation. Against this resistance Buddhism brought the same effort at persuasion that it had used against the greatest deities of the Hindu pantheon: the top Shintō gods were explained as special Japanese manifestations of the highest figures in the Buddhist pantheon.

Thus the Sun Goddess was to be equated with the ineffable centre of the Tantric theological diagram, the sun-like Buddha principle Vairocana. Though more flattering than the status of defender, however, this parallelism failed to soften the last hard core of native pride. The imperial cults at Ise, in particular, were jealously watched. The proximity of monasteries was guarded against; even the use of Buddhist terminology, or the admission of monks to the shrine precincts, was taboo. In consequence the architecture at Ise has remained almost as free from outside influence as that of the corresponding imperial cult in China, worship at the Altar of Heaven.

One of the most conspicuous instances of assimilation, on the other hand, concerns the martial Shintō god, Hachiman. The origins of this being (whose name means 'Eight Banners', and is also read Yawata) are obscure. Buddhist sources claim that he first showed himself as a god in 570 in the province of Buzen (the northern tip of Kyūshū, just inside the Shimonoseki straits), in the Usa district. Doubtless for this reason his earliest important shrine, in the province of Higo in west Kyūshū, was called the Usa Hachiman-gū. In 740 or 741, shortly after an abortive revolt in Kyūshū had been suppressed, thank-offerings were made to him by the Throne. These included, by one account, a sustaining fief, jewels, and a monk-architect; by another, a brocaded cap, two of the most popular Buddhist sūtras, and the erection for him of a three-storeyed pagoda. In 749 a shrine was set up in the imperial palace (as the result of his appearance in a dream to the empress); the dedication included a week-long rite of penitence performed by forty

monks. In 750 he conveyed his respects to the recently cast Great Buddha at Tōdaiji, and became the guardian of that temple. His prestige in this generation was so great that he was consulted as an oracle in 769, to counter the attempt of the unscrupulous favourite Dōkyō to make himself emperor. In 781 he was given the perfect syncretic title, 'Hachiman the Great Bodhisattva'.

It might be noted parenthetically that at this same time, in 767, when a new Eastern Precinct was added to the ministry concerned with Shintō, Jingikan, its unprecedented magnificence – it was roofed with glazed tiles and had painted decorations – led people to call it 'the jewel-palace'.[2]

The identifying feature of the Hachiman shrine is a pair of small buildings, set parallel and so close together that their eaves almost touch [235]. The two are the same length and of similar appearance, small gabled boxes with their long sides to the front. The rear member is the sanctuary or *honden*. The front member, *gejin*, is a somewhat shallower box, so that its ridge is slightly lower. The enclosure between the two has a flat roof under their eaves. The complex stands on posts, and is surrounded by a railed balcony. Over the front staircase is a two-post porch, extending the slope of the gejin roof. In the two chief examples of the type visible today, the Usa shrine in Kyūshū and the Iwashimizu Hachiman-gū in Kyōto, the gables are ornamented by finials of Chinese origin, and the roofs exhibit Chinese curves; there are no such primitive details as those on the Ise sanctuaries.[3]

Since the Hachiman cult was so strongly permeated by Buddhist influence, I think it justifiable to explain its unique double building as an intrusion from the mainland. The type may have been worked out as late as the eighth century, perhaps by the very monk-architects who built the god a pagoda.[4] It is certainly allied to the 'paired halls' recorded for the

monastery of Saidaiji in Nara, or the dual refectory at Hōryūji. An alternative explanation would be that the Hachiman-zukuri was of earlier origin, and owed its continental flavour to the special receptivity of Kyūshū to influences from near-by Korea.

Another important Shintō monument that probably acquired at least the basis for its present appearance during the age of Chinese cultural dominance was the great shrine of the Fujiwara clan at Nara, the Kasuga Jinsha. Various bits of evidence make it likely that the four tutelary Fujiwara deities were being worshipped on the present foothills site by the 750s. In 765 they were allotted a supporting fief, which in 801 was changed to an annual state subsidy. A text dated 768 reads like a prayer of dedication, and in the history of the shrine, *Kasuga Shajiki*, is claimed as belonging to the first completion of the buildings. The earliest detailed evidence is a synopsis of the annual festivals contained in an anthology of rituals practised during the era from 859 to 877, the *Jōgan Gishiki*. The description makes it certain that there were then four sanctuaries side by side; a barrier wall in front of them; shelters in the inner and outer precincts; and northern and southern gates approached from the west, or city side (although the shrine faces south, its site discourages any full symmetry). A similar synopsis from the beginning of the tenth century in the *Engi Kamonshiki* refers to a middle gate between palisades. Prominent features of the present layout, the two torii by the main entrance and a veranda corridor surrounding the nucleus, are known to have been added only in the twelfth century.

Much of this disposition is visible today, or in the precise drawings of the shrine given in the early fourteenth-century *Kasuga-gongen-reikenki*. The latter shows several views of the sanctuary group from different angles, including a portion of the (then two-storeyed) south middle gate, with a torii and a palisade

250. Worship at the Kasuga shrine,
from the *Kasuga-gongen-reikenki*

251. Typical Kasuga shrine sanctuary, traditional

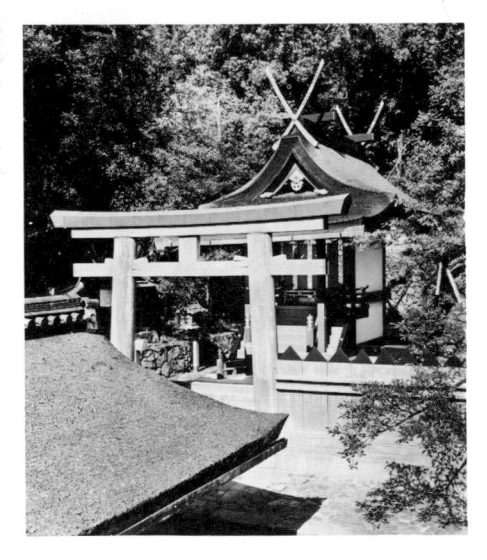

in between [250]. It is of course problematical whether the sanctuary type itself was created as early as 768. The basic form is extremely simple, a gabled box set end to on a high platform, like a reduced model, only one bay square, of the Izumo Taisha. As at Izumo the roof is strongly curved, and the chigi and katsuogi are mere appendages. The chief differences are red-painted woodwork, and the incorporation of the roof over the staircase with the main gable, to become a kind of penthouse [251]. This last feature may be a later refinement. In a now lost version of the Kasuga type erected at Kyōto, apparently for the Ume-no-miya Jinsha, the four boxes were incorporated into a single structure with one all-over roof of complex form [252]. The greater ingenuity shown here suggests an even later date. There is a record that one of the sanctuaries of this shrine was burned down in 1096; it seems likely, therefore, that at that time the four were separate buildings (as in the Kasuga Jinsha). Their amalgamation probably took place in the

early twelfth century, that is to say shortly before their appearance was recorded in the *Nenjū-gyōji*.[5]

At the Kasuga Jinsha the impulse to borrow Chinese or at least Buddhist forms must have been greatly encouraged by the close connexion between the shrine and the neighbouring temple maintained by Fujiwara patronage, Kōfukuji. The fourfold Kasuga deities, personified together under the name Kasuga Myōjin or Kasuga Gongen, were the guardians of the latter. Temple and shrine are intimately interwoven in the long record of miracles illustrated in the Kasuga scrolls.

It is impossible to trace here the lesser permutations undergone by Shintō shrines during the Middle Ages.[6] In the late Heian and Kamakura periods, except for the few places where architecture was bound securely to the distant past, Shintō buildings followed the general trend toward richer and more eclectic decoration. Several survivors possess details that complement those provided by Buddhist monuments. One of the most charming versions of the late Heian kaerumata is that seen in the left and right-hand sanctuaries of the Ujigami Jinsha.[7] There, inside the elegantly elongated legs, is the first sign of a transfer of interest to

the kaerumata interior: a quasi-floral motif sprouting from the bottom centre. The stage of pictorialization fashionable several centuries later, again, is well illustrated in the porch of the Gōryō Jinsha: an asymmetrical design of sunflowers floating on conventionalized waves.[8]

The general look of a number of Shintō precincts is recorded in Kamakura picture-scrolls. The Ippen biography, for example, has a view of the famous island shrine of Itsuku-shima (or Miyajima), in the Inland Sea. One cannot be sure, of course, how accurately so faraway a place would have been rendered by a Kyōto painter, though the Ippen master, Eni, obviously took pains to make his local colour convincing. At least it can be said that the

252 (*opposite*). The Ume-no-miya shrine, from the *Nenjū-gyōji*

253 (*above*). The Itsukushima shrine, from the *Ippen-shōnin-eden*

layout shown might well have been a fore-runner of the present precinct [253].[9] The general plan is like that of a formal Buddhist temple, with water replacing the ground outside and inside the court. The middle gate is meaningless, and the dancers must perform on a stage reached by a bridge. Here it is a haiden that corresponds to the icon hall at the back of the cloisters; the honden is immediately behind.

One of the Ippen scrolls shows the head-quarters of the Hachiman cult in Kyōto, the Iwashimizu Hachiman-gū. The pairing of honden and haiden characteristic of the Hachi-man-zukuri is there carried out in two abnor-

mally long, shed-like buildings [254]. The artist perhaps exaggerated a little; but in the modern shrine, where the same necessity exists of worshipping three deities in a row, both honden and haiden have the unusual proportions of 56 by 11 feet. Note that the identity of the three gods is not insisted on outside, as it was in the Ume-no-miya shrine.

The *Matsuzaki-tenjin-engi* of 1311, illustrating the Matsuzaki shrine in Yamaguchi, shows a more typical combination, full of Buddhist details [255].

254. The Iwashimizu Hachiman shrine, from the *Ippen-shōnin-eden*

255. The Matsuzaki shrine, from the *Matsuzaki-tenjin-engi*, fourteenth century

BUDDHIST ARCHITECTURE OF THE KAMAKURA PERIOD

When a paroxysm of civil war smashed the old order in the later twelfth century, Buddhist architecture shared in the new freedom that followed. The Heian style, created by a conservative aristocracy to serve a timeless religion, had pursued its own narrow path of development with imperturbable slowness. The swiftly rising cross-currents of the Kamakura age brought instead an almost anarchic variety. At least four sharply contrasted phenomena characterized Buddhist building between the late twelfth and late fourteenth centuries, and three of these represented a radical break with Heian custom. One was in intention archaistic, a turning back to the memory of Nara. Two were exotic; Chinese styles introduced by special backers. Only the fourth marked a further stage of progress in the direction already explored; and even that was now enriched, or confused, by novelties far outside the experience of the past.

The first phenomenon was the least important in area affected and duration of influence. The early military regime at Kamakura was not too revolutionary to recognize the value of tradition. Gradually stripping the Kyōto court of authority and wealth, the Shōgunate found it useful to patronize another society that symbolized as purely, but less dangerously, the values of the past: that of Nara. A policy of reviving the religious life of the old capital was initiated by the conqueror, Minamoto no Yoritomo, in part from a sense of feudal responsibility; the two greatest Nara houses, Tōdaiji and Kōfukuji, had been Minamoto partisans during the civil war, and had taken catastrophic punishment after a Taira success.

The rebuilding of Tōdaiji in particular was punctiliously carried out as a first claim on the overlord's gratitude. For several generations largesse was scattered among other temples of the Nara vicinity, reviving their ancient ceremonies and repairing or replacing icons and buildings. A large percentage of the halls and gates still visible there, that can claim a respectable antiquity, date from this period. Properly enough, their interest today is chiefly antiquarian. Because it was natural to erect them on the original sites, still marked by platforms and pillar bases, the Kamakura period restorations have kept alive something of the formal dignity of the Tempyō style. The buildings in plan and details may still subscribe to the eighth-century formulas. Excellent examples of such archaism are the kondō and lecture hall of Taimadera. Hōryūji has four noteworthy Kamakura halls outside its ancient nucleus. At Yakushiji the most ancient surviving hall is the Tōindō of 1285, east of the pagoda.

As might be expected, none of this work is of the first interest. The consistently conservative buildings by the very faithfulness of their imitation underline the disappearance of the subtleties of proportion and outline that had animated the Nara originals. The less conservative may suffer from stylistic inconsistency; in the Tōindō a Tempyō-like exterior gives way inside to the elegant lightness of late Heian. Admiration for the past at the same time doubtless hampered the development of more modern designs around Nara. At Hōryūji the Shōryōin, a chapel to the deified Prince Shōtoku, shows many of the features of the fully-developed hall of worship found in Tendai

256. Hōryūji, Shōryōin, altars,
twelfth and thirteenth centuries

and Shingon use elsewhere. Compared to the
boldness of spatial disposition seen in the best
of them, however, it seems insipid; only its
ornamental details show enough contemporary
gusto to be memorable [256].[1]

The two imported systems are called by the
Japanese *Karayō* and *Tenjikuyō*, the 'Chinese'
and 'Indian' styles respectively. Both names
are misleading. 'Karayō' is written with the
character that literally stands for the T'ang
dynasty. The style, on the other hand, is that
of the Sung, almost as different from the T'ang
formulas that had been borrowed in the Nara

age as Perpendicular differs from the Gothic
of the thirteenth century. More precisely, the
Karayō seems to have represented the official
building code of the Southern Sung, ruling
during the twelfth and thirteenth centuries
from Hangchow. Why the Tenjikuyō was so
named is still a mystery. Perhaps the choice
was purely conventional: for medieval Japan
the two great sources for Buddhist forms were
China and India. Perhaps the name reflects a
Japanese feeling about the style. It is heavy,
impressive by size and multiplication of parts,
almost barbarously strange in contrast with the

lucidity of the T'ang and Sung codes. All these were qualities that could readily be referred to the mysterious memory image of India; the more easily, perhaps, because Japanese historians had forgotten, or had never known, the actual origin of the Tenjikuyō. As we shall see,

decision to adopt it seems to have been made by a single cleric, one of the last great pilgrims to China, Chōgen. With the experience of a journey to the south Chinese Buddhist headquarters in 1167–8, and the backing of his master Hōnen Shōnin, the founder of the

257. Tōdaiji, great south gate,
twelfth century

it was probably at home in the south Chinese coastal provinces, where it had developed as a local style strikingly different from the imperial standard of the Chinese capital.

THE 'INDIAN STYLE', TENJIKUYŌ[2]

The importation of the Tenjikuyō was an accidental by-product of the revival of Nara Buddhism. It was used most extensively in the rebuilding of Tōdaiji; its most impressive monument is the one survivor from that project, the *nandaimon* or great south gate [257]. The

'Pure Land' or Jōdo sect, Chōgen was appointed director of the Tōdaiji restoration in 1181 (immediately after the Taira downfall, and only a year since the burning of the temple as a Taira reprisal). In addition to his activity at Nara, he affected the architecture of his generation by setting up in various provinces special buildings for Jōdo devotions. One of the two other survivors in the Tenjikuyō group belongs in that category, and shows how the style could be adapted to the needs of a hall of worship: the Jōdodō of Jōdoji in Hyōgo-ken, erected in 1194. The third building is a library

dedicated in 1198 in the monastery where Chōgen lived for many years, Kami-daigo.

Although the uses and dimensions of the three are radically different, they all bear the unmistakable stamp of the 'Indian style'. Chōgen's personal responsibility, again, is stressed by the rapid decline of the style after his death in 1205. As analysis will make evident, its character was so alien to Japanese taste that it could make headway only as a new fashion, pushed by an energetic backer. Even at Tōdaiji, where the temple carpenters were most familiar with its peculiarities, it soon lost predominance. By the later thirteenth century its forms had been assimilated into a more congenial compromise style. By the fourteenth, except for the restoration or rebuilding of a Tenjikuyō original, it had been almost completely forgotten.

The technical knowledge required was probably brought to Japan by immigrant Chinese. Two brothers by the name of Ch'ên were employed by Chōgen to direct the recasting of the Tōdaiji colossal Buddha. In 1186 he and they formed the nucleus of a party that explored the mountains of the province of Suō for the giant timbers required for rebuilding. Though they are named only as sculptors, it seems likely that they or their assistants had sufficient knowledge of carpentry, in the provincial manner of their homeland, to be able to act as advisory architects as well.

258. (A) Kami-daigo, sūtra library, and Nagasaki, 'law-protecting hall' of Sōfukuji; (B) Jōdōji, Jōdodō, and Tōdaiji, great south gate

Since the potentialities of the Tenjikuyō in group design can be traced only in the rebuilding of Tōdaiji, it seems to have contributed no novelties to the Japanese repertory of monastery planning. The plan of the one hall of worship, the Jōdodō, is entirely Chinese in its directness and simplicity: a square within a square [258]. The Tōdaiji gatehouse, being like all Far Eastern entrance-ways almost purely monumental, is strictly symmetrical about both axes. The Kami-daigo library consists of an oblong chamber housing the sūtra cases, and a magobisashi across the front [258]. Since that sort of primitive asymmetry was possible in both China and Japan, it points to no specific origin.

The Chinese flavour of the Tenjikuyō naturally requires a single-shell roof. The three extant buildings still retain this feature. The nandaimon and Jōdodō are tiled, and so fully consistent. The library has a shingled roof; perhaps as a result of later repairs, or possibly a sign, like the magobisashi, that even the original design there was modified by Japanese habits.

The most peculiar feature of the 'Indian style' is its bracketing. The main columns, in the first place, rise all the way to the underside of the roof. At the scale of Tōdaiji this requirement is both visually overwhelming and from a practical standpoint inconvenient. In the nandaimon the pillars reach to about 65 feet; in the lost Daibutsuden, they rose half as high again. Small wonder, then, that Chōgen and his assistants had to go far afield for a stand of timber gigantic enough to use in the restoration. (As a structural axiom the fact tells something, also, about the home of the Tenjikuyō in China; in historic times the style could never have grown to importance in the denuded north.) After the trees had been selected, it remained a task of heartbreaking difficulty to get them to Nara. Only a network of rivers with the Inland Sea between, and an ingenious use of windlasses (improvised by the Chinese?)

brought the labour required down to manageable proportions. On the last lap overland, physical and symbolic exertions were combined in a stupendous show. The logs were hauled in great wagons, each drawn by 120 oxen and as many of the devotees as wished to acquire merit thereby; even, in a strictly nominal sense, by the retired emperor Shirakawa II and his consorts.

The bracketing added to the tall Tenjikuyō pillar has two exceptional features: the system is (so to speak) two-dimensional only, and it passes through the body of the column instead of mounting from a capital at the top. The arms emerge from the building, each with a bearing-block at its end to assist the further projection of the one above. Under the roofs of the nandaimon there are no less than ten such tiers, seven rising regularly to hold the main eaves, and three more receding to hold a higher, intermediate purlin [258, 259]. Since the narrow interior there requires a much less elaborate system than the heavy overhang, the

259. Tōdaiji, great south gate, bracketing detail

bracketing is almost all on the outside. Stability is restored by making approximately every third arm the continuation of a tie-beam that runs through the whole structure.

At the scale of a large building, the unmodified application of this formula would provide only narrow and very widely spaced points of support for the eaves purlin. Both the nandaimon and the Jōdodō show departures from the principle required for safety. At the top of the bracketing staircase, one longitudinal arm is allowed, to widen the bearing surface. More important is an intercolumnar device used to halve the span when necessary; a big level arm, balancing the weights of inner and outer purlins above a beam joining the column tops, as a fulcrum. In the Jōdodō the same device is used also on the line of the chancel columns.

In place of the conventional tiers of small, longitudinal bracket arms, the nandaimon achieves an equivalent sidewise bracing under the eaves by continuous longitudinal beams. The two tiers of these under each roof serve visually as long horizontals preparing for the underlined accent of the eaves; and by their direction and simplicity contrast forcibly with the crowded transverse planes of the brackets. The rafters carry out the general theme of bold simplicity by being exposed in only a single tier; in the other Chinese styles two tiers are standard. Doubtless for the same reason their ends are hidden by a shield at the edge of the eaves. Above or near the corner one can see the rafters beginning to radiate, until they finally run parallel to the diagonal of the corner eaves beam.

Interior framing is given character by heavy girders, bulging at the sides [258]. The ends are carved as if curving downward, in memory of the traditional arched form – the 'moon' or 'rainbow beam' of the texts – but the girder is really horizontal. The beam tiers under the open roofs of the Jōdodō and the library are separated widely by round posts, like smaller columns, giving an effect both of boldness and of height.

The general character of the 'Indian style' makes it naturally deficient in decorative details. In part for this reason, and in part also, perhaps, from their uses, the three buildings lack ceilings, canopies, altar platforms, and railings. Their column bases are merely utilitarian. The original doors preserved in the Kami-daigo sūtra case (inside the library) reveal their Chinese flavour by being panelled; but the design is elementary, an open, reticulated panel at the top and three rectangles below, divided by a simply moulded framework. The only form in which a rudimentary ornamental interest is noticeable is the treatment given to the projecting ends of certain transverse members; the timber being cut on a downward slant in a series of shallow, cyma-like mouldings. This is most frequent in the *kibana*, the free end of a bracket or beam emerging for a short distance on the far side of its column, without any structural function. It is the typical termination, also, of the upper and lower ends of the intercolumnar lever arm, and of the fulcrum timber of the latter. In the nandaimon, for special accents, the idea is elaborated by doubling. The two bracket arms just under the eaves purlin have their kibana cut on opposite slants, so that they count together on a more monumental scale. Each of the great diagonal beams that run out to the corners of the eaves has its end cut out in a wide fork, in which the insides of the two prongs are similarly moulded.

Although no wood-framed 'Indian style' building of Sung date is known in China, enough clues may be assembled to demonstrate that the home of the Tenjikuyō lay probably in the middle coastal provinces. It is certainly a closely related manner that may be seen in many Buddhist halls of more recent periods in that area, particularly in Fukien. A doubly interesting example is the Buddha hall of the

Ch'an monastery Wan-fu-ssu in Fu-ch'ing-hsien, Fukien. The framing technique and details of this building retain a pungent 'Indian style' flavour. The monastery is also noteworthy as the source from which the last branch of Ch'an was exported to Japan at the end of Ming (its local mountain, Huang-po-shan, gave the derivative its sect name, Ōbaku-san). The Ōbakusan headquarters at Mampu-kuji, near Uji, founded in 1661, at a much greater distance than its parent from the original 'Indian style', still preserves a few tell-tale details; the Dharma hall, for example, uses transverse, inserted bracket arms.[3]

Collateral evidence locating the source of the Tenjikuyō is given also by some monuments of actual Sung date, like the two granite pagodas at Ch'üan-chou, Fukien, where not even a change of material has hidden its revealing peculiarities.

Why was the Tenjikuyō chosen for the rebuilding of Tōdaiji, the greatest architectural effort of medieval Japan? Chōgen must have seen in China the rival Karayō, and have weighed its imperial orthodoxy against the other's rudeness. Perhaps the deciding factor was merely the arrival in Japan at an opportune moment of Chinese experts who worked in the 'Indian style'. On the other hand, not only was its boldness far better suited to the scale and tradition of Tōdaiji than the Karayō elaboration; there was also a sympathy between its homeliness and the spirit of the warrior class that gave energy to the rebuilding. The Tenjikuyō is perhaps the best monument to the character stamped on the early Kamakura regime by Yoritomo and his formidable wife, the 'Nun-shōgun' Lady Masako.

THE 'CHINESE STYLE', KARAYŌ[4]

The Karayō came to Japan as a speciality of Zen, the latest phase of Chinese Buddhism to acquire authority in the Far East. Its sectarian use apparently began during the mid thirteenth century, with the propagandist activity at Kamakura of a Chinese missionary, Tao-lung (or Dōryū); he converted the regent, Hōjō no Tokiyori, and so was able to implant the Zen system firmly at the de facto capital.[5] The new monastery of which he was made abbot, Kenchōji, was completed in 1253 as a professed replica of one of the famous Ch'an headquarters at Hangchow. In those last decades before the Mongol conquest of south China, communication by sea with the region of the Yangtze estuary was still easy. Numerous emigrant Chinese Ch'an masters and Japanese pilgrims brought to the island kingdom an ever more complete store of information. One Japanese, Gikai, made a four-year pilgrimage from 1259 on, to study in precise detail both the monastic rules and the architectural environment proper to the sect. Three manuscript versions of his notes have survived, with a large number of drawings carefully recording the buildings and ritual furnishings of the Ch'an houses in Chekiang, Kiangsu, and Fukien. Of another of the Kamakura establishments, Engakuji, tradition holds that the regent who was governing at the time, Tokimune, dispatched its architect in 1279 to Hangchow to study a specially celebrated original.

All such evidence goes to show that a determined effort was made by the organizers of Zen to bring over Chinese usage – including a characteristic architecture – in as complete and correct a form as possible. A dozen or so buildings remain from the Kamakura period to testify to the success of the architectural undertaking. Clearly the products of a standardized building code, they are all very much alike. They have no exact parallels in China outside of Gikai's drawings, because the late Southern Sung phase that they represent has not survived on the continent. Their style, however, can be fitted perfectly into the Chinese development.

The peculiar Japanese devotion to hallowed Ch'an originals has made the whole of Zen architecture in Japan, of whatever date, almost uniformly valuable as evidence for the repertory imported in the Kamakura period. The early Karayō survivors are all of chapel size, and in almost every case have owed their survival to their out-of-the-way location. The metropolitan Zen houses of first rank – Nanzenji, Daitokuji, Sōfukuji, and Myōshinji in Kyōto; Kenchōji and Engakuji in Kamakura – stand today with impressive groups of buildings, however, that preserve with remarkable fidelity the early characteristics. Like the Kamakura period restorations of Nara monuments in the preceding Chinese style, the major halls still occupy the original stone platforms, and rise on pillars from the original bases. Though they may date from the Edo period, their details scrupulously follow the traditional formulas. It is legitimate, then, to reconstruct the thirteenth-century look of at least the monumental centre of a large Zen monastery from what is visible today in a well-equipped house like Daitokuji.

If the Tenjikuyō reflects something of the unschooled frankness and vigour of the samurai of early Kamakura, the Karayō, as we shall see, is equally at home in the decline of the military regime. By the later thirteenth century, Yoritomo's successors in the Shōgunate had become as ornamental as the puppet chancellors and premiers of the Kyōto court. Even the actual custodians of military supremacy, the Hōjō regents, grew with every generation more luxurious and sophisticated, as their entourage was infected by Kyōto habits. When the Zen style won its final monopoly as the preferred manner of the Kamakura regime, its almost feminine charm reached an audience that without the accident of a new fashion would quite probably have been as satisfied with the delicate richness of the Hōōdō or the Konjikidō.

Some of the extant early halls, preserved by their isolation, belong to small hillside retreats where the terrain makes a formal plan as impracticable as it had been for the mountain headquarters of Tendai and Shingon. The metropolitan Zen houses, laid out on almost level ground in Kyōto or up the gently sloping valleys around Kamakura, are normally organized along a rigid axis, leading south wherever possible. Four major monumental constructions, gateways and halls, stand in single file from front to rear.[6] Secondary buildings like the library, the bell and drum houses, the bathhouse, etc., are balanced on either side. Apart from the fact that the Chinese plans drawn by Gikai are apt to be more elaborate, with more elements and a stricter symmetry, there is a revealing national difference chiefly in the treatment of the abbot's quarters, hōjō, at the back of the monumental nucleus. Like the 'U' dormitories of the T'ang style, the quarters of the Ch'an abbots were formal buildings dominated by the axis. At this point the readiness of the thirteenth-century Japanese to borrow and adapt themselves to a new Chinese system broke down. The Japanese hōjō may be entered by a doorway on or near the axis; but like the sub-precincts that fill out the monastery compound, it is an informal, wide-sprawling construction in the native style.

At least some of the original establishments had veranda corridors, though none have been preserved. Pagodas, too, might be erected, but had no relation to the central nucleus. None remains in any metropolitan establishment. One survivor of Muromachi date, in the small Anrakuji in the Prefecture of Nagano, is interesting because its Chinese characteristics include the octagonal plan rarely attempted in Japan.

Individual Karayō buildings fall into three major types: the triple gate, sammon, and two varieties of hall distinguished by size. The

260. Nanzenji, Sammon (main gate), Edo period

first, seen for example in the Edo period sammon of Nanzenji, is two-storeyed, with three openings [260]. The Karayō version has a new function, and so a new form, not found in the T'ang standard. The second storey now contains a large chamber housing specially chosen icons: usually Kannon and a group of Arhats or Rakan. Since the gatehouse proper has no space in which an interior stair could be set, access must be provided outside the main rectangle. At Nanzenji there is a small, detached stair-house at either end, from which a kind of enclosed bridge-stair rises to the second storey. Both these features, the upper shrine and the exterior stair, are well attested in China for the same general period.[7]

Since a cardinal feature of Ch'an or Zen is its return to a stricter monasticism, the hall of worship is designed to accommodate a clerical congregation only. Its plan can thus preserve the traditional Chinese symmetrical simplicity. The large hall formula is used without much variation for both of the two major, axial buildings, the Buddha hall or Butsuden and the Dharma hall or Hattō. Applied with as little regard for period or site as (say) the Greek temple of neo-classicism in the West, it restates the old chancel-and-ambulatory system. The chancel is a spacious area, five by four bays, covered by a flat 'mirror' ceiling painted in ink with the unvarying Zen theme of a dragon among storm clouds. The surrounding aisle

261. Daitokuji, Hattō, seventeenth century, interior

has exposed rafters [261, 266]. Absolute symmetry is prevented only by one sign of human use. The focus of religious practice, an altar platform with images in the Butsuden and a high lecture platform with stairs and abbot's throne in the Hattō, stands on axis at the back of the chancel, with a partition behind it.

The smaller type represented by the early monuments is paradoxically more complicated. The plan is again a square; at the simplest a single, open room, three by three bays, elsewhere, five by five, with a chancel and ambulatory [268]. Where there is an aisle, it is again narrow and low, with exposed rafters. The central space, rather than the box-like directness of the large hall type, has an extraordinarily restless, up-thrusting quality. It expands upward into a kind of wood-framed pyramid interior, designed and pieced together with the ingenuity that in China seems to have reached its climax under the Sung. The centre, one bay square, is marked above by its own small, 'mirror' ceiling; and below has the platform altar at its rear, with a partition between two columns to screen off the back aisle [268, 269]. If the construction were monotonously straightforward, there would have to be two columns at the front of the central square, also, to define it fully and to provide a direct support for the ceiling. Instead, in the interests of spaciousness, these are omitted; their structural function being assumed by a necessarily complicated framework of girders, beams, inter-beam posts, and bracketing. Details will be analysed below. Here it should be noticed that this straining for effect produces an interior totally unlike anything in Japanese experience, and at an opposite pole from the non-architectonic preferences of late Heian.

One early hall is an outstanding exception to the severity of the usual Zen plan. At Eihōji, near Nagoya, there are two extant buildings of fourteenth-century date; one, the Kannondō, stands well to one side of the norm by reason

of its general plainness. Far at the other extreme is the Kaisandō, a memorial chapel erected in 1352 to the monastery's founder, Musō Kokushi [262, 263, 266, 270]. Here appears for the first time in remaining Japanese

262. Eihōji, Kaisandō, fourteenth century, front

monuments the threefold combination of building blocks later to be widely used (particularly for the mortuary shrines of the Tokugawa Shōguns) under the name *gongen-zukuri*.[8] At the rear stands a double-eaved sanctuary, *shidō*. In front, under a single but higher roof, is the fore-hall for memorial services, *raidō*. Fitted between, with a low roof under the others, is a connecting passage-way, the *ai-no-ma*. The rear block is a three-bay square, with four interior columns holding a flat ceiling. The ai-no-ma, covered by exposed rafters, is the widest element in plan; it runs back to overlap a third of the shidō and so increases its floor area. The raidō, again three bays square, has no interior columns. Instead, two large girders

263 (*below*). Eihōji, Kaisandō, fourteenth century, beam system of fore-hall

264 (*opposite*). Engakuji, relic hall, thirteenth century, front

cross from front to rear; and from them rises the typical chancel square of beams, posts, brackets, and 'mirror' ceiling. As the illustrations reveal, both interior and exterior of the Kaisandō are crowded with disparate elements to a degree unusual even in the general bustle of Karayō designing.

As I have shown in a preceding chapter, unmistakable parallels to the Kaisandō scheme may be found on the continent [236]. Even the function served by such similar compound buildings in China is comparable; they must originally, as their names indicate, have been memorial chapels to human beings. In spite of the Japanese claim that the Kaisandō design was a Japanese invention, then, it seems on the whole probable that the idea entered

Japan as a special department of the Zen repertory.

The front block of the Kaisandō is sufficiently typical of the Karayō that its proportions may be taken for comparison with those of an equally normal hall in Japanese style: say the Amidadō of Shiramizu. In the Zen chapel the ratio between height of wall columns and width of façade is about 1 to 2; in the other it is about 1 to 3·5. This much greater relative height of the 'order', plus the pyramidal piling-up of the room inside, reflect a Chinese admiration for verticality. The reflection is a pallid one, to be sure. The Karayō in Japanese use shows only a fraction of that passion for height that may be imagined from the Japanese pilgrims' descriptions of the towers they saw in China; or that

is to be seen in Sung paintings and surviving buildings, or even in the high altars and thrones of modern Peking. Even in the watered-down Karayō there is still a great contrast to pure Japanese taste, with its preference for horizontality and ground-hugging.

The Karayō canon demands stone platforms and tiled floors and roofs. Heterodoxy is frequent among the existing roofs of the early chapels. A large proportion today have the cypress shingles of Japanese habit. Some in preceding centuries had been thatched, presumably because their country homes, in the isolation of the feudal age, could provide no better means of repair. An absurd thatched roof still covers the delicate proportions of the most famous survivor, the relic hall, *shariden*,

of Engakuji at Kamakura [264, 268].[9] The drawing shows on the left the present state, and on the right a restoration of the original, the sort of low, pyramidal, tiled roof natural to Chinese construction. Perhaps some of the chapels were shingled from the start, either because of a relatively late date or because of local building conditions. In the case of the Kaisandō it is hard to imagine so close an interweaving of roof planes on a small scale in the clumsy medium of tiles.

Karayō bracketing reveals, more clearly than any other feature of the style, a stage beyond the classical norm of T'ang. Two novelties are of prime importance. In the first place, the eaves support is no longer restricted to the column axes. Depending on the width of the

bay, one or two bracketing complexes identical with those above the columns are spaced between them, resting on the wall beam. In the second, the slanting lever arm is used in all but the most modest combinations; and its upper end is now exposed, giving visible support to the aisle purlin and so contributing

265 (*above and below*). Karayō bracketing, Kamakura period

to the dynamic variety of the interior [265–9]. The scale of the bracketing in relation to pillar height is noticeably smaller than before. The steps outward are relatively short, so that the whole projection is much more conservative. All the steps branch upward or sidewise in almost identical fashion, and are so closely spaced that the intervals between no longer count. In place of bold spans and sturdy members, there is a cautious piecing-together of a multitude of small parts. Structural ingenuity survives; but the visual effect is first of all ornamental, so that the bracketing along a façade assumes the character of a rich cornice. A new enrichment may be traced throughout the details as well. Timber ends become richly moulded; the lower end of the lever arm is no longer merely sliced off at a slant, but is curved and sharpened almost to a point, to contrast with the overlapping planes behind.

In the most pretentious Karayō bracketing there are two such lever ends, or 'beaks', in each complex. The Chinese had used this doubling since late T'ang. At the outset its purpose may well have been to compensate for an already marked loss in bracketing size, by duplicating a crucial member; the two arms were parallel and virtually identical. At the evolutionary stage of the Karayō, functional and visual effect have been separated. The appearance of two 'beaks' on the exterior may still mean the use of two complete lever arms, as it does in the Kaisandō [266A]. Elsewhere the lower 'beak' may be fictitious while the remaining lever is braced by another member, seen only inside [267, 268]. It is possible, again, for both 'beaks' to be fictitious [266B]. These marks of stylistic lateness seem to have characterized Sung architecture as a whole. The best source of our knowledge of the Northern Sung style, the extant architectural manual *Ying Tsao Fa Shih* published in 1100, reveals in its illustrations both the false 'beak' and the concealed interior brace.[10]

266. (A) Eihōji, Kaisandō;
(B) typical large Zen hall, based on the Hattō of Daitokuji

A

I 5FT

Roof Construction
Hypothetical

B

0 20FT

267. Engakuji, relic hall, bracketing

Since all surviving Zen buildings in Japan have been re-roofed by the native double-shell method, their present state nullifies almost all the structural cunning exhibited in the 'Chinese style'. Far more important than the small, intricately locked bracketing are the long lever timbers called *hanegi*, hidden between the inner and outer shells. In particular the aisle purlin has been robbed of virtually all its supporting function. This general change lends a special interest to the structural detailing of the small sixteenth-century Butsuden of Shuon-an, where the native-type roof seems to have been used from the start [268].[11] There the aisle purlin not only holds no more than a line of rafters; but these rafters themselves are merely a kind of ceiling, for they stop at the wall, and other rafters emerge outside at a different level and slope. Thus the Chinese ideal unity of exterior and interior survives only as a fiction; a condition normal enough in the

purely Japanese development, but rare in the Karayō.

The interior bracketing under the 'mirror' ceiling of a big metropolitan hall has the opulent regularity of a High Renaissance entablature [261, 266B]. On the scale of the relic hall of Engakuji, the same repertory of elements will be re-combined to produce an effect full of surprises and bold stratagems. As we have seen, the standard problem there is to support a one-bay flat ceiling at the centre, on two columns instead of the full square of four. A square superstructure is created at the top, with beams and bracketing just under the 'mirror'; and it is held by four supports that at *their* tops are identical in form. The rear two are proper columns; but the front two are merely squat round posts, each of which is supported by a powerful transverse girder. The wall plane and the central superstructure are further tied together by some sort of small,

268. (A) Shuon-an,
Buddha hall;
(B) Engakuji,
relic hall

A

B

Existing Roof

Original Tile Roof?

0 15FT

curving beam, continuing upward from the point where the lever arm strikes the aisle purlin [269]. Every extant hall shows small individual preferences in carrying out this design, but all agree in principle.

The typical Karayō girder is a working member, and so like the most critical portions of the bracketing system has been allowed to retain an architectonic spareness. Its cross-section is the tall oblong proper to a well-

269. Seihakuji, Buddha hall, interior beam system

designed beam; as in the Tenjikuyō, arching survives only as a short, conventional curve at either end. Even here there are a few flourishes. There is a panel with half quatrefoil ends on the underside; and on each face there is a narrow sinkage running parallel to the bottom edge, which near each end terminates in a diagonal running up to the top curve. When an inter-beam post is set on the girder, its fit is made both more secure and visually more emphatic by a long moulded overlap, called *yuiwata* from its resemblance to a hair ornament. For the special purpose of joining different levels, the Karayō provides a peculiar type of beam, called *ebi-kōryō* from its resemblance to a shrimp. Here again the Chinese prototype had once been directly functional; in Zen use the shape is stylized, and the original purpose may be so far forgotten that the ebi-

kōryō is used on a horizontal. Thus it often replaces the ordinary aisle beam [266B, 268B].

A minor change distinguishes the base from which the Karayō bracketing rises. In the T'ang style, where bracketing had been limited to the column tops, the flat intercolumnar struts or kaerumata had been able to stand on a single beam. The Sung solution, already preached in the *Ying Tsao Fa Shih*, was to build up something like a T-beam, with the flat upper plank wide enough to hold the new intercolumnar complexes, and the lower one set on edge for tensile strength. In the Karayō code the combination remains sturdy. At outside corners the instinct for decoration pulls both beams well past the corner pillar, so that their ends may be carved in a rich sequence of mouldings.

What seems to be an original gable field has been preserved through the re-roofings of the Kaisandō. Three structural members are exposed: a transverse beam, a king-post, and the end of the ridge-pole, plus the inevitable small bracketed transitions. Decorative zest is allowed free play with the non-structural elements, particularly the pendants, *gegyō*, or 'hanging fish', that conceal the ends of the ridge-pole and the two lower purlins. Each of the three gegyō used is a two-tiered palmette, drawn with crisp elegance, and fitted to the long, bare sweep of the bargeboard by a shallow cresting of leaf forms [270]. No original roof finials remain, but the proper look of a Karayō ridge acroterion may be imagined from Gikai's sketches made in China, or from Buddhist paintings executed in the Kamakura period under Chinese inspiration. It must have been a quasi-realistic fish, with a mouth wide open to swallow the ridge; much like the later Japanese adaptations seen, for example, in the famous gold dolphins of Nagoya castle. The realism of the form makes its proper home south China; the north, at least from the T'ang shibi down to the palaces of Peking, always prefers a highly conventionalized bird or dragon.

270. Eihōji, Kaisandō, fourteenth century, side

Both doors and windows may be crowned by a cusped arch, vigorously outlined in the early monuments. Windows are latticed, usually by vertical and horizontal bars set in pairs for variety; the Kaisandō shows instead a fragile diaper pattern of circles and diamonds, modern but imitating old fragments. A strongly Chinese look argues for their authenticity. The door is built up of several panels of different sizes, and delicately moulded frames. In the large hall type each major doorway has four valves, so that each half can fold back on itself.

The ornamental proclivities of the 'Chinese style' reach their natural conclusion in highly developed ritual furniture. Gikai's drawings illustrate a variety of Chinese originals, some largely sculptural. The piece best represented in Japan, the central altar or throne platform, is strongly architectural. The design, indeed, is merely a modification of the rich Sung basement type frequently illustrated in the *Ying Tsao Fa Shih*; a silhouette flaring widely at top and bottom and pulled in between, through an elaborate series of large and small mouldings. Its ultimate prototype, from one point of view, may perhaps have been the Greco-Roman plinth, to which medieval Indian taste added intricacy. From the Buddhist standpoint, it was the hour-glass form of the mythical mountain Sumeru that gave the altar both its silhouette and its name, *Shumidan*. As a basement the design was executed in stone; as a platform, in Japan, it becomes a wooden construction. The top surface is enclosed by a railing, that at larger scale might equally well frame a terrace. The railing members are crisply profiled, and enriched by floral capitals or newels. The most elaborate early altar, that of the relic hall, has in

addition a cut-out, flat dado frieze of lions and peonies in rinceau form.

In the large halls the platforms are very high, and so must be reached by ladder-like stairs at the front and each end; an idea roughly comparable to that seen in the imperial thrones in Peking. The Hattō platform holds a high armchair throne, of the type seen in early portraits of Zen abbots. The Butsuden platform is set out with offering furniture, so that the icons must be placed on an even higher level at the back, in an enclosed shrine extending part-way across the rear aisle. Though the solution is awkward, the plan provides no other place.

THE 'JAPANESE STYLE', WAYŌ,
AND THE ECLECTIC STYLE, SETTCHŪYŌ[12]

By far the greatest number of Kamakura Buddhist monuments bear little or no relationship to the new architectural fashions imported from China. Like the great majority of Kamakura Buddhist paintings, they stand as a direct continuation of Heian custom, serving the still very powerful sects of Tendai and Shingon. In them the conservatism of earlier centuries may still survive as an all-important factor, concealing or denying the passage of time. A highly specialized type like the pagoda, ringed about by symbolism and almost completely static from the standpoint of use, may reveal its date of construction only by small peculiarities of proportioning and detail. We have seen how in the mid-Heian period this same principle made the five-storeyed pagoda at Daigoji nearly indistinguishable from a Nara original. In the same way the imposing late twelfth-century tahōtō at Ishiyamadera can stand almost perfectly for its vanished Heian predecessors [246].[13]

The halls of worship for the most part illustrate the culmination of the gradual process that I have traced in an earlier chapter: the mutual accommodation of secret ritual and a large lay audience. We have seen that as early as the tenth century an up-to-date building like the lecture hall of Myōrakuji might foreshadow a great part of the final solution. Its complex plan is found almost exactly reproduced in an extant ⟨post-⟩ Kamakura hall on Hieizan, the Shakadō; a layout deeper than a square, completely asymmetrical from front to rear, and with a spacious raidō all across its façade.[14] As will be remembered, however, the construction of the lecture hall was still at a relatively primitive stage, in that each of its two plan areas was crowned by a separate roof [238]. By the thirteenth century the single, all-enclosing roof must have become a commonplace, capable of adjustment to any reasonable plan variations below.

In defining the group of Tendai and Shingon halls to be analysed below, it is an advantage to extend the farther limit of the period covered to the end of the fourteenth century. This entails the addition to the Kamakura age proper of that transitional period, from 1336 to 1392, that the Japanese call *Nambokuchō*, the age of 'southern and northern regimes'; two generations during which the supremacy of the Ashikaga Shōguns was not yet fully established, and the imperial line was divided into two rival courts. The Nambokuchō era was an Indian summer for the remnants of Heian society that had survived the first hard frosts of Kamakura dictatorship; a false renaissance, ending quickly in their virtual extinction under the Ashikaga. The old esoteric sects shared the brief revival and then the long submergence of the aristocracy that had patronized them. Their last supporter of national importance was the emperor Daigo II (1319–38), a valiant but ill-fated champion of the old order. The momentum of habit made possible the erection of many Tendai and Shingon halls on a large scale during the rest of the century. When the Ashikaga had consolidated their new order at Kyōto and the Zen sect had tightened its

monopoly of military patronage, support for the esoteric houses was almost entirely cut off. There were very few new erections; immemorial ceremonies were discontinued; buildings fell into dilapidation, or were burned and not replaced. The history of Tōdaiji furnishes an apt illustration. When the monastery was burned for the second time in 1567, in one of the innumerable petty squabbles of the feudal age, it was left in ruins for over a century.

The two dozen or so extant halls erected for Tendai or Shingon use, between the late twelfth and late fourteenth centuries and at points widely scattered over the Japanese islands, show an appropriate variety. Most variable are the minor details. The earlier monuments fall into the category called *Wayō*, the national style, a direct continuation of

Heian practices. Those of the fourteenth century are apt to reveal a mixture of new details borrowed from the Chinese, and so are characterized by the name *Settchūyō*, the 'mixed style'. Ground plans and overall massing have a general consistency unaffected by imported novelties, and not much altered by the passage of time. In that regard a standard seems to have been established by the beginning of the Kamakura period, and to have been followed with a fair degree of fidelity.

In plan the normal Kamakura layout is a rectangle varying on one side or the other of a square, and separated into front and rear by a partition running across its full width. The front area, *raidō*, is at least two bays deep; and on that scale is usually an open chamber unobstructed by columns [271]. With three bays

271. Kanshinji, main hall, fourteenth century, interior of fore-hall or raidō

a subdivision is introduced. In the main hall of Saimyōji, for instance [272],[15] the effect is like the truncated front half of a traditional chancel-and-ambulatory building. There is an exterior aisle, the *gejin*, that turns at either end to run to the rear, and encloses a two-bay *chūjin*. Between these two, to emphasize a minor difference in use, there may be a low barrier. In the exceptionally large main hall of Taisenji on the island of Shikoku, where the raidō is four bays deep, the gejin is doubled to two bays in depth across the front, and returns to normal aisle dimensions at the ends [273].[16]

Behind the grilled partition the secret *naijin* may be laid out with an even greater variety. Often there are columns to frame off spaces at the ends and rear that recall the old ambulatory but are no longer used as a continuous passage.

272 (*above*). Saimyōji, main hall

273 (*below*). Taisenji, main hall

274. Kanshinji, main hall,
fourteenth century, interior of chancel

The end aisles are closed off, so as to turn each one into a subsidiary chapel with an altar against its back wall. The rear space is apt to become a utility room as well as a setting for further small altars; where its function is considered important, it may be deepened to two bays. The platform altar, Shumidan, usually occupies one bay of depth and three of width; in front of it is a floor area sufficient for the demands of esoteric ritual [274]. Columns are often set out less for structural reasons than for visual effectiveness and enclosure. There is almost always a considerable freedom, within the limits of regularity and left-and-right symmetry. The difference between boldness and timidity in this regard may be extreme. A thirteenth-century monument in Kyōto, the main hall of Daihōonji, represents an exag-

gerated conservatism; not one interior support is omitted.[17] Equally exaggerated in the other direction is the design of the Kanjōdō, or hall for the abhiseka rite of baptism, in Murōji.[18] The plan covers five bays by five; inside the only structural columns are the four in line that separate the public and the secret halves [275]. Four very slender pillars rise in the chancel, but they are used only to display the

275. Murōji, hall

276. Ishideji, main hall

twin Tantric Mandalas. Only a degree less cavalier is the layout of the naijin at Ishideji [276].[19] Four structural columns surround the altar, to be sure; their placing, however, has no reference to any other column axes. An orthodox Chinese architect would have dismissed this nonchalance as a mark of ignorance or anarchy. Behind it, of course, must lie a confidence in the structural elasticity of the invisibly framed roof, acquired over many generations of experiment.[20]

The front façade of the hall is often made inviting by a porch, usually three bays wide and covered by a prolongation of the main roof [277]. Heian paintings show this idea in common use for palaces and mansions by at least the eleventh century; presumably it was borrowed from that source to increase the temple's comfort and homeliness. In visual effect it heightens the contrast between front and rear, which smaller details may reinforce. Sometimes, for example, the open wood veranda surrounds only the public area. The wall treatments, again, may differ radically in the two halves. The naijin is usually walled in; the raidō may be completely open, with grilled shutters all across the front and hinged doors at the ends [272].

Cross-sections reveal a comparable boldness and variety. Three kinds of overhead enclosure were traditional by the Kamakura age for interior spaces: the symmetrical 'open roof', the single slope of rafters over an aisle, and the flat, coffered ceiling. This repertory was handled with a happy balance between appropriateness and freedom. The 'open roof' is used with proper monumentality to dignify the chancel, or less frequently the raidō or, at Chōjuji, both rooms [278].[21] The flat ceiling can be given scale and emphasis by powerful cross-beams. The informal aisle treatment is used where it is natural, round the perimeter. If the raidō is exceptionally deep, an aisle character may be given to the first bay by exposed rafters. Since

277. Kanshinji, main hall, fourteenth century, front

the traditional aisle columns have been removed (except perhaps for one at each end), the break between rafters and the ceiling beyond is made over a heavy longitudinal beam. It should be remembered that none of these devices has any connexion with the real framing of the roof, which is hidden above them.

The 'Japanese style' continues the bracketing techniques of the Heian period, sometimes repeating the elaborate complex first worked out in the eighth century. This side of Wayō practice was especially vulnerable to pressure from the new Chinese styles. One main hall, that of Shōshōin, shows a complete surrender;[22] though its plan has the typical Kamakura freedom, the bracketing is carried out in the 'Chinese style', even to the use of the exposed interior lever arm [279]. More often there is a

278. Chōjuji, main hall

279. Shōshōin, main hall

mixture. An otherwise traditional complex may borrow the 'Indian style' feature of using only transverse arms, or the two exposed lever arms of the Karayō. The development of native taste may be traced with least contamination in the intercolumnar motif, kaerumata. We have seen this element change from an original sturdiness to the fragile elegance of late Heian. In Kamakura use the legs may be even more pronouncedly non-structural; the emphasis turns more and more to a sculptural enrichment of the space between them. The process is first a steady growth of ornament, until the area has been filled; then a shift towards more free and pictorial compositions, which by the end of the period may be quite asymmetrical.

Chinese influence may again be traced in late Kamakura beams. The wall beam will often be found to run past the corner so that its projection can be cut off in Karayō or Tenjikuyō mouldings [280]. The girder inside may be

280. Kanshinji, main hall,
fourteenth century, corner detail

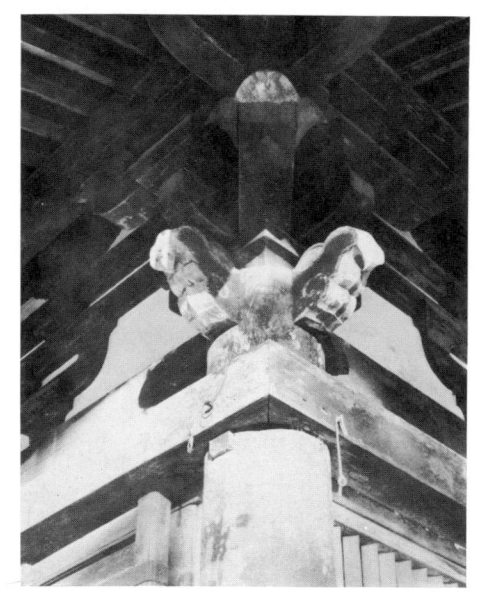

carved in imitation of the Karayō formula. Against these should be set a kind of wall beam that represents a purely Japanese development, presumably intended to give a greater stability against earthquake shocks. In the Sanjusangen-dō, for example,[23] each wall is braced by three tiers of these column-enclosing beams; heavy, solid horizontals that have the incidental effect of emphasizing the breadth of the building.

The favourite roof form is the hip-and-gable. The depth of the hall and the space required for the double-shell framing make the average roof high and very prominent. The gable field may be correspondingly large, and so count much more than before in the side elevation. Its design may feature the old exposed beam-and-king-post theme, or the more elaborate variant of the Karayō; in any case what is visible has nothing to do with the real roof construction behind it. From the repertory of the tile ornaments the old Chinese shibi has disappeared. The main ridge acroterion is apt to be a large, flattish, horseshoe-shaped tile, with a mask cast on its front that gives it the name 'demon tile', oni-kawara. A less emphatic form is simply made up of quasi-functional tile elements.

An unusually complex roof is shown in the picture-scroll Ippen-shōnin-eden, covering the kondō of Zenkōji in Shinano Province [281]. If the artist is to be trusted, his building must have been the one erected in 1270. The basic form is a hip-and-gable; but on the central axis this is intersected by a transverse ridge, producing extra gables at the front and rear.[24] We shall find the gabled facade a commonplace in the Momoyama style for every kind of building; this early Buddhist forerunner must have borrowed the idea from the Shintō repertory.

A minor roofing novelty is the karahafu, 'Chinese gable', presumably an importation (though it belongs to neither the Tenjikuyō nor the Karayō). It has the shape of a very flat arch with widely elongated ends. Its principal use is to provide a new kind of visual emphasis;

thus it appears like a pediment over the centre of the altar shrine in the Hōryūji Shōryōin, backed by the symbolic shelter of a shallow, shingled roof [256].[25] Set on a lengthwise axis it may enrich the simplest sort of two-post gateway (and so appears in many Kamakura picture-scrolls).

Doors and windows belong to the least changing part of the native style. Hinged doors are still flat, with no more enrichment than that provided by small metal fittings and a deeply moulded frame. Windows are closed by vertical bars. The domestic tradition is drawn on to furnish the large, grilled shutters that sometimes replace hinged doors all across the front of a raidō. (It was apparently in the palace also that the standard contrast was worked out, by which shutters across the front were opposed to hinged doors at the ends [272].) The semi-domestic lightness and simplicity of detail that we have seen characterizing part of the late Heian style plays the same role in Kamakura, for example in the partitions and ceiling of the Shōryōin [282].

281 (*above*). View of Zenkōji, from the *Ippen-shōnin-eden*

282 (*below*). Hōryūji, Shōryōin, detail of partition

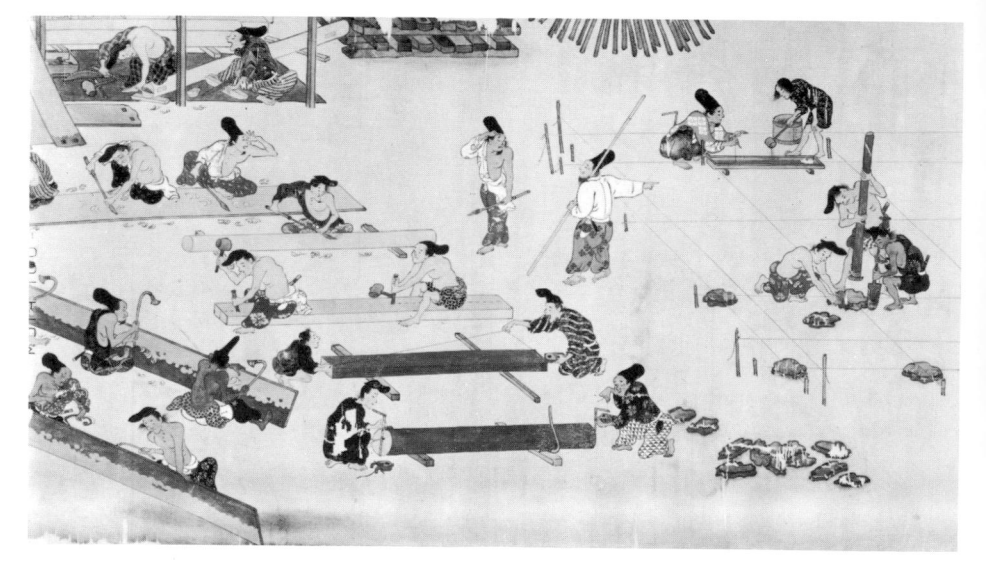

Several of the Kamakura picture-scrolls contain informative views of the construction of temple and shrine buildings, three of which are reproduced here [283–5].

283 (*top*). Construction methods, from the picture-scroll *Ishiyamadera-engi*, fourteenth century

284 (*above*). Construction methods, from the *Kasuga-gongen-reikenki*

285. Construction methods,
from the *Matsuzaki-tenjin-engi*,
with detail

DOMESTIC ARCHITECTURE OF THE KAMAKURA PERIOD

Although no houses have been preserved from this period, a great wealth of precise information may be drawn from contemporary picture-scrolls. The encyclopaedic interests of Kamakura Yamato-e cover every kind of setting for human activity, from the mansion to the hovel. In domestic architecture the illustrative style at its best is almost as accurate as a photograph, and is more revealing; since one of its conventions permits the removal of the roof to show both interior and exterior in a single view.

Japanese historians distinguish at this time the gradual extinction of the shinden-zukuri, with the court society it had served, and the emergence of two new forms that were to dominate the higher levels of domestic construction thereafter: the *buke-zukuri* of the warrior caste, and the *shoin-zukuri* of the Buddhist priests. To Western students, accustomed to striking changes of style and to a much greater variety of structural methods and visual effects, the distinction tells so little that it seems hardly more than an outline-maker's convenience. The buke-zukuri must have first shown itself as a rural type based on the farmhouse. What niceties of detail were proper to its social level were borrowed from the shinden standard. Its use by the military class was signalized by a few, primitive facilities for defence: a stockade, a strengthened gate, a guard-house, in forms that could as well have existed in the age of Queen 'Pimiku'. The only buke-zukuri worthy of the title in Western eyes is the castle form of the late sixteenth century. The shoin-zukuri owes its name and its claim to special identity to what in the West would be a single, secondary detail. The *shoin* was a

study, whose lighting was improved by a kind of bay window: a feature new in Japanese exteriors, but less emphatic than for instance the late Gothic oriel. By the period when the two 'styles' are commonly granted maturity, the heyday of Ashikaga rule in fifteenth-century Kyōto, the reminders of their martial or scholarly origin had been so thoroughly overlaid by changes and elaboration that the dividing line between them was virtually meaningless. I shall henceforth refer to them only in those instances where the names are without question applicable.[1]

The one truly important distinction in Japanese domestic architecture (above the level of simple utility) is that between the Chinese and the native styles. The process of evolution from one of these to the other continued during the Kamakura age, bringing to the shinden-zukuri tradition in particular a further degree of change. The general plan of the mansion advanced even farther toward asymmetry, and toward an irregular flowing-together of building masses. Both of these tendencies were doubtless encouraged by the new modesty of scale forced on the court aristocracy by loss of income; the modern ideal discouraged duplication, and by drawing the main blocks together worked for a greater compactness. (It should be remembered, however, that the Kamakura revolution made austerity fashionable only for a brief period, and that thereafter those who could afford the expense were still likely to build extravagantly. The later Shōguns' palaces at Kamakura must have had much of the look of a great Kyōto mansion, reproducing even so effete a detail as the 'fishing hall', *tsuridono*.)

286. Mansion of the Ōmiya no Gondaibu, Toshinari, from the *Kasuga-gongen-reikenki*

A beautifully precise example of the working-out of the modern principles of design is given by the *Kasuga-gongen-reikenki* in its picture of a noble house belonging to the so-called Ōmiya no Gondaibu, Toshinari [286]. Entrance through a smallish gate on the east leads into a clients' court; on the north side of which, partly screened off, is a new plan element necessary in the age of force, the guards' house with its lounging samurai. The mansion proper is entered under the fashionable 'Chinese gable', *karahafu*; this is the vestibule where the guest leaves his carriage. The shinden lies immediately beyond, without any linking corridor. Its principal façade, in actual use, seems to be the western, since that side has a 'broad hisashi', and opens on a second private court. At the far side of the latter a group of falconers sit in front of what corresponds to a west tai-no-ya. Still father to the west, beyond a wall, stretches the garden with the traditional features, including a 'fishing hall'. In this house, therefore, as it was drawn at the beginning of the fourteenth century by an artist whose work as a whole is conspicuously literal, even the immemorial orientation toward the south has been changed.

287. Mansion of the regent Kujō no Michiie, from the *Ishiyamadera-engi*

Most of the details belong to the long-established domestic vocabulary, but the novelties betray the taste of their time by a consistent emphasis on decoration. Fences have a simple but eye-catching top frieze. The main door is hooded by an arched gable. The west tai is screened by an almost gaudy chequerboard. The visible interior floors, it should be noticed, are about half-covered by fitted mats, *tatami*. Incidental refinements on the old ways of enjoying nature are a screened aviary and a tray landscape on a high stand, both on the garden front of the west tai-no-ya.

A view given in the *Ishiyamadera-engi* of the mansion of the regent Fujiwara (or Kujō) no Michiie has the advantage of revealing the shinden interior [287]. Here all floors are covered with tatami of standard size. The visible partitions are painted sliding screens. Those in the lord's moya enhance its bare dignity by their Chinese subjects; what can be seen along the bottoms suggests the theme of the Tōji folding screen, T'ang gentlemen making a visit in the country.[2] In contrast the femininity of the ladies' room is heightened by paintings of flowering grasses, the genre exploited by later Tosa masters.

A much simpler way of life is revealed by the view in the same picture-scroll of the house of a Fujiwara gentleman, a Junior Assistant

288. House of a Fujiwara gentleman, from the *Ishiyamadera-engi*

Minister of Ceremonial holding the lower grade of the main fifth court rank [288]. The outer court has a guard-house like that in the *Kasuga* mansion, but everything else is at a much more modest level. There is no visible garden complex; the shinden block is directly adjoined on the west by a stable and kitchen wing. There is no entrance karahafu; in the living-room, where the whole family crowds together, there is only a partial equipment with tatami, and the vertical enclosure by walls or screens is as direct and unpretentious as in a middle-class home today.

A real buke-zukuri, identified by the owner's known position, is shown in the first illustration in the pictorial biography of Hōnen Shōnin:

289 (*above*). Birthplace of Hōnen Shōnin, from the picture-scroll *Hōnen-shōnin-eden*, thirteenth century

290 (*opposite*). Village scene, from the *Ippen-shōnin-eden*

the house where Hōnen was born in the Province of Mimasaka, in 1133, as the son of a local military official [289]. The main building, with its thatch and plank roofs, looks at first sight like a farm-house. Closer inspection shows that at least the floor of the main room seems to be covered with tatami; and that the sliding screen door is a translucent one, covered only with paper (like the shōji used today). The entrance wing, doubling as a guards' shelter, strikes a note of big-city sophistication by its 'Chinese gable'.

One picture in the pictorial biography of Ippen Shōnin renders perfectly the straggling, ramshackle look of a little country village [290]. A *Kasuga* close-up shows the bareness of a

291. Poor man's dwelling,
from the *Kasuga-gongen-reikenki*

house on the lower fringe of gentility, with no amenities except a somewhat more generous allotment of space than would have been possible at a lower social stratum [291].

An early version of the shoin-zukuri is shown in a *Kasuga* illustration depicting the country retreat of a priest of Fujiwara lineage, one Gedatsu Jōnin. The incident referred to, a visit paid him by the Kasuga deity in the guise of a young monk, is dated 1195; it is obvious, however, that the artist has supplied a setting from his own period more than a century later. The little shoin bay is seen as one of a group of new Chinese features, grafted on to the familiar native house type. The old abbot sits in a chair of Sung design, brewing himself tea in a Chinese pot. The projecting bay is roofed with half the curve of a 'Chinese gable'; and the screen paintings are landscapes done in the Sung ink style [292]. These innovations must have come as part of the Zen baggage from Hangchow; they foreshadow the

deeper Chinese colouring which was to be achieved under the Ashikaga in the fifteenth century.

The shoin bay apparently became a popular feature of priests' houses by late Kamakura, for it is frequent in picture-scrolls of that time. That it could spread as a fashionable novelty to secular construction is attested by a mansion setting in the early fourteenth-century *Matsu-zaki-tenjin-engi*. A variant form with the same general purpose may be found in some scrolls, also projecting under its own penthouse roof; this is a library alcove, a *todana* with a long reading shelf and cases for books, without a window. (Similar shallow projecting bays under their own low roofs occur sometimes in formal Zen architecture, as a means of housing the memorial tablets of deceased priors at the rear of a chapel.[3]) These forms seem at first sight trivial, and, as I have argued above, can hardly be used to define a coherent style. They have, all the same, a real historic importance, as

292. Priest's dwelling,
from the *Kasuga-gongen-reikenki*

being the first step toward the fully developed interior architecture of later centuries. The *Kasuga* view of the mid-Kamakura house of the regent Michiie shows a room in which the architect has provided only enclosure [287, *left*]. The enclosing planes are pleasingly varied in material and decoration; of the vertical ones, some are plaster walls, others movable screens. But the screens move back only to give access to other, like rooms; the only usable space is that determined by the rectangle of the floor, and a piece of furniture must stand within the room. The mature interior of recent centuries differs chiefly in the fact that the floor area is supplemented by built-in spaces on one or more sides. A reception room will be visually dominated by the open toko-no-ma alcove, with its studied arrangement of flowers, scroll, and ornamental shelves. Any room will probably have at least a deep closet all along one side, hidden behind sliding screens. The most carefully worked-out interiors may include the

shoin window itself as a key feature (and to the historian, a reminder of the humble origins of the whole system).

The toko-no-ma proper cannot be found in picture-scrolls of a strictly defined Kamakura date. Its prototype is to be sought in the paraphernalia of the priest's private chapel: a grouping for devotional purposes of a hanging icon, and a flower stand set in front of the wall. The necessary further step by which this complex was placed in a recess of its own is proven for the immediate post-Kamakura period by an illustration in a picture-scroll of 1351, the *Boki Ekotoba*, a biography of Shūshō, an abbot of the Shin sect. Though it is a priest's room that is shown, the alcove frames not an icon, but a horizontal landscape kakemono, of the sort that might be found hanging in any later toko-no-ma. Presumably the idea was suggested by the success of the book alcove, *todana*, rather than being borrowed fully-fledged from China.

Another relatively inconspicuous Kamakura detail destined to lead the way toward a radical change is the 'Chinese gable', *karahafu*. Traditional exterior design in the Far East (above the primitive stage of the Shintō shrine) had always relegated the gable to the secondary, end façade, and had given first preference to the hipped roof. The first departure from this immemorial law was probably carried out in the Sung dynasty, as part of a general move toward richness and variety. In Sung architectural paintings the big triangle of the gable field will often be found marking each axis, as emphatic as a Baroque pediment. The roof as a whole thus has two crossing ridges, and looks the same from all four sides. The karahafu must have been an incidental result of this experimentation; its curve has a strong south Chinese flavour. Japanese borrowing occasionally went farther, to modify the main roof in something like the Sung manner; at least so that a gable field might be visible over the entrance. This is particularly noticeable in the tsuridono, but seems to have occurred most frequently in Buddhist architecture of a semi-formal type. In later Japanese exteriors, as we shall see, the device was used consistently and on the largest scale.

SECULAR ARCHITECTURE

OF MUROMACHI, MOMOYAMA, AND EDO

The history of domestic architecture during the last five hundred years may be roughly summarized by assigning one characteristic process to each period. In Muromachi, the chief concern of the epicurean court of the Ashikaga Shōguns was to work out a fusion of the inherited strains. In Momoyama, under the aggressive plebeian genius of Hideyoshi, the capacities of secular building were pushed to new extremes; on the one hand, into a new world of size and runaway magnificence, on the other towards an opposite ideal of reticence. In the first generations of Edo the ebullience of the Momoyama style was tamed, and its achievements were drawn into a new amalgamation. Thereafter the evolutionary process slowed almost to a standstill. What motion survived was of a different sort; a filtering-down of forms and standards from the top social levels through a great part of the social hierarchy.[1]

The return of the Ashikaga to Kyōto in 1336 signalized the sealing of the breach between the court and military societies that had been opened by Yoritomo's move to Kamakura. In a different sense it marked the incipient break-up of military unity. The new Shōguns became with every generation more helpless in the face of disruption. As their positions became more ornamental they turned ever more whole-heartedly to the kind of escape that was traditional in Kyōto palaces. The career of the Shōgun Yoshimasa, with his 'silver pavilion', his tea-master, his Nō players, and his painting collection, has much of the sunset atmosphere of the last Fujiwara generations, when the

civil wars were beginning. It is no wonder, then, that memories of the shinden-zukuri should still have been strong in the great Muromachi houses. The chief difference that separated Ashikaga taste from that of late Heian was its contact with China. The Shōguns inherited and maintained the Zen monopoly. Their advisers in almost every field, from taxation to the tea cult, were Zen monks, whose traditional link with China was now strengthened by renewed intercourse with the Ming. The metropolitan Zen monasteries were maintained under Ashikaga patronage as faithful replicas of the standard that had been established at Hangchow. In painting the authority of the Southern Sung ink style went almost unchallenged.

What is interesting in the secular architecture of Muromachi society, however, is precisely that it was so lightly tinged by the prevailing fashion. So far as we know, no Shōgun built for his personal use a structure more than partly Chinese in appearance. Little remains to prove this, but one monument states the case clearly. The predilections of the first aesthete-Shōgun, Yoshimitsu (1358–1408), are demonstrated in one of the landmarks of Kyōto, the 'golden pavilion', Kinkakuji. The building was erected in 1397 for an established part villa and part monastery, occupied by Yoshimitsu as a ruler turned monk (in the style of the Heian retired emperors).[2] The pavilion was in part a Zen chapel. Its position on the north side of a garden lake recalled the old shinden type; while to Muromachi eyes the site must also have suggested the kind of water-side kiosk often

displayed in Sung paintings. This confluence of ideas resulted in a frank eclecticism. From a distance the mass – three storeys, mounting four-square to a curving pyramidal roof – has a Chinese look [293]. Seen closer, the grace and lightness of the visible framing, its natural colour, and the shingled roof restore the balance on the Japanese side. The details fall one way or the other under the dictates of convenience or aesthetic choice. The bracketing as a whole is very simple, but the second-floor balcony is held by transverse arms in the 'Indian style'. In the first and second storeys the openings are filled with grilled shutters or flat plank doors, in the native tradition. On the top floor are the types familiar in the formal Zen repertory, the door leaves richly panelled, and the windows topped by a cusped arch. To the pavilion is

293. Kinkakuji ('golden pavilion'), 1397

linked a small kiosk, standing over the water like a tsuridono. Handled with Ashikaga taste, all these divergent details merge in an effect as satisfying, and as characteristic of the time, as that of an ink painting by Shūbun.

Neither the 'golden pavilion' nor its smaller, 'silver' cousin of 1483 is particularly interesting inside.[3] The compound of the latter, however, contains also a small companion hall, the Tōgūdō, in which Muromachi eclecticism is extended to the interior. About half the depth is allotted to the needs of a Buddhist chapel. Of the remainder a rear corner is taken up by an element unimaginable in any earlier period: a room for the tea ceremony in which its builder, the Shōgun Yoshimasa (1435–90), delighted. The dimensions of the chamber are set by the standard size of a floor mat, tatami, about 6 by 3 feet; it is a '4½-mat room', and so has the square shape favoured by Yoshimasa's famous tea-master, Shukō (1422–1502). In the half-mat centre is sunk the little fire-box for the tea-pot. The origins of the tea cult make it natural that the room should be embellished by the built-in features that we have seen in priests' houses of the fourteenth century. The rear wall has a simple version of the two-part design that has since become almost inescapable in decent Japanese houses: an open alcove, and a narrower recess alongside crossed by ornamental shelves (the first here taking a mat length, the second a half mat). Presumably it is a sign of early date that the larger alcove is used not for the familiar toko-no-ma, with its hanging picture and flower arrangement, but is instead a kind of shoin window.

The few other comparable interiors remaining from Muromachi show a similar immaturity.[4]

The much more numerous Momoyama buildings of domestic type approximate the later standard with greater regularity. The principles followed are clearly displayed in a modest priests' residence at Onjōji erected probably around 1601, the Kōjōin. The plan has become an oblong entered from the narrow end; a change foreshadowed in a few late Kamakura buildings, as we have seen, and now carried out frequently [294]. The main block is subdivided unevenly by crossing partitions into four main rooms. Each room is a square or deeper, and is designed to accentuate depth rather than breadth. The two largest are both

294. Onjōji, Kōjōin
(priests' guests' house), c. 1600, plan

18-mat rooms, the front one being used to receive guests, and the rear one, a step higher, being the master's chamber. The latter has across its back the now orthodox combination, a long, high toko-no-ma with a smaller shelf recess alongside to give it scale. Off a rear corner projects a 2-mat shoin bay with its own toko-no-ma; the master's dressing-room, nando, is on the opposite side. The building is surrounded by a veranda, engawa, which is widened on the main long side, facing the garden, and at the front corner is further enlarged to become a kind of half-open porch.

In elevation the Kōjōin has the traditional lightness and simplicity, but reveals its late date by the big gable rising above its entrance

295. Onjōji, Kōjōin (priests' guests' house), c. 1600

wall [295]. The gable accent is repeated in a curving karahafu hood over the door; and movement is accentuated by the emergence of a secondary gable at right angles, to cover the corner porch. The exterior has thus a dynamic irregularity very unlike the placid orderliness of the shinden-zukuri.

The Momoyama period has been remembered best as an age of magnificent display. When the conquests of Nobunaga and Hideyoshi had shaken the fragments of feudal Japan together into something like a unified state, it became once more possible to build on a royal scale. In the last quarter of the sixteenth century the desire and the physical capacity to build met on a level hardly realized since the old days at Nara. One of Hideyoshi's grandiose projects, indeed, was to set up a colossal Buddha and a Daibutsuden in Kyōto to rival or surpass the memory of Tōdaiji.[5] His castle-palaces, Jurakudai in Kyōto and Fushimi in Momoyama, were an astonishment to their time, and have remained fabulous in popular imagination.[6] Many of their famous buildings happily survived the collapse of the regime. Fushimi, in particular, was not burned by the Tokugawa (as would have happened in China), but was dismembered; its salvage was widely distributed, chiefly to temples in and around the capital. The most generous share was allotted to the western, or 'original', branch of the Honganji sect, Nishi Honganji in Kyōto: a group of buildings that still may be visited, and that gives the best possible idea of the setting in which Hideyoshi moved as a despot.

⟨Recent studies have revealed that there is little that can be actually proved to have been moved to Kyōto from the castle. In fact, the

296. Throne hall of the
western, 'original', Honganji, plan

original Fushimi Castle at Shigatsu Mukōjima
was totally damaged by an earthquake in 1596,
and the castle was rebuilt on a different site at
Kobatayama. It was then burnt during the war
of Sekigahara in 1600. After that the castle was
rebuilt, but it was abandoned in 1619, although
it was again partly repaired in 1623. The shoin
in Nishi Honganji in Kyōto, on the other hand,
shows no sign of having been dismantled and
reassembled on the site.[7] The shoin was
probably built in 1632.[8] According to Dr Fuji-
oka's studies, one of the buildings which was
probably moved from the Fushimi Castle is
the Kyakuden of the Saikyōji Buddhist temple
at Otsu in Shiga Prefecture. It is a simple shoin
hall with less decoration and was built in 1598.
Because of the tradition of the hall having been
moved from the castle, and because it bears so
many marks of repair probably due to its

damage from the earthquake, one may well
believe in the move.[9] ⟩

The largest of the Honganji acquisitions,
the shoin, is a one-storeyed hall, a greatly
expanded and extravagantly decorated version
of the design we have seen in the Kōjōin. The
main block is again laid out on the basis of
crossing main partitions, here so far off centre
that three-quarters of the width is assigned to
the state apartments [296]. The throne hall has
two parts. In the front is a square retainers'
area of 162 mats, subdivided into three aisles.
At the back is the lord's dais, with a big toko-
no-ma in the centre, a shoin cabinet with
ornamental shelving on one side, and a for-
malized passage-way on the other. Behind are
rooms of a more comfortable size, with another
shoin suite at one rear corner. The audience
hall is a marvel of Momoyama decorative art.
Walls and sliding screens are covered with
paintings in the heroically colourful manner
developed by Kanō Eitoku; the ceilings are
richly coffered. The dividing line between
retainers and lord is stressed by an openwork
frieze, ramma; there the instinct to create a
rich, pictorial sculpture in wood, which we last
saw beginning in the kaerumata fields of
Kamakura, has reached a climax of imaginative
boldness. The glitter of gold and the sheen of
black lacquer are everywhere.

In a long, historical perspective the shoin is
most interesting not because it is large and
brilliantly ornamented, but because it so
flagrantly lacks any kind of monumentality.
The proportions of the big hall are those of a
basement. There is no proper vista, for the
entrance is through a protruding vestibule bay,
a genkan, at a front corner, at right angles to the
hall proper. At the point where all eyes focus,
the lord's dais, which in a Chinese hall would
be dignified by height, the Momoyama archi-
tect has taken the opposite course; his top
horizontal frame is pulled down by sculptured
ramma and curtains half-way to the floor. The

297 and 298. Kuro-shoin of the western, 'original', Honganji, late sixteenth century, veranda (*below*) and interior (*opposite*)

shoin, in short, is a building of domestic type, inflated to palace dimensions. It is so because the Japanese by 1600 had pursued their native preferences so single-mindedly and for so long that no other way of building remained at their disposal.

A smaller one-storey hall adjoining the shoin on the north-east, the kuro-shoin 〈 built in 1657〉, shows by its elegant simplicity and perfect scale the virtues lost in the throne apartments. Here materials and workmanship are of the highest quality. The porch floor gleams like a bronze mirror, the sliding doors have a satiny smoothness; at the same time high finish is so cunningly matched by natural-ness that one has almost the sense of being in a different world, where Nature of herself takes purer and clearer forms [297, 298]. Noteworthy are the ways in which traditional details have been re-studied to give a fresher interest; the crisp refinement of the ribs that subdivide the doors, the delicacy of openwork ramma un-troubled by sculpture. The broad wall surfaces are in pale colours, little affected by the paint-ings (which here are in the misty Kanō version of the Sung ink style). Crossed by widely separated vertical and horizontal bands, they show much of the discipline of design that the West has in recent decades learned to appre-ciate in the compositions of Mondrian. At the bottom, simplest of all, spreads the matting, neutral to the eye and pleasantly resilient to the foot. Its visible extension from one room to another, between wide-opened sliding screens,

helps greatly to create the sense of a continuous flow of interior space.

A third re-used building of Hideyoshi, the Hiunkaku,[10] reveals the mature Japanese feeling for intimate, picturesque arrangements. The building has a rambling plan, overlooking the garden lake of the temple. Part of it is three storeys high, in the old belvedere tradition, and there are still a few Chinese details inherited through Zen [299]. The Chinese geometry of

'artless buildings', and implies most obviously the absence of the forms of display found in the throne hall. A construction in sukiya taste must seem simple, though its simplicity and apparent artlessness may well conceal an intense creative effort. The two characters read 'Suki' are said to have been made famous by being written as the name tablet of a simple shelter by Shukō, the fifteenth-century founder of the tea cult. The most consistent and

299. Hiunkaku pavilion in the garden of the western, 'original', Honganji, late sixteenth century

Kinkakuji has yielded almost completely to irregularity, however; there are projecting bays and breaks in the roof outline everywhere. The interior includes the now familiar shoin appointments, including a tea-chamber.

Japanese historians describe the type of building seen at a relatively high stage of elaboration in the kuro-shoin and Hiunkaku as 'sukiya'.[11] The phrase means something like

thorough-going examples of the quality of 'artlessness' are furnished by the tea-houses, *chashitsu*, in which the cult has been celebrated since his time. Something of sukiya idealism is discernible today in almost every Japanese home with any pretensions to gentility, by much the same sort of diffusion that carried Palladian echoes to the New England villages. Its historical foundation lies in the preferences

300. Daitokuji, tea-room of the Ryūkōin, seventeenth century

that I have traced from the beginnings of Japanese domestic architecture: delight in natural materials and colours, pleasure in bareness and simplicity, insistence on proximity to nature. What distinguishes a sukiya building from its Yamato farm-house ancestor, or from the shinden-zukuri, is its extreme artfulness in creating the illusion of natural simplicity. It is in a peculiarly Japanese and very sophisticated way a means of escape from social problems and responsibilities. The tea-house, in particular, is a miniature world, isolated from everything else except its own patch of garden, often entered by a kind of symbolic renunciation through an uncomfortably tiny door. Inside everything is clean, compact, orderly [300, 306]. The materials are those offered by nature, the same that grow in the garden outside or in near-by woods; here they have been shaped to human needs, in a way that has emphasized their proper characteristics to be the components of a more harmonious beauty. The space is so small that the occupants can devote themselves with complete absorption to the ritual carried out in their midst. All that is seen, felt, and done seems completely controlled by human wills directed towards harmony and peace.

No account of Japanese architecture could do justice to its final development without emphasizing the tea-house, both as a form in itself and as an ideal influencing the whole of residential design. Unfortunately the aesthetic effect of the chashitsu, which is its whole reason for existence, is impossible to convey by description, and can be suggested only in fractions by even the best photographs. The tea-house is a kind of inside-out sculpture in planes, lines, and textures, understandable only when the observer is in his proper place inside it, feeling its enclosure around his body. Its appreciation comes as the climax to a series of impressions accumulated in passing through the garden and waiting in the porch; lacking

such preparation, it is like the finale passage of a sonata played alone.

A few introductory facts about the development of chashitsu architecture can be stated. From simple beginnings under the Ashikaga, the type reached its greatest creative age in Momoyama under Sen no Rikyū (1520–91). The fact that his two chief patrons as tea-master were the warriors Nobunaga and Hideyoshi tells a good deal about the claim of the cult to popularity. Historians are apt to say that the tea-ceremony was fully appreciated only by the Ashikaga Shōguns, and under Hideyoshi was vulgarized. On their side is the record of a kind of bank holiday proclaimed by the generalissimo in 1587, to which every kind of tea drinker was invited, and which ran through ten days of lavish entertainment. It is hard to reconcile such exhibitions with the kind of development given the chashitsu by Rikyū in the same period, which tended consistently towards the opposite extreme. To him is ascribed the preference that brought a general reduction in size, from Shukō's 4½ mats to 3 or even 2 (i.e. a room 6 feet square). His taste legitimized the affectation of primitive simplicity, the search for roughness and crookedness, the climax of seclusion epitomized by the dwarfed 'creeping-in door'. It seems to me likely that the great despot-generals (Hideyoshi in particular, because he lived long enough to enjoy the pleasures of victory) exhibited at high intensity the psychological contradictions often found in the Japanese personality. They liked power and raw magnificence, and knew the political value of public display. When tired and surfeited they turned for relief to the opposite set of experiences embodied in the tea cult; and valued those the more, as they were made the more drastically astringent and purgative.

A historically important subdivision of secular architecture developed in late Muromachi and Momoyama was the castle. The type

301. Himeji, castle, late sixteenth century

survives primarily in a number of large buildings comparable to the European donjon, towers raised on high bases formed of enormous stone blocks. The emergence of such constructions in the later sixteenth century reflects in general the rising scale of feudal warfare, which had made the old wooden stockade obsolete.[12] More specifically they represent the first appearance in Japan of Western technology, taught by European experts: an acquaintance with firearms, and a compensating improvement in means of defence. The Japanese castles served their purpose (against very inefficient cannon) moderately well. The most formidable, the headquarters of Hideyoshi's heir at Ōsaka,

survived one campaign against Tokugawa forces, and in a second fell after a desperate month's siege. The remaining donjons, *tenshu*, are grim and efficient only in their stone foundations. The typical white-plastered or wood-sheathed superstructure is embellished by an eaves line for every storey, slanting up into one or two false gables [301]. Like pediments in a Baroque spire, these rise through various combinations, to be crowned by the real roof, tiles for fire-proofing. The visual effect has something of the gaiety of a belvedere in a Sung picture.

Smaller, simpler constructions using the same vocabulary have survived sporadically to

illustrate other parts of the castle. Nagoya, for example, has a massive, fortified gatehouse, and Himeji a wall with corner pavilions which suggest comparisons with the city fortifications of China; they are much lower but are built more substantially in their lower courses, of stone instead of brick.

In a brief history, little can be profitably said about the domestic style of the Edo period. The quantity of preserved material is of course very large, and most of it is still unpublished. The buildings discourage analysis by being at once standardized in their general characteristics and infinitely varied in details. Except under special circumstances they are all built from the same narrow repertory of materials and equipped in the same general way. They continue the national taste for light construction and sliding partitions that permit a maximum openness. They all have in various degrees the contrived artlessness of the sukiya tradition, and exploit as freely as possible the potentialities of picturesque irregularity. The difference between the lord's house and the commoner's is incomparably less than it was, for example, in eighteenth-century England.[13] The Japanese equivalent for marble and a giant Palladian order is usually a better quality of the standard house materials, and superior workmanship. The mansion may be large in total floor area, but its most spacious room will be far below the scale of an Adam saloon. Height will vary least of all. Far from exploiting the grandeur of a towering façade, the Japanese house will be most luxurious when it is closest to the ground. Second storeys have been a part of the urban vocabulary for centuries, but as a result of spatial necessity rather than choice.

The Edo house type as it survives today requires the less notice because its continuation into the modern world has been well described by many Westerners in love with its charm. It is, finally, in essentials the same type that had

already been worked out by the end of the Momoyama period; in houses as in religious architecture the Tokugawa age found little of importance to add.

Two Kyōto buildings of early Edo date deserve mention for their exceptionally high quality: the complexes belonging to the Nijō and Katsura palaces.[14] Neither can be called a pure Tokugawa monument. Large portions of both had originally been built for Hideyoshi, and whatever creative impulse animated the rest was probably a survival from the Momoyama outburst. The two show a kind of planning not seen except in embryo in earlier designs, however, and this may represent an advance beyond the Momoyama standard as real as that seen, for instance, in early seventeenth-century Kanō painting by comparison with the style of Eitoku. Both plans are made up of four staggered building blocks [302]. The overlap may be wide, so that the rear block looks like an ordinary wing; or there may be not much more than a meeting of corners; or the two adjacent blocks may be linked by a short corridor. In any case it is clear that the idea was an outgrowth of the experiments in grouping performed during Kamakura and Muromachi; and that part of its purpose was to provide an extensive floor area throughout which almost every room could front on a garden or court. The same sort of preference for light and openness had once been satisfied by the group plan of the shinden-zukuri, but with little variation. Here, as one would expect, the emphasis is all on flexibility, irregularity, and unexpectedness, both in the relations between rooms and in the kinds of outdoor space – garden or courtyard – on which the sliding partitions open.

The Nijō palace served as the Kyōto headquarters of the Tokugawa Shōgunate. There is an historical aptness, then, in its general similarity to the Honganji throne hall. The

302. Katsura detached palace, plan

broad front, sweeping up into a big gable field, is impressive, and the interior is richly decorated in the Momoyama manner, with carved wood, black lacquer, gold, and highly coloured screen paintings [303]. The Katsura palace, though comparable in plan, has otherwise a very pungent sukiya flavour. The whole complex has the atmosphere of the tea cult, varying from room to room but almost always consistently simple and spare [304–6]. Its high quality, like that of the best chashitsu, consists in effects that cannot be described: charming

vistas through rooms or outward into the famous garden, interesting movements of wall planes, unexpected changes in room proportions, ingeniously re-designed details. The standard of taste involved is so peculiarly a Japanese creation that the Westerner should perhaps not expect to be able to follow it in complete agreement. The Japanese critics warmly praise some Katsura details that to Western eyes are likely to look like demonstrations of the ease with which charm can pass over into cuteness, or simplicity into affectation.

303 (overleaf). Nijō palace, 'great' shoin, seventeenth century

304–6. Katsura detached palace, seventeenth century,
garden view (*opposite*), veranda (*above left*), and tea-room (*above right*)

RELIGIOUS ARCHITECTURE

OF MUROMACHI, MOMOYAMA, AND EDO[1]

By the standards of Western criticism, Japanese Buddhist architecture completed the last major phase of its evolution in the fourteenth century. The vast majority of existing buildings of course post-date that period, and most have some claim to interest. A very large number testify to the skill and self-respect of the Japanese carpenter. Some are big and dramatic; others are marvels of decorative ingenuity; many have a good deal of the engaging simplicity of the late residential style. On strict analysis, however, Buddhist architecture has since the end of Kamakura declined into a routine, easily summarized and demanding no prolonged critical attention.

Most buildings set up have been replacements, more or less affected by the memory of their predecessors. In the Zen sect, as we have seen, the authority of the archetypes has so successfully resisted the passage of time that even an eighteenth-century restoration will look like a careful (though insensitive) copy of the Southern Sung original. More often the new temple building will reveal an eclecticism more consistent and unabashed than had been possible in Kamakura (and in principle not much more meritorious than the assembling of medieval details from all over Europe in the Gothic Revival). The most impressive of the late structures, the huge and sumptuously ornamented halls serving the popular Amida sects, are basically only expansions of the raidō-and-sanctuary formula matured in Kamakura. The single current of development, moving steadily and irresistibly in one direction until the eighteenth century, has been an interest in decoration, shown most clearly in the evolution of ornamental wood sculpture.

The look of a Buddhist establishment of recent centuries is markedly different from the original Chinese standard. There are no fixed principles of arrangement; not even irregularity is universal. Southward orientation is still frequent. In the most influential of the new sects, Shin, this has been replaced by a more modern orthodoxy, however; the main buildings face east, as does the Buddha Amida in his heaven. The very kinds of buildings testify to profound changes in the constitution of Buddhism. The early establishments had been monasteries; the late ones (outside of the Zen sect) are popular temples served by a relatively few priests, who are usually married. Vanished are cloister corridors, lecture hall, pagoda (except in Nichiren temples),[2] formal dormitory and refectory blocks, balanced bell and library 'towers'. The priests' quarters are like private houses, walled off from the public area in their gardens. Most curious of all, the chief hall of worship in the biggest establishments is likely to be dedicated not to any conventional figure in the Buddhist pantheon, but to a Japanese priest, founder of the sect; not to Amida, even, but to Shinran, Hōnen, or Nichiren. At a popular pilgrimage centre a whole new class of buildings – shelters, refreshment booths, offices for the sale of charms – will rise wherever required to serve the worshippers' lesser needs.

The one general plan-type developed to answer the requirements of popular Buddhism is found in major temples of the Shin sect,

epitomized by the two Honganji in Kyōto.[3] There are always two buildings facing east, side by side and linked by a roofed corridor, with a gateway through the entrance wall in front of each [307]. The larger, normally on

[308].[7] Though the plan type was derived from the needs of esoteric, Tendai worship, it serves a religion in which the ceremonies are publicly performed; the chancel is fully visible, and no more than a memory of secrecy remains

307. Two main halls
of the eastern, 'Ōtani', Honganji, plan

308. Founder's hall of the Chionin, plan

the proper left (the place of greater honour), is the mieidō or goeidō,[4] dedicated in memory of Shinran Shōnin. The other, a hall of Amida, in the Honganji versions illustrates nicely the process of face-saving in architecture. Much smaller in area, it is as a rule two storeys high in appearance, and looks richer through the use of 'Chinese style' details. The goeidō standard permits only a single storey, and follows at least in part the simpler 'Japanese style'.[5] The goeidō will be assigned the more imposing gateway; but the gate of the Amidadō, though small, will have the special elaboration of a karamon roof, with curving gables.

In the Kyōto headquarters of the Jōdo sect, Chionin, the same sort of two-hall balance is adapted to a cramped hillside site.[6] As a result the two must stand at right angles to each other, with the Amidadō turned east and the goeidō facing south. There is no place for interrelated gateways.

The Chionin on behalf of Jōdo, and the Honganji on behalf of Shin, illustrate two different extremes in the evolution of the popular hall of worship. The goeidō of the former is much closer in general proportions to the Kamakura norm. Its great size makes the raidō spacious enough for almost any crowd

to keep the main images closed in shrines. The visual effectiveness of the scheme can be best appreciated on great holy days, when the chancel is filled with high priests from all over Japan, and the raidō packed with lay worshippers. These last look on in wondering humility, all black or dark brown except for a sprinkling of girls and children in flowered kimono. On the other side of the chancel rail brocaded vestments are massed like a huge bed of exotic flowers. Beyond the seated priests, the lamps twinkle on the pure gold surfaces of the altar furnishings. The air prickles with incense, and seems to throb with the responses chanted by a hundred throats. In the imagination of the faithful, the scene must stand as a convincing promise, wonderfully close and real, of the beauty and majesty of the Western Paradise.

In the typical Shin hall the space allotted to the congregation is even larger, ranging up to half the total. The largest raidō, that of the Eastern Honganji in Kyōto, is so spacious that it must be subdivided by four longitudinal rows of columns [307].[8] The effect of the Tendai hall prototype has been better preserved than by Jōdo, since the whole rear is closed off by a partition. The function of this, however, has become almost that of a theatre

curtain. Closed while the congregation accumulates, it communicates a sense of dramatic mystery. Something like an orchestra of priests begins the service, in full view, since they sit with their equipment in the innermost bay of the raidō, a kind of presbytery marked by a railing. At a crucial point in the service doors are opened; and as if on a stage, brilliantly lit, one sees the altar, the image shrine, the hangings, and the lamps, all a glitter of gold.

The greatest Shin halls are masterpieces of calculated eclecticism. Their Buddhist inheritance is obvious, and no one who has seen a Shin service will underestimate the power of its theatricality. The third major component is an interior magnificence borrowed from the Momoyama palace style. The Honganji raidō continue, as closely as their use and Buddhist custom permit, the standard of interior design set by Hideyoshi's throne hall. In particular the partition across the rear might have served any Momoyama or early Edo palace; there are the same gorgeous painted screens, the same rich fittings, the same heavy carved ramma across the top. As in a residence, the floor area used by the congregation is covered by tatami. The different purpose of the presbytery is stressed by a change of floor surface, to polished wood; while the yet higher holiness of the sanctuary requires a raised level, like the lord's dais. The palace atmosphere is lessened in part by the greater monumentality of Buddhist tradition, massive columns and substantial bracketing. It is affected also by theatrical needs; all-over decoration of the raidō must be played down in favour of the proscenium partition.

The Shin sanctuary area suffers from a typical theatre inconvenience, cramped dimensions and inflexible spaces. The whole layout and scale – three or five rooms of moderate size in a row – suggest a residential suite. Even the central chamber permits not much more than a tableau of service immediately around the altar. Thus the Shin hall has the virtues and drawbacks of the traditional European theatre; while the Chionin is more like the experimental theatre designs of the twentieth century, in which attempts have been made to expand the stage area and minimize the barrier between performers and audience.

A special ground-plan inherited from earlier practice but used with greater catholicity in recent centuries is the *gongen-zukuri*: a three-part complex in which sanctuary and raidō are separate blocks, connected by a wide, room-like corridor. We have seen the design in Zen use in the Kaisandō of Eihōji, and have traced its probable origin in China. In the Edo period it gained a unique prestige by being chosen for the central building of the mausoleum of Tokugawa Ieyasu at Nikkō, the sumptuous Tōshōgū. That example was faithfully followed in the hardly less ostentatious precinct of Iemitsu; and the two created a precedent that ruled all subsequent Tokugawa mausolea.[9] The choice had a historical aptness, since the tomb sanctuary was analogous to a memorial chapel in a monastery. It had been anticipated by a growing use of the gongen-zukuri in Shintō constructions of the Momoyama period.

A straightforward Shintō version may be seen at the Ōsaki Hachiman Jinsha in Sendai, completed in 1607 by a Date lord. The front block corresponds to the familiar free-standing haiden. The intermediate space is several steps lower and paved with stone, to preserve the sense of a descent to ground level. To reach the sanctuary, one climbs up a ladder-like stair. In elevation the two main blocks are marked by separate hip-and-gable roofs, as in the Kaisandō. Momoyama taste is betrayed by the richness of the interior. Outside, it is shown first of all by the fact that the transverse roof is permitted to project as a big gable field on the façade; and then by the emergence of a smaller, curving karahafu over the middle bay of the porch.

The willingness of certain Shintō cults to accept an architectural type of Buddhist origin may from one standpoint imply an extreme of subservience. From another it may well have been encouraged by a long-accumulated realization of the advantage of gathering all the primary activities of Shintō worship under the shelter of one roof. A monument of 1394 bears witness to a Shintō impulse to experiment with the kind of plan that had proved so convenient for Buddhist use in the Kamakura period. Like the gongen-zukuri examples, the big main hall of the Kibitsu Jinsha in the outskirts of Okayama provides a continuous roof and wall protection around what would otherwise be free-standing haiden and honden blocks. As compared with the gongen-zukuri this solution is manifestly immature, however. The building is a large oblong mass with the end to the front, reached through a narrower entrance wing. The main block looks like a much enlarged Hachiman complex (the simpler prototype of the gongen-zukuri). The long side façade shows two big gable fields and a connecting roof between, half Chinese and half Yamato in details. The awkwardly attached front wing is covered by a true gable, seen end-on like a pediment, and is surrounded by a low penthouse veranda. Inside there is a naive transition from large to small scale. Under the gable one is in a high, narrow corridor rising to the underside of the roof. One mounts to the main block up a steep ladder-stair, through a porch of outdoor type. Thereafter there are two more stairs, and flat ceilings that also step up, but less and less with each floor rise; until the final stage has the miniature scale of a normal sanctuary. The twin gable fields on the outside have the frank falsity we have found in Kamakura Buddhist halls. They speak of a general separation of what is beneath into closed and open halves, in the fashion of the hachiman-zukuri; but have no direct connexion with any part of the interior design.[10]

A number of late halls built as replacements convey a good deal of their predecessors' character. The existing kondō of Tōji in Kyōto, and the Daibutsuden of Tōdaiji, erected at the end of the sixteenth and seventeenth centuries respectively, retain the impressiveness of the original dimensions (though both show their lateness by clumsy details like the axial karahafu [190]).[11] The early Edo lecture hall of Enryakuji on Hieizan, again, is full of the ancient Tantric mystery. From a raidō of Kamakura type one can look, when the doors are opened, into an almost pitch-dark chancel; the stone floor several steps below is invisible, so that the images on the altar seem to float in blackness.[12]

With a restraint due to its conservative surroundings the Enryakuji lecture hall illustrates the freedom of choice from different sources permitted to a late temple architect. First the two-storeyed mass and then many details – the eaves-bracketing, the tiled roof, the panelled doors, the cusped-arch frame of the window – belong to the Zen repertory [309]. On the other hand the building is surrounded by a typical native-style wooden balcony, and is closed all along the front, except for the axial doorway, by grilled shutters. There is even an occasional kaerumata in the wall plane, or between beam tiers. Across the front the mixing of Karayō and Wayō has created a structural difficulty – the need to hold up a clerestory wall set one bay in, above a raidō two bays deep – which is solved by stout transverse girders. The actual date of the building is revealed best by an innovation perhaps connected with Hideyoshi's campaigns in Korea; the transformation of the lower tier of bracketing 'beaks' into the sculptured heads of lions, elephants, and dragons.[13]

Indebtedness to the continent was a factor in the last phase of Japanese Buddhist architecture, as the lecture hall shows. The significant novelty was its unimportance. After the

309. Enryakuji, lecture hall

Ashikaga enthusiasm for Southern Sung had subsided, native taste was too solidly established to be much moved by any further admiration for the mainland styles. The fact, proved everywhere by the absence of any new Chinese influence, is substantiated also by the two isolated cases in which Chinese architectural forms were imported in quantity.

The earlier instance was bound up with a last, dying wave of missionary impulse from Chinese Buddhism. A sub-sect of Ch'an in Fukien, called Huang-po-shan from the location of its headquarters, was transferred to Japan at the time of the Manchu conquest, through the emigration of its then abbot, Yin-yüan. In 1661

a Japanese offshoot was planted south of Kyōto, on a hill renamed Ōbakusan in honour of the Chinese original. The monastery erected there, Mampukuji, was governed by thirteen Chinese abbots in succession, passing into full Japanese control only in 1738. It remains a vigorous Zen headquarters today, built in a style recognizably different from the Edo norm. Even there, however, one sees a compromise in which the indigenous component is strong. The general plan, drawn out on a long central axis, is that of a late Chinese monastery; details like railings, column bases, and roof ornaments were copied from late Ming. For the bracketing dependence was placed chiefly on the long acclimatized

310. Nikkō, mausoleum of Tokugawa Ieyasu,
gateway called Yōemeimon, seventeenth century

Karayō, the Zen formula of Southern Sung; and the roof framing followed the efficient native double-shell technique.

A Chinese style reproduced with something like the fidelity of the Kamakura or Nara period was possible in that age only in one place, where the circumstances were unique: the port of Nagasaki, serving the religious needs of emigrant Chinese. Three monasteries there were built as dependencies of Huang-po-shan, and at first sight look as if they had been transplanted bodily from South China. Even they, however, use Japanese-style roofs [258A].[14] The Nagasaki buildings disclose a more unexpected link with the Japanese development in their bracketing, which is clearly in the same stylistic tradition that the Japanese had borrowed a half millennium earlier in the guise of the 'Indian style', Tenjikuyō. This is natural

enough, since, as we have seen, buildings preserved on the mainland define the original home of the Tenjikuyō as a south Chinese area centring on Fukien.

The instinct of the late periods for rich decoration involved a natural economic problem. Ornament is always expensive, and in recent Japanese history the ability to spend freely has been permitted only to relatively few. The full potentialities of decorated architecture can be studied only in rare monuments; notably the mortuary precincts of the first and third Tokugawa Shōguns at Nikkō [310]. Almost any building with a claim to architectural interest will show the effects of the late ornamental instinct in some degree, however. By it the eclecticism of the age was given consistency. In choosing among his alternatives for a feature, the late designer was apt to

311. Saidaiji, main hall,
detail of porch, eighteenth century

pick whichever one could best enhance visual richness. Among door and window treatments, for example, those of the 'Chinese style' were particularly favoured, for their panelling and cusping. The Karayō beam type, again, was used by preference in conspicuous places like a porch; and its once discreet mouldings were accentuated until they covered the whole timber surface [311]. 'Japanese style' bracketing, valued as a reminder of antiquity, had in its proper character an unfashionable simplicity and directness. To improve it, then, the lever arm might be doubled, in imitation of Karayō practice, or be given 'Chinese' mouldings. Even more dependence was placed on an unprecedented enrichment of a key Wayō feature, the kaerumata.

We have seen this last form develop in the Kamakura period from graceful leg outlines

to a dense sculptural filling of the interior. Once the limits of the frame had been reached, the designs ceased for a time to grow outward, or to become more elaborate. Their creators turned, instead, toward greater variety and unexpectedness; accepting first a bold asymmetry, and then exploring the compositional possibilities opened up by decorative painting. By the end of Momoyama the kaerumata repertory had taken in as many as possible of the themes worked out by the Kanō masters: designs of foliage, flowers, and fruit, or stock combinations like tiger and bamboo, lion and peony, or heron and lotus. In the seventeenth century the pace of sculptural development was maintained by the concentration of skill and competitive instinct for a full generation at Nikkō. There is a noticeable difference even between the early ornamental style of the

Tōshōgū and the final embellishments of the Daiyūin. The latter are more ingenious than ever before, as patiently and intricately carved at miniature scale as a late Gothic retable in Flanders. The subjects are now often scenes from Chinese stories, performed like a puppet-show by tiny wooden actors; miracles of craftsmanship, all a little too far away to be clearly seen. Even the Daiyūin was not the climax, as architectural sculpture went on growing in richness for at least another century. In that last phase it expanded again in area, pushing out to an extraordinary height of relief, and extending sidewise until the kaerumata frame was hidden by foliage, cloud scrolls, or the tails of birds or dragons. Occasionally, as a logical conclusion, the kaerumata legs were omitted entirely, and nothing was left but a kind of bush of carved wood, roughly following the traditional outlines [311].

It is natural to marvel at the technical virtuosity of this decoration, but its tangled luxuriance has the smell of autumn. The killing frost of aesthetic fatigue set in by the nineteenth century. The latest kaerumata are suddenly as naked as a November tree – in which state they reveal the loss of every grace of line and proportion that once had made the form beautiful.

The impulse to add a rich sculptural decoration could not be satisfied with the small fields furnished by kaerumata alone. The search for larger areas brought in other members: the frames around special doorways, the corbels under the rafters of a Wayō porch, the space above a door lintel corresponding to a ramma lattice. Best suited of all was the traditionally elaborate small gateway type called *karamon*. Every conscientious visitor to Kyōto has admired the karamon of the Western Honganji, for example, and has learned that it 'is popu-

larly known as Higurashi no Mon or Day-spending Gate, suggesting that a whole day is required to take in all its beauties.'[15] In all these places wooden sculpture waxed and grew into a rank tangle, and was finally blighted, in the same way; and its eventual disappearance disclosed the same bleak poverty in underlying forms.

Doubtless as a result of the Japanese vacillation between two aesthetic poles, much of this sculptural extravagance exists in unpainted wood. The typical karamon, like the partitions inside a Shin hall, is brightly coloured and gilded, but even then the dazzle below is topped by a prim, dark cover of shingles. It is only at Nikkō that the efforts of the architect and the wood-carver to reach maximum richness in a whole group of buildings have been complemented by an equal emphasis on colour, inside and out. The key is almost barbarically high, hot red, intense light blue, gold accents, a contrabass of black lacquer; the ultimate visual shock is given by key areas painted a dazzling white [310]. The roofs lack what would in China have been the natural crowning note, a brilliant glaze on coloured tiles; as a second-best solution, their surfaces are of copper, against which the ridges stand out by gilding. It is the environment that furnishes a last, illuminating contrast between Chinese and Japanese ways. A Chinese temple or palace group of equal ostentation would have stood in a setting almost completely artificial, framed by high walls, marble pavements, and the sky. The Nikkō precincts are surrounded by a dense forest of cryptomeria, a serene depth of shadow into which their tumult sinks without an echo. The ultimate effect on the observer is not too different from that made by the Ise shrines.

NOTES

Bold numbers indicate page reference

PART ONE: PAINTING AND SCULPTURE

Many of the pieces cited by Paine are illustrated in more recent publications, which are listed in the additional bibliography for each chapter. Additions made to the Notes for this edition are in angular brackets.

CHAPTER 2

24. 1. Robert K. Reischauer, *Early Japanese History*, 2 vols (Princeton, 1937), vol. 1, 20.
25. 2. Kenji Takahashi, 'Haniwa Oyobi Sōshingu', *Kōkogaku Kōza* (Yūzankaku, 1930), vol. 2, 11.

CHAPTER 3

27. 1. ⟨ An alternative and more probable date, found in another early source, is A.D. 538. Cf. G. Renondeau, 'La date de l'introduction du bouddhisme au Japon', *T'oung Pao* (1959).⟩
2. ⟨ As Coomaraswamy pointed out long ago, there are strictly speaking no priests in Buddhism, since there is no ritual of sacrifice. There are therefore only monks and monasteries. However, in certain syncretic forms of later Buddhism, it is hard to avoid describing some Buddhist structures as temples. Throughout this book, Paine followed conventional usage of his day, and it has not been thought necessary to amend it.⟩
29. 3. *The Saddharma-Pundarīka*, trans. by H. Kern (Oxford, 1909).
4. ⟨ Modern romanization Kannon. In this book Paine retains the old style for certain Japanese words.⟩
30. 5. ⟨ A more accurate term would be 'school'. The religious and intellectual differences between Buddhist groups were rarely such as to imply mutual exclusion. In this instance too Paine was following conventional usage among writers of his day.⟩
32. 6. This Yakushi is now sometimes considered to be a copy made later in the seventh century to replace a lost original.

46. 7. H. Minamoto, *An Illustrated History of Japanese Art*, trans. by H. G. Henderson (Kyōto, Hoshino, 1935).
48. 8. Tōichirō Naitō, *The Wall-Paintings of Hōryūji*, trans. by W. R. B. Acker and Benjamin Rowland, Jr (Baltimore, Waverley Press, 1943), 20 and 22.

CHAPTER 4

52. 1. Sir Charles Eliot, *Japanese Buddhism* (London, Arnold, 1935), 230.
2. George B. Sansom, *Japan*, *A Short Cultural History* (London, The Cresset Press, 1931), 122 ff.
3. Serge Elisseeff, 'The Bommōkyō and the Great Buddha of the Tōdaiji', *Harvard Journal of Asiatic Studies* (April 1926).
4. ⟨ Paine means the Buddhist *dharma*, a complex term which modern scholars prefer to leave untranslated.⟩
53. 5. *Op. cit.*, 24.
54. 6. Ryukan Kimura, *A Historical Study of the Terms Hīnāyāna and Mahāyāna and the Origin of Mahāyāna Buddhism* (University of Calcutta, 1927), 89.
55. 7. ⟨ See John M. Rosenfield, 'Studies in Japanese Portraiture: the Statue of Vimalakirti at Hokke-ji', *Ars Orientalis*, VI (1966), 213–22.⟩
56. 8. Marinus W. de Visser, *Ancient Buddhism in Japan* (Paris, Geuthner, 1928), 132.
57. 9 ⟨ See Sherwood F. Moran, 'Ashura, a Dry-Lacquer Statue of the Nara Period', *Artibus Asiae*, XXVII, 1/2 (1964), 97–133.⟩
58. 10. Langdon Warner, *The Craft of the Japanese Sculptor* (New York, McFarlane, Warde, McFarlane and Japan Society of New York, 1936).
70. 11. ⟨ Somewhat similar paintings of figures under trees have been found at Astāna, in Central Asia, suggesting a Chinese origin for the type of composition at least.⟩
72. 12. Kojiro Tomita, *Portfolio of Chinese Paintings in the Museum* (Museum of Fine Arts, Boston, 1938), plates 52–5.

CHAPTER 5

77. 1. See Minamoto, *op. cit.*, no. 43.
81. 2. At Hōryūji is a Nine-headed Kwannon carved of sandalwood and uncoloured. It was imported from China, and is believed to have been the prototype of such figures as the Hokkeji Kwannon.
3. ⟨ See Sherwood F. Moran, 'Early Heian Sculpture at Its Best: Three Outstanding Examples', *Artibus Asiae*, XXXIV, 2/3 (1972), 119–61.⟩
86. 4. The early date of the painting of the Red Fudō is doubted by many scholars, but stylistically it is still the best example of the change in figure composition.
87. 5. *Art Bulletin*, vol. **24**, December 1942.

CHAPTER 6

91. 1. See Minamoto, *op. cit.*, no. 50.
94. 2. See Minamoto, *op. cit.*, no. 69.
100. 3. ⟨ See Sherwood F. Moran, 'The Death of Buddha, a Painting at Kōyasan', *Artibus Asiae*, XXXVI, 1/2 (1974), 97–146.⟩
104. 4. ⟨ Cf. Dietrich Seckel, 'Kirikane: Die Schnittgold-Dekoration in der japanischen Kunst, ihre Technik und ihre Geschichte', *Oriens Extremus*, I, 1 (July 1954).⟩
108. 5. *Kokka Magazine*, nos 626 and 633.
6. See *Exhibition of Japanese Painting and Sculpture*, no. 29.

CHAPTER 7

110. 1. See Minamoto, *op. cit.*, no. 83.
115. 2. See Minamoto, *op. cit.*, no. 87.
3. See *Exhibition of Japanese Painting and Sculpture*, no. 88.
118. 4. ⟨ This judgement might be questioned today. Paine does not discuss Muromachi sculpture or Buddhist handscroll painting, or the spirited painting and sculpture inspired by Zen Buddhism in the seventeenth and eighteenth centuries.⟩
121. 5. See Minamoto, *op. cit.*, no. 116.
124. 6. See *Exhibition of Japanese Painting and Sculpture*, no. 13.
131. 7. See *op. cit.*, no. 14.

CHAPTER 8

134. 1. ⟨ Cf. A. C. Soper, 'The Illustrative Method of the Tokugawa "Genji" Pictures', *Art Bulletin*, XXXVII (March 1955), 1–17.⟩
2. For a reproduction in colour see Minamoto, *op. cit.*, no. 77.
142. 3. ⟨ The scroll of Diseases is now split up and dispersed among various collections.⟩
146. 4. Other sections appear in *Exhibition of Japanese Painting and Sculpture*, no. 22. Because of the very decorative use of strong colours the date of these scrolls is being currently questioned, and has been placed as late as the Muromachi period.
151. 5. *Kokka Magazine*, no. 636.
6. *Illustrated Catalogue of a Special Loan Exhibition of Art Treasures from Japan* (Museum of Fine Arts, Boston, 1936), no. 26.
152. 7. Kōjirō Tomita, 'The Burning of the Sanjō Palace', *Bulletin of the Museum of Fine Arts* (Boston, Oct. 1925).

CHAPTER 9

161. 1. The painting is now thought to be an old copy.
2. See Minamoto, *op. cit.*, no. 121.
162. 3. Kaō's painting of Kanzan is figured in *Exhibition of Japanese Painting and Sculpture*, no. 33.
164. 4. See E. Grosse, *Le Lavis en Extrême Orient* (Paris, G. Crès), plate 73.
169. 5. See Minamoto, *op. cit.*, no. 127.
170. 6. See Sansom, *op. cit.*, plates XVI and XVII.
172. 7. See *Exhibition of Japanese Painting and Sculpture*, no. 43.
175. 8. See Sansom, *op. cit.*, plate XVIII.
179. 9. See *Exhibition of Japanese Painting and Sculpture*, no. 46.
182. 10. *Op. cit.*, no. 49, where it is attributed to the Momoyama period.

CHAPTER 10

190. 1. *Kokka Magazine*, nos 596 and 625. The latter pair is now in the Brooklyn Museum of Art.
2. See Kōjirō Tomita, *Portfolio of Chinese Paintings in the Museum* (Museum of Fine Arts, Boston, 1938), plate 87.
193. 3. *Bijutsu Kenkyū*, vol. 1, Jan. 1932. *The Tōhaku gasetsu* has been edited, with a modern Japanese translation, by Minamoto Toyomune.
194. 4. Asatarō Miyamori, *An Anthology of Haiku Ancient and Modern* (Tōkyō, 1932), 124.
5. For a reproduction in colour see Minamoto, *op. cit.*, no. 147.

195. 6. R. A. B. Ponsonby Fane, *Kyōto* (Hong Kong, 1931).

CHAPTER 11

208. 1. See Minamoto, *op. cit.*, no. 172.

2. See *Illustrated Catalogue of a Special Loan Exhibition of Art Treasures from Japan* (Boston, Museum of Fine Arts, 1936), no. 78 A and B.

CHAPTER 12

214. 1. ⟨ This is not quite accurate. The scroll was badly damaged in the 1923 earthquake, when fifty-six poems were lost. The remainder is now divided between several collections, among them the Powers and the Burke collections. ⟩

214. 2. ⟨ Another owner, the former Baron Masuda, divided the Deer scroll in 1935. Most of the first portion is now in the Atami Art Museum; the second portion is in the Seattle Art Museum. ⟩

216. 3. ⟨ Cf. Miyeko Murase, 'Japanese Screen Paintings of the Hōgen and Heiji Insurrections', *Artibus Asiae*, XXIX, 2/3 (1967), 193–228. ⟩

4. For an illustration in colour of the Thunder God see *Exhibition of Japanese Painting and Sculpture*, frontispiece.

217. 5. ⟨ Several more such scrolls have been identified since Paine wrote, in both Japanese and Western collections. ⟩

6. ⟨ Now in the possession of the National Commission for Protection of Cultural Properties. ⟩

CHAPTER 13

226. 1. See Minamoto, *op. cit.*, no. 182.

2. See *Exhibition of Japanese Painting and Sculpture*, no. 70.

227. 3. ⟨ Now in the Art Museum, Princeton University. ⟩

228. 4. See *Japanese Screen Paintings – Birds, Flowers and Animals* (Museum of Fine Arts, Boston, 1935), no. 35.

CHAPTER 14

237. 1. ⟨ Since Paine wrote, interest in *bunjinga* has increased greatly, and now many museums and private collectors in the West possess examples by the best artists of the school. ⟩

238. 2. A. Miyamori, *An Anthology of Haiku Ancient and Modern* (Tōkyō, 1932).

243. 3. The artist's sketch of the same subject is illustrated in *Exhibition of Japanese Painting and Sculpture*, no. 68.

CHAPTER 15

247. 1. See Minamoto, *op. cit.*, no. 153.

CHAPTER 16

260. 1. S. Takahashi, *Ukiyo-e Nihyaku Gojū Nen* (Tōkyō, Chūō Kōron-sha, 1939), 45.

2. This information was obtained from Prof. John Hall of the University of Michigan, Ann Arbor.

262. 3. ⟨ R. Keyes has suggested a date of 1759 for the print to which Paine refers. Earlier than this, however, is another actor print by Harunobu, of Matsumoto Kōshirō III and Nakamura Tomijūrō I, datable to a performance in 1757. This print survives only in a nineteenth-century proof, in the Museum of Fine Arts, Boston. ⟩

4. ⟨ Cf. references cited in the additional bibliography for Chapter 13. ⟩

5. ⟨ Over 140 designs are now known from this series. ⟩

263. 6. ⟨ Only ten of the twelve paintings survive. ⟩

265. 7. ⟨ Actually this technique is seen already in certain prints by Harunobu. ⟩

267. 8. See Laurence Binyon and J. J. O'Brien Sexton, *Japanese Colour Prints* (New York, Scribner's, 1923), plate 38.

271. 9. As translated by Kōjirō Tomita.

272. 10. As translated by Y. Noguchi in *Hiroshige* (London, 1940). Azuma refers to the Eastern Capital of Edo and the Land of the West to the Paradise of Amida.

PART TWO : ARCHITECTURE

CHAPTER 17

276. 1. Quoted from a famous song about the origins of the Chou dynasty, in the Chinese 'Poetry Classic', *Shih Ching* (translated by A. Waley, *The Book of Songs* (Boston and New York, 1937), 248). Many early Chinese texts refer to a primitive age when men lived in 'holes' or 'nests', before there were proper buildings. Pit-dwellings are mentioned also in the early dynastic histories as a characteristic of some of the northern barbarians; e.g. in the *Hou Han Shu*, with reference to the inhabitants of Korea.

277. 2. From the translation of the early history *Nihon Shoki* by W. G. Aston, under the title *Nihongi*

(*Trans. and Proc. of the Japan Soc., London*, Suppl. 1; 1 (London, 1896), 203). The book's chronology is largely fictitious; my revised dating follows R. K. Reischauer, *Early Japanese History* (Princeton, 1937).

3. *Nihongi*, I, 123.

4. *Op. cit.*, I, 297.

5. *Op. cit.*, II, 375.

278. 6. Published as belonging to a private collector, Mr Ōhashi Hachirō, and attributed to the first or second century A.D.

279. 7. Property of the Imperial Household Department.

280. 8. Housed in the National Museum, Tōkyō.

282. 9. Translation by B. H. Chamberlain, *The Kojiki* (*Trans. of the Asiatic Soc. of Japan*, X, Suppl.) (Tōkyō, 1906).

10. There are two alternately used enclosures, side by side. At the end of each cycle a new group of buildings is set up to match the one in use. At the final moment the symbols that mark the divine presence are transferred by night. Thereafter the old precinct is dismantled, and its hallowed materials are put to some worthy use elsewhere.

11. *Nihongi*, I, 80.

12. The present height is 80 feet, which is exceptionally large for a Shintō sanctuary. This is said, however, to be only half that of the building of 1248; and that in turn had been only half of an earlier. Famed for its size during the Heian period, being named with the two best-known representatives of the Buddhist and secular fields, the Daibutsuden of Tōdaiji and the imperial Hall of Audience. The traditional height dimensions given, first 320 and then 160 feet, are unlikely; not only for technical reasons, but because they are just 20 and 10 times, respectively, the orthodox height of a Buddha image (and so are likely to have been invented as a piece of Shintō propaganda).

284. 13. *Kojiki*, 20; *Nihongi*, I, 12, 14.

14. *Nihongi*, I, 151.

15. Presumably in a cult building not too unlike the palace hall where the goddess had previously been honoured. It may be noted that *miya* means both 'shrine' and 'palace' in ancient Japanese, just as the Chinese *kung* meant both 'palace' and 'ancestral temple'.

285. 16. *Kojiki*, 389.

286. 17. *Op. cit.*, 38 and 91.

18. *Op. cit.*, 160; *Nihongi*, I, 112.

19. *Nihongi*, I, 58. For boats, cryptomeria and camphor-wood; for palace buildings, cypress; for coffins, the black pine, *Podocarpus*.

20. *Op. cit.*, I, 132; *Kojiki*, 88, 123, 125. During the reign of Suinin (later third century), the 'holy store-

house' of the Isonokami shrine was built so high that it had to be reached by a ladder; *Nihongi*, I, 184.

21. *Nihongi*, I, 379 ff.

22. *Op. cit.*, I, 277.

23. *Op. cit.*, I, 407.

287. 24. *Op. cit.*, I, 269.

25. *Op. cit.*, I, 361, 359.

26. *Op. cit.*, I, 216.

288. 27. Described in detail by R. A. B. Ponsonby Fane, in *Trans. and Proc. of the Japan Soc., London*, XVIII (1920–1), 20 ff.

28. The largest imperial mausoleum in China, that of the first emperor of the Ch'in dynasty (late third century B.C.), has a square mound about 380 yds on a side.

CHAPTER 18

291. 1. Architectural remains from the seventh century are:

Hokkiji (at Ikaruga-machi, Ikoma-gun, Nara-ken): three-storeyed pagoda.

Hōrinji (same village): three-storeyed pagoda (burned down in 1944).

Hōryūji (at Ikaruga-machi, same district): front half of cloisters; middle gate; kondō, or 'golden hall'; five-storeyed pagoda; Tamamushi shrine.

Remains from the eighth century are:

Eizanji (at Gojō-shi, Nara-ken): octagonal hall.

Gankōji Gokurakubō (in Nara city): miniature five-storeyed pagoda.

Hōryūji: east gate; refectory group, called jikidō and hosodono; sūtra library.

Hōryūji Eastern Precinct, or Tōin: Dempōdō; Yumedono.

Kairyūōji (in Nara city): western 'golden hall'; miniature five-storeyed pagoda.

Shin Yakushiji (in Nara city): main hall.

Taimadera (at Taima-machi, Kita-katsuragi-gun, Nara-ken): three-storeyed eastern and western pagodas.

Tōdaiji (in Nara city): rear half of Hokkedō, or Sangatsudō; Hokkedō sūtra storehouse; Kangakuin sūtra storehouse; Shōsōin storehouse; gate called Tegaimon.

Tōshōdaiji (at Nara-shi, Nara-ken): 'golden hall'; lecture hall; sūtra storehouse; treasury.

Yakushiji (Nara-shi): three-storeyed pagoda.

2. *Nihongi*, II, 65 ff.

3. *Op. cit.*, II, 195. The text notes: 'as is instanced by his cutting down the trees of the shrine of Ikukuni-no-dama.'

292. 4. *Op. cit.*, II, 117. The translation is probably faulty in one detail. Where Aston calls one of the

specialists 'a man learned in the art of making braziers and chargers', he was actually an expert caster of the bronze disks used on pagoda spires.

294. 5. In 1949 the interior of the kondō was very badly scorched, and its famous frescoes were almost totally obliterated, by a fire due to negligence. So sturdily was the hall built, however, that none of its construction gave way, though the wood was deeply charred. The superstructure was not affected, since at the time the kondō was partly dismantled.

296. 6. The present bell tower was built during the Heian period, to replace a predecessor matching the library. In their original free-standing state, both 'towers' may have had the kind of plastered, sloping first storeys shown in the view of Kōfukuji given in illustration 228.

300. 7. For a more detailed presentation of this argument, see Soper, 'Notes on Sculpture of the "Suikō Period"', *Art Bulletin*, June 1951, 88 ff.

302. 8. In the process they quite outstripped their former tutors, the Koreans. There were no known Silla monasteries that could compare with those clustered around Nara.

307. 9. Temple tradition ascribes its erection, with the rest of the monastery complex, to 731, with the empress Kōmyō as patroness.

308. 10. Dated by style. See Soper, *Evolution*, 83, note 138.

310. 11. Tōshōdaiji was established in 759 to be the home of the celebrated Chinese missionary Chien-chên (or Ganjin). In view of the high honour in which he was held by the Japanese court, it has been argued that he would have been installed only in a completed monastery; and so that the kondō dates from about 759. On the other hand it is generally admitted that the lecture hall was a gift from the Nara palace (requiring only to be dismantled, moved, and set up on the new site). Temple records assert that the kondō's erection was supervised by a Chinese follower, the monk Ju-pao (who died in 815); he 'got together those whose Karma had given them the privilege of being donors, and erected the said hall.' This sounds like a campaign undertaken after imperial attention had turned elsewhere. The quotation is from the *Shoji Engi-shū*, a summary of the history of various temples, written in the early eleventh century.

12. Early records are lacking for all three.

313. 13. Incised on the stone lintel of the Ta-yen-t'a pagoda in Hsi-an-fu (which probably dates from the pagoda's first extensive remodelling, in the 701–5 period).

314. 14. The Tamamushi shrine, which in general tallies with the Hōryūji style, shows an ingenious attempt to overcome the difficulty [195]. The axes of its bracketing complexes radiate from a common point. This permits an equal distribution of spans; but it is hard to imagine how such a scheme could have been extended to the interior of a real building.

318. 15. A Tōdaiji history says it was founded in 733. Mentioned in a non-partisan record of 749 concerning sūtra-copying, under the name *Kenjakudō* (from its main icon, the Fukukenjaku Kannon).

322. 16. No records explain construction in an eighth-century style. The temple's present state demonstrates the artificiality of the Chinese fashion. Taimadera was laid out in the approved T'ang manner, facing south. Its site lay in hills, however; the approach from the south proved inconvenient, and was given up. The twin pagodas today, instead of announcing the entrance, stand neglected in corners on the edge of the brush.

323. 17. The inventory states that the temple was dedicated in 764, to fulfil a vow made by the empress Kōken.

18. See below, pp. 338–9.

19. See below, pp. 371–2.

CHAPTER 19

325. 1. *Nihongi*, II, 179, 191, 249, 338, 345, 362, and 375.

2. *Op. cit.*, II, 400, 401, 405, 408, 409, and 417.

326. 3. ⟨ The site of the Heijōkyō Palace has been excavated since 1963 by the National Research Institute of Cultural Properties in Nara. The results have been published by the Institute in four volumes so far, under the title of *Heijōkyū Hakkutsu Chōsa-hōkoku* (Report of the Excavation and Survey of the Palace of Heijō). ⟩

4. See Ponsonby Fane, *Kyoto, its History and Vicissitudes since its Foundation in 792 to 1868* (Hong Kong, 1931), 5 ff.; or the originals from which this was reprinted, four papers written for *Trans. of the Japan Soc. of London*, from vols XXII (1925) to XXV (1928).

5. The emperor Shōmu had experimented with alternative sites from 741 to 745, perhaps because clerical pressure made him restless. If so, his return to Nara marked a surrender, for the construction of Tōdaiji was begun there immediately afterward.

329. 6. Locations in Ch'ang-an were given first by the ward, which had its own name. Here, presumably, the Chinese (who were well aware of the theoretical value of absolute clarity and order) betrayed their ineradicable instinct towards separatism by giving each ward individuality. In practice, also, the T'ang ward had a degree of autonomy, since it was surrounded by its own wall through which passage was controlled.

330. 7. The surviving lecture hall of Tōshōdaiji is said

to have been originally built as one of the forehalls in the Nara Chōdōin. A layout comparable to that of the Chōdōin survives in the old Manchu palace at Mukden. There a deep oblong area just east of the main, axial compound contains at the rear an octagonal 'Great Hall of Administration', Ta-cheng-tien; and in front, two rows of smallish, square buildings, five on a side, assigned to the princes convened in audience.

331. 8. Erected in 1895, at about two-thirds the scale of the original. See Ponsonby Fane, *op. cit.*, 393 (or his 1928 paper, 205).

9. See below, p. 351.

10. Ponsonby Fane discusses this compound under the name Hōgaku-in (an alternative reading of the characters); *op. cit.*, 44, or his 1925 paper, 150.

11. It is of incidental interest that the name chosen for Nara, i.e. Heijō, had been that of the first Northern Wei capital, at Ta-t'ung-fu in Shansi (there being read P'ing-ch'eng).

332. 12. See Ponsonby Fane, *op. cit.*, 339 ff., or his 1928 paper, 151 ff.

339. 13. The reconstruction of this building, from the texts listing and describing its materials, has been made by Sekino Masaru.

14. ⟨ The painstaking investigations of the Dempōdō chapel in Hōryūji, made by Dr Kiyoshi Asano, have revealed that it was primarily a domestic hall before it was turned over to Buddhist use. The restoration indicates that the hall had a square room with a wooden floor and an open space on the short side with a wide open veranda. The wall was of mud, and the roof of cypress bark. The column had a stone base, unlike the Toyonari-dono. The inside structure consists of beams and *kaerumata*, similar to a Buddhist building. It can be said, therefore, that the hall was much more elaborate than the Toyonari-dono [223] and that the style was rather Chinese. It was built by an aristocratic family c. 730. Cf. Asano, Kiyoshi, *Hōryū-ji Kenchiku Sōran* (Kyōto, 1953), 262–324.⟩

340. 15. The hall that matched the Seiryōden in the symmetrical layout of the Kōkyo, the Ryōkiden on the east, had a much simpler plan that may show what the Seiryōden itself was like before it was subdivided for more convenient use. It was like an elongated Shishinden. See Ponsonby Fane, *op. cit.*, 71, or his 1925 paper, 177.

342. 16. The Chinese history of the Sung dynasty notes that in 1179 a minor precinct of the palace at Hangchow 'was constructed of Japanese pine, and was left unpainted'. This must have been an imitation of the shinden type, as described by the Chinese merchants who were then beginning to organize large-scale trading operations by sea with Japan. In a Chinese setting it must have been as exotic and whimsical as was the European style imitated much later in the Summer Palace outside Peking.

344. 17. See below, pp. 350–1 and 361–2.

18. Presumably a Japanese derivative of the Chinese bed-alcove illustrated in the famous painting of 'Admonitions' attributed to Ku K'ai-chih, in the British Museum. See O. Sirén, *A History of Early Chinese Painting* (London and New York, 1933), plate 10.

CHAPTER 20

345. 1. Architectural remains of the Heian period are:
Bunrakuji (at Ōtoyo-mura, Nagaoka-gun, Kōchi-ken): Yakushidō.
Byōdōin (at Uji-shi, Kyōto-fu): the 'phoenix hall', Hōōdō.
Chūsonji (at Hiraizumi-machi, Nishi-iwai-gun, Iwate-ken): the 'gold-coloured hall', Konjikidō.
Daigoji (at Daigo, Fushimi-ku, Kyōto city): five-storeyed pagoda; Yakushidō; kondō.
Fukiji (at Bungo-takada-shi, Nishi-kunisaki-gun, Ōita-ken): the 'great hall', *ōdō*.
Hōkaiji (at Hino, Fushimi-ku, Kyōto city): Amidadō.
Hōryūji: lecture hall; bell tower.
Ichijōji (at Hōjō-machi, Kasai-gun, Hyōgo-ken): three-storeyed pagoda.
Ishiyamadera (at Ōtsu-shi, Shiga-ken): rear half of main hall.
Jōruriji (at Tomio-machi, Kyōto-fu): main hall; three-storeyed pagoda.
Kakurinji (at Kakogawa-shi, Hyōgo-ken): jōgyōdō, 'hall of Samadhi attained by constant walking'; Taishidō hall of Prince (Shōtoku).
Kōryūji (in Kyōto city): lecture hall.
Kōzōji (at Kakuda-shi, Miyagiken): Amidadō.
Murōji (at Murō-mura, Uda-gun, Nara-ken): rear half of kondō; five-storeyed pagoda.
Ōjōgokurakuin, or Sanzen-in (at Ōhara-raigōin-machi, Sakyō-ku, Kyōto): main hall.
Sambutsuji (at Misasa-machi, Tōhaku-gun, Tottori-ken): Oku-no-in; Nōkyōdō (?).
Shiramizu, or Gangōji, Amidadō (at Uchigō-shi, Fukushima-ken).
Taimadera (at Taima-machi, Kita-katsuragi-gun, Hyōgo-ken): three-storeyed pagoda.

347. 2. In the standard late Chinese plan visible at Peking, the analogous structures housing the temple bell and drum are inevitable features of the first courtyard inside the gateway.

348. 3. An early ninth-century collection of Buddhist

propaganda, the *Nihon Reiiki*, tells that it was originally planned to build the twin pagodas of Saidaiji at Nara as octagonal towers, seven storeys high. A high Fujiwara minister, Nagate, who had them altered to five storeys and the conventional square form, went to Hell for that reason on his death in 771. The one surviving octagonal pagoda in Japan is that of Anrakuji in Nagano-ken, erected in the Sung style favoured by the Zen sect, probably in the fifteenth century.

4. That too had been the central element in a cloister courtyard, having a lecture hall at the north side.

350. 5. ⟨ The site was excavated in 1954–8. The temple consists of two minor temples, Kashōji and Enryūji, of which the latter was bigger and built by Fujiwara Motohira some time between 1141 and 1156. In both temples the main hall had wing corridors which projected from both sides and ran forward, just like the main hall of Hosshōji in Kyōto. It is evident that Motohira copied the scheme of the Kyōto temple to introduce the urban culture to his local capital [226]. Cf. Dr Fujishima, Gaijirō, ed. Hiraizumi (Tokyo, 1961).⟩

356. 6. The history of this structure illustrates both the simplicity of early Tendai and the subsequent rapid advance towards size and magnificence. At the outset it was a shingled chapel to Yakushi, only 30 by $15\frac{1}{2}$ feet in plan and 12 feet to the eaves. In the 880s it was rebuilt on a much more impressive scale, eleven bays across, with a full ambulatory. It was burned down in 935 and rebuilt – apparently in the same form – by 940. Even at that size it could not accommodate the demands made on the national headquarters of the sect. The single aisle across the front was hopelessly inadequate. Out of the inconvenience suffered by clergy and laity alike came a remodelling in 980, by which a magobisashi was added. Thereafter, as the dedication record put it metaphorically, 'the dove-coloured throng might soar and move about without hindrance; the flocking pigeons had a place to rest.' The present Komponchūdō shows the results of a still later alteration, using the mature raidō formula.

7.⟨ The single-slope roof shown in the drawing, while appropriate to the sort of temporary shelter from which crowds listened to the itinerant preacher Ippen, would have been too informal for the permanent use intended at Kōryūji. In addition it has been argued that Soper's whole hypothesis of a separate fore-hall at Kōryūji is improbable. The term *maehisashi* used in the text should probably be interpreted as a synonym for *magobisashi*, a mere enlargement of the front veranda of the kondō. See Inoue, Michio, *Nihon kenchiku no kūkan* (Space in Japanese Architecture) (Tōkyō, 1969), 160. It should be remembered, however, that free-standing fore-halls had already existed in the Nara period, as must be inferred from the inventory of the Nara monastery Saidaiji by a term that Soper translates 'paired halls' (his p. 192).⟩

360. 8. One difficulty encountered in searching for Chinese precedents is the lack of a standard, permanent architectural terminology. What the early age knew as *hsien* was probably the form called *yen-wu* in Sung texts, and *pao-hsia* in those of Ch'ing. I have not found any exact Chinese equivalent for raidō, i.e. any *li-t'ang*.

361. 9. What records exist are confusing. The temple was founded in 1047, as a dedication to Yakushi. The first reference to worship of Amida is dated 1142. The present main hall doubtless falls somewhere between those two dates.

362. 10. The temple had disastrous fires in 818 and 1150. The present lecture hall probably dates from the rebuilding completed in 1165. Its length does not tally with the old records; I believe in the Edo period repair work removed its two end bays. Otherwise it probably reproduces the ninth-century form.

363. 11. Originally built in the tenth century; reconstructed in 1121.

12. The date much disputed. The temple seems to have had five buildings called Amidadō in the late eleventh and twelfth centuries. Most likely the existing hall was one built in the 1090s.

365. 13. In Sanskrit, Prabhūtaratna.

14. In Buddhist legend, the original of the design was the mysterious 'Iron Stūpa' in south India, within which the holy doctor Nāgārjuna was taught the Tantric scriptures by beings too glorious and terrible to describe. A Heian picture of the scene shows the hōtō form without any square enclosure; see O. Fischer, *Die Kunst Indiens, Chinas, und Japans* (Berlin, 1928), and 1. 367. 15. The erection of the Murōji pagoda (with the rest of the temple) is traditionally ascribed to Kōbō Daishi. It has been claimed, however, that the pagoda was inherited from an existing small temple on the site, founded in the 770s and 780s by a priest from Kōfukuji to placate a local water-dragon. The Daigoji pagoda was completed in 951, being modelled on one at an unknown temple, Fukōji.

368. 16. Modern Japanese reconstructions of the original Tōdaiji Daibutsuden are likely to show the same sort of break at the middle of the lower eaves. The evidence for this is a picture in the twelfth-century scroll *Shigisan-engi* that purports to show the Daibutsuden. I believe that such a feature is unthinkable in the monumental eighth-century repertory. The picture I explain by the supposition that the artist (being a Kyōto resident) had never seen the Daibut-

suden; and took for his model, instead, the most appropriate great hall in Kyōto, presumably that of Hōjōji. There an eaves break would have been appropriate. It should be remembered that the Hōōdō was built by the son of the patron of Hōjōji, and so might have imitated some of the Kyōto temple's details.

369. 17. A beam inscription records that the Konjikidō was erected by Kiyohira in 1126. To preserve its decoration it was enclosed within a larger building in 1288.

18. Traditionally built in 1184 by a grand-daughter of Kiyohira, the nun Toku, in emulation of the Konjikidō.

CHAPTER 21

371. 1. The one Shintō survivor from the Late Heian period is:

Ujigami Jinsha (at Uji-shi, Kyōto-fu): sanctuary.
Remains from the Kamakura period (dated or ascribed by style) are:

Enjōji (at Nara-shi): sanctuaries of the tutelary shrines, *Kasugadō* and *Hakusandō* (thirteenth century).

Goryō Jinsha (at Kamo-mura, Sōraku-gun, Kyōto-fu): sanctuary (fourteenth century).

Hachiman Jinsha (at Ono-shi, Hyōgo-ken): haiden of the tutelary Hachiman shrine (fourteenth century).

Hakusan Jinsha (at Uji): haiden (thirteenth century).

Isonokami Jingū (at Tenri-shi, Nara-ken): haiden of the subordinate Izumo-takeo Jinsha, recently transferred there from precincts of a deserted Buddhist temple, Eikyūji; also haiden and two-storeyed gate of the main shrine (thirteenth century).

Itsukushima Jinsha (at Miyajima-machi, Saeki-gun, Hiroshima-ken): buildings of the 'shrine of the guest gods', Kyakushinsha (thirteenth century).

Kasuga Jinsha (at Ōtsu-shi, Shiga-ken): sanctuary (fourteenth century).

Mikami Jinsha (at Yasu-machi, Yasu-gun, Shiga-ken): sanctuary, two-storeyed gate (thirteenth century).

Onjōji (outside Ōtsu, Shiga-ken): tutelary shrine of the Silla god, *Shinra Zenshindō* (fourteenth century).

Ōno Jinsha (at Rittō-machi, Kurita-gun, Shiga-ken): two-storeyed gate (thirteenth century?).

Oshitate Jinsha (at Kotō-machi, Aichi-gun, Shiga-ken): sanctuary (fourteenth century); gate (four-

teenth century).

Sage Jinsha (at Tanabe-machi, Tzuzuki-gun, Kyōto-fu): sanctuary (1585).

Sakurai Jinsha (at Sakai-shi, Ōsaka-fu): haiden (thirteenth century).

Takemikumari Jinsha (at Akasaka-mura, Minami-kawachi-gun, Ōsaka-fu): three sanctuaries (fourteenth century).

Udamikumari Jinsha (at Udano-machi, Uda-gun, Nara-ken): three sanctuaries (fourteenth century).

Uji Jinsha (at Uji): sanctuary (fourteenth century).

Ujigami Jinsha (at Uji): haiden; building covering sanctuaries (thirteenth century?).

372. 2. Not 'roofed with lapis lazuli' as some histories make it. The misunderstanding arises from the double meaning of *ruri*, the Chinese *liu-li*, which can mean both lapis and glass or glazing.

3. See below, pp. 375–6 and illustration 254, for further notes on the layout of the Iwashimizu shrine.

4. On the Chinese use of the term *pai-tien*, the equivalent of haiden, in cult precincts comparable to those of Shintō, see Soper, *Evolution*, 180.

374. 5. The same design (called *aidono*) is visible in Kyōto today in the double sanctuaries of the Hirano Jinsha, as rebuilt in the seventeenth century (where each building comprises two *honden*, side by side).

6. Most of the Kamakura sanctuaries follow either the Kasuga type, or the even simpler design called *nagare-zukuri*: a gabled building broadside to, whose front roof is prolonged to cover a porch over the steps. At the Takemikumari Jinsha the two types are used together in a row of three sanctuaries, with the emphatic, pediment-like gable of the Kasuga-zukuri at the centre, and the more unassuming nagare-zukuri balancing on either side. A large sanctuary may be almost indistinguishable from a Buddha hall; e.g. the honden of the Mikami Jinsha, which has a hip-and-gable roof.

7. Dated by style. Here there are three small sanctuaries in a row, enclosed inside a nagare-zukuri building of Kamakura date.

375. 8. A nagare-zukuri building, dated by style. There is some question whether the kaerumata fill – since it is detachable – is original or a replacement. The design of the sculpture is much more in keeping with Momoyama taste than with that of the fourteenth century.

9. Made important by Taira patronage in the twelfth century. Frequent fires; rebuilt in 1215 and again in 1241. The present form is largely the result of a restoration completed in 1556 by the daimyo Mōri Motonari. In comparison with the Ippen view of the main shrine, there is much less the look of a Buddhist temple today. The enclosure by veranda corridors has

been broken up; and a large wing, the Haraidono or 'hall of purification', has been pushed forward from the haiden into the water-courtyard area. The same sort of Haraidono, however, is present in the 'shrine of the guest gods', which is supposed to date from 1241; a fact that casts a little doubt on the accuracy of Eni's picture. (It could be assumed, on the other hand, that the main precinct was built in a more traditional way, imitating a predecessor.)

CHAPTER 22

378. 1. For further information on this traditional type of hall, see below, pp. 402–3.

379. 2. 'Indian style' remains are:

Daigoji: sūtra library in the upper temple, Kamidaigo.

Jōdoji (at Ono-shi, Hyōgo-ken): Jōdodō.

Tōdaiji: great south gate, nandaimon. Later, and more mixed in style are: the bell pavilion; the front half, raidō, of the Hokkedō; the Kaisandō, or *Ryōbendō*; a founder's memorial chapel.

383. 3. See below, pp. 437–8.

4. 'Chinese style' remains are:

Ankokuji (at Fukuyama-shi, Hiroshima-ken): Shakadō.

Bannaji (at Ashikaga-shi, Tochigi-ken): main hall.

Eifukuji (in Shimonoseki city, Yamaguchi-ken): Kannondō (destroyed in the Second World War).

Eihōji (at Tajimu-shi, Gifu-ken): Kaisandō; Kannondō.

Engakuji (at Kamakura-shi, Kanagawa-ken): relic hall, shariden.

Fusaiji (at Sonobe-machi, Funai-gun, Kyōto-fu): main hall.

Jinkakuji (at Asaji-machi, Ōno-gun, Ōita-ken): main hall.

Kōzanji (at Shimonseki-shi, Yamaguchi-ken): Buddha hall.

Seihakuji (at Yamanashi-shi, Yamanashi-ken): Buddha hall.

Ten-onji (at Nukada-machi, Nukada-gun, Aichi-ken): Buddha hall.

Zenpukuin Shakadō (at Shimotsu-machi, Kaisō-gun, Wakayama-ken).

5. The introduction of special architectural forms for Zen lagged far behind the doctrine. The first proponent of the new sect, Eisai, crossed to China as a companion of Chōgen in 1167, and his first monastery was erected by permission of Yoritomo's widow, in the neighbourhood of Kamakura, in 1200. Neither that hermitage, Jūfukuji, nor the two earliest Kyōto houses in which Zen was practised experimentally alongside more familiar forms of Buddhism – Ken-

ninji in 1202 and Tōfukuji in 1236 – can have had any distinct architectural character.

384. 6. From south to north: the chokushimon, gate of the imperial envoy; the sammon, triple gateway; the Butsuden, Buddha hall; and the Hattō, Dharma hall.

385. 7. The travel record of the eleventh-century pilgrim Jōjin speaks often of worshipping images of the 500 Rakan in the upper storey of a temple gateway. In the Yūan dynasty palace at Peking, again, the main gate tower seems to have had a form much like an enlarged sammon.

387. 8. See below, pp. 435 and 436.

389. 9. ⟨ It used to be assumed that the shariden was built in the 1280s and that it represented the 'Kara' or Zen style of the Kamakura period. Recent studies, however, have revealed that the original one was burnt down in 1563, and that the present hall was most likely moved from another temple, Taiheiji, in Kamakura. The date of the existing building is not certain, but is quite likely the early fifteenth century, since the style is very like that of the Jizōdō of Shōfukuji in Tōkyō, which was built in 1407, according to the inscription found on one of its structural members. Cf. Kawazoe, Taketane, *Engakuji Shariden Sanken-ron*, in *Yamato Bunka Kenkyū*, vol. 5, nos 5, 7, and 10 (1960); also Engakuji, ed. Engakuji-shi (Tōkyō, 1964), 257–62.

On the other hand, Soper has in personal correspondence with the present reviser questioned the validity of this argument, in the case of a stylistic tradition so conservative and repetitious as that of the Karayō. A building like the Shariden should be judged first of all by comparison with Southern Sung or Yuan originals extant in China.⟩

390. 10. Republished by the Commercial Press, Shanghai, in 1929, as 'the *Ying Tsao Fa Shih* of Li Ming-chung'. ⟨ The text and its interpretation have been studied in Japan by Dr Takuichi Takeshima since 1939, and his results are partly published in *Kenchikushi* (vol. III (1941), 31–46, 120–30, 343–52, 431–40, 524–37; vol. IV (1942), 64–75, 329–35, 439–62; vol. V (1943), 13–20, 147–55, 207–18, 270–3, 321–8). I am delighted to be able to report that his collected papers are to be published in three volumes: *Eizōhō-shiki no Kenkyū*. The first volume came out in 1970, published by Chūoh Kōron Bijutsu-shuppansha in Tōkyō. It contains the Japanese translation of the text and the author's interpretation.⟩

392. 11. At Tanabe-machi, Tzuzuki-gun, Kyōto-fu. Said to have been erected in the era from 1504 to 1520. Also called Takigi no Ikkyūji, after a priest Ikkyū (1394–1481), the restorer of its fortunes.

396. 12. Remains are:

Akishinodera (at Nara-shi, Nara-ken): main hall.

Bujōji (at Sakyō-ku, Kyōto): main hall.
Byōdōin: Kannondō.
Chōhoji (at Shimotsu-machi, Kaisō-gun, Waka-yama-ken): main hall; tahōtō.
Chōjuji (at Ishibe-machi, Kōga-gun, Shiga-ken): main hall.
Daifukkōji (at Tanba-machi, Funai-gun, Kyōto-fu): main hall; tahōtō.
Daihōonji (in Kyōto city): main hall.
Daizenji (at Katsunuma-machi, Higashi-yama-nashi-gun, Yamanashi-ken): main hall.
Enryakuji (at Ōtsu-shi, Shiga-ken): Shakadō.
Fukutokuji (at Ōshika-mura, Shimoina-gun, Nag-ano-ken): main hall.
Futaiji (in Nara city): great south gate; main hall; pagoda (unfinished).
Gankōji Gokurakubō (in Nara city): main hall.
Hannyaji (in Nara city): two-storeyed gate.
Hōryūji: Kaminodō; Shōryōin; in the Eastern Precinct, edono, shariden, and raidō of the Yumedono.
Ishiteji (at Matsuyama-shi, Ehime-ken): main hall; three-storeyed pagoda.
Ishiyamadera: tahōtō.
Jōdoji (in Onomichi city, Hiroshima-ken): Ami-dadō; main hall; tahōtō.
Jōmyōji (at Arita-shi, Wakayama-ken): main hall; tahōtō.
Kaijūsenji (at Kamo-machi, Sōraku-gun, Kyōto-fu): five-storeyed pagoda.
Kakurinji: main hall
Kanshinji (at Kawachi-nagano-shi, Ōsaka-fu): main hall
Kikōji (at Nara-shi, Nara-ken): main hall.
Kōfukuji– 'north octagonal hall', hokuendō; three-storeyed pagoda.
Kongōbuji (on Kōyasan, Wakayama-ken): Fudōdō.
Kongōji (at Kawachi-nagano-shi, Ōsaka-fu): main hall.
Kongōrinji (at Hatashō-machi, Shiga-ken): main hall.
Kongōsammaiin (on Kōyasan): tahōtō.
Murōji: main or baptismal hall, kanjōdō.
Myōrakuji (at Kohama-shi, Fukui-ken): main hall.
Rengeōin (in Kyōto): 'thirty-three-bay hall', San-jūsangendō.
Ryōsenji (at Nara-shi, Nara-ken): main hall; three-storeyed pagoda.
Saimyōji (at Kōra-machi, Shiga-ken): main hall; three-storeyed pagoda.
Shōshōin (in Wakayama city): main hall ⟨ until 1945⟩.
Taimadera: kondō; lecture hall.
Taisanji (at Tarumi-ku, Kōbe-shi, Hyōgo-ken):

main hall.
Taisanji (at Matsuyama-shi, Ehime-ken): main hall.
Tōji, or Kyōōgokokuji (in Kyōto city): various small gates.
Yakushiji: 'eastern precinct hall', Tōindō.
13. As part of the extensive additions to the temple made under the patronage of Minamoto no Yoritomo.
14. Originally the main hall of the rival Tendai house on Lake Biwa, Onjōji; dated by style. Oda Nobunaga burned down the Enryakuji buildings in 1571. When the monk Senshun was granted permission to rebuild by Hideyoshi, he was aided also by a gift of materials from Onjōji, which Hideyoshi had just demolished. ⟨ This was at first the Miroku Hall at Onjōji, which was built most likely in the mid fourteenth century, and was moved to the present site in 1561.⟩
398. 15. Dated by style. ⟨ The main hall was probably built in the early Kamakura period. It was originally a square hall of five bays in each direction but was enlarged to the present plan in the middle of the period. Cf. the report of its restoration in 1939.⟩
16. ⟨ Built in 1305; cf. the report of its restoration in 1956.⟩
400. 17. ⟨ Built in 1227 according to an inscription.⟩
18. Dated by style.
19. Dated by style.
20. ⟨ The development of the plan of Buddhist halls in the medieval period has recently been studied thoroughly by Dr Nobuo Itō in his book *Chūsei Wayō Kenchiku no Kenkyū* (Studies of the Medieval (Buddhist) Halls of Wayō Style) (Tōkyō, 1961, limited edition). Professor Soper's statement, however, is still a valid outline of the development.⟩
21. Dated by style. ⟨ It is assumed that the raidō was primarily a earth floor in place of the present one; cf. the restoration report (1957).⟩
401. 22. Dated by style, but must post-date the transfer of the temple to the Wakayama neighbourhood in 1302, from Shikoku island. ⟨ The Shō-shōin main hall or Fudōdō, Wakamatsu city, was burnt down during the Second World War in 1945.⟩
402. 23. First built to hold a thousand images in 1164. Burned in 1249, re-erected in 1266.
24. Tradition carries the founding of Zenkōji back to the seventh century; so that it is appropriate that the picture shows a 'Kudara' general plan, like that of Shitennōji. The kondō of 1270 seems to have had a plan something like that of the Shishinden in the imperial palace, with non-continuous hisashi that produced re-entrant corners in the main eaves. The final complication was added by a front porch.
403. 25. The oldest east dormitory block, first altered

to be a chapel to Prince Shōtoku in 1108–21, and apparently rebuilt in the early thirteenth century.

CHAPTER 23

407. 1. ⟨ As Professor Soper points out, the existence of buke-zukuri is doubtful. It is one of the achievements of recent research that the domestic architecture of the Kamakura and the following Muromachi period has become much better known. See Dr Mitsugu Kawakami, *Nihon Chūsei Jūtakushi Kenkyū* (Studies in Medieval Domestic Architecture in Japan) (Kyōto, 1967); Dr Teijo Itō, *Chūsei Jūkyoshi* (History of the Medieval House) (Tōkyō, 1958). It is most likely that there was no particular house type for the warrior class. Their houses were more or less a simplified version of the preceding shinden type in the Heian period. Therefore, the term *buke-zukuri* is no longer used by historians; cf. Dr Hirotarō Ōta (ed.), *Japanese Architecture and Gardens* (Tōkyō, 1966), 97–8.⟩

409. 2. Michiie (1192–1252), the leading nobleman of his generation, was also the first important patron of Zen in Kyōto. It is just possible that the Chinese screens on the picture-scroll were intended as a reminder of his Sinophile leanings.

412. 3. For example, in the Buddha hall of Fusaiji.

CHAPTER 24

415. 1. ⟨ On the main themes of secular buildings during these periods such as Imperial palaces, shoin halls, castles, and tea-houses, remarkable publications have come out by Dr Michio Fujioka, Dr Sutemi Horiguchi, Dr Osamu Mori, Dr Kiyoshi Hirai, Dr Masao Nakamura, Dr Kōji Nishikawa, the late Dr Shigeru Matsuzaki, and others. For a summary of the results of these studies see Dr Hirotarō Ōta (ed.), *op. cit.*, 97–111.⟩

2. Formally titled Rokuonji. The 'golden pavilion' was deliberately burned in 1950 by a deranged student-monk ⟨ but was rebuilt in its original form in 1955⟩.

417. 3. Formally titled Jishōji.

4. A probable fifteenth-century example is the interior of the Yoshitsune-no-ma, now belonging to the Yoshimizu Jinsha on Mount Yoshino (so called because Minamoto no Yoshitsune was popularly said to have hidden there). The whole end wall of the big room is used to hang pictures, but is not recessed like a proper toko-no-ma. The actual alcove runs along the side wall to a length of two mats, and is unusually complex. Its right half has the look of a shoin bay, and at the end is framed by an arched, Zen-type window.

The left half is walled in, like a toko-no-ma, and has ornamental shelving at its end, opposite the arch. Unconventionality is still apparent in a building from the second quarter of the sixteenth century, the small shoin of Reunin (one of the residential precincts of the Kyōto Zen house, Myōshinji). There the shelving, in a kind of open closet, is across one end of a shoin-like alcove; the toko-no-ma is in an adjacent room.

418. 5. I.e. Hōkōji, which was begun in 1586, dedicated in 1589, destroyed by an earthquake in 1596, rebuilt by Hideyoshi's son in 1614, and toppled by another quake in 1662. The Daibutsuden of 1589 stood on a platform about 330 by 220 feet (a little larger than that of the Tōdaiji), and was 160 feet high. See Ponsonby Fane, *op. cit.*, 299 ff., or his 1927 paper, 147 ff. ⟨ According to an annotated plan owned by the Heinouchi, a family of master builders in Kyōto, the hall itself was about 292 by 181 feet in plan. The last successor on the site was destroyed by lightning in 1798.⟩

6. *Op. cit.*, 261, 313 ff., or his 1927 paper, 109, 161 ff.

419. 7. ⟨ Cf. the restoration report (1959).⟩

8. ⟨ Cf. Dr Michio Fujioka, *Kinsei Kenchikushi Ronshū* (Studies in Late Medieval Architecture) (Tōkyō, 1969), 146–50.⟩

9. ⟨ Cf. Dr M. Fujioka and K. Tsunenari, *Shoin*, II (Tōkyō, 1969), 97.⟩

422. 10. ⟨ It is believed that the hall was moved from the Hideyoshi's Jurakudai in Kyōto, but so far no proof has come forward.⟩

11. ⟨ The term *sukiya* generally refers to a hall of shoin style with a touch of the simplicity of a tea-house.⟩

425. 12. The new standard of size and ostentation was set by Oda Nobunaga's Azuchi Castle on the shore of Lake Biwa, completed in 1576 and destroyed six years later. Great numbers were in existence by the beginning of Edo. The Tokugawa policy of centralization naturally discouraged castle-building, however; and many survivors from the feudal age were demolished in the late nineteenth century. Those that remained suffered severely from the bombing of Japanese cities during the Second World War. Some of the best known were burned down: i.e. those at Hiroshima, Matsuyama, Nagoya, Sendai, and Wakayama.

426. 13. The relative modesty and uniformity of domestic architecture of the Edo period must have been due in part to the severe sumptuary laws issued (and sometimes enforced) by the Shogunate. Typical edicts are quoted by Sadler, *A Short History of Japanese Architecture* (Sydney and London, 1941). The general feeling of the Japanese about plainness and austerity – the psychological basis for the sukiya

tradition raises a nice problem for the amateur sociologist. I suspect that the Japanese aesthetic instinct worked a good deal like the Puritan's zeal for righteousness before the Lord. Suki taste was admittedly the highest good, and was deeply satisfying. It could not answer all emotional needs; and some were strong enough to burst through the discipline almost as wildly as religious hysteria. The Japanese reaction to brilliant colours in nature – to cherry blossoms in spring, and red leaves in autumn – is a benign, temporary insanity. The colours and patterns of the kimono worn by those to whom custom has granted a degree of ethical irresponsibility – children, marriageable girls, the geisha – may be almost barbaric. The same sort of pressure forced the traditional code to admit the existence of a sphere of organized pleasure, centring round the theatre, where everything was gaudy and gay. Its most natural and open outlet, the justification for colour and opulence in religious architecture, was the vision of a Heaven all gold and incense.

14. Ponsonby Fane, *op. cit.*, 271, 296 ff., or his 1927 paper, 119 ff., 144 ff., respectively. The Katsura palace was begun to house an imperial prince adopted by Hideyoshi. From that phase remains the 'old shoin'. The rest is said to have been designed by Kobori Enshū (1579–1647), the tea-tutor of Tokugawa Iemitsu. The erection of the rear block, the 'new shoin', is linked with a visit made to the palace by the emperor Minoo II (reigned 1611–28).

⟨ Several important studies of the Katsura palace were published after the Second World War (cf. Supplementary Bibliography to Chapter 24), but there is no precision about the date of each building and the architects who designed them.⟩

CHAPTER 25

433. 1. The great number of existing remains makes impracticable the sort of catalogue I have given for earlier periods.

2. Nichiren based his teachings on the *Lotus Sūtra*, in which the most popular miracle is the appearance of a miraculous stūpa-pagoda. Nichiren houses are likely to have any of the standard Japanese pagoda varieties, prominently set near the front of the compound.

434. 3. See Ponsonby Fane, *op. cit.*, 279, 291 ff., or his 1927 paper, 127, 139 ff. The 'original', Hompa-honganji, represents the planting in Kyōto, through Hideyoshi's favour, of a sect that had been exiled (as a result of Tendai jealousy) since the fourteenth century. Shin fortunes rose so fast thereafter that in 1602 Ieyasu found it prudent to divide the sect into two, keeping the original house on the west and giving land for an 'Ōtani' branch on the east.

4. ⟨ The term goeidō appears frequently in this chapter, but it is commonly called mieidō. It is also called Taishidō or the Founder's Hall. A mieidō represents primarily a burial hall of Shinran, the founder of the sect, and the Amidadō represents a place for preaching. Both halls started as a small square building of three bays in each direction, but they were gradually enlarged around 1500, mainly owing to the increased number of believers. Cf. Dr N. Itō, *op cit.*, 351–70.⟩

5. Records show that even in the Kamakura period headquarters the founder's hall was five bays wide and the Amidadō only three. In the Hompa-honganji design, by exception, the goeidō is on the proper right. This is because the temple first faced westward, at which time the goeidō had its normal place on the left. In 1618 the orientation was reversed, each building being turned around on its own site.

6. Famous as the burial place of the Jōdo founder, Hōnen. The site has been occupied since the 1230s, and favoured by all the Kyōto grandees in turn.

7. The existing goeidō is an erection by Iemitsu in the 1630s, on the model of a burned hall of the beginning of the century (which Ieyasu had made much larger than its predecessors).

8. Both the existing East Honganji halls are late nineteenth-century sequels to a series of disastrous fires. The West Honganji goeidō was built in the 1630s, enlarging a predecessor of 1618. The design had been a square eleven bays on a side, ever since Hideyoshi had given his patronage to the sect when it was still located in Ōsaka, in 1586. The western Amidadō dates from 1760.

435. 9. Ieyasu's remains were moved to Nikkō in 1617. The mausoleum scheme was greatly enlarged and beautified by Iemitsu's efforts from 1624 to 1636, the whole of Japan being called on for contributions – in part, at least, to exhaust any surplus of energy and wealth that might have been directed toward rebellion. Iemitsu's own precinct, the Daiyūin, was built on the same model, but on a slightly reduced scale, in 1651–4. The much less ambitious tomb precincts of the later Shōguns are grouped in Tōkyō, chiefly around the temple of Zōjōji (and so suffered greatly during the Second World War).

436. 10. ⟨ The Kibitsu Jinsha in Okayama was rebuilt in 1425 according to the inscriptions; cf. the restoration report of 1956.⟩

11. ⟨ The kondō of Tōji or Kyōōgokuji was rebuilt in 1606, and the Daibutsuden of Tōdaiji in Nara in 1709.⟩

12. ⟨ The lecture hall or kōdō of Enryakuji on Hieizan, built in 1642, was burnt down in 1956.⟩

13. For the possible Korean and Chinese sources of this idea, see Soper, *Evolution*, 288.

438. 14. Kōfukuji, Sōfukuji, and Fukusaiji. The last two were destroyed by the bombing of Nagasaki in 1945. The oldest buildings went back to the seventeenth century.

440. 15. Quoted from Ponsonby Fane, *op. cit.*, 289, or his 1927 paper, 137.

BIBLIOGRAPHY

Part One: Painting and Sculpture

GENERAL WORKS

Several books on Buddhism are included as a help to the student of iconography.

ANESAKI, Masaharu. *Buddhist Art in its Relation to Buddhist Ideals with Special Reference to Buddhism in Japan.* London, 1916.

BINYON, Laurence. *Painting in the Far East.* 3rd and revised edition. London, 1923; paperback edition, New York, Dover Publications, 1959.

BOWIE, Henry P. *On the Laws of Japanese Painting.* San Francisco, 1911; paperback edition, New York, Dover Publications, 1952.

BUHOT, Jean. *Histoire des arts du Japon.* Paris, 1949.

COATES, Harper H., and ISHIZUKA, Ryugaku. *Honen, The Buddhist Saint.* Kyōto, 1925.

ELIOT, Sir Charles. *Japanese Buddhism.* London, 1935.

FANE, R. A. B. Ponsonby. *Kyoto.* Hong Kong, 1931.

FENOLLOSA, Ernest F. *Epochs of Chinese and Japanese Art,* 2 vols. New York, 1913; paperback edition, New York, Dover Publications, 1963.

GROUSSET, René. *Les Civilisations de l'Orient,* vol. IV, *Le Japon.* Paris, 1930.

Index of Japanese Painters. The Society of Friends of Eastern Art, Tōkyō, 1941; revised edition, Rutland, Vermont, and Tōkyō, 1958.

KIMURA, Ryukan. *A Historical Study of the terms Hīnāyāna and Mahāyāna and the Origins of Mahāyāna Buddhism.* Calcutta, 1927.

KUBOTA, Kanroku, ed. *Masterpieces Selected from the Fine Arts of the Far East,* 15 vols. Tōkyō, 1913.

MINAMOTO H. *An Illustrated History of Japanese Art,* translated by H. G. Henderson. Kyōto, 1935.

MIYAMORI, Asatarō. *An Anthology of Haiku Ancient and Modern.* Tōkyō, 1932.

OKAKURA, Kakuzo. *The Ideals of the East.* London, 1920.

RADHAKRISHNAN, S. *Indian Philosophy.* London, 1923.

REISCHAUER, Robert K. *Early Japanese History,* 2 vols. Princeton, 1937.

SANSOM, George B. *Japan, A Short Cultural History.* London, 1931; revised edition, London, 1948.

SUZUKI, Daisetz Teitaro. *The Lankavatara Sutra.* London, 1932.

TSUDA, Noritake. *Handbook of Japanese Art.* Tōkyō, 1935.

VISSER, Marinus W. de. *Ancient Buddhism in Japan.* Paris, 1928.

WALEY, Arthur. *An Introduction to the Study of Chinese Painting.* London, 1923.

WARNER, Langdon. *The Enduring Art of Japan.* Harvard, 1952; paperback edition, New York, Grove Press, 1958.

SCULPTURE

Album of Japanese Sculpture, Bijutsu Shuppan-sha, Tōkyō, 1952. III Hakuho Period, IV Tempyo Period, V Heian Period.

NOGAMI, Toyoichirō. *Masks of Japan.* Tōkyō, 1935.

WARNER, Langdon. *Japanese Sculpture of the Suiko Period.* Yale, 1923.

WARNER, Langdon. *The Craft of the Japanese Sculptor.* New York, 1936.

PAINTING AND PRINTS

BINYON, Laurence, and SEXTON, J. J. O'Brien. *Japanese Colour Prints.* New York, 1923; 2nd edition, ed. Basil Gray, London, 1960.

FICKE, Arthur D. *Chats on Japanese Prints.* London, 1928; reprinted Tōkyō and Rutland, Vermont, 1958.

HIRANO, Chie. *Kiyonaga.* Harvard, 1939.

HOLMES, C. J. *Hokusai.* New York, 1901.

NAITŌ, Tōichirō. *The Wall-Paintings of Hōryūji,* translated by W. R. B. Acker and Benjamin Rowland, Jr, Baltimore, 1943.

NOGUCHI, Y. *Hiroshige.* New York, 1921; London, 1934 and 1940.

TAJIMA, Shiichi. *Masterpieces Selected from the Kōrin School,* 4 vols. Tōkyō, 1913.

TAJIMA, Shiichi. *Masterpieces Selected from the Ukiyoye School,* 5 vols. Tōkyō, 1907.

TODA, Kenji. *Japanese Scroll Painting.* Chicago, 1935.

ILLUSTRATIVE WORKS

Some works with Japanese titles are included here because of their value as illustrative material.

Catalogue of Art Treasures of Ten Great Temples of Nara, 25 vols. Tōkyō, 1932.

Exhibition of Japanese Painting and Sculpture Sponsored by the Government of Japan. National Gallery of Art, Washington, The Metropolitan Museum of Art, New York, Museum of Fine Arts, Boston, The Art Institute of Chicago, Seattle Art Museum, Seattle, 1953.

HARADA, Jirō. *A Collection of Collotype Reproductions of Japanese Art.* Eugene, Oregon, 1936.

HENDERSON, Harold G., and PAINE, Robert T., Jr, eds. *Oriental Art*, Series o, Section III, *Japanese Art.* The University Prints, Newton, Massachusetts.

Higashiyama Suibokuga Shū. Tōkyō, 1936. 13 folders. Magnificent illustrations of ink paintings.

Nihon Kokuhō Zenshū. Tōkyō, 1923. 42 nos. A general work on the National Treasures of Japan with brief texts in Japanese.

Pageant of Japanese Art, edited by staff members of the Tōkyō National Museum, vol. 2, Painting, Part 2. Tōto Bunka Co. Tōkyō, 1952.

WORKS IN JAPANESE

AKIYAMA, K. *Momoyama Jidai Shōheiga Zushū.* Tōkyō, 1929. Tremendous illustrations of screen paintings.

DOI, Tsuguyoshi. *Kyōto Bijutsu Taikan* IV, Kyōto Kaiga I. Tōkyō, 1933.

FUKUI, R. *Bijutsu Kōwa.* Privately printed.

FUKUI, R. *Nihon Suibokuga no Genryū* in *Onshi Kyōto Hakubutsukan Kōen Shū*, No. 7. Kyōto, 1930.

FUKUI, R. *Rokudō Emaki Kaisetsu.* Tōkyō, 1931.

HAMADA, K. *Nihon Bijutsushi Kenkyū.* Tōkyō, 1940.

Kamakura Jidai Bukkyō Shiryō Shiseki. Tōkyō, 1931.

NAITO, Tōichirō. *Nihon Kobijutsushi.* Kyōto, 1937.

SAKAI, S. *Nihon Mokuchōshi.* Tōkyō, 1929.

SAWAMURA, S. *Nihon Kaigashi no Kenkyū.* Kyōto, 1931.

SHIMOMISE, S. *Nihon Kaigashi Kenkyū.* Tōkyō, 1948.

TAKI, S., and KUME, K. *Nihon Kobijutsu Annai.* Tōkyō, 1931.

Zōzō Meiki. Tōkyō, 1926.

MAGAZINES

Bijutsu Kenkyū.
The Journal of Art Studies, published by the Institute of Art Research, Tōkyō. Titles of the articles and plates are given in English.

Kokka.
An art periodical originally famous for its wood-block colour illustrations. Later numbers have brief explanations

in English or French.

ADDITIONAL BIBLIOGRAPHY TO PART ONE
CONTRIBUTED BY D. B. WATERHOUSE

A: General Works
 (1) Illustrative Series
 (2) Exhibitions and Illustrative Volumes
 (3) General Surveys and Histories
 (4) Collections of Essays
 (5) Buddhist and Shintō Art
 (6) Monastery and Shrine Collections
 (7) Institutional Collections
 (a) Guides and Histories
 (b) Catalogues and Illustrative Volumes
 (8) Private Collections
 (9) General Works on Sculpture
 (a) Illustrative Volumes and Series
 (b) Surveys, Histories, and Special Studies
 (c) Collections of Essays
 (10) General Works on Painting
 (a) Illustrative Volumes and Series
 (b) Surveys, Histories, and Special Studies
 (c) Collections of Essays
 (11) General Reference Works
 (12) Biographical Dictionaries
 (13) Bibliographies
 (14) Periodicals
B: Chapter Bibliographies

A: GENERAL WORKS

(1) *Illustrative Series*

Bijutsu Kenkyūjo, ed. (1938–42): *Nihon bijutsu shiryō* 5 vols. Kyōto: Benridō.

Benridō, ed. (1970): *Kyōto-fu bunkazai zuroku.* 2 vols. Kyōto: Benridō.

Chikuma Shobō, ed. (1965–6): *Nihon bunka shi.* 8 vols. Tōkyō: Chikuma Shobō.

Chikuma Shobō, ed. (1971–2): *Nihon bijutsukan.* 12 vols. Tōkyō: Chikuma Shobō.

Kadokawa Shoten, ed. (1960–7): *Sekai bijutsu zenshū. Nihon hen.* 11 vols. Tōkyō: Kadokawa Shoten.

Kōdansha, ed. (1959–61): *Nihon bijutsu taikei.* 11 vols. Tōkyō: Kōdansha.

Kōdansha, ed. (1963–4): *Nihon bijutsu.* (*Sekai bijutsu taikei*, Vols. 11–12.) Tōkyō: Kōdansha.

Mainichi Shimbunsha, ed. (1963–7): *Kokuhō.* 6 vols. plates, 6 vols. text. Tōkyō: Mainichi Shimbunsha.

Mainichi Shimbunsha, ed. (1967–8): (*Genshoku-ban*) *Kokuhō.* 12 vols. Tōkyō: Mainichi Shimbunsha.

Mainichi Shimbunsha, ed. (1972–): *Jūyō bunkazai.* Vols. 1– (in progress). Tōkyō: Mainichi

Shimbunsha.

Mombushō, ed. (1924–39): *Nippon kokuhō zenshū*. 84 vols. Tōkyō: Nippon Kokuhō Zenshū Kankōkai.

Murayama Jungo (1909): *Tōyō bijutsu zufu*. 2 vols. Tōkyō: Kokka-sha.

Shōgakkan, ed. (1958): *Zusetsu Nihon bunka shi*. 14 vols. Tōkyō: Shōgakkan.

Shōgakkan, ed. (1966–72): *Genshoku Nihon no bijutsu*. 30 vols. Tōkyō: Shōgakkan.

Tajima Shiichi (1899–1908): *Shimbi taikan*. 20 vols. Tōkyō: Shimbi Shoin.

Tajima Shiichi (1908–18): *Tōyō bijutsu taikan*. 15 vols. Tōkyō: Shimbi Shoin.

Tōkyō Kokuritsu Hakubutsukan, ed. (1952–5): *Nihon bijutsu zenshū*. 6 vols. Tōkyō: Tōto Bunka Kōeki Kabushiki Kaisha.

Tokyo National Museum, ed. (1952–5): *Pageant of Japanese Art*. 6 vols. Tōkyō: Tōto Bunka Kabushiki Kaisha. (Translation of previous item.)

Tokyo National Museum, ed. (1958): *Pageant of Japanese Art*. 6 vols. Popular Edition. Tōkyō: Tōto Shuppan Company, Ltd. (distributed by Charles E. Tuttle Company).

(2) Exhibitions and Illustrative Volumes

Arts Council (1958): *Art Treasures from Japan. An Exhibition of Paintings and Sculpture*. London: The Arts Council.

Bunkachō and Shōgakkan, eds. (1974): *Nihon bijutsu meihin sen*. Tōkyō: Shōgakkan.

Commission for Protection of Cultural Properties, *et al.*, eds. (1965): *Art Treasures from Japan*. Tokyo: Kodansha International, Ltd.

Government of Japan, ed. (1953): *Exhibition of Japanese Painting and Sculpture*. Washington: National Gallery of Art; etc.

Ikeda Shōtarō, ed. (1941): *(Ikeda Daisendō) Ko bijutsu shūhō*. 2 vols. Ōsaka: Ikeda Shōtarō.

Japanische Ausschuss für die Berliner Ausstellung Altjapanischer Kunst (1939): *Gedächtniskatalog der Ausstellung Altjapanischer Kunst/ Berurin Nippon ko bijutsu tenrankai kinen zuroku*. 2 vols. Tōkyō: Japanische Ausschuss für die Berliner Ausstellung Altjapanischer Kunst.

Kokka Taikan Hakkōjo, ed. (1917): *Kokka taikan*. Tōkyō: Kokka Taikan Hakkōjo.

Mainichi Shimbunsha, ed. (1958): *Kinsei bijutsu meihin ten*. Tōkyō: Mainichi Shimbunsha.

Mayuyama Junkichi (1966): *Japanese Art in the West*. Tōkyō: Mayuyama & Co.

Museum of Fine Arts, Boston (1936): *Illustrated Catalogue of a Special Loan Exhibition of Art Treasures from Japan*. Boston: Museum of Fine Arts.

Museum für Ostasiatische Kunst (1969): *Kunst-*

schätze aus Japan. Zürich: Kunsthaus Zürich.

Office of the Imperial Japanese Government Commission to the Japan–British Exhibition (1910): *An Illustrated Catalogue of Japanese Old Fine Arts Displayed at the Japan–British Exhibition, London 1910*. 2 vols. Tōkyō: The Shimbi Shoin.

Ostier, Janette (1974): *Art japonais. Le jeu de l'éternel et de l'éphémère*. Paris: Galerie Janette Ostier.

Staatliche Museen, Berlin (1939): *Ausstellung Altjapanischer Kunst*. Berlin: Verlag für Kunstwissenschaft.

Tōkyō Bijutsu-shō Kyōdō Kumiai (1964): *(Orimpikku kinen) Ko bijutsu tenkan tokubetsu sokubaikai*. Tōkyō: Tōkyō Bijutsu-shō Kyōdō Kumiai.

Tōkyō Kokuritsu Hakubutsukan (1964): *Nihon ko bijutsu ten zuroku*. Tōkyō: Benridō.

Tōkyō Kokuritsu Hakubutsukan (1968): *Edo bijutsu zuroku*. Tōkyō: Tōkyō Kokuritsu Hakubutsukan.

Tokyo National Museum (1964): *Exhibition of Japanese Old Art Treasures in Tokyo Olympic Games*. Tokyo: Tokyo National Museum.

Yomiuri Shimbunsha, ed. (1929): *Nippon meihō tenrankai zuroku*. 2 vols. Tōkyō: Yomiuri Shimbunsha.

(3) General Surveys and Histories

Buhot, Jean (1949): *Histoire des arts du Japon*, 1 (all published). Paris: Van Oest.

Commission Impériale du Japon (1900): *Histoire de l'art du Japon*. Paris: Maurice de Brunoff.

Fujikake Shizuya (1941): *Nippon bijutsu taikei*. 3 vols. (all published). Tōkyō: Seibundō Shinkōsha.

Fujita Tsuneyo *et al.*, eds. (1960): *Nippon bijutsu zenshi*. 2 vols. Tōkyō: Bijutsu Shuppansha. (Repr., 6 vols. and supplementary vol., 1968–9.)

Gonse, Louis (1883): *L'art japonais*. 2 vols. Limited ed., 1400 copies. Paris: A. Quantin. (Repr., 1 vol., Paris: Maison Quantin, n.d.; and Paris: Alcide Picard & Kaan, n.d.)

Heibonsha, ed. (1966–7): *Nihon no bijutsu*. 25 vols. and 5 supplementary vols. Tōkyō: Heibonsha.

Kawakita Michiaki (1963): *Introduction to Japanese Art*. Tokyo: Kokusai Bunka Shinkokai.

Kikuchi Sadao (1960): *Japanese Arts – What and Where?* Tokyo: Japan Travel Bureau.

Kokuritsu Hakubutsukan (1952): *Nihon bijutsu ryakushi*. Kyōto: Benridō. (Rev. ed. of Teishitsu Hakubutsukan 1938.)

Kyōto Kokuritsu Hakubutsukan (1958): *Heian jidai no bijutsu*. Kyōto: Benridō.

Machida Kōichi (1965): *Gaisetsu Nihon bijutsu shi*. Tōkyō: Yoshikawa Kōbunkan.

Minamoto Toyomune (1931): *Nippon bijutsu shi zuroku*. Kyōto: Hoshino Shoten.

Minamoto Toyomune (1935): *An Illustrated History*

of Japanese Art. Translated by Harold G. Henderson. Kyōto: Hoshino Shoten. (Translation of Minamoto 1931.)

Mochimaru Kazuo and Kuno Takeshi (1954): *Nihon bijutsu shi yōsetsu*. Tōkyō: Yoshikawa Kōbunkan.

Noma Seiroku (1966–7): *The Arts of Japan*. 2 vols. Translated by John Rosenfield and Glen Webb. Tokyo: Kodansha International.

Swann, Peter C. (1958): *An Introduction to the Arts of Japan*. Oxford: Bruno Cassirer.

Tani Shin-ichi (1948): *Nippon bijutsu shi gaisetsu*. Tōkyō: Tōkyōdō.

Tazawa Yutaka and Ōoka Minoru (1932): *Zusetsu Nippon bijutsu shi*. 2 vols. Tōkyō: Iwanami Shoten. (Rev. ed., 1957.)

Tazawa Yutaka, ed. (1952): *A Pictorial History of Japanese Art*. Tokyo.

Teishitsu Hakubutsukan (1938): *Nippon bijutsu ryakushi*. Kyōto: Benridō. (Repr. 1943; rev. ed. of Tōkyō Teishitsu Hakubutsukan 1901.)

Tōkyō Teishitsu Hakubutsukan (1901): (*Kōhon*) *Nippon teikoku bijutsu ryakushi*. Tōkyō: Ryūmonkan.

Tsuda Noritake (1935): *Handbook of Japanese Art*. Tokyo. (2nd ed., London: George Allen & Unwin Ltd, 1937.)

Warner, Langdon (1952): *The Enduring Art of Japan*. Cambridge, Mass.: Harvard University Press.

Yashiro Yukio (1958): *2000 Years of Japanese Art*. Ed. Peter C. Swann. London and New York.

Yashiro Yukio (1960): *Art Treasures of Japan*. 2 vols. Tokyo: Kokusai Bunka Shinkokai.

(4) *Collections of Essays*

Akiyama Teruo (1943): *Nippon bijutsu ronkō*. Tōkyō: Daiichi Shobō.

Bunkazai Hogo Iinkai (1961): *Nihon no bunkazai*. 2 vols. Tōkyō: Daiichi Hōki Shuppan.

Bunkazai Hogo Iinkai (1967): *Bunkazai no kanshō*. Tōkyō: Daiichi Hōki Shuppan.

Hamada Kōsaku (1940): *Nippon bijutsu shi kenkyū*. Tōkyō: Zauhō Kankōkai.

Hamada Kōsaku (1942): *Tōyō bijutsu shi kenkyū*. Tōkyō: Zauhō Kankōkai. (Repr. 1943.)

Kageyama Haruki (1965): *Shiseki ronkō*. Kyōto: Yamamoto Koshū Shashin Kōgei-bu.

Kobayashi Ta-ichirō (1973): *Kobayashi Ta-ichirō chosaku shū*. 8 vols. Kyōto: Tankōsha.

Sawamura Sentarō (1932): *Tōyō bijutsu shi no kenkyū*. Kyōto: Hoshino Shoten.

Tanaka Ichimatsu et al. (1955): *Kōgaku-teki hōhō ni yoru ko bijutsu-hin no kenkyū*. Tōkyō: Yoshikawa Kōbunkan.

Tanaka Ichimatsu (1958): *Nihon bijutsu no tembō*. Tōkyō: Bijutsu Shuppansha.

Yashiro Yukio (1942): *Tōyō bijutsu shi ronkō*. 2 vols. Tōkyō: Zauhō Kankōkai.

Yashiro Yukio (1943): *Nihon bijutsu no tokushitsu*. Tōkyō: Iwanami Shoten. (Repr. 1965.)

(5) *Buddhist and Shintō Art*

Fukuda Kisaburō (1934): *Kanshiki-jō ni okeru Nippon bukkyō bijutsu no kenkyū*. Tōkyō: Rinkō Shoten.

Hamada Takashi (1970): *Zuzō*. (*Nihon no bijutsu*, 55.) Tōkyō: Shibundō.

Ishida Mosaku (1967): *Bukkyō bijutsu no kihon*. Tōkyō: Tōkyō Bijutsu.

Kageyama Haruki (1962): *Shintō bijutsu no kenkyū*. Kyōto: Yamamoto Koshū Shashin Kōgei-bu.

Kageyama Haruki (1965): *Shintō no bijutsu*. (*Hanawa sensho*, 48.) Tōkyō: Hanawa Shobō.

Kageyama Haruki (1967): *Shintō bijutsu*. (*Nihon no bijutsu*, 18.) Tōkyō: Shibundō.

Kageyama Haruki (1973a): *The Arts of Shinto*. New York and Tokyo: Weatherhill and Shibundō. (Translation of Kageyama 1967.)

Kageyama Haruki (1973b): *Shintō bijutsu. Sono shosō to tenkai*. Tōkyō: Yūzankaku Shuppan.

Kageyama Haruki (1974): *Bukkyō kōko to sono shūhen*. Tōkyō: Yūzankaku Shuppan.

Kameda Tsutomu (1970): *Nihon bukkyō bijutsu shi josetsu*. Tōkyō: Gakugei Shorin.

Kisshō Masao (1943): *Bukkyō sonzō kōwa*. Kyōto: Ichijō Shobō.

Mochizuki Shinjō, Sawa Ryūken, and Umehara Takeshi (1971): (*Teihon*) *Butsuzō. Kokoro to katachi*. Tōkyō: Nihon Hōsō Shuppan Kyōkai.

Mochizuki Shinjō, ed. (1973): *Nihon bukkyō bijutsu hihō*. Tōkyō: Sansaisha.

Naitō Tōichirō (1932): *Nippon bukkyō zuzō shi*, 1. Tōkyō: Tōhō Shoin.

Nara Kokuritsu Hakubutsukan (1959): *Bukkyō bijutsu nyūmon*. Nara: Nara Kokuritsu Hakubutsukan.

Nara Kokuritsu Hakubutsukan (1970): *Bukkyō bijutsu meihin ten*. Nara: Nara Kokuritsu Hakubutsukan.

Nara Kokuritsu Hakubutsukan (1971): *Bukkyō bijutsu meihin ten zuroku*. Nara: Nara Kokuritsu Hakubutsukan.

Nara Kokuritsu Hakubutsukan (1971–): *Kokuhō, jūyō bunkazai bukkyō bijutsu*. Vols. 1– (in progress). Tōkyō: Shōgakkan.

Nara Kokuritsu Hakubutsukan (1974): *Amida-butsu chōzō*. Nara: Nara Kokuritsu Hakubutsukan.

Ōkura Shūkokan (1939): *Shintō bijutsu tenrankai zuroku*. Tōkyō: Ōkura Shūkokan.

Ōkura Shūkokan (1941): *Shintō bijutsu ten zuroku*. Tōkyō: Ōkura Shūkokan.

Ono Gemmyō (1916): *Bukkyō no bijutsu oyobi rekishi*. Tōkyō: Bussho Kenkyūkai.

Ono Gemmyō (1918): *Butsuzō no kenkyū*. Tōkyō: Heigo Shuppansha.
Ono Gemmyō (1921): *Ezukai bukkyō bijutsu kōwa*. Tōkyō: Zōkyō Shoin.
Ono Gemmyō (1925): *Bukkyō bijutsu gairon*. Tōkyō.
Ono Gemmyō (1927): *Bukkyō bijutsu kōwa*. Tōkyō: Kōshisha Shobō.
Ono Gemmyō (1937): *Bukkyō no bijutsu to rekishi*. Tōkyō: Daizō Shuppan.
Ōta Koboku (1974): *Suributsu inbutsu*. Kyōto: Sogeisha.
Takata Osamu (1969): *Bukkyō bijutsu shi ronkō*. Tōkyō: Chūō Kōron Bijutsu Shuppansha.
Tanaka Shigehisa (1961): *Miroku Bosatsu no yubi*. Kyōto: Yamamoto Koshū Shashin Kōgei-bu.
Tobe Ryūkichi (1929): *Nippon bukkyō bijutsu no kenkyū*. Tōkyō: Geien Junreisha.
Tōkyō Teishitsu Hakubutsukan (1926): *Saiun jikō. Bukkyō bijutsu zuroku*. Tōkyō: Yoshida Kōzaburō.
Yamanaka (1936): *Exhibition of Japanese Buddhistic Art, Specially Brought Over from Japan*. Boston: Yamanaka & Co., Inc.

(6) *Monastery and Shrine Collections* (for Hōryūji, see listings for Chapter 3, below; for the Shōsōin, see listings for Chapter 4; for Byōdōin and Chūsonji, see listings for Chapter 6)

Asahi Shimbunsha, ed. (1958): *Tōji*. Tōkyō: Asahi Shimbunsha.
Bijutsu Shuppansha, ed. (1958–61): *Nihon no tera*. 14 vols. Tōkyō: Bijutsu Shuppansha. (Repr. in 1 vol., 1969.)
Bijutsu Shuppansha, ed. (1961): *Nihon no tera. Kyōto*. Tōkyō: Bijutsu Shuppansha. (6 vols. of the 14-vol. set, issued as 1 vol.)
Domon Ken (1968): *Koji junrei*. 3 vols. Tōkyō: Bijutsu Shuppansha.
Domon Ken (1973): *Tōdaiji*. Tōkyō: Heibonsha.
Domon Ken et al. (n.d.): *The Muro-ji. An Eighth Century Japanese Temple, Its Art and History*. Tōkyō: Bijutsu Shuppansha.
Fujimoto Yohachi (1973): *Kōyasan*. Tōkyō: Sansaisha.
Fukuyama Toshio and Kuno Takeshi (1958): *Yakushiji*. Tōkyō: Tōkyō Daigaku Shuppankai.
Honganji, ed. (1937): *Ryūkoku shūei*. Kyōto: Honganji.
Irie Taikichi (1973): *Tōshōdaiji*. Tōkyō: Mainichi Shimbunsha.
Isonokami Jingū, ed. (1929): *Isonokami Jingū hōmotsu shi*. Nara: Ōokayama Shoten.
Iwanami Shoten (1973–4): *Nara no tera*. 20 vols. Tōkyō: Iwanami Shoten.
Jingū Chōkokan Nōgyōkan (1969): *Jingū Chōkokan,*

Nōgyōkan. Ise: Jingū Chōkokan Nōgyōkan.
Kashima Jingū, ed. (1939): *Kashima Jingū hōmotsu shi*. Kashima: Kashima Jingū.
Kasuga Taisha, ed. (1968): *Kasuga Taisha hihō ten*. Nara: Kasuga Taisha.
Kidder, J. Edward, Jr. (1964): *Japanese Temples. Sculpture, Paintings, Gardens and Architecture*. London: Thames and Hudson.
Kinki Nihon Tetsudō Sōritsu Gojū Shūnen Kinen Shuppan Henshūjo, ed. (1960–70): *Kinki Nihon sōsho*. 10 vols. Osaka: Kinki Nihon Tetsudō Kabushiki Kaisha.
Kōdansha, ed. (1968–9): *Hihō*. 12 vols. Tōkyō: Kōdansha.
Kokkasha, ed. (1909): *Yasan reihō shū*. Tōkyō: Kokkasha.
Kyōto Hakubutsukan (1930): *Tōfukuji meihō shū*. Kyōto: Benridō.
Machida Kōichi (1976): *Yamato koji junreki*. Tōkyō: Yūshindō Kōbunsha.
Mainichi Shimbunsha, ed. (1971): *Yakushiji*. Tōkyō: Mainichi Shimbunsha.
Minamoto Toyomune (1959): *Daitokuji*. Tōkyō: Asahi Shimbunsha.
Miyazaki Enjun (1961): *Nishi Honganji. Sono bijutsu to rekishi*. Kyōto and Tōkyō: Tankō Shinsha.
Mochizuki Shinjō, ed. (1963): *Kōryūji*. Kyōto: Yamamoto Koshū Shashin Kōgei-bu.
Mori Kanchō (1947): *Shin Yakushiji*. Kyōto: Kawahara Shoten.
Mori Kanchō (1948): *Ryūkōin meihō zuroku*. Kōyasan: Ryūkōin.
Moriguchi Narakichi (1926): *Kasuga Jinja taikan*. Nara: Kasuga Jinja.
Nara Roku Daiji Taikan Kankōkai, ed. (1968–73): *Nara roku daiji taikan*. 14 vols. Tōkyō: Iwanami Shoten.
Nihon Bukkyō Fukyūkai, ed. (1975): *Eiheiji Senshōkaku tenjō-e*. Kyōto: Nihon Bukkyō Fukyūkai.
Nihon Keizai Shimbunsha, ed. (1975): *Daigoji mikkyō bijutsu ten*. Tōkyō: Nihon Keizai Shimbunsha.
Ōba Iwao (1941a): *Jingū Chōkokan zuroku*. Ise: Jingū Shichō.
Ōba Iwao (1941b): *Katori Jingū hōmotsu shi*. Katori: Katori Jingū.
Ogawa Seiyō (1924): *Murōji taikan*. Nara: Asuka-en.
Ogawa Seiyō (1928): *Hokkedō taikan*. Nara: Asuka-en.
Okada Kaigyoku (1938): *Daigo reihō san*. Kyōto: Daigoji.
Onshi Kyōto Hakubutsukan (1933): *Daitokuji meihō shū*. Kyōto: Benridō.
Onshi Kyōto Hakubutsukan (1934): *Tōji meihō shū*. Kyōto: Kobayashi Shashin Seihanjo.
Onshi Kyōto Hakubutsukan (1935): *Myōshinji meihō*

zuroku. Kyōto: Kobayashi Shashin Seihanjo.

Onshi Kyōto Hakubutsukan (1937): *Tendai reika*. Kyōto: Kobayashi Shashin Seihanjo.

Ōoka Minoru (1973): *Temples of Nara and Their Art*. New York and Tokyo: Weatherhill and Heibonsha.

Sakamoto Manshichi and Machida Kōichi (1960): *Yakushiji*. Tōkyō: Jitsugyō no Nihonsha.

Shimbi Shoin (1910): *Nihon no jiin to hōmotsu*. 3 vols. Tōkyō: Shimbi Shoin.

Shimbi Shoin (1910): *Japanese Temples and Their Treasures*. Tōkyō: Shimbi Shoin.

Takahashi Yukihiko *et al*. (1975): *Akishinodera*. Tōkyō: Geiryū Shuppan Kabushiki Kaisha.

Takeda Tsuneo (1973): *Nanzenji semmen byōbu*. (*Bijutsu senshū*, Vol. 6.) Kyōto: Fuji Āto Shuppan.

Tōkyō Bijutsu Gakkō (1913–30): *Nanto shichi daiji ōkagami*. 155 vols. Tōkyō: Nanto Shichi Daiji Ōkagami Hakkōjo.

Tōkyō Bijutsu Gakkō (1932–42): *Ōkagami sōsho*. 32 vols. Tōkyō: Ōtsuka Kōgeisha. (Enlarged and rev. repr. of Tōkyō Bijutsu Gakkō 1913–30.)

Yabuuchi Hikoya (1935): *Kachō shūei*. Kyōto: Chion-in.

(7) *Institutional Collections*

(a) *Guides and Histories*

Japanese National Commission for UNESCO (1960): *Museums in Japan*. [Tokyo]: Japanese National Commission for UNESCO.

Misugi Takatoshi (1966): *Nihon no hakubutsukan*. Ōsaka: Hōikusha.

Misugi Takatoshi (1968): *Zenkoku bijutsukan, hakubutsukan gaido*. Ōsaka: Sōgensha.

Roberts, Laurance P. (1967): *The Connoisseur's Guide to Japanese Museums*. Tokyo.

Saitō Ryūzō (1974): *Nihon bijutsu-in shi*. Tōkyō: Chūō Kōron Bijutsu Shuppan.

Takeda Michitarō (1976): *Zoku Nihon bijutsu-in shi*. Tōkyō: Chūō Kōron Bijutsu Shuppan.

Tōkyō-to Hakubutsukan Kyōgikai, ed. (1970): *Tōkyō no hakubutsukan*. Tōkyō: Tōkyō-to Hakubutsukan Kyōgikai.

(b) *Catalogues and Illustrative Volumes*

Anderson, William (1886): *Descriptive and Historical Catalogue of a Collection of Japanese and Chinese Paintings in the British Museum*. London: Longmans & Co., B. Quaritch & Trübner & Co.

Fujita Bijutsukan (1954): *Fujita Bijutsukan shozōhin mokuroku*. 2 vols. Ōsaka: Fujita Bijutsukan.

Fujita Bijutsukan (1972): *Fujita Bijutsukan meihin zuroku*. Tōkyō: Nihon Keizai Shimbunsha.

Hakone Bijutsukan and Atami Bijutsukan (1957):

Meihin *mokuroku*. Atami: Atami Shōji Kabushiki Kaisha.

Hakone Bijutsukan and Atami Bijutsukan (1968): *Meihin zuroku*. 2 vols. Atami: Atami Shōji Kabushiki Kaisha.

Harada Jiro (1934): *Examples of Japanese Art in the Imperial Household Museum*. Tokyo: The Imperial Household Museum.

Idemitsu Bijutsukan (1968): *Idemitsu Bijutsukan meihin ten*. Tōkyō: Idemitsu Bijutsukan.

Iwasaki Koyata (1921): *Seikadō kanshō*. 3 vols. Tōkyō: Kokkasha.

Kanō Jirobei (1930–1): *Hakkaku-chō*. 6 vols. Kōbe: Hakkaku Sansō.

Kōbe Shiritsu Namban Bijutsukan Henshū Iinkai, ed. (1968–71): *Kōbe Shiritsu Namban Bijutsukan zuroku*. 5 vols. Kōbe: Kōbe Shiritsu Namban Bijutsukan.

Kōdansha, ed. (1966–72): *Sekai no bijutsukan*. 36 vols. Tōkyō: Kōdansha.

Kyōto Kokuritsu Hakubutsukan (1966): *Kyōto Kokuritsu Hakubutsukan zōhin mokuroku*. Kyōto: Kyōto Kokuritsu Hakubutsukan.

Mainichi Shimbunsha, ed. (1971): *Gotō Bijutsukan*. 2 vols. Tōkyō: Mainich Shimbunsha.

Nezu Bijutsukan (1970): *Nezu Bijutsukan meihin mokuroku*. Tōkyō: Nezu Bijutsukan.

Nezu Ka-ichirō (1939–43): *Seizanshō seishō*. 10 vols. Tōkyō: Nezu Ka-ichirō.

Nishimura Kiyoshi (1960): *Gotō Bijutsukan meihin zuroku*. Tōkyō: Gotō Bijutsukan.

Ōkura Bunkazaidan (1962): *Shūko meikan*. Tōkyō: Ōkura Bunkazaidan.

Ōkura Bunkazaidan (n.d.): *Ōkura Shūkokan zuroku*. Tōkyō: Ōkura Shūkokan.

Ōsaka Shiritsu Bijutsukan (1936): (*Kaikan kinen*) *Meihō tenkan zuroku*. Ōsaka: Ōsaka-shi Yakusho.

Santorī Bijutsukan Jimusho-kyoku (1966): *Santorī Bijutsukan zuroku*. Tōkyō: Santorī Bijutsukan.

Santorī Bijutsukan Jimusho-kyoku (1971): *Santorī Bijutsukan zuroku*. Tōkyō: Santorī Bijutsukan.

Seattle Art Museum (1960): *Japanese Art in the Seattle Art Museum*. Seattle: Seattle Art Museum.

Seitokudō, ed. (1930): (*Rōma kaisai*) *Nippon bijutsu tenrankai kinen zuroku*. 2 vols. Tōkyō: Seitokudō.

Shirahata Yoshi (1948): *Higurashi*. Kamakura: Tokiwayama Bunko.

Tayama Hōnan (1954): *Birankan*. Kamakura: Tokiwayama Bunko.

Tokiwayama Bunko and Sugahara Hisao, eds. (1967): *Hibai yokō*. Tōkyō: Jitsugyō no Sekaisha.

Tokugawa Bijutsukan (1962): *Tokugawa Bijutsukan*. 2 vols. Tōkyō: Tōkyō Chūnichi Shimbun Shuppanbu.

Tokugawa Bijutsukan (1969): *Tokugawa Bijutsukan*

meihin zuroku. Nagoya: Tokugawa Bijutsukan.

Tōkyō Bijutsu Gakkō (1914): *Tōkyō Bijutsu Gakkō zōhin mokuroku*. Tōkyō: Shimbi Shoin.

Tōkyō Geijutsu Daigaku (1954–61): *Tōkyō Geijutsu Daigaku zōhin mokuroku*. 5 vols. Tōkyō: Tōkyō Geijutsu Daigaku.

Tōkyō Kokuritsu Hakubutsukan (1952): *Tōkyō Kokuritsu Hakubutsukan shūzō meihin mokuroku*. Tōkyō: Tōkyō Kokuritsu Hakubutsukan.

Tōkyō Kokuritsu Hakubutsukan (1952–6): *Shūzō-hin mokuroku*. 3 vols. Tōkyō: Tōkyō Kokuritsu Hakubutsukan.

Tōkyō Kokuritsu Hakubutsukan (1959): *Tōkyō Kokuritsu Hakubutsukan meihin hyakusen*. Tōkyō: Tōkyō Kokuritsu Hakubutsukan.

Tōkyō Kokuritsu Hakubutsukan (1967–70): *Tōkyō Kokuritsu Hakubutsukan*. 3 vols. Tōkyō: Kōdansha.

Yamato Bunkakan (1970): *Yamato Bunkakan meihin zuroku*. Nara: Yamato Bunkakan.

Yamato Bunkakan (1974–5): *Yamato Bunkakan shozō-hin zuhan mokuroku*. 3 vols. Nara: Yamato Bunkakan.

(8) *Private Collections*

Aimi Shigeichi (1917): *Asano Kōshaku kahō efu*. Tōkyō: Geikaisha.

Arts Council (1970): *The Harari Collection of Japanese Paintings and Drawings*. London: The Arts Council.

Endō Ichisaku (1913): (*Ōtani-ke gozōhin*) *Shashin chō*. Kyōto: Endō Ichisaku.

Hillier, J. (1970): *Catalogue of the Japanese Paintings and Prints in the Collection of Mr & Mrs Richard P. Gale*. 2 vols. London: Routledge & Kegan Paul, Ltd, for The Minneapolis Institute of Arts.

Hillier, J. (1970–3): *The Harari Collection of Japanese Paintings and Drawings*. London: Lund Humphries, and Boston: Boston Book and Art.

Kawasaki Yoshitarō (1914): *Chōshunkaku kanshō*. 6 vols. Tōkyō: Kokkasha.

Kawasaki Yoshitarō (1927): *Kawasaki Danshaku-ke zōhin nyūsatsu mokuroku*. Tōkyō: Shunkō Bijutsusha.

Kawasaki Yoshitarō (1935): *Kawasaki Danshaku-ke zōhin nyūsatsu mokuroku*. Ōsaka: Chōshunkaku Zōhin Zuroku Kankōkai.

Kokkasha, ed. (1912): *Segai-an kanshō*. Tōkyō: Kokkasha.

Murase, Miyeko (1975): *Japanese Art. Selections from the Mary and Jackson Burke Collection*. New York: The Metropolitan Museum of Art.

Mutō Sanji (1928): *Chōshō seikan*. 3 vols. Ōsaka: Shunkō Bijutsusha.

Murayama Ryūhei (1914): *Gen-an kanshō*. Tōkyō Kokkasha.

Ōsaka Bijutsu Kurabu (1934.4.5): *Kōsetsusai zōhin tenkan zuroku*. Ōsaka: Ōsaka Bijutsu Kurabu.

Ōsaka Bijutsu Kurabu (1935.11.9): *Sannōsō zōhin tenkan zuroku*. Ōsaka: Ōsaka Bijutsu Kurabu.

Ōsaka Bijutsu Kurabu (1936.11.18): *Tamura-ke zōhin tenkan zuroku*. Ōsaka: Ōsaka Bijutsu Kurabu.

Ōsaka Bijutsu Kurabu (1937.1.24): *Kōunken zōhin nyūsatsu mokuroku*. Ōsaka: Ōsaka Bijutsu Kurabu.

Ōsaka Bijutsu Kurabu (1937.4.13): *Kōsetsusai zōhin tenkan zuroku*. Ōsaka: Ōsaka Bijutsu Kurabu.

Rosenfield, John M., and Shimada, Shūjirō (1970): *Traditions of Japanese Art. Selections from the Kimiko and John Powers Collection*. Cambridge: Fogg Art Museum, Harvard University.

Sekiguchi Heiichirō (1910): *Kankochō*. Tōkyō: Shimbi Shoin.

Shimizu, Yoshiaki (1967): *Japanese Paintings from the Collection of Joe D. Price*. [Lawrence]: Museum of Art, The University of Kansas.

Togari Soshin-an (1933–4): *Sōken-an bijutsu shūsei zuroku*. 3 vols. Nagasaki: Kyūshū Denki Kidō Kabushiki Kaisha.

Tōkyō Bijutsu Kurabu (1927.4.4): *Kishū Tokugawa-ke zōhin tenkan mokuroku*. Tōkyō: Tōkyō Bijutsu Kurabu.

Tōkyō Bijutsu Kurabu (1934.11.26): *Asada-ke zōhin tenkan nyūsatsu*. Tōkyō: Tōkyō Bijutsu Kurabu.

(9) *General Works on Sculpture*

(a) *Illustrative Volumes and Series*

Bijutsushi Gakkai, ed. (1943): *Besson Kyōto butsuzō zusetsu*. Kyōto: Ichijō Shobō.

Bijutsu Shuppansha, ed. (1951–2): *Nihon no chōkoku*. 6 parts. Tōkyō: Bijutsu Shuppansha. (2nd ed., rev., in 1 vol., 1960.)

Bijutsu Shuppansha, ed. (1953): *Album of Japanese Sculpture*. Tōkyō: Bijutsu Shuppansha.

Honolulu Academy of Arts (1957): *Treasures from Japan. Sculpture and Decorative Arts. A Special Loan Exhibition*. [Honolulu]: Honolulu Academy of Arts.

Kidder, J. Edward, Jr (1961): *Masterpieces of Japanese Sculpture*. Tōkyō and Rutland, Vt.: Bijutsu Shuppansha and Charles E. Tuttle Company. (Translation of Bijutsu Shuppansha 1960. Also French and German translations.)

Kōkogaku-kai, ed. (1932): *Zōzō meiki*. Tōkyō: Kōkogaku-kai. (Rev. ed., 1936.)

Kokuyaku Himitsu Giki Hensankyoku, ed. (1934): *Butsuzō sōkan*. Tōkyō: Kokusho Kankōkai. (Repr. 1973.)

Mainichi Shimbunsha, ed. (1970): (*Kokuhō 50-sen*) *Nihon no chōkoku*. Tōkyō, *etc*.: Mainichi Shimbunsha.

Maruo Shōzaburō *et al.*, eds. (1966–71): *Nihon chō-koku shi kiso shiryō shūsei. Heian jidai: zōzō meiki hen.* 8 vols. plates, 8 vols. text. Tōkyō: Chūō Kōron Bijutsu Shuppan.

Maruo Shōzaburō *et al.*, eds. (1973–): *Nihon chōkoku shi kiso shiryō shūsei. Heian jidai: jūyō sakuhin hen.* Vols. 1– (in progress). Tōkyō: Chūō Kōron Bijutsu Shuppan.

Nara Kokuritsu Hakubutsukan (1976): *Heian Ka-makura no kondō butsu. Mokuroku.* Nara: Nara Kokuritsu Hakubutsukan.

Sakamoto Manshichi and Uehara Shōichi (1967): *Kokuhō chōzō.* 3 vols. Tōkyō: Tokken Shoten.

Tōkyō Kokuritsu Hakubutsukan (1972): *Tokubetsu ten zuroku. Heian jidai no chōkoku.* Tōkyō: Benridō.

Ueno Naoteru and Sakamoto Manshichi (1958): *Nihon chōkoku zukan.* Tōkyō: Asahi Shimbunsha.

(b) *Surveys, Histories, and Special Studies*

Butsuzō Kenkyūkai, ed. (1934): *Nippon butsuzō zusetsu.* Tōkyō: Butsuzō Kenkyūkai.

Irie Taikichi (1968): *Butsuzō no hyōjō.* Tōkyō: Jim-butsu Ōraisha.

Kanamori Jun (1948): *Nippon chōkoku shiyō.* Tōkyō.

Kaneko Ryōun (1959): *Nippon no chōkoku.* Tōkyō: Shakai Shisō Kenkyūkai.

Kobayashi Takeshi (1952): *Nihon chōkoku.* Tōkyō: Sōgensha. (11th ed., 1961.)

Kobayashi Takeshi (1960): *Nihon no chōkoku.* Tōkyō: Shibundō. (Repr. 1963.)

Kuno Takeshi (1959): *Nihon no chōkoku.* Tōkyō: Yoshikawa·Kōbunkan.

Kuno Takeshi (1961): *Butsuzō.* Tōkyō: Gakuseisha.

Kuno Takeshi (1963): *A Guide to Japanese Sculpture.* Tōkyō: Mayuyama and Co.

Kuno Takeshi (1975): *Butsuzō no tabi. Henkyō no kobutsu.* Tōkyō: Geisōdō.

Kuno Takeshi (1976): *Oshidashibutsu to senbutsu.* (*Nihon no bijutsu*, 118.) Tōkyō: Shibundō.

Kurata Bunsaku (1965): *Butsuzō no mikata (gihō to hyōgen).* Tōkyō: Daiichi Hōki Shuppansha.

Kurata Bunsaku (1973): *Zōnai nōnyūhin.* (*Nihon no bijutsu*, 86.) Tōkyō: Shibundō.

Machida Kōichi (1968): *Nihon no butsuzō. Kobijutsu no kanshō.* Tōkyō: Kin-ensha.

Machida Kōichi (1974): *Nihon kodai chōkoku shi gaisetsu.* Tōkyō: Chūō Kōron Bijutsu Shuppan.

Myōchin Tsuneyo (1935): *Butsuzō chōkoku.* Kyōto: Suzukake Shuppan-bu.

Nagajima Katsumasa (1975): *Toyama no chōkoku. Inori to bi no keifu.* Toyama: Kōgen Shuppan.

Naitō Tōichirō (1927–31): *Butsuzō tsūkai.* Vols. 1–2 (all issued). Tōkyō: Rokumeisō.

Nishimura Kōchō (1976): *Butsuzō no sai hakken.*

Tōkyō: Yoshikawa Kōbunkan.

Ono Ken-ichirō (1942): *Shinzō.* Tōkyō: Hōunsha.

Sakai Saisui (1929): *Nippon mokuchō shi.* Tōkyō: Taimusu Shuppansha. (Repr. 1930.)

Tsukamoto Zenryū and Nakano Genzō (1968): *Kyōto no butsuzō.* Kyōto: Tankōsha.

Ueno Naoteru and Ogawa Seiyō (1942): *Jōdai no chōkoku.* Tōkyō: Asahi Shimbunsha.

Warner, Langdon (1936): *The Craft of the Japanese Sculptor.* New York: McFarlane, Warde, McFarlane, and Japan Society of New York.

Watson, William (1959): *Sculpture of Japan from the Fifth to The Fifteenth Century.* London: The Studio Limited.

With, Karl (1920): *Buddhistische Plastik in Japan.* 2nd ed. Wien: Kunstverlag Anton Schroll & Co.

(c) *Collections of Essays*

Adachi Yasushi (1944): *Nihon chōkoku shi no kenkyū.* Tōkyō: Ryūginsha.

Ikawa Kazuko (1975): *Nihon ko chōkoku shi ron.* Tōkyō: Kōdansha.

Kanamori Jun (1949): *Nihon chōkoku shi no kenkyū.* Kyōto: Kawahara Shoten.

Kobayashi Takeshi (1947): *Nihon chōkoku shi kenkyū.* Tamba-ichi: Yōtokusha.

Kuno Takeshi *et al.* (1964): *Kantō chōkoku no kenkyū.* Tōkyō: Gakuseisha.

Kuno Takeshi (1971): *Tōhoku kodai chōkoku shi no kenkyū.* Tōkyō: Chūō Kōron Bijutsu Shuppan.

Kurata Bunsaku (1965): *Butsuzō no zōnai to nōnyūhin.* Atami: Atami Shōji Kabushiki Kaisha.

Maruo Shōzaburō (1955): *Nippon chōkoku tembō.* 4 vols. Tōkyō: Nihon Bunkazai.

Noma Seiroku (1943): *Nippon chōkoku no bi.* Tōkyō: Fuji Shobō.

Oka Naomi (1966): *Shinzō chōkoku no kenkyū.* Tōkyō: Kadokawa Shoten.

(10) *General Works on Painting*

(a) *Illustrative Volumes and Series*

Bijutsu Shuppansha, ed. (1955–6): *Nippon no koten. Kaiga hen.* 6 vols. Tōkyō: Bijutsu Shuppansha.

Bowie, Theodore (1975): *Japanese Drawing.* Bloomington: Indiana University Art Museum.

Chūō Bijutsusha, ed. (1929): *Nihon fūzoku-ga taisei.* 10 vols. Tōkyō: Chūō Bijutsusha.

Gakushū Kenkyūsha (1969): (*Ō-Bei shūzō Nihon kaiga shūsei*) *Zaigai hihō.* 3 vols. Ed. Shimada Shūjirō (Vols. 1, 2) and Narazaki Muneshige (Vol. 3). Tōkyō: Gakushū Kenkyūsha.

Grilli, Elise (1959): *Golden Screens of Japan.* New

York: Crown Publishers, Inc., and London: Elek Books.

Grilli, Elise (1970): *The Art of the Japanese Screen*. New York and Tokyo: Weatherhill and Bijutsu Shuppansha. (Repr. 1971.)

Heibonsha, ed. (1956): *Nihon no meiga*. 12 vols. Tōkyō: Heibonsha.

Hillier, J. R. (1965): *Japanese Drawings, from the 17th through the 19th Century*. New York: Shorewood Publishers, Inc.

Hōchi Shimbunsha, ed. (1934): (*Kokuhō jūyō bijutsuhin*) *Kaiga tenrankai sōmokuroku*. 6 vols. Tōkyō: Ōtsuka Kōgeisha.

Kōdansha, ed. (1969–71): *Nihon kaigakan*. 11 vols. Tōkyō: Kōdansha.

Kōdansha, ed. (1973–): *Nihon no meiga*. Vols. 1– (in progress). Tōkyō: Kōdansha.

Kyōto Hakubutsukan (1941): *Kinsei meiga taikan*. 2 vols. Kyōto: Benridō.

Kyōto Kaiga Semmon Gakkō (1929–48): *Nippon meiga fu. Butsuga hen*. 22 parts. Kyōto: Benridō.

Kyōto Kokuritsu Hakubutsukan (1969): *Chūsei shōbyō-ga*. Kyōto: Kyōto Kokuritsu Hakubutsukan.

Mainichi Shimbunsha, ed. (1970): (*Kokuhō 50 sen*) *Nihon no kaiga*. Tōkyō, *etc*.: Mainichi Shimbunsha.

Mizuo Hiroshi (1967): *Ōgi-e meihin shū*. Kyōto: Kabushiki Kaisha Tankō Shinsha.

Murase, Miyeko (1971): *Byōbu. Japanese Screens from New York Collections*. New York: The Asia Society, Inc.

Nippon Bijutsu Gakuin (1920): *Fusuma-e zenshū*. 2 vols. Tōkyō.

Onshi Kyōto Hakubutsukan (1933): *Semmen gafu*. Kyōto: Geisōdō.

Onshi Kyōto Hakubutsukan (1941): *Nippon Kinsei meiga taikan*. 2 vols. Kyōto: Nakajima Taiseikaku Shuppanbu.

Ostier, Janette (1971): *Paysages japonais. Espace réel, espace métaphysique*. Paris: Galerie Janette Ostier.

Paine, R. T. (1935): *Japanese Screen Paintings*. 2 vols. Boston: Museum of Fine Arts.

Paine, R. T. (1939): *Ten Japanese Paintings in the Museum of Fine Arts, Boston*. New York: The Japan Society of New York.

Shūeisha (1966–7): (*Kokuhō*) *Nihon no meiga*. 4 vols. Ed. Noma Seiroku and Kawakita Michiaki. Tōkyō: Shūeisha.

Shūeisha (1976–): *Nihon bijutsu kaiga zenshū*. 25 vols. (in progress). Tōkyō: Shūeisha.

Tanaka Ichimatsu and Kobayashi Hideo, eds. (1966): *Nihon no kaiga*. Tōkyō: Chikuma Shobō.

Tōhō Shoin (1931–2): *Nihon-ga taisei*. 55 vols. Tōkyō: Tōhō Shoin.

Toyoda Yutaka (1933): *Koga*. Tōkyō: Kokindō.

Wada Mikio (1919): *Zetsudai shihō chō*. Tōkyō: Seigei Shuppan Gōshigaisha.

(b) *Surveys, Histories, and Special Studies*

Akiyama, Terukazu (1961): *La peinture japonaise*. Geneva: Editions d'Art, Albert Skira. (Eng. trans., *Japanese Painting*, 1961.)

Fujioka Sakutarō (1903): *Kinsei kaiga shi*. Tōkyō: Kinkōdō. (15th ed., rev., 1926; repr. Tōkyō: Sōgensha, 1941.)

Haruyama Takematsu (1949): *Nippon jōdai kaiga shi*. Tōkyō: Asahi Shimbunsha.

Haruyama Takematsu (1953): *Nippon chūsei kaiga shi*. Tōkyō: Asahi Shimbunsha.

Miyao Shigeo (1967): *Nihon no giga. Rekishi to fūzoku*. Tōkyō: Daiichi Hōki Shuppan Kabushiki Kaisha.

Naitō Tōichirō (1934–5): *Nippon bukkyō kaiga shi*. 3 vols. Kyōto: Masatsune Shoin.

Nakamura Tanio (1959): *Sumie no bi*. Tōkyō: Meiji Shobō.

Ōmura Fumio, ed. (1948): *Kō Nippon kaiga shi*. Vol. 1. Tōkyō: Hōunsha.

Takazaki Fujihiko (1966): *Nihon bukkyō kaiga shi*. Kyōto: Kyūryūdō.

Tsuji Nobuo (1970): *Kisō no keifu. Matabei – Kuniyoshi*. Tōkyō: Bijutsu Shuppansha.

(c) *Collections of Essays*

Doi Tsugiyoshi (1944): *Nippon Kinsei kaiga kō*. Kyōto: Kuwana Bunseidō.

Doi Tsugiyoshi (1948): *Kinsei kaiga shūkō*. Kyōto: Geisōdō Shuppanbu.

Doi Tsugiyoshi (1970): *Kinsei kaiga no kenkyū*. Tōkyō: Bijutsu Shuppansha.

Imazeki Tempō, ed. (1916): *Tōyō garon shūsei*. 2 vols. Tōkyō: Dokuga Shoin.

Kokusho Kankōkai (1928–9): *Nippon shoga-en*. 2 vols. Tōkyō: Kokusho Kankōkai. (Repr. Tōkyō: Meicho Kankōkai, 1970.)

Sakazaki Shizuka (1917): *Nippon gadan taikan*. Tōkyō.

Sakazaki Shizuka (1926–8) *Nippon garon taikan*. Vols. 1–2 (all published). Tōkyō: Arusu.

Sawamura Sentarō (1931): *Nippon kaiga shi no kenkyū*. Kyōto: Hoshino Shoten.

Shimomise Shizuichi (1956): *Nihon kaiga shi kenkyū*. Tōkyō: Fuzanbō.

Taki Seiichi (1943): *Taki Setsuan bijutsu ronshū. Nippon hen*. Tōkyō: Zauhō Kankōkai.

Tanaka Ichimatsu (1958): *Nihon kaiga shi no tembō*. Tōkyō: Bijutsu Shuppansha.

Tanaka Ichimatsu (1966): *Nihon kaiga shi ronshū*. Tōkyō: Chūō Kōron Bijutsu Shuppan.

Tanaka Shigehisa (1944): *Nippon hekiga no kenkyū*.

Ōsaka: Tōkadō Shobō.
Tani Shin-ichi (1941) *Kinsei Nippon kaiga shi ron*. Tōkyō: Dōtōsha.

(11) *General Reference Works*

Bunkachō, ed. (1972): *Jūyō bijutsuhin-tō nintei butsuken mokuroku*. Kyōto: Shibunkaku.
Bunkachō, ed. (1974): *Shitei bunkazai sōgō mokuroku*. Tōkyō: Daiichi Hōki Shuppan.
Bunkazai Kyōkai (1951–7): *Kokuhō zuroku*. 4 vols. Tōkyō: Bunkazai Kyōkai.
Bunkazai Hogo Iinkai, ed. (1961): *Kokuhō jiten*. Kyōto: Benridō. (Rev. and enlarged ed., 1968.)
Commission for Protection of Cultural Properties (1951–7): *National Treasures of Japan*. 4 vols. Tōkyō: Bunkazai Kyōkai. (Eng. ed. of Bunkazai Kyōkai 1951–7.)
Kobayashi Takeshi and Fujita Tsuneyo (1952): *Nippon bijutsu shi nempyō*. Tōkyō: Sōgensha.
Kuno Takeshi, ed. (1975): *Butsuzō jiten*. Tōkyō: Tōkyōdō Shuppan.
Kurokawa Harumura (1910): (*Teisei zōho*) *Kōko gafu*. 11 vols. In *Kurokawa Mayori zenshū* (6 vols., Tōkyō: Kokusho Kankōkai), Vols. 1–2. (Repr., 1 vol., Tōkyō: Kōkoku Kokusho Kankōkai, 1925.)
Mainichi Shimbunsha, ed. (1970): *Kokuhō jūyō bunkazai annai*. Tōkyō: Mainichi Shimbunsha.
Minamoto Toyomune (1940): *Nippon bijutsu shi nempyō*. Kyōto: Hoshino Shoten.
Minamoto Hōshū (Toyomune), ed. (1972): *Nihon bijutsu shi nempyō*. Tōkyō: Zauhō Kankōkai.
Nara-ken Kyōiku Iinkai Jimukyoku, ed. (1960): *Nara-ken no bunkazai*. Kōriyama-ichi: Nara-ken Kankō Shimbunsha. (3rd ed., rev. and enlarged, 1970.)
Nippon Bijutsuin (1916): *Bijutsu jiten*. Tōkyō.
Nihon Kōkogaku Kyōkai, ed. (1962): *Nihon kōkogaku jiten*. Tōkyō: Tōkyōdō Shuppan.
Okudaira Hideo (1957): *Nippon bijutsu benran*. Tōkyō: Bijutsu Shuppansha.
Saitō Ryūzō (1925): *Gadai jiten*. Tōkyō: Hakubunkan. (5th ed., 1929.)
Sawa Ryūken, ed. (1961): *Butsuzō zuten*. Tōkyō: Yoshikawa Kōbunkan.
Sawa Ryūken, ed. (1963): *Butsuzō annai*. Tōkyō: Yoshikawa Kōbunkan.
Suzuki Jūzō (1962): *Nihon hanga benran*. Tōkyō: Kōdansha.
Taki Sei-ichi, ed. (1931): *Nihon ko bijutsu annai*. 2 vols. Tōkyō: Heigo Shuppansha.
Tani Shin-ichi and Noma Seiroku, eds. (1952): *Nippon bijutsu jiten*. Tōkyō: Tōkyōdō.
Yoshida Teruji (1965–71): *Ukiyoe jiten*. 3 vols. Tōkyō: Gabundō.

(12) *Biographical Dictionaries*

Araki Nori (1934): *Dai Nippon Shoga Meika Taikan*. 4 vols. Tōkyō: Dai Nippon Shoga Meika Taikan Kankōkai.
Asaoka Okisada (1904): (*Zōtei*) *Koga bikō*. 17 vols. Rev. and enlarged by Ōta Kin. Tōkyō: Kōbunkan. (Repr. 4 vols., Tōkyō: Yoshikawa Kōbunkan, 1905.)
Hori Naonori and Kurokawa Harumura (1899): *Fusō meiga den*. 2 vols. In *Shiryō taikan*. Rev. by Kurokawa Mamichi. Tōkyō: Tetsugaku Shoin.
Ikeda Tsunetarō and Seikōkan Hensanbu, eds. (1926): (*Zōho*) *Nippon shoga kottō daijiten*. Tōkyō: Seikōkan Shoten.
Inoue Kazuo (1931): *Ukiyoe-shi den*. Tōkyō: Watanabe Hanga-ten.
Ishida Seitarō, ed. (1914): *Nippon shoga meika hennenshi*. 8 vols. Kyōto: Ishida Kōsuke.
Kuwabara Yōjirō (1930): (*Zōho*) *Ukiyoe-shi jinmei jisho*. Kyōto: Geisōdō.
Miyazaki Yukimaro, ed. (1908): *Dai Nippon meika zensho*. 7 vols. Tōkyō: Seizandō Shobō. (8th ed., 1911.)
Muramatsu Shōfū (1940–43): *Honchō gajin den*. 6 vols. Tōkyō: Chūō Kōronsha. (Repr., 1972–3.)
Roberts, Laurance P. (1976): *A Dictionary of Japanese Artists. Painting, Sculpture, Ceramics, Prints, Lacquer*. Tokyo and New York: Weatherhill.
Satō Aiko (1967): *Nihon mei gaka den*. Tōkyō: Seiabō.
Sawada Akira (1927): *Nippon gaka jiten*. 2 vols. Tōkyō: Kigensha. (Repr., Kyōto: Daigakudō Shoten, 1970.)
Shimizu Tōru (1954): *Ukiyoe jinmei jiten*. Tōkyō: Bijutsu Kurabu Shuppan.
Society of Friends of Eastern Art (1940): *Index of Japanese Painters*. Tokyo: Society of Friends of Eastern Art. (Repr., Rutland, Vt., and Tokyo: Charles E. Tuttle Company, 1958.)

(13) *Bibliographies*

Bijutsu Kenkyūjo, ed. (1941): *Tōyō bijutsu bunken mokuroku*. Tōkyō: Zauhō Kankōkai. (Repr., Tōkyō: Hakurinsha, 1967.)
Bijutsu Kenkyūjo, ed. (1969): *Nihon Tōyō ko bijutsu bunken mokuroku*. Tōkyō: Chūō Kōron Bijutsu Shuppan.
Harigaya Kaneyoshi *et al.* (1972): *Ukiyo bunken mokuroku*. 2 vols. Tōkyō: Mitō Shooku.
Kokkasha, ed. (1956): *Kokka sakuin*. Tōkyō: Asahi Shimbunsha.
Kokuritsu Bunkazai Kenkyūjo Bijutsu-bu (1954): *Tōyō bijutsu bunken mokuroku, 1946–1950*. Tōkyō.
Kokusai Bunka Shinkokai, ed. (1959): *K.B.S. Bibliography of Standard Reference Books for Japanese*

Studies, with Descriptive Notes. Vol. VII(A): *Arts and Crafts.* Tokyo: Kokusai Bunka Shinkokai. (Rev. ed., re-titled *Traditional Art and Architecture*, 1971.)

Tōkyō Kokuritsu Hakubutsukan (1948): *Tōyō bijutsu bunken mokuroku zokuhen, 1922–1945.* Tōkyō: Tōkyō Kokuritsu Hakubutsukan.

UNESCO, ed. (1973): *Bukkyō bijutsu bunken mokuroku, 1960–1969.* Tōkyō: Chūō Kōron Bijutsu Shuppan.

(14) *Periodicals*

Artistic Japan. 1888–91. 36 nos. in 6 vols. London: Sampson Low.

Bijutsu Gahō/ Fine Arts Magazine. Tōkyō: Gahōsha.

Bijutsu Kenkyū. 1932– . Tōkyō: Tōkyō Kokuritsu Bunkazai Kenkyūjo.

Bijutsushi. 1950– . Kyōto: Benridō.

Bukkyō Geijutsu/ Ars Buddhica. 1948– . Ōsaka: Mainichi Shimbunsha.

Fūzoku Gahō. 1889–1916. Nos.1–478. Tōkyō: Tōyōdō. (Repr. 1976–9.)

Gasetsu. 1937–44. Nos. 1–90. Tōkyō: Bijutsu Kenkyūjo.

Kobijutsu. 1963– . Tōkyō: Sansaisha.

Kokka. 1889– . Tōkyō: Kokkasha.

Kobunkazai no Kagaku. 1952– . Tōkyō: Kobunka Shiryō Shizen Kagaku Kenkyūkai.

Kokuritsu Hakubutsukan Nyūsu. Tōkyō: Tōkyō Kokuritsu Hakubutsukan.

Le Japon artistique. 1888–91. 36 nos. in 6 vols. Paris.

Myūjiamu/ Museum. 1951– . Tōkyō: Bijutsu Shuppansha.

Nara. 1924–34. Nos. 1–16. Nara: Nara Hakkōjo.

Nara Kokuritsu Bunkazai Kenkyūjo Gakuhō. 1954– . Tenri: Yōtokusha.

Nihon Bunkazai. 1955– . Tōkyō: Hoshikai Shuppanbu.

Nihon no bijutsu. 1966– . Tōkyō: Shibundō.

Nihon Kōkogaku Nempō. 1948– . Tōkyō: Nihon Kōkogaku Kyōkai.

Tōkyō Kokuritsu Hakubutsukan Kiyo. 1965– . Tōkyō: Tōkyō Kokuritsu Hakubutsukan.

Ukiyoe Geijutsu/ Ukiyo-e Art. 1962– . Tōkyō: Nihon Ukiyoe Kyōkai.

Ukiyoe no Kenkyū. 1921–9. Nos. 1–23. Tōkyō: Nippon Ukiyoe Kyōkai

Yamato Bunka. 1951– . Ōsaka: Yamato Bunkakan.

Yamato Bunka Kenkyū. 1954– . Nara: Yamato Bunka Kenkyūkai.

B: CHAPTER BIBLIOGRAPHIES

Chapter 2

(a) *General and Illustrative*

Groot, G. J. (1951): *The Prehistory of Japan.* New York.

Haguenauer, Ch. (1956): *Origines de la civilisation japonaise. Introduction à l'étude de la préhistoire du Japon (première partie).* (All published.) Paris.

Heibonsha, ed. (1959–62): *Sekai kōkogaku taikei.* 16 vols. Tōkyō: Heibonsha.

Kawade Shobō, ed. (1955): *Nihon kōkogaku kōza.* 7 vols. Tōkyō: Kawade Shobō.

Kidder, J. Edward, Jr (1959): *Japan Before Buddhism.* London: Thames & Hudson, and New York: Praeger. (Rev. ed., 1966.)

Kidder, J. Edward, Jr (1964): *Early Japanese Art. The Great Tombs and Treasures.* Princeton: Princeton University Press, and London: Thames & Hudson.

Kidder, J. Edward, Jr (1965): *The Birth of Japanese Art.* New York and Washington.

Kobayashi Yukio (1961): *Nihon kōkogaku gaisetsu.* Tōkyō.

Kōdansha, ed. (1964–5): *Nihon genshi bijutsu.* 6 vols. Tōkyō: Kōdansha.

Kōdansha, ed. (1977–) *Nihon genshi bijutsu taikei.* 6 vols. (in progress). Tōkyō: Kōdansha.

Murai Iwao (1971): *Kofun.* (*Nihon no bijutsu,* 57.) Tōkyō: Shibundō.

Saitō Tadashi (1955): *Nihon kōkogaku zukan.* Tōkyō: Yoshikawa Kōbunkan.

Saitō Tadashi (1961): *Nihon kofun no kenkyū.* Tōkyō: Yoshikawa Kōbunkan.

(b) *Haniwa, Pottery, and Dōtaku*

Gotō Shuichi (1931): *Haniwa shūsei zukan.* Teishitsu Hakubutsukan.

Gotō Shuichi (1933): *Haniwa ie shūsei. Akabori Chausuyama kofun kenkyū.* Tōkyō.

Kanaya Katsumi (1962): *Haniwa no tanjō.* Tōkyō: Kōdansha.

Kidder, J. Edward, Jr (1957): *The Jōmon Pottery of Japan* (*Artibus Asiae Supplementum,* XVII.) Ascona: Artibus Asiae.

Kidder, J. Edward, Jr (1968): *Jōmon Pottery.* Tokyo and Palo Alto: Kōdansha International.

Kobayashi Hisao (1967): *Kyūshū Jōmon doki no kenkyū.* Kumamoto: Kobayashi Hisao Sensei Ikō Kankōkai.

Miki Fumio (1957): *Haniwa.* Tōkyō: Asahi Shimbunsha.

Miki Fumio (1958): *Haniwa.* Tōkyō: Kōdansha.

Miki Fumio (1960): *Haniwa, The Clay Sculpture of*

Proto-historic Japan. Translated by Roy Andrew Miller. Rutland, Vt., and Tokyo: Charles E. Tuttle Company.

Miki Fumio (1967): *Haniwa.* (*Nihon no bijutsu*, 19.) Tōkyō: Shibundō.

Miki Fumio (1973): *Dōtaku.* (*Nihon no bijutsu*, 88.) Tōkyō: Shibundō.

Noma Seiroku (1942): *Haniwa no bi.* Tōkyō: Jurakusha.

Noma Seiroku (1957): *Tsuchi no geijutsu.* Tōkyō: Bijutsu Shuppansha.

Santorī Bijutsukan (1969): *Dogū to domen.* Tōkyō: Suntory Museum of Art.

Takahashi Kenji (1927): *Haniwa oyobi sōshingu.* Tōkyō: Kōkogaku Kōsha.

Takiguchi Hiroshi (1963): *Haniwa.* Tōkyō: Nihon Keizai Shimbunsha.

Takiguchi Shūzō and Noguchi Yoshimaro (1959): *Nihon no dogū.* Tōkyō: Kiinokuniya Shoten.

Tōkyō Teishitsu Hakubutsukan (1920): *Nippon haniwa zushū.* Tōkyō: Rekishi Sankōzu Kankōkai.

Tsuboi Masagorō (1901): *Haniwa kō.* Tōkyō: Tōyōsha.

Umehara Sueji (1927): *Dōtaku no kenkyū.* Tōkyō.

(c) *Tomb Painting*

Kobayashi Yukio (1964): *Sōshoku kofun.* Tōkyō: Heibonsha.

Kusaka Hakkō (1967): *Sōshoku kofun.* Tōkyō: Asahi Shimbunsha.

Otomi Shigetaka (1974): *Sōshoku kofun to moyō.* Tōkyō: Kōdansha.

Saitō Tadashi (1973): *Nihon sōshoku kofun no kenkyū.* 2 vols. Tōkyō: Kōdansha.

Saitō Tadashi (1975): *Kofun no kaiga.* (*Nihon no bijutsu*, 110.) Tōkyō: Shibundō.

Sakai Akihiro and Mori Teijirō (1972): *Sōshoku kofun.* Tōkyō: Asahi Shimbunsha.

Takahashi Kenji (1933): *Nippon genshi kaiga.* Tōkyō: Ōokayama Shoten.

Takamatsuzuka Kofun Sōgō Gakujutsu Chōsakai (1973): *Takamatsuzuka kofun hekiga.* Tōkyō: Bunkachō.

Chapter 3

(a) *General*

Kobayashi Takeshi (1948): *Gomotsu kondō butsuzō.* Tōkyō: Kokuritsu Hakubutsukan.

Matsushita, Takaaki (1959): *Japan, Ancient Buddhist Paintings.* New York: The New York Graphic Society.

Naitō Tōichirō (1943): *Asuka jidai no bijutsu.* Kyōto: Masatsune Shoin.

Noma Seiroku (1952): *Gomotsu kondō butsu.* Kyōto: Benridō.

Noma Seiroku and Taeda Mikihiro (1964): *Kondō butsu.* Tōkyō: Takeuchi Shoten.

Terao Isamu (1950): *Asuka chōkoku saiken.* Tōkyō.

Uehara Kazu (1968): (*Zōho*) *Tamamushi-zushi no kenkyū. Asuka Hakuhō bijutsu yōshiki shiron.* Tōkyō: Gannandō Shoten.

Uehara Shoichi, ed. (1968): *Asuka Hakuhō chōkoku.* (*Nihon no bijutsu*, 21.) Tōkyō: Shibundō.

Warner, Langdon (1923): *Japanese Sculpture of the Suiko Period.* New Haven: Yale University Press.

(b) *Hōryūji*

Asahi Shimbunsha, ed. (1968): *Hōryūji. Hekiga to Kondō.* Tōkyō: Asahi Shimbunsha.

Auboyer, Jeannine (1941): *Les influences et les réminiscences étrangères au Kondō du Hōryūji.* (Publications du Musée Guimet, Documents d'Art et d'Archéologie, II.) Paris: Librairie Orientaliste Paul Geuthner.

Benridō, ed. (1951): *Hōryūji Kondō hekiga shū/ Wall Paintings in the Kondo, Horyuji Monastery.* Kyōto: Benridō.

Bunkazai Hogo Iinkai (1961): *Hōryūji Kondō hekiga shū.* Tōkyō.

Hamada Kōsaku (1926): *Kudara Kannon.* Tōkyō: Idea Shoin.

Haruyama Takematsu (1948): *Keikōtō-shita no Hōryūji hekiga.* Nara: Ikaruga-sha.

Hōryūji, ed. (1954): *Hōryūji hihō no chōsa.* Nara: Hōryūji.

Kuno Takeshi and Hasegawa Denjirō (1958): *Hōryūji no chōkoku.* Tōkyō: Chūō Kōron Bijutsu Shuppan.

Kuno Takeshi et al. (1966): *Hōryūji no chōkoku.* Tōkyō: Bijutsu Shuppansha.

Mizuno Seiichi (1965): *Hōryūji.* (*Nihon no bijutsu*, Vol. 4.) Tōkyō: Heibonsha.

Mizuno Seiichi (1975): *Asuka Buddhist Art. Horyuji.* New York and Tokyo: Weatherhill. (Adaptation of Mizuno 1965.)

Murata Jirō, Ueno Teruo and Satō Tatsuzō (1960): *Hōryūji.* Tōkyō, etc.: Mainichi Shimbunsha.

Naitō, Tōichirō (1943): *The Wall-Paintings of Horyuji.* Translated and ed. by W. R. B. Acker and Benjamin Rowland, Jr. 2 vols. Baltimore: Waverly Press, Inc.

Nishikawa Shinji (1966): *Hōryūji Gojūtō no sozō.* Tōkyō: Nigensha.

Tanaka Ichimatsu (1952): *Hōryūji Kondō hekiga.* Kyōto: Benridō.

Tazawa Yutaka et al. (1949): *Hōryūji Shaka Sanzonzō.* Tōkyō: Iwanami Shoten.

Tazawa Yutaka et al. (1954): *Hōryūji Hōzō shōkondō*

butsuzō. Tōkyō: Iwanami Shoten.

Tōkyō Kokuritsu Hakubutsukan (1959): *Hōryūji kennō hōmotsu zuroku*. Tōkyō: Tōkyō Kokuritsu Hakubutsukan.

Tōkyō Kokuritsu Hakubutsukan (1966–75): *Hōryūji kennō hōmotsu*. 3 vols. Tōkyō: Kōdansha.

Tōkyō Kokuritsu Hakubutsukan (1967): *Hōryūji kennō hōmotsu mokuroku*. Tōkyō: Tōkyō Kokuritsu Hakubutsukan.

Chapter 4

(a) General

Asahi Shimbunsha, ed. (1961): *Tempyō no jihō*. Tōkyō: Asahi Shimbunsha.

Ishida Mosaku (1943): *Nara jidai bunka zakkō*. Tōkyō: Sōgensha.

Kawamoto Atsuo (1950): *Tempyō geijutsu no sōzōryoku*. Nagoya: Reimei Shobō.

Kobayashi Takeshi (1958): *Nara no bijutsu*. Tōkyō: Sōgensha.

Kuno Takeshi (1971): *Nara hyakubutsu*. Tōkyō: Kashima Kenkyūjo Shuppan.

Machida Kōichi (1947): *Tempyō chōkoku no tenkei*. Tōkyō: Zauhō Kankōkai.

Machida Kōichi (1973): *Nara ko bijutsu danshō*. Tōkyō: Yūshindō.

Oyama Shoten, ed. (1945): *Tempyō chōkoku*. Tōkyō: Oyama Shoten.

Sugiyama Jirō (1967): *Tempyō chōkoku*. (*Nihon no bijutsu*, 15.) Tōkyō: Shibundō.

Sugiyama Jirō (1968): *Daibutsu konryū*. Tōkyō: Gakuseisha.

Teishitsu Hakubutsukan (1937): *Tempyō jihō*. Tōkyō: Teishitsu Hakubutsukan.

Warner, Langdon (1959): *Japanese Sculpture of the Tempyō Period. Masterpieces of the Eighth Century*. Cambridge: Harvard University Press.

(b) Shōsōin

Asahi Shimbunsha, ed. (1960–2): *Shōsōin hōmotsu*. 3 vols. Tōkyō: Asahi Shimbunsha.

Harada Jirō (1932): *English Catalogue of Treasures in the Imperial Repository, Shōsōin*. Tōkyō: Imperial Household Museum.

Harada Jirō (1950): *The Shōsōin. An Eighth Century Repository*. Tōkyō: Mayuyama & Co.

Ishida Mosaku (1955): *Shōsōin Gigaku-men no kenkyū*. Tōkyō: Bijutsu Shuppansha.

Ishida Mosaku (1963): *Shōsōin to Tōdaiji*. Tōkyō: Mainichi Shūgakkai.

Ishida Mosaku and Wada Gun-ichi (1954): *Shōsōin*. Tōkyō: Mainichi Shimbunsha.

Shōsōin Jimusho (1965): *Shōsōin no hōmotsu*. Tōkyō: Asahi Shimbunsha.

Shōsōin Jimusho (1968): (*Kunaichō zōhan*) *Shōsōin no kaiga*. Tōkyō: Nihon Keizai Shimbunsha.

Sugiyama Jirō (1975): *Shōsōin. Ryūsa to shio no ka no himitsu o saguru*. Tōkyō: Burēn Shuppan.

Teishitsu Hakubutsukan (1928–55): *Shōsōin gomotsu zuroku*. 18 vols. Tōkyō: Teishitsu Hakubutsukan.

(c) Early Maṇḍalas

Bunkazai Hogo Iinkai, ed. (1964): *Kokuhō tsuzure-ori Taima Mandara*. Kyōto: Benridō.

Gakujutsusho Shuppankai, ed. (1969): *Chikō Mandara*. Tōkyō: Gakujutsusho Shuppankai.

Chapter 5

(a) General

Hasumi Shigeyasu (1962): *Kōnin Jōgan jidai no bijutsu*. Tōkyō: Tōkyō Daigaku Shuppankai.

Ishida Naotoyo (1969): *Mikkyō-ga*. (*Nihon no bijutsu*, 33.) Tōkyō: Shibundō.

Kuno Takeshi (1974): *Heian shoki chōkoku shi no kenkyū*. 2 vols. Tōkyō: Yoshikawa Kōbunkan.

Kurata Bunsaku (1967): *Mikkyō jiin to Jōgan chōkoku*. (*Genshoku Nihon no bijutsu*, Vol. 5.) Tōkyō: Shōgakkan.

Kurata Bunsaku (1970): *Jōgan chōkoku*. (*Nihon no bijutsu*, 44.) Tōkyō: Shibundō.

Saunders, E. Dale (1960): *Mudrā, a Study of Symbolic Gestures in Japanese Buddhist Sculpture*. New York: Pantheon Books.

Sawa Ryūken (1940): *Zuzō*. (*Tōyō Bijutsu Bunko*.) Tōkyō: Atoriesha.

Sawa Ryūken (1947): *Mikkyō bijutsu*. Kyōto: Daihasshū Shuppan Kabushiki Kaisha.

Sawa Ryūken (1955): *Mikkyō bijutsu ron*. Kyōto: Benridō. (2nd ed., 1960; 3rd ed., 1969.)

Sawa Ryūken (1961): *Nihon no mikkyō bijutsu*. Kyōto: Benridō.

Sawa Ryūken (1964): *Mikkyō no bijutsu*. (*Nihon no bijutsu*, Vol. 8.) Tōkyō: Heibonsha.

Sawa Ryūken (1972): *Art in Japanese Esoteric Buddhism*. New York and Tokyo: Weatherhill and Heibonsha. (Adaptation of Sawa 1964.)

Sawa Ryūken (1974): *Mikkyō no tera, sono rekishi to bijutsu*. Kyōto: Hōzōkan.

Takata Osamu (1959): *Daigoji Gojūtō hekiga*. Kyōto: Benridō.

Tōkyō Shimbun, ed. (1970): *Tendai no hihō ten*. Tōkyō: Tōkyō Shimbun.

(b) Maṇḍalas

Chandra, L. (1971): *The Esoteric Iconography of Japanese Mandalas*. New Delhi: International Aca-

demy of Indian Culture.

Hamada Takashi (1971): *Mandara no sekai. Mikkyō kaiga no tenkai*. Tōkyō: Bijutsu Shuppansha.

Tajima, Ryūjun (1959): *Les deux grands mandalas et le doctrine de l'ésoterisme Shingon*. Tōkyō.

Toganoo Shōun (1927): *Mandara no kenkyū*. Kōyasan: Kōyasan Daigaku Shuppanbu. (Repr. in *Toganoo zenshū*, Vol. 4, Kōyasan, 1958.)

Tōkyō Kokuritsu Bunkazai Kenkyūjo, ed. (1968): *Takao Mandara*. Tōkyō: Yoshikawa Kōbunkan.

Chapter 6

(a) *General*

Bijutsu Kenkyūjo, ed. (1938): *Fukiji hekiga*. (*Bijutsu Kenkyūjo Shiryō*, No. 6.) Tōkyō: Bijutsu Kenkyūjo.

Maruo Shōzaburō (1934): *Fujiwara no chōkoku*. Tōkyō: Iwanami Shoten.

Nakano Genzō (1970): *Fujiwara chōkoku*. (*Nihon no bijutsu*, 50.) Tōkyō: Shibundō.

Rosenfield, John (1967): *Japanese Arts of the Heian Period, 794–1185*. New York: The Asia Society, Inc.

Teishitsu Hakubutsukan (1937): *Fujiwara bijutsu shūei*. Kyōto: Benridō.

(b) *Byōdōin*

Bijutsu Kenkyūjo (1936): *Hōōdō unchū kuyō-butsu*. Tōkyō: Bijutsu Konwakai.

Bunkazai Hogo Iinkai (1958): *Hōōdō zufu. Hekiga hen*. Tōkyō: Bunkazai Hogo Iinkai.

Tsuda Noritake (1930): *Hōōdō no kenkyū*. Tōkyō: Oka Shoin.

(c) *Chūsonji*

Asahi Shimbunsha, ed. (1959): *Chūsonji*. Tōkyō: Asahi Shimbunsha.

Fujishima Gaijirō (1961): *Hiraizumi. Mōtsūji to Kanjizaiō-in no kenkyū*. Tōkyō: Tōkyō Daigaku Shuppankai.

Fujishima Gaijiro (1971): *Chūsonji*. Tōkyō: Kawade Shobō Shinsha.

Hiraizumi Chōsakai (1955): *Hiraizumi*.

Ishida Mosaku, ed. (1941): *Chūsonji taikan*. 3 vols. Tōkyō: Nihon Shuppan Haikyū Kabushikisha.

Saitō Ryūzō (1918): *Chūsonji taikan*. Tōkyō: Seikasha.

(d) *Shōtoku Taishi Eden*

Kikutake Jun-ichi (1973): *Shōtoku Taishi Eden*. (*Nihon no bijutsu*, 91.) Tōkyō: Shibundō.

Nara Kokuritsu Hakubutsukan (1965): *Shōtoku Taishi Eden. Haru no tokubetsu ten*. Nara: Nara Kokuritsu Hakubutsukan.

Nara Kokuritsu Hakubutsukan (1969): *Shōtoku Taishi Eden*. Tōkyō: Tōkyō Bijutsu.

Tanaka Shigehisa (1943): *Shōtoku Taishi Eden to sonzō no kenkyū*. Kyōto: Yamamoto Koshū Shashin Kōgei-bu.

Chapter 7

(a) *General*

Asahi Shimbunsha, ed. (1958): *Kamakura no bijutsu*. Tōkyō: Asahi Shimbunsha.

Ishida Ichirō (1956): *Jōdo-kyō bijutsu*. Kyōto: Heirakuji Shoten.

Kamakura Kokuhōkan (1953–61): *Kamakura Kokuhōkan zuroku*. 8 vols. Kamakura: Kamakura Kokuhōkan.

Kyōto Kokuritsu Hakubutsukan (1961): *Nihon no setsuwa-ga*. Kyōto: Benridō.

Matsushita Takaaki, ed. (1974): (*Kenkyū happyō to zadankai*) *Jōdo-kyō bijutsu no tenkai*. Hōkoku-sho. Kyōto: Bukkyō Bijutsu Kenkyū Ueno Kinen Zaidan Josei Kenkyūkai.

Mori Tōru (1971): *Kamakura jidai shōzō-ga no kenkyū*. Tōkyō: Misuzu Shobō.

Murayama Shūichi (1966): *Jōdo-kyō geijutsu to Mida shinkō*. Tōkyō: Shibundō.

Murayama Shūichi (1974): *Honji suijaku*. Tōkyō: Yoshikawa Kōbunkan.

Nara Kokuritsu Hakubutsukan (1956): *Raigō bijutsu ten mokuroku*. Nara: Nara Kokuritsu Hakubutsukan.

Nara Kokuritsu Hakubutsukan (1964): *Suijaku bijutsu*. Tōkyō: Kadokawa Shoten.

Nara Teishitsu Hakubutsukan (1938): *Nippon shōzō-ga zuroku*. Tōkyō: Benridō.

Shirahata Yoshi (1966): *Shōzō-ga*. (*Nihon no bijutsu*, 8.) Tōkyō: Shibundō.

(b) *Sculpture*

Kobayashi Takeshi (1954): *Busshi Unkei no kenkyū*. (*Nara Kokuritsu Bunkazai Kenkyūjo Gakuhō*, Vol. 1.) Tenri: Yōtokusha.

Kobayashi Takeshi (1969): *Shōzō chōkoku*. Tōkyō: Yoshikawa Kōbunkan.

Kuno Takeshi (1974): *Unkei no chōkoku*. Tōkyō: Heibonsha.

Maruo Shōzaburō (1940): *Dai busshi Unkei*. Tōkyō: Nippon Bunka Kyōkai.

Miyama Susumu and Yahagi Kazumi (1966): *Kamakura no chōkoku*. Tōkyō: Chūnichi Shimbun Shuppankyoku.

Mōri Hisashi (1954): *Kaikei no kenkyū*. Kyōto: privately printed.

Mōri Hisashi (1961): *Busshi Kaikei ron*. Tōkyō: Yoshikawa Kōbunkan.

Mōri Hisashi (1964): *Unkei to Kamakura chōkoku*. (*Nihon no bijutsu*, Vol. 11.) Tōkyō: Heibonsha.

Mōri Hisashi (1967): *Shōzō chōkoku*. (*Nihon no bijutsu*, 10.) Tōkyō: Shibundō.

Mōri Hisashi (1974): *Sculpture of the Kamakura Period*. New York and Tokyo: Weatherhill and Heibonsha. (Translation of Mōri 1964).

Nara Teishitsu Hakubutsukan (1932): *Kamakura chōkoku zuroku*. Kyōto: Benridō.

Nishikawa Shinji (1969): *Kamakura chōkoku*. (*Nihon no bijutsu*, 40.) Tōkyō: Shibundō.

Nishikawa Shinji (1976): *Chōsō chōkoku*. (*Nihon no bijutsu*, 123.) Tōkyō: Shibundō.

Okamoto Kenjirō (1948): *Unkei ron*. Tōkyō: Shinzenbisha.

Shibue Jirō (1974): *Kamakura chōkoku shi no kenkyū*. Yokohama: Yūrindō.

Tanabe Saburōsuke (1972): *Unkei to Kaikei*. (*Nihon no bijutsu*, 78.) Tōkyō: Shibundō.

Tanaka Manshū (1948): *Unkei*. Kyōto: Geisōdō.

(c) *Masks*

Gotō Shuku (1964): *Nō-men shi kenkyū josetsu*. Tōkyō: Meizendō Shoten.

Irie Yoshinori (1943): *Nō-men kentō*. Tōkyō: Shunjūsha Shōhakkan.

Kaneko Ryōun (1975): *Nō Kyōgen men*. (*Nihon no bijutsu*, 108.) Tōkyō: Shibundō.

Kaneko Ryōun and Taeda Mikihiro (1966): *Nihon no men*. Tōkyō: Chikuma Shobō.

Katayama Kurōemon (1944): *Kanze-ke denrai Nō-men shū*. Tōkyō: Hinoki Shoten.

Kongō Iwao (1930): *Nōgaku komen taikan*. Tōkyō: Nihon Tosho Kankōkai.

Kongō Iwao (1940): *Nō to Nō-men*. Tōkyō: Kōbundō Shobō.

Kongō Iwao (1940): *Nō-men*. 10 parts. Tōkyō: Kōbundō Shobō.

Kyōto Hakubutsukan (1933): *Nōgaku komen shū*. Kyōto: Kyōto Hakubutsukan.

Kyōto Kokuritsu Hakubutsukan (1965): *Nō-men sen*. Kyōto: Kōrinsha Shuppan Kabushiki Kaisha.

Mōri Hisashi (1955): *Nihon no kamen*. Kyōto: Kyōto Kokuritsu Hakubutsukan.

Nakajima Yasunosuke (1930–1): *Nōgaku komen taikan*. 12 vols. Kyōto: Nakajima Yasunosuke.

Nogami Toyoichirō (1935): *Nihon no kamen*. Tōkyō.

Nogami Toyoichirō (1936–7): *Nō-men*. 10 vols. Tōkyō: Iwanami Shoten.

Nogami Toyoichirō (1944): *Nō-men ronkō*. Tōkyō: Koyama Shoten.

Noma Seiroku (1943): *Nihon kamen shi*. Tōkyō: Keibun Shoin.

Noma Seiroku (1956): *Men*. Tōkyō: Kōdansha.

Perzynski, Friedrich (1925): *Japanische Masken*. 2 vols. Berlin and Leipzig: Walter de Gruyter.

Saitō Yoshinosuke, ed. (1920): *Nō-men taikan*. Tōkyō: Nōgaku Shoin.

Shirasu Masako (1964): *Nō-men*. Tōkyō: Kyūryūdō.

Takano Tatsuyuki (1942): *Men to Kyōgen*. Tōkyō: Tōkyōdō.

Teishitsu Hakubutsukan (1935): *Nippon kogaku men*. Tōkyō: Jurakusha.

Tōkyō Kokuritsu Hakubutsukan (1970): *Tōkyō Kokuritsu Hakubutsukan zuhan mokuroku. Kamen hen*. Tōkyō: Tōkyō Kokuritsu Hakubutsukan.

Yokoi Haruno (1928): *Nō-men shiwa*. Tōkyō: Nōgaku Shimpōsha.

Chapter 8

(a) *Yamato-e and Kara-e*

Akiyama Terukazu (1964): *Heian jidai sezoku-ga no kenkyū*. Tōkyō: Yoshikawa Kōbunkan.

Haruyama Takematsu (1950): *Heian-chō kaiga shi*. Tōkyō: Asahi Shimbunsha.

Ienaga Saburō (1942): *Jōdai Yamato-e nempyō*. Tōkyō: Zauhō Kankōkai. (Rev. ed., Tōkyō: Bokusui Shobō, 1966.)

Ienaga Saburō (1946): *Jōdai Yamato-e zenshi*. Kyōto: Kōtō Shoin. (Rev. ed., Tōkyō: Bokusui Shobō, 1966.)

Ienaga Saburō (1964): *Yamato-e*. (*Nihon no bijutsu*, Vol. 10.) Tōkyō: Heibonsha.

Ienaga Saburō (1973): *Painting in the Yamato Style*. New York and Tokyo: Weatherhill and Heibonsha. (Translation of Ienaga 1964.)

Kobayashi Ta-ichirō (1946): *Yamato-e shi ron*. Kyōto: Zenkoku Shobō.

Sakurai Seikō (1969): *Yamato-e to gunki monogatari*. Tōkyō: Mokujisha.

Shimomise Shizuichi (1944): *Kara-e to Yamato-e*. Ōsaka: Shinshindō.

Shimomise Shizuichi (1945): *Yamato-e shi kenkyū*. Tōkyō: Fuzambō.

Shimomise Shizuichi (1956): *Yamato-e shi = emakimono shi*. Tōkyō: Fuzambō.

Shirahata Yoshi (1967): *Yamato-e*. Kyōto: Kawahara Shoten.

(b) *Handscroll Painting*

Akiyama Terukazu (1968): *Ōchō emaki no tanjō. 'Genji Monogatari Emaki' o megutte*. (*Chūō Shinsho*, Vol. 173.) Tōkyō: Chūō Kōronsha.

Akiyama Terukazu (1976): *Genji-e*. (*Nihon no bijutsu*, 119.) Tōkyō: Shibundō.

Asano Nagatake *et al.*, eds. (1962): *Nihon kassen emaki*. Tōkyō: Jimbutsu Ōraisha.

Fujita Tsuneyo and Akiyama Terukazu (1957): *Shigisan Engi Emaki*. Tōkyō: Tōkyō Daigaku

Shuppankai.

Grilli, Elise (1958): *Japanese Picture Scrolls*. New York: Crown Publishers, Inc., and London: Elek Books.

Kadokawa Shoten, ed. (1957–): *Nihon emakimono zenshū*. Vols. 1– . (In progress.) Tōkyō: Kadokawa Shoten.

Kadokawa Shoten, ed. (1975–): *Shinshū Nihon emakimono zenshū*. Vols. 1– . (In progress.) Tōkyō: Kadokawa Shoten.

Kasai Masaaki (1971): *Shigisan Engi Emaki no kenkyū*. Kyōto: Heirakuji Shoten.

Kasai Masaaki (1973): *Tenjin Engi no rekishi*. (*Fūzoku Bunka Shi Sensho*, 10.) Tōkyō: Yūzankaku Shuppan.

Maho Tōru (1974): *Hōnen Shōnin Eden*. (*Nihon no bijutsu*, 95.) Tōkyō: Shibundō.

Miya Tsugio (1971): *Ippen Shōnin Eden*. (*Nihon no bijutsu*, 56). Tōkyō: Shibundō.

Miya Tsugio (1973): *Nihon no jigoku-e*. Tōkyō: Haga Shoten.

Mochizuki Shinjō (1940): *Emakimono no kanshō*. Tōkyō: Hōunsha.

Mushanokōji Jō (1963): *Emaki*. Tōkyō: Bijutsu Shuppansha.

Nara Kokuritsu Hakubutsukan (1971): *Shaji engi-e ten*. Nara: Nara Kokuritsu Hakubutsukan.

Nara Kokuritsu Hakubutsukan (1975): *Shaji engi-e*. Tōkyō: Kadokawa Shoten.

Okudaira Hideo (1940): *Emaki no kōsei*. (*Tōyō Bijutsu Bunko*.) Tōkyō: Atoriesha.

Okudaira Hideo (1957): *Emaki*. Tōkyō: Bijutsu Shuppansha.

Okudaira Hideo (1959): *Emaki no sekai*. Tōkyō: Sōgensha.

Okudaira Hideo (1962): *Emaki. Japanese Picture Scrolls*. Rutland, Vt., and Tokyo: Charles E. Tuttle Company.

Okudaira Hideo (1966): *Emakimono*. (*Nihon no bijutsu*, 2.) Tōkyō: Shibundō.

Ono Noritaka (1962): *Genji Monogatari zufu*. Tōkyō.

Seckel, Dietrich (1959): *Emakimono. The Art of the Japanese Painted Handscroll*. London: Jonathan Cape, and New York: Pantheon Books.

Shibusawa Keizō (1964–8): *Emakimono ni yoru Nihon jōmin seikatsu sakuin*. 5 vols. Tōkyō: Kadokawa Shoten.

Shirahata Yoshi (1968): *Ōchō no emaki*. Tōkyō: Kashima Shuppankai.

Shirahata Yoshi (1970): *Monogatari emaki*. (*Nihon no bijutsu*, 49.) Tōkyō: Shibundō.

Suzuki Keizō (1961): *Shoki emakimono no fūzoku shiteki kenkyū*. Tōkyō: Yoshikawa Kōbunkan.

Tanaka Ichimatsu, ed. (1929–43): *Nippon emakimono shūsei*. 22 vols., and 7 supplementary vols. Tōkyō:

Yūzankaku.

Tanaka Ichimatsu (1956): *Emakimono*. Tōkyō: Kōdansha.

Toda, Kenji (1935): *Japanese Scroll Painting*. Chicago: The University of Chicago Press.

Tōhō Shoin (1928): *Nippon emakimono zenshū*. 12 vols. Tōkyō: Tōhō Shoin.

Ueno Naoaki (1950): *Emakimono kenkyū*. Tōkyō: Iwanami Shoten.

Umezu Jirō (1968): *Emakimono sōkō*. Tōkyō: Chūō Kōron Bijutsu Shuppan.

Umezu Jirō (1969): *Emakimono zanketsu no fu*. Tōkyō: Kadokawa Shoten.

Umezu Jirō (1972): *Emakimono sōshi*. Kyōto: Hōzōkan.

(c) *Taira Sūtras and Sūtra Fans*

Akiyama Terukazu et al. (1972): *Semmen Hokekyō no kenkyū*. Tōkyō: Kashima Kenkyūjo Shuppan.

Kyōto Kokuritsu Hakubutsukan (1973): *Heike Nōkyō*. Kyōto: Kyōto Kōrinsha Shuppan.

Nara Teishitsu Hakubutsukan (1940): *Heike Nōkyō zuroku*. Kyōto: Benridō.

(d) *Kasen-e*

Mori Tōru (1970): *Uta-awase-e no kenkyū. Kasen-e*. Tōkyō: Kadokawa Shoten.

Shirahata Yoshi (1974): *Kasen-e*. (*Nihon no bijutsu*, 96.) Tōkyō: Shibundō.

Tōkyō Bijutsu Seinenkai (1962): *Sanjūrokkasen. Satake-bon*. Tōkyō: Tōkyō Bijutsu Seinenkai.

Tōkyō Bijutsu Seinenkai (1972): *Kasen. Sanjūrokkasen-e*. Tōkyō: Tōkyō Bijutsu Seinenkai.

Chapter 9

(a) *General*

Awakawa Yasuichi (1970): *Zen Painting*. Tōkyō and Palo Alto: Kōdansha International.

Dōmei Tsūshinsha, ed. (1971): *Higashiyama suiboku gashū*. 10 parts in 2 ports. Tōkyō: Dōmei Tsūshinsha.

Fontein, Jan, and Hickman, Money L. (1970): *Zen Painting and Calligraphy*. Boston: Museum of Fine Arts.

Fukui Rikichirō (1930): *Nippon suiboku-ga no genryū*. (Kyōto Hakubutsukan Kōen Shū, No. 7.) Kyōto.

Jurakusha (1933–6): *Higashiyama suiboku gashū*. 13 vols. Tōkyō: Jurakusha.

Kanazawa Hiroshi (1972): *Shoki suiboku-ga*. (*Nihon no bijutsu*, 69.) Tōkyō: Shibundō.

Kōdansha, ed. (1974–): *Suiboku bijutsu taikei*. Vols. 1– . (In progress.) Tōkyō: Kōdansha.

Kyōto Kokuritsu Hakubutsukan (1967): *Muromachi*

jidai bijutsu ten zuroku. Kyōto: Kyōto Kokuritsu Hakubutsukan.

Mainichi Shimbunsha Jūyō Bunkazai Iinkai, ed. (1971–): *Suiboku-ga*. Vols. 1– . (In progress.) Tōkyō: Mainichi Shimbunsha.

Matsushita Takaaki (1960): *Muromachi suiboku-ga*. Vol. 1 (all issued). Tōkyō: Muromachi Suiboku-ga Kankōkai.

Matsushita Takaaki (1967): *Suiboku-ga*. (*Nihon no bijutsu*, Vol. 13.) Tōkyō: Heibonsha.

Matsushita Takaaki (1975): *Ink Painting*. New York and Tokyo: Weatherhill and Heibonsha. (Translation of Matsushita 1967.)

Nezu Bijutsukan (1962): *Shōshō hakkei ten zuroku*. Tōkyō: Nezu Bijutsukan.

Ostier, Janette (1968): *Zen*. Paris: Galerie Janette Ostier.

Saito, Ryukyu (1959): *Japanese Ink-Painting*. Rutland, Vt., and Tokyo: Charles E. Tuttle Company.

Santorī Bijutsukan (1967): *Sengoku bushō no e*. Tōkyō: Santorī Bijutsukan.

Sawamura Sentarō (1931): *Nippon suiboku-ga no kenkyū*. Tōkyō.

Shimizu, Yoshiaki, and Wheelwright, Carolyn, eds. (1976): *Japanese Ink Paintings from American Collections. The Muromachi Period*. Princeton: The Art Museum, Princeton University.

Sugahara Hisao (1967): *Japanese Ink Painting and Calligraphy, from the Collection of the Tokiwayama Bunko, Kamakura, Japan*. Brooklyn: The Brooklyn Museum.

Tankōsha (1972): *Gyobutsu shūsei*. 2 vols. Kyōto: Kabushiki Kaisha Tankōsha.

Tani Shin-ichi (1942): *Muromachi jidai bijutsu shi ron*. Tōkyō: Tōkyōdō.

Tōkyō Kokuritsu Hakubutsukan (1963): *Sō Gen no suiboku-ga*. Kyōto: Benridō.

Wakimoto Sokurō (1935): *Muromachi jidai no kaiga*. Tōkyō: Iwanami Shoten.

Watanabe Hajime (1948): *Higashiyama suiboku-ga no kenkyū*. Tōkyō: Zauhō Kankōkai.

Watanabe Akiyoshi (1976): *Shōshō hakkei zu*. (*Nihon no bijutsu*, 124.) Tōkyō: Shibundō.

Yashiro Yukio (1969): *Suiboku-ga*. (*Iwanami Shinsho*, 736.) Tōkyō: Iwanami Shoten.

(b) *Particular Artists*

Akiyama Teruo (1939): *Sōami Shiki sansui gasatsu*. Kyōto: Benridō.

Covell, Jon Carter (1941): *Under the Seal of Sesshu*. New York: privately printed.

Grilli, Elise, and Nakamura Tanio (1957): *Sesshu Toyo (1420–1506)*. Rutland, Vt., and Tokyo: Charles E. Tuttle Company.

Hasumi Shigeyasu (1958): *Sesshū*. Tōkyō.

Hasumi Shigeyasu (1961): *Sesshū Tōyō ron. Sono ningen-zō to sakuhin*. Tōkyō: Chikuma Shobō.

Kumagai Nobuo (1958): *Sesshū Tōyō*. Tōkyō: Tōkyō Daigaku Shuppankai.

Matsushita Takaaki (1974): *Sesshū*. (*Nihon no bijutsu*, 100.) Tōkyō: Shibundō.

Matsushita Takaaki and Suzuki Kei (1959): *Ryōkai, Mokkei, Gyokkan*. Tōkyō: Jurakusha.

Nakamura Tanio (1971): *Sesson to Kantō suiboku-ga*. (*Nihon no bijutsu*, 63.) Tōkyō: Shibundō.

Numata Raisuke (1912): *Gashō Sesshū*. Tōkyō: Juseidō.

Tajima Shiichi (1903–07): *Motonobu gashū*. 3 vols. Tōkyō: Shimbi Shoin.

Tajima Shiichi (1909): *Sesshū gashū*. Tōkyō: Shimbi Shoin.

Tajima Shiichi (1910): *Sesshū gashū zokushū*. Tōkyō: Shimbi Shoin

Tanaka Ichimatsu (1969): *Shūbun kara Sesshū e*. (*Nihon no bijutsu*, Vol. 12.) Tōkyō: Heibonsha.

Tanaka Ichimatsu (1972): *Japanese Ink Painting. Shūbun to Sesshū*. New York and Tokyo: Weatherhill and Heibonsha.

Tōkyō Kokuritsu Hakubutsukan (1956): *Sesshū*. Kyōto: Benridō.

Tōkyō Kokuritsu Hakubutsukan (1974): *Sesson. Tokubetsu tenkan*. Tōkyō: Tōkyō Kokuritsu Hakubutsukan.

Yamato Bunkakan (1961): *Sesson meisaku tokubetsu shutchin mokuroku*. Nara: Yamato Bunkanan.

Yoshimura Teiji (1975): *Sesshū*. Tōkyō: Kōdansha.

Chapter 10

Akiyama Teruo (1929): *Momoyama jidai shōheki-ga zushū*. Tōkyō: Jurakusha.

Akiyama Teruo (1930–5): *Kinpeki sōshoku-ga shū*. 4 vols. Tōkyō: Jurakusha.

Bijutsu Kenkyūjo (1937): *Momoyama jidai kinpeki shōheki-ga*. 2 vols. Tōkyō: Ōtsuka Kōgeisha.

Bijutsu Shuppansha (1966–71): *Shōheki-ga zenshū*. 10 vols. Tōkyō: Bijutsu Shuppansha.

Doi Tsugiyoshi (1943): *Sanraku to Sansetsu*. Kyōto: Kuwana Bunseidō. (Repr. 1944.)

Doi Tsugiyoshi (1943): *Momoyama shōhekiga no kanshō*. Tōkyō: Hōunsha.

Doi Tsugiyoshi (1944): *Sanraku-ha gashū*. Kyōto: Kuwana Bunseidō.

Doi Tsugiyoshi (1964): *Hasegawa Tōhaku, Shinshun dōjin setsu*. Kyōto: Bunkadō Shoten.

Doi Tsugiyoshi (1973): *Hasegawa Tōhaku*. (*Nihon no bijutsu*, 87.) Tōkyō: Shibundō.

Gray, Basil (1955): *Japanese Screen Painting*. London: Faber & Faber.

Meech-Pekarik, Julia, et al. (1975): Momoyama. Japanese Art in the Age of Grandeur. New York: The Metropolitan Museum of Art.

Minamoto Hōshū (1936): Nippon meihō Momoyama byōbu taikan. Kyōto: Kokumin Shimbunsha.

Minamoto Hōshū, ed. (n.d.): Tōhaku gasetsu. Kyōto: Bunkadō Shoten.

Mizuo Hiroshi (1963): Koto no shōheki-ga. Kyōto: Tankōsha.

Nakai Sōtarō (1927): Eitoku to Sanraku. Tōkyō: Chūō Bijutsusha.

Nakamura Tanio (1957): Eitoku. Tōkyō: Heibonsha.

Onshi Kyōto Hakubutsukan (1936): Momoyama jidai shō-byōbu gashū. Kyōto: Geisōdō.

Ōsaka-shi Yakusho (1935): Momoyama jidai bijutsu kōgei tenkan zuroku. Kyōto: Benridō.

Takeda Tsuneo (1971): Momoyama no kachō to fūzoku. Shōheki-ga no sekai. (NHK Bukkusu, 142.) Tōkyō: Nihon Hōsō Shuppan Kyōkai.

Takeda Tsuneo (1974): Kanō Eitoku. (Nihon no bijutsu, 94.) Tōkyō: Shibundō.

Tanaka Ichimatsu (1957): Momoyama no bi. Tōkyō: Bijutsu Shuppansha.

Teishitsu Hakubutsukan (1940): Nijō Rikyū shōheki-ga taikan. Kyōto: Benridō.

Wakisaka Atsushi (1970): Tōhaku. (Tōyō Bijutsu Sensho.) Tōkyō: Sansaisha.

Yamanaka Shōkai (1936): Jidai byōbu. Ōsaka: Yamanaka Shōkai.

Yoshimura Teiji (1968): Higashiyama bunka. Tōkyō: Bijutsu Shuppansha.

Chapter 11

Asahi Masahide (1932): Ōtsu-e. Kyōto: Naigaisha.

Asahi Masahide (1957): Ōtsu-e. Tōkyō: Bijutsu Shuppansha.

Doi Tsugiyoshi (1974): Kanō Tan-yū to sono shūhen. Kyōto: Kyōto Shimbunsha.

Katagiri Shūzō (1958): Ōtsu-e ni tsuite. Ōtsu: Katagiri Shūzō.

Katagiri Shūzō (1967): Ōtsu-e ni tsuite, 2 vols. Ōtsu: Ōtsu-e Hōzon Shinkōkai.

Katagiri Shūzō (1971): Ōtsu-e zufu.

Maeder, Julius (1944): Vom Ōtsu-e zum berühmtesten Bild der Welt. Zürich: Verlag E. A. Hofmann.

Matoya Katsu (1953): Ōtsu-e. Ōtsu: Ōtsu-e Hōzon Shinkōkai.

Morikawa Toshiyoshi (1926): Ōtsu-e senshū. Tōkyō: Ōtsu-e Kai.

Nippon Bijutsu Kyōkai (1931): Fukko Yamato-e shū. Tōkyō: Kōgeisha.

Onshi Kyōto Hakubutsukan (1929): Tamechika gashū. Kyōto: Benridō.

Saitō Ken, ed. (1912–14): Kanō-ha taikan. 2 vols.

Tōkyō: Kanō-ha Taikan Hakkōjo.

Sansaisha (1971): Tokushū. Ōtsu-e. (Ko Bijutsu, No. 33.) Tōkyō: Sansaisha.

Tōkyō Bijutsu Gakkō (1921): Hōgai Sensei iboku zenshū. Tōkyō: Saitō Shobō.

Umezawa Waken (1920): Hōgai to Gahō. Tōkyō: Junsei Bijutsu-sha.

Yanagi Sōetsu (1928): Shoki Ōtsu-e. Tōkyō: Kōseikai Shuppanbu. (2nd ed., 1930.)

Yanagi Sōetsu (1960): Ōtsu zuroku. Tōkyō: Sansaisha.

Yokoi Kiyoshi (1958): Early Ōtsu-e. Tōkyō: Mayuyama & Co.

Yoshikawa Mikata (1936): Ōtsu-e. Tōkyō: Kōseikaku.

Chapter 12

(a) General

Kōrinsha (1964:5): Sōtatsu Kōrin-ha semmen gashū. 10 parts Kyōto: Kōrinsha Shuppan.

Kōrinsha (1968–9): Rimpa kōgei senshū. 10 parts. Kyōto: Kōrinsha Shuppan.

Kyōto Shoin (1973–5): Rimpa kaiga senshū. 20 parts. Kyōto: Kyōto Shoin.

Lee, Sherman E. (1961): Japanese Decorative Style. Cleveland: The Cleveland Museum of Art.

Mainichi Shimbunsha (1957): Kōetsu, Sōtatsu, Kōrin meisaku zuroku. Tōkyō: Mainichi Shimbunsha.

Mizuo Hiroshi (1966): Sōtatsu to Kōrin. (Nihon no bijutsu, Vol. 18.) Tokyo: Heibonsha.

Mizuo Hiroshi (1972): Edo Painting. Sotatsu and Korin. New York and Tokyo: Weatherhill and Heibonsha. (Translation of Mizuo 1966.)

Nihon Keizai Shimbunsha (1959): Rimpa shūsaku shū. Tōkyō: Nihon Keizai Shimbunsha.

Semmen Gashū Kankōkai, ed. (1926): Sōtatsu Kōrin semmen gashū. Tōkyō: Kōyōsha.

Stern, Harold P. (1971): Rimpa. Masterworks of the Japanese Decorative School. New York: Japan Society, Inc.

Tōkyō Kokuritsu Hakubutsukan (1952): Sōtatsu Kōrin-ha zuroku. Kyōto: Benridō.

Tōkyō Kokuritsu Hakubutsukan (1973): Rimpa. Sōritsu hyakunen kinen tokubetsu ten zuroku. Kyōto: Benridō.

(b) Kōetsu and Sōtatsu

Aimi Kōu (1956): Sōtatsu hitsu hatake kaeshi no byōbu. Tōkyō: Mitochū.

Ejima Ihei et al. (1970): Kōetsu utai-bon. Kyōto: Yūshūdō.

Grilli, Elise (1956): Sotatsu. Rutland, Vt., and Tokyo: Charles E. Tuttle Company.

Hayashiya Tatsusaburō (1970): Kōetsu. Tōkyō: Daiichi Hōki Shuppan.

Hiraki Seikō (1966): *Gashō Kōetsu*. Tōkyō: Tōkyō Kōetsu Kankōkai.

Kōrinsha (1966): (*Doitsu Berurin Kokuritsu Hakubutsukan zō*) *Kōetsu shikishi chō*. Commentary by Minamoto Hōshū. Kyōto: Kōrinsha Shuppan Kabushiki Kaisha.

Kōrinsha (1967): (*Yamatane Bijutsukan zō*) *Kōetsu tanzaku chō*. Commentary by Minamoto Hoshu. Kyōto: Kōrinsha Shuppan Kabushiki Kaisha.

Masaki Atsuzō (1945): *Hon-ami gyōjōki to Kōetsu*. Tōkyō: Daigadō. (Repr., Tōkyō: Chūō Kōron Bijutsu Shuppan, 1965.)

Murashige Yasushi (1970): *Sōtatsu*. (*Tōyō Bijutsu Sensho*.) Tōkyō: Sansaisha.

Nihon Keizai Shimbunsha (1961): *Tawaraya Sōtatsu ten*. Tōkyō: Nihon Keizai Shimbunsha.

Nihon Keizai Shimbunsha (1966): *Sōtatsu*. Tōkyō: Nihon Keizai Shimbunsha.

Nippon Bijutsu Kyōkai (1912): *Sōtatsu gashū*. Tōkyō: Shimbi Shoin.

Nippon Bijutsu Kyōkai (1915): *Kōetsu-ha san meika shū*. Tōkyō: Shimbi Shoin.

Ogiwara Yasunosuke (1955): *Sōtatsu suiboku-ga*. Tōkyō: Tōkyō Bijutsusha.

Omote Akira (1965): *Kōzan Bunko-bon no kenkyū. Utai-bon no bu*. Tōkyō: Wanya Shoten.

Onshi Kyōto Hakubutsukan (1935): *Kōetsu ihō*. Kyōto: Benridō.

Tanaka Ichimatsu (1955): *Sōtatsu*. (Āto Bukkusu.) Tōkyō: Kōdansha.

Tani Shin-ichi (1938): *Sōtatsu*. (*Tōyō Bijutsu Bunko*.) Tōkyō: Atoriesha.

Tokugawa Yoshinori (1948): *Sōtatsu no suiboku-ga*. Tōkyō: Zauhō Kankōkai.

Ushikubo, D. J. R. (1926): *Life of Kōyetsu*. Kyōto: Jigyokudō.

Waterhouse, D. B. (1966): *Tawaraya Sōtatsu and the Deer Scroll*. Seattle: Center for Asian Arts, University of Washington.

Watson, William (1959): *Sōtatsu*. London: Faber & Faber.

Yamane Yūzō (1956): *Sōtatsu*. Tōkyō: Heibonsha.

Yamane Yūzō (1962): *Sōtatsu*. Tōkyō: Nihon Keizai Shimbunsha.

Yamato Bunkakan (1965): *Kōetsu ten*. Nara: Yamato Bunkakan.

(c) *Kōrin and Kenzan*

Aimi Kōu (1958): *Kōrin*. Tōkyō: Misuzu Shobō.

Bijutsu Shuppansha (1955): *Kōhakubai zu, Enshika zu.* (*Nihon no koten. Kaiga hen*.) Tōkyō: Bijutsu Shuppansha.

Chizawa Teiji (1957): *Kōrin*. Tōkyō: Heibonsha.

Chizawa Teiji (1970): *Kōrin*. (*Nihon no bijutsu*, 53.)

Tōkyō: Shibundō.

Geisōdō (1907): *Kōrin moyō*. 2 vols. Kyōto: Geisōdō.

Geisōdō (1920): *Kōrin zuroku*. Kyōto: Geisōdō.

Hiraki Seikō (1956): *Kōrin to Kenzan*. Tōkyō: Ryōshin Shobō.

Kamimura Masuo (1940): *Kenzan, Hōitsu*. Tōkyō: Takamizawa Mokuhansha.

Kobayashi Bunshichi (1901): *Ogata-ryū shi taika shū*. Tōkyō: Kobayashi Bunshichi.

Kobayashi Ta-ichirō (1951): *Kenzan*. Tōkyō: Yūzankaku.

Kobayashi Ta-ichirō (1974): *Kōrin to Kenzan*. (*Kobayashi Ta-ichirō chosaku shū*, Vol. 6.) Kyōto: Tankōsha.

Kokkasha (1906): *Kōrin Kenzan meisaku shū*. Tōkyō: Kokkasha.

Kushi Takushin (1972): *Kenzan*. Tōkyō: Yūzankaku.

Kyōto Shoin (1952): *Kōrin-ha meiga shū*. 2 vols. Kyōto: Kyōto Shoin.

Kyōto Shoin (1953): *Kōrin-ha semmen gashū*. Kyōto: Kyōto Shoin.

Leach, Bernard (1966): *Kenzan and His Tradition*. London: Faber & Faber.

Nakano Kimei (1889): *Ogata-ryū hyakuzu*. Tōkyō: Shun-yōdō.

Nihon Keizai Shimbunsha (1965): *Kōrin meisaku ten*. Tōkyō: Nihon Keizai Shimbunsha.

Perzynski, Friedrich (1902): *Kōrin und seine Zeit*. Berlin: Marquardt & Co.

Randall, Doanda (1959): *Kōrin*. New York: Crown Publishers.

Tajima Shiichi (1903–06): *Kōrin-ha gashū*. 5 vols. Tōkyō: Shimbi Shoin.

Tanaka Ichimatsu *et al.* (1958): *Kōrin*. Tōkyō: Nihon Keizai Shimbunsha.

Yamane Yūzō (1962–): *Kōrin kankei shiryō to sono kenkyū*. Vol. 1– (in progress). Tōkyō: Chūō Kōron Bijutsu Shuppan.

(d) *Hōitsu and Shikō*

Doi Tsugiyoshi (1972): *Watanabe Shikō. Shōheki-ga*. Kyōto: Mitsumura Suiko Shoten.

Onshi Kyōto Hakubutsukan (1930): *Hōitsu Shōnin gashū*. Kyōto: Unsōdō.

Tanaka Heiandō, ed. (1937): *Hōitsu kachō shiki emaki*. Tōkyō: Tanaka Heiandō.

Chapter 13

(a) *Maruyama and Shijō Schools*

Hillier, J. (1974): *The Uninhibited Brush. Japanese Art in the Shijō Style*. London: Hugh M. Moss (Publishing), Ltd.

Kokkasha (1911): *Maruyama Shijō gakan*. Tōkyō:

Kokkasha.

Koya Jakuhyō (1916): *Maruyama Ōkyo*. (*Bijutsu Sōsho*.) Tōkyō: Bijutsu Sōsho Kankōkai.

Mitchell, C. H. (1971): *The Ilustrated Books of the Nanga, Maruyama, Shijo, and Other Related Schools of Japan. A Biobibliography*. With the assistance of Osamu Ueda. Tōkyō: privately printed. (Rev. ed., Los Angeles: Dawson's Book Shop, 1972.)

Moes, Robert (1973): *Rosetsu. Exhibition of Paintings by Nagasawa Rosetsu*. Denver: Denver Art Museum.

Onshi Kyōto Hakubutsukan (1936): *Ōkyo meiga fu*. Kyōto: Kobayashi Shashin Seihanjo Shuppanbu.

Onshi Kyōto Hakubutsukan (1937): *Rosetsu meiga fu*. Kyōto: Geisōdō.

Saitō Ken, ed. (1915): *Maruyama Shijō-ha rakkan impu*. Tōkyō: Juseidō.

Suzuki Susumu (1939): *Ōkyo*. (*Tōyō Bijutsu Bunko*.) Tōkyō: Atoriesha.

Suzuki Suzumu (1969): *Ōkyo to Goshun*. (*Nihon no bijutsu*, 39.) Tōkyō: Shibundō.

Suzuki Susumu (1973): *Kinsei itan no geijutsu. Jakuchū, Shōhaku, Rosetsu*. Tōkyō: Maria Shobō.

Tajima Shiichi (1907): *Maruyama-ha gashū*. 2 vols. Tōkyō: Shimbi Shoin.

Tajima Shiichi (1911): *Shijō-ha gashū*. Tōkyō: Shimbi Shoin.

Tōkyō Teishitsu Hakubutsukan (1937): *Ōkyo shasei chō*. Tōkyō: Tōkyō Teishitsu Hakubutsukan.

Toyama Usaburō, ed. (1936): *Ōkyo yōfū gashū*. Tōkyō: Kōgeisha.

(b) *Nagasaki and Dutch-influenced Artists*

French, Calvin L. (1974): *Shiba Kōkan. Artist, Innovator, and Pioneer in the Westernization of Japan*. New York and Tokyo: Weatherhill.

Hirafuku Hyakusui (1929): *Nihon yōga shokō*. Tōkyō: Iwanami Shoten.

Hosono Masanobu (1974): *Shiba Kōkan – Edo yōfū-ga no higeki-teki senkusha*. Tōkyō: Dokubai Shimbunsha.

Koga Jūjirō (1944): *Nagasaki kaiga zenshi*. Tōkyō: Hokkō Shobō. (Repr., Nagasaki: Nagasaki Bunkensha, 1966.)

Kuroda Genji (1924): *Seiyō no eikyō o uketaru Nippon-ga*. Kyōto: Naigai Shuppan.

Kuroda Genji (1929): *Kamigata-e ichiran*, Kyōto: Satō Shōtarō Shōten.

Kuroda Genji (1932): *Nagasaki-kei yōga*. Tōkyō: Sōgensha.

Kuroda Genji (1972): *Shiba Kōkan*. Tōkyō: Tōkyō Bijutsu.

Nagami Tokutarō (1927): *Nagasaki no bijutsu shi*. Enlarged ed. Tōkyō: Kateidō. (Repr., Kyōto: Rinsen Shoten, 1974.)

Nagayama Tokihide (1918): (*Taigai shiryō*) *Bijutsu taikan*. Vol. 1 (all issued?). Nagasaki: Onishi Kumezō.

Nakai Sōtarō (1942): *Shiba Kōkan*. Tōkyō: Atoriesha.

Nishimura Tei (1941): *Nippon dōban gashi*. Tōkyō: Shomotsu Tembōsha. (Repr. Takatsuki-ichi: Zenkoku Shobō, 1971.)

Ono Tadashige (1968): *Edo no yōgaka*. Tōkyō: Sansaisha.

Onshi Kyōto Hakubutsukan (1939): *Nagasaki-ha shasei Nansō meiga sen*. Kyōto: Benridō.

Shimmura Izuru and Gotō Hakuzan (1925): (*Meiji izen*) *Yōga ruishū*. Kyōto: Heian Seikadō.

Sugano Yō (1963): *Dōban-ga no gihō*. Tōkyō: Bijutsu Shuppansha.

Sugano Yō (1974): *Nihon dōban-ga no kenkyū. Kinsei*. Tōkyō: Bijutsu Shuppansha.

Toyama Usaburō (1932): *Nippon shoki yōga shikō*. Tōkyō: Kensetsusha.

Yamato Bunkakan (1969): (*Yōga no senkakusha*) *Shiba Kōkan ten*. Nara: Yamato Bunkakan.

(c) *Jakuchū*

Maria Shobō (1968): *Jakuchū tenjō-e*. Tōkyō: Maria Shobō. (3rd ed., 1970.)

Tajima Shiichi (1902): *Jakuchū meiga shū*. Tōkyō: Shimbi Shoin.

Tōkyō: Kokuritsu Hakubutsukan (1971): *Jakuchū. Tokubetsu tenkan*. Tōkyō: Tōkyō Kokuritsu Hakubutsukan.

Tōkyō Teishitsu Hakubutsukan (1926): *Gyobutsu Jakuchū dōshoku saiga seiei*. Tōkyō: Shichijō Kenzō.

Tsuji Nobuo (1974): *Jakuchū*. Tōkyō: Bijutsu Shuppansha.

Chapter 14

(a) *General*

Aoki Masaji (1949): *Nikka bunjinga dan*. Tōkyō: Kōbunkan.

Cahill, James (1972): *Scholar Painters of Japan. The Nanga School*. New York: The Asia Society, Inc.

Chūō Kōronsha (1957–9): *Nanga kenkyū*. 29 nos. Tōkyō: Chūō Kōronsha.

Chūō Kōronsha (1974–): *Bunjinga suihen*. 20 vols. (In progress.) Tōkyō: Chūō Kōronsha.

Covell, Jon C. (1962): *Japanese Landscape Painting*. New York: Crown Publishers, Inc.

Ichijima Kenkichi (1935): *Bunjin bokkaku o kataru*. Tōkyō: Nanyū Shoin.

Iijima Isamu (1966): *Bunjinga*. (*Nihon no bijutsu*, 4.) Tōkyō: Shibundō.

Ishikawa Jun (1959): *Nanga daitai*. (*Nihon Bunka Kenkyū*, 2.) Tōkyō: Shinchōsha.

Kindai Bijutsukan (1964): *Nihon shoki nanga ten*. Kamakura: Kindai Bijutsukan.

Kokkasha (1910): *Nanga shū*. 3 vols. Tōkyō: Kokkasha. (4th ed., 1918.)

Kubota Kanroku (1910): *Nanga jūtaika shū*. 2 vols. Tōkyō: Shimbi Shoin. (2nd ed., 1914.)

Milne Henderson (1975): *An Exhibition of Nanga Fan Painting*. London: Milne Henderson.

Nihon Keizai Shimbunsha (1971): (*Nanga meisaku ten*) *Nihon no bunjinga*. Ōsaka: Nihon Keizai Shimbunsha.

Okada Rihei (1973): *Haiga no bi*. Tōkyō: Hōshobō.

Tajima Shiichi (1909): *Bunjinga santaika shū*. Tōkyō: Shimbi Shoin.

Tanaka Kisaku (1972): *Shoki nanga no kenkyū*. Tōkyō: Chūō Kōron Bijutsu Shuppansha.

Togari Soshin-an (1934): *Ike Kashō Sha Shunsei Jūben Jūgi gasetsu*. Kyōto: Benridō.

Tōkyō Kokuritsu Hakubutsukan (1951): *Nihon nanga shū*. Kyōto: Benridō.

Tōkyō Kokuritsu Hakubutsukan (1962): *Nihon bunjinga kokunai hirō meisaku ten*. Tōkyō: Yomiuri Shimbunsha.

Tōkyō Kokuritsu Hakubutsukan (1965): *Nihon no bunjinga ten mokuroku*. Tōkyō: Tōkyō Kokuritsu Hakubutsukan.

Tōkyō Kokuritsu Hakubutsukan (1966): *Nihon no bunjinga*. Kyōto: Benridō.

Umezawa Seiichi (Waken) (1919): *Nippon nanga shi*. Tōkyō: Nanyōdō Shoten.

Umezawa Seiichi (1924): *Nanga kenkyū nanga no mikata*.

Umezawa Seiichi (1929): *Zōho Nippon nanga shi*. Kyōto: Rakutō Shoin. (Repr. 1931; also Kyōto: Shin Kyōku, 1933.)

Yamamoto Gen (1968): *Kaishien gaden kokuyaku shakkai. Tōyōga no egakikata shōkai*. Tōkyō: Geisōdō.

Yeung, Kao May-ching (1974): *Literati Paintings from Japan*. Preface by Hsio-yen Shih. Hong Kong: Art Gallery, Institute of Chinese Studies, Chinese University of Hong Kong.

Yonezawa Kaho and Yoshizawa Chū (1966): *Bunjinga*. (*Nihon no bijutsu*, Vol. 23.) Tōkyō: Heibonsha.

Yoshizawa Chū (1958): *Nanga*. Tōkyō: Misuzu Shobō.

Yoshizawa Chū et al. (1969): *Nanga to shasei-ga*. (*Genshoku Nihon no bijutsu*, Vol. 18.) Tōkyō: Shōgakkan.

(b) *Taiga*

Aimi Kōu (1916): *Ike Taiga*. Tōkyō: Bijutsu Sōsho Kankōkai.

Aoyama Tamikichi (1939): *Taigadō shoga chō*. Kyōto: Kusakabe Shoten.

Chūō Kōron Bijutsu Shuppan (1957–9): *Ikeno Taiga gafu*. 5 vols. Tōkyō: Chūō Kōron Bijutsu Shuppan.

Chūō Kōron Bijutsu Shuppan (1970): *Taiga no sho*. Tōkyō: Chūō Kōron Bijutsu Shuppan.

Hagiwara Annosuke (1942): *Taigadō iboku shō*. Kyōto: Hagiwara Annosuke.

Hitomi Shōka (1926): *Ike Taiga*. Tōkyō: Chūō Bijutsusha.

Hitomi Shōka (1937): *Taigadō o chūshin ni*. 5 nos. Kyōto: Kōyōro.

Kosugi Hōan (1942): *Taigadō*. Tōkyō: Mikasa Shobō.

Matsushita Hidemaro (1967): *Ike Taiga*. Tōkyō: Shunjūsha.

Matsushita Hidemaro (1970): *Ike Taiga Shōshō hakkei semmen chō*. Tōkyō: Chūō Kōron Bijutsu Shuppan.

Mori Senzō (1940): *Taiga*. (*Tōyō Bijutsu Bunko*, 21.) Tōkyō: Atoriesha.

Onshi Kyōto Hakubutsukan (1933): *Ikeno Taiga meiga fu*. Kyōto: Benridō.

Shibata Chikugai (1925): *Ike Taiga sensei senji yokō*. Tōkyō: Shibata-dō.

Suzuki Susumu and Takami Jun (1958): *Taiga*. Tōkyō: Misuzu Shobō.

Suzuki Susumu (1975): *Ike Taiga*. (*Nihon no bijutsu*, 114.) Tōkyō: Shibundō.

Yamanaka Rankei (1939): *Taigadō*. Tōkyō: Atoriesha.

Yoshizawa Chū (1957): *Ikeno Taiga*. (*Nihon no meiga*.) Tōkyō: Heibonsha.

Yoshizawa Chū (1960): *Ikeno Taiga sakuhin shū*. 2 vols. Tōkyō: Chūō Kōron Bijutsu Shuppansha.

Yoshizawa Chū (1973): *Ike Taiga*. Tōkyō: Shōgakkan.

(c) *Buson*

Andō Tsugio (1970): *Yosa Buson*. Tōkyō: Chikuma Shobō.

French, Calvin L., et al. (1974): *The Poet-Painters. Buson and His Followers*. Ann Arbor: The University of Michigan Museum of Art.

Hagiwara Sakutarō (1940): *Kyōshū no shijin Yosa Buson*. Tōkyō: Daiichi Shobō.

Kan Kampei (1925): *Buson no shin kenkyū*. Ōsaka: Ōsaka Mainichi Shimbunsha.

Kan Kampei (1926): *Buson to sono shūhen*. Ōsaka: Ōsaka Mainichi Shimbunsha.

Katō Hekigodō (1926): *Gajin Buson*. Tōkyō: Chūō Bijutsusha.

Katō Hekigodō (1930): *Buson*. (*Haijin shinseki zenshū*, Vol. 7.) Tōkyō: Heibonsha.

Kuriyama Riichi (1951): *Buson*. Tōkyō: Ichigaya Shuppansha.

Kuriyama Riichi (1955): *Buson*. Tōkyō: Kōbundō.

Morimoto Tetsurō (1959): *Shijin Yosa Buson no sekai*. Tōkyō: Shibundō.

Mutō Sanji, ed. (1922): *Buson gashū*. Tōkyō: Shimbi Shoin.
Nogihara Taizō (1933): *Kaitei Buson zenshū*. Kyōto: Kōseikaku.
Nogihara Taizō (1943): *Buson*. Tōkyō: Sōgensha.
Onshi Kyōto Hakubutsukan (1932): *Buson ihō*. Kyōto: Kobayashi Shashin Seihanjo Shuppanbu.
Sasaki Jōhei (1975): *Yosa Buson*. (*Nihon no bijutsu*, 109.) Tōkyō: Shibundō.
Shimizu Takayuki (1947): *Buson hyōden*. Tōkyō: Dai Hasshu Shuppan.
Shimizu Takayuki (1947): *Buson no geijutsu*. Tōkyō: Shibundō.
Shimizu Takayuki (1956): *Buson no kaishaku to kanshō*. Tōkyō: Meiji Shoin.
Suzuki Susumu (1956): *Buson*. (*Nihon no meiga*.) Tōkyō: Heibonsha.
Suzuki Susumu (1958): *Buson*. Tōkyō: Nihon Keizai Shimbunsha.
Teruoka Yasutaka (1954): *Buson – shōgai to bijutsu*. Tōkyō: Meiji Shoin.
Teruoka Yasutaka, ed. (1959): *Buson shū; Issa shū*. Tōkyō: Iwanami Shoten.
Watson, William (1960): *Yosano Buson*. London: Faber & Faber.
Yahankai (1933): *Buson meiga fu*. Kyōto: Benridō.

(d) *Gyokudō*

Akiba Kei, ed. (1940): *Gyokudō kinshi gafu*. Tōkyō: Jurakusha.
Miyake Kyūnosuke (1955–8): *Uragami Gyokudō shinseki shū*. 3 vols. Tōkyō: Bijutsu Shuppansha.
Miyake Kyūnosuke (1956): *Gyokudō*. Tōkyō: Bijutsu Shuppansha.
Nagamatsu Shun-yō (1925): *Gyokudō meiga san*. Ōsaka: Kiju Kinen Shuppan.
Ōhara Magosaburō (1933): *Uragami Gyokudō gafu*.
Shirasu Murabito (1924): *Gyokudō kinshi iboku shū*. Tōkyō: Bunseidō.
Suzuki Susumu (1958): *Uragami Gyokudō gashū*. Tōkyō: Nihon Keizai Shimbunsha.
Suzuki Susumu et al. (1970): *Tokushū. Uragami Gyokudō sono hito to sakuhin*. (*Kobijutsu*, No. 30.) Tōkyō: Sansaisha.
Tatsukawa Kiyoshi (1976): *Uragami Gyokudō. Hito to geijutsu*. Tōkyō: Kokusho Kankōkai.
Yano Kyōson (1926): *Uragami Gyokudō*. Tōkyō: Chūō Bijutsusha.

(e) *Mokubei*

Akiba Kei, ed. (1939): *Mokubei meiga*. Tōkyō: Jurakusha.
Nezu Bijutsukan (1960): *Aoki Mokubei ga*. Tōkyō: Nihon Keizai Shimbunsha.

Jurakusha, ed. (1942): *Mokubei meitō fu*. Tōkyō: Jurakusha.
Wakimoto Sokurō (1921): *Heian meitō-den (Mokubei)*. Kyōto: Rakutō-kai.

(f) *Chikuden*

Chikuden-kai (1955): *Chikuden sensei hyakunijūnen sai kinen gafu*. Tōkyō: Chikuden-kai.
Hyakunen Kinen Ten Kyōkai (1935): *Chikuden sensei meiga fu*. 2 vols.
Idemitsu Bijutsukan (n.d.): *Tanomura Chikuden*. Tōkyō: Idemitsu Bijutsukan.
Kizaki Aikichi (1934): *Tanomura Chikuden sensei*. Tōkyō: Sanyōkai.
Shimbi Shoin (1934): *Tanomura Chikuden sensei hyakusen chō*. 2 vols. Tōkyō: Shimbi Shoin.
Suzuki Susumu (1962): *Tanomura Chikuden ga*. Tōkyō: Nihon Keizai Shimbunsha.
Suzuki Susumu (1964): *Chikuden*. Tōkyō: Nihon Keizai Shimbunsha.
Togari Soshin-an, ed. (1935): *Chikuden meiseki dai zushi*. 2 vols. Kyōto: Benridō.

(g) *Kazan*

Fujimori Seikichi (1962): *Watanabe Kazan no hito to geijutsu*. Tōkyō: Shunjūsha.
Iijima Isamu (n.d.): *Kazan, Watanabe Noboru. 1793 (Kansei 5) – 1841 (Tempō 12)*. (*Kōdansha Āto Bukkusu* 18.) Tōkyō: Kōdansha.
Kazan-kai (1915): *Kazan zenshū*. Tōkyō: Kazan-kai.
Kokkasha (1908): *Kazan Chūgyo-jō*. Tōkyō: Kokkasha.
Kurahara Korehito (1969): *Watanabe Kazan, Isso hyakutai*. Tōkyō: Iwazaki Bijutsusha.
Kurahara Korehito (1973): *Watanabe Kazan. Shisō to geijutsu*. Tōkyō: Shin Nihon Shuppansha.
Mori Senzō (1942): *Watanabe Kazan*. 4th ed. Tōkyō: Sōgensha. (Repr., Tōkyō: Sōgen Shinsha, 1961.)
Ozawa Kōichi (1965): *Kazan Watanabe Noboru*. Aichi: Tawaramachi Bunkazai Chōsakai.
Suganuma Teizō (1947): *Kazan no kenkyū*. Tōkyō: Zauhō Kankōkai. (Repr., Tōkyō: Mokujisha, 1969.)
Sugiura Mimpei (1972): *Kazan tansaku*. Tōkyō: Kawade Shobō Shinsha.
Suzuki Seisetsu (1941): *Kazan zenshū*. Tōkyō: Toyohashi Kazan Sōsho Shuppansha.
Yashiro Yukio et al., eds. (1962): *Kazan*. Tōkyō: Tōkyō Chūnichi Shimbunsha.
Yoshizawa Chū (1956): *Watanabe Kazan*. Tōkyō: Tōkyō Daigaku Shuppankai.

(h) *Other Artists*

Matsushita Hidemaro (1959): *Kuwayama Gyokushū*. Tōkyō: Chūō Kōron Bijutsu Shuppan.

Onshi Kyōto Hakubutsukan (1938): *Bunchō ihō.* Kyōto: Benridō.

Suzuki Einosuke (1932): *Bunchō iboku ten zuroku.* 2 vols.

Yamato Bunka Kenkyūkai (1961): *Ryū Rikyō.* (*Yamato Bunka Kenkyū,* combined No., Apr.–June, 1961.)

Chapter 15

(a) *Namban Painting*

Chizawa Teiji (1961): *Kirishitan no bijutsu.* Tōkyō: Hōbunkaku.

Ikenaga Hajime (1932): *Hōsai banka dai hōkan.* 2 vols. Ōsaka: Sōgensha.

Ikenaga Hajime (1940): *Taigai kankei bijutsu shiryō nempyō.* Kōbe: Ikenaga Bijutsukan.

Ikenaga Hajime (1955): *Namban bijutsu sōmokuroku.* Kōbe: Shiritsu Kōbe Bijutsukan.

Kuga Ichio (1973): (*Shin shiryō ni motozuku*) *Kirishitan bijutsu no kenkyū.* Ōsaka: Kuga Ichio.

Kyōto Teikoku Daigaku Bungaku-bu (1923): *Kirishitan ibutsu no kenkyū.* (*Kyōto Teikoku Daigaku Bungaku-bu Kōkogaku Kenkyū Hōkoku,* Vol. 7.) Tōkyō: Tōkō Shoin. (Repr., 1926.)

Matsuda Kiichi (1969): *Kirishitan shijitsu to bijutsu.* Kyōto: Tankōsha.

Nagami Tokutarō (1930): *Namban byōbu taisei.* Tōkyō: Kōgeisha.

Nagami Tokutarō (1943): *Namban bijutsu shū.* Kyōto: Taigadō.

Namban-kai (1928): *Namban bijutsu shū.* Kyōto: Unsōdō.

Nishimura Tei (1945): *Nippon shoki yōfū-ga no kenkyū.* Kyōto: Zenkoku Shobō.

Nishimura Tei (1958): *Namban bijutsu.* Tōkyō: Kōdansha.

Okamoto Yoshitimo (1953): *Kirishitan yōga shi josetsu.* Tōkyō: Shōrinsha.

Okamoto Yoshitomo (1955): *Namban byōbu kō.* Tōkyō: Shōrinsha.

Okamoto Yoshitomo (1967): *Namban bijutsu.* (*Nihon no bijutsu,* Vol. 19.) Tōkyō: Heibonsha.

Okamoto Yoshitomo (1972): *The Namban Art of Japan.* New York and Tokyo: Weatherhill and Heibonsha. (Translation of Okamoto 1967.)

Okamoto Yoshitomo and Takamizawa Tadao (1970): *Namban byōbu.* 2 vols. Tōkyō: Kabushiki Kaisha Kashima Kenkyūjo Shuppankai.

Ōsaka Shiritsu Hakubutsukan (1971): *Kirishitan no ayumi.* Ōsaka: Ōsaka Shiritsu Hakubutsukan.

Sakamoto Mitsuru (1973): *Shoki yōfū-ga.* (*Nihon no bijutsu,* 80.) Tōkyō: Shibundō.

Takemura Satoru (1964): *Kirishitan ibutsu no kenkyū.*

Tōkyō: Kaibunsha.

Tōkyō Kokuritsu Hakubutsukan (1972): *Tōkyō Kokuritsu Hakubutsukan zuhan mokuroku. Kirishitan kankei ihin hen.* Tōkyō: Tōkyō Bijutsu.

(b) *Early Genre and Ukiyoe Painting*

Bijutsu Shuppansha (1955): *Kage yūraku zu.* Tōkyō: Bijutsu Shuppansha.

Fujikake Shizuya (1915): *Ukiyoe taika gashū.* Tōkyō: Ukiyoe Kenkyūkai.

Fujikake Shizuya (1924): *Ukiyoe.* Tōkyō: Yūzankaku.

Hōchi Shimbunsha (1932): *Nikuhitsu ukiyoe senshū.* Tōkyō: Hōchi Shimbunsha.

Idemitsu Bijutsukan (1971): *Kinsei Nihon fūzoku-ga ten.* Tōkyō: Idemitsu Bijutsukan.

Kaneko Fusui (1964): *Ukiyoe nikuhitsu gashū.* Tōkyō: Ryokuen Shobō.

Kaneko Fusui (1969): (*Kobayashi Wasaku-ke zō*) *Ukiyoe nikuhitsu meihin gashū.* Tōkyō: Gabundō.

Kishida Ryūsei (1926): *Shoki nikuhitsu ukiyoe.* Tōkyō: Iwanami Shoten.

Kōdansha (1962–3): *Nikuhitsu ukiyoe.* 2 vols. Tōkyō: Kōdansha. (Rev. ed., 1970.)

Kondō Ichitarō (1956): *Nikuhitsu ukiyoe.* Tōkyō: Dentsū.

Kondō Ichitarō (1957): *Kinsei shoki fūzoku-ga.* Tōkyō: Tōkyō Kokuritsu Hakubutsukan.

Kondō Ichitarō (1957): *Shoki fūzoku-ga.* (*Nihon no meiga.*) Tōkyō: Heibonsha.

Kondo Ichitaro (1961): *Japanese Genre Painting. The Lively Art of Renaissance Japan.* Rutland, Vt., and Tokyo: Charles E. Tuttle Company.

Kunaichō, ed. (1969): *Rakuchū ezu.* Tōkyō: Yoshikawa Kōbunkan.

Kyōto Kokuritsu Hakubutsukan (1961): *Nihon no setsuwa-ga.* Kyōto: Benridō.

Kyōto Kokuritsu Hakubutsukan (1966): *Rakuchū Rakugai zu.* Tōkyō: Kadokawa Shoten.

Kyōto Kokuritsu Hakubutsukan (1970): *Kyō meisho fūzoku zuten mokuroku.* Kyōto: Kyōto Kokuritsu Hakubutsukan.

Mainichi Shimbunsha (1957): *Nikuhitsu ukiyoe meisaku ten mokuroku.* Tōkyō: Isetan.

Mainichi Shimbunsha (1962): *Ukiyoe nikuhitsu ten.* Tōkyō: Mitsukoshiya.

Mainichi Shimbunsha (1964): *Nikuhitsu ukiyoe meisaku ten.* Tōkyō: Isetan.

Mitsukoshi (1954): *Nikuhitsu ukiyoe meisaku shū.* Tōkyō: Mitsukoshiya.

Mitsukoshi (1972): *Ukiyoe nikuhitsu meihin ten mokuroku.* Tōkyō: Ukokudō.

Narazaki Muneshige (1965): *Shoki ukiyoe.* Tōkyō: Kōdansha.

Ōmura Seigai (1943): *Kinsei fūzoku-ga shi.* Tōkyō:

Hōunsha.

Onshi Kyōto Hakubutsukan (1933): *Nikuhitsu ukiyoe taikan*. Kyōto: Benridō.

Onshi Kyōto Hakubutsukan (1935): *Nikuhitsu ukiyoe shū*. Kyōto: Geisōdō.

Satō Yoshi (1939): *Kinsei fūzoku ga*. (*Tōyō Bijutsu Bunko*.) Tōkyō: Atoriesha.

Shoki Ukiyoe Senshū Kankōkai (1928): *Shoki ukiyoe senshū*. Tōkyō: Jurakusha.

Stern, H. P. (1973): *Freer Gallery of Art, Fiftieth Anniversary Exhibition, I. Ukiyo-e Painting*. Washington: Smithsonian Institution.

Suwa Haruo and Naitō Akira (1972): *Edo zu byōbu*. Tōkyō: Mainichi Shimbunsha.

Suzuki Susumu *et al.* (1971): *Edo zu byōbu*. Tōkyō: Heibonsha.

Tajima Shiichi (1906–8): *Ukiyoe-ha gashū*. 5 vols. Tōkyō: Shimbi Shoin. (Repr., 1930, with additional vol. Also an English ed., *Masterpieces Selected from the Ukiyoyé School*, 5 vols., 1907–8.)

Takeda Tsuneo (1967): *Kinsei shoki fūzoku ga*. (*Nihon no bijutsu*, 20.) Tōkyō: Shibundō.

Tanaka Kei (1919): *Ukiyoe gashū*. 2 vols. Tōkyō: Tanaka Kei.

Tanaka Kisaku and Kishida Ryūsei (1927): *Shoki ukiyoe shūhō*. Tōkyō: Tanrokudō. (Repr., Tōkyō: Tanaka Shashin Seihan Insatsusho, 1928.)

Tanaka Masuzō, ed. (1911–13): *Ukiyoe gashū*. 3 vols. Tōkyō: Juseidō.

Tokugawa Bijutsukan (1969): (*Ukiyoe no seiritsu o saguru*) *Kinsei shoki fūzoku-ga ten*. Nagoya: Tokugawa Bijutsukan.

Tōkyō Kokuritsu Hakubutsukan (1957): *Kinsei shoki fūzoku-ga*. Kyōto: Benridō.

Tōkyō Kokuritsu Hakubutsukan (1957): *Kinsei shoki fūzoku-ga ten zuroku*. Tōkyō: Tōkyō Kokuritsu Hakubutsukan.

Tsuji Nobuo (1976): *Rakuchū Rakugai zu*. (*Nihon no bijutsu*, 121.) Tōkyō: Shibundō.

Yamane Yūzō (1967): *Momoyama no fūzoku-ga*. (*Nihon no bijutsu*, Vol. 17.) Tōkyō: Heibonsha.

Yamane Yūzō (1973): *Momoyama Genre Painting*. New York and Tokyo: Weatherhill and Heibonsha. (Translation of Yamane 1967.)

Young, Martie W., and Smith, Robert J. (1966): *Japanese Painters of the Floating World*. Ithaca: Andrew Dickson White Museum of Art, and Utica: Munson–Williams–Proctor Institute.

Chapter 16

(a) *Illustrative Series and General Surveys*

Asai Yūsuke (1935–6): *Kinsei nishikie sesō shi*. 8 vols. Tōkyō: Heibonsha.

Binyon, Laurence, and Sexton, J. J. O'B. (1923): *Japanese Colour Prints*. London: Ernest Benn. (2nd ed., London: Faber & Faber, 1960.)

Gakushū Kenkyūsha (1969–73): *Zaigai hihō. Ō-Bei shūzō ukiyoe shūsei*. Tōkyō: Gakushū Kenkyūsha.

Hara Sakae (1916): *Ukiyoe no moro ha*. 2 vols. Tōkyō: Kōgakkan.

Kikuchi Sadao (1969): *A Treasury of Japanese Wood Block Prints. Ukiyo-e*. New York: Crown Publishers. (Rev. version, Tōkyō: Tōkyō International Publishers, 1970. Both based on Tōkyō Kokuritsu Hakubutsukan 1956–8.)

Kōdansha (1961–2): *Nihon hanga bijutsu zenshū*. 8 vols. Tōkyō: Kōdansha.

Kōdansha (1965–6): *Ukiyoe. Bijin-ga, yakusha-e*. 7 vols. Tōkyō: Kōdansha.

Kōdansha (1968–9): *Masterworks of Ukiyo-e*. 10 vols. Tokyo and Palo Alto: Kōdansha International. (Mainly based on Kōdansha 1965–6.)

Kurth, Julius (1925–9): *Die Geschichte des Japanischen Holzschnitts*. 3 vols. Leipzig.

Lane, Richard (1962): *Masters of the Japanese Print*. London: Thames and Hudson, and New York: Praeger.

Michener, James (1954): *The Floating World*. New York: Random House.

Narazaki Muneshige and Mitchell, C. H. (1966): *The Japanese Print. Its Evolution and Essence*. Tokyo and Palo Alto: Kōdansha International.

Nihon Ukiyoe Kyōkai (1927): *Ukiyoe Kabuki gashū*. Tōkyō: Tōkō Shoin.

Nihon Ukiyoe Kyōkai (1966–8): *Ukiyoe meisaku senshū*. 20 vols. Tōkyō: Yamada Shoin.

Rumpf, Fritz (1924): *Meister des Japanischen Holzschnittes*. Berlin and Leipzig: Walter de Gruyter.

Sasagawa Rimpū *et al.* (1933–4): *Ukiyoe taika shūsei*. 20 vols. and 6 supplementary vols. Tōkyō: Daihōkaku Shuppan.

Shibui Kiyoshi (1926–8): *Genroku ko hanga shūei*. 2 vols. Tōkyō: Ko Hanga Kenkyū Gakkai.

Shuzui Kenji and Akiba Yoshimi (1931): *Kabuki zusetsu*. Tōkyō: Manyōkaku. (3rd ed., Tōkyō: Chūbunkan Shoten, 1944.)

Takahashi Seiichirō (1961): *Ukiyoe nihyaku gojūnen, shinshū*. Tōkyō: Chūō Kōron Bijutsu Shuppan.

Takahashi Seiichirō (1961): *The Japanese Woodblock Print through Two Hundred and Fifty Years*. Rev. ed. Tōkyō: Chūō Kōron Bijutsu Shuppan. (Translation of previous item.)

Tanaka Kisaku (1928): *Ukiyoe gaisetsu*. Tōkyō: Iwanami Shoten. (Repr., 1971.)

Tōkyō Kokuritsu Hakubutsukan (1956–8): *Ukiyoe zenshū*. 6 vols. Tōkyō: Kawade Shobō.

Yamana Kakuzō (1930): *Nihon no ukiyoe-shi*. Tōkyō:

Daiichi Shobō.

Yamamura Kōka and Machida Hirose (1919): *Shibai nishikie shūsei*. Tōkyō: Seikasha.

Yoshida Teruji, ed. (1931–2): *Ukiyoe taisei*. 12 vols. Tōkyō: Tōhō Shoin.

Yoshida Teruji (1939): *Ukiyoe tokuhon*. Tōkyō: Takamizawa Mokuhansha. (Repr. 1945.)

Yoshida Teruji (1943): *Ukiyoe bisan*. Tōkyō: Hokkō Shobō.

Yoshida Teruji (1962): *Ukiyoe abuna-e*. 3 vols. Tōkyō: Ryokuen Shobō.

Yoshida Teruji (1965–71): *Ukiyoe jiten*. 3 vols. Tōkyō: Gabundō.

(b) *Catalogues of Collections and Exhibitions*

Binyon, Laurence (1916): *A Catalogue of Japanese and Chinese Woodcuts . . . in the British Museum*. London: The Trustees of the British Museum.

Chūō Kōronsha (1976–): *Takahashi Seiichirō korekushon ukiyoe*. 7 vols. (in progress). Tōkyō: Chūō Kōronsha.

Gentles, Margaret O. (1965): *The Clarence Buckingham Collection of Japanese Prints. Volume II*. Chicago: The Art Institute of Chicago.

Gunsaulus, Helen C. (1955): *The Clarence Buckingham Collection of Japanese Prints*. Chicago: The Art Institute of Chicago.

Kawaura Ken-ichi (1918): *Ukiyoe hanga zenshū*. Tōkyō: Yoshizawa Shoten.

Kawaura Ken-ichi (1919): *Album of Old Japanese Prints of the Ukiyo-ye School*. Tōkyō: Yoshizawa & Co.

Keyes, Roger S., and Mizushima Keiko (1973): *The Theatrical World of Osaka Prints*. Philadelphia: Philadelphia Museum of Art.

Ledoux, Louis V. (1942–51): *Japanese Prints . . . in the Collection of Louis V. Ledoux*. 5 vols. New York: E. Weyhe (Vols. 1–3), and Princeton: Princeton University Press (Vols. 4–5).

Mainichi Shimbunsha (1964–6): *Hiraki korekushon ukiyoe*. 5 vols. Tōkyō: Mainichi Shimbunsha.

Michener, James (1959): *Japanese Prints from the Early Masters to the Modern*. Rutland, Vt., and Tokyo: Charles E. Tuttle Co.

Miura Hidenosuke (1925): *Matsukata ukiyoe hanga shū*. Ōsaka: Taiyō Shuppansha.

Moslé, A. G. (1914): *Œuvres d'art japonais . . . Collection Moslé*. 2 vols. Leipzig: E. A. Seemann.

Rumpf, Fritz (1928): *Sammlung Tony Straus-Negbaur. Japanische Holzschnitte des 17. bis 19. Jahrhunderts*. Berlin: Paul Cassirer u. Hugo Helbing.

Schmidt, Steffi (1971): *Katalog der chinesischen und japanischen Holzschnitte im Museum für Ostasiatische Kunst, Berlin*. Berlin: Bruno Hessling Verlag.

Stern, H. P. (1969): *Master Prints of Japan. Ukiyo-e Hanga*. New York: Harry N. Abrams, Inc.

Tōkyō Kokuritsu Hakubutsukan (1960–3): *Tōkyō Kokuritsu Hakubutsukan zuhan mokuroku. Ukiyoe hanga hen*. 3 vols. Tōkyō: Tōkyō Kokuritsu Hakubutsukan.

Vignier, Ch., and Inada Hogitaro, eds. (1909–14): *Estampes japonaises . . . exposées au Musée des Arts Décoratifs*. 6 vols. Paris: Longuet.

Waterhouse, D. B. (1964): *Harunobu and His Age*. London: The Trustees of the British Museum.

Waterhouse, D. B. (1975): *Images of Eighteenth-Century Japan*. Toronto: Royal Ontario Museum.

(c) *Particular Artists*

Bowie, Theodore (1964): *The Drawings of Hokusai*. Bloomington: Indiana University Press.

Goncourt, Edmond de (1891): *Outamaro. Le peintre des maisons vertes*. Paris: Bibliothèque-Charpentier.

Goncourt, Edmond de (1896): *Hokousai*. Paris.

Henderson, Harold G., and Ledoux, Louis V. (1939): *The Surviving Works of Sharaku*. New York: E. Weyhe.

Hillier J. (1955): *Hokusai. Paintings, Drawings and Woodcuts*. London: Phaidon Press.

Hillier, J. (1961): *Utamaro. Colour Prints and Paintings*. London: Phaidon Press.

Hillier, J. (1970): *Suzuki Harunobu*. Philadelphia: The Philadelphia Museum of Art.

Hirano, Chie (1939): *Kiyonaga. A Study of His Life and Works*. Cambridge: Harvard University Press.

Lane, Richard (1959): *Kaigetsudō*. Tōkyō: Kōdansha.

Mainichi Shimbunsha (1975): *Nikuhitsu Katsushika Hokusai*.

Miyatake Gaikotsu (1910): *Okumura Masanobu gafu*. Ōsaka: Gazoku Bunko.

Miyatake Gaikotsu (1911): *Nishikawa Sukenobu gafu*. Ōsaka: Gazoku Bunko.

Nakamura Masayoshi (1970): *Sharaku*. Tōkyō: Nōberu Shobō.

Ozaki Shūdō (1967): *Hokusai*. Tōkyō: Nihon Keizai Shimbunsha.

Robinson, B. W. (1961): *Kuniyoshi*. London: Her Majesty's Stationery Office.

Rumpf, Fritz (1932): *Sharaku*. Berlin: Lankwitz-Würfel Verlag.

Shibui Kiyoshi (1964): *Ukiyoe zuten 13. Utamaro*. (All published.) Tōkyō: Kazama Shobō.

Strange, E. F. (1925): *The Colour Prints of Hiroshige*. London: Cassell and Co.

Suzuki Jūzō (1970): *Hiroshige*. Tōkyō: Nihon Keizai Shimbunsha.

Suzuki Jūzō et al. (1971–3): *Hokusai tokuhon sashie shūsei*. 5 vols. Tōkyō: Bijutsu Shuppansha.

Uchida Minoru (1918): *Hiroshige*. Tōkyō: Iwanami Shoten. (Rev., enlarged ed., 1930.)

Yoshida Teruji (1941): *Utamaro zenshū*. Tōkyō: Takamizawa Mokuhansha.

Yoshida Teruji (1942): *Harunobu zenshū*. Tokyo: Takamizawa Mokuhansha.

Yoshida Teruji (1953): *Harunobu*. Tōkyō: Asoka Shobō.

(d) *Special Studies*

Einstein, Carl (n.d.): *Der Frühere Japanische Holzschnitt*. Berlin: Verlag Ernst Wasmuth.

Fujikake Shizuya (1943): *Ukiyoe no kenkyū*. 3 vols. Tōkyō: Yūzankaku.

Higuchi Hiroshi (1971): *Nagasaki ukiyoe*. Tōkyō: Mitō Shooku.

Ishida Mosaku *et al.* (1964): *Japanese Buddhist Prints*. Tokyo and Palo Alto: Kōdansha International. (Adaptation of Kōdansha 1961–2, Vol. 1.)

Ishii Kendō (1920): *Nishikie no kaiin no kōshō*. Tōkyō: Ise Tatsu Shōten. (Rev., enlarged ed., 1932.)

Ishii Kendō (1920): *Jihon nishikie ton-ya fu*. Tōkyō: Ise Tatsu Shōten.

Ishii Kendō (1929): *Nishikie no hori to suri*. Tōkyō: Geisōdō. (Repr. 1966.)

Nagami Tokutarō (1926): *Zoku Nagasaki hanga shū*. Tōkyō: Kateidō.

(e) *Book Illustration*

Brown, Louise Norton (1924): *Block Printing and Book Illustration in Japan*. London: George Routledge & Sons, and New York: E. P. Dutton & Co.

Hayashi Yoshikazu (1962–8): *Embon kenkyū*. 13 vols. Tōkyō: Yūkō Shobō.

Holloway, Owen E. (1957): *Graphic Art of Japan. The Classical School*. London: Alec Tiranti.

Kurokawa Mamichi, ed. (1914–15): *Nihon fūzoku zue*. 12 vols. Tōkyō: Nihon Fūzoku Zue Kankōkai.

Mizutani Futō (1916): *E-iri jōruri shi*. 3 vols. Tōkyō: Seika Shoin.

Mizutani Futō (1936): *Shinshū e-iri jōruri shi*. Tōkyō: Taiyōsha.

Nakata Katsunosuke (1950): *Ehon no kenkyū*. Tōkyō: Bijutsu Shuppansha.

Oda Kazuma (1931): *Ukiyoe to sashie geijutsu*. Tōkyō: Banrikaku.

Rumpf, Fritz (1932): *Das Ise Monogatari von 1608 und sein Einfluss auf die Buchillustration des 17. Jahrhunderts in Japan*. Berlin: Würfel Verlag.

Shibui Kiyoshi (1932–3): *Ukiyoe naishi*. 2 vols. Tōkyō: Daihōkaku Shobō.

Shibui Kiyoshi (1935): *Yoshiwara-bon*. Tōkyō: Ko Hanga Kenkyū Gakkai.

Toda Kenji (1931): *Descriptive Catalogue of Japanese and Chinese Illustrated Books in the Ryerson Library of the Art Institute of Chicago*. Chicago: The Art Institute of Chicago.

Part Two: Architecture

In Western Languages

BUHOT, Jean. *Histoire des arts du Japon. I, Des origines à 1350.* (Annales du Musée Guimet, Bib. d'art, nouv. sér. V.) Paris, 1949.

Imperial Japanese Commission to the Panama-Pacific International Exposition. *Japanese Temples and their Treasures*. Tōkyō, 1915.

MORSE, Edward S. *Japanese Homes and their Surroundings*. Boston, 1886; Dover ed., New York, 1961.

SADLER, A. L. *A Short History of Japanese Architecture*. Sydney and London, 1941.

SOPER, Alexander C. *The Evolution of Buddhist Architecture in Japan*. Princeton, 1942.

TAUT, Bruno. *Houses and Peoples of Japan*. Tōkyō, 1937; 2nd ed., Tōkyō, 1958.

In Japanese

GENERAL WORKS

AMANUMA, Shunichi. *Nihon Kenchikushiyō*. Nara, 1927.

AMANUMA, Shunichi, and SATO, Suke. *Dainihon Kenchiku Zenshi*. Ōsaka, 1933.

HATTORI, Katsukichi. *Nihon Kenchiku-shi*. Tōkyō, 1933.

HATTORI, Katsukichi. *Nihon Ko-kenchiku-shi*. Kyōto, 1926 ff.

Nihon Kenchiku Gakkai (Architectural Institute of Japan). *Nihon Kenchiku-shi Zushū* (Picture Book of Japanese Architecture in History, with comments). Tōkyō, 1947; Shōkokusha, rev., 1963.

SEKINO, Masaru, and ŌTA, Hirotarō. *Nihon Bijutsu Zusetsu*. (Section on architectural history.) Tōkyō, 1950.

SEKINO, Tadashi. *Nihon Kenchiku Kōwa*. Tōkyō, 1936.

SPECIALIZED WORKS

FUKUYAMA, Toshio. *Nihon Kenchiku-shi no Kenkyū*. Kyōto, 1943.

SEKINO, Masaru. *Nihon Jūtaka Shōshi*. Tōkyō, 1942.

CHAPTER 17

Translated titles used hereafter are those found on a Western-language title page, if any.

KASAI, S. 'Archaeological Consideration of Old Burial Mound at Hashizuka', *Kōkogaku Zasshi*, XXXIII, 3, 1943.

SEKINO, Tadashi. 'Architecture de l'époque protohistorique', *Tōyō Bijutsu*, 1930. (Special number on prehistoric and protohistoric arts.)

UMEHARA, Sueji. *Nihon no Ko-fumbo*. Tōkyō, 1947.

CHAPTER 18

ADACHI, Kō. 'Chapelle principale de Sin-yakusizi' (Shin Yakushiji), *Tōyō Bijutsu*, 1934. (Special number on the Nara period III.)

ADACHI, Kō. 'Stupa à sept étages, huit angles dans Saidaizi' (Saidaiji), *Tōyō Bijutsu*, XII, 1931.

ADACHI, Kō. 'On the date of the Tōtō of the Yakushiji temple', *Kokka*, Nos. 483, 485, 487, 491, 1931.

AIZU, Yaicchi. *Hōryūji, Hokkiji, Hōrinji Konryū Nendai no Kenkyū*. Tōkyō, 1933.

AMANUMA, Shunichi. 'Details of the Tempyō Architecture', *Bukkyō Bijutsu*, V, 1925.

FUKUYAMA, T. 'Hōrinji no Konryū ni kan-suru Gimon', *Yumedono*, XII, 1934.

FUKUYAMA, T. 'Questions on Hokkedō in Tōdaizi' (Todaiji), *Tōyō Bijutsu*, XXIII, 1936.

FUKUYAMA, T. 'Etude sur l'époque d'érection de Tōsyōdaizi' (Tōshōdaiji), *Tōyō Bijutsu*, XXIII, 1936. (Special number on the Nara period III.)

FUKUYAMA, T. 'Palais impérial de Nara, Hokkezi, chapelle du Grand Bouddha dans Tōdaizi et Dempōdō dans Hōryūzi' (Hōryūji), *Tōyō Bijutsu*, XXIII, 1936.

HAMADA, Seiryō. 'Hōryūji no Kondō to Rokuchō no Sekkutsu-ji', *Hōun*, VI, 1933.

HASEGAWA, Teruō. 'Shitennōji Kenchiku-ron', *Kenchiku Zasshi*, XXXIX, 1925.

ISHIDA, Mosaku. 'Pros and Cons of the Reconstruction of Hōryūji', *Kōkogaku Zasshi*, XXXIII, 6, 1943.

KITA, Sadakichi. 'Hōryūji Saikon Hi-saikon-ron no Kaiko', *Yumedono*, XII, 1934.

KOBAYASHI, ,Takeshi. 'Sur l'érection de Kondō de Tōsyōdaizi', *Tōyō Bijutsu*, 1933. (Special number on the Nara period II.)

ŌOKA, Minoru. 'Nanto Shichi-daiji Kenchiku-ron: Yakushiji', *Kenchiku Zasshi*, XLIII, 1930.

SEKINO, Tadashi. 'Origins and Characteristics of the Asuka Architecture', *Bukkyō Bijutsu*, XIII, 1929.

CHAPTER 19

KITA, S. 'Fujiwara-kyō no Kenkyū', *Yumedono*, XV, 1936.

SEKINO, Masuru. 'Zai Shigaraki Fujiwara no Toyonari no Itadono Kō', *Hōun*, XX, 1937.

URAMATSU KOZEN (1736–1804). *Daidairizu Kōshō* (Studies on the Heian Palace), completed in the 1790s. Published in *Zōtei Kojitsu Sōsho*, 3 vols. 1929–30.

CHAPTER 20

ADACHI, Kō. 'Sur la date de l'érection de la chapelle d'Amitabha à Hōkaizi' (Hōkaiji), *Tōyō Bijutsu*, XX, 1934.

AMANUMA, Shunichi. 'On the Architecture of the Amida Hall in the Heian Period', *Bukkyō Bijutsu*, X, 1927.

FUKUYAMA, T. 'Shoki Tendai Shingon Jiin no Kenchiku', *Bukkyō Kōkogaku Kōza*, III, 1936.

ŌOKA, Minoru. 'Tendai Shingon no Jiin Kenchiku', *Bukkyō Bijutsu*, XV, 1937.

CHAPTER 22

ADACHI, Kō. 'Kegon-stupa in Kentyōzi' (Kenchōji), *Tōyō Bijutsu*, XXIII, 1936.

AMANUMA, Shunichi. 'La Chapelle principale de "Shōseiin" et la chapelle "Shakadō" d'Umeda', *Tōyō Bijutsu*, I–II, 1929.

KANDA, Tomio. 'Sur l'architecture de Zyōdōdō dans Zyōdōzi' (Jōdodō, Jōdoji), *Tōyō Bijutsu*, XVIII, 1933.

TANABE, Tai. 'Zen-shū no Jiin Kenchiku', *Bukkyō Kōkogaku Kōza*, I, 1936.

CHAPTER 24

FUJISHIMA, Gaijirō. 'Nichiren-shū Jiin no Kenchiku', *Bukkyō Kōkogaku Kōza*, XIV, 1937.

FUJIWARA, Giichi. 'Jōdo Shin-shū no Jiin Kenchiku', *Bukkyō Kōkogaku Kōza*, IX, 1937.

ADDITIONAL BIBLIOGRAPHY TO PART TWO
CONTRIBUTED BY BUNJI KOBAYASHI

In Western Languages

ALEX, William. *Japanese Architecture* (The Great Ages of World Architecture). New York, 1963.

BLASER, Werner. *Japanese Temples and Tea Houses*. New York, 1956.

BLASER, Werner. *Structure and Form in Japan*. New York, 1963.

CARVER, Norman H. *Form and Space of Japanese Architecture*. Tōkyō, 1955.

DREXLER, Arthur. *The Architecture of Japan*. New York, Museum of Modern Art, 1966.

ENGEL, Heinrich. *The Japanese House. A Tradition for Contemporary Architecture*. Tōkyō, 1964.

GUNSAULUS, H. C. *Japanese Temples and Houses*. Chicago, 1924.

ISHIMOTO, Y. *Katsura: Tradition and Creation in Japanese Architecture* (texts by W. Gropius and K. Tange). New Haven, 1960.

ITŌ, ,Teiji, and FUTAGAWA, Y. *The Essential Japanese House*. Tōkyō, 1967.

Japan Times (ed.). *Architectural Japan, Old and New*. Tōkyō, 1936.

KIDDER, J. Edward. *Japanese Temples*. Tōkyō, 1966.

KIRBY, John B. *From Castle to Tea House*. Tōkyō, 1962.

KITAO, Harumichi. *Shoin Architecture in Detailed Illustrations*. Tōkyō, 1956.

KOBAYASHI, Bunji. *Japanese Architecture* (with captions in English). Tōkyō, 1968, rev. 1970.

NISHIHARA, Kiyoyuki. *Japanese Houses*. San Francisco, Calif., 1971.

ŌTA, Hirotarō (ed.). *Japanese Architecture and Gardens*. Tōkyō, 1966.

SHIN-KENCHUKUSHA (ed.). *A Guide to Japanese Architecture* (mostly modern architecture). Tōkyō, 1971.

YOSHIDA, Tetsuro. *The Japanese House and Garden*. New York and London, 1955, rev. 1959.

Articles in *Japan Architect*

Japan Architect, the English version of *Shin-kenchiku* (New Architecture), a monthly periodical published by Shin-kenchiku-sha, Tōkyō, since 1956, has produced a series of articles on many important historical buildings as well as on the philosophy behind them, each written by an expert and fully illustrated, with detailed description, history, measured drawings, and discussion of the technical problems of each building. They are very useful for advanced study.

A. *General*

ITŌ, Nobuo. 'The Styles of Japanese Architecture', June 1964, 69–73, 81–2, 88–91, 93–9.

ITŌ, Yōtarō. 'Kiwari-module of Traditional Japanese Architecture', June 1956, 63–4.

WATANABE, Yasutada. 'Architecture in the Asuka Period', June/July 1961, 14–18.

WATANABE, Yasutada. 'Styles and Technique in Ancient Japanese Architecture', June 1964, 100–1.

B. *Shintō Buildings*

FUKUYAMA, Toshio. 'Kasuga Taisha Shrine', January 1958, 86–90.

HARYU, Ichirō. 'The Tōshōgū at Nikkō', June 1964, 87.

HORIGUCHI, Sutemi. 'The Ancient Form of the Izumo Shrine', March 1961, 8–13.

'Ise Shrine', January/February 1959, 56–62.

MIYAGAWA, Torao. 'Reflections on the Ise Shrine', January/February 1959, 63–5.

MURATA, Jirō. 'Mioya Shrine of Kamo', December 1962, 84–91.

ŌMORI, Kenji. 'The Iwashimizu Hachiman Shrine', September 1964, 83–91, October 1964, 95–102.

ŌMORI, Kenji. 'The Main Hall of Ujigami Shrine', December 1964, 79–89.

ŌMORI, Kenji. 'The Ujigami Shrine Worship Hall', January 1965, 86–93.

ŌMORI, Kenji. 'The Seiryū-dō Worship Hall of Daigo-ji', March 1966, 87–94.

C. *Buddhist Buildings*

FUTAGAWA, Yukio. 'The Hall of the Great Buddha at the Tōdai-ji', June 1964, 47.

HIGUCHI, Kiyoshi. 'The Tōshōdai-ji', June 1964, 75–82.

ITŌ, Nobuo. 'The Nandaimon of the Tōdaiji Monastery', May 1957, 43–50.

ITŌ, Nobuo. 'The Hōryū-ji Temple', May 1961, 8–13.

ITŌ, Teiji. 'The Sangatsudō Hall of Tōdaiji', June 1957, 47–56.

KOBAYASHI, Bunji. 'Buddhist Halls of the Rakan-ji in Edo', January/February 1967, 141–52.

MORITA, Keiichi. 'Buddhist Temple Rengeōin', October 1956, 2–6.

MOTORA, Isao. 'Kiyomizu Shrine', November 1956, 2–8.

MURATA, Jirō. 'Hōoh-dō of Byōdō-in', December 1957, 40–1.

MURATA, Jirō. 'The Phoenix Hall at the Byōdō-in', January/February 1962, 122–7, March 1962, 82–9, April 1962, 81–7.

MURATA, Jirō. 'The Main Hall of the Daihōonji Temple', June 1962, 78–83, July 1962, 80–5.

MURATA, Jirō. 'The East Pagoda of the Yakushiji Temple', August 1962, 84–91.

MURATA, Jirō. 'The Main Hall of the Shūon-an Temple', September 1962, 76–81.

MURATA, Jirō. 'The Main Hall and West Gate of Kiyomizu Temple', October 1962, 86–93.

MURATA, Jirō, . 'The Pagoda of Ishiyama-dera', November 1962, 84–91.

MURATA, Jirō, . 'The Main Hall of Tōshōdai-ji', February 1963, 93–9.

MURATA, Jirō, . 'The Amitabha Hall at Hōkai-ji', May 1963, 105–9, June 1963, 97–103.

MURATA, Jirō, . 'The Five Storied Pagoda at Daigo-ji', July 1963, 91–7, August 1963, 97–103.

MURATA, Jirō. 'The Daishidō of the Kyōoh-gokoku-ji', September 1963, 86–93.

MURATA, Jirō. 'The Karamon of Daitoku-ji', December 1963, 75–83.

ŌKURA, Saburō. 'The Amitabha Hall, Hōkai-ji Monastery', September 1956, 27–32.

ŌMORI, Kenji. 'Main Hall of the Jōruri-ji', January 1964, 91–9.

ŌMORI, Kenji. 'The Reliquary Hall of the Enkaku-ji', May 1964, 83–90.

ŌMORI, Kenji. 'The Main Hall of the Kōryū-ji Keikyū-in', July 1964, 85–91.

ŌMORI, Kenji. 'The Amitabha Hall of the Kōrenji', August 1964, 91–8.

ŌMORI, Kenji. 'The Main Hall of the Chōju-ji', February 1965, 81–90.

ŌMORI, Kenji. 'The Great South Gate of Tōdai-ji', May 1965, 80–9.

ŌMORI, Kenji. 'The Buddha Hall of the Jishō-ji', December 1965, 85–93, January/February 1966, 121–9.

SHINOHARA, Kazuo. 'Jōdo-dō at the Jōdo-ji', June 1964, 48.

TAKESHIMA, , Takuichi. 'The Kondō and the Pagoda of Hōryū-ji', January 1957, 4–14.

TAKIZAWA, Mayumi. 'The East Pagoda of Yakushiji Temple', December 1956, 2–7.

D. Palaces and Castles

KISHIDA, Hideto. 'The Mauling of the Kyoto Palace', January/February 1963, 10–22.

'Kogosho in the Imperial Palace in Kyoto', April 1959, 6–16.

ŌKAWA, Naomi. 'Matsumoto Castle', September 1957, 34–42.

ŌMORI, Kenji. 'The Hikone Castle Dungeon', March 1965, 86–95, April 1965, 87–95.

ŌMORI, Kenji. 'The Himeji Castle Dungeon', April 1966, 87–96, May 1966, 83–91.

E. Domestic Architecture

FUJIOKA, Michio. 'Chōshūkaku in Sankei-en Garden', October 1957, 4–12.

FUJIOKA, Michio. 'Rinshun Pavilion', August 1958, 45–52.

FUJIOKA, Michio. ''The Katsura Detached Palace', July 1965, 85–94, August 1965, 85–94, September 1965, 87–96.

FUJIOKA, Michio. 'The Sumiya', August 1966, 87–95.

ITŌ, Teiji. 'The Katsura Villa', Novmber 1956, 61–8.

MURATA, Jirō. 'The Kōjō-in Pavilion at the Onjō-ji', May 1962, 80–7.

MURATA, Jirō. 'The Golden Pavilion', March 1963, 90–7, April 1963, 86–93.

MURATA, Jirō. 'The Daishi-dō of the Kyōoh-gokoku-ji', September 1963, 86–93.

MURATA, Jirō. 'The Shoin in the Manju-in', October 1963, 87–94, November 1963, 85–93.

ŌMORI, Kenji. 'Audience Hall and Shiro-shoin of the Nishi-Hongan-ji', March 1964, 93–100.

ŌMORI, Kenji. 'The Ryōgin-an Hōjō of the Tōfuku-ji', April 1964, 83–90.

ŌMORI, Kenji. 'The Silver Pavilion of Jishō-ji', November 1965, 86–95.

SHINOHARA, Kazuo. 'The Kō-no-ma of the Nishi-Hongan-ji', June 1964, 52–3.

TANIGUCHI, Yoshirō. 'Garden of Shūgakuin Detached Palace', April 1957, 3–8.

F. Tea-houses

FURUTA, Shōkin. 'Philosophy of Chashitsu, Tea Room – Introductory', January 1964, 86–90.

FURUTA, Shōkin. 'Philosophy of Chashitsu, Tea Room – Nijiriguchi', February 1964, 91–6.

FURUTA, Shōkin. 'Philosophy of Chashitsu, Tea Room – Tokonoma', March 1964, 87–92.

FURUTA, Shōkin. 'Philosophy of Chashitsu, Tea Room – Window', April 1964, 77–82.

FURUTA, Shōkin. 'Philosophy of Chashitsu, Tea Room – Garden', May 1964, 78–82.

FURUTA, Shōkin. 'Philosophy of Chashitsu, Tea Room – Flowers in the Tea-room', July 1964, 80–4.

FURUTA, Shōkin. 'Philosophy of Chashitsu, Tea Room – Stepping Stones', August 1964, 85–90.

FURUTA, Shōkin. 'Philosophy of Chashitsu, Tea Room – The Significance of Water', September 1964, 68–72.

FURUTA, Shōkin. 'Philosophy of Chashitsu, Tea Room – Ink Paintings for the Tokonoma, Bokuseki and Bokuga', October 1964, 88–94.

FURUTA, Shōkin. 'Philosophy of Chashitsu, Tea Room – Conclusion: The Tea Ceremony of Sen-no Rikyū', December 1964, 75–8.

HAYAKAWA, Masao. 'Space in the Tea-house Style', June 1964, 64–7.

MASUDA, Tomoya. 'Shōnantei of Saihō-ji Moss Garden', February 1957, 2–9.

ŌTA, Hirotarō. 'Historical Comments on Rikyū and Tea-room, Taian', August 1957, 32–9.

SHIRAI, Seiichi. 'Two-mats Tea-room, Taian', August 1957, 40–1.

'The Shunsōro in the Sankei-en Garden', April 1959, 43–8.

'Tōshintei Tea House', November 1957, 62–9.

G. Old Urban and Rural Houses

FUJIOKA, Michio. 'The Sumiya in Kyoto', August 1966, 87–95.

KURATA, Michitada. 'Farmhouses in Central Musashino', May 1958, 62–72.

ŌKAWA, Naomi. 'The Imanishi House in the Town of Imai', July 1959, 51–8.

H. Philosophy

Chashitsu, philosophy of, see above F. Tea-houses.

HAYAKAWA, Masao. 'Space in the Tea-house Style', June 1964, 64–7.

KARAKI, Junzō. 'The Japanese View of Nature', June 1964, 22–3.

KŌJIRO, Yūichirō. 'Architecture and Nature in Japan', June 1964, 24–35.

KŌJIRO, Yūichirō. 'Posts: The Basis of Japanese Interior Space', June 1964, 44–6.

KŌJIRO, Yūichirō. 'Space without Ceilings', June 1964, 61–3.

SHINOHARA, Kazuo. 'The Japanese Conception of Space', June 1964, 57.

I. Miscellaneous

ASANO, Kiyoshi. 'The Shōsōin Repository', January/February 1959, 66–72.

HARADA, Minoru. 'An Understanding of Japanese Architecture', June 1964, 43.

KISHIDA, Hideto. 'Castles in the Air', January 1963, 126–33.

TANIGUCHI, Yoshiro. 'Garden of Shūgakuin Detached Palace', April 1957, 3–8.

WATSON, Burton. 'Hillside Halls of Japanese Buddhism', June 1964, 36–42.

Japanese books and selected articles

GENERAL WORKS

AMANUMA, Shun-ichi. Nihon Kenchiku-shi Zuroku (Pictorial Records of Japanese Architecture in History). 6 vols. Hoshino Shoten, 1933–9.

Committee for Protection of Cultural Properties (ed.). Kokuhō Jiten (Encyclopedia of National Treasures). Benridō, 1961.

ITŌ, Nobuo. 'The Styles of Japanese Architecture', Japan Architect, June 1964.

Nihon Kenchiku-shi (History of Japanese Architecture), Kenchikugaku Taikei, IV. Shōkokusha, rev., 1968.

ŌOKA, Minoru. Nihon no Kenchiku (Architecture of Japan). Chūohkōron Bijutsu Shuppan, 1967.

ŌTA, Hirotarō. Nihon Kenchiku-shi Josetsu (An Introduction to the History of Japanese Architecture). Shōkokusha, rev., 1969.

ŌTA, Hirotarō. Nihon no Kenchiku (Architecture in Japan). Chikuma Shobō, 1968.

Sekai Kenchiku Zenshū (Encyclopedia of World Architecture), I–III (Japan). Heibon-sha, 1959–61.

SPECIALIZED WORKS

ASANO, Kiyoshi. Koji Kaitai (Disassembling Old Temple Buildings). Gakusei-sha, 1969.

Committee for Protection of Cultural Properties (ed.). Shitei Bunkazai Sōgō Mokuroku, Kenzōbutsu-hen (Inventory of the Registered Cultural Properties, Volume of Buildings). Daiichi Hōki Shuppan, 1967.

FUJITA, Motoharu. Heiankyō Hensen-shi (History of the Heian Capital). Suzukake Shuppanbu, 1930.

FUKUYAMA, Toshio. Nihon Kenchiku-shi Kenkyū (Studies on Japanese Architecture in History). Bokusui-shobō, 1968.

FUKUYAMA, Toshio (ed.). Jinja Kozushū (Collected Old Drawings of Shinto Temples). Nihon Dentsū-tsūshin Shuppanbu, 1942.

INAGAKI, Eizō. Jinja to Reibyō (Shinto Temples and Mausolea Temples) (Genshoku Nihon no Bijutsu, XVI). Shōgakukan, 1969.

INOUE, Mitsuo. Nihon Kenchiku no Kūkan (Space in Japanese Architecture). Kajima Shuppankai, 1969.

ITŌ, Heizaemon. Kenchiku no Gishiki (Rituals in Building Execution). Shōkokusha, 1959.

ITŌ, Yōtarō. 'Kiwari-module of Traditional Japanese Architecture', Japan Architect, June 1956, 63–4.

KIDA, Sadakichi. Teito (Capitals). Nihon Gakujutsu Shinkōkai, 1939.

NAKAMURA, Yūzō. Zusetsu Nihon Mokkōgu-shi (Illustrated History of Japanese Building Tools). Shinsei-sha, 1967.

ŌTA, Hirotarō. Nihon Jūtakushi (History of the Japanese House) (Kenchikugaku Taikei, XXVIII). Shōkokusha, 1970.

SEKINO, Masaru. Bunkazai to Kenchiku-shi (Cultural Properties and Architectural History). Kajima Shuppankai, 1969.

WATANABE, Yasutada. 'Styles and Technique in Ancient Japanese Architecture', Japan Architect, June 1964.

YANAGIDA, Kunio. Kyojū Shūzoku Goi (Glossary of House-living in Folklore). Minkan Denshō-no Kai, 1939.

JAPANESE GARDENS

Classical books

Sakutei-ki or *Senzai-hishō*. Written by Tachibana Toshitsuna (1028–94) in the Heian Period. Collection of Tanimura, in Kanazawa-shi. The reproduction was published in 2 scrolls, Kichōtosho Fukuseikai, 1938. See Dr Tamura's book cited below (Chapter 19).
Senzai narabini Nogata no Zu, probably compiled in the 1440s. Collection of Maeda in Tokyo.
Shokoku Chatei Meiseki Zu. Published in the late seventeenth century.
Tsukiyama Teizō-den. 2 vols. The first volume was written by Kitamura Enkin-sai in 1735, the second by Kakijima Kenshūri.

Modern books

HORIGUCHI, Sutemi. *Niwa to Kūkankōsei no Dentō* (Traditions in Gardening and Space Composition). Kajima Shuppankai, 1956.
Kyūtei no Niwa (Gardens of Palaces), 3 vols., text by T. Itō and others. Tankōshinsha, 1968.
Vol. I *Sentō Gosho* (The Ex-emperor's Palace).
Vol. II *Katsura Rikyū* (The Katsura Villa).
Vol. III *Shūgaku-in Rikyū* (Shūgaku-in Villa).
MORI, Osamu. *Nihon Teien no Dentō* (Traditions of Japanese Gardens). Ichijō Shobō, 1944.
MORI, Osamu. *Typical Japanese Gardens*. Shibata Publishing Co., 1962.
MORI, Osamu. *Nihon no Teien* (Gardens in Japan). Yoshikawa Kōbunkan, 1964.
NEWSOM, Samuel. *A Japanese Garden Manual for Westerners*. Tōkyō News Service, 1965.
SHIGEMORI, Mirei. *Nihon Teien-shi Zukan* (Pictorial Records of Japanese Gardens in History). 23 vols. Yūkōsha, 1937.
TANAKA, Masao. *Nihon no Teien* (Gardens in Japan). Kajima Shuppankai, 1967.
YOSHINAGA, Yoshinobu. *Nihon no Teien* (Gardens in Japan). Shibundō, 1958.
YOSHINAGA, Yoshinobu. *Nihon no Teien* (Gardens in Japan). Shōkokusha, 1958.
YOSHINAGA, Yoshinobu. *Nihon Teien no Kōsei to Hyōgen* (Composition and Expression of Japanese Gardens). Shōkokusha, 1962.

CHAPTER 17

FUJIMORI, Eiichi. *Idojiri* (Report of the Excavations of Idojiri). Chūohkōron Bijutsu Shuppan, 1965.
FUKUYAMA, Toshio. *Jingū no Kenchiku nikansuru*

Shiteki Chōsa (Historical Researches on Ise Jingū Buildings). Jingū Shichō, 1949.
GOTŌ, Moriichi. *Kōzukenokuni Sahagun Akaborimura Imai Chausuyama Kofun* (Survey of Chausuyama Burial Mound) (Transactions of the Imperial Household Museum in Tōkyō, VI). 1933.
Hiraide (Report of the Excavations in Hiraide). Asahi Shinbunsha, 1955.
HORIGUCHI, Sutemi. 'The Ancient Form of the Izumo Shrine', *Japan Architect*, March 1961.
Ise: Nihon Kenchiku no Genkei (Ise: The Origin of Japanese Architecture) (text by K. Tange and N. Kawazoe). Asahi Shinbunsha, 1962.
MIYAGAWA, Torao. 'Reflections on the Ise Shrine', *Japan Architect*, January/February 1959.
MIYASAKA, Fusakazu. *Togariishi*. Gakusei-sha, 1968.
Toro (Report of Excavations at Toro). Mainichi Shinbunsha, 1954.
WATANABE, Yasutada. *Ise to Izumo* (Ise and Izumo Shintō Temple) (*Nihon Bijutsu*, III). Heibonsha, 1964.

CHAPTER 18

AMANUMA, Shun-ichi. *Shitennōji Zuroku* (Pictorial Records of Shitennōji). 2 vols. Office of Shitennōji, 1936.
ASANO, Kiyoshi. *Hōryūji Kenchiku Sōkan* (Buildings of Hōryūji). Benridō, 1953.
ASANO, Kiyoshi. *Narajidai Kenchiku no Kenkyū* (Studies on Architecture in the Nara Period). Chūōkōron Bijutsu Shuppan, 1969.
ASANO, Kiyoshi. 'The Shōsōin Repository', *Japan Architect*, January/February 1959.
ASANO, Kiyoshi, and MŌRI, H. *Nara no Jiin to Tempyō Chōkoku* (Buddhist Temples in Nara and the Sculptures in the Tempyō Period) (*Genshoku Nihon no Bijutsu*, III). Shōgakukan, 1969.
Asuka-dera (Report of the Excavations of Asuka-dera). Research Institute of Cultural Properties in Nara, 1958.
Asuka Hakuhō no Kogawara (Roof-tiles in the Asuka and Hakuhō Periods). National Museum in Nara, 1970.
Eizanji Hakkakudō no Kenkyū (Studies on the Octagonal Hall of Eizanji). Bijutsu Kenkyūjo, 1951.
FUKUYAMA, Toshio. *Narachō Jiin no Kenkyū* (Studies on the Buddhist Temples in the Nara Period). Kōtōshoin, 1948.
FUKUYAMA, Toshio. *Narachō no Tōdaiji* (Tōdaiji in the Nara Period). Kōtōshoin, 1947.
FUKUYAMA, Toshio, and AKIYAMA, M. *Eizanji Hakkakudō* (The Octagonal Hall of Eizanji). National Museum in Tōkyō, 1950.

FUKUYAMA, Toshio, and HISANO, K. *Yakushiji.* Tōdai Shuppankai, 1959.

Gubukuji (Excavations Report of former *Kawaharadera*). Research Institute of Cultural Properties in Nara, 1960.

ISHIDA, Mosaku. *Asukajidai Jiinshi no Kenkyū* (Studies on the Sites of Buddhist Temples in the Asuka Period). 2 vols. Shōtoku Taishi Hōsankai, 1936; Ōtsuka Kōgeisha, 1944.

ISHIDA, Mosaku. *Tōdaiji to Kokubunji* (Tōdaiji and Kokubunji). Shibundō, 1959.

ISHIDA, Mosaku. *Narajidai Bunka Zakkō* (Cultural Studies of the Nara Period). Sōgensha, 1944.

ISHIDA, Mosaku. *Shōsōin to Tōdaiji* (Shōsōin and Tōdaiji). Mainichi Shūgakkai, 1962.

ISHIDA, Mosaku. *Garan Ronkō* (Studies on Buddhist Architecture). Yōtokusha, 1948.

ITŌ, Nobuo. 'The Hōryūji Temple', *Japan Architect*, May 1961.

ITŌ, Teiji. 'The Sangatsudō Hall of Tōdaiji', *Japan Architect*, June 1957.

Kōfukuji Jikidō Hakkutsu Chōsa Hōkoku (Excavation Report of the Dining Hall in Kōfukuji). Research Institute of Cultural Properties in Nara, 1959.

Kokubunji no Kenkyū (Studies on Kokubunji), ed. Bun-ei Tsunoda, Kōkogaku Kenkyūkai, 2 vols. 1938.

MACHIDA, Kōichi. *Yakushiji.* Jitsugyō Nihonsha, 1960.

MŌRI, Hisashi. *Shin-yakushiji Kō* (A Study on Shin-yakushiji). Kawara Shoten, 1947.

MURATA, Jirō. *Hōryūji no Kenkyū-shi* (History of the Studies on Hōryūji). Mainichi Shinbunsha, 1949.

MURATA, Jirō. 'The East Pagoda of the Yakushiji Temple', *Japan Architect*, August 1962.

MURATA, Jirō. 'The Main Hall of Tōshōdaiji', *Japan Architect*, February 1963.

Narajidai Sōbō no Kenkyū (Studies on the Monks' Quarters in the Nara Period). Research Institute of Cultural Properties in Nara, 1957.

Nara Rokudaiji Taikan (Pictorial Records of the Six Major Buddhist Temples in Nara). Iwanami Shoten, 1968–.

ŌOKA, Minoru. *Nanto Shichidaiji no Kenkyū* (Studies on the Seven Major Buddhist Temples in Nara). Chūōhkōron Bijutsu Shuppan, 1966.

ŌTA, Hirotarō. *Hōryūji Kenchiku* (Architecture of Hōryūji). Shōkokusha, 1943.

Shitennōji, ed. Committee for Protection of Cultural Properties, Excavation Reports, VI, 1967.

SUZUKI, Kakichi, and HISANO, K. *Hōryūji* (*Genshoku Nihon no Bijutsu*, II). Shōgakukan, 1969.

TAKESHIMA, Takuichi. 'The Kondō and the Pagoda of Hōryūji', *Japan Architect*, January 1957.

Tōdaiji Hokkedō no Kenkyū, ed. Kinki Nihon Tetsudō. Ōyasu Shuppan, 1948.

Tōshōdaiji, ed. Kinki Nihon Tetsudō. 1960.

Tōshōdaiji Ronsō (Collected Articles on Tōshōdaiji), ed. Tōshōdaiji. Kuwana Bunseidō, 1944.

TSUNODA, Bun-ei. *Saeki no Imaemishi* (Biographical Study of the Officer who supervised the Building of Tōdaiji). Yoshikawa Kōbunkan, 1963.

UEHARA, Kazu. *Tamamushi no Zushi no Kenkyū* (Studies on Tamamushi no Zushi). Nihon Gakujutsu Shinkōkai, 1964.

CHAPTER 19

ADACHI, Yasushi (i.e., Kō), and KISHI, K. *Fujiwara-kyō-shi Densetsushi Takadono no Kenkyū* (Studies on the Imperial Palace in the Fujiwara Capital). 2 vols. Reports of Nihon Kobunka Kenkyūjo, 1936, 1941.

FUKUYAMA, Toshio. *Daigokuden no Kenkyū* (Studies on Daigokuden or the Throne Hall in the Heian Palace). Heian Jingū, 1956.

Heian Tsūshi (History of the City of Kyōto). City Authority of Kyōto, 1895.

Heijōgū-shi (Site of the Heijō Palace). Committee for Protection of Cultural Properties, 1957.

Heijōgū-shi (Site of the Heijō Palace), I, *Den-Asuka Itabuki no Miya-shi Hakkutsu Hōkoku* (Excavation Report of Asuka Itabuki Palace in the Legent). Research Institute of Cultural Properties, Nara, 1961.

Heijōgū-shi Hakkutsu Hōkoku (Excavation Reports of the Site of Heijō Palace), II–IV, to be continued. Research Institute of Cultural Properties, Nara, 1962–6.

HIGO, Kazuo. *Ohtsukyō-shi no Kenkyū* (Studies on the Ohtsu Capital). Bunsendō-shoten, 1940.

Hōryūji Tōin ni okeru Hakkutsu Chōsa (Excavation Report in Tōin of Hōryūji). National Museum in Tōkyō, 1948.

MORI, Osamu. *Heian-jidai Teien no Kenkyū* (Studies on the Gardens in the Heian Period). Kuwana Bunseidō, 1945.

MURAYAMA, Shūichi. *Heian-kyō* (The Capital of Heian). Shibundō, 1958.

SEKINO, Tadashi. *Heijōkyō oyobi Daidairi Kō* (Studies on Heijō Capital and its Palace) (*Transactions of the Tōkyō Imperial University, School of Technology*, III). 1907.

SUGIYAMA, Shinzō. *In-no Gosho to Midō* (Ex-emperors' Palaces and their Buddhist Chapels). Research Institute of Cultural Properties in Nara, 1962.

TAKAI, Teizaburō. *Hitachi no Kuni, Nūbarigun Jōdaiiseki no Kenkyū* (Studies on the Ancient Sites in

Niibari County, present Ibaragi Prefecture). Kuwana Bunseidō, 1944.
TAMURA, Tsuyoshi. *Sakuteiki* (a study of *Sakuteiki*, a guide book on gardening in the Heian period). Sagami Shobō, 1964.

CHAPTER 20

Committee for Protection of Cultural Properties (ed.). *Byōdōin Zufu* (Pictorial Record of Byōdōin). 2 vols. 1958.
Committee for Protection of Cultural Properties (ed.). *Daigoji Gojū-no-tō Zufu* (Pictorial Record of the Five Storied Pagoda of Daigoji). Benridō, 1961.
Committee for Protection of Cultural Properties (ed.). *Muryōkōin-shi* (The Site of Muryōkōin). Yoshikawa Kōbunkan, 1954.
Committee for Protection of Cultural Properties (ed.). *Taimadera Mandara-dō Zufu* (Pictorial Record of Mandara-dō in Taima-dera). Benridō, 1963.
FUJISHIMA, Gaijirō (ed.). *Hiraizumi: Mōtsuji to Kanjizaiohin no Kenkyū* (Studies on Hiraizumi: Mōtsuji and Kanjizaiohin). Tōdai Shuppankai, 1961.
FUKUYAMA, Toshio. *Byōdōin to Chūsonji* (Byōdōin and Chūsonji) (*Nihon no Bijutsu*, IX). Heibon-sha, 1964.
FUKUYAMA, Toshio, and MORI, T. *Byōdōin Zukan* (Pictorial Record of Byōdōin). Kuwana Bunseidō, 1944.
ISHIDA, M (ed.). *Chūsonji Takiyō* (Pictorial Record of Chūsonji). Ōtsuka Kōgeisha, 1941.
KUDŌ, Yoshiaki, and others. *Amidadō to Fujiwara Chōkoku* (Hall of Amitabha and Sculptures in the Fujiwara Period) (*Genshoku Nihon no Bijutsu*, VI). Shōgakukan, 1969.
KURATA, Bunsaku. *Mikkyō Jiin to Jōgan Chōkoku* (Buddhist Tempes of Esoteric Sect and Sculptures in the Jōgan Period) (*Genshoku Nihon no Bijutsu*, V). Shōgakukan, 1969.
MORI, Osamu, and KOBAYASHI, T. *Jōruriji*. Rokumeisō Shuppanbu, 1957.
MURATA, Jirō. 'Hōoh-dō of Byōdō-in', *Japan Architect*, December 1957.
MURATA, Jirō. 'The Phoenix Hall at the Byōdō-in', *Japan Architect*, January/February, March, April, 1962.
MURATA, Jirō. 'The Amitabha Hall at Hōkaiji', *Japan Architect*, May, June, 1963.
MURATA, Jirō. 'The Five Storied Pagoda at Daigoji', *Japan Architect*, July, August, 1963.
ŌMORI, Kenji. 'Main Hall of the Jōruriji', *Japan Architect*, January 1964.
TAKADA, Osamu. *Daigoji Gojū-no-tō Hekiga* (Wall Paintings of the Five Storied Pagoda in Daigoji). Yoshikawa Kōbunkan, 1959.

CHAPTER 21

FUKUYAMA, Toshio. 'Kasuga Taisha Shrine', *Japan Architect*, January 1958.
Hihō Itsukushima (Treasures of Itsukushima Shinto Temple). Kōdansha, 1967.
MIYAJI, Naoichi. *Shindō Ronkō* (Studies on Shinto Religion). Kokin Shoin, 1942.
Nihon no Yashiro (Shinto Temples in Japan). Shōkokusha, 1962.
MURATA, Jirō. 'Mioya Shrine of Kamo', *Japan Architect*, December 1962.
ŌMORI, Kenji. 'The Iwashimizu Hachiman Shrine', *Japan Architect*, September, October, 1964.
ŌMORI, Kenji. 'The Main Hall of Ujigami Shrine', *Japan Architect*, December 1964.
ŌMORI, Kenji. 'The Ujigami Shrine Worship Hall', *Japan Architect*, January 1965.
ŌMORI, Kenji. 'The Seiryūdō Worship Hall of Daigoji', *Japan Architect*, March 1966.

CHAPTER 22

Chōgen Shōnin no Kenkyū (Studies on the Monk Chōgen). Nanto Bukkyō Kenkyūkai, 1955.
ITŌ, Nobuo. *Chūsei Wayō Kenchiku no Kenkyū* (Studies of Wayō Architecture in the Medieval Period). Shōkokusha, 1961.
ITŌ, Nobuo. 'The Nandaimon of the Tōdaiji Monastery', *Japan Architect*, May 1957.
ITŌ, Nobuo, and KOBAYASHI, T. *Chūsei Jiin to Kamakura Chōkoku* (Medieval Buddhist Temples and Sculptures in the Kamakura Period) (*Genshoku Nihon no Bijutsu*, IX). Shōgakukan, 1968.
KUDŌ, Yoshiaki. *Kaijūsenji*. Chūohkōron Bijutsu Shuppan, 1968.
MORITA, Keiichi. 'Buddhist Temple Rengeōin', *Japan Architect*, October 1956.
MURATA, Jirō. 'The Main Hall of Daihōonji Temple', *Japan Architect*, June, July, 1962.
MURATA, Jirō. 'The Pagoda of Ishiyama-dera', *Japan Architect*, November 1962.
ŌMORI, Kenji. 'The Great South Gate of Tōdaiji', *Japan Architect*, May 1965.
ŌTA, Hirotarō. *Chūsei no Kenchiku* (Medieval Architecture). Shōkokusha, 1957.
ŌTA, Hirotarō, and others. *Zendera to Ishiniwa* (Zen Temples and Stone Gardens) (*Genshoku Nihon no Bijutsu*, X). Shōgakukan, 1969.

CHAPTER 23

KAWAKAMI, Mitsugu. *Shinden-zukuri kara Shoin-zukuri e* (From Shinden Style to Shoin Style) (*Sekai Kenchiku Zenshū*, II). Heibon-sha, 1960.
KAWAKAMI, Mitsugu. *Nihon Chūsei Jūtaku no Kenkyū* (Studies on Medieval Residences in Japan). Bokusui Shobō, 1967.

CHAPTER 24

1. Residences

FUJIOKA, Michio. *Kyōto Gosho* (The Imperial Palace in Kyōto). Shōkokusha, 1956.
FUJIOKA, Michio. *Shiro to Jōkamachi* (Castles and Castle Towns). Sōgen-sha, 1955.
FUJIOKA, Michio. *Shiro to Shoin* (Castles and Shoin) (*Genshoku Nihon no Bijutsu*, XII). Shōgakukan, 1969.
FUJIOKA, Michio. *Shiro to Shoin* (Castles and Shoin) (*Nihon no Bijutsu*, XVI). Shōgakukan, 1971.
FUJIOKA, Michio. *Kinsei Kenchiku-shi Ronshū* (Studies on Late Medieval Architecture). Chūohkōron Bijutsu Shuppan, 1969.
FUJIOKA, Michio. *Katsura Rikyū* (The Katsura Villa). Chūohkōron Bijutsu Shuppan, 1965.
FUJIOKA, Michio. *Sumiya*. Shōkokusha, 1955.
FUJIOKA, Michio. 'Chōshūkaku in Sankei-en Garden', *Japan Architect*, October 1957.
FUJIOKA, Michio. 'Rinshun Pavilion', *Japan Architect*, August 1958.
FUJIOKA, Michio. 'The Katsura Detached Palace', *Japan Architect*, July-September 1965.
FUJIOKA, Michio. 'The Sumiya', *Japan Architect*, August 1966.
FUJIOKA, Michio, and TSUNENNARI, K. *Shoin* (Shoin Halls). 2 vols. Sōgensha, 1969.
HIRAI, Kiyoshi. *Nihon no Kinsei Jūtaku* (Residences in Late Medieval Japan). Kajima Shuppankai, 1968.
HISATSUNE, Hideharu. *Katsura Rikyū* (The Katsura Villa). Shinchōsha, 1962.
HORIGUCHI, Sutemi. *Katsura Rikyū* (The Katsura Villa). Mainichi Shinbun-sha, 1952.
ITŌ, Teiji. *Chūsei Jūkyo-shi* (History of the Medieval House). Tōdai Shuppankai, 1958.
KAWAKAMI, Mitsugu. *Kinkaku to Ginkaku* (Golden Pavilion and Silver Pavilion). Tankōshin-sha, 1964.
KAWAKAMI, Mitsugu. *Zen-in no Kenchiku* (The Monks' Residences in the Zen Temples). Kawara Shoten, 1968.
KAWAKAMI, Mitsugu, and NAKAMURA, Masao. *Katsura Rikyū to Chashitsu* (Katsura Villa and Tea Houses) (*Genshoku Nihon no Bijutsu*, XV). Shōgakukan, 1967.

KITAO, Harumichi. *Kokuhō Shoin Zushū* (Pictorial Books of Shoin). 13 vols. Kōyōsha, 1938-40.
MORI, Osamu. *Shūgaku-in Rikyū no Fukugen-teki Kenkyū* (A Study on the Restoration of the Shūgaku-in Villa). Yōtokusha, 1954.
MORI, Osamu. *Katsura Rikyū* (The Katsura Villa). Tōto Shuppansha, 1955.
MORI, Osamu. *Chūsei Teien Bunka-shi* (The Cultural History of Gardens in the Medieval Period). Research Institute of Cultural Properties in Nara, 1959.
MURATA, Jirō. 'The Kōjō-in Pavilion at the Onjōji', *Japan Architect*, May 1962.
MURATA, Jirō. 'The Golden Pavilion', *Japan Architect*, March, April, 1963.
MURATA, Jirō. 'The Taishidō of the Kyōohgokokuji', *Japan Architect*, September 1963.
MURATA, Jirō. 'The Shoin in the Manjuin', *Japan Architect*, October, November, 1963.
MURATA, Jirō, and others. *Kyōto Gosho* (The Imperial Palace in Kyōto). Tankōshinsha, 1962.
ŌKAWA, Naomi. 'The Imanishi House in the Town of Imai', *Japan Architect*, July 1959.
ŌKUMA, Yoshikuni. *Doro-e to Daimyō Yashiki* (Painting in Distemper and the Feudal Lords' Mansions). Ohtsuka-Kōgei-sha, 1939.
ŌMORI, Kenji. 'Audience Hall and Shiro Shoin of the Nishi Honganji', *Japan Architect*, March 1964.
ŌMORI, Kenji. 'The Ryōgin-an Hōjō of the Tōfukuji', *Japan Architect*, April 1964.
ŌMORI, Kenji. 'The Silver Pavilion of Jishōji', *Japan Architect*, November 1965.
Rakuchū Rakugai Zu (Paintings in and outside Kyōto), ed. National Museum in Kyōto. Kadokawa Shoten, 1966.
WATSUJI, Tetsurō. *Katsura Rikyū* (The Katsura Villa). Chūohkōron-sha, 1958.

2. Tea-houses

Cha to Kenchiku to Niwa (The Tea Cult, its Architecture, and Gardens) (*Zusetsu Sadō Taikei*, IV). Kadokawa Shoten, 1962.
Chashitsu Okoshi Ezu (Collection of Tilt-up Plans of Tea Houses), ed. Sutemi Horiguchi. 12 vols. Bokusui Shobō, 1963-7.
FURUTA, Shōkin. 'Philosophy of Chashitsu (or Tea Room)', *Japan Architect*, January-May, July-October, December, 1964.
HAYAKAWA, Masao. 'Space in the Tea-House Style', *Japan Architect*, June 1964.
HORIGUCHI, Sutemi. *Kusaniwa* (Grass Gardens). Chikuma Shobō, 1967.
HORIGUCHI, Sutemi. *Rikyū no Chashitsu* (Tea Houses of Rikyū). Kajima Shuppankai, 1968.
HORIGUCHI, Sutemi. *Rikyū no Cha* (The Tea Cult of

Rikyū). Iwanami Shoten, 1951.

HORIGUCHI, Sutemi. *Chashitsu Kenkyū* (Studies on the Tea House). Kajima Shuppankai, 1969.

ITō, Teiji. 'The Katsura Villa', *Japan Architect*, November 1956.

ITō, Teiji, and others. *Shakkei to Tsubo-niwa* ('Borrowed Scenery' and Court-type Gardens). Tankōshin-sha, 1965.

KITAO, Harumichi. *Sukiya Shūsei* (Collection of *Sukiya*). 20 vols. Kōyōsha, 1935–8.

KITAO, Harumichi. *Sukiya zukai Jiten* (Illustrated Dictionary of *Sukiya*). Shōkokusha, 1959.

MORI, Osamu. *Kobori Enshū no Sakuji* (Design Activities of Enshū). Research Institute of Cultural Properties in Nara, 1966.

MORI, Osamu. *Kobori Enshū* (Biographical Study of Kobori Enshū). Yoshikawa Kōbunkan, 1967.

MORI, Osamu. *Teien to sono Tatemono* (Gardens and Pavilions) (*Nihon no Bijutsu*, XXXIV). Shibundō, 1969.

MURATA, Jirō, and others. *Chashitsu* (Tea House). Tankō Shinsha, 1959.

NAKAMURA, Masao. *Cha no Kenkyū* (A Study of the Tea Cult). Kawara Shoten, 1968.

NAKAMURA, Masao. *Chashitsu no Kenkyū* (Studies on the Tea House). Bokusui Shobō, 1971.

NAKAMURA, Masao. *Chashō to Kenchiku* (Tea Masters and Architecture). Kajima Shuppankai, 1971.

ōTA, Hirotarō. 'Historical Comments on Rikyū and Tea-room, Tai-an', *Japan Architect*, August 1957.

'The Shunsōro in the Sankei-en Garden', *Japan Architect*, April 1959.

'Tōshintei Tea House', *Japan Architect*, November 1957.

3. Castles and Towns

FUJIOKA, Michio. *Nihon no Shiro* (Castles in Japan). Shibundō, 1960.

HARADA, Tomihiko. *Nihon Hōken Tojō* (The Castle Town in Feudal Japan). Tōdai Shuppankai, 1957.

IWAO, Seiichi. *Nanyō Nihonjin-machi no Kenkyū* (Studies on the Japanese Colonies in South Asia). Iwanami Shoten, 1966.

KIDO, Hisashi. *Nagoya-jō* (Nagoya Castle). Shōkokusha, 1943.

KOMURO, Eiichi. *Chūsei Jōkaku no Kenkyū* (Studies of Medieval Castles). Jinbutsu Ōraisha, 1965.

Nagoya-jō (Nagoya Castle), ed. City of Nagoya. Shōkokusha, 1953.

NAITō, Akira. *Edo to Edo-jō* (The City of Edo and its Castle). Kajima Shuppankai, 1966.

Nihon Jōkaku Zenshū (Collected Pictorial Records of Japanese Castles). 10 vols. Nihon Jōkaku Kyōkai, 1960–1.

OKAWA, Naomi. 'Matsumoto Castle', *Japan Architect*, September 1957.

ōMORI, Kenji. 'The Hikone Castle Dungeon', *Japan Architect*, March, April, 1965.

ōMORI, Kenji. 'The Himeji Castle Dungeon', *Japan Architect*, April, May, 1966.

Ōsaka-jō no Kenkyū (Studies on Ōsaka Castle), ed. The City University of Ōsaka, Ōsaka-jōshi Kenkyūkai, 1959.

ONO, Hitoshi. *Kinsei Jōkamachi no Kenkyū* (Studies of Late Medieval Castle Towns). Shibundō, 1928.

SAWASHIMA, Eitarō, and others. *Nijō-jō* (Nijō Castle). Sagami Shobō, 1942.

Shiro, ed. Shōkokusha Publishing Co. 1970.

TOBA, Masao. *Kinsei Jōkaku-shi Kenkyū* (Studies of Late Medieval Castles). Nihon Jōkaku Kyōkai, 1962.

4. Others

KIDO, Hisashi. *Shizutani-kō* (The Shizutani School of the Feudal Clan). Chūohkōron Bijutsu Shuppan, 1968.

MATSUZAKI, Shigeru. *Nihon Nōson Butai no Kenkyū* (Studies on the Village Theatre in Japan). 1967.

SUDA, Atsuo. *Nihon Gekijō-shi no Kenkyū* (Studies on the History of Japanese Theatre). Sagami Shobō, 1957.

CHAPTER 25

HARYū, Ichirō. 'The Tōshōgū at Nikkō', *Japan Architect*, June 1964.

KOBAYASHI, Bunji. 'Buddhist Halls of the Rakan-ji in Edo', *Japan Architect*, January/February 1967.

MURATA, Jirō. 'The Main Hall and West Gate of Kiyomizu-dera', *Japan Architect*, October 1962.

MURATA, Jirō. 'The Karamon of Daigo-ji', *Japan Architect*, December 1963.

ōKAWA, Naomi. *Katsura to Nikkō* (Katsura Villa and Nikkō Burial Temple) (*Nihon no Bijutsu*, XX). Heibonsha, 1964.

ōMORI, Kenji. 'The Iwashimizu Hachiman Shrine', *Japan Architect*, September, October, 1964.

TANABE, Yasushi. *Nikkō-byō Kenchiku* (Nikkō Burial Temple Architecture). Shōkokusha, 1944.

TANABE, Yasushi. *Tokugawake Reibyō* (The Burial Temples of the Tokugawa Families). Shōkokusha, 1942.

LIST OF ILLUSTRATIONS

Itsukushima shrine

89. Sūtras written on Painted Fans, By a Well, late Heian period. H. *c.* 23cm: 9¼in. *Shitennōji* (Asukaen, Nara)

90. Legends of Mount Shigi, The Flying Storehouse (detail), late Heian period. H. *c.* 31cm: 1ft ¼in. *Chōgosonshiji*

91. Abbot Toba (attr.): Animal caricatures, a monkey worshipping a frog (detail), late Heian period. H. *c.* 30cm: 1ft. *Kōzanji*

92. Abbot Toba (attr.): Animal caricatures, a frog throwing a hare, late Heian period. H. *c.* 30cm: 1ft. *Kōzanji*

93. Hungry Demons, Water Offering, Kamakura period. H. *c.* 27cm: 10¾in. *The Commission for the Protection of Cultural Properties* (University Prints, Newton, Mass.)

94. Wasp Hell, Kamakura period. H. *c.* 27cm: 10½in. *The Commission for the Protection of Cultural Properties*

95. Scroll of Diseases, the Man with Loose Teeth, Kamakura period. H. *c.* 26cm: 10¼in. *Sekido Collection (formerly)*

96. Takanobu (1142–1205): Portrait of Yoritomo, Kamakura period. H. *c.* 139cm: 4ft 6¾in. *Jingoji* (Asukaen, Nara)

97. The Adventures of Kibi in China (detail), Kamakura period. H. *c.* 32cm: 1ft ⅝in. *Boston, Museum of Fine Arts*

98. Life of Michizane (detail), Kamakura period, 1219(?). H. *c.* 52cm: 1ft 8½in. *Kitano shrine*

99. Legends of the Kegon Sect, Gangyō preaching (detail), Kamakura period. H. *c.* 30cm: 1ft. *Kōzanji*

100. Nobuzane: Thirty-six Poets, Kintada, Kamakura period. H. *c.* 28cm: 11in. *Washington, Smithsonian Institution, Freer Gallery of Art*

101. Imperial Bodyguards (detail), Kamakura period, 1247. H. *c.* 29cm: 11¼in. *Ōkura Shūkokan Collection*

102. A Fast Bullock, Kamakura period. H. *c.* 31cm: 1ft ¼in. *Seattle Art Museum*

103. Tales of the Heiji Insurrection, Burning of the Sanjō Palace (detail), Kamakura period. H. *c.* 41cm: 1ft 4¼in. *Boston, Museum of Fine Arts*

104. Eni: Life of Ippen (detail), Kamakura period, 1299. H. *c.* 38cm: 1ft 3in. *Kangikōji*

105. Life of Hōnen (detail), Kamakura period. H. *c.* 33cm: 1ft ⅞in. *Chionin*

106. Tales of Saigyō (detail), Kamakura period. H. *c.* 32cm: 1ft ½in. *Reimeikai Foundation*

107. Boki Eshi (detail), Kamakura period. H. *c.* 30cm: 1ft. *Nishi Honganji*

108. Mokuan: Hotei, fourteenth century. H. *c.* 114cm: 3ft 9in. *Sumitomo Collection*

109. Ryōzen: White Heron, fourteenth century. H. *c.*

35cm: 1ft 1⅞in. *Nagatake Asano Collection*

110. Chō Densu: Shōichi, the National Master, Muromachi period. H. *c.* 255cm: 8ft 4½in. *Tōfukuji*

111. Josetsu: The Three Teachers, Muromachi period. H. *c.* 57cm: 1ft 10⅜in. *Ryōsokuin*

112. Shūbun: Studio of the Three Worthies, Muromachi period, 1418. H. *c.* 102cm: 3ft 4in. *Tōkyō, Seikadō Foundation*

113. Jasoku (d. 1483): Portrait of Lin-chi, Muromachi period. H. *c.* 87cm: 2ft 10¼in. *Yōtokuin*

114. Zōsan: Eight Views at the Confluence of the Hsiao and Hsiang Rivers, Muromachi period. H. *c.* 158cm: 5ft 2⅜in. *Boston, Museum of Fine Arts*

115. Sesshū (1420–1506): Winter Landscape, Muromachi period. H. *c.* 46cm: 1ft 6¼in. *Tōkyō National Museum*

116. Sesshū (1420–1506): Ink-Splash Landscape, Muromachi period, 1495. H. *c.* 149cm: 4ft 10¾in. *Tōkyō National Museum*

117. Shūkō: Monkeys, Muromachi period, late fifteenth century. H. *c.* 97cm: 3ft 2¼in. *Boston, Museum of Fine Arts*

118. Shūgetsu: Wild Goose and Reeds, Muromachi period, late fifteenth century. H. *c.* 100cm: 3ft 3⅜in. *Zenjurō Watanabe Collection*

119. Sesson (*c.* 1504–89): Hawk on Pine Tree, Muromachi period. H. *c.* 127cm: 4ft 1⅞in. *Tōkyō National Museum*

120. Nōami (1397–1494): The Pines of Miho, Muromachi period. H. *c.* 155cm: 5ft 1in. *Formerly Shūzō Kuki Collection*

121. Kei Shoki (d. 1523): Daruma, Muromachi period. H. *c.* 93cm: 3ft ½in. *Nanzenji*

122. Masanobu (*c.* 1434–*c.* 1530): Crane, Muromachi period. H. *c.* 157cm: 5ft 1¾in. *Shinjuan*

123. Motonobu (1476–1559): The Story of Hsiang-yen, Muromachi period. H. *c.* 212cm: 6ft 11⅜in. *Tōkyō National Museum*

124. Anon.: Moon Landscape, late Muromachi period. H. *c.* 148cm: 4ft 10½in. *Tōkyō National Museum*

125. Hideyori: Maple Viewing at Takao, late Muromachi period. H. *c.* 149cm: 4ft 10½in. *Tōkyō National Museum*

126. Eitoku (1543–90) (attr.): Cypress Trees, Momoyama period. H. *c.* 170cm: 5ft 7in. *Tōkyō National Museum*

127. Eitoku (1543–90): Chao Fu and his Ox, Momoyama period. H. *c.* 125cm: 4ft 1⅜in. *Tōkyō National Museum*

128. Yūshō (1533–1615): Plum Tree, Momoyama period. H. *c.* 137cm: 4ft 5⅝in. *Kenninji*

129. Yūshō (1533–1615): Fishing Nets, Momoyama period. H. *c.* 160cm: 5ft 3in. *Imperial Household Collection*

Museum of Fine Arts

173. Harvesting shelter, traditional modern
174. Dōtaku (detail; redrawn). *Ōhashi Collection*
175. Mirror back from Nara Prefecture, fifth century. Bronze. *Imperial Household Department* (Takahashi Photo Service, Chūō-Ku, Tōkyō)
176. Ise, inner shrine, sanctuary, traditional since the third century (Japan Information Centre)
177 and 178. Pottery house models from Gumma Prefecture, fifth century. *Tōkyō National Museum* (Harada Jirō and the Tōkyō National Museum)
179. Izumo shrine, sanctuary, traditional (last rebuilt in 1744) (Asukaen, Nara)
180. Reconstructions of early monasteries: (A) and (B) Shitennōji; (C)Yakushiji (redrawn by A. Soper)
181. Hōkōji, plan (from the report of the excavations, redrawn by Paul White)
182. Hōryūji: (A) and (C) reconstructions of original buildings; (B) and (D) plans of present buildings (redrawn by A. Soper)
183. Hōryūji, courtyard nucleus from the south-east, seventh century
184. Hōryūji, middle gate, seventh century
185. Hōryūji, lecture hall, tenth century
186. Hōryūji, sūtra library, eighth century
187. Hōryūji, refectory complex, eighth century
188. Hōryūji, Yumedono chapel, eighth century
189. Tōdaiji, reconstruction of original nucleus: (A) general plan; (B) block plan for scale comparison with other monasteries (redrawn by A. Soper)
190. Tōdaiji, Daibutsuden or 'great Buddha hall', second rebuilding *c.* 1700 (B. Kobayashi)
191. Tōdaiji, Shōsōin storehouse, eighth century.
192. Hōryūji, veranda corridor
193. Kairyūōji, west kondō, detail of end wall, eighth century
194. (A) Tōshōdaiji, kondō or 'golden hall', with present roof and reconstruction of original roof; (B) Hai-hui-tien of Hua-yen-ssu, China (redrawn by A. Soper)
195. The Tamamushi shrine, seventh century. *Hōryūji* (The late Professor Amanuma Shunichi, Kyōto University)
196. (A) Hōryūji, kondō; (B) Tōdaiji, Hokkedō (redrawn by A. Soper)
197. Hōryūji, kondō or 'golden hall', seventh century, interior from the south-west
198. (A) to (E) schematic development of bracketing (redrawn by A. Soper); (F) engraving from a lintel of the Ta-yen pagoda at Hsi-an-fu, China (redrawn by P. J. Darvall)
199. Hōryūji, kondō, eaves bracketing (redrawn by A. Soper
200. Hōryūji, middle gate, seventh century, detail of corner

201. Hōryūji, kondō, seventh century, eaves bracketing and railing (Asukaen, Nara)
202. Hōrinji, pagoda, seventh century (Asukaen, Nara)
203. Yakushiji, east pagoda, eighth century, eaves bracketing (redrawn by A. Soper)
204. Yakushiji, east pagoda, eighth century
205. Tōdaiji, Hokkedō or Sangatsudō, eighth century, interior from the south-west
206. Tōshōdaiji, kondō, eighth century, interior from the east (The late Professor Amanuma Shunichi, Kyōto University)
207. Tōshōdaiji, kondō, eighth century, front (Asukaen, Nara)
208. Tōshōdaiji, kondō, eighth century, detail of south-west corner
209. Tōshōdaiji, kondō, eighth century, eaves bracketing (redrawn by A. Soper)
210. Tōshōdaiji, kondō, eighth century, ceiling
211. Kyōto, imperial palace compound, plan showing the imperial residence (Kōkyo) and the Chōdōin and Burakuin (redrawn by P. J. Darvall)
212. Kyōto, imperial palace, plan of the Chōdōin (redrawn by P. J. Darvall)
213. Buddhist Ceremony in front of the Heian Hall of State (Daigokuden), Kyōto, from the picture-scroll *Nenjū-gyōji*, copy of a twelfth-century original (Harada Jirō and the Tōkyō National Museum)
214. Kyōto, buildings of the Heian Jingū, reproducing the Heian Hall of State, nineteenth century (Japan Information Centre)
215. Kyōto, Kōkyo (imperial residence), block plan (Professor Sekino Masaru, Tōkyō University, redrawn, by P. J. Darvall)
216. Kyōto, Kōkyo (imperial residence), plan of the central buildings (redrawn by P. J. Darvall)
217. Kyōto, imperial palace, Shishinden, nineteenth-century rebuilding (Japan Information Centre)
218. Kyōto, imperial palace, Shishinden, nineteenth-century rebuilding, front veranda (hisashi)
219. Kyōto, imperial palace, Shishinden, nineteenth-century rebuilding, throne chamber (Professor Sekino Masaru, Tōkyō University)
220. Kyōto, imperial palace, Seiryōden seen from the rear of the Shishinden, nineteenth-century rebuilding
221. Kyōto, imperial palace, Seiryōden, interior
222. Ceremony in the courtyard of the Shishinden, Kyōto, seen from the east, from the picture-scroll *Nenjū-gyōji* (Harada Jirō and the Tōkyō National Museum)
223. Mansion of Fujiwara no Toyonari, reconstruction (Professor Sekino Masaru, Tōkyo University)

INDEX

References to the Notes are given only where they indicate matters of special interest or importance: such references are given to the page on which the note occurs, followed by the number of the chapter to which it belongs, and the number of the note. Thus 448(21)⁵ indicates page 448, chapter 21, note 5.